GW01402910

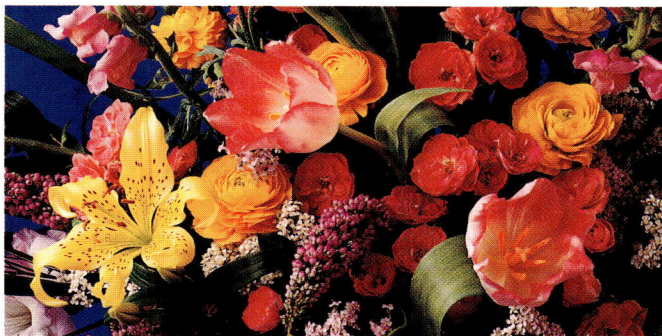

Design With Flowers®

The Trendsetter For

Creative Floral Design

Floral design communicates the vibrancy of life. By combining colors, forms and textures with unique artistic ability, a designer adds the encore to the magnificent handiwork of Mother Nature.

Each time a singer performs, the artist embellishes the musical works of a great composer with incomparable personal interpretation. In like manner, the floral artist adds that essential, unequaled touch of originality when combining the masterworks of Mother Nature into a design of flowers.

In this Premiere Edition of Design With Flowers, you will examine over 200 works of the most talented floral artists in the world of contemporary floral design. Each design is a masterpiece. It communicates the heart and the soul of the artist who created it.

As you study the works of master craftspeople, whether the medium is flowers, paints, music, dance, sculpture, a garden or a fabric, you become more enlightened because you have touched the life and the creative spirit of another individual. In this experience of exploring and gaining new insight, you develop a broadened perspective of creativity.

Seldom do you find creativity through isolation of self. In the community of others, you discover the inspiration to become the very best you can be by stretching and expanding your unique talents and strengths.

The Art, The Understanding, The Expression Of Floral Design

To become a talented floral designer, you must make a commitment to lifelong learning. No designer ever knows everything there is to know about floral design. When you make a commitment to excellence—you pledge to be the very best you can possibly be. This requires becoming a student again and again—every time you have an opportunity to explore the new. Through this learning, you develop a constant appetite for change and growth.

The phrase "art of floral design" implies a bewildering variety of meanings. To some, the art of floral design refers to skill—the technical know-how and the adeptness in using these skills. Others understand the art of floral design to mean beauty—the sensual quality of materials such as color and shape. The art of floral design is often explained based on the ordering and harmonizing of materials—how materials are combined and presented in a design.

Some see the art of floral design as self-expression through which the artist communicates his personal views. Others look upon the art of floral design as a method for creating an immediacy of emotional response—the "Wow! It's magnificent!" reaction.

Floral design is therapeutic. Some gain profound personal pleasure from working with flowers and creating a design that pleases them. Often these floral artists are oblivious to what others think since they enjoy the process of producing something they find personally fulfilling.

Just as floral designing can be therapeutic to the creator, it is therapeutic to the recipient. Flowers soften the sorrow and comfort the living in times of personal trauma. Flowers soothe the discomfort of illness. Because they are full of life and symbols of life itself, flowers celebrate the joyous occasions of living. Flowers court romance. They bring the beauty of love into the relationships of those who journey through life together.

The art of creating designs with flowers is a bonding of doing and showing feeling. The doing cannot be divorced from the feeling; otherwise, a design is no more than an amalgamation of various materials that an insensitive robot could assemble. Without the feeling, the unique perspective of the person who creates, art is not art. The outcomes are no more than mechanical processes.

Individuals with artistic temperaments, who use flowers as their medium of creative expression, approach floral design from three distinct viewpoints.

Some floral designers create through imitation. This is not a disparaging comment. Many great artists learn their art through imitation. From this method of education, they discover the basics of design. This inceptive step empowers them with the ability and confidence to develop their unique approach to creativity.

A floral designer proficient in imitation can copy a design and do it as well as the original. Copying is a form of creativity. There is an element of ingenuity in following a pattern just as there is inventiveness in creating the pattern.

There is danger, however, in becoming a creative imitator. Nothing you copy is ever a faithful expression of your personal creative feelings. The design imitator simply duplicates both the style and the feeling of the originator.

A second method of creativity used by many skilled floral designers is innovation. The innovator is sparked by something he or she experiences and then expounds on this experience.

Most professional floral designers and amateur flower arrangers, use the innovation approach to creativity. The creative stimulus is seeing and experiencing a floral design and then interpreting it with a unique, individual style.

Creative innovators have a need, even an insatiable urge to change. No matter what they see, they immediately envision a way of expressing the idea differently. Through the years, I have worked with thousands of floral designers. I have found that the more distinguishing creativity an individual possesses, the less satisfied the artist is with the usual or the norm. The creative spirits of a truly innovative designer live outside these boundaries. What the innovator sees and experiences are the sources of inspiration for these talented artists. Nevertheless, this designer must add his or her unique brush strokes when adapting and expressing the idea.

The third approach to creativity is pure imagination. This method resides in those few floral artists who experience pictures in their minds. Whenever these uniquely talented designers see flowers, they immediately picture a way to present them creatively. These imaginative artists don't seek or need outside stimulation to spark their imaginations. They have an inborn creative generator. When you mention a need, a thought or a germinating idea, he or she without hesitation sees many ways to articulate it with flowers.

Truly imaginative floral designers often live in a dangerous world of criticism. Since they originate so many ideas, they could be labeled as "far out." Every imaginative artist has some far out ideas—this is an important characteristic of the breed. When you study the works of Picasso, who some art authorities consider to be one of the most imaginative painters, you review a wide diversity of styles—some very unconventional. Though the imaginative flower artist can communicate in many different styles of design, some of the creations will be controversial—loved by some, hated by others.

Talented and qualified floral designers express two differing views about the use of materials in a floral composition. One position states that materials should dictate the form of the design. Artists who work from this perspective are masters in free-form composition. The placement of a stem of flowers or other material is determined by the natural form of the item. A curving stem is placed to highlight the naturalness of this characteristic. Artists who believe that the inherent features of materials should be emphasized have a lenient attitude about structured form.

The opposite point of view states that the form of the floral composition is the most important characteristic. Therefore, all materials must be adjusted to conform to the predetermined form of the design. The Classical Triangle, Classical Horizontal, Classical Fan-Shape and all other Classical and formal configurations in floral design are examples of form dictated design. The beauty of these designs is not so much the distinction of the materials as the perfection of the composition form.

Contemporary floral design emerges from a rich, centuries-old heritage. It is appropriate that we begin this Premiere Edition of Design With Flowers® with a brief history of flower arrangement. Methods for teaching and learning the art of floral design have changed drastically in the past decade. The Elements And Principles Of Design Method that places all emphasis on technique has been superseded with The Design Process that focuses first on The Idea and then teaches how to express this idea creatively. This Premiere Edition includes complete information about The Design Process©, the 21st Century Method of design education.

Experience the wonderful personal fulfillment and rewards that are yours when you unleash the full measure of your creativity. Gain inspiration and insight from each floral design you explore. Don't criticize. Instead, ask, "What can I do to learn from this experience?" Unleashing your creativity is a process of searching, experiencing, learning and application.

Intrinsic to the life of all creative floral designers are two complementary needs: a need for making order out of experience, and the need for disorder—experiencing the unexpected. As dissimilar as these needs might seem, there is an interconnectedness. For wherever there is art, there is an artist. In the life of every artist, there is the driving urge to learn, to stretch, and to develop to the fullest extent of his or her creative abilities. This internal prodding to change and grow demands experiencing the new and valuing the unexpected. Learning takes place when the disorder of the new—the unexpected—can be put into application. Utilization of what you learn lifts you to a new vision and opportunity to experience the fullness of your creative talents in floral design.

Contents

Design With Flowers®
The Trend Setter For Creative Floral Design
Premiere Edition

Publisher
CRB Publishing, Inc.

Produced by
Herb Mitchell Associates, Inc.
234 E. 17th Street, Suite 202
Costa Mesa, California 92627-3868
714-631-5551 FAX: 714-631-4010

Author and Editor-in-Chief
Herb Mitchell CMC, AIFD

Publishing Production Director
Bob Mitchell

Floral Design Artists In Residence
Dennis Buttelwerth
Haskell Eargle, AIFD
Richard Seekins, AIFD

Contributing Floral Design Artists
Brian Benton
Osamu Honjo, AIFD
Keita Kawasaki
Michael Polychrones, AIFD
Ken Senter, AIFD
Noriko Snelson, AIFD
Perry Walston, AIFD
Matt Wood, AIFD

Creative Director
Janet Murray

Photographers
de Gennaro Associates
Tom Miyasaki
Dennis Skinner
David Wong

Illustrators
Craig McIntosh
Diana Merzoian

Color Separations
Color Service, Inc.
Bob Walters

Published in 1991 by

CRB Publishing, Inc.
4510 Winnetka Avenue
Woodland Hills, CA 91365

ISBN: 0-9627922-1-9

Printed in Hong Kong

The Design With Flowers® Creative Staff

HERB MITCHELL, AIFD, began his career in the floral industry over forty years ago as a floral designer. He is recognized worldwide as a talented floral artist and design authority, a skilled and experienced teacher, commentator, seminar leader and author. He is Past President of The American Institute of Floral Designers, recipient of the AIFD Distinguished Service Award and is a Fellow of AIFD. In 1978 and 1984, Herb was a float judge for the Pasadena Tournament of Roses. Herb was inducted into the Floriculture Hall Of Fame in 1984 honoring his innovative and distinguished service to the floral industry.

BOB MITCHELL grew up in the flower business and is an experienced floral financial management and marketing specialist. Since joining Herb Mitchell Associates in 1984, Bob has become a recognized authority in the design and production of magazines, books, advertising campaigns, audio-visual and video programs used by all segments of the floral industry. His production credits include many of the major magazines and books introduced in the floral trade. Bob was on the creative team and responsible for producing and staging the first National Convention held by American Floral Services.

DENNIS BUTTELWERTH, AAF, an Artist In Residence for Design With Flowers, is owner of Dennis Buttelwerth Florist in Cincinnati, Ohio. For over 30 years, Dennis has been a leading personage in floral design in the United States. He has created the floral designs, planned and produced complete functions for some of the nation's largest weddings, parties and civic events. Dennis has appeared on design programs throughout the nation. His creative work has been featured in the industry's leading design magazines, books, in-shop selling aids and advertising campaigns.

HASKELL EARGLE, AIFD, an Artist in Residence for Design With Flowers, is internationally known for his unique ability to design in any style and with any materials. He has been the featured floral artist on design programs throughout the United States, Mexico, England, Holland and Germany. In 1990, he sold his very successful flower shop in Monroe, North Carolina to devote full time to special projects. Haskell was one of the first floral designers to work on a design team for specialized magazine, book and promotion photography. More than 1,000 of Haskell's designs have appeared in industry publications.

RICHARD SEEKINS, AIFD, an Artist in Residence for Design With Flowers, is a talented and versatile floral artist with over 35 years experience in retailing, wholesaling, importing, product development and creative design for photography. As a designer, commentator and teacher, Richard has appeared on design programs throughout the world. Three times he won the Sweepstakes at prestigious headdress balls. As Floral Director for Pasadena Tournament of Roses float builders, Richard has participated in 14 trophy awards and one Sweepstakes award. He is currently Floral Director for CHRISMA Floats.

5

MICHAEL POLYCHRONES, AAF, AIFD, PFC-I, owner of Michael's Flowers-Springfield, in Springfield, Virginia, is an internationally acclaimed designer, commentator, lecturer and teacher. As one of the most respected talents in the floral industry, he is the recipient of the American Institute of Floral Designers Award of Distinguished Service, the SAF Sylvia Award of Design, the Tommy Bright Award for Commentary Excellence and was a floral judge for the 1988 Pasadena Tournament of Roses. Michael has appeared on many television programs and his design work has been featured in all major design publications.

BRIAN BENTON grew up in the flower business and is one of America's young, talented, emerging floral designers. He is Vice-President of his family business, Flowers By Dick & Son, in Akron, Ohio. Brian has appeared on many design programs and was a finalist in the 1988 FTD America's Cup Competition. In 1987, he was a Bronze Medalist in the AFS Great American Design Contest. He is an Ambassador for Smithers-Oasis Co. A member of the Board of Directors for the Ohio Florist Association, Brian serves on the decorations and retail committees.

PERRY WALSTON, AIFD, is one of America's popular floral artists with expertise in creative design and display. His broad experience as a design consultant to retailers, wholesalers and manufacturers includes comprehensive experience in designing showrooms, establishing floral trends and product lines. Perry was a Bronze Medalist at the 1987 and 1988 AFS Great American Design Contests. He was on the design teams for the 1985 and 1989 Presidential Inaugurations and for American Express at the Winter Olympics in Calgary. Perry's work has appeared in many industry and consumer publications.

KEN SENTER, AIFD is owner of Ken Senter Floral Design School and manages the design room for Chris Lindsay Designs in Costa Mesa, California. He is an experienced specialist in planning and producing flower decorations for large weddings, parties and social events. Ken holds a floriculture degree from Texas A&M University. He was Texas State Designer Of The Year, a finalist in the 1987 and 1988 AFS Great American Design Contest and won the SAF Sylvia Cup in 1986. Ken has designed on programs in 18 states, in Mexico and Indonesia. He is a board member of the American Institute of Floral Designers.

OSAMU HONJO, AIFD, is a brilliant floral artist schooled in Japan and is a 3rd Degree Master with teaching certification from the Ohara School of Ikebana. Osamu owns Floral Decor by Osamu in Glendale, California. He has an extensive list of impressive professional credits—a USA finalist in the 1988 World Cup Competition, Grand Prize Winner in the 1985 Selo Cup Competition, Sylvia Award Winner at the 1984 SAF Convention and FTD America's Cup District Winner in 1984. Osamu consults on design and product development throughout the world. His design work has appeared in major floral publications.

MATT WOOD, AIFD, holds a degree in Retail Floristry Management from Mississippi State University. He owned a retail flower and gift shop prior to opening Matt Wood and Associates in Jackson, Mississippi—a free-lance design and consulting firm serving retail florists, interior design firms and manufacturers. Matt has worked with wholesalers and retailers in presenting design programs, product development and product presentation. He has appeared on design programs throughout the United States and was on the design team for the 1989 Presidential Inauguration.

NORIKO SNELSON, AIFD, graduated from the Seifu-Heika School of Ikebana in Tokyo. Her grandmother and mother were teachers at Seifu-Heika and Sogetsu Schools of Ikebana. Noriko and her husband owned Summertime Florist in El Toro, California, where she was the head designer. She was selected twice as a Southern California Top Designer. Noriko won the St. Jude Award of the Damas De Caridad Headdress Ball. Since selling her flower shop, she is a free-lance floral artist and works on special creative design assignments.

DIANA MERZOIAN, AIFD, is a multi-talented artist. As a floral designer, Diana is well-known for her unique abilities in working with flowers. She is also a commercial and commission fine artist. In addition to designing limited edition lithographs and greeting cards, Diana is a gifted illustrator. Her illustrations have appeared in Design With Flowers and other floral publications. She owns and operates High Sierra Naturals, a flower growing company and Natural Expressions, a floral brokerage company in Porterville, California.

KEITA KAWASAKI, Guest Artist, is President of Mami Flower Design School in Tokyo. A brilliant young artist and talented instructor in 20th Century Japanese Flower Arrangement, Keita received his fine arts training in the United States and returned to Japan to teach in his mother's floral design school. Keita, like many of his contemporaries, moves away from traditional Ikebana to an interpretive, contemporary style of floral design that allows more room for personal expression. His work is featured in the finest exhibitions in Japan. Keita teaches 20th Century Japanese flower arrangement throughout the world.

CRAIG MCINTOSH holds a degree in Architecture from the University of Oregon. He began his career concentrating in technical architectural drawings while he continued to develop his illustration skills. Craig specializes in architectural illustration and designs and remodels private residences. His illustrations of flower arrangements appear in Design With Flowers.

BOB WALTERS is one of the nation's leading authorities on color separation. He is Vice President, Sales Management, and a stockholder of Color Service, Inc. in Monterey Park, California. For over 25 years, Bob has been a key member of the production team for major floral magazines, books and advertising programs created by Herb Mitchell Associates, Inc. He and Color Service are recognized authorities in the color separation of floral subjects. Bob works with Walt Disney Productions, Warner Bros. Records, Harry & David, Jackson & Perkins Roses and many other national accounts.

JANET MURRAY, the Creative Director for Design With Flowers, graduated from The University of California, Los Angeles with a degree in Graphic Design. She also studied at the Art Center in Pasadena and the Ad Center in Los Angeles. A talented, contemporary designer, Janet has been the graphic designer for many major publications, books and advertising campaigns in the floral industry. She has been recognized for her award-winning designs in merchandising, advertising and stationery. Janet owns her own graphic design firm in Costa Mesa, California.

DENNIS SKINNER, DAVID WONG AND TOM MIYASAKI, owners of deGennaro Associates in Los Angeles are recognized as the leading photographic illustrators of floral subjects in the United States. For over 20 years, these talented photographers have worked with Herb Mitchell Associates, Inc. and creating photographic illustrations for the floral industry's leading design magazines, books, audio-visual programs and advertising campaigns. Besides their expertise in photographing floral subjects, deGennaro Associates are internationally acknowledged as leading specialists in food photography. They are selected to photograph many cookbooks, illustrations for food packaging and food illustrations for major national advertising campaigns. The prestigious deGennaro name is often seen in national shelter magazines with credits for covers and many editorial photographs.

THE ✦ FRENCH PERIOD

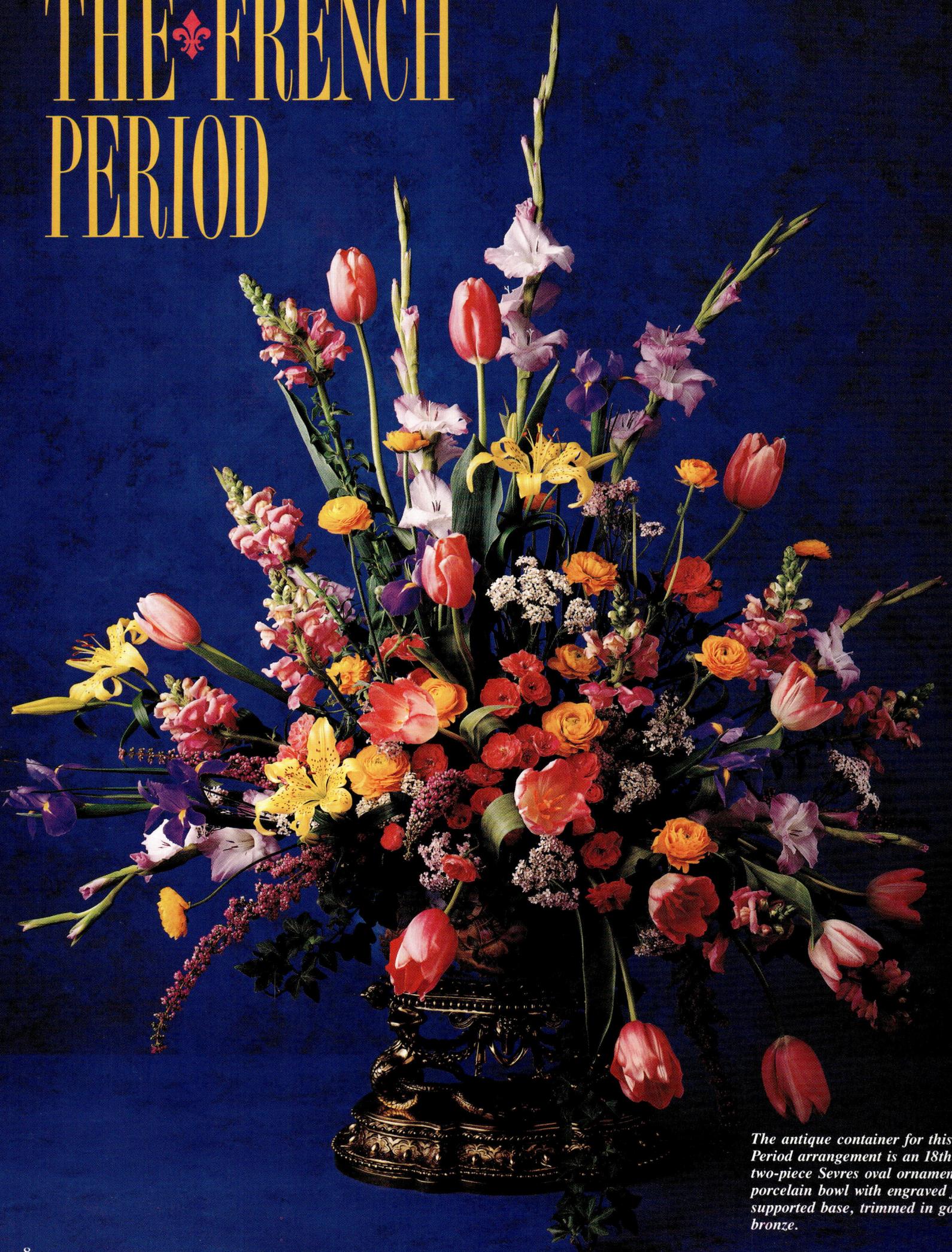

The antique container for this French Period arrangement is an 18th Century, two-piece Sevres oval ornamental porcelain bowl with engraved figure supported base, trimmed in gold and bronze.

The heritage of professional floral design is rooted in the rich history of flower arrangement. Many of the historic arrangements are not practical from a commercial point of view. Nonetheless, the professional flower artist is knowledgeable in this history. A painter studies the historical masters to glean insight into techniques that help him develop his painting skills. Likewise, the floral designer who is serious about becoming a professional artist must examine the important historical periods that have influenced the art of flower design.

The feeling of a mass design—yet never massive.

During the 17th and 18th Centuries, attention focused on King Louis XIV and his successors. All arts, including flower arrangement, were inextricably tied to the king and his courtiers. The arts expressed the luxury and Baroque magnificence of the aristocracy.

The most authentic information about French Period flower arrangements comes from studying the works of master French painters. Painters often established the style composition reproduced in flower arrangements.

Distinctive forms, gracefully curving stems and arrangement styles with clearly defined outlines identify the French Period. Materials with distinguishing and interesting forms were favored. Opulence and elegance were expressed in all flower arrangements. The designs were decorative, large in scale and used as impressive and significant decorative accents.

During the French Period, gladioli and snapdragons were introduced. One historian states, "This is a period in history when women wielded an enormous 'power behind the throne.' All forms of art seemed to express femininity." Roses were the most beloved flower. The historical French flower arrangement included many varieties of blossoms in favored colors of pink, rose, mauve, yellow and blue.

The look of the French Period arrangement conveyed the feeling of a mass design. Yet, it was never overpowering with massiveness. This French Period look of extravagance maintains the relaxed ambience of elegance in flower arrangements without yielding to overdone massiveness.

The arrangement pictured on the cover and on the opposite page is an interpretation of the historical flower composition popular in the French Period. The form of design is full and elegant. Flowers and greens are placed in a modified fan shape with flowing and graceful lines. In a French-influenced design, there is always a feeling of lavish abundance of materials, but never overbearing massiveness. Each flower form and color is distinct and visually important.

Pictured to the left is a contemporary interpretation of a French Period design. The quantity of flowers is limited. Yet, the arrangement expresses the French grandiose feeling of elegance and tasteful extravagance.

The important design knowledge to gain from the French Period is that a French-influenced arrangement declares visual luxury regardless of size. The style is controlled within a fan-shaped form. Lines are relaxed and unstructured. One historian explains a French Period floral arrangement with these words, "unstructured, flowing line elegance."

This contemporary French Period design is arranged in Direction Vase No. 501427 from Toscany Imports, Ltd., 386 Park Avenue South, New York, NY 10016

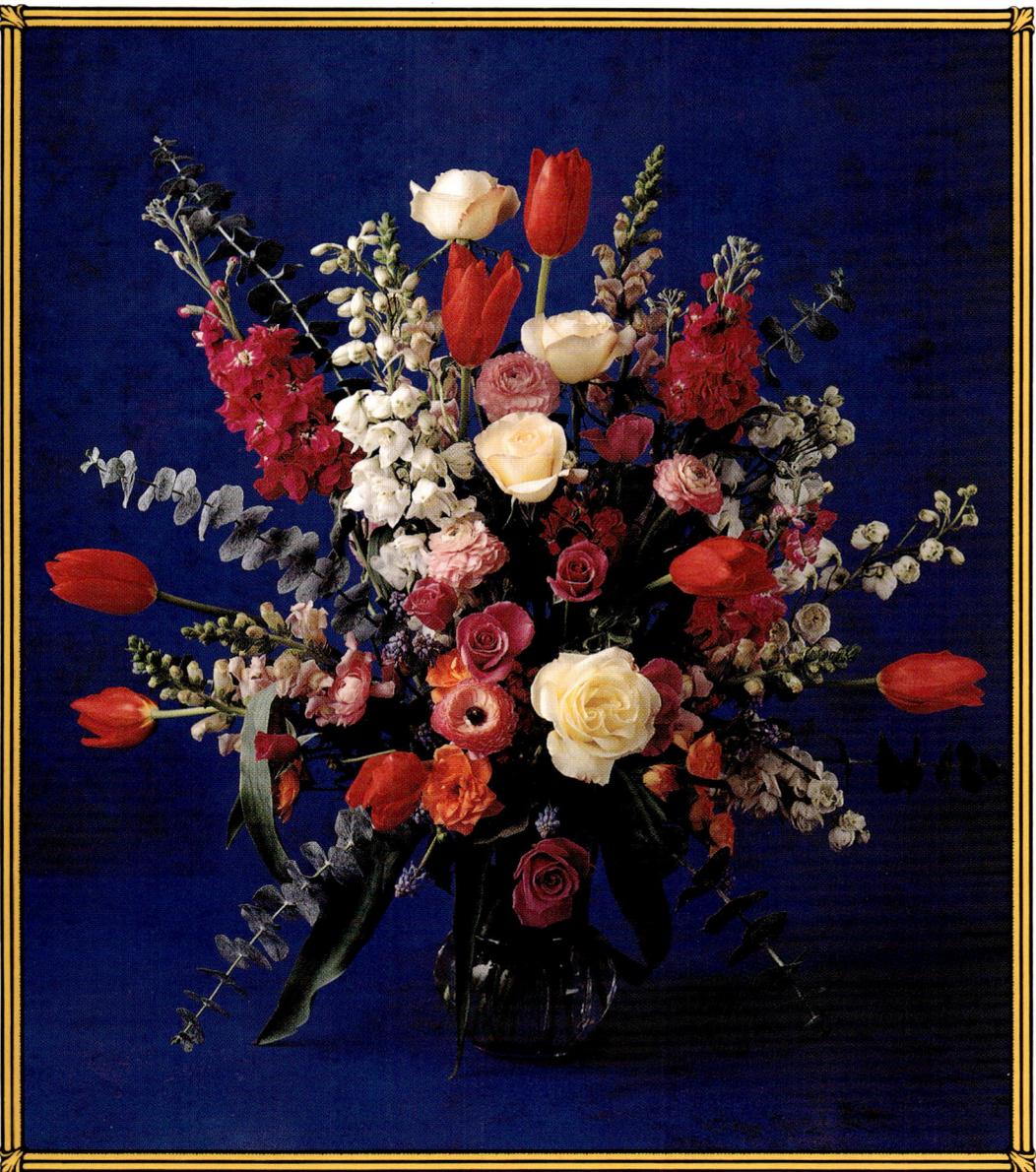

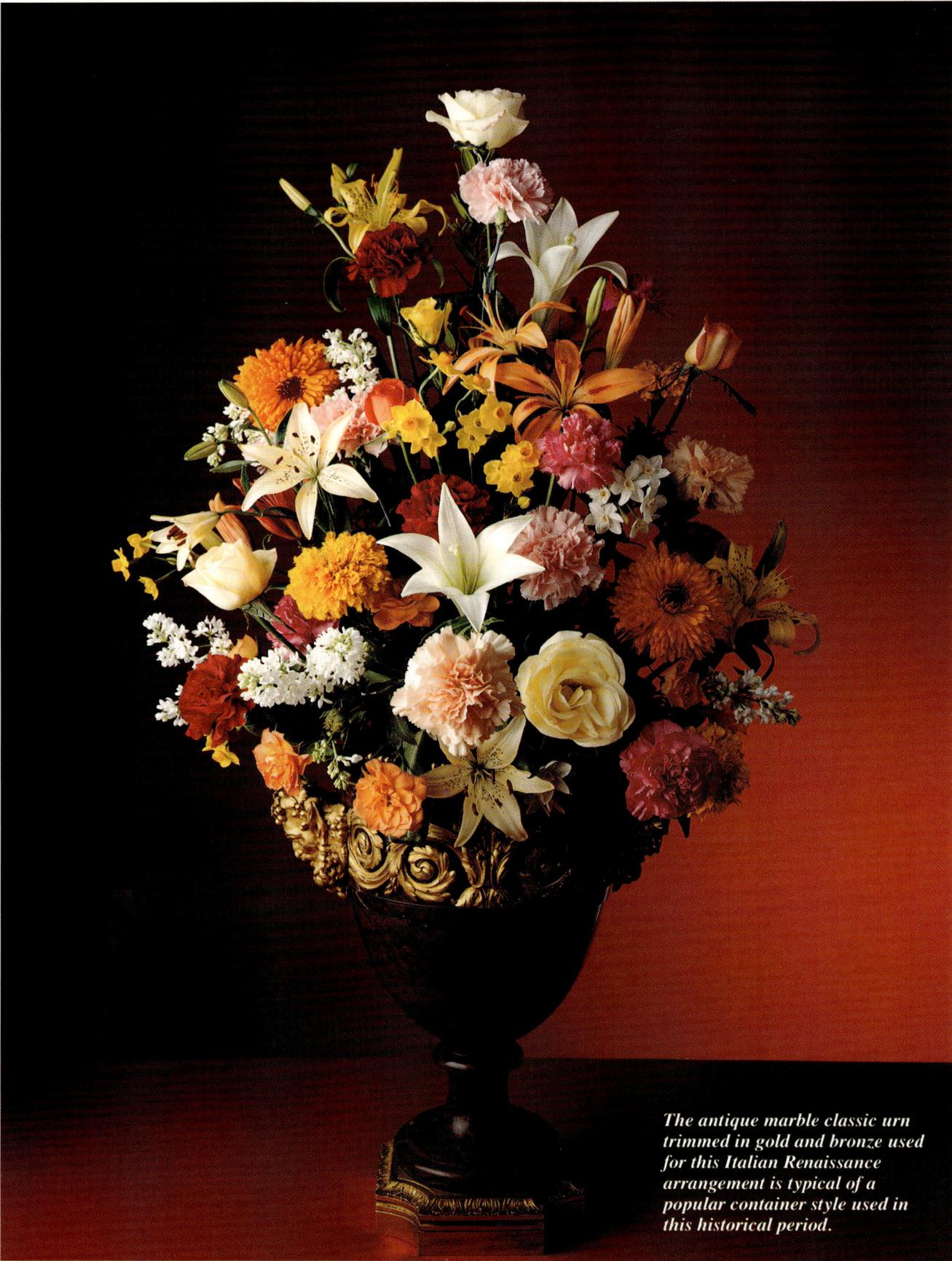

The antique marble classic urn trimmed in gold and bronze used for this Italian Renaissance arrangement is typical of a popular container style used in this historical period.

The ITALIAN
Renaissance

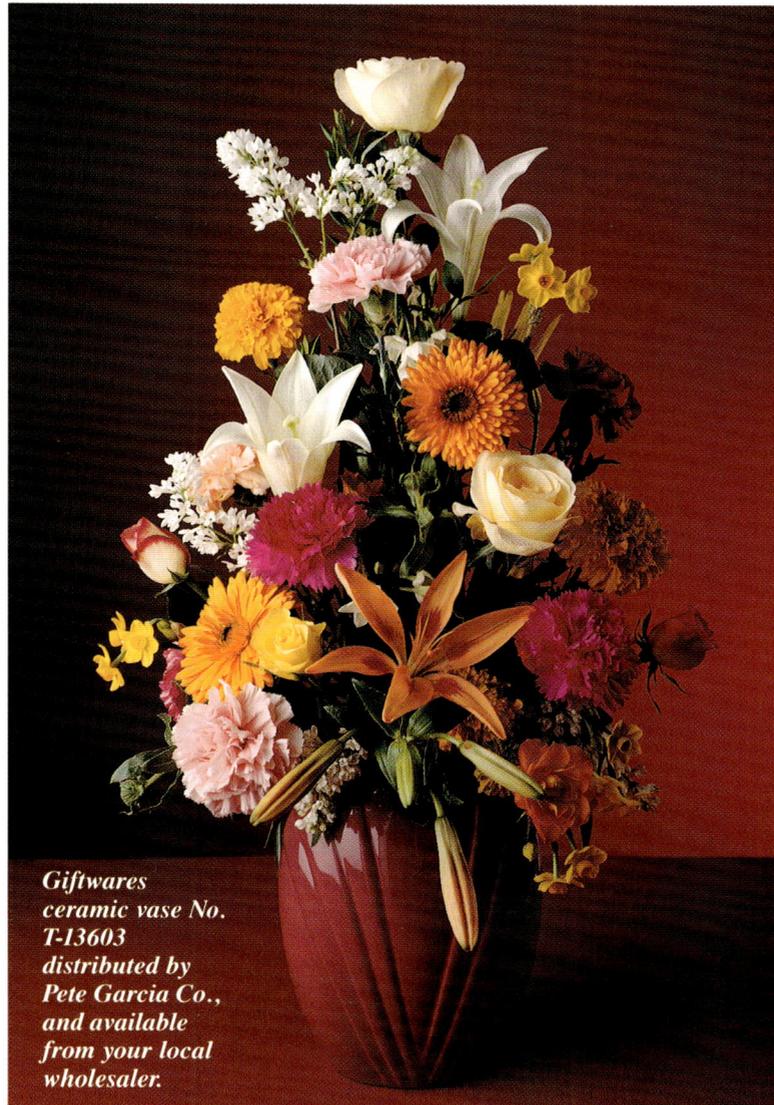

Giftwares ceramic vase No. T-13603 distributed by Pete Garcia Co., and available from your local wholesaler.

As we study the influential periods in the history of flower arrangement, we recognize that floral decoration is as old as civilization itself. The excavated remains of ancient cultures corroborate that flowers always have been a source for adornment of architecture and many decorative accessories.

History records that ancient Egyptians decorated with cut flowers placed in vases. We find the lotus flower used as early as 2500 BC in Egyptian art. The lotus was the flower of the goddess Iris and therefore considered sacred. Bowls of flowers adorned the banquet tables of the Egyptians. Valuable gold and silver vases filled with lotus blossoms were used in burial processions and often offered as a tribute.

During the decline of the Roman Empire, rose blossoms and rose petals were strewn lavishly on banquet tables and couches and on streets and lakes. History tells us that both Nero and Cleopatra used roses and rose petals extravagantly for ceremonies and entertaining.

Mixed flowers appeared for the first time in the world-famous Second Century Roman mosaic, the *Basket of Flowers* now in the Vatican Museum. The basket design included roses, Roman hyacinths, a double anemone, tulips, red carnations and a blue morning glory.

The Italian Renaissance, the classically inspired revival of European arts, began in Italy in the 14th Century and lasted until 1580. During this period, the use of flowers became more profound. Art belonged to the church. Flowers were used with important emphasis on symbolism to express abstract concepts of love, purity and humility. The rose is pictured in subjects portraying sacred love. The white lily was the symbol of fertility and chastity. *Lilium candidum* appeared in so many paintings of the Annunciation that it became known as the Madonna Lily. The current Exotica International still lists *Lilium candidum* as the Madonna Lily.

Books on the art of the Italian Renaissance describe how to assemble bouquets by tying the flowers together with all the heads turning out. Instructions clearly state that the most important flower must be placed at the center top of the bouquet. The ingenious method of covering the stems by laying narcissus leaves lengthwise over the stems and then tying them to the stems with thread is described in detail.

From this art of the tied bouquet comes the arrangement style of the Italian Renaissance. Flowers were inserted into vases so only the blossoms showed. Stems were covered with other blossoms creating a mass-like design. One historian records that flower arrangements in the Italian Renaissance period were "a stiff display rather than a graceful gathering of blossoms."

The arrangement pictured to the far left is an accurate interpretation of the Italian Renaissance style of the 14th Century. The arrangement style was somewhat conical in form with the sides extended and then pulled in to the top of the container. Horizontal line never appeared in Italian Renaissance floral design. Bright colored flowers were massed, emphasizing contrasts in blossom form. Even with this tightly assembled style, each flower stood out with individual distinction.

Pictured on this page is a contemporary interpretation of the Italian Renaissance arrangement. This composition illustrates how the style of the Italian Renaissance has interesting and practical application in a professional 20th Century floral design. The elongated conical form with blossoms pulled into the rim of the container is a primary characteristic of the Italian Renaissance arrangement. Flowers should be compact without voids or negative space. The Italian Renaissance arrangement contains a variety of flowers in distinctive forms and a range of spirited colors.

The Dutch And Flemish

This Flemish-influenced arrangement is designed in a 17th Century Flemish Art Nouveau Gouda vase from Ancient Times Antiques, 3305 Laguna Canyon Rd., Laguna Beach, CA 92651.

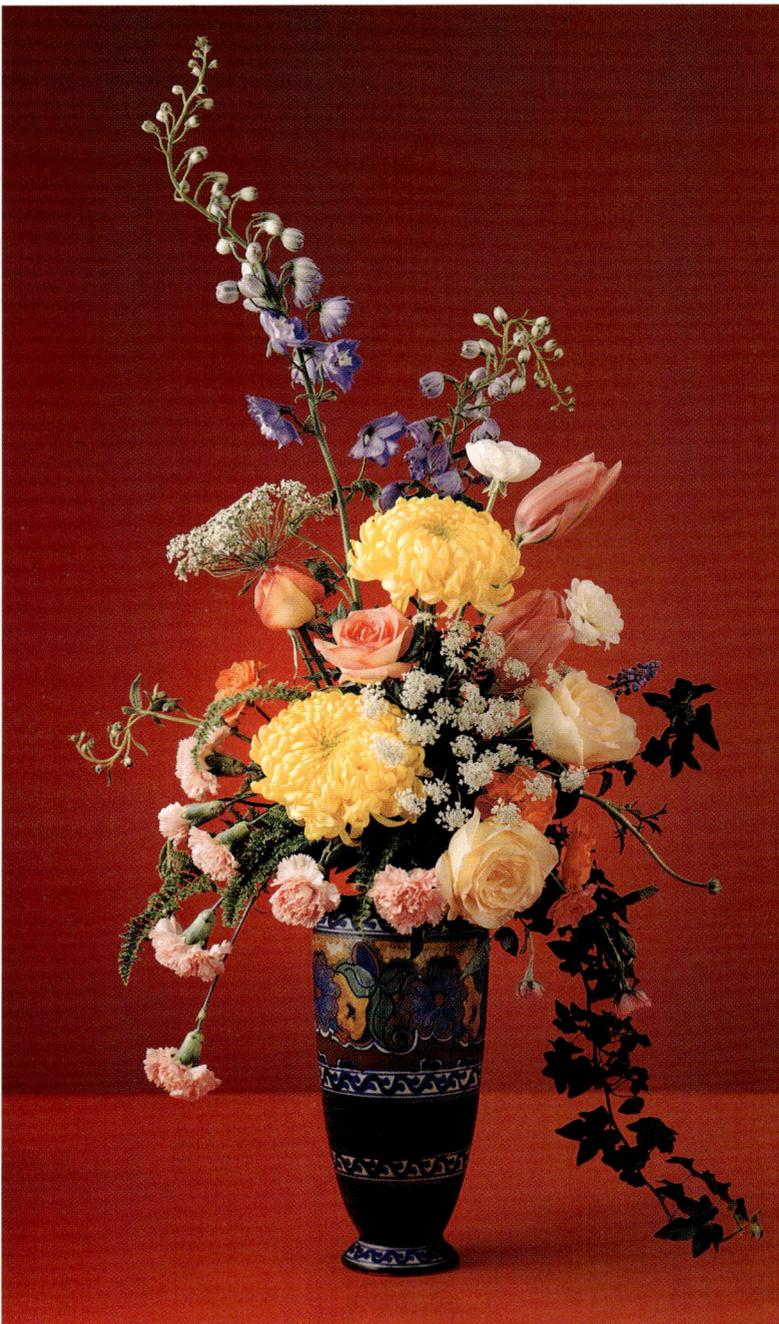

Before the 17th Century, the patrons of the arts included only the church and nobility. The religious upheaval of the 17th Century Reformation brought about social changes. The previously ignored middle class came into prominence. The arts, including the use of flowers, formerly reserved for the church and nobility, became a way of life.

Historians record that Western flower arrangement began during the 17th Century in Holland. Dutch and Flemish master artists turned to the still-life presentation of flower arrangements. Artists found a new freedom of expression in lavish paintings combining flowers, fruits, bird nests and other decorative objects. The Dutch and Flemish artists did not paint from an actual arrangement. Instead, they composed as they painted from visualizations in their minds. Those who arranged flowers used their paintings as examples from which they copied.

No other period in the history of flower arrangement provided so many examples of mixed flowers grouped in opulent designs.

The arrangement pictured to the left interprets a Flemish approach to floral design. The artist controls the design with a limited quantity of flowers. Nevertheless, the design presents an impressive range of blossoms and colors. This particular form of Dutch-Flemish arrangement is patterned after one of the styles of Jan Breughel, considered the most prolific flower painter of the Flemish school.

The heightened interest in growing flowers encouraged flower arrangement during the Dutch and Flemish period. By

The container for the Dutch-Flemish arrangement above is an early 18th Century Dutch Delft Jug from Ancient Times Antiques, 3305 Laguna Canyon Rd., Laguna Beach, CA 92651.

Period

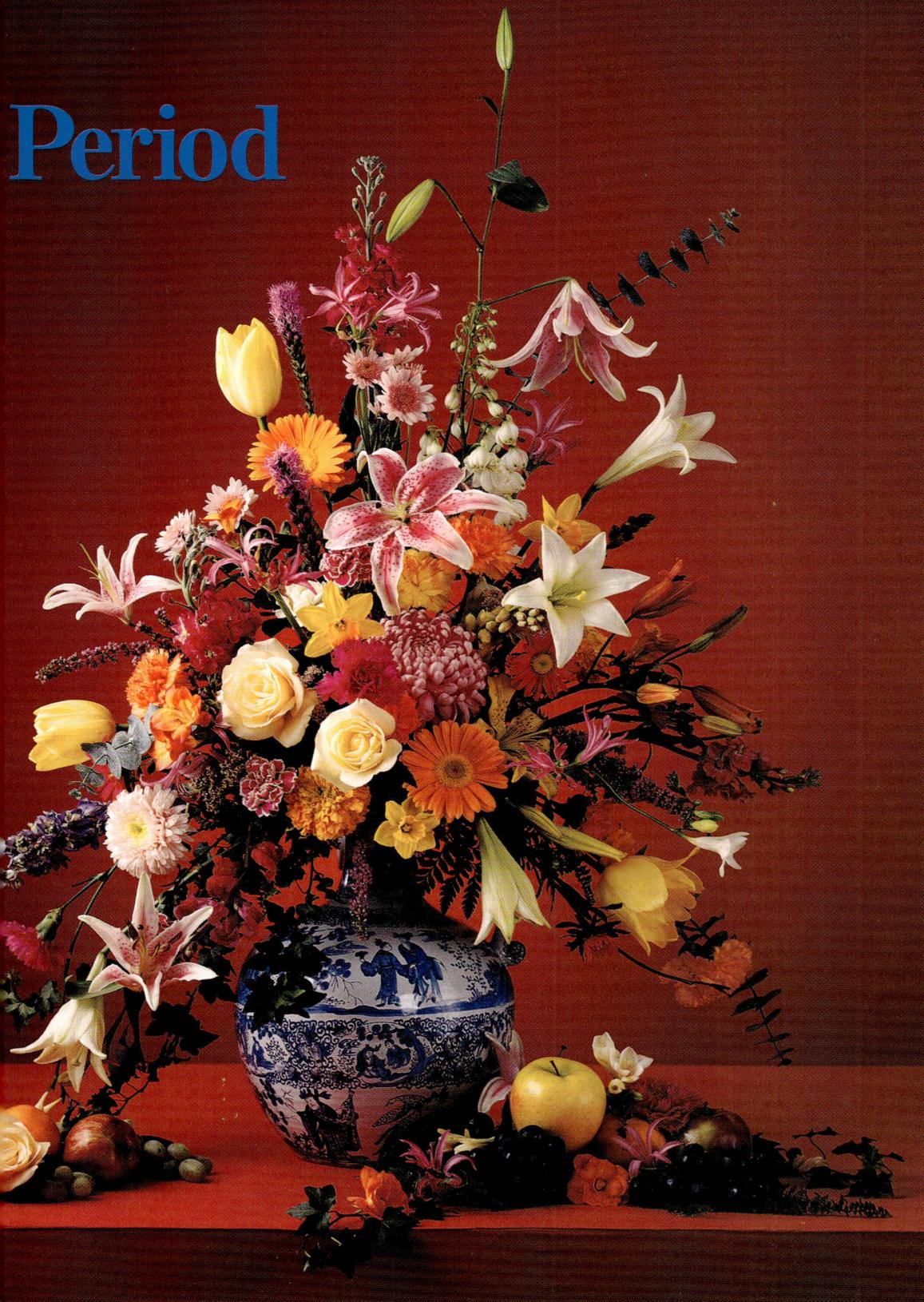

jugs and other ordinary everyday objects. As the 17th Century progressed, many beautiful glass shapes manufactured in Germany and Venice appeared with artistic displays of flowers. Soon, blue and white Oriental porcelain from China became the rage for flower arrangements. Enterprising Dutch craftsman capitalized on this popular style and developed a cheaper container known as Delft.

Variety is a major distinguishing characteristic of the Dutch-Flemish arrangement. Tulips, roses, peonies, iris, lilies, the old-fashioned snowball and a selection of miscellaneous garden flowers were gathered into most floral arrangements.

As we study the master Dutch and Flemish artists, we discover some of the traditional elements of flower arrangement. Design form, line, texture and depth are only a few of the important attributes of the Dutch-Flemish arrangement. The presentation of color is another important lesson to be gleaned from the Dutch and Flemish artist. Many historians state that the art of presenting color in floral design started in the Dutch and Flemish period.

The arrangement pictured on this page is a contemporary interpretation of the Dutch-Flemish styling. Presented in a Delft container, the composition displays the generous style of the Dutch-Flemish design. The artist uses a wide range of flower forms and colors. Yet, all motion is gradual. The embellishment with fruit and flowers at the base is another distinctive characteristic of a flower arrangement depicting this period.

The variety of flowers in a design is one of the most important heritages of the Dutch-Flemish influence in contemporary floral design. This philosophy is beautifully expressed in the composition pictured, which combines chrysanthemums and lilies with petite miniature carnations and freesia.

The use of color in an expansive spectrum of hues and values is another essential quality of the 20th Century Dutch-Flemish arrangement.

The oval is the historical form for the Dutch-Flemish design. As this period of floral art progressed through the last three centuries, the oval form moved gradually to a soft triangle. The form of the Dutch-Flemish composition is less important in contemporary interpretation than the variety of materials and colors presented.

1634, gardening was the popular pastime. Growing tulips became a famous method for gambling because of the tulip's tendency to "break." When a tulip breaks, the splitting colors form many variations in flecks and stripes. These variations were so unpredictable that "Tulipomania" was an era of speculation. Tulip growers gambled high stakes predicting whether bulbs would break with yellow ground-color and red markings or white ground-color with rose or purple markings. Tulipomania ended in 1637 with many lost fortunes.

During the Dutch and Flemish period, flowers became part of everyday home life.

Another important contribution of the Dutch and Flemish period in the history of flower arrangement is variety in containers. In the early part of this era, containers were bottle-shaped vessels,

THE ENGLISH TRADITION

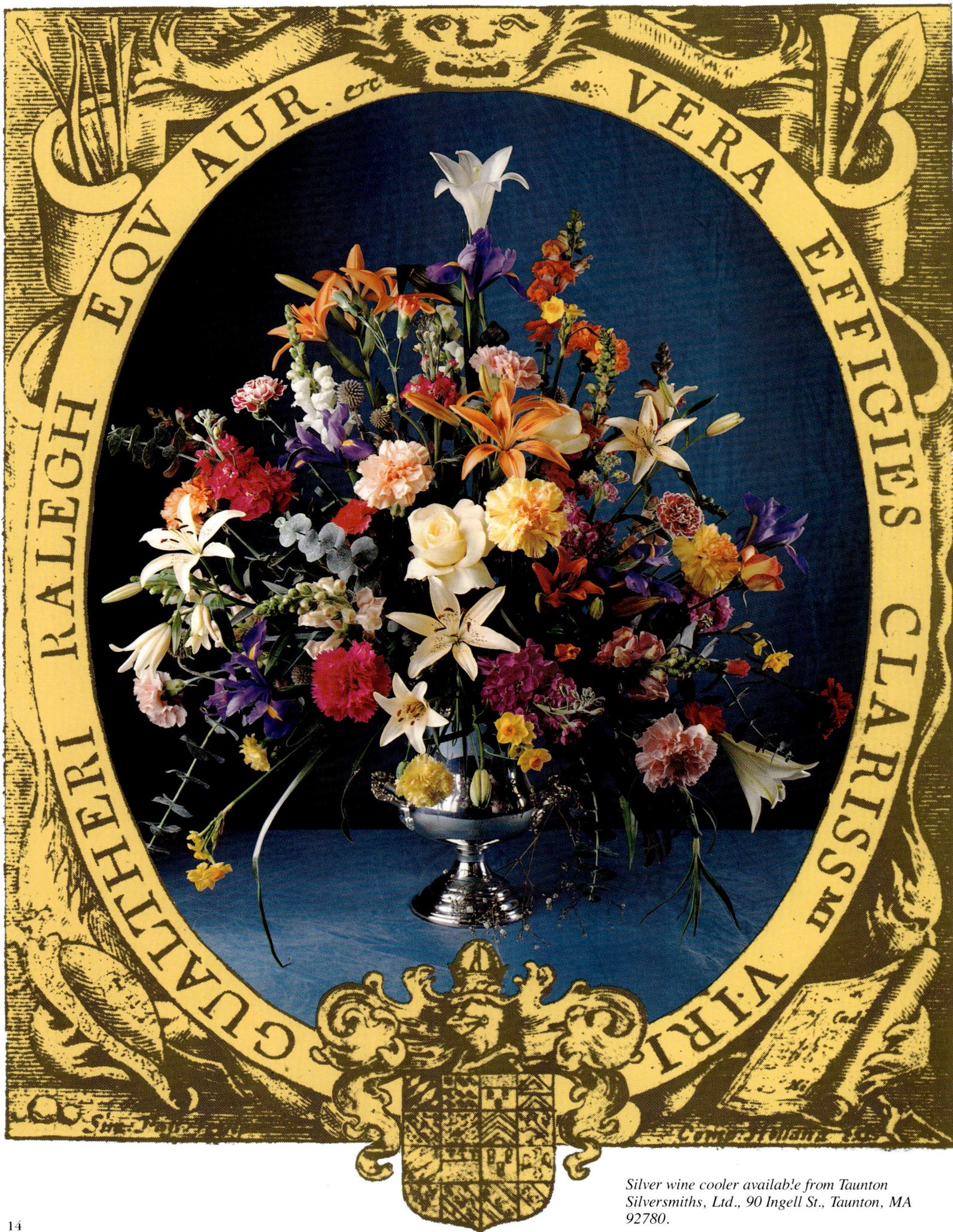

Silver wine cooler availab!e from Taunton Silversmiths, Ltd., 90 Ingell St., Taunton, MA 92780.

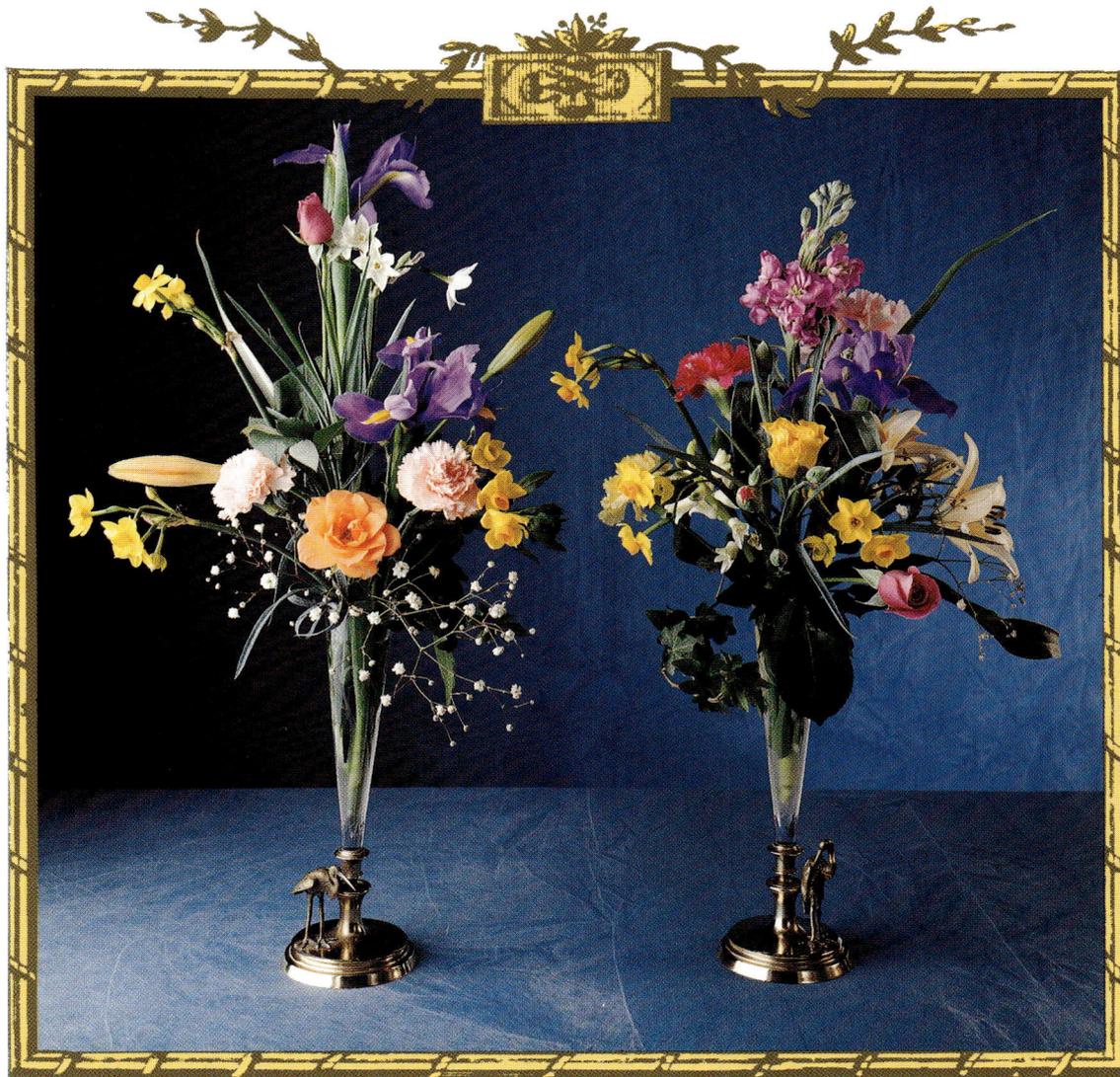

Antique Victorian 1850 crystal and brass bud bases from Roberta Gauthey Antiques, 1166 Glenneyre, Laguna Beach, CA 92651.

As the history of flower arrangement emerges from the various countries and cultures, we recognize one consistent detail. The interest in gardening has a direct relationship to the development of flower arrangement. Almost every historical record about flower arrangement starts with comments regarding the gardening practices which then unfold into flower arranging.

Few people throughout the history of flower arrangement loved flowers and gardens as much as the British. This interest in gardening dates back to the Middle Ages. Home owners had small kitchen gardens attached to their houses in which they grew marigolds, violets, roses, iris and primroses. Blossoms from these plants were used for homemade medicines, cosmetics, flavoring and even salads. In the early history of the English Tradition, cut flowers were used for making garlands and chaplets. The use of cut flowers is also noted in the history of the English church. Fresh blossoms were used for rituals, and the clergy wore crowns of flowers in processions.

The history of the English Tradition includes many comments about the importance of the fragrance of flowers. Perhaps the British were the first to place

important value on growing fragrant flowers. It was thought that the perfume from the blossoms would clear the air of pestilence. One of the earliest records of the English Tradition in flowers states, "their nosegays were finely intermingled with sundry sorts of fragraunte flowers." We are not certain whether the custom of using dried flowers and herbs started in the English Tradition era. However, 18th Century writings include references to "long-lasting dried bouquets."

The first reference to English flower arrangements appeared in the 1636 edition of John Gerarde's book *Herball.* It contained flower arrangements made with many garden favorites. Gerarde described these arrangements as "being strangers unto us, and giving the beauty and bravery of their colours so early before many of our owne bred flowers, the more to entice us to their delight." Gerarde verifies that the English flower arrangement contained varieties of flowers from all parts of the world.

English history records many references to arrangements of fresh flowers used in the English drawing rooms with furniture by Chippendale, Hepplewhite and Sheraton. There is no one style which typifies the English Tradition. Flowers were arranged in an

extensive variety of containers from elegant Victorian crystal and brass bud vases holding a few blossoms, to handled urns made of glazed earthenware with a silver lustre finish filled abundantly with flowers.

The magnificent arrangement pictured on the opposite page is similar to that found on 18th Century English prints. The handled container came in many shapes; from the wine cooler as we know it today, to squatty, oval urns and tall, vertical, ceramic vases with ornate decorations.

The Victorian bud vases pictured above give another perspective on the English Tradition of flower arrangement. Often, even a few blossoms slipped into a bud vase included the wide variety of flowers and colors typical of English flower arrangements.

As we reflect on the contribution of the English Tradition to 20th Century professional flower arranging, we recognize that the unstructured arrangement of mixed flowers has a strong English legacy. The influential characteristic of the English Tradition design is the wide variety of flowers used in arrangements. Some historians state that the English Tradition arrangement is the first recorded use of flowers from every part of the world.

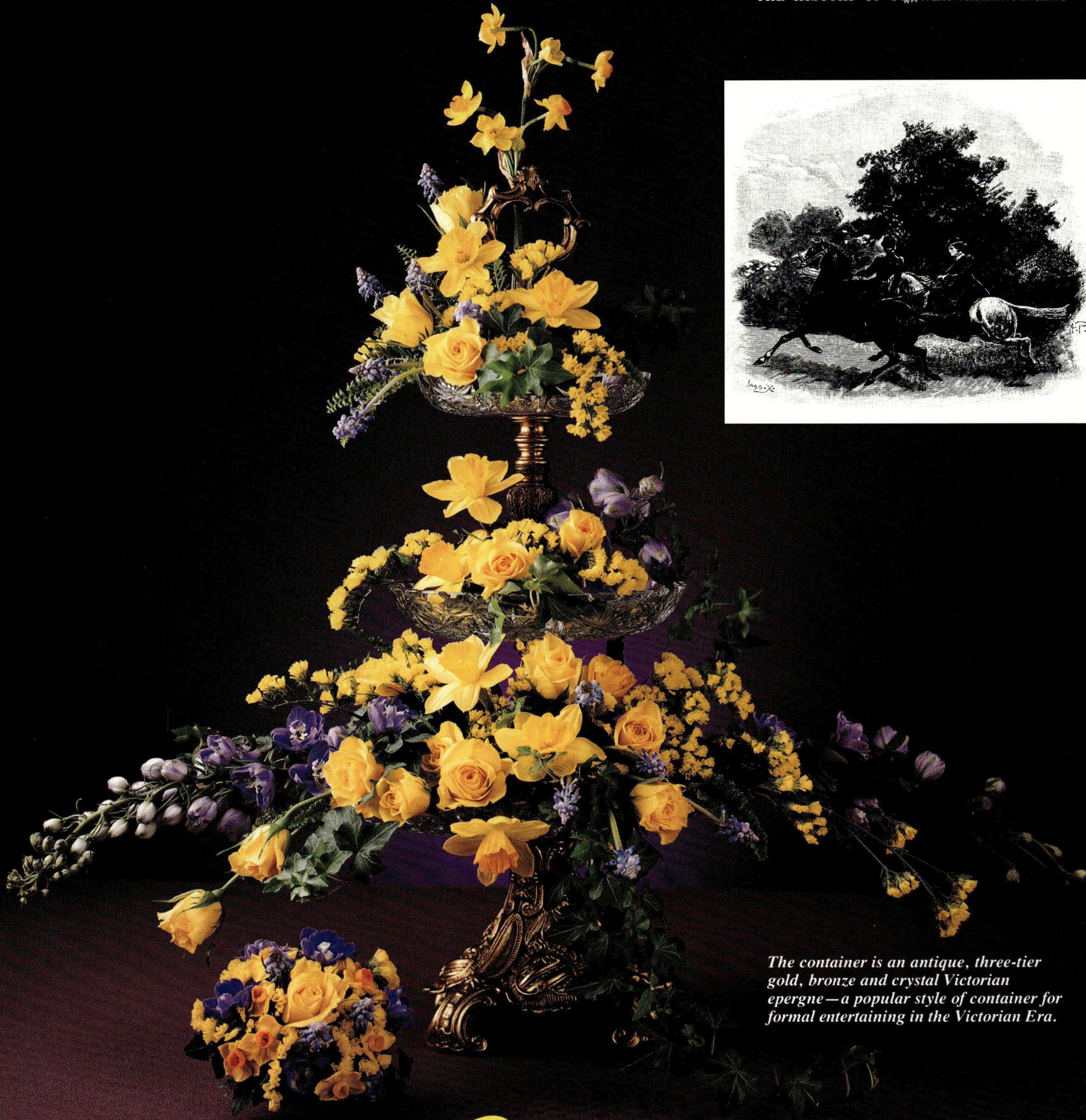

The container is an antique, three-tier gold, bronze and crystal Victorian epergne — a popular style of container for formal entertaining in the Victorian Era.

"Love your flowers. By some subtle sense the dear things always detect their friends, and for them they will live longer and bloom more freely than they ever will for a stranger."

The *Victorian* Era

The 19th Century was a period of great enthusiasm for flowers, plants and gardening. Some historians state that the Victorian Era made the most significant contribution to establishing the use of plants and flowers in the everyday pattern of life.

Every proper Victorian lady appeared at a social gathering carrying a nosegay of fresh flowers. Many nosegays were made at home. During the Victorian Era, the sentimental message of flowers was an important reason for using them. A young man admiring a lady would bring her a nosegay of flowers with a romantic note referring to the meaning of the flowers in the nosegay. Many people carefully studied the language of flowers. Romances progressed by sending flowers and nosegays to carry the message of love.

The proper, quality presentation of flowers was an important consideration in how they were used. Flowers were used profusely in homes during the Victorian Era. In 1838, Edward Sayers writes in the *American Flower Garden Companion,* "Now an almost universal practice is to have cut flowers in rooms as natural ornaments." In his writings, Sayers includes information about caring for cut flowers. Sayers' first rule was to change the water frequently. His second rule was to cut off half an inch or an inch of a stem to open up pores that had become closed after cutting.

The Victorian Era established the first "formal rules for flower arranging."

A proliferation of magazines and books about the art of flower arranging appeared during the Victorian Era. Several historians state that the first formal schooling in floral design began in the Victorian Era.

St. Nicholas Magazine, a popular source of flower information in the Victorian Era, provided extensive information about flower arranging. "The knack of flower arranging," according to this magazine, "cannot be taught. But there are a few rules and principles on the subject so simple that even a child can understand them and follow them."

Rule 1. Give careful attention to the color of the vase. Reds and blues should never be used. Bronze, black, dark green, white or silver "always produce a good effect." Baskets are recommended. And "clear glass shows the graceful clasping of the stems and is perhaps the prettiest of all."

Rule 2. Select an appropriate shape in a vase. A round bowl or a tall vase with a saucer-shaped base is appropriate for the center of a dinner table. Delicate flowers should be placed by themselves in slender, tapering vases. Violets should be nestled in a cup.

Rule 3. Avoid stiffness and crowding. "What can be uglier than the great tasteless bunches into which the ordinary florist ties his wares, or what could be more extravagant?" states the *St. Nicholas Magazine.* Group flowers as they grow with a "cloud of light foliage in and about them to set off their forms and colors."

Rule 4. When you mix flowers, never put clashing colors side by side. "Scarlets and pinks spoil each other. So do blues and purples. Every group of mixed flowers requires one little pinch of yellow to make it vivid."

Rule 5. Love your flowers. "By some subtle sense the dear things always detect their friends, and for them they will live longer and bloom more freely than they ever will for a stranger."

The elegant epergne arrangement pictured on the opposite page is a contemporary interpretation of the formal approach to Victorian styling. The design suggests a 20th Century Victorian look. It illustrates the importance of using color effectively and the graceful and impressive presentation of flowers.

Pictured on this page is an interpretation of the informal style of arrangement found in the Victorian Era.

The container, a favorite style for the more informal arrangement, is an antique Victorian Wavecrest biscuit barrel from Roberta Gauthey Antiques, 1166 Glenneyre, Laguna Beach, CA 92651.

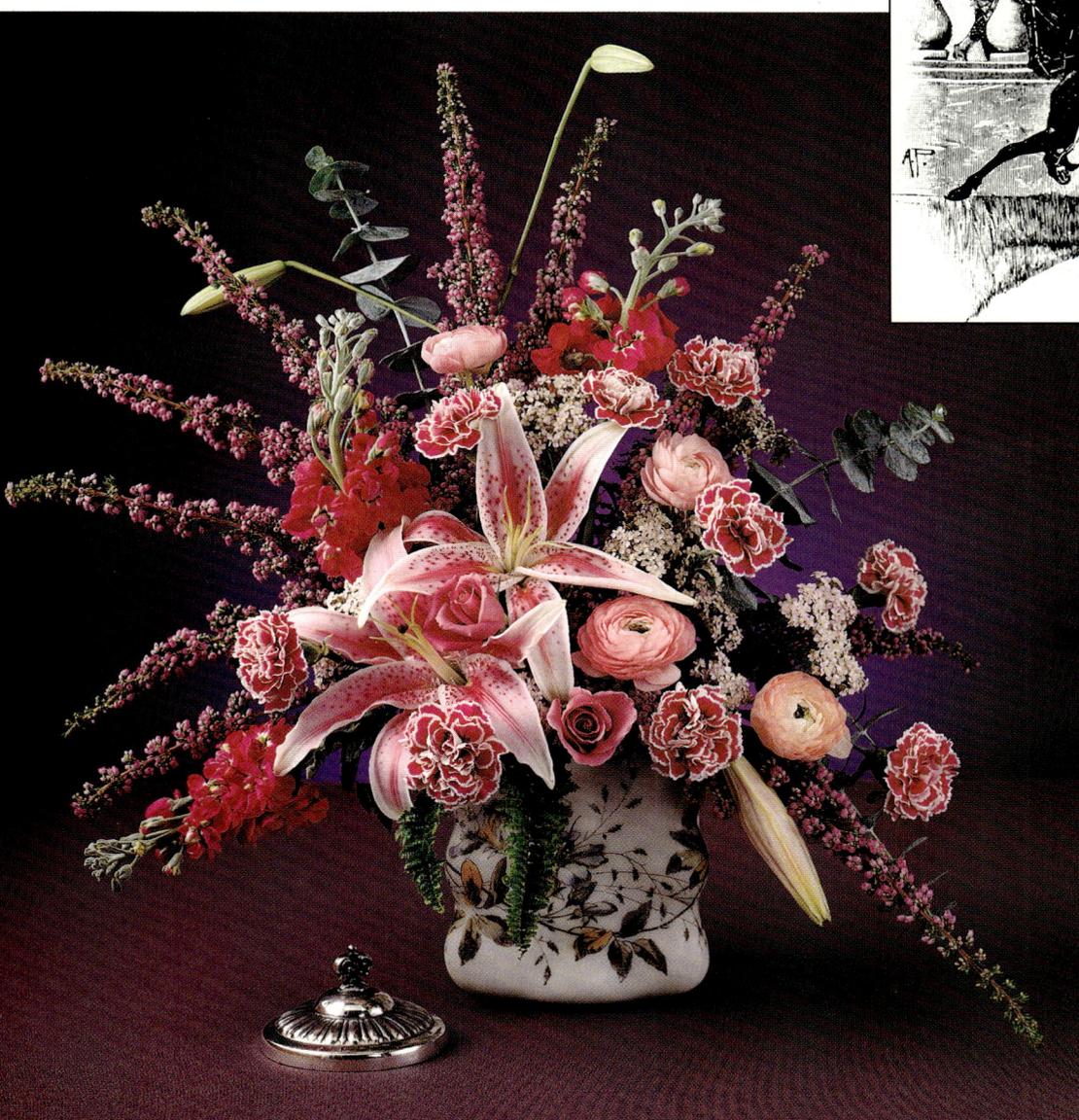

CHINA - THE

The Chinese first contributed to the development of the art of flower arrangement. "Contemplative, and with a characteristically sensitive appreciation of nature, the Chinese learned to enjoy the quiet beauty of a few perfect blossoms or a branch of interesting shape. This refined taste was passed on to Japan, along with Buddhism, and developed into a highly symbolic art. The Chinese way of arranging flowers has never been as obviously studied or stylized as that of the Japanese. However subtle the differences may be between the two, we recognize that we are indebted to both these peoples for their appreciation of line in flower design, as well as for their emphasis on the individual form, texture and color of a few chosen blossoms."

Julia S. Berrall

Appreciation for Chinese flower arrangement requires an understanding of three philosophies that influenced the use of flowers. (1) The art of contemplation as practiced by the followers of Confucius. (2) The principle of the preservation of life as taught by Buddhism. (3) The floral symbolism which developed as folklore.

Confucius states that enjoyment comes from simplicity. His writings emphasize that viewing too many things at the same time causes distraction. Only by experiencing one thing at a time can an individual appreciate beauty and discover tranquility.

Since preservation of life is one of the important principles of Buddhism, Chinese Buddhists used cut flowers sparingly. The Chinese garden was small in scale. It had a likeness to nature and was a place for contemplation. Very few flowers were grown. Therefore, many Chinese flower arrangements featured plant material with only a few blossoms.

The striking composition pictured is an interpretation of a traditional Chinese flower arrangement. Symbolism, conservation of life and appreciation of beauty are magnificently expressed. The fig branches communicate a reflection of nature. Detail is simplified in the presentation of the fresh flowers. Creative attention is concentrated on space relationships, visual emphasis of materials, unity and a feeling of rhythm.

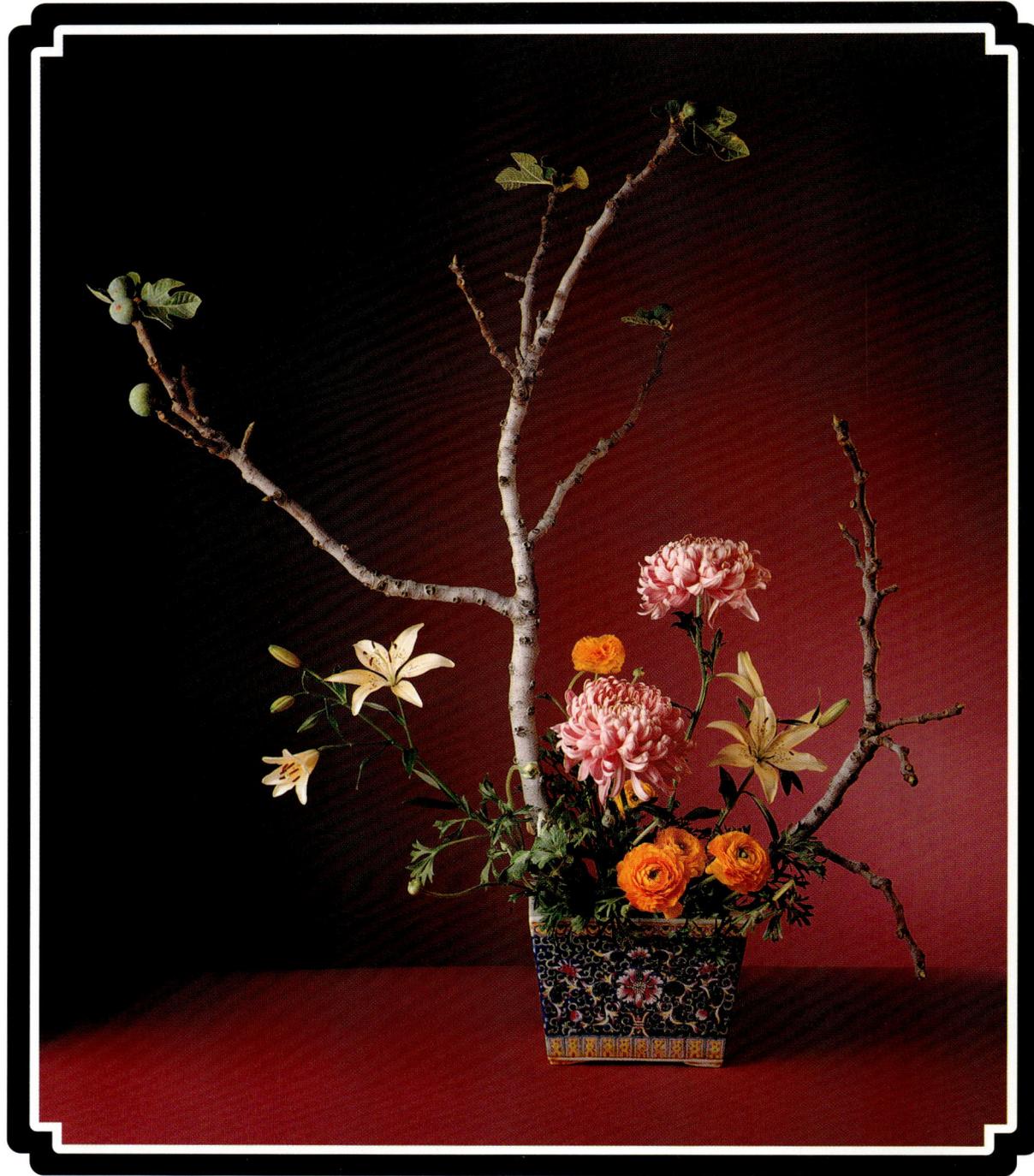

The Chinese container is a 19th Century porcelain from Warren Imports, P.O. Box 1138, Laguna Beach, CA 92652.

18

FLOWERY KINGDOM

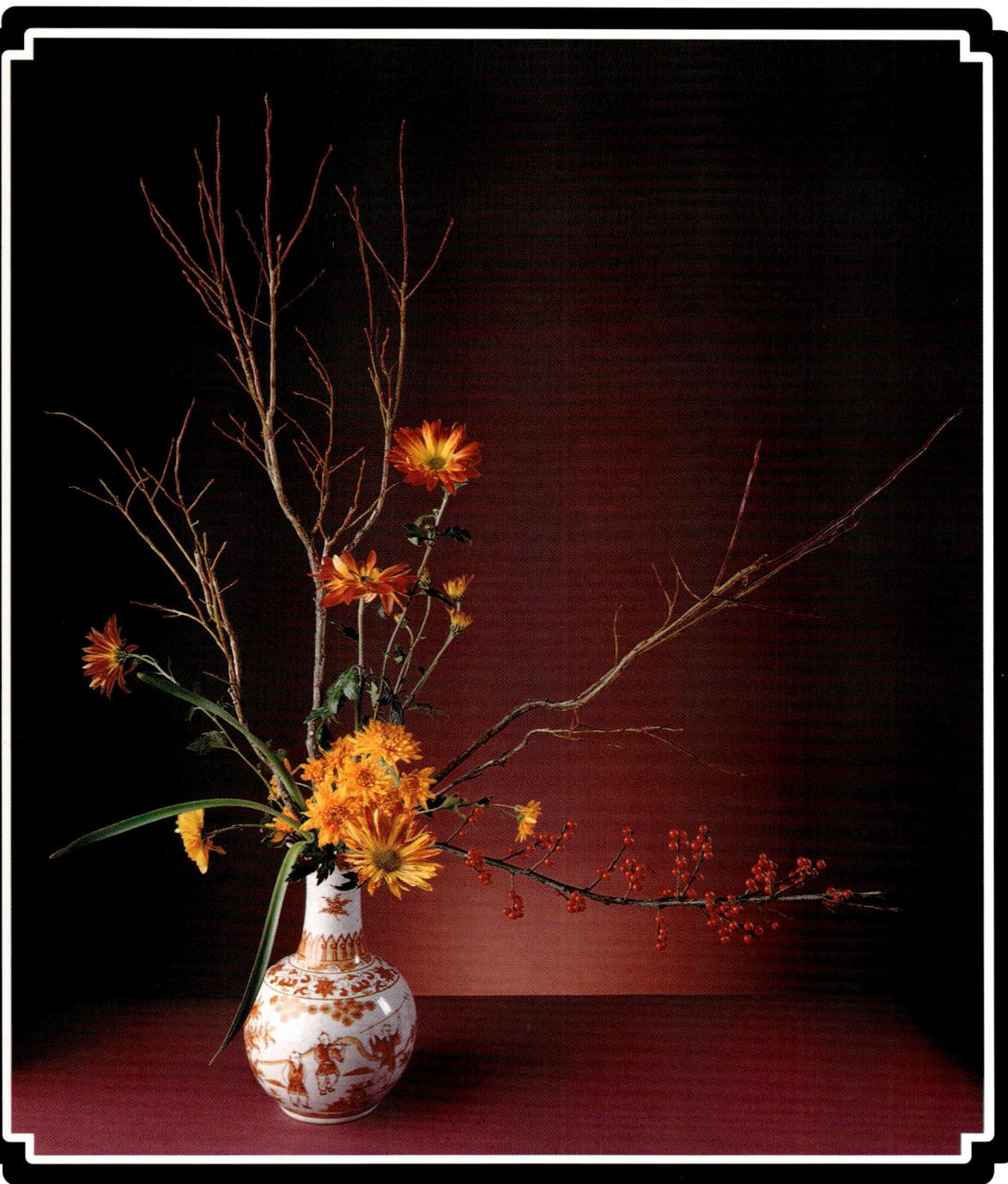

Similar containers available from Otagari, 475 Eccles Ave., South San Francisco, CA 94080. Huckleberry branches from HOH Grown, P.O. Box 2135, Forks, WA 98331.

hinese folklore about flowers is interesting and suggests why the manner in which flowers were used was so important. The history of Chinese flower arrangement states that all flowers, because of their fragile beauty, were considered to be feminine. Therefore, they were given women's names. The four seasons were commonly identified by the white plum blossom in the winter, the peony in the springtime, the lotus in the summer and the chrysanthemum in the fall.

The peach tree, the pear tree and bamboo all expressed long life, an important philosophy of the Chinese. Paper white narcissus were forced to bloom for the Chinese New Year to bring success, luck and good fortune for the year ahead. The orchid was the emblem of love and beauty. Tiger lilies, pomegranates and orchids were symbols of fertility.

In an authentic Chinese flower arrangement, the philosophy of the design and how the artist expresses it in the composition are as significant as the plant materials used. One concept in Chinese flower arrangement expresses opposition. The sun and moon are opposites. Men and women are opposites. A barren branch and a branch bursting with vegetation are opposites. Nature presents many opposites.

The arrangement pictured on page 14 illustrates an application of this concept of opposites in flower design by positioning materials in pairs. The two fig branches are placed in opposite positions. The difference in size also suggests opposition. The lilies appear on opposite sides of the design. The ranunculus and the chrysanthemums do not imply direct opposites, yet the pairing of the groupings supports this concept in the design.

The 20th Century professional floral artist can incorporate the principles of Chinese flower arrangement in his work in many impressive ways. The arrangement pictured on this page combines the Chinese philosophy with Western influence in design style. The red huckleberry and the ilex emphasize nature and longevity. The use of a singular type of flower in two varieties suggests simplicity as does the unpretentious color harmony.

THE HISTORY OF FLOWER ARRANGEMENT

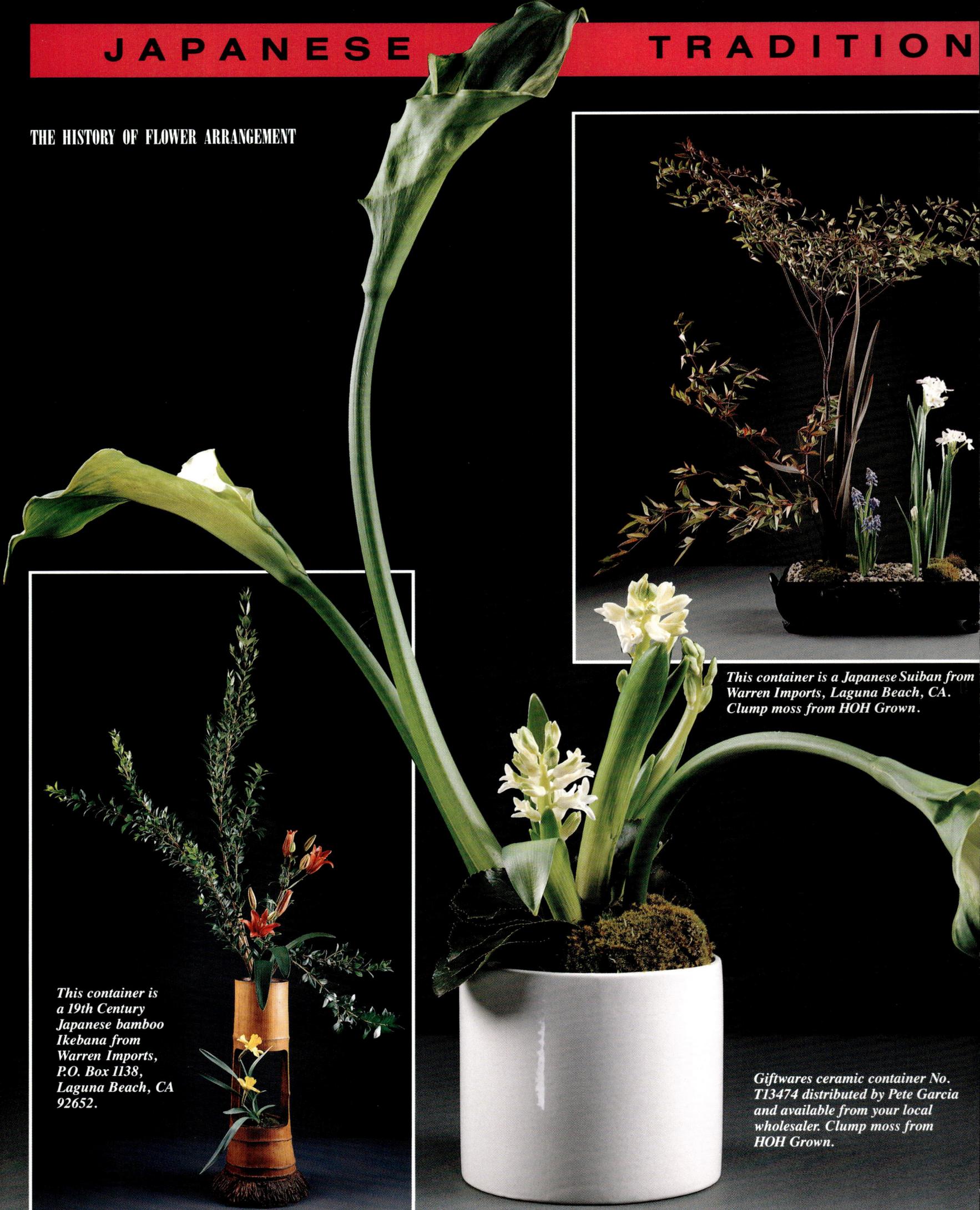

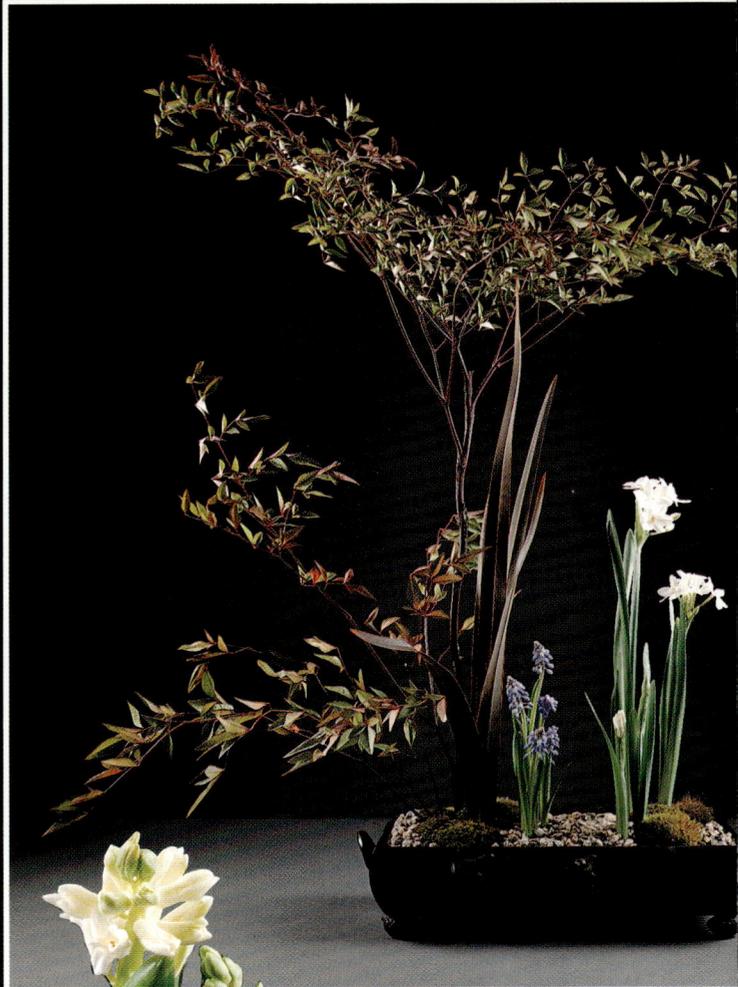

This container is a Japanese Suiban from Warren Imports, Laguna Beach, CA. Clump moss from HOH Grown.

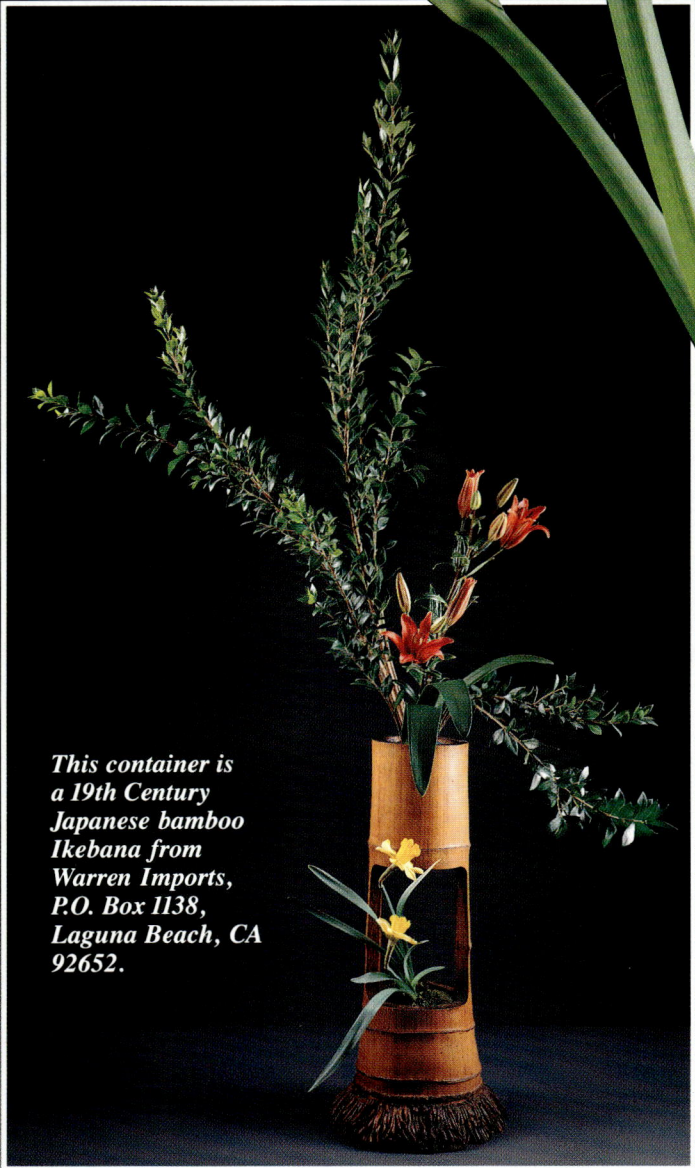

This container is a 19th Century Japanese bamboo Ikebana from Warren Imports, P.O. Box 1138, Laguna Beach, CA 92652.

Giftwares ceramic container No. T13474 distributed by Pete Garcia and available from your local wholesaler. Clump moss from HOH Grown.

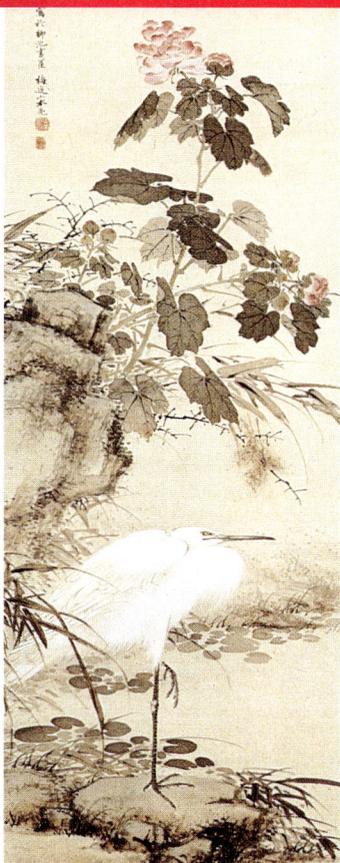

For more than 1,000 years the Japanese have practiced the art of flower arrangement. Before the 15th Century, flower arrangements were reserved for the temple. Slowly, flower arranging became important in the Japanese home and reached its peak in the 18th Century. During this period of development, many rules for Japanese flower arrangement were established and symbolism became an important part of the art.

Classic Japanese flower art focuses on the asymmetrical. The composition is strictly linear in nature, based on three main lines of related height proportions. The classical form places far more emphasis on line and silhouette than it does on color.

The word Ikebana, which literally means flower arrangement, must be interpreted as "living plant material." Ikebana is an art that encompasses far more than flowers.

There are many different schools of Japanese flower arrangement. All use the art principles of the three branches—heaven, man and earth. Most schools today identify them as Shin, Soe and Tai or Hikae. In the Ohara school these same three branches are known as subject, secondary and object.

Shin, which means heaven or spiritual truth, is the strongest, longest and most important material in the composition. Shin is about one-and-one-half to three times as long as the length or diameter and height of the container together.

Soe means support, help and harmonizer. According to its length and weight, Soe is the second most important material. Soe is approximately two-thirds to three-quarters the length of Shin. Traditionally, students of Ikebana consider Soe to symbolize man situated between heaven and earth.

Tai or Hikae symbolizes body or material substance. In many schools, Tai or Hikae represents earth. This is the smallest and shortest material in the composition. Tai or Hikae is approximately one-third to one-half the length of Shin.

Traditional Japanese flower arrangements are divided into two basic groups—classical and naturalistic. The classical group includes Rikka and Seika. The naturalistic group consists of Moribana and Nageire.

Rikka is a classical arrangement of standing plant materials. In early history, this highly stylized composition was the primary form of Japanese flower art. The first forms of Rikka, used mainly for the temple, stood six or more feet tall and required days to complete. Seldom is this style seen today.

Seika is a formalized treatment of line using fresh flowers or branches. It is characterized by three distinct points of a triangle or crescent. Today, the Seika style is basically the same form that has been perpetuated for over 500 years.

Moribana includes all arrangements created in low, shallow containers. This style of arrangement implies a rather free, natural presentation of flowers. There are three classes of Moribana: upright, slanting and hanging.

Nageire covers all arrangements in tall, upright containers. The broad definition of this style is natural or casual looking. Nageire compositions express a free, true-to-nature appearance and emphasize line. There are three styles in Nageire: upright, slanting and hanging.

The arrangement pictured at the bottom left on page 16 is a slanting style Nageire. The tallest stem of myrtle represents Shin—heaven or spiritual truth. The stem of myrtle to the left of Shin stands for Soe—support, helper or harmonizer. The shortest piece of myrtle to the right represents Tai or Hikae—body or material substance. The lilies and daffodils are helpers, supplements to Shin, Soe and Tai. Some schools identify these supplements as Jushi. They are always shorter than the main stem they complement. In this composition, the lilies supplement Soe and the daffodils support Tai.

The arrangement pictured in the upper right is an upright, parallel Moribana, technically described as a rhythmical Moribana. The tallest stem of Nandina is Shin. It has two supplements—the shorter stem of Nandina and the flax leaves. The tallest stem of white Narcissus is Soe which is supplemented with the shorter stem of Narcissus. The tallest Muscari is Tai, supported with the shorter stems of Muscari.

The center arrangement is a 20th Century interpretation of a slanting style Nageire. The green calla lilies establish Shin, Soe and Tai—heaven, earth and man. The white hyacinths and the galax leaves are supplements.

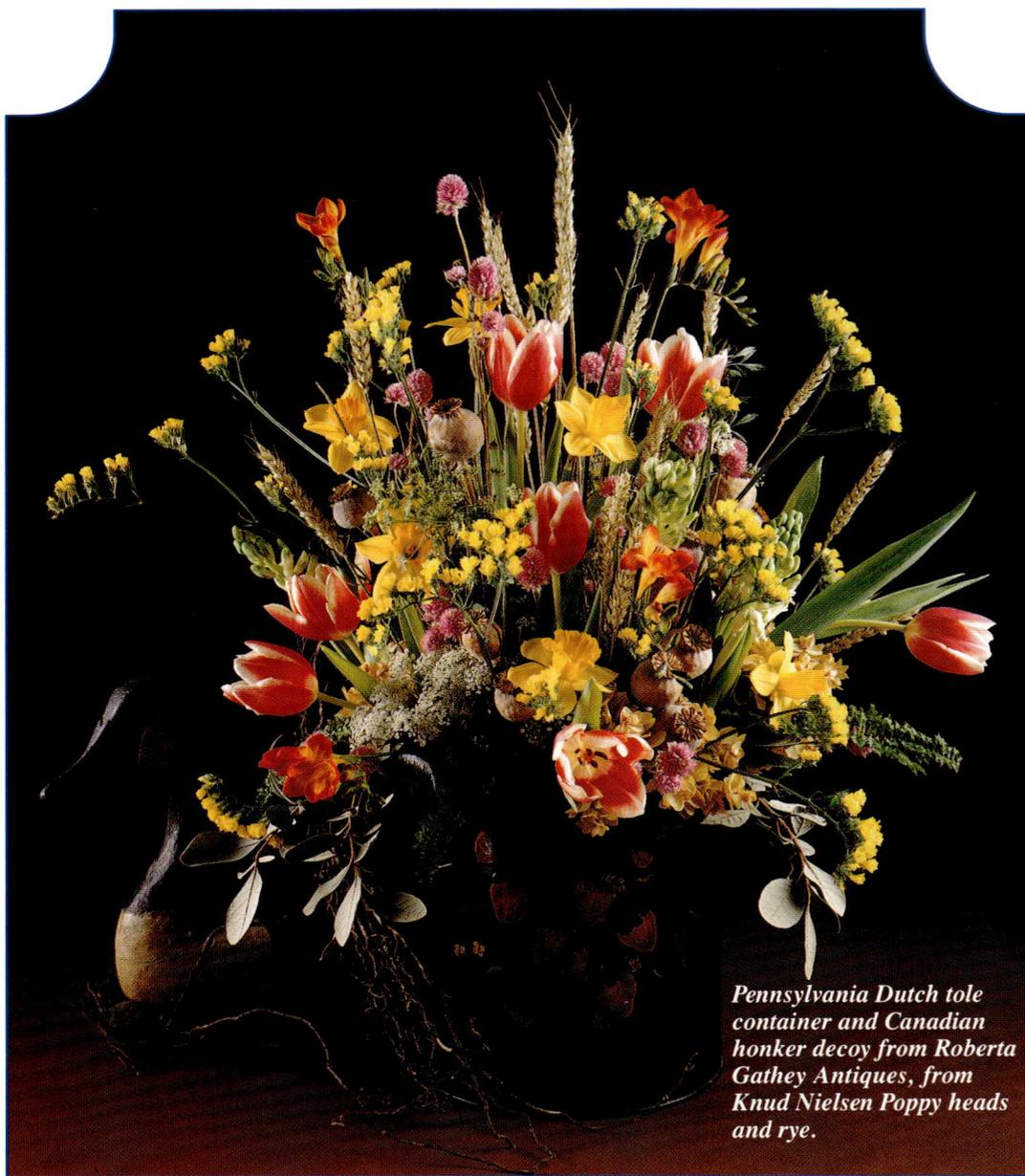

Pennsylvania Dutch tole container and Canadian honker decoy from Roberta Gathey Antiques, from Knud Nielsen Poppy heads and rye.

U nlike Europe, China and Japan there are few pictures and no artifacts recording the history of flower arrangement in the United States.

The lifestyle of the early New England settlers focused only on survival. Gardens provided food and plants, flowers for medicine—peonies for healing power, rose petals to prepare syrups for sore throats and soothing pain, and marigolds for a hot drink stimulant to induce perspiration and reduce fever. The wild flowers of the New England countryside were not used for flower arrangements.

Nieuw Amsterdam, a center of Dutch culture in the New World, became known for growing apple, pear, peach, plum and cherry trees. These Dutch settlers brought with them a love for flowers.

They placed their garden-grown flowers in stoneware jugs, simple pottery utensils and pewter containers brought with them from Holland.

The founding of Williamsburg in 1689 as the capital city, the balance of trade, and slave labor brought wealth and leisure. Tobacco, rice, indigo and cotton were grown and sent around the world. In turn, these settlers imported fine furniture, textiles, wallpaper and chinaware. Flowers and plants were both exported and imported.

Early 18th Century history suggests that flower arrangements in this period included cultivated flowers with wild flowers and grains. The composition pictured above interprets the arrangement style of the 18th Century.

B y the 19th Century, the lifestyle in America became more settled. There were great divisions in the classes and wealth of the population. The wealthy developed affluent social lifestyles.

Because of the abundance of slave labor in the early 1800's, gardens abounded with extensive varieties of flowers and plants. Many were expensive imports from all over the world. Others were hybridized and cultivated wild flowers. The moneyed population had access to fine containers from Europe and China. There is little historical information about the use of flowers in this mid-period in America. Those

THE HISTORY OF FLOWER ARRANGEMENT

18th, 19th and 20th

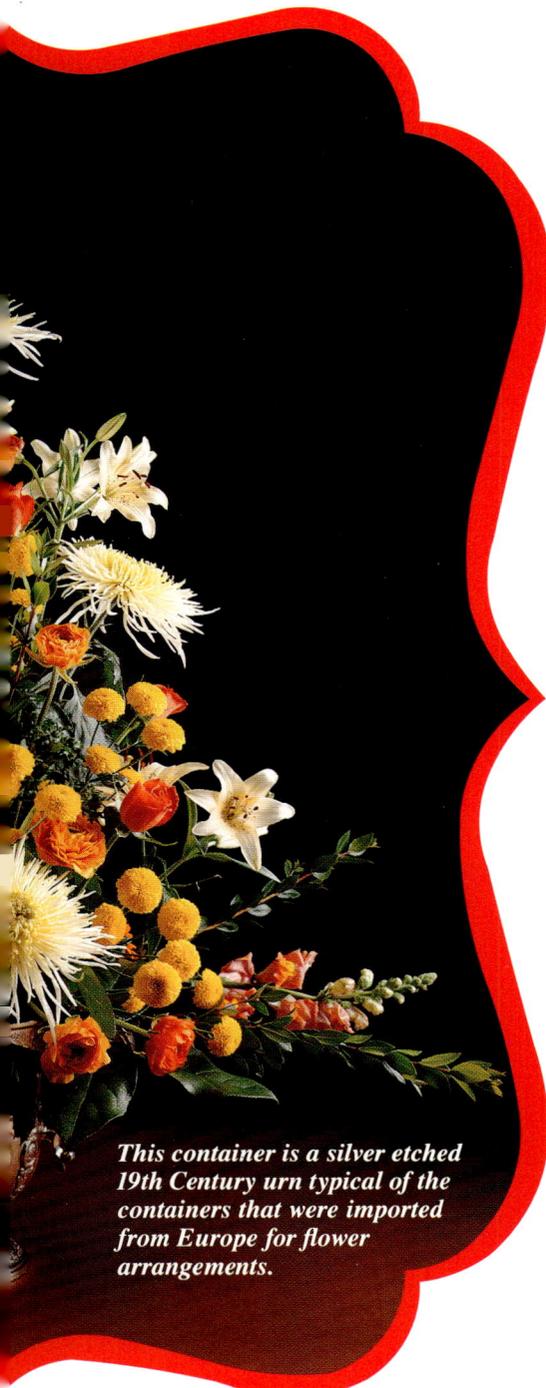

This container is a silver etched 19th Century urn typical of the containers that were imported from Europe for flower arrangements.

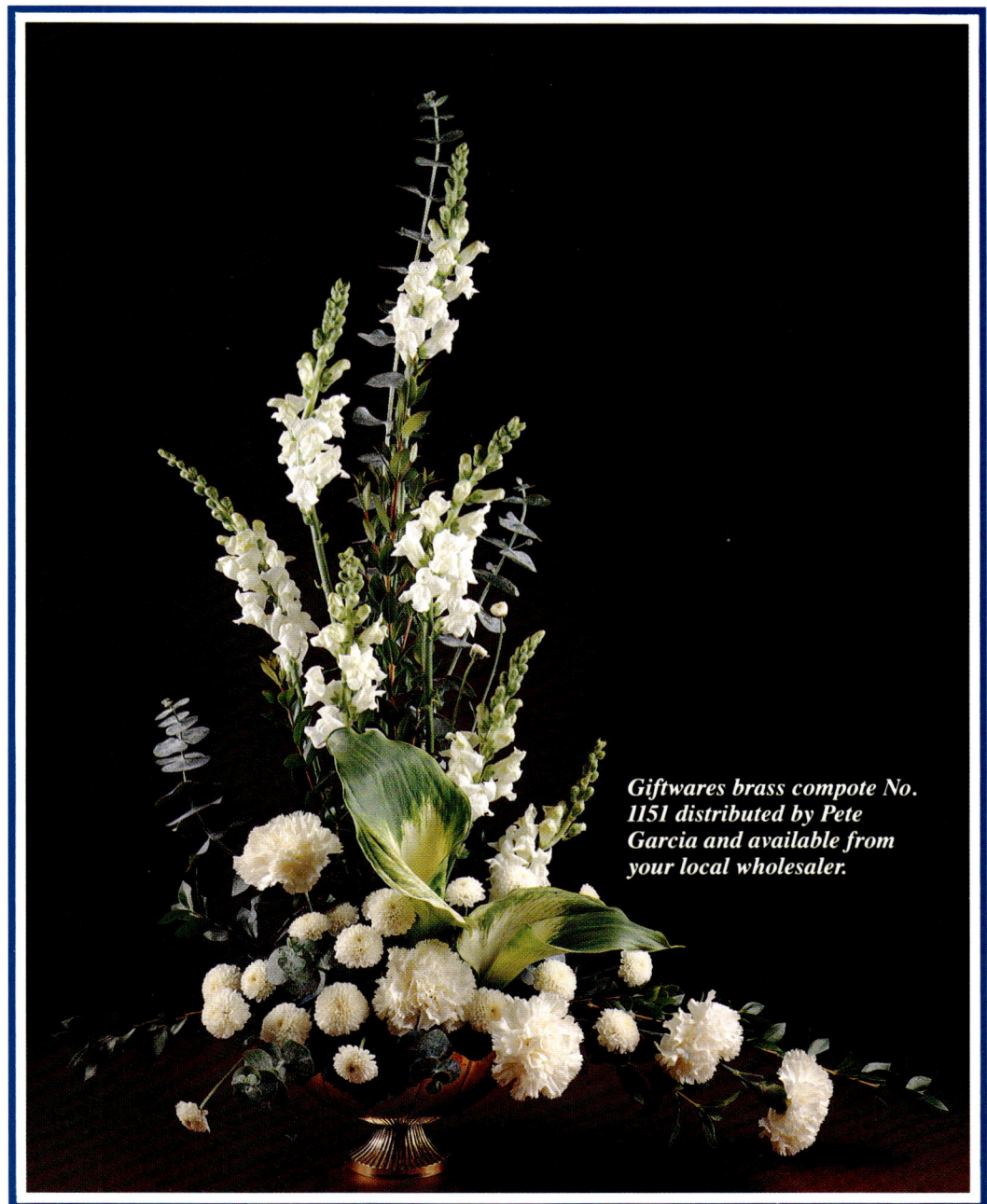

Giftwares brass compote No. 1151 distributed by Pete Garcia and available from your local wholesaler.

historians who have researched photographs state that extravagant parties, dinners and luxurious entertaining were a way of life for the wealthy. And, flowers were used—often lavishly—to decorate for these festivities. Some historians suggest that by 1825 those who specialized in "making bouquets" were engaged to create these decorations.

In the 1800's, most arrangements were round and overladen with flowers and foliages. One historian records, "Very little taste and style were apparent in the arrangement of flowers until the mid 1900's."

Flower arrangement in the United States started at home as a cottage industry and then became a commercial endeavor. Some historians suggest that flower arrangement as a profession did not begin until the Western style emerged in the mid 1900's. Even though we cannot refer to an authoritative source for a definition, the common understanding is that Western Style combines the massiveness of the European design with the line emphasis from China and Japan.

The arrangement in the center is an example of Western Style in the traditional triangular, symmetrical form. It combines the massive influence of the

European arrangement with the sensitivity for line from the Orient. The triangular form, which can be expressed in any size and with any flowers, is a traditional look of contemporary 20th Century flower arrangement.

As the interest in line design advanced, the asymmetrical form became popular. Like the symmetrical triangular arrangement, the asymmetrical design is an important part of the history of flower arrangement in the United States. The white and green composition pictured above is an example of the typical asymmetrical style created in most flower shops today.

Century America

There is no limit to the beauty of Spring

The carefully planned repetition of the groupings of two and three blossoms in this composition brings a feeling of order and organization to this design.

Container No. 644B from Del Rey Plastics Corporation, distributed by Pete Garcia, and Oasis® floral foam are available from your local wholesaler.

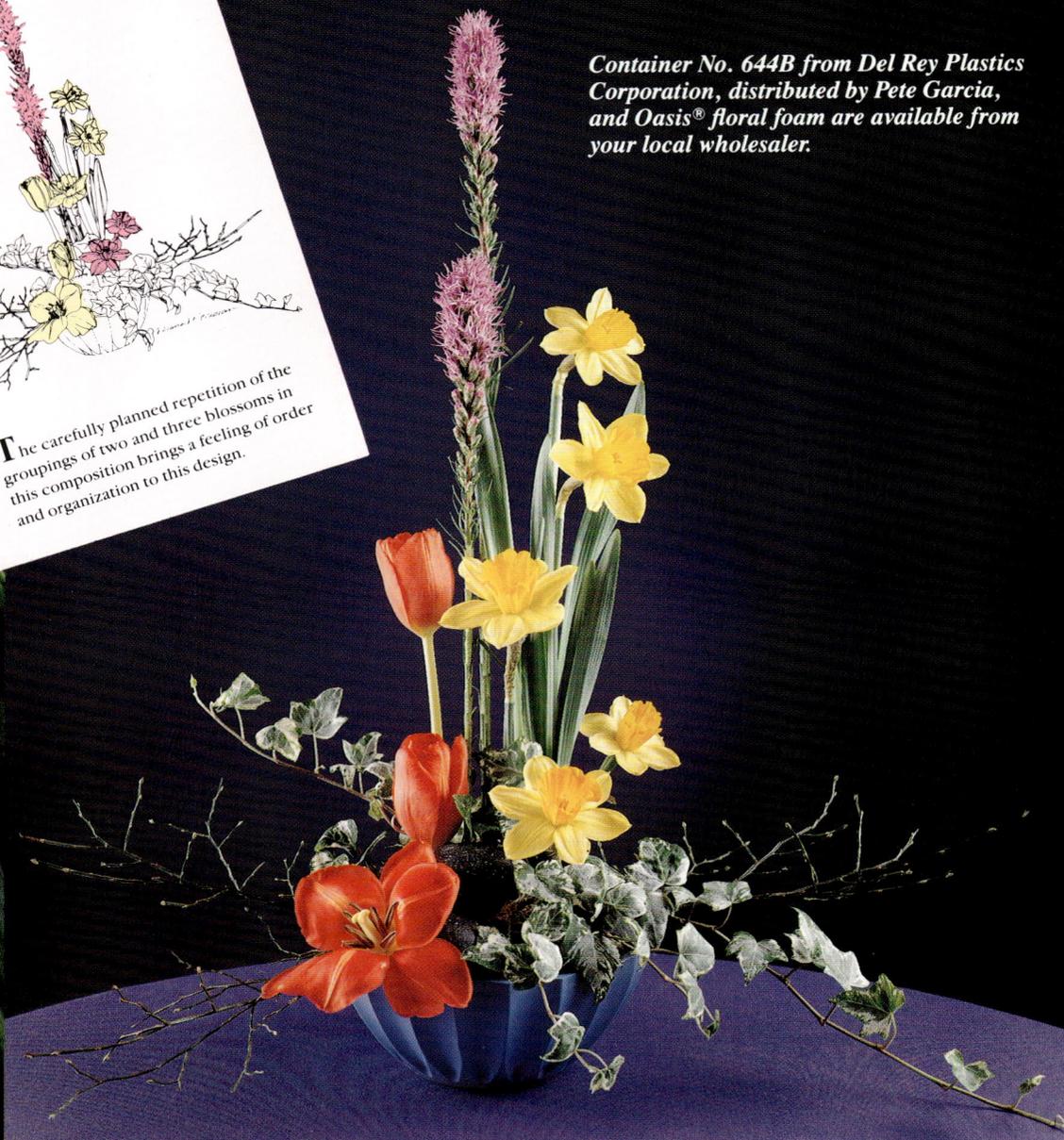

Some designers remain only flower arrangers because they refuse to stretch to gain professional knowledge. They claim that becoming too engrossed in the technical considerations of a professional design destroys creative spontaneity. Perhaps this is true for some. Our objective is to go far beyond presenting you with pretty pictures for you to "ooh" and "aah" about. You gain little knowledge by oohing and aahing. Understanding what's behind the design that causes the viewer to ooh and aah is where learning takes place.

Professional floral design is far more than spontaneity. It is knowledge. The absolutely wonderful arrangement pictured to the left trumpets Spring. It merits a choir of oohs and aahs. Unless we understand what accounts for the exciting visual impression, we have little we can store in our bank of knowledge to use in future designs.

Professional floral design is a study in relationships. All kinds of relationships. Relationships in form. Relationships in color. Relationships in texture. Relationships in dominance and acquiescence.

In this symmetrically balanced Spring arrangement, the artist chose to use two stems of liatris, three stems of tulips and five stems of daffodils. Even this selection of materials moving in a Fibonacci numerical sequence is a relationship.

This bright composition breathlessly heralds Spring by presenting an important relationship in color. The red tulips and the yellow daffodils are primary colors. The red-violet liatris are an intermediate color. This planned relationship of one intermediate color combined with two primary colors achieves color vibrancy not possible with other color harmonies.

The placement of the blossoms in this composition achieves another relationship. The two Narcissus in the lower area of the design repeat the pairing of the liatris. The grouping of three daffodils repeats the grouping of the three tulips.

Professional floral design is more than a study in relationships. It is an understanding of contrasts.

The smart, bright, contemporary, Spring design pictured to the right combines a minimum quantity of materials to achieve an exciting, luxurious look. How does the artist accomplish this? By depending on spontaneity? Of course not. The artist carefully thought out and visually planned this composition before selecting a single blossom and inserting flowers into the container.

Check out the magnificent color. Three very chic, smartly-in-fashion colors—blue-violet iris, red-violet tulips and a violet container—contrasted with complementary yellow Narcissus.

Analyze the structure of the composition. The two iris, the three stems of Narcissus and the single stem of Equisetum are placed in parallel positions. In contrast, the tulips, the succulents and the fern fronds radiate into and out of a central focal point. By combining parallel placement with radiating placement and creating contrast, the artist brings visual energy to the composition.

Consider the forms of the materials used in the design. The iris, the Narcissus, the tulips, the succulents, the fern fronds and the Equisetum triangles—all have distinctly different forms.

Professional floral design is more than spontaneity. It is knowing how. How to select colors to cause an impression. How to combine forms to generate visual energy. How to place materials to create distinction. This how-to knowledge that can be used over and over again establishes an individual as a professional floral artist.

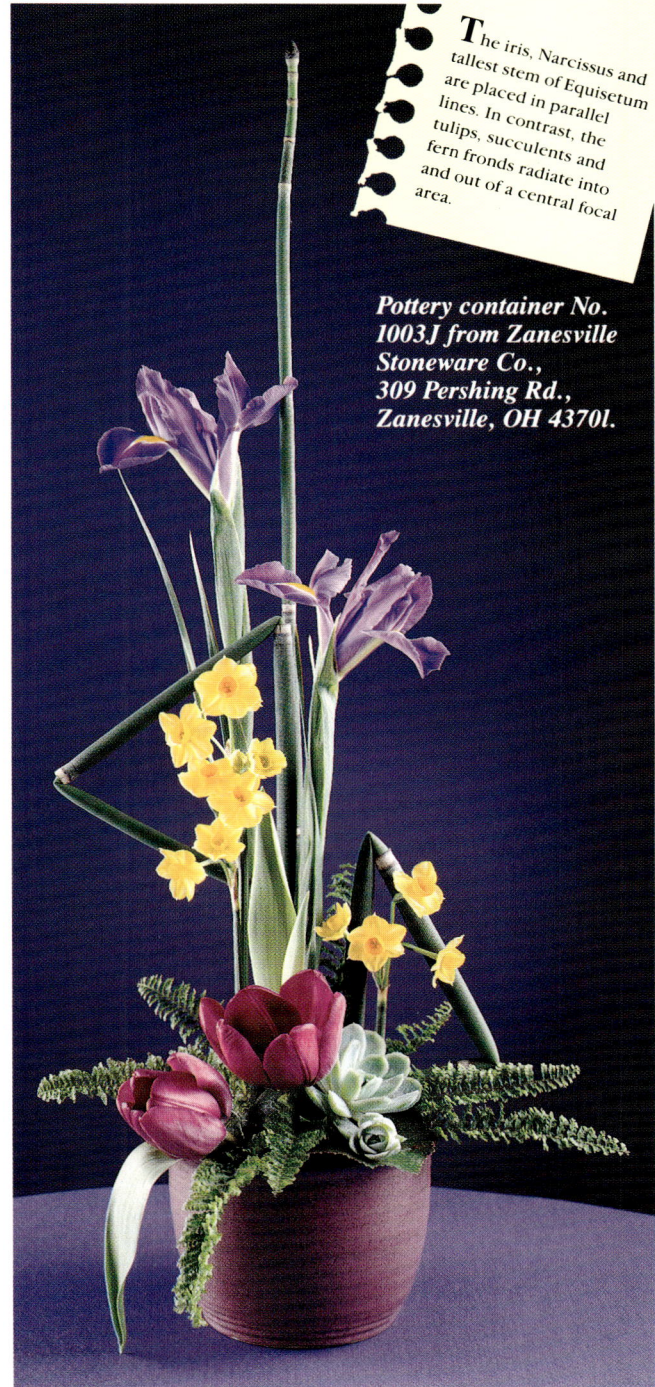

The iris, Narcissus and tallest stem of Equisetum are placed in parallel lines. In contrast, the tulips, succulents and fern fronds radiate into and out of a central focal area.

Pottery container No. 1003J from Zanesville Stoneware Co., 309 Pershing Rd., Zanesville, OH 43701.

Spring unlocks the power

"Creativity is concerned with bringing about new ideas and updating old ones. Since most information is available to everyone, it is the creativity with which an individual can look at the data that makes the big difference. Creativity is the competitive tool that matters most. Even apart from competition, creativity is necessary to develop new ideas that make the fullest use of the available knowledge. Creativity is not only concerned with generating new ideas but with escaping from old ones."
Edward deBono, in Lateral Thinking.

Creativity is a learned skill. Even those who have inborn creative characteristics must learn the skills of creativity. Do not confuse creativity with artistic skills. Being artistic, an adroitness with the hands, is no more than an expression of one facet of creativity.

All forms of creativity begin with thinking, the ability to use your mind. Every flower arrangement starts in the mind and uses one of two methods of creativity. The designer either looks at a picture and copies the arrangement, or he mentally recalls an image of something he has seen and copies this likeness.

The designer who uses the second method of creativity appraises the possibilities. Then, he creates from a perspective of being original. This artist visualizes his own possibilities rather than working from established patterns. Established patterns come from (1) pictures and/or (2) information gathered and stored in the mind that creates a consistent visual image.

Either of these methods of creativity can be expressed artistically by the floral artist who understands the elements, principles and techniques of professional floral design. Technically, these two methods of creativity are known as association and disassociation.

The two Spring arrangements pictured are excellent examples of creative design by association and disassociation.

The logical approach to design is working with an established pattern. An artist gathers a grouping of flowers and he sees them arranged in a comfortable, traditional arrangement, which is usually an established pattern. The beautiful Spring mantel decoration below features a traditional, triangular arrangement. Artistically, it is beautiful. Aesthetically, it is very pleasing. Technically, it is created with impeccable technical skill in professional design. From a creativity viewpoint however, it follows an established pattern.

Even in being creative through association, the artist expresses disassociation by moving away from the standard triangular arrangement. A soft, flowing line introduced on the high left side with a stem of leptospermum moves through the composition and concludes with the strand of ivy on the lower right. The gerbera, freesia and liatris on the lower right cause the design to move away from the expected equidistant triangle.

The striking basket of Spring flowers arranged in parallel lines represents creativity through disassociation. The artist moves away from an established pattern into a new possibility. The presentation at the base of the composition is another creative move in disassociation. It does not follow established pattern.

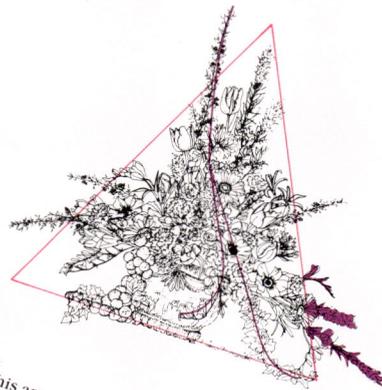

This arrangement falls within an equidistant triangle, a traditional, expectation form of design. To break away from the established pattern the artist introduces a flowing high left to low right line.

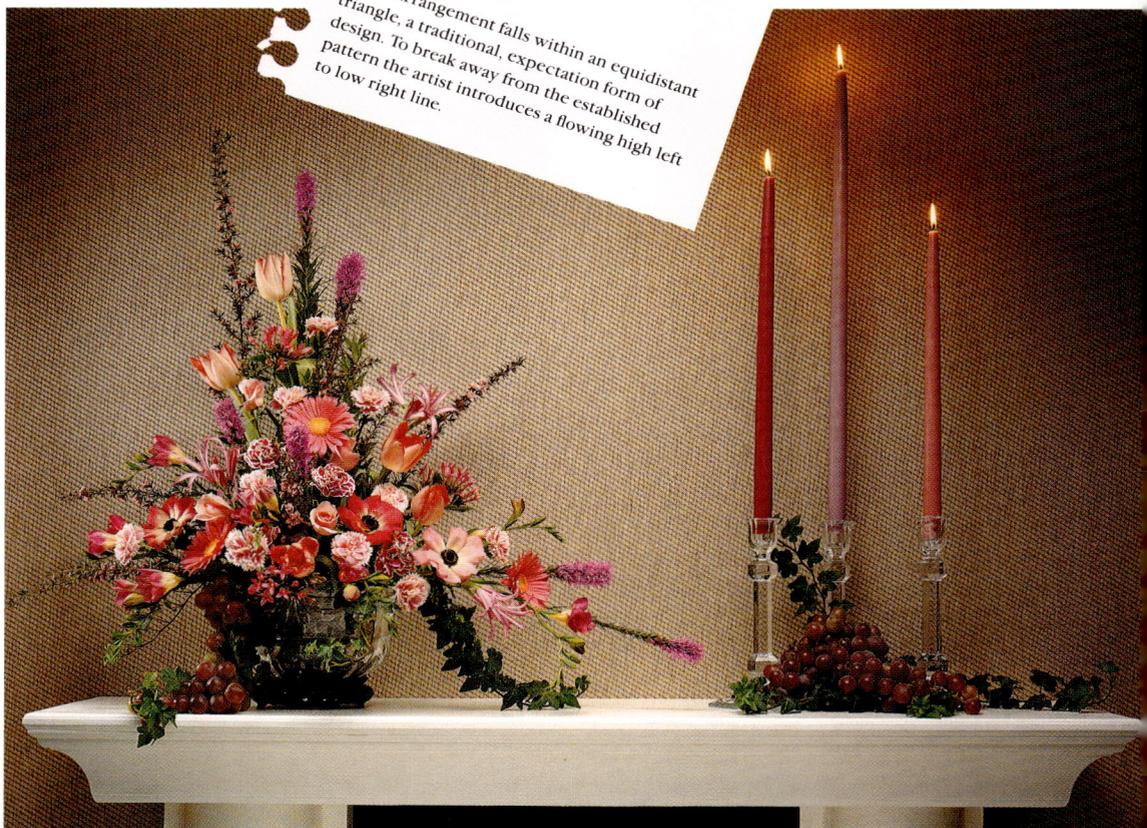

26

There are two distinct parallel lines in this composition. One with only tulips and one with three different flowers. This use of material is a disassociation since the expected pattern would be to use only one variety of flower in each parallel line. The presentation of materials at the base adds another dimension of unexpected creativity.

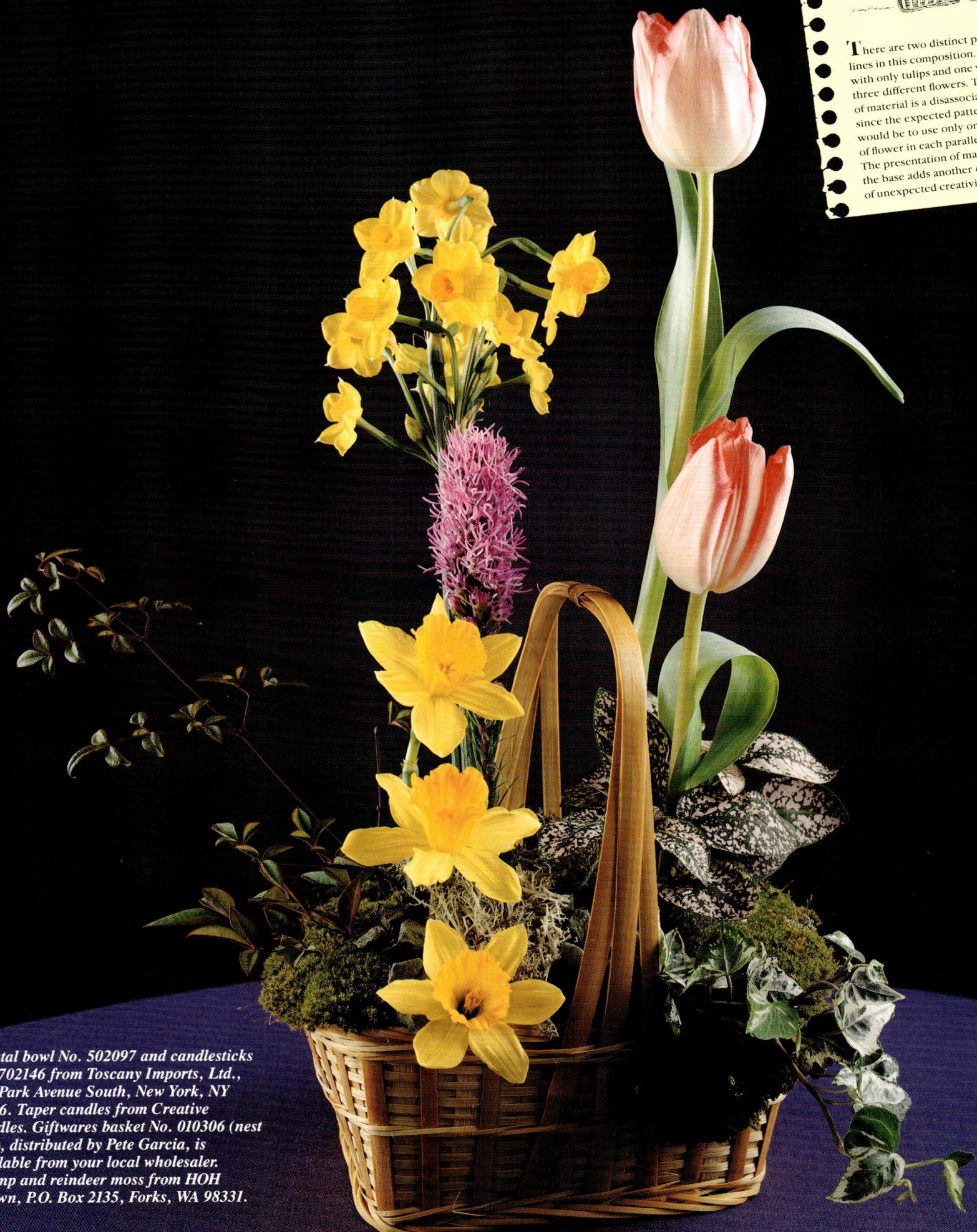

Crystal bowl No. 502097 and candlesticks No. 702146 from Toscany Imports, Ltd., 386 Park Avenue South, New York, NY 10016. Taper candles from Creative Candles. Giftwares basket No. 010306 (nest of 3), distributed by Pete Garcia, is available from your local wholesaler. Clump and reindeer moss from HOH Grown, P.O. Box 2135, Forks, WA 98331.

Spring- there is no saturation point in design

A professional floral artist creates visual dynamics with flowers. A ladder leaning precariously against a wall creates a visual dynamic. If this same ladder were placed with every precaution for safety, it would not have the same dynamic.

Picture a diver preparing to jump off a high cliff into a body of water. As he stands straight, appraising the situation and preparing himself to dive, he communicates one dynamic. Just as soon as he bends, leans forward and poises himself to jump, the visual dynamic changes.

In floral design, the presentation of line is an effective way to influence the visual dynamics of the composition. Study carefully the arrangement pictured with two iris, two opened tulips and two daffodils. This composition demands and holds attention because of the line dynamics. It has visual drama resulting from the studied presentation of line.

The two iris stand tall, lofty and erect in a strong vertical line position. In the central focal area, two tulips cluster together in an explicitly diagonal line. The two daffodils frame the composition with smooth, curving lines. And, two fronds of curly fern jet out of the composition on the opposite side in an opposing diagonal line. The voids of the barren iris and daffodil stems add another visual dynamic to this beautiful composition.

In floral art, anything identified as dynamic must express motion and energy. Often the motion and energy which produce visual dynamics are expressed through opposition. The arousing visual dynamics in this flower composition result from the opposition between straight, diagonal and curving lines.

This Spring arrangement is an outstanding example showing how you can offer your customers striking, creative, professional designs at affordable prices.

Construction Tips: Insert wires into the stems of the daffodils. Then, gently form the curved stems before inserting them into the saturated floral foam in the container. The rock and moss treatment at the base of the composition is an essential characteristic of this design style.

T he method of line presentation in a composition heightens visual dynamics. Conversely, if line is not clearly introduced and resolved, the visual dynamics of the composition are weakened.

Direction of line, thickness of line and repetition of line are three factors which enhance visual dynamics. Dynamics through line opposition as illustrated in the arrangement of iris, tulips and daffodils are not effective unless the lines can be distinct and unencumbered. In most cases, this requires the generous use of negative space and voids. Line confusion produces visual confusion, not visual dynamics.

The elegant basket tray of flowers is an excellent example of organization of line to create visual dynamics. There are only two types of lines in this composition— vertical and diagonal. The heather, the protea foliage and the fern fronds at the ends of the composition are in opposing line positions to the vertical rows of the flowers. This opposition, even though very gentle, introduces visual energy.

Visual dynamics are achieved through the presentation of lines in different thicknesses. As you scan across this wonderful collage of beautiful blossoms, notice that each row is a different width.

The color harmony heightens the visual dynamics of the composition. Closely associated pinks in miniature carnations, roses and bouvardia, lavender anemones, red- lavender miniature carnations and heather with a brilliant contrast of unexpected white tulips speak out with color elegance. Each flower and each color is repeated throughout the row. In this type of studied floral composition, color choice is extremely important. The visual dynamics would be violated if the colors failed to move together in close sequences.

Construction Tips: Create this lovely composition in any low, rectangular basket lined with polyfoil and filled with pieces of saturated flower foam. This style of design is an excellent suggestion for a centerpiece, a coffee table or for a serving credenza.

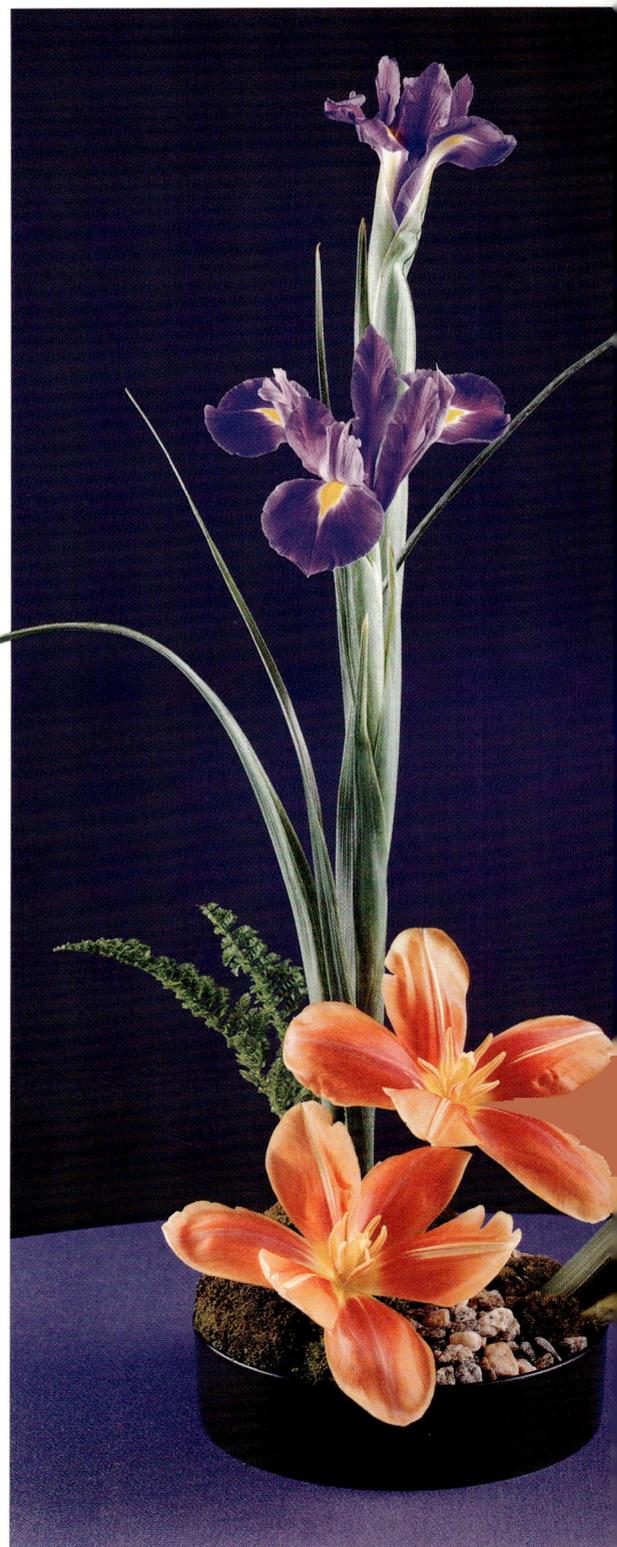

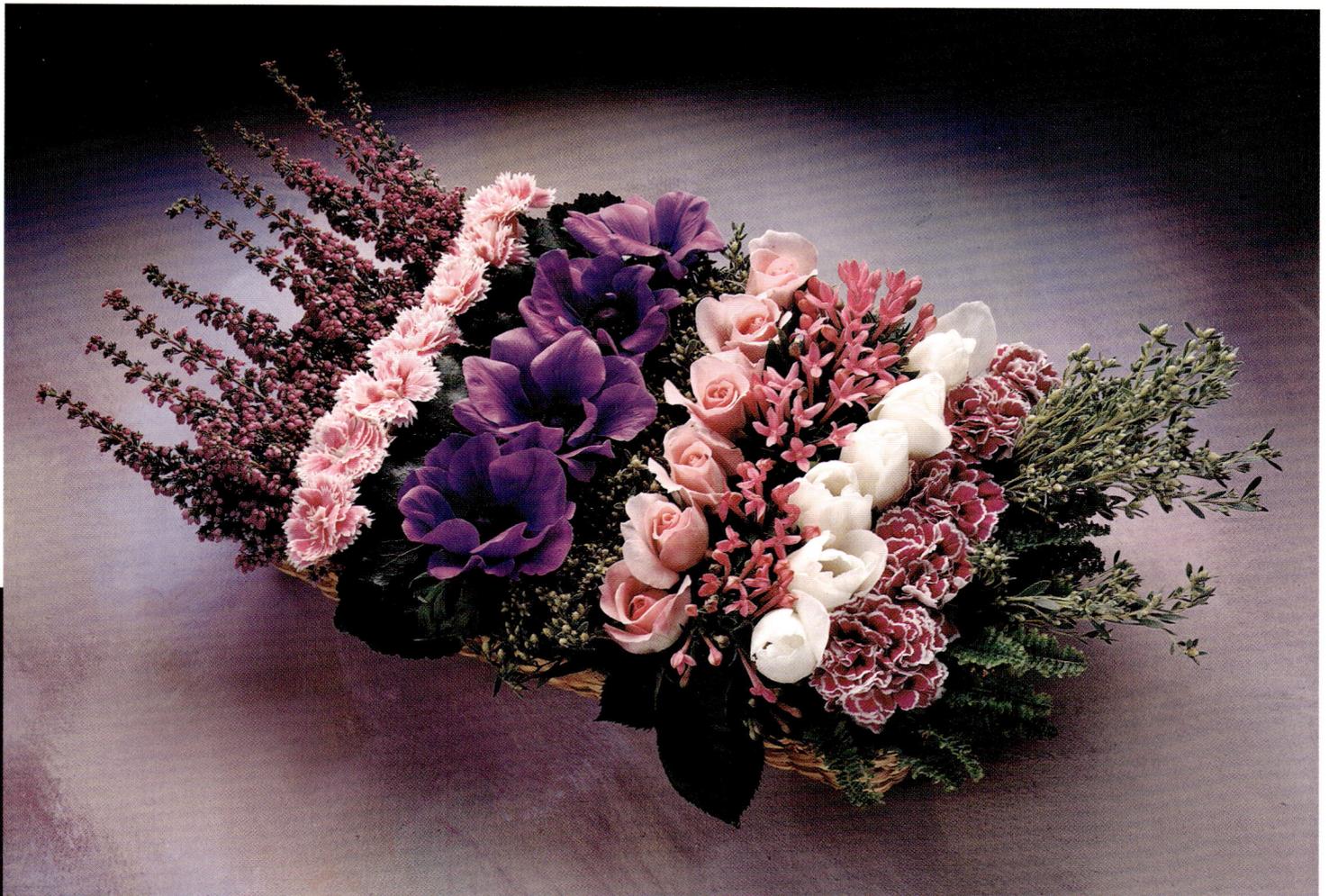

Basket available from your local wholesaler.

Small designer tray No.16 from Syndicate Sales, available from your local wholesaler. Clump moss from HOH Grown.

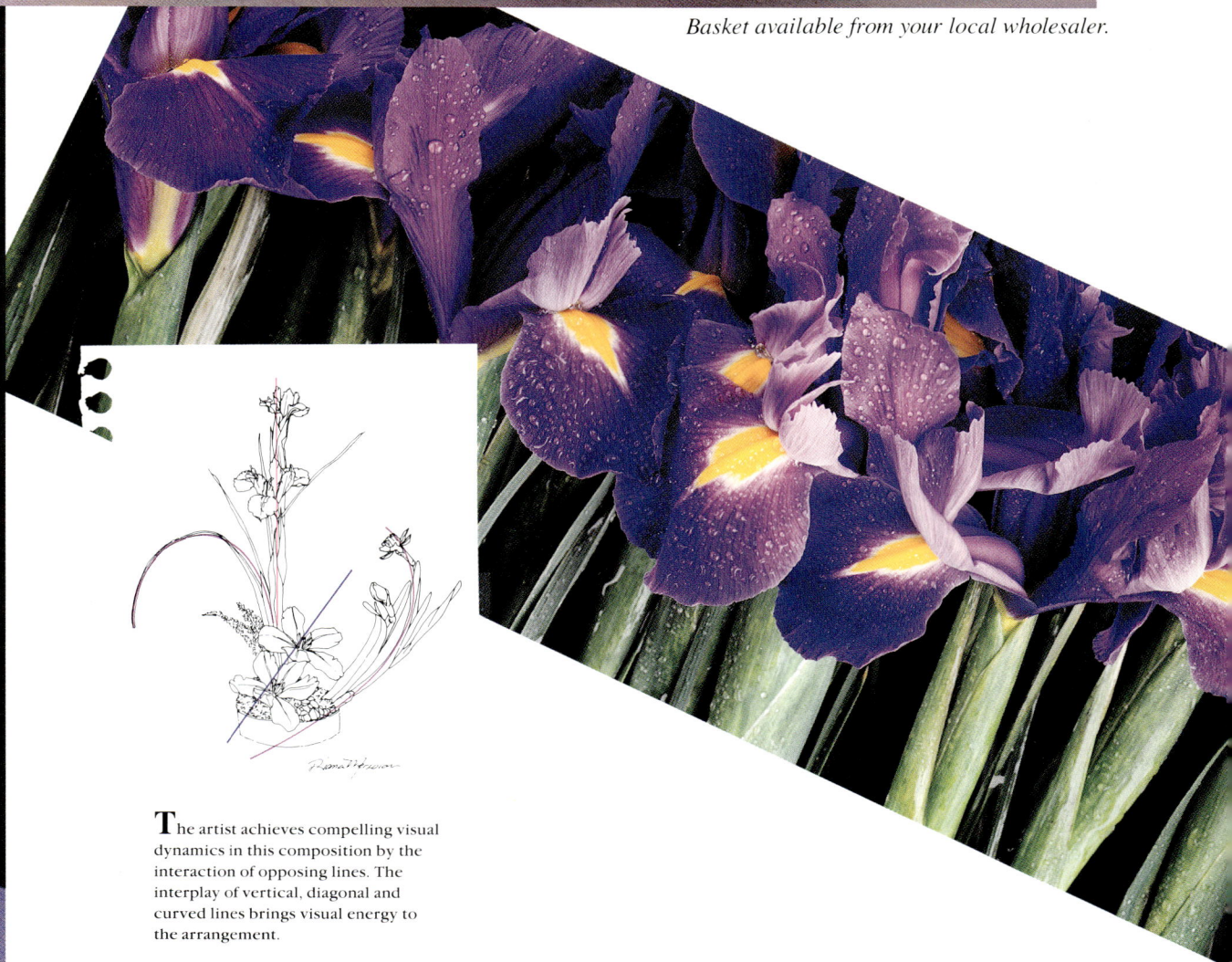

The artist achieves compelling visual dynamics in this composition by the interaction of opposing lines. The interplay of vertical, diagonal and curved lines brings visual energy to the arrangement.

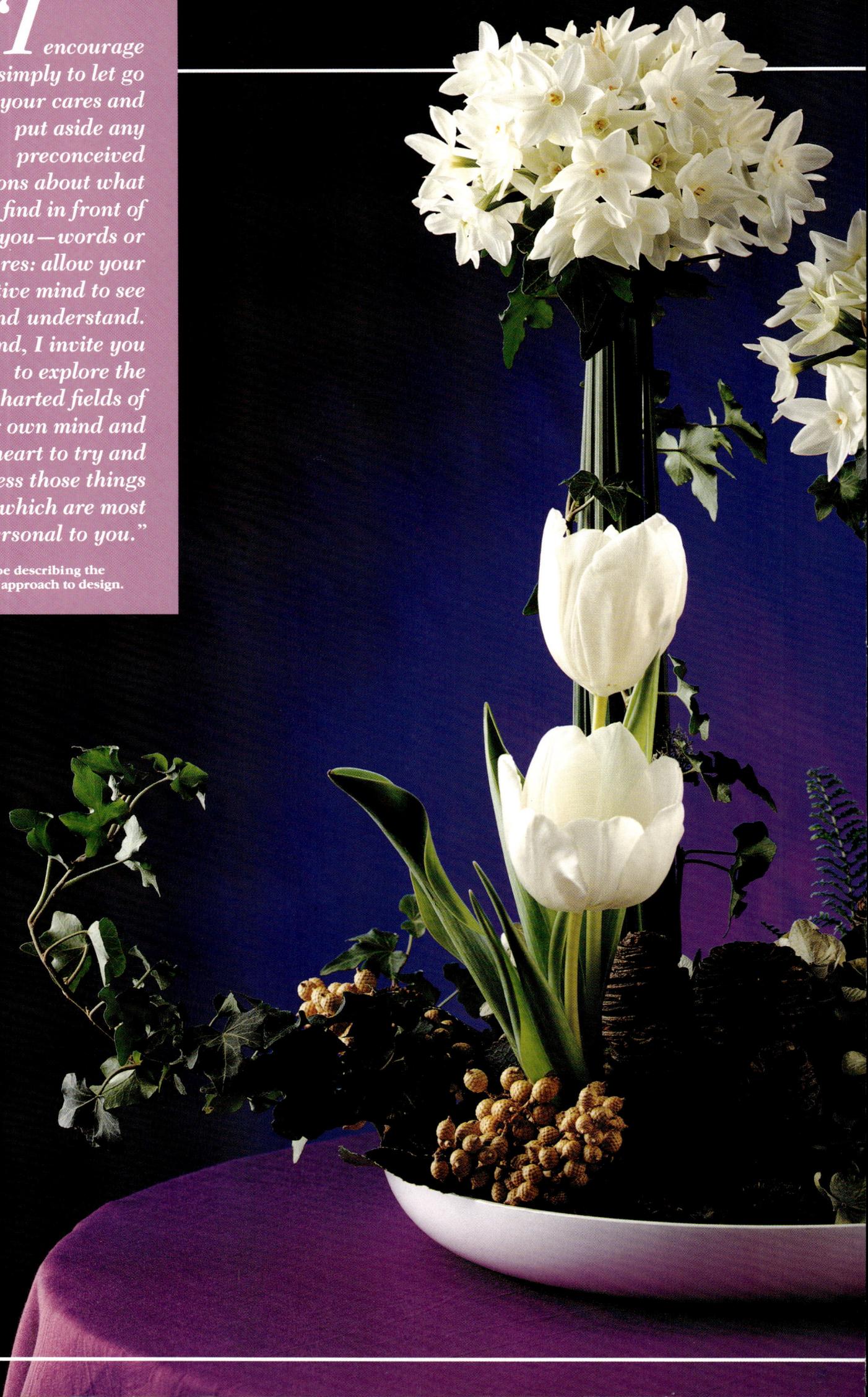

LET THE TECHNIQUE MAKE THE LOOK

BANDING, the process of tying materials together is a design technique, a method of "handling and presenting materials." We are not sure when or where the banding technique originated. Banding was first mentioned in the history of flower arrangement during the Italian Renaissance in the 1300 to 1550 era. It is believed, however, that as early as the 6th Century, the Japanese used the banding technique in preparing materials for Rikka arrangements for the temples.

This marvelous composition expresses an elegant form of banding with ivy. The artist grouped stems of white narcissus, tied them loosely with raffia and then banded them with ivy. (Since the ivy is not in water, spray it on both sides with Design Master Clear Life before banding it around the narcissus.)

To create this striking composition anchor two pieces of saturated flower foam in a Lomey Designer Dish. Insert a bunch of narcissus into each piece of foam and band with ivy. Then position the white tulips. Use a basing technique to create the foundation with fresh ivy and fern, dried hydrangea, canella and spiral cones.

Use this method of presentation with two banded groupings of many varieties of flowers.

LET GO! BE CREATIVE!

Lomey medium Designer Dish; Knud Nielsen dry hydrangea, canella and spiral cones; Design Master Clear Life and, Oasis® floral foam available from your local wholesaler.

Banding Techniques

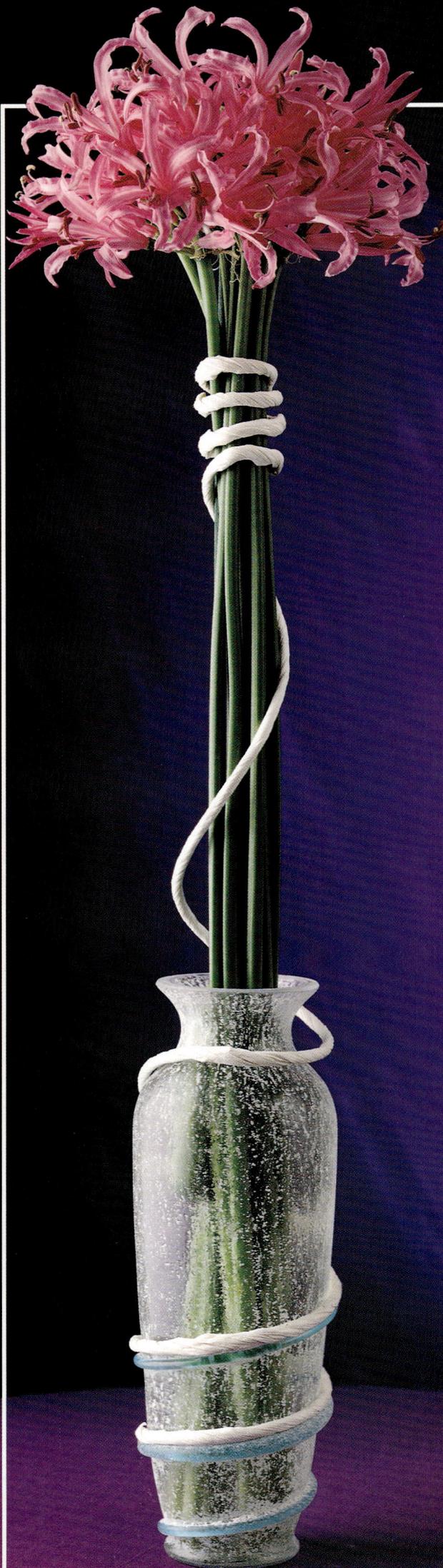

BANDING
WITH A
TWIST

DESIGNING requires intellectual work, but is far more than an intellectual exercise. Professional floral design develops from a marriage of intellect and intuition. To a certain extent, things you learn intellectually become so much a part of you that you use them without thinking. Working intuitively however, means moving out from this unconscious competency and exploring beyond what you know.

Gathering new ideas, probing beyond what you know, is an important part of the creative design process. When viewing the work of another artist, search for ways to adapt, adjust and modify. Seldom do you find an idea that can be copied exactly as seen. Instead, look for ways to apply the idea to your own creative environment.

This sophisticated vase design is another example of banding. The artist placed ten stems of nerine lilies in the vase and then banded them with wired paper ribbon. In this composition, the blue swirls on the vase establish the circular banding pattern. The wired paper ribbon glued to the container accents the swirls of the vase.

Adapt this same idea to many types of banding designs. The elegant Toyo vase is the perfect container for this composition. Nevertheless, don't let the vase restrict you. Glue swirls of wired paper ribbon to any cylindrical container. Use one color on the vase and another color to band the flowers and circle down to the container. Band carnations, iris or any other flower depending on the look you want and the budget.

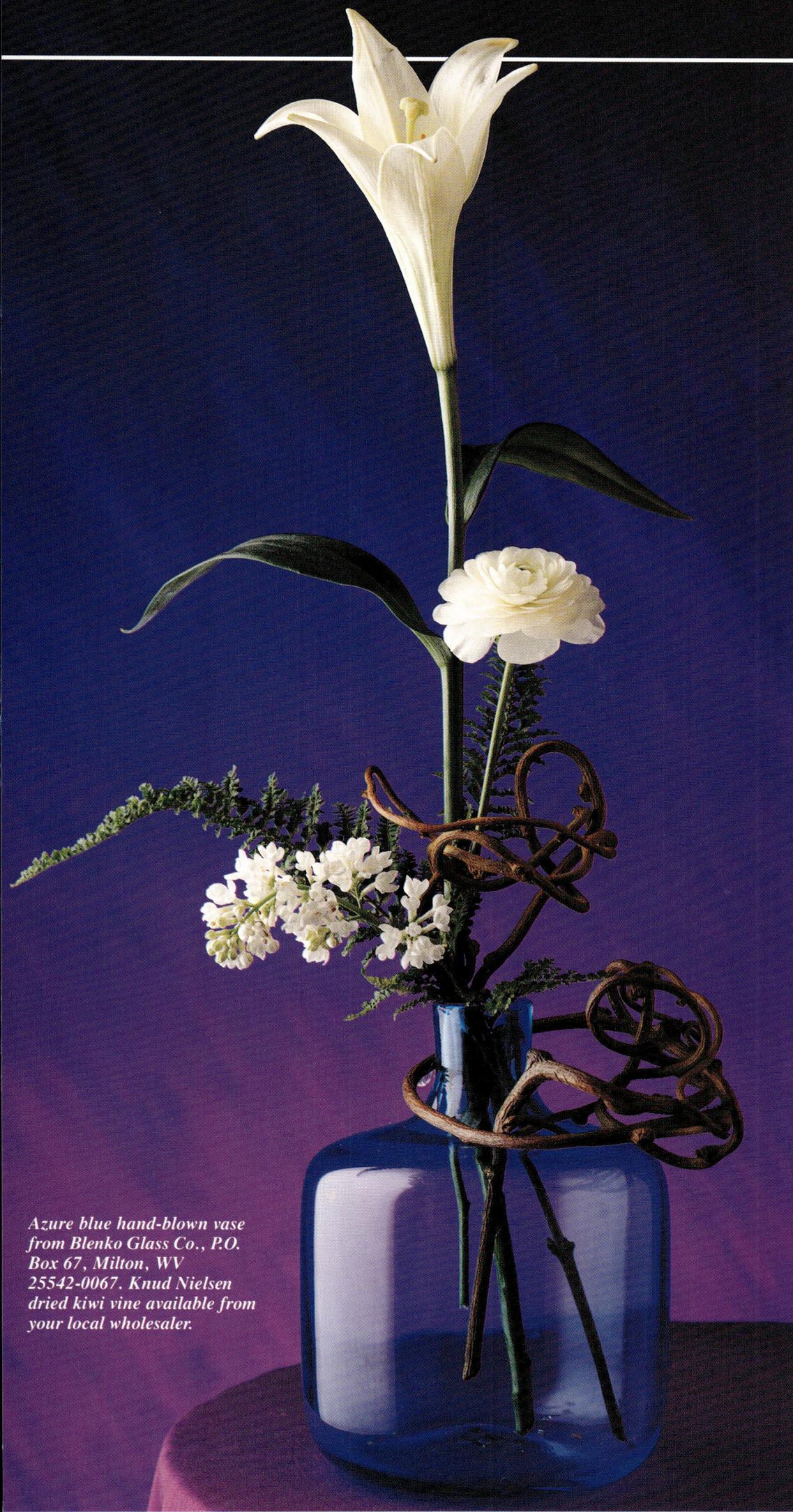

VARIATIONS on

a theme produce many interesting adaptations. This is a frequent creative approach in writing music. The composer develops one central theme. Often, it is first introduced in its pure, melodic form. Then, the composer repeats this theme over and over again in different variations. A variation either simplifies or embellishes the central theme.

Banding, as a technique of professional design, is a central theme. It can be used in its purest, simplified form like tying a group of flowers together with raffia, to the embellished variations pictured. As in music, variations on a theme in floral design amplify the visual impact of the composition.

The technique for using the banding variation pictured is important. First, place a curled stem of kiwi vine over the neck of the vase and glue it in place. Next, insert a stem of kiwi vine in the container as the flower holder. Then, position the blossoms and greens making sure they are secure. Notice that the artist used an assortment of blossoms rather than several stems of the same flower.

The wonderful Blenko glass vase is an integral part of this composition. Don't let this one variation get stuck in your mind as the only possibility. Use this kiwi vine banding idea on many vases and with a wide assortment of blossoms.

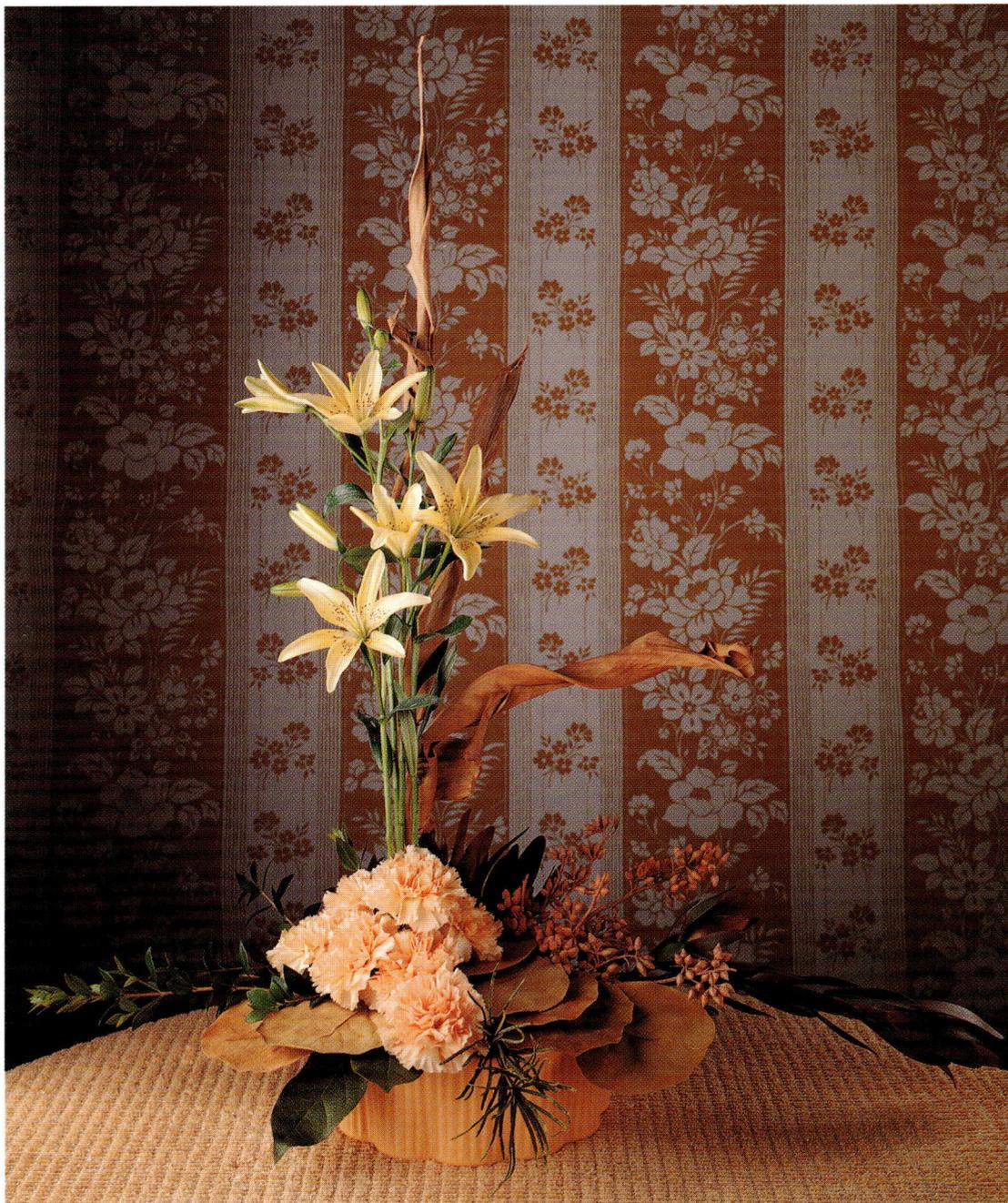

The total effect of a composition is greater than the sum of its constituent parts.

Container No. R309 from A. L. Randall Co., P.O. Box 82, Prairie View, IL 60069. Knud Nielsen Watercolors™ strelitzia, sea grape leaves and euk fruit available from your local wholesaler.

Professional art—flower arrangement is a professional art—considers the Gestalt school of psychology extremely important in understanding how to create compositions. From their research, the Gestalt psychologists learned that the whole (the floral design) is far more than a sum of its parts (the flowers and other materials). And, this whole (the floral design) cannot be perceived by a simple addition of isolated parts (everything that goes into the design). Each part (each material used in a floral composition) is influenced by those around it. **A**n important Gestalt design principle—SIMILARITY—states that when we see things that are similar, we naturally group them by shape, size and color or value. The key premise of this grouping according to Gestalt is that similarity is necessary before one can notice difference. **I**n the compo- sition pictured above, the Gestalt principle of Similarity is beautifully illustrated. All materials are presented in impressive groupings. The striking visual beauty of the composition—the perception—is not the groupings, but the differences in the materials emphasized by the groupings.

Taper candles from Creative Candles, P.O. Box 412514, Kansas City, MO 64141.

Gestalt psychologists focused on how we see and organize visual information into a meaningful whole. Whenever you create a floral design, you are organizing visual information (flowers, materials and accessories) into a meaningful whole (a design.)

When everything that "happens" in a composition, the interaction of all elements, is aesthetically pleasing to the viewer, the total effect is perceived as more pleasing than the sum of its constituent parts. It is called "good Gestalt." **T**he mantel composition illustrates the Gestalt principle of PROXIMITY, or nearness. When individual visual units are next to, or near one another, they are in proximity and perceived as a group. The visual perception, the effect of seeing this group is greater than any of the single parts. **I**n this mantel composition, the artist combines Similarity with Proximity. Each of the groupings of two brass candlesticks establishes a similarity. The visual impact of groupings is far greater than the impression of any one candlestick. In organizing the presentation, the artist placed the two candlesticks with flower arrangements in one prox- imity and the two with candles in another proximity. As a total composition, the proximity of all elements (the whole) is much greater, much more visually impressive than the sum of the individual parts.

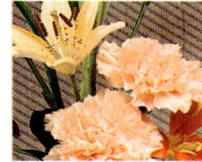

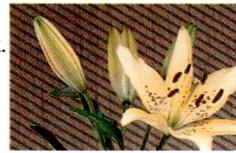

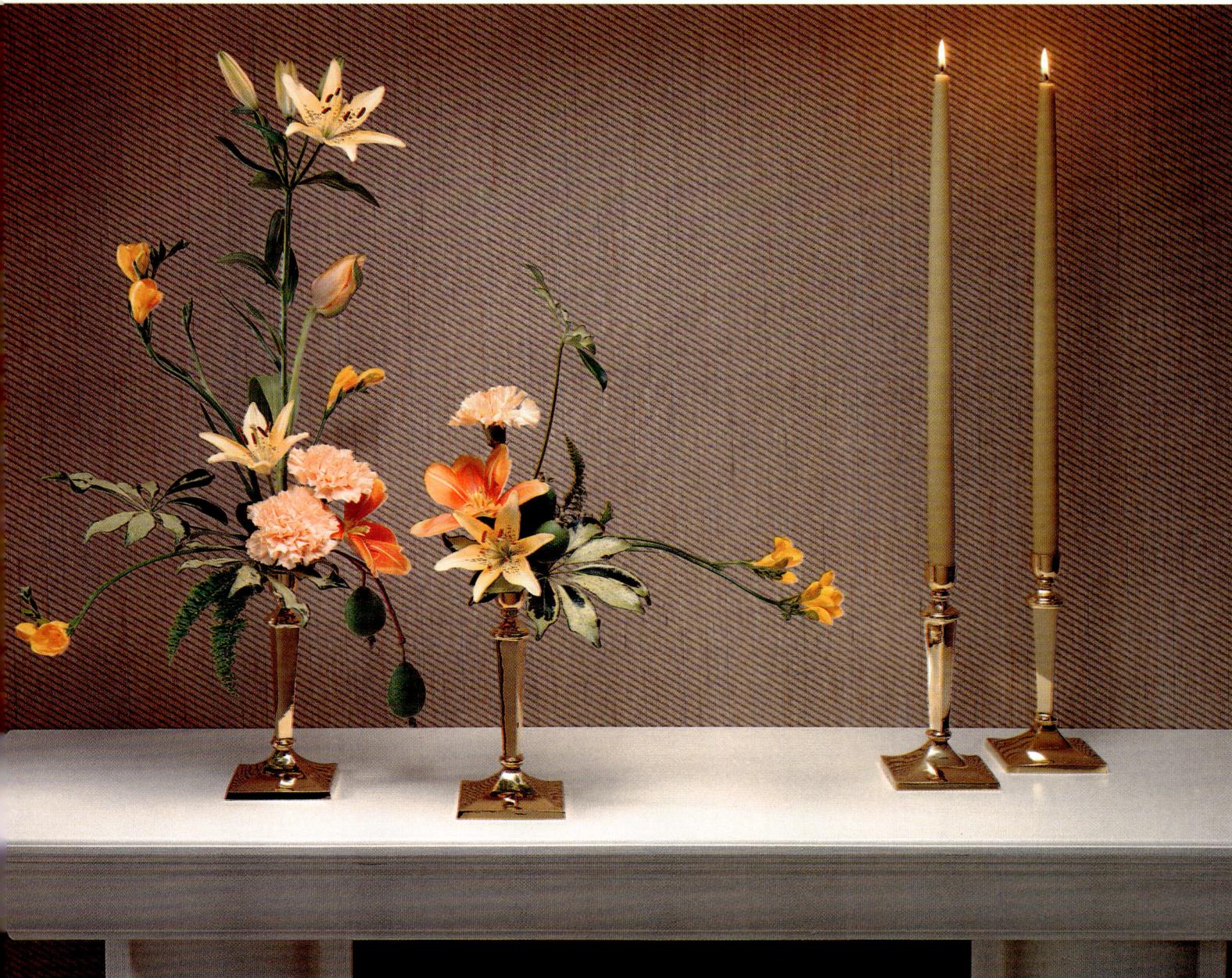

The Gestalt Design Principles

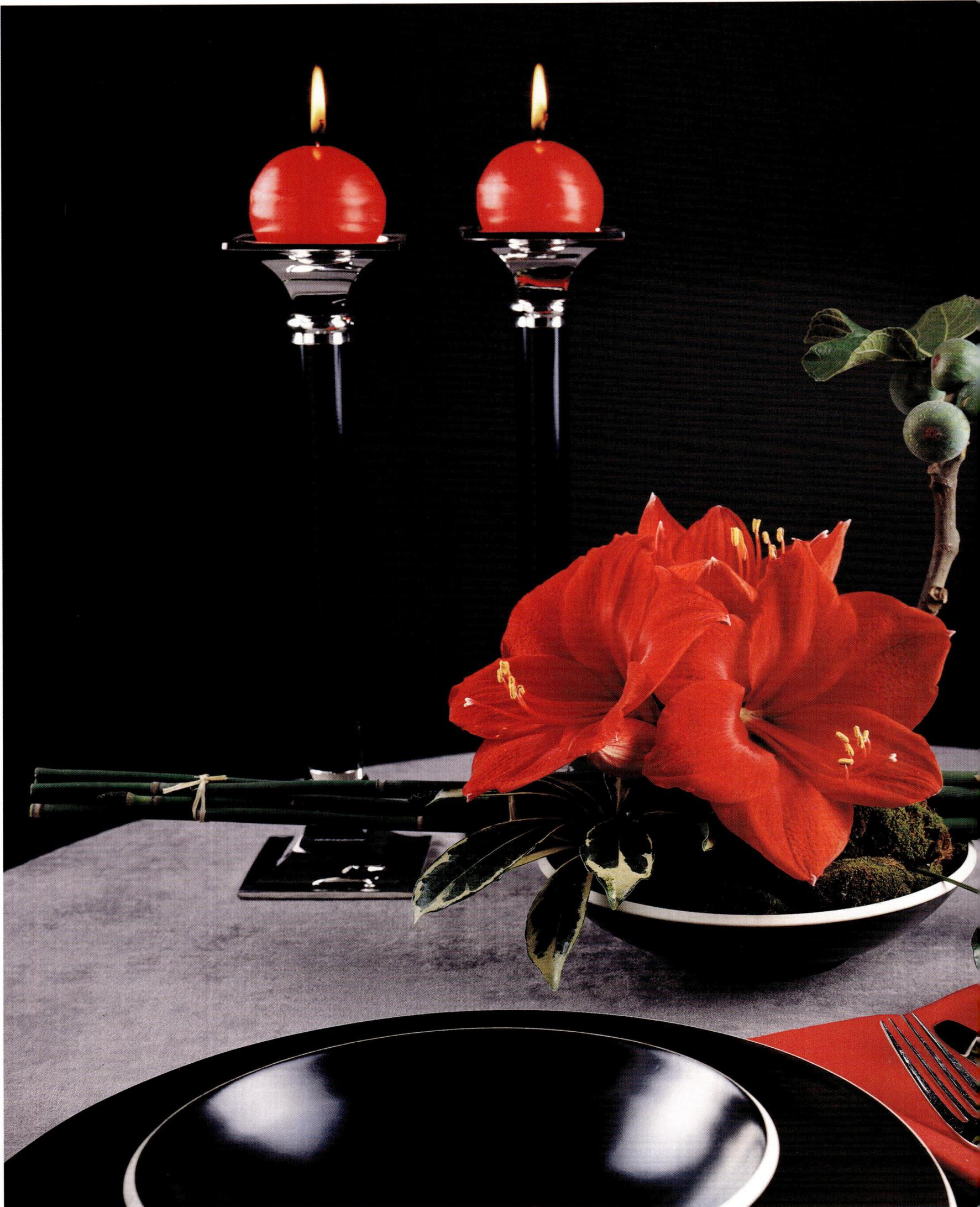

Every floral arrangement you create is placed somewhere in a setting. It becomes a part of the surroundings. The Gestalt design principle which addresses the environment in which a design is viewed is called Figure/Ground. The fundamental law of perception that makes it possible to discern objects is the Figure/Ground relationship. The eye and the mind automatically separate an object from its surroundings. When the environment is confused, the eye has difficulty making this separation. And, when the viewer is unable to make this separation, or when the environment is not in harmony with the object, the perception—the value—of the object is lessened.

The brilliant table arrangement pictured is an incredibly wonderful example in Figure/ Ground perception. All of the surroundings, the total environment (the ground), calls dramatic attention to the arrangement (the figure.) The artist banded two groupings of equisetum and inserted the ends into sides of the saturated floral foam then covered the base with moss. Then, he placed the amaryllis blossoms in a crowning cluster. The branch of fruited fig and the stem of variegated schefflera complement the composition with cautious accent.

Ball candles from Creative Candles, Box 412514, Kansas City, Mo 64141.

SPLASH!

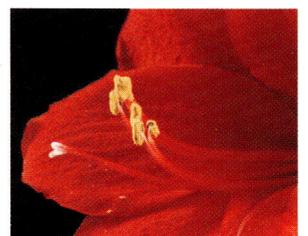

**A design is only
visible to the extent
that it is dissimilar
from its surroundings.**

The Gestalt art principle of CONTINUATION states that the viewer's eye will follow a line or curve. As illustrated in the superb

PLAYING WITH STYLE

composition of gerbera and pussy willow, the eye is pleased by shapes that are uninterrupted by differing shapes, so it continues to follow the line. Both the gerbera and the pussy willow carry the eye in a continuous curving line pattern. This same Gestalt principle of CONTINUATION states that the eye forms a harmonious re- lationship with adjoining shapes when one shape flows into the other without visual intervention. The composition of silk French roses and poppy pods, color washed with grey, illustrates how two dissimilar materials and groupings can achieve visual continuation because of the continuity in the movement of the line of the materials.

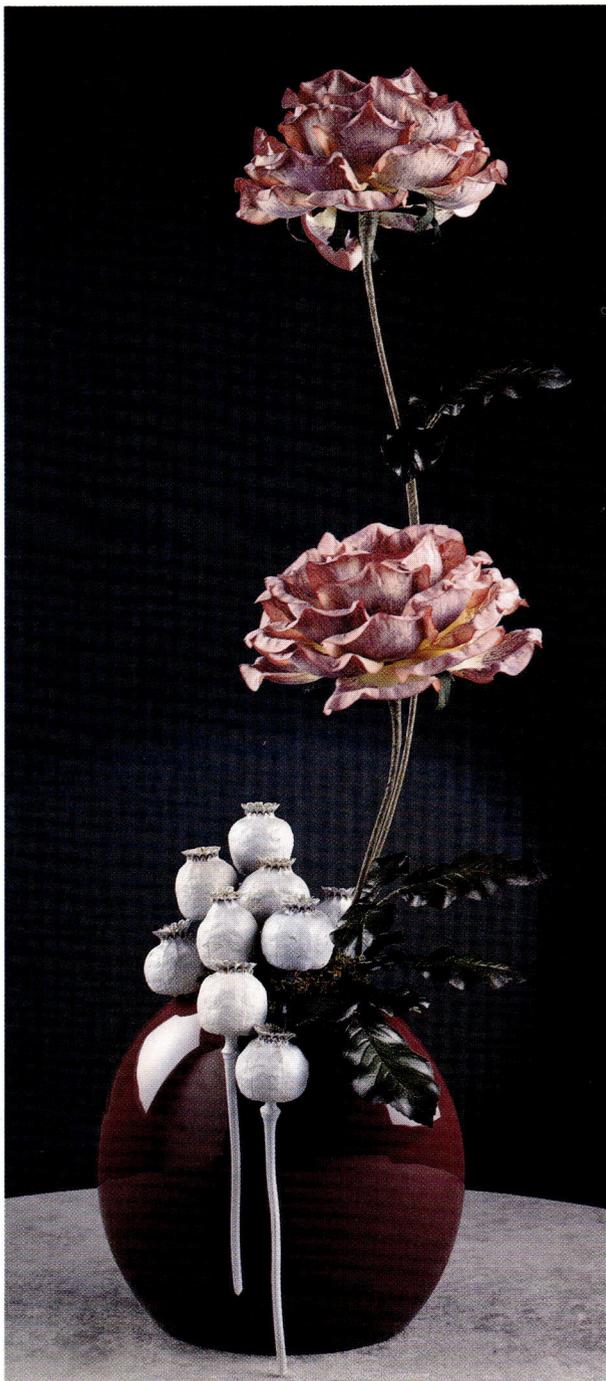

Handblown, swirled vase No. 212 from Brent Gill Associates, 7908 Kandy Lane, North Richland Hills, TX 76180. Lomey caged floral foam used on top of vase for arrangement available from your local wholesaler.

Continuation is the conscious process of moving the eye in a continuous line pattern.

Ceramic pillow vase No. 818 from Shorecraft Industries, 2967 N. Goldie Rd., Oak Harbor, WA 98277. French rose No. 575 from Dark's Silk Flowers, P.O. Box 8621, Ft. Worth, TX 76124. Poppy pods and Design Master Dove Grey spray color available from your local wholesaler.

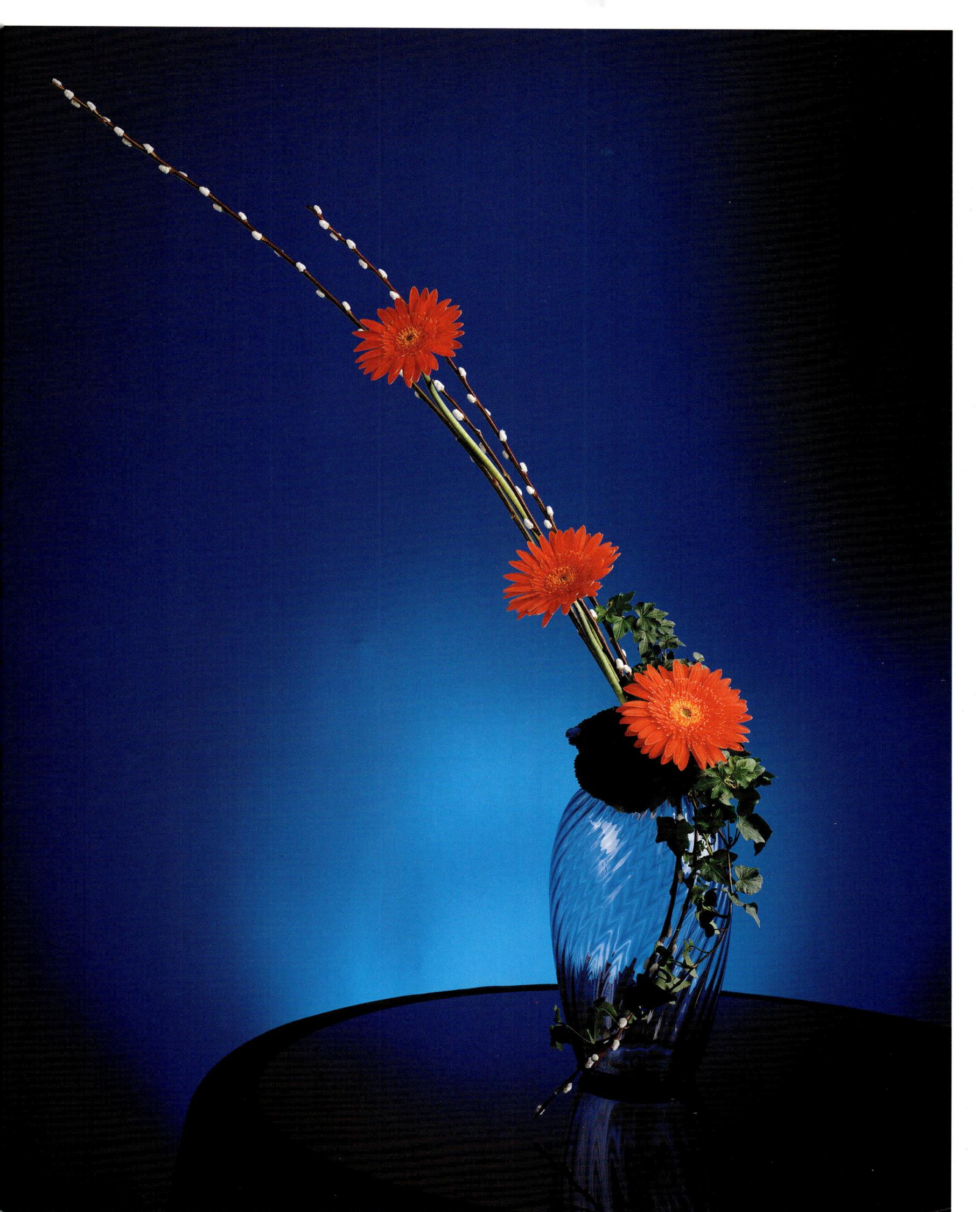

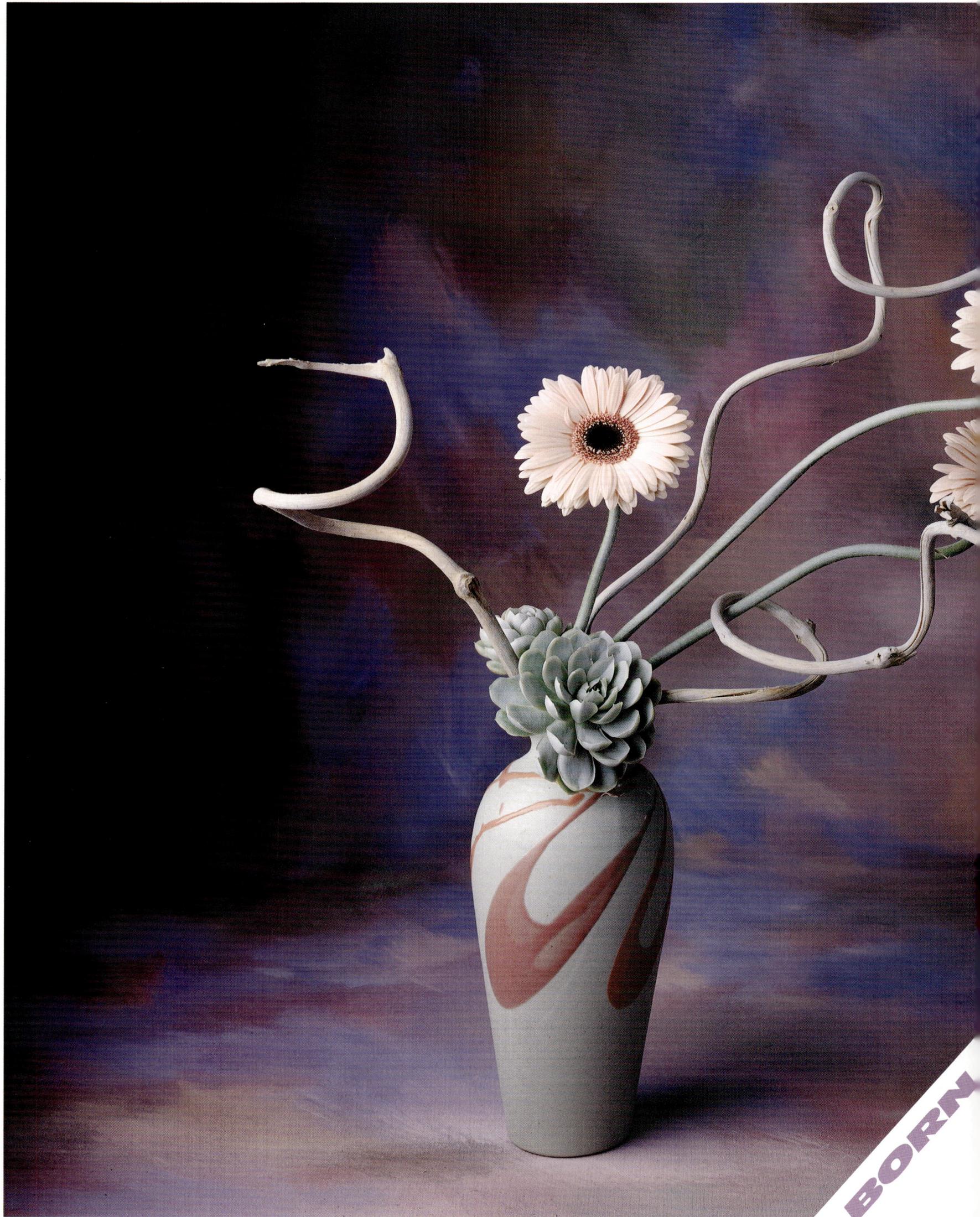

BORN

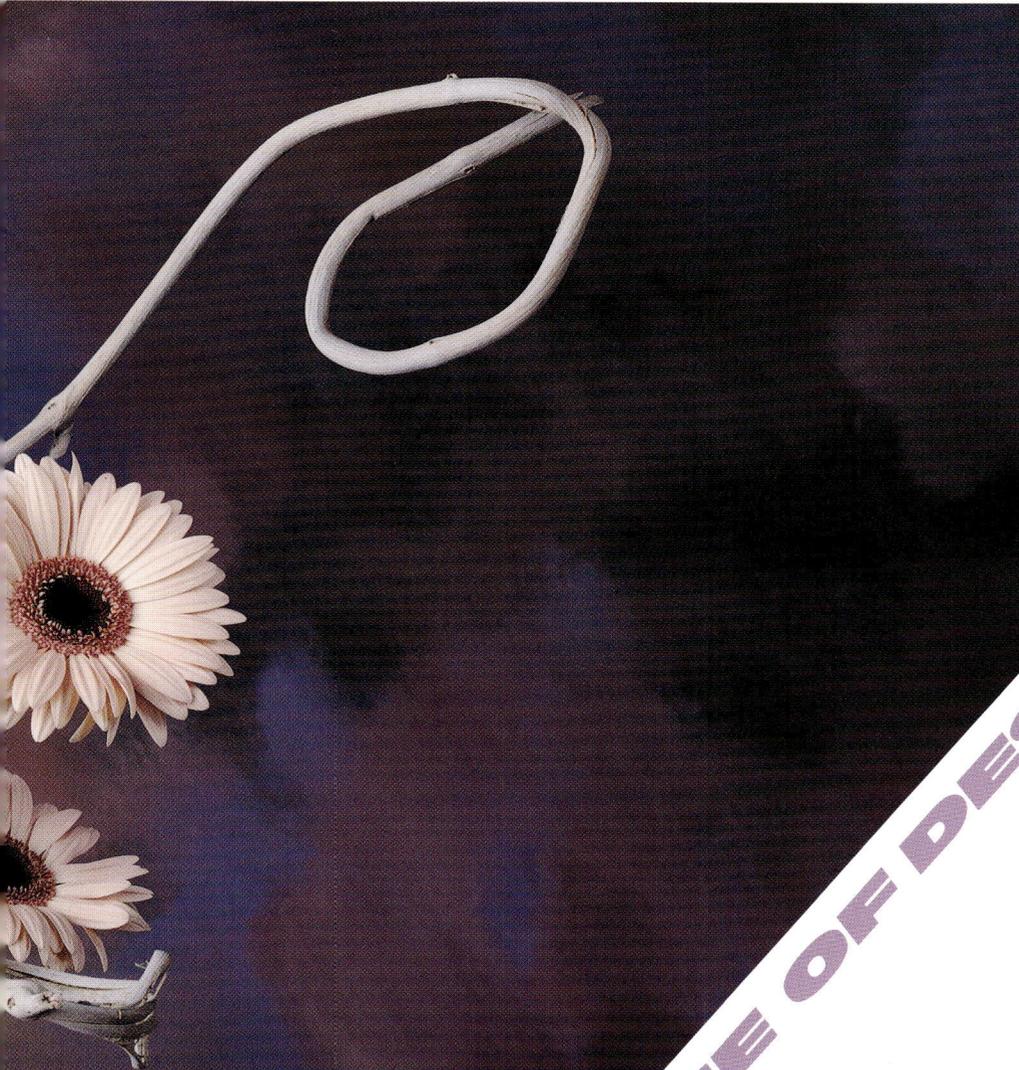

The Gestalt art principle of CLOSURE has important applications in professional floral design. This axiom states that familiar shapes are more readily seen as complete than incomplete. When the eye completes a line, a curve, or a circle to form a familiar shape, closure has occurred.

This stunning composition is a beautiful example of closure. All round forms close. The gerbera and the succulents complete a circle. Even the panchu spring washed with soft color moves out into curls that close. And, the splashes of color on the vase are in shapes that close. Open forms and lines take the eye off into space. Unless there is a purpose for this open-ended spaciousness, creating closure in a composition makes it more pleasing to view.

Vase No. 40-3662 from Toyo Trading Co., 13000 S. Spring St., Los Angeles, CA 90061. Knud Nielsen panchu spring and Design Master Color available from your local wholesaler.

Compositions which provide closure are more pleasing and comfortable to the viewer. And, closure keeps attention focused— the eye does not wander off into space.

The Creative Process

A floral artist thinks conceptually. Developing conceptual awareness is an essential skill for a professional floral designer. Conceptual awareness develops from two different directions.

(1) From product to idea to design. A designer sees specific materials and then conceptualizes the most effective way to organize them in a design.

(2) Idea to product to design. The second method of conceptual awareness begins when a designer visualizes a completed design. This is the idea. After conceptualizing the idea, the designer gathers the materials needed. Then he creates.

Conceptual AWA

In any floral design, the most important consideration is conceptual awareness. All flower compositions begin with an artist's conceptual awareness—''the idea'' for the presentation of the specific materials.

Visual Literacy

Technically, conceptual awareness is ''visual literacy.'' Visual literacy is a competence in visual expression and communication. It involves insights and skills no less disciplined than those required for proficiency in engineering and construction.

A floral design is a composition, a structure composed of various materials. The manner in which the artist presents these materials creates a visual communication. Therefore, a floral composition is a visual structure which communicates to the viewer.

Visual Communication

Acquiring the professional skills to communicate through floral design is no different from learning how to communicate verbally. Floral design as a method of communication requires an artist to learn all the technical essentials of professional design. With this knowledge he can develop and express his unique creative talents.

The Foundation

The creative foundation for every floral design is conceptual awareness. It is expressed in composition. Understanding composition and mastering the skill to present materials in persuasive creations is the mark of a professional floral artist. If a floral design is not persuasive, it is no more than an obscure grouping of flowers. A compelling composition is essential for a flower design to be distinctive, pleasing and remembered.

Composition

In professional floral design, composition means the organization or grouping of different materials into a unified whole. Simply stated, composition is the specific order in which an artist presents all the visual components in a design. Composition includes the elements and principles of design as well as the techniques used in deploying these ingredients.

Composition Illustrated

The composition pictured illustrates the important technical considerations in creating a composition. There are four distinct components. (1) The display platter. (2) The vase. (3) The floral design in the vase. (4) The floral design at the base. The composition is the presentation of these four components to achieve influential visual unity.

As you study this composition, identify how it communicates to you. There is an overall impression - your initial reaction. Then, the composition communicates the various parts that make up the whole. The form of the design communicates. Color communicates. Texture communicates. Line communicates. Every significant component in the composition communicates.

Asymmetrical Format

This composition reflects an asymmetrical format. All the materials fall within an asymmetrical framework.

The floral design at the bottom repeats the asymmetrical form of the total composition. This form within a form technique is an effective method to reinforce the strength of visual form.

Three straight lines configure the asymmetrical form. The round lines of the plate and the curving lines of the vase are dynamic. They contrast the straight

lines of the asymmetrical form. This emphatic contrast between the straight lines and the round and curving lines makes an energetic visual statement. The visual communication of this design is far more influential because of these contrasts.

Creative Collaboration

The striking pottery plate and vase are original, hand made designs by Evans Ceramics. Identified as Ancient Sands, the distinctive look of the pottery features a unique glaze. Tony Evans, head designer and owner of Evans Ceramics, Inc. expresses his profound creative philosophy. ''I believe in creative collaboration. We have a unique group of

RENESS

designers who work together effectively. Our philosophy is that a designer can function effectively in a commercial atmosphere if he respects and supports the creativity of others. I endorse the Gestalt theory of creativity which states that the whole is more than the sum of the parts. Collaborative design enables us to combine the talents of the finest artists for a product that is far better than any one artist could create on his own.''

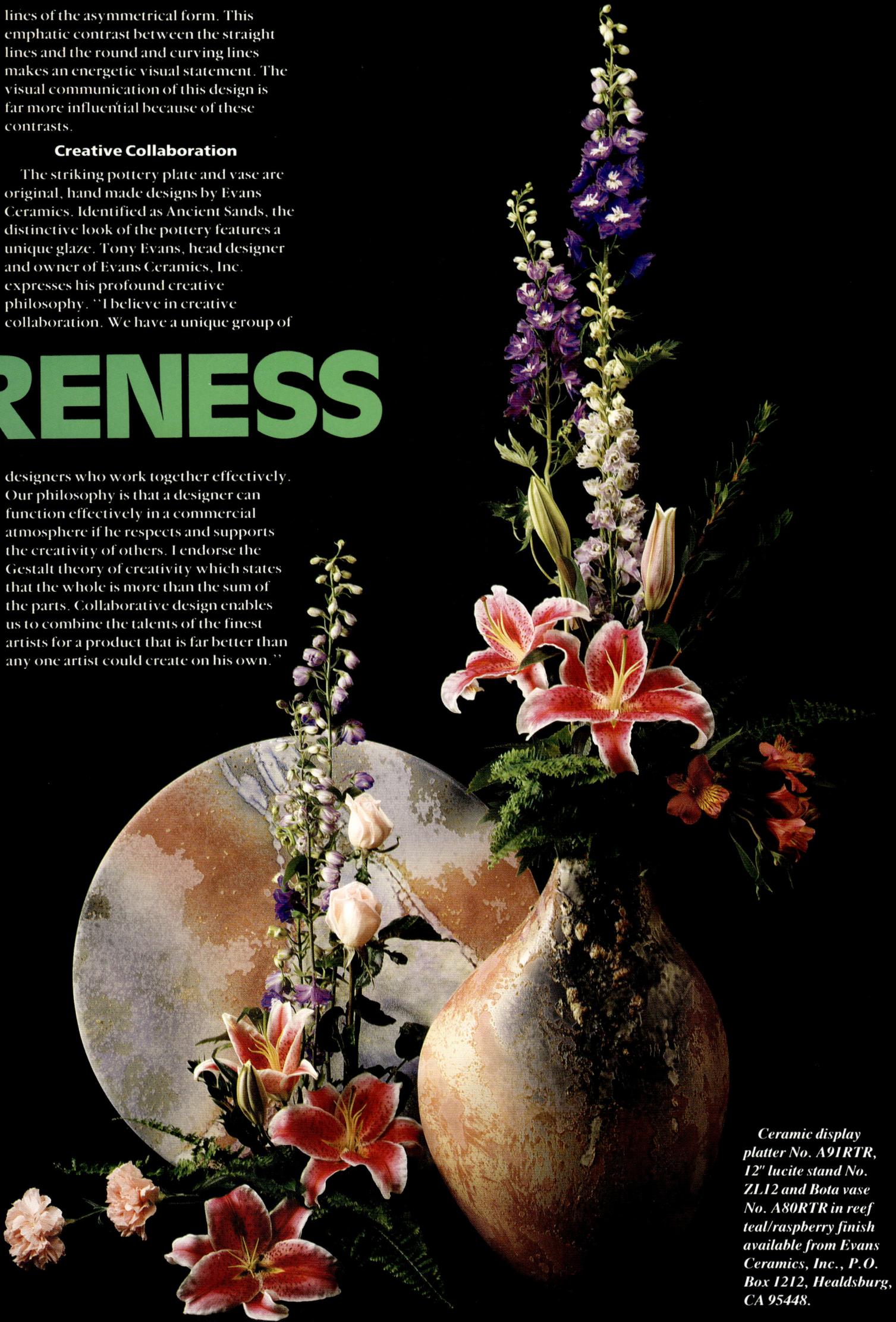

Ceramic display platter No. A91RTR, 12" lucite stand No. ZL12 and Bota vase No. A80RTR in reef teal/raspberry finish available from Evans Ceramics, Inc., P.O. Box 1212, Healdsburg, CA 95448.

REVISITING THE BASICS
THE IMPORTANCE OF PROPORTION

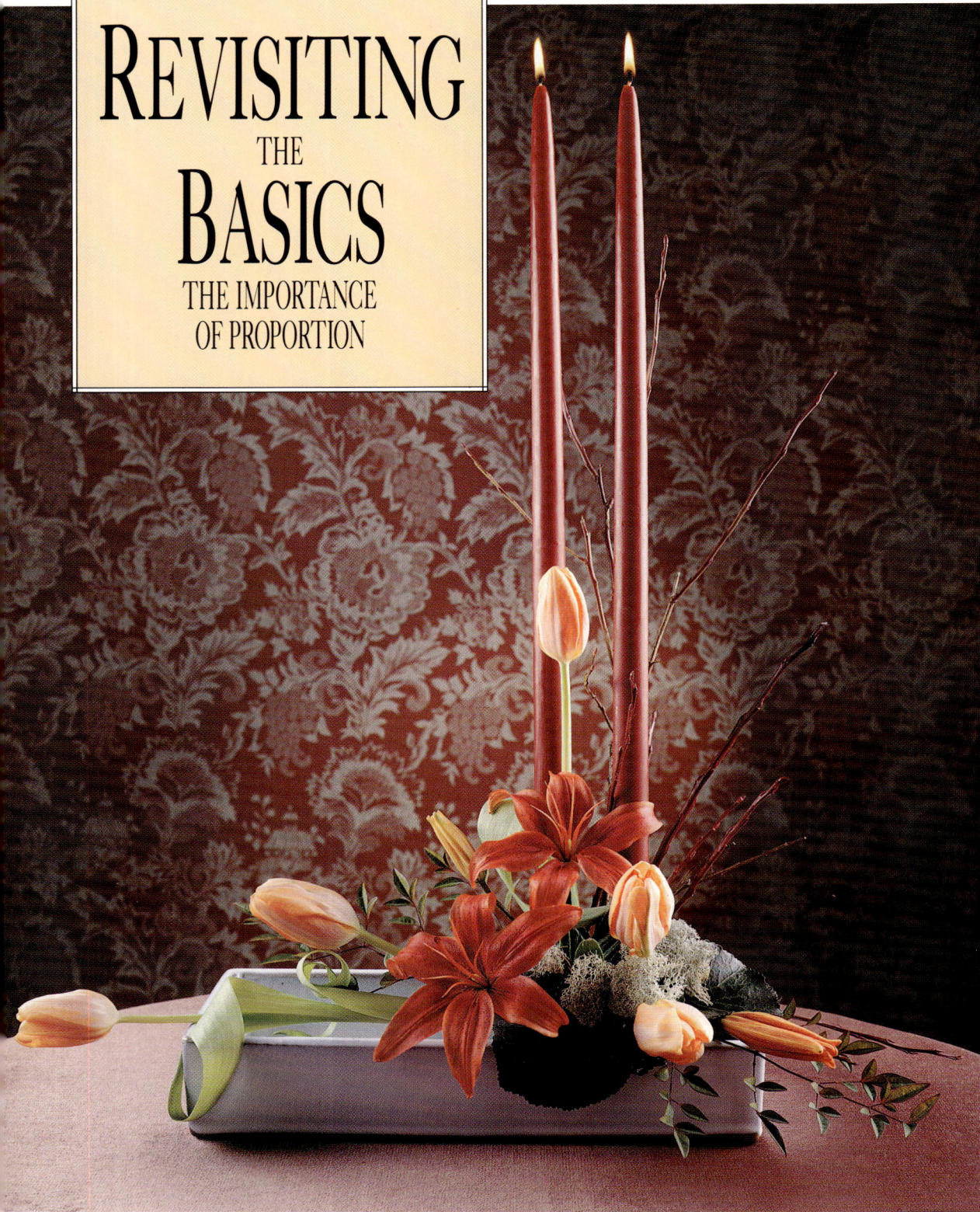

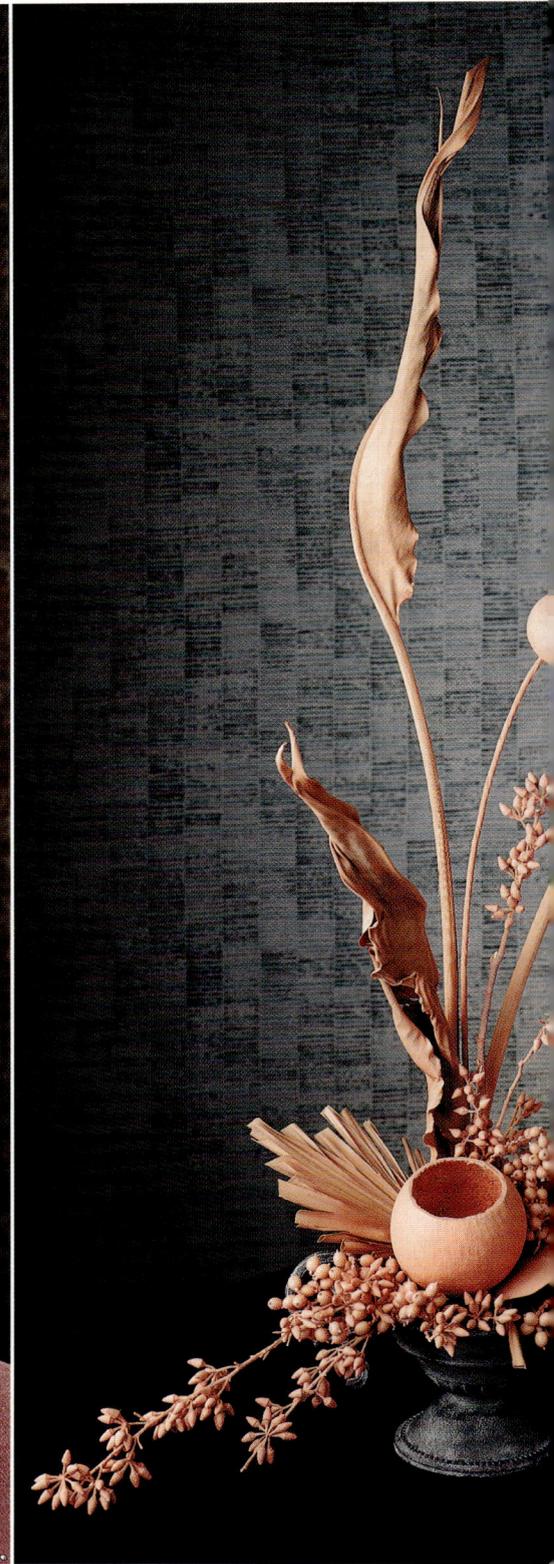

Container No. 34-1422 from Toyo Trading Co., 13000 S. Spring St., Los Angeles, CA. 90061. Candles from Creative Candles. Deciduous huckleberry from HOH Grown. Knud Nielsen reindeer moss and Design Master color spray on deciduous huckleberry available from your local wholesaler.

b a

ARRANGEMENT ←——— CANDLE ⌐b

The artist used the Golden Mean in creating this arrangement. The centermost candle bisects at the Golden Mean point. The proportion of the design to the left of these candles and the area to the right is approximately 1.6 to 1.

b a

ARRANGEMENT ←——— CRANE ⌐b

The artist presents this composition in a setting using the Golden Mean Format for a most pleasing visual presentation. The proportion of the arrangement to the crane is approximately 1.6 to 1.

PROPORTION REFERS TO size relationships within a composition. When someone suggests that the height of an arrangement should be one-and-one-half or two times the height of the container, the individual is explaining a size relationship. The point of relationship is the height of the materials to the height of the container. Both are parts of the composition.

The GOLDEN MEAN, or sometimes called the Golden Section, is a traditional proportion used historically to express the secret of visual harmony. In its simplest form, it consists of a line divided so it has the most pleasing visual proportion.

This ancient Greek Golden Mean mathematical proportion has an important application in professional floral design. In fact, the theory that the height of an arrangement should be approximately one-and-one-half to two times the height of the container comes from this ancient Golden Mean.

The rectangle illustrated below represents the Golden Mean. The proportion of this Golden Mean rectangle is as follows: If the shortest side is 1, the longest side is 1.6—a 1 to 1.6 proportion.

Now, turn the rectangle on end. The short side (1) represents the vase, the long side the height of the arrangement (1.6). This is the source of the traditional proportion of vase to arrangement height.

The Golden Mean has other important applications to floral design as illustrated in the two compositions pictured. In the composition with the dried materials and brass crane accessory, the proportion of the arrangement to the crane is 1.6 to 1. In composing the placement of the elements in this composition, the artist followed the Golden Mean to achieve the most visually pleasing presentation.

In the candle composition, the area of the arrangement to the left of the candles is approximately 1.6, and the area to the right is 1—the Golden Mean proportion. In this arrangement, the artist placed the candles at the most visually pleasing section of the composition.

Patina finished brass bowl No. 33-2081 and crane No. 19-4521 from Toyo Trading. Knud Nielsen Watercolors™ strelitzia, euk fruit, canella, bell cups, cut palmetto and sea grape leaves available from your local wholesaler.

The Greek Parthenon is the most outstanding example of beautiful proportion in the history of art, and it was built based on the Golden Mean. This historical example of Greek architecture was designed in modules to insure a unified relation of each module to the whole.

The Golden Mean

b
a
Height of Design = 1.6
b
b
Vase = 1
a

a = 1
b = 1.6

Thinking And Creating Visually

TEXTURE—THE NATURE of the surface of a work of art, particularly the way its appearance stimulates the spectator's sense of touch. The texture is an integral part of any work, from the expressive and ragged appearance of rough-edged materials to the smoothness of a highly glazed porcelain vase.

The intriguing Evans Ceramics' softly textured vase accented with rope and a textured medallion communicates strong and interesting visual texture. The Knud Nielsen dried materials in a variety of forms and surfaces reinforce the textural feel of this composition.

In painting, the rhythm and give-and-take of the brush stroke creates marvelously textured lines. In this composition, the artist interprets this brushstroke approach in the presentation of lines, creating texture that reaches out to be touched.

We are accustomed to appraising texture by touch. Texture means sensation. We move our fingers over an object and we receive a slick, rough, sandy, bumpy, hairy or coarsely-woven sensation.

A small highly textured material will contrast with and balance a larger grouping of materials with smooth texture.

Strong, even dramatic contrasts of texture heighten the visual perception of a composition.

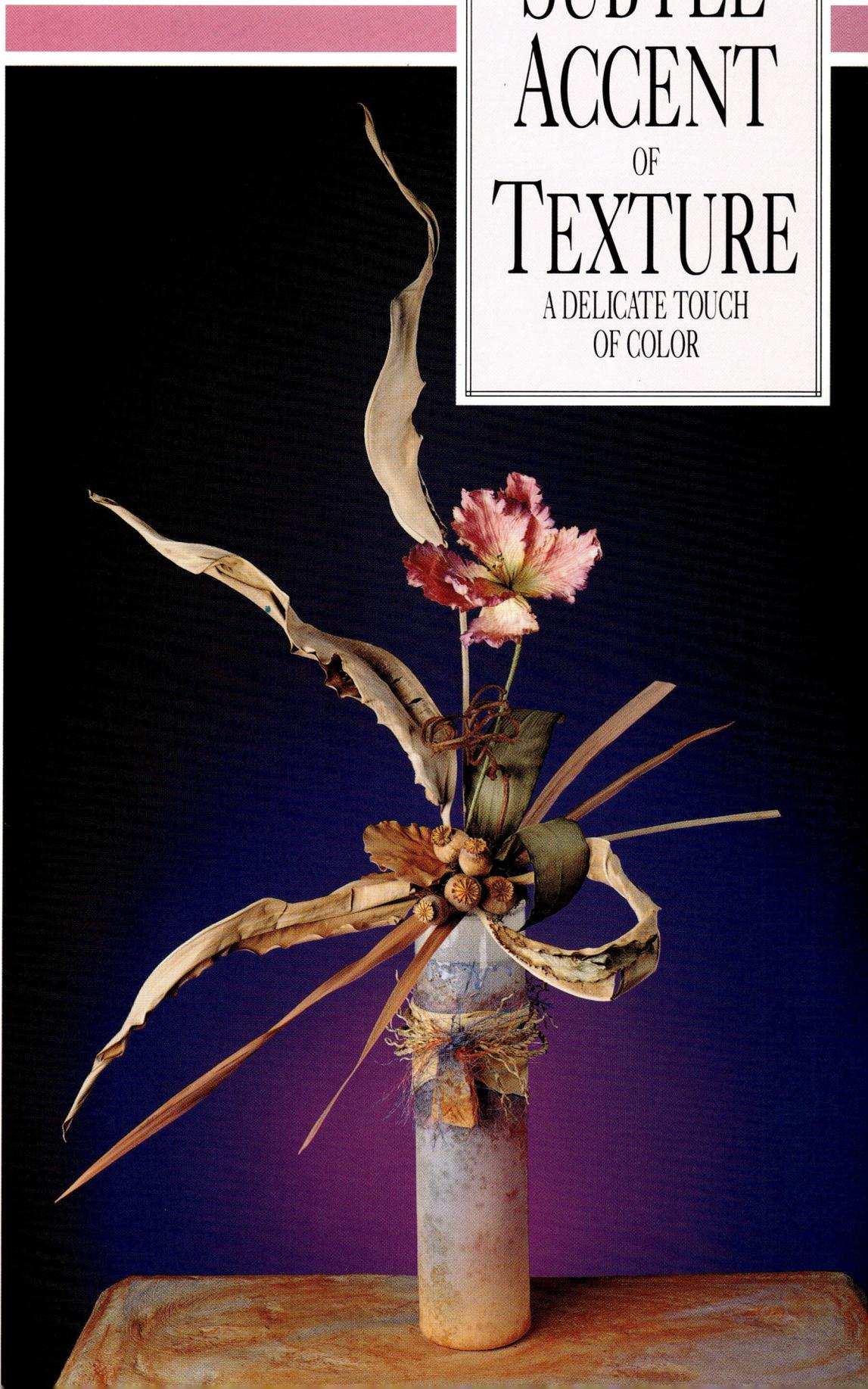

Cylinder No. W20 ATO from Evans Ceramics, Inc. Ancient Sands Collection, P.O. Box 1212, Healdsburg, CA 95448. Parrot tulip No. 308 from American Prestige, Inc., P.O. Box 19736, Little Rock, AR 72210. Knud Nielsen dried kiwi vine, strelitzia, sabel palm and poppy heads available from your local wholesaler.

A

SUBTLE ACCENT

OF

TEXTURE

A DELICATE TOUCH OF COLOR

Combining varied textures adds interest and visual excitement to a design. Texture brings distinction and enhances the visual value of a composition.

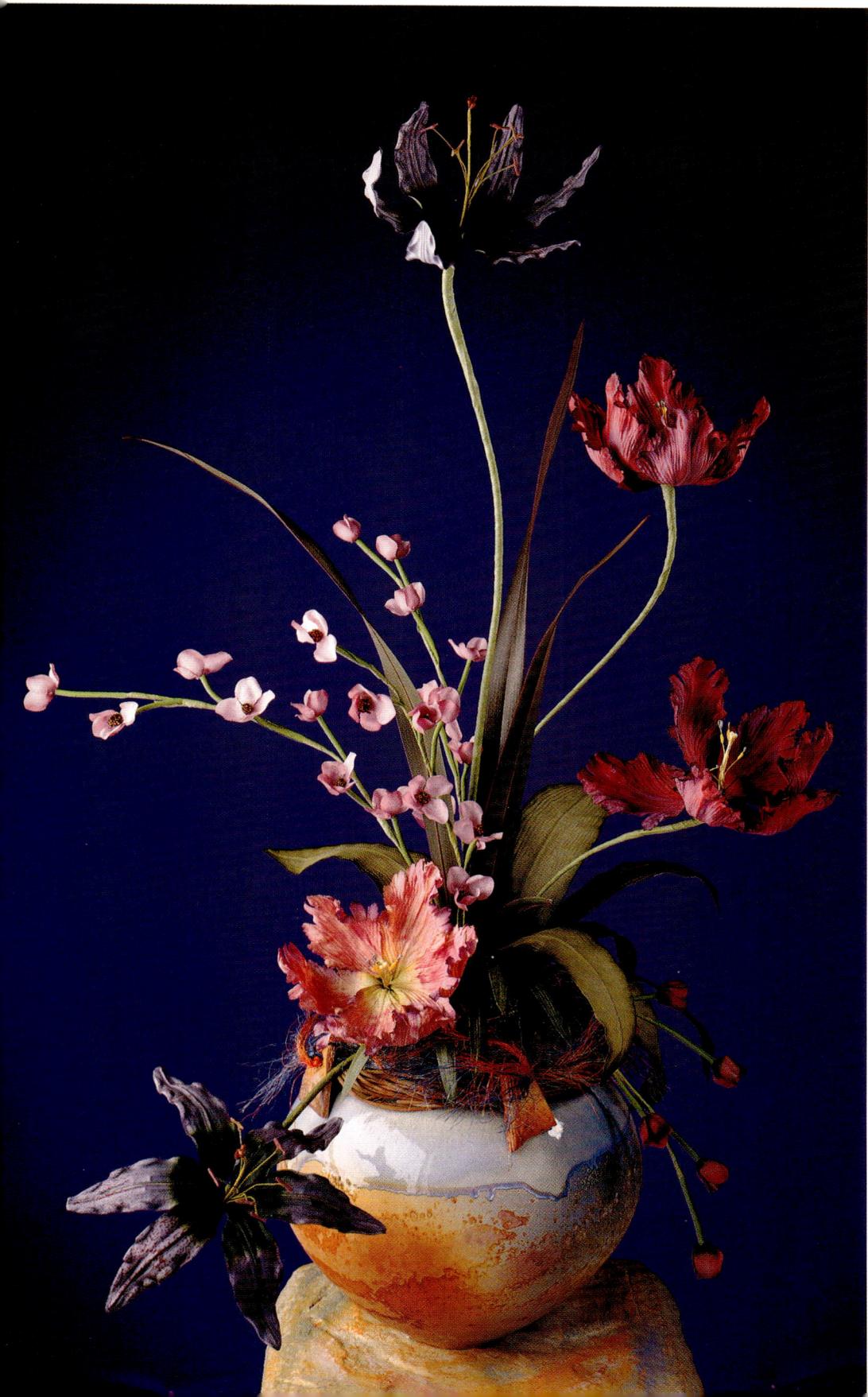

In floral design, we broaden this understanding of texture to include visual texture. We look at a composition and we see texture. Even though we do not touch, we perceive how it would feel. This is visual texture.

All flower compositions have both actual texture and a textural effect the viewer perceives visually. Any material that has a surface has a texture. Often a viewer's eye will mentally record texture. Automatically he reaches out to touch— to verify that the texture he sees is the same texture he expects to feel.

This attracting arrangement of silk flowers is a very textural composition. There are soft differences in the texture of the container moving from a shiny glaze to a rougher sand-like surface. The roping and pottery chip around the top of the container speak out with an even stronger dimension in texture.

Since the vase is a dominant statement in texture, the artist chose to keep the materials within a softer, less harsh texture.

The arrangement pictured presents two different ways of working with texture. The arrangement on the opposite page has a strong textural appearance. This composition pictured on this page has a smoother, more subtle feeling.

Understand texture. Work with texture. Recognize how to present it to achieve the most impressive effect from the materials.

Ceramic sphere container No. W22 ATA from Evans Ceramics, Inc., P.O. Box 1212, Healdsburg, CA 95448. Parrot tulip No. 308, valley branch No. 452 and lily No. 224 from American Prestige, Inc., P.O. Box 19736, Little Rock, AR 72219.

A tetrad is a grouping
of four colors on the
12-color color wheel. A
tetrad includes one
primary color, one
secondary color and two
intermediate colors.

MODERN COLOR

YOU CAN'T BE WITHOUT IT

Yellow

RedOrange *BlueGreen*

Violet

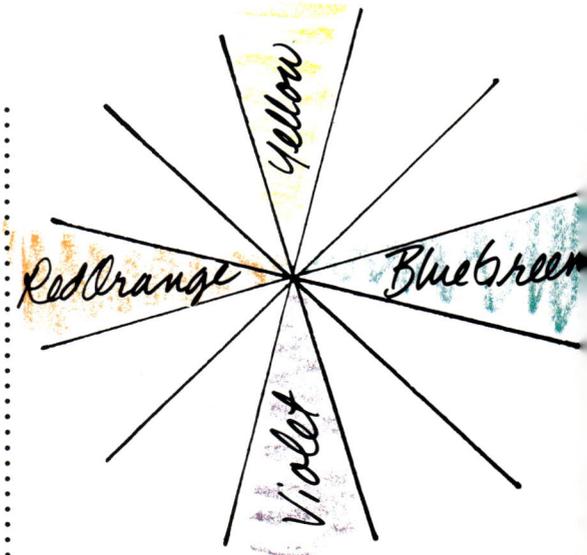

THERE'S A NEW KID ON the color block. She really isn't new. She's just being rediscovered.

Her name is tetrad. You'll notice her name popping up in home decoration magazines and in books written by interior designers. It's a new spark of color—an exciting contemporary touch to modern-day decor.

A tetrad is a group of four colors equidistant on the color wheel. Primary yellow, intermediate blue-green, secondary violet and intermediate red-orange form a tetrad. Red, yellow-orange, green and blue-violet are another tetrad. Blue, red-violet, orange and yellow-green form a third tetrad. Since there are 12 colors on the traditional color wheel, there are three tetrads including four colors. Each starts with a primary color.

To create a tetrad, start with a primary color. Skip two colors on the color wheel to the intermediate color. Skip two more colors to the secondary color, and then skip two more to the next secondary color. A tetrad includes one primary color, one secondary color and two intermediate colors.

The colorful arrangement pictured is a tetrad: miniature carnations in yellow, blueberry juniper in blue-green, freesia in violet and gerbera in red-orange.

Lomey medium Designer Dish and Oasis® floral foam available from your local wholesaler.

Red-Violet

As you study color as it applies to professional floral design, two fundamentals become important. Effective color either achieves contrast or unity. Anything in-between often is a hodgepodge that might look nice, but not exceptional. The responsibility of a professional floral design is not nice arrangements, but exceptional designs. Reaching this level of creative, professional excellence means understanding how to present color.

Color unity is the focus of the arrangement pictured to the right. Both the carnations and the dendrobium orchids are in the red-lavender color family.

By tiering the containers and arranging the carnations in a vertical design in the top dish, and the orchids in a horizontal design in the bottom, the artist achieves form and line contrast. Color unity can be nondescript, even boring. Distinctive design style is essential.

These practical containers with brass metallic finish give the look of brass inexpensively. If your budget doesn't allow for carnations and orchids, be intuitive. Use any flowers appropriate to the design and the price.

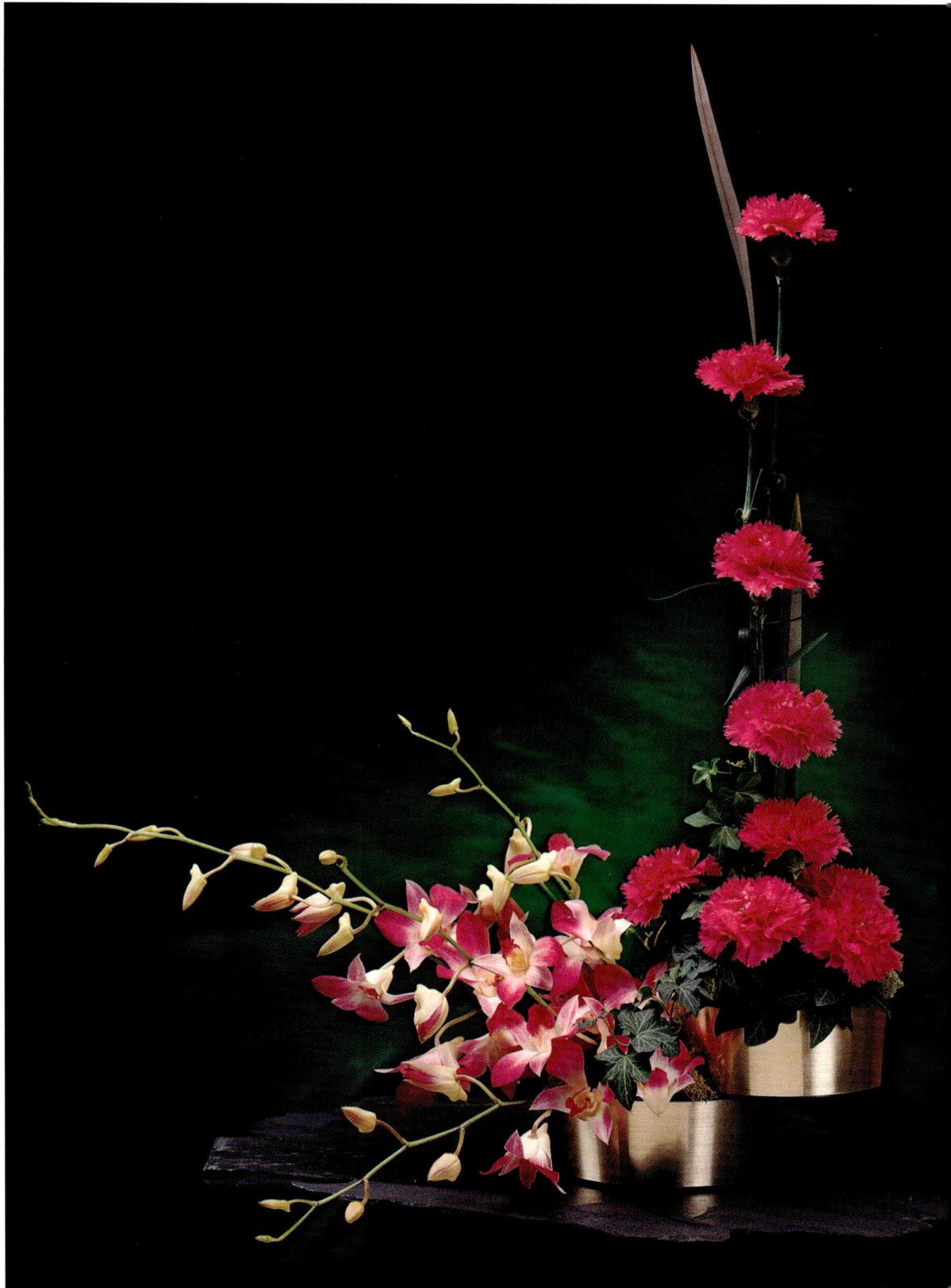

Stackable containers No. M1 from Midamco, 6630 N. Kostner, Lincolnwood, IL 60646. Use a Lomey rim pad, available from your local wholesaler on the lower container to hold the upper container.

THE PURPOSE OF EVERY design is to meet a plan. Most of these plans are based on orders either already sold or to be sold. The system of creating to fulfill a plan is called the design process.

Every floral design, whether a small vase with only a few blossoms or a large, impressive, creative presentation of flowers, involves the consideration of the concrete and the abstract, the tangible and the intangible elements. The concrete and the tangible are easy to identify and explain: the purpose of the design, the price, the container, the flowers and materials. The abstract and the intangible—the creativity behind the idea, the communication of the composition and style of the artist—are much more illusive. Nevertheless, the competitive value of any design lies in the abstract and the intangible.

Both of the wonderful silk compositions pictured illustrate how a qualified artist combines the concrete and the tangible with the abstract and the intangible to achieve professional, creative design. In these creations, who is to say which is more important ... color? Form? Texture? Line? Personal style?

No one would debate, however, that it is the personal style of the artist that accounts for the distinction, the originality of each of the designs.

The composition in the table setting is of a more traditional, triangular form. Yet, it expresses a unique, personal style. In contrast, the blue composition is hi-tech and contemporary, expressing a totally different personal style.

Crystal vase No. 272294 and candlesticks No. 702135 from Toscany Imports, Ltd., 386 Park Ave. S., New York, NY 10016. Silk glory vine No. 952, tulip No. 948 and monarch tulip No. 945 from Dark's Silk Flowers, P.O. Box 8621, Ft. Worth, TX 76124. Candles from Creative Candles.

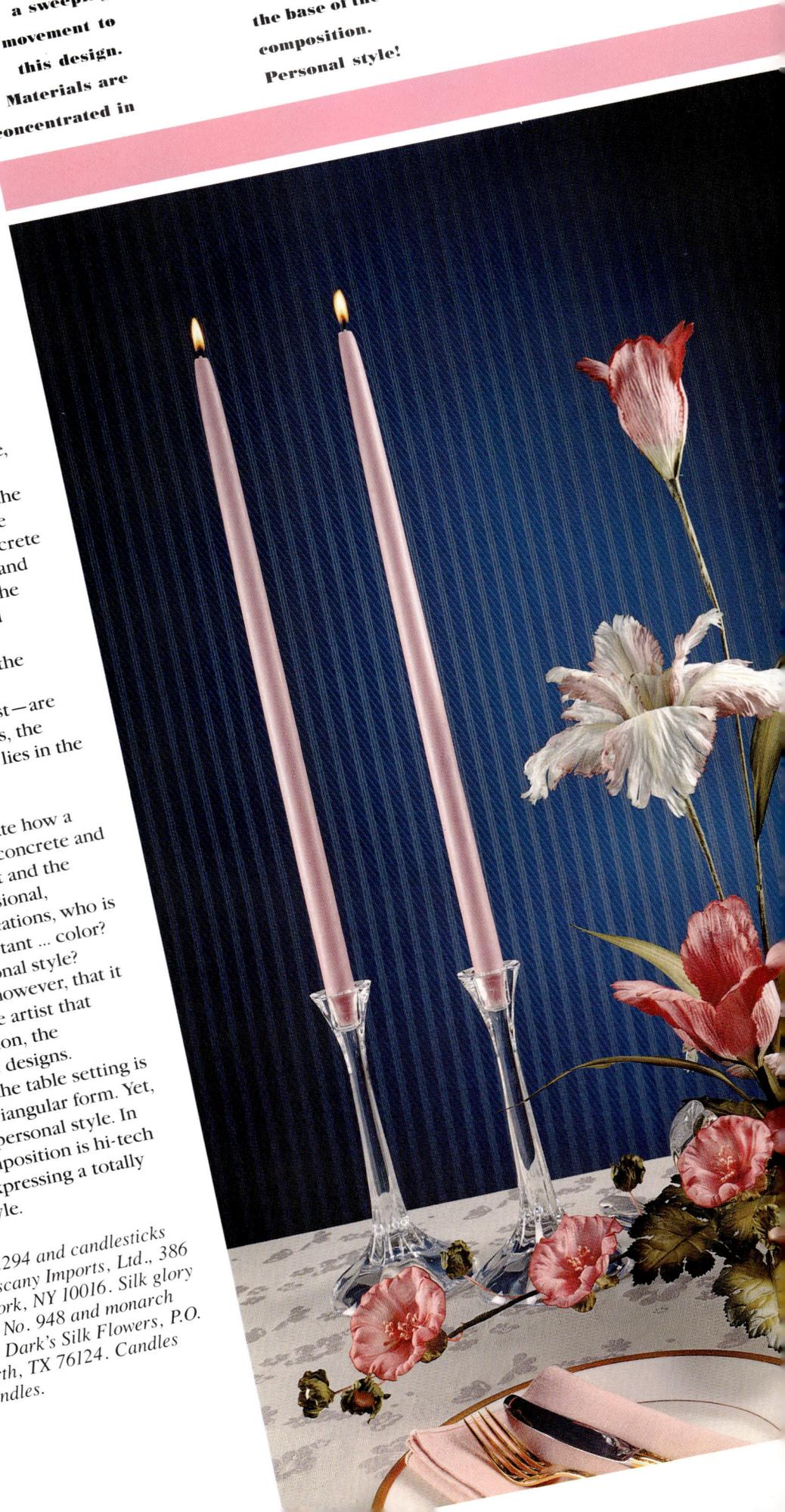

COLOR, FORM, TEXTURE

AND

LINE

ACCENT ON PERSONAL STYLE

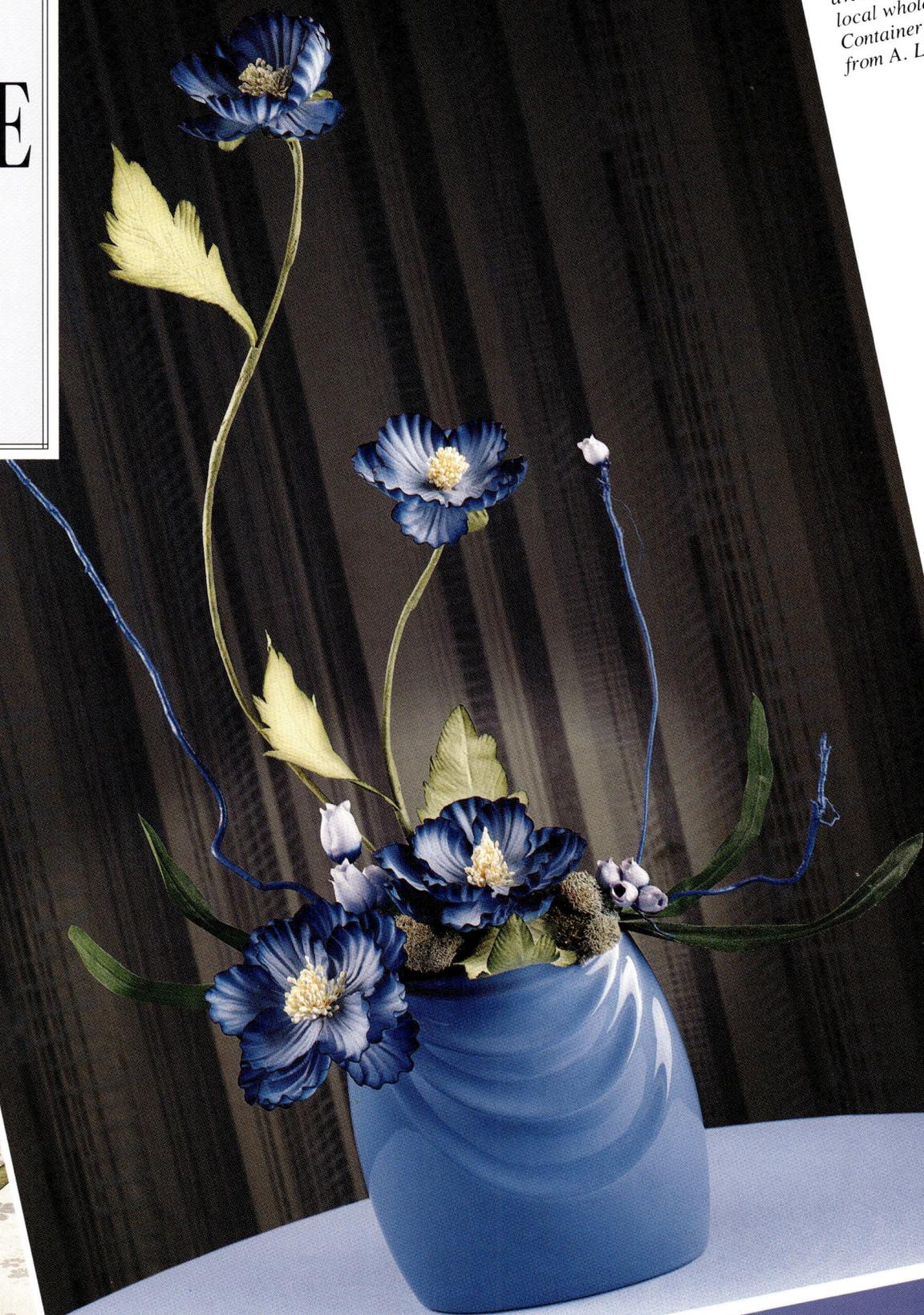

Silk ornamental poppy No. 891 from Dark's Silk Flowers, P.O. Box 8621, Ft. Worth, TX 76124. Nouvette's hops No. H856 and Sahara® II dry foam available from your local wholesaler. Container No. 5055 from A. L. Randall.

Style. Monochromatic color. Painted branches frame the composition. Sensitive contrasts between straight and curving lines. Personal style!

51

Stylish. Fashion-Forward. Accessory-Minded.

A CLEAR SENSE OF FOCUS AND STYLE

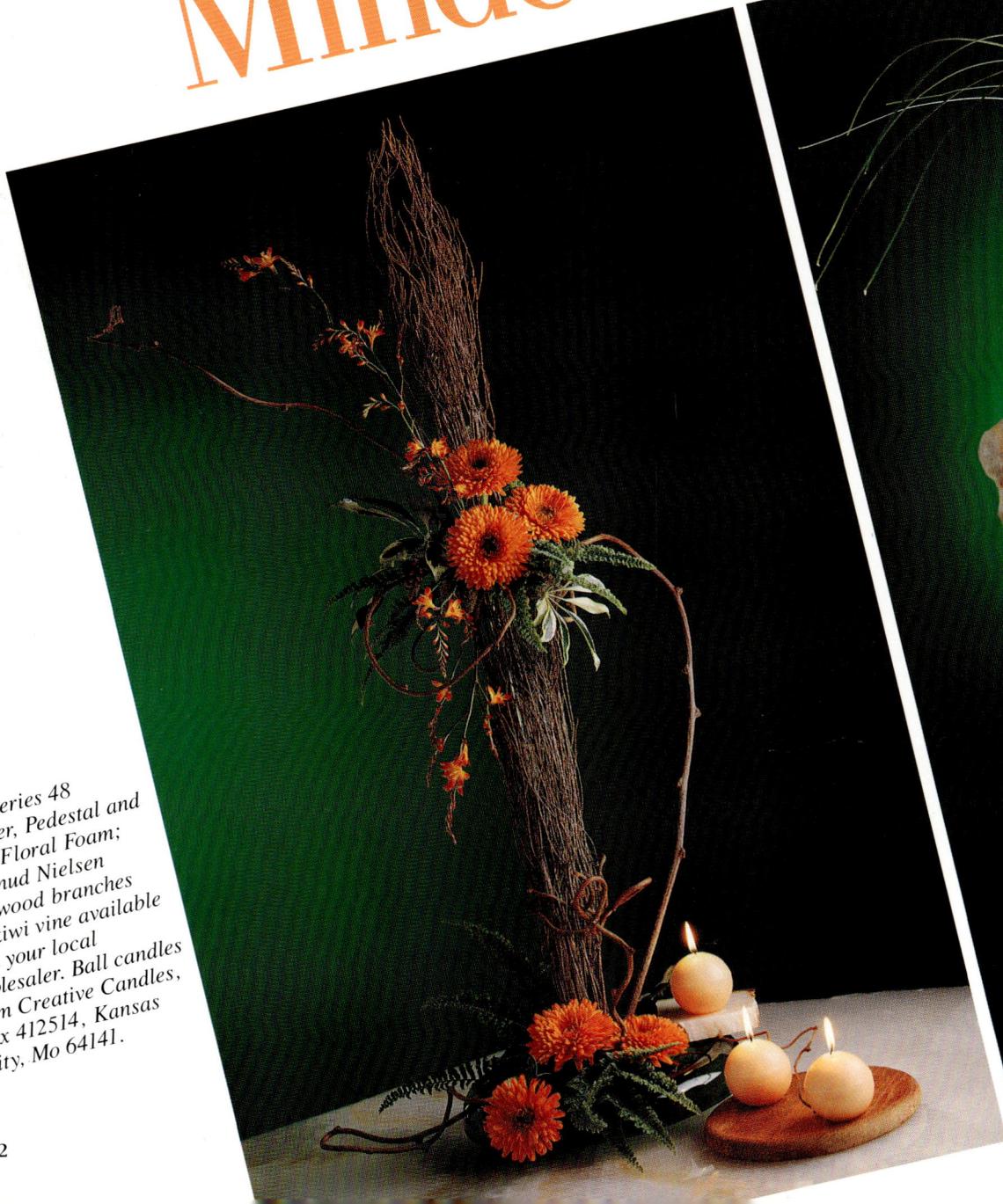

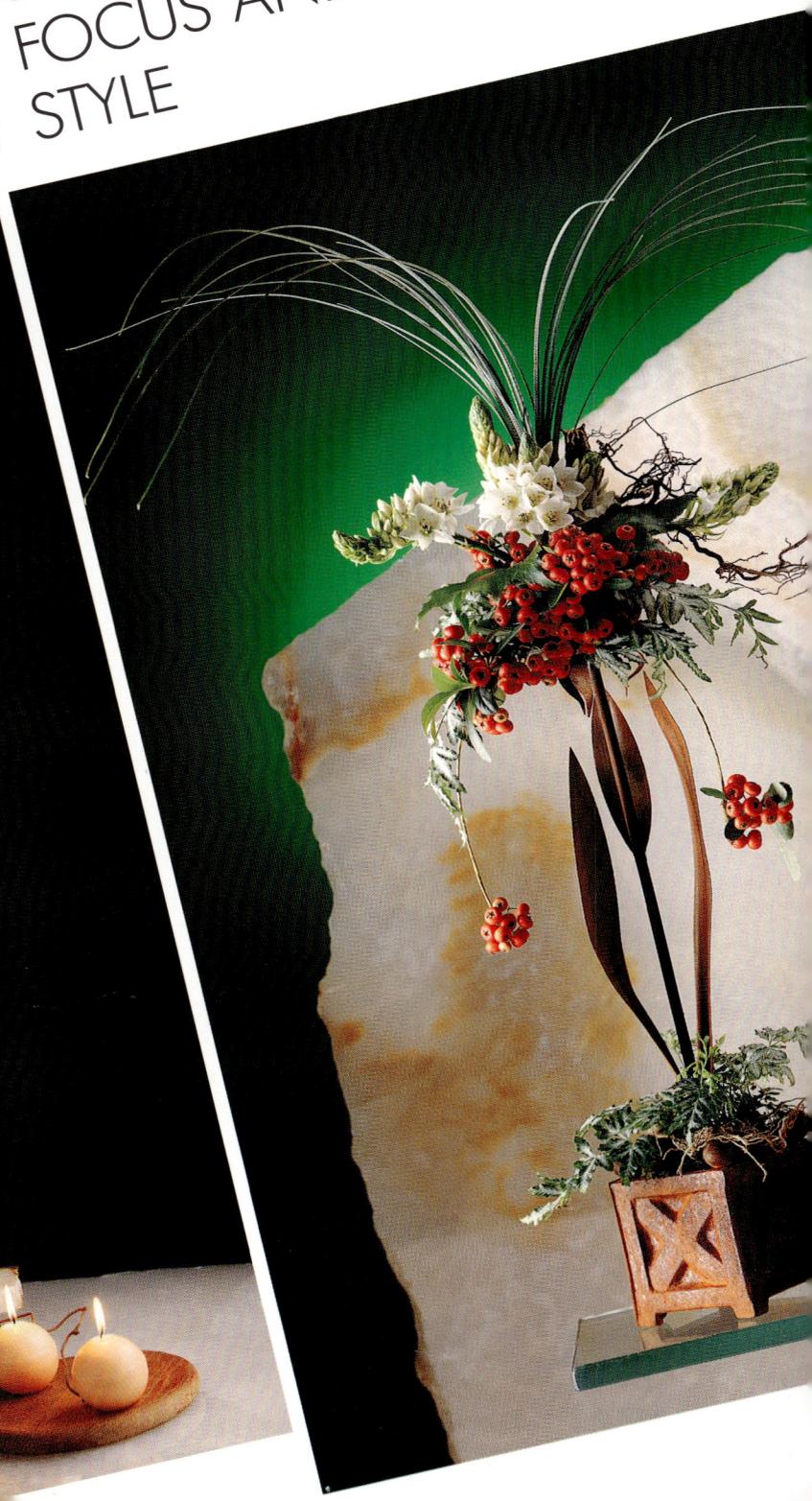

Design professionals know what it means to experience the inspiration of an idea that gets their creative juices flowing. Very often, all it takes is a glimmer of a concept—and suddenly, form, color and texture come together. The design materializes into a wonderful composition. The decorations pictured show how a design emerges from an embryo of an idea.

To construct the design to the far left, slip a Lomey large, dry Caged Floral Foam over a Lomey 31" Pedestal and push down to the bottom. Then, glue another large, dry Caged Floral Foam to the top of the pedestal. Glue the pedestal into a Lomey Series 48 container. Thoroughly saturate both the bottom and top pieces of foam after they are glued into place as outlined above.

Insert stems of Knud Nielsen silverwood into the foam at the bottom, pull up around the pedestal and anchor into the top piece of foam with greening pins. Next, insert the pieces of Kiwi vine. Finish the composition by arranging the calendula blossoms, the montbretia and the foliages.

In creating the design, pay close attention to the important line movement the artist achieves with the flowing linear placement of the kiwi vine and montbretia, the precise linear placement of the foliages and the tight groupings of the calendula blossoms.

The arrangements on top of the Department 56 Botanica Rust Topiaries transform these decorative accessories into a striking decoration. Glue an Oasis Iglu™ on top of each topiary and arrange with ornithogalum, pyracantha berries, river roots and a variety of ferns and ivies cut from 4-inch plants.

Notice how the fountain of bear grass erupts from a crown formation of pyracantha berries and ornithogalum blossoms. In contrast, the artist maintains the arrangement to the right in a more controlled, crescent-like format.

The base design with lily blossoms, fern foliages and votive candles establishes a central point of visual weight. This central point is secondary to the visual importance of the topiaries. It unifies. It brings the composition together. It does not compete.

Botanica Rust Topiaries No. 4112-2 from Department 56, Inc., 1200 Second Avenue S., Minneapolis, MN 55403. Foliose lichen and river roots from HOH Grown, P.O. Box 2135, Forks, WA 983231. Votive candles from Candle-lite, P.O. Box 42364, Cincinnati, OH 45242. Oasis Iglus™, Knud Nielsen reindeer moss and roly-poly votive candle cups available from your local wholesaler.

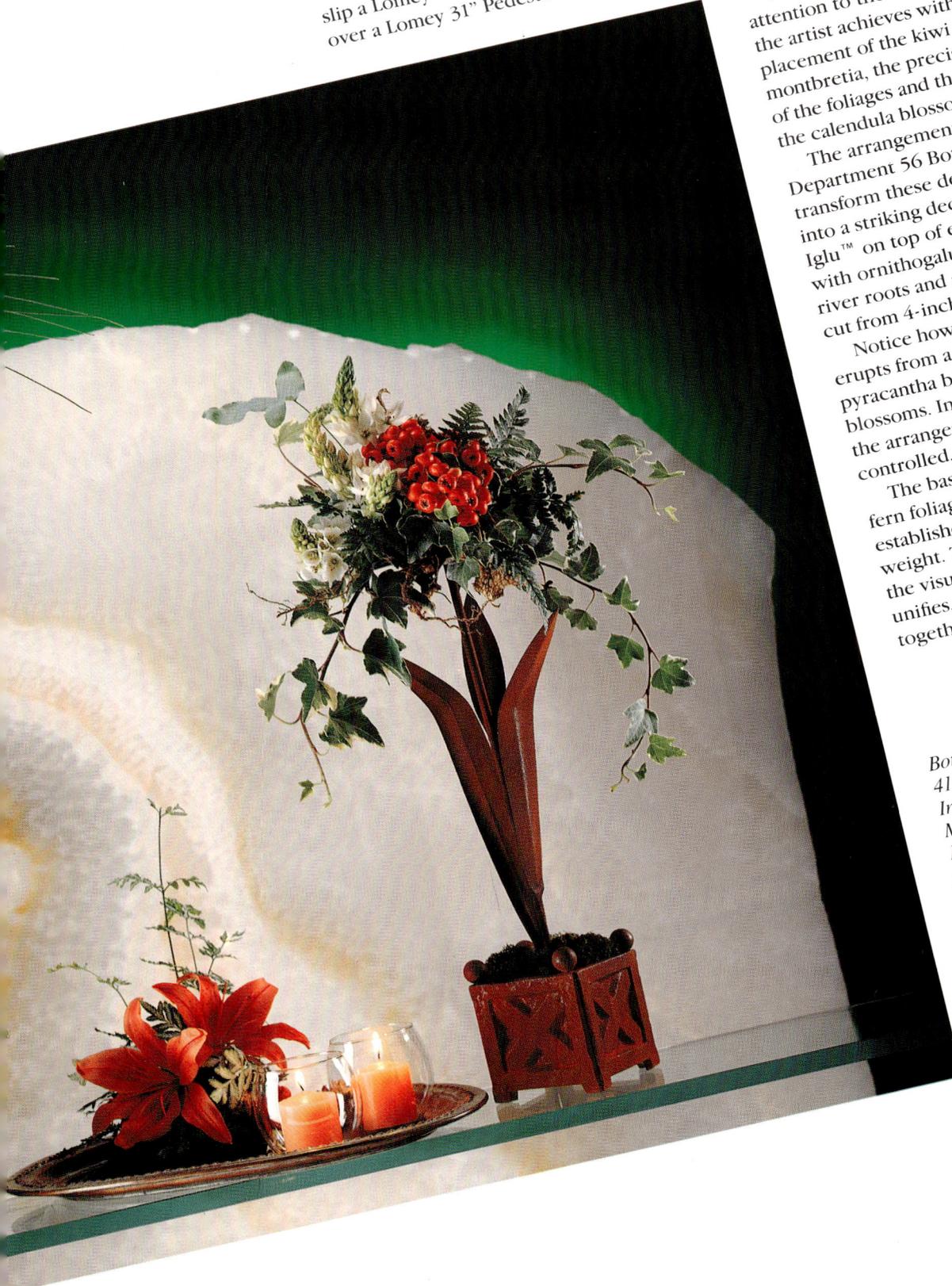

Visual Esthetic Design

As you become competent in the elements, principles and techniques of professional floral design you often express your creativity through the interpretative use of line.

The basics of line in professional floral design are easy to understand and use. There are only two broad categories—structured and relaxed.

A structured line is a planned line—"a conscious relationship between the flow and unity of lines in a composition." Vertical, horizontal, diagonal and circular lines are all structured lines. They have definite, easy-to-identify patterns and relationships.

A relaxed, or unstructured line is an unplanned or spontaneous line—"a natural, voluntary line movement that emerges as the artist combines the elements in a composition."

It is difficult to use only structured or relaxed lines in a floral composition. When Mother Nature is not so precise. When relaxed lines dominate, the design has a natural, even unarranged appearance. Structured lines create a formality, a feeling of planned, even contrived organization.

The arrangement below communicates a more relaxed, natural feeling. Some of the lines are free-flowing and casual. The rose with the curved line and bud at the top visually relaxes the design.

Precise, structured line is the theme of the liatris and anemone composition. The liatris moves across the base of the design in a planned, regimental horizontal line. The leucadendron foliage and anemone blossoms flow into the central focal area in a formal, linear movement. Every material is exactly in place according to plan.

These two designs are somewhat alike in form. Yet, there is a difference in the feeling they convey. This difference is communicated through the presentation of line. The roses convey informality. The composition with liatris and anemone expresses order and formality.

The tri lily bowl for the roses is No. L5 from Coronet Ceramics Corp., 14520 Joanbridge, Baldwin Park, CA 91706. The round medium bowl No. TI3598 from Giftwares is distributed by Pete Garcia and available from your local wholesaler. Garden Valley Ranch roses available May through October from L. Piazza Wholesale Florist, 821 Jefferson St., Oakland, CA 94607.

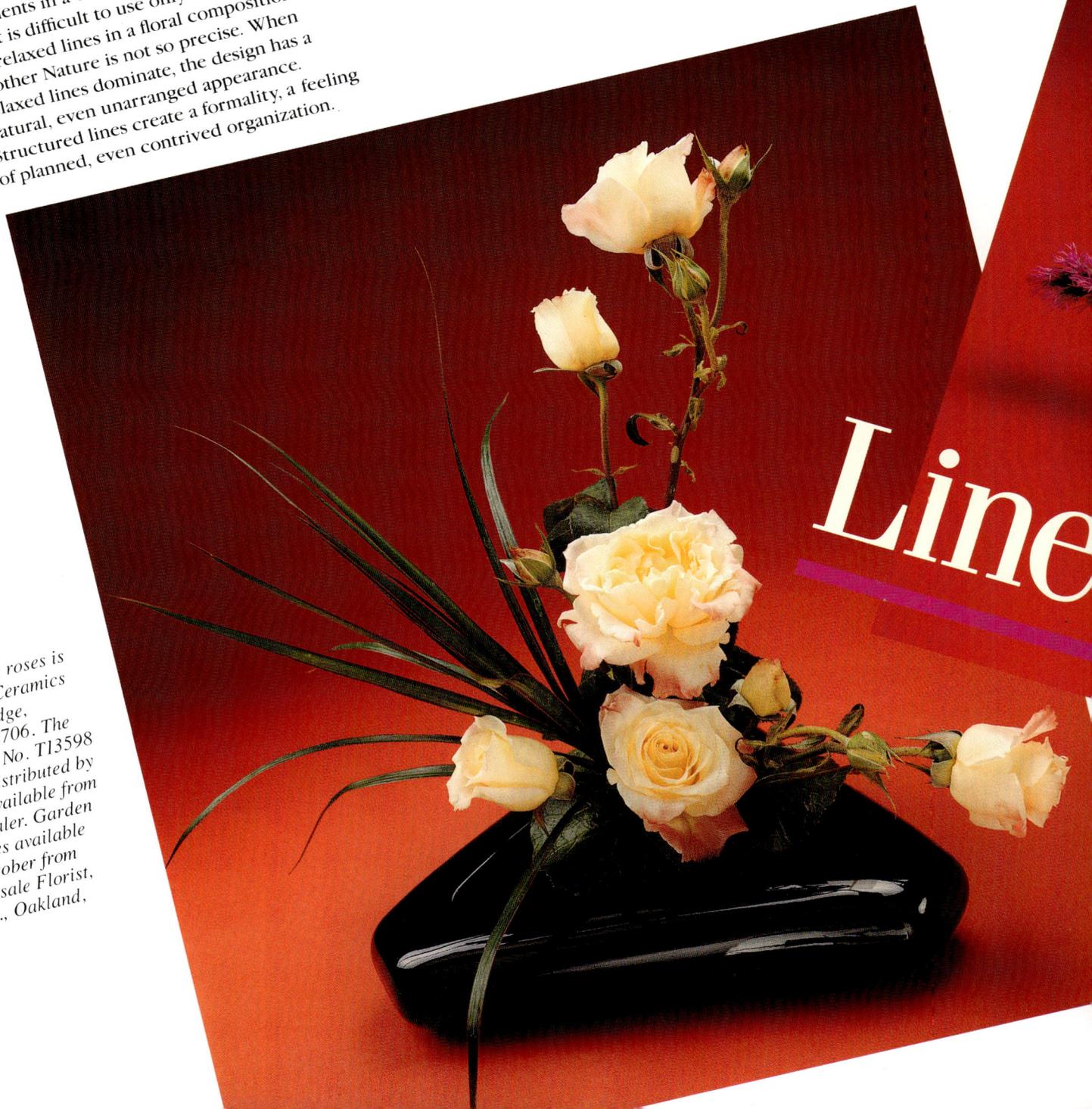

Line

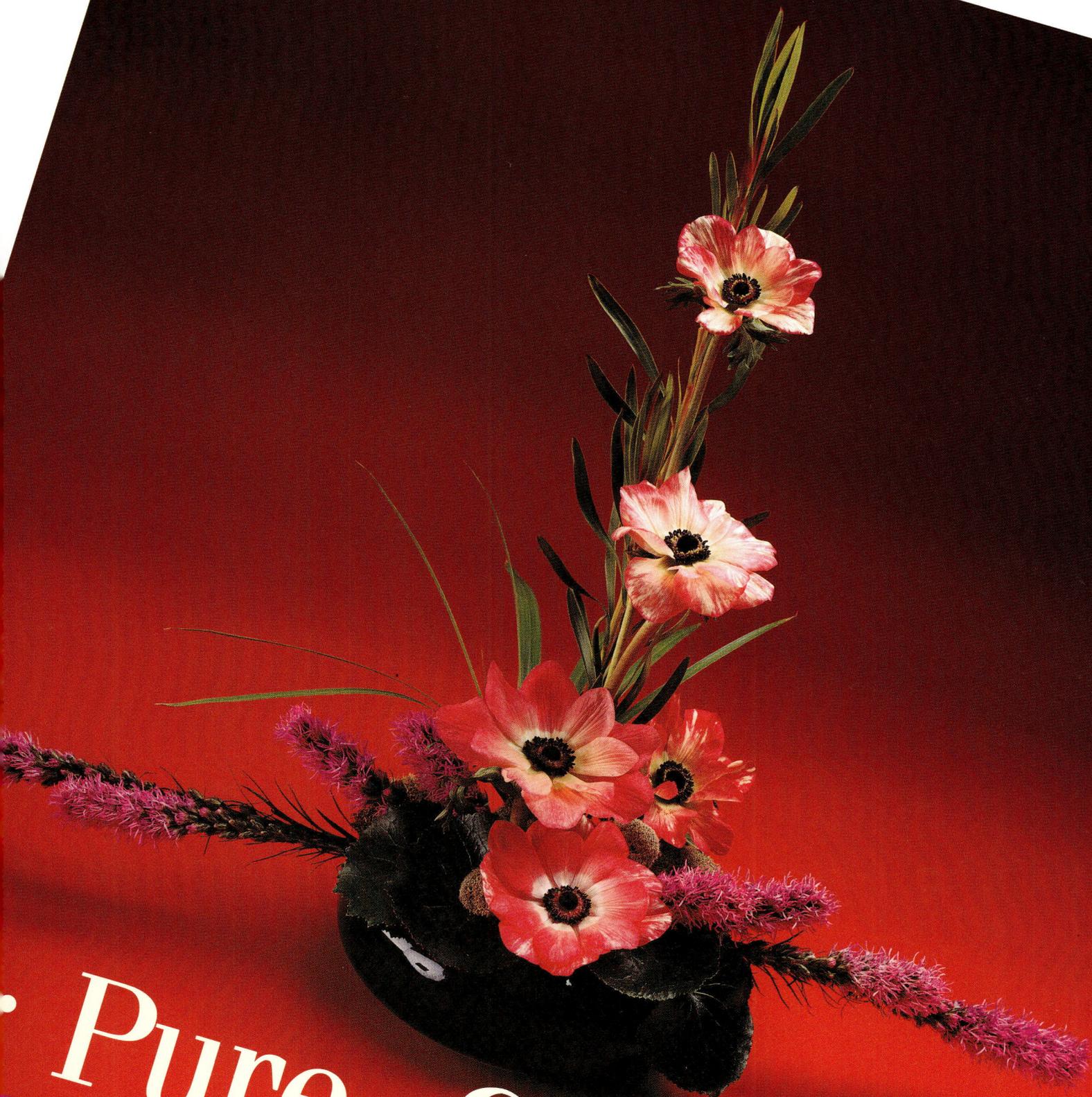

Pure & Simple

THE BEAUTY AND THE MAGIC OF LINE

Beyond The Sameness

WONDERFUL IDEAS AND UNMISTAKABLE STYLE

P art of being a professional floral artist is the ability to come up with distinctive ideas that stand out with creative style. Like having the right dress and tuxedo hanging in the closet ready for that special occasion, possessing a repertoire of ideas sets you apart as a desirable specialist.

The composition of tulips, gerbera and lemons is a wonderful study in elegant simplicity. It's an idea you can store in your bank of creative assets to call on when that special occasion arises. Or better yet, use it as a visual presentation in your store to showcase your talents and your merchandise.

Follow the pattern of design. As you discovered on page 53 of the January issue of DESIGN WITH FLOWERS, the Fibonacci Series is a method for bringing order to a composition. The single succulent on the table plus the single lemon equal two, expressed in the two votive lights to the right. (The Fibonacci Series $1 + 1 = 2$). Then, the artist repeated this resolution of two in two tulips, two gerbera, two lemons and two votives. This technique of creating a definite numerical series and then repeating it to form a pattern is an interesting and distinguishing technique in contemporary floral design.

Another noteworthy point in this composition is the simplicity of color. Simplicity reinforces simplicity. Restraint creates distinction.

The composition in yellow, orange and blue is more vibrant and flamboyant. The intermingling complementary color harmonies between the blues, blue-violets and violets and the yellows and yellow-oranges create a spirited presentation in color. Add to this color the form contrasts

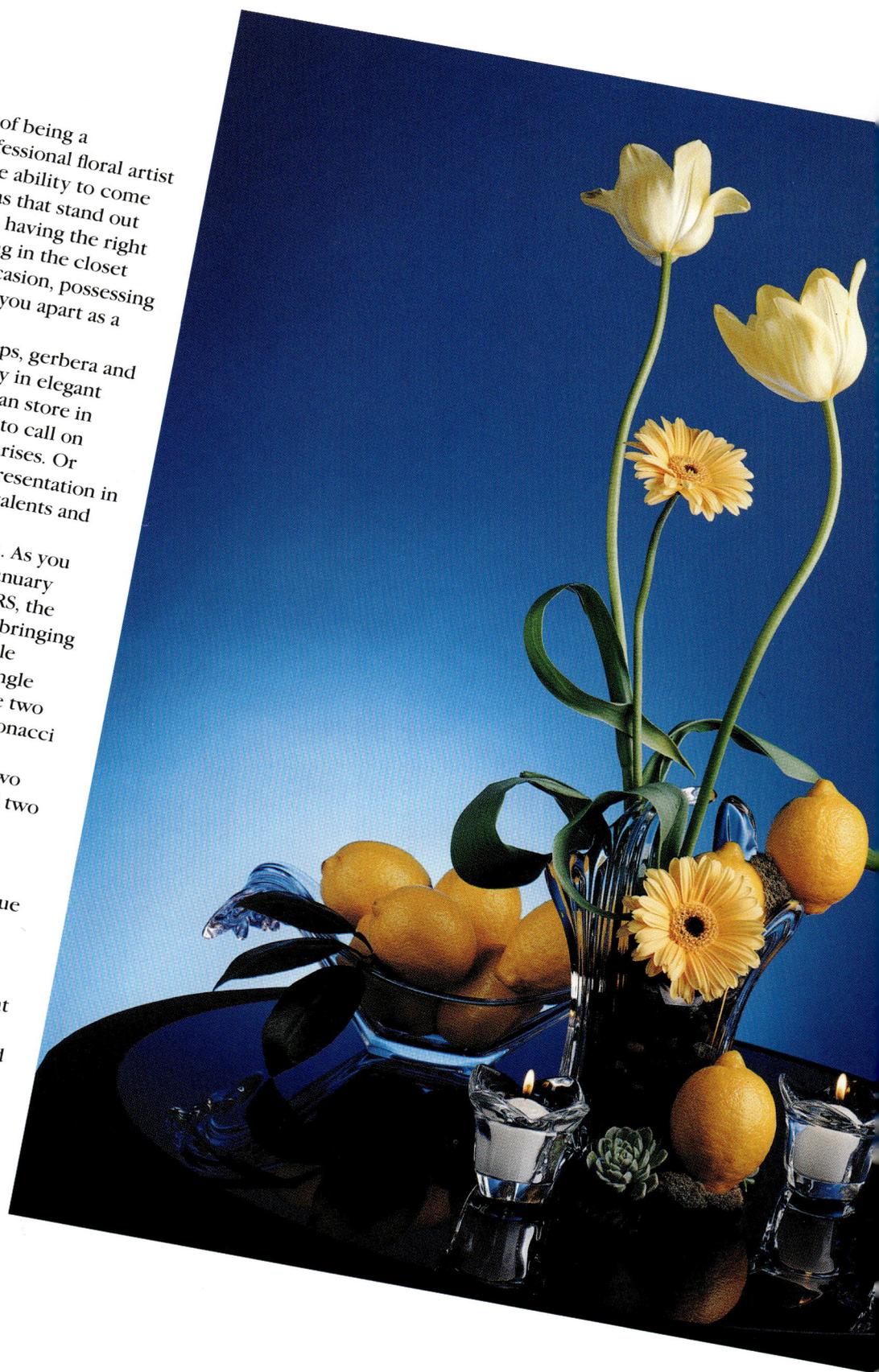

of the materials and the creative distinction of the composition becomes even more pronounced. Then, notice how the artist uses precise numerical repetition—two candles, two roses, two gerbera, two lilies, two stems of delphinium, two pieces of foliage in a dominant upward position—to achieve a pattern in presentation.

Crystal vases from Toscany Imports' flora vase assortment No. 272294 and tulip crystal votives No. 590027, 386 Park Ave., S., New York, NY 10016. Swirl ball container No. 734C from Coronet Ceramics Corp., 145200 Joanbridge, Baldwin Park, CA 91706. Candles from Creative Candles.

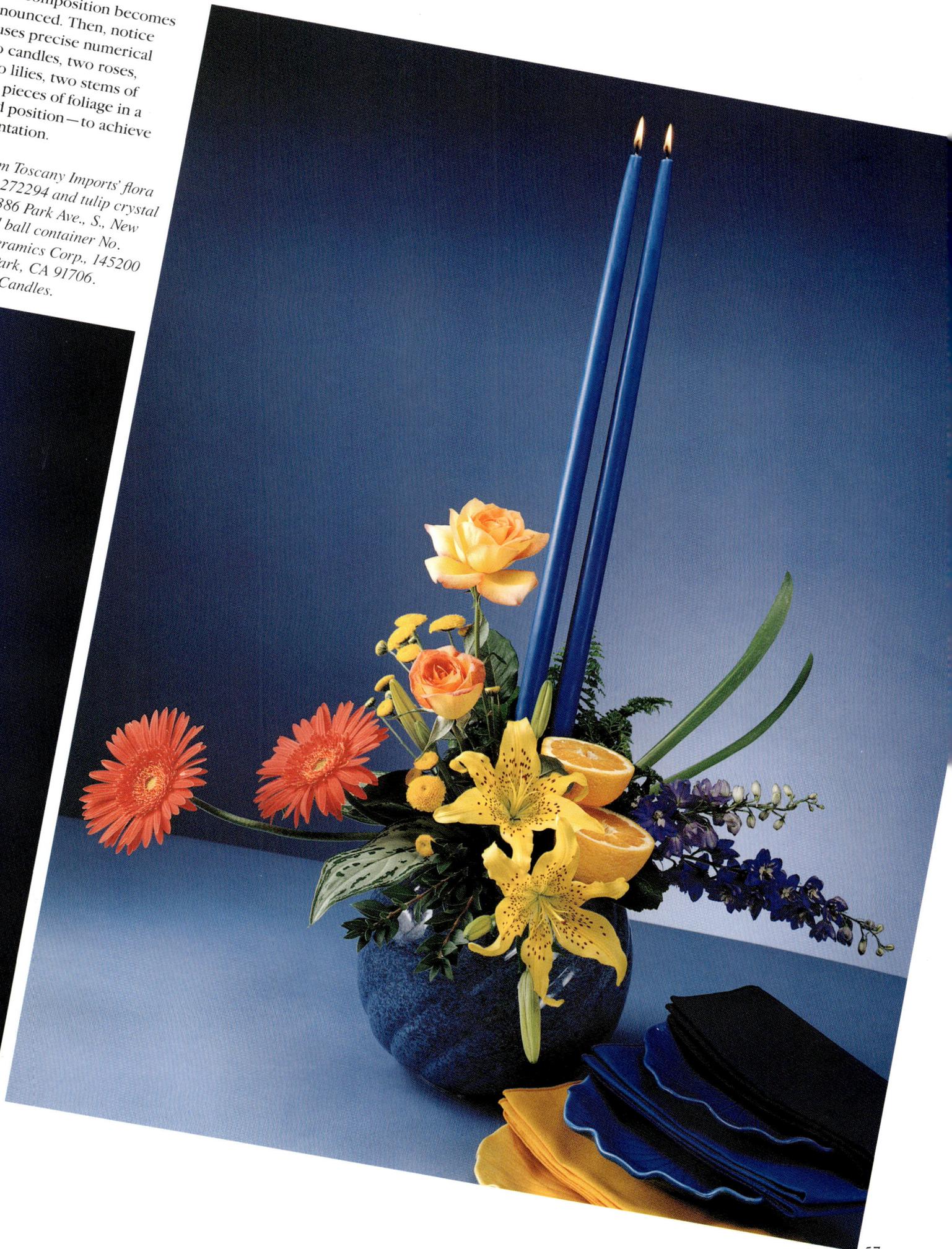

The Design Process · The Design Process
BALANCE · UNITY · CONTRAST · THE DESIGN PROCESS · EMPHASIS · LINE · FORM · IDEA

The striking black, flowered tablecloth and the pink napkins are from Immediate Tablecloth, 40-44 Austin St., Newark, NJ 07114. The black squat vase, No. 1596 from Vase D'Lite is available from your local wholesaler.

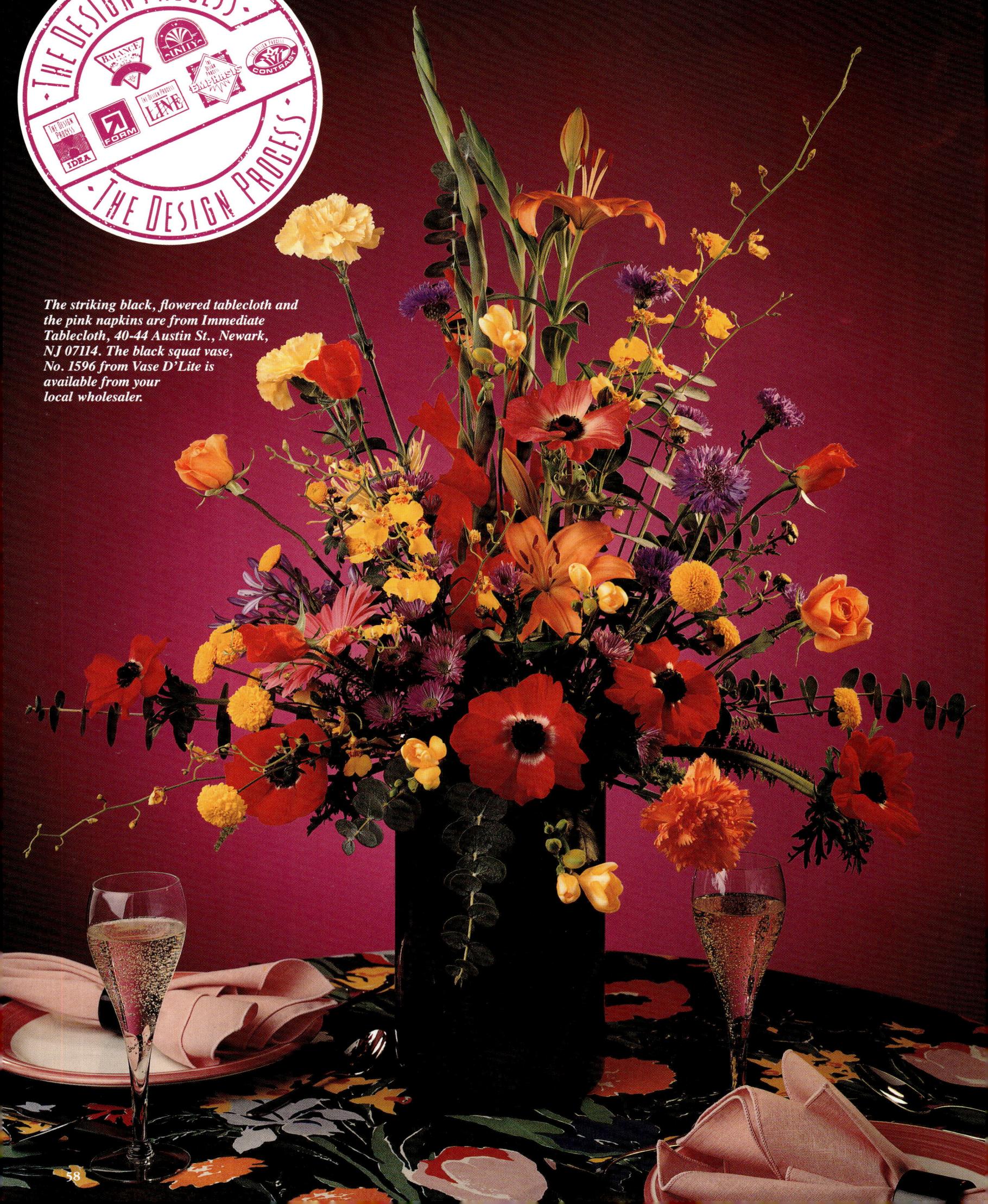

THE DESIGN PROCESS

Dramatic changes are emerging in the methods used to teach professional floral design. For several years, we have followed the evolution of the newer approaches to design education. And now, for the first time in the floral industry, Design With Flowers presents The Design Process—a new and practical way to study and teach floral design.

Profitable

The Design Process endorses practical, profitable creativity. Always interpret The Design Process as a profitable approach to design—charging an appropriate, profitable price for whatever you create.

Individuality

Professional floral design has deteriorated to the common, the ordinary, the monotonous. Today, standardization, and artless, mundane design is sold everywhere. This emphasis on industry-wide standardization stifles and replaces individual creativity. Yet, the future of the successful flower shop demands unique creativity, not standardization.

Traditional

For over 50 years, floral design instruction has focused on the elements, principles and techniques of design. This out-dated approach is technical and structured. It embraces mastering these fundamentals before introducing the expression of individual creativity.

Essentials

The Design Process integrates some of the traditional basics. The difference is the approach to design. The Design Process includes seven essential components: (1) The idea. (2) Form. (3) Balance. (4) Unity. (5) Line. (6) Emphasis. (7) Contrast. And, the process is sequential. The idea is most

important. Without an idea, there is no design. Second, an idea is expressed in form. And within this form there is composition—balance, unity, line, emphasis and contrast.

The Design Process places assertive focus on the artist rather than the procedure.

Authorities

Robin Landa states: "Design is a medium that allows the artist to express feelings, philosophies, and ideas and to communicate messages in a meaningful way. Design organizes the designer's thoughts and translates them into form."

David Pye states: "The designer always has a freedom of choice. That choice is the central issue. Design is done to get results, but the freedom of choice about what the thing designed shall look like matters as much as getting the result and sometimes more."

Discipline

Each section in this issue covers one component of The Design Process. Discipline yourself to think The Design Process. As you master this approach, you will develop a creative uniqueness that differentiates you from other designers who are embedded in standardization.

Example

The magnificent composition pictured here and on the cover is an exceptional example of The Design Process. The floral design starts with an idea. Then, the artist establishes a defined triangular form. Within this form, the artist creates a distinctive, unique flower composition incorporating balance, unity, line, emphasis and contrast. The style of the design is loose and expressive. It is structured to achieve compositional unity, but still communicates a comfortable informality.

The Design Process is a new approach to studying and teaching floral design. This method stretches you and inspires you to develop your full creativity. It encourages you to think about floral design from a new perspective. The Design Process excites a resurgence of individual creativity, commercially practical in a floral world overtaken by standardization.

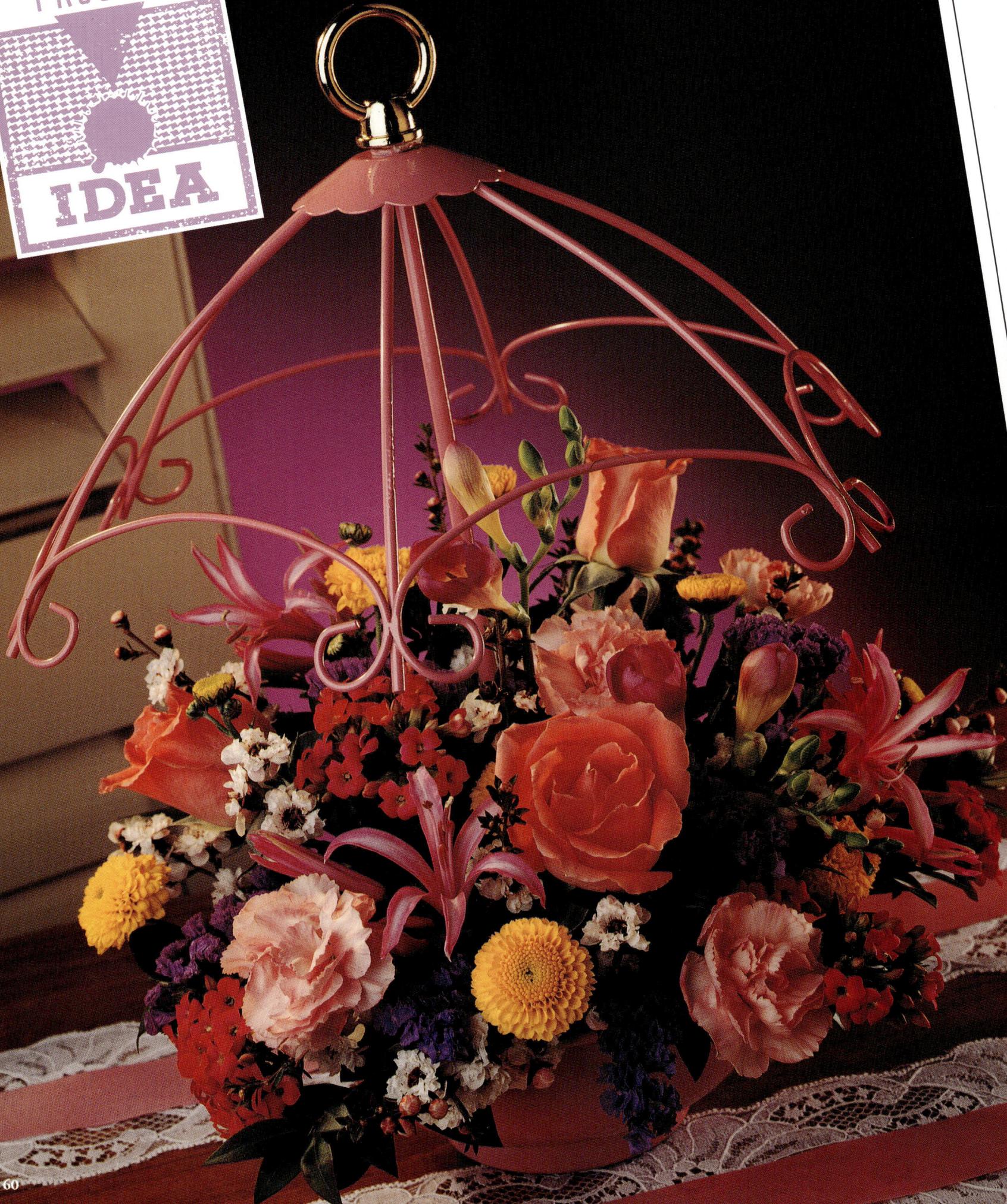

A nod to casual sophistication

The idea of a design, the first step in The Design Process, is the all-important pause for creative planning. It determines how distinct and unique a composition will be. Communication is the primary function of a floral design. Every floral composition begins with a message to be communicated. The idea, the concept of the design, is the medium of communication. For a floral design to communicate fully and convincingly to the recipient, the artist must have a working knowledge of the term "idea."

Floral design is a form of visual art. From the visual art point of view, idea is defined as: "the representation of a thought that can be translated into visual form that communicates a defined, predetermined message."

Understanding this definition is an important step in mastering The Design Process in floral design. An idea is first a thought. This process occurs only in the brain. Then, the idea takes on visual form that projects how the idea will be expressed in a composition. And third, the purpose of the idea is to communicate a predetermined message.

In their writings on idea formation, Cheatham, Cheatham and Owens state, "Ideas are non-sensory. They cannot be seen, touched, tasted, heard, or smelled. Our senses are only able to come in contact with the results of ideas once they have been materially produced."

The designer had the freedom to select any style of arrangement and any combination of flowers for the pink parasol container. In his mind, he conceived the idea for a presentation of mixed flowers in a wonderful array of assorted colors. Then, he formulated his idea for the form of the design and the

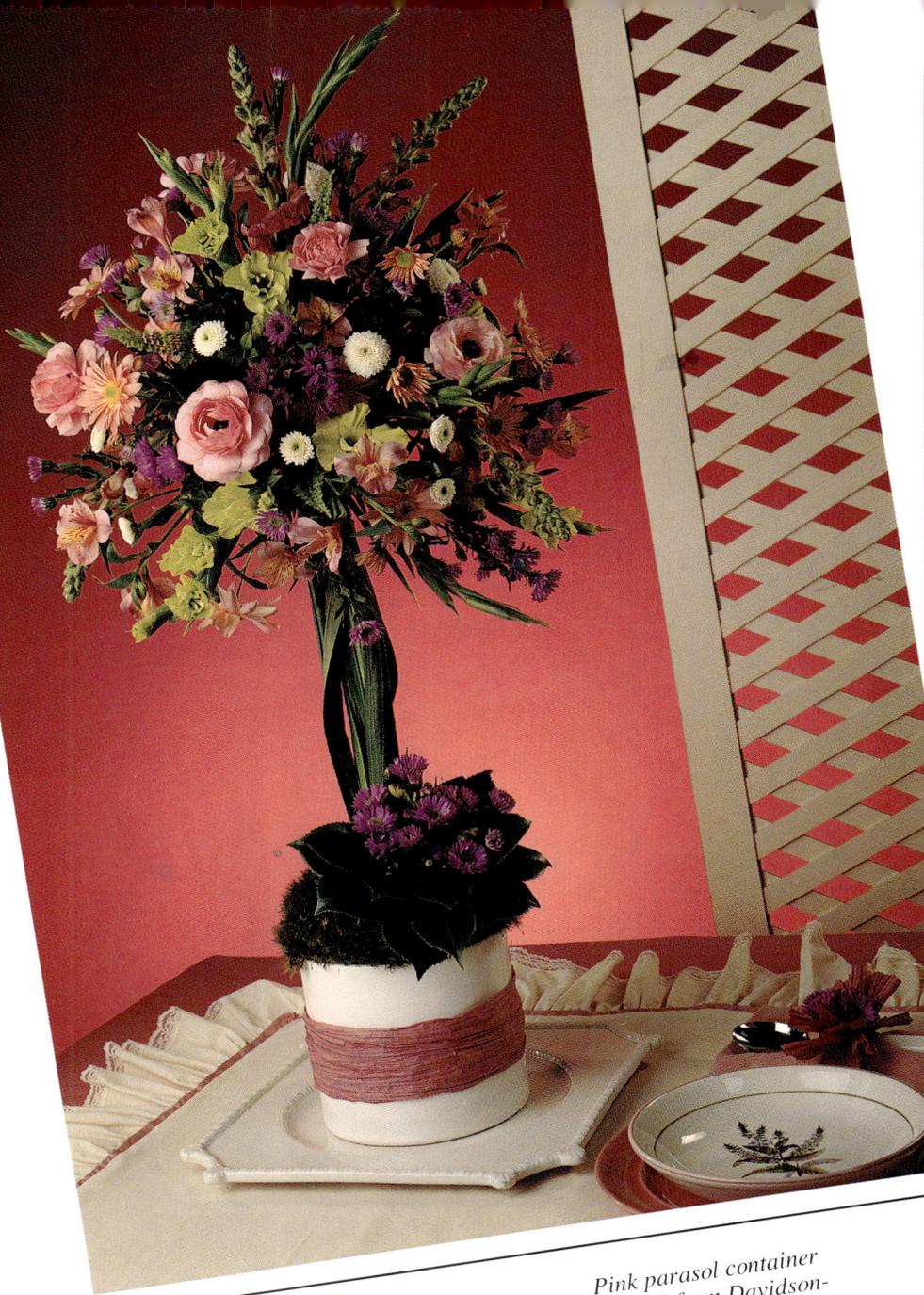

materials he would use. By keeping the flowers within the framework of the container, the designer centered visual emphasis which highlighted the novel characteristics of the design.

The topiary design emerged from an assignment for a decoration to accent a party serving table. The purpose was clearly defined. Yet, the artist had unlimited creative possibilities. In his creative planning process, he visualized the topiary. Then, he visualized the presentation for the idea—the form of the composition.

The pole for the topiary is a Lomey design pedestal with a large caged floral foam on top. After gluing the pedestal base to the container, the artist circled the container with Knud Nielsen paper ribbon and filled it with saturated floral foam. Then, he inserted wooden dowel rods around the pedestal stem to secure it and covered these mechanics with gladioli foliage. The nosegay-like cluster of camellia leaves and miniature asters adds a secondary accent at the base of the design.

Pink parasol container No. 110 from Davidson-Uphoff, P.O. Box 184, Clarendon Hills, IL 60514. McGinley Mills ribbons used on the table available from your local wholesaler. Giftwares ceramic planter used for the topiary distributed by Pete Garcia; Knud Nielsen paper ribbon and mood moss, Lomey pedestals and caged floral foam available from your local wholesaler. Tablecloths from Immediate Tablecloth, 40–44 Austin St., Newark, NJ 07114.

Basket No. P1718 from the Jim Marvin
Collection, Route 7, Box 44, Dickson,
TN 37055.

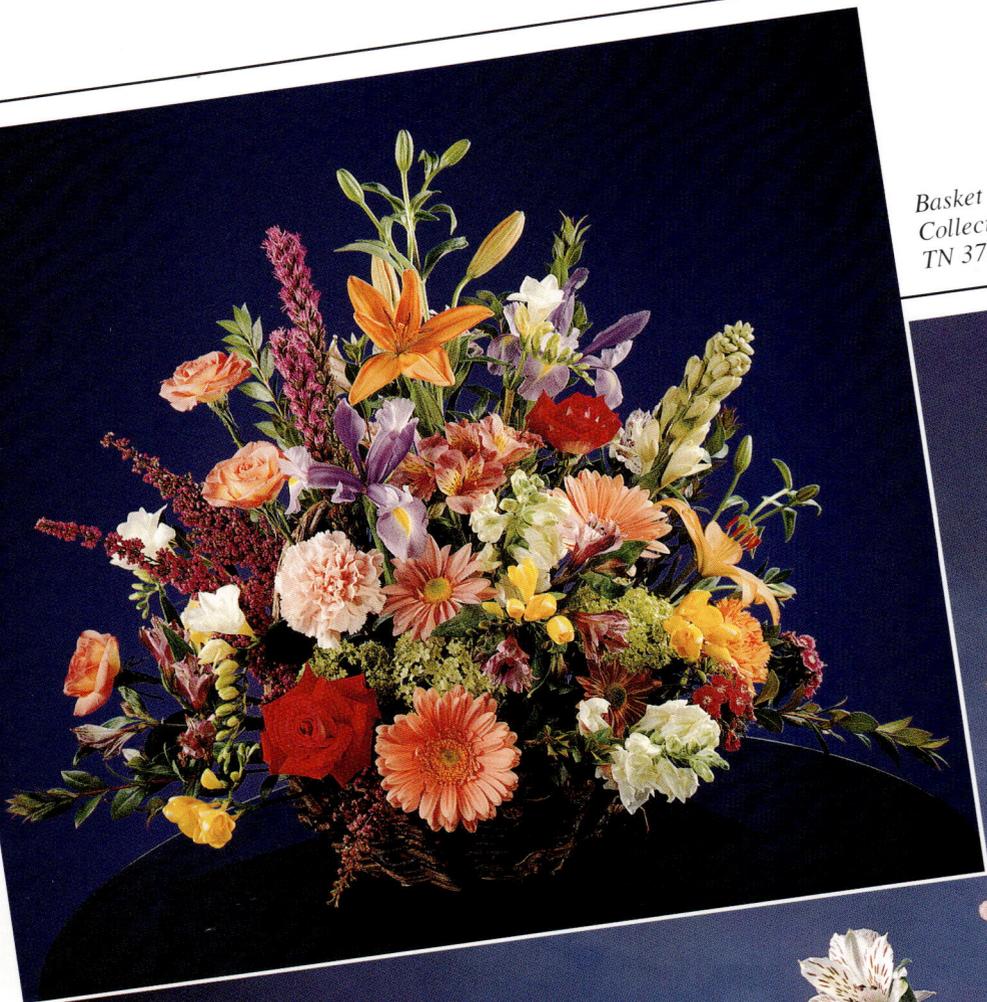

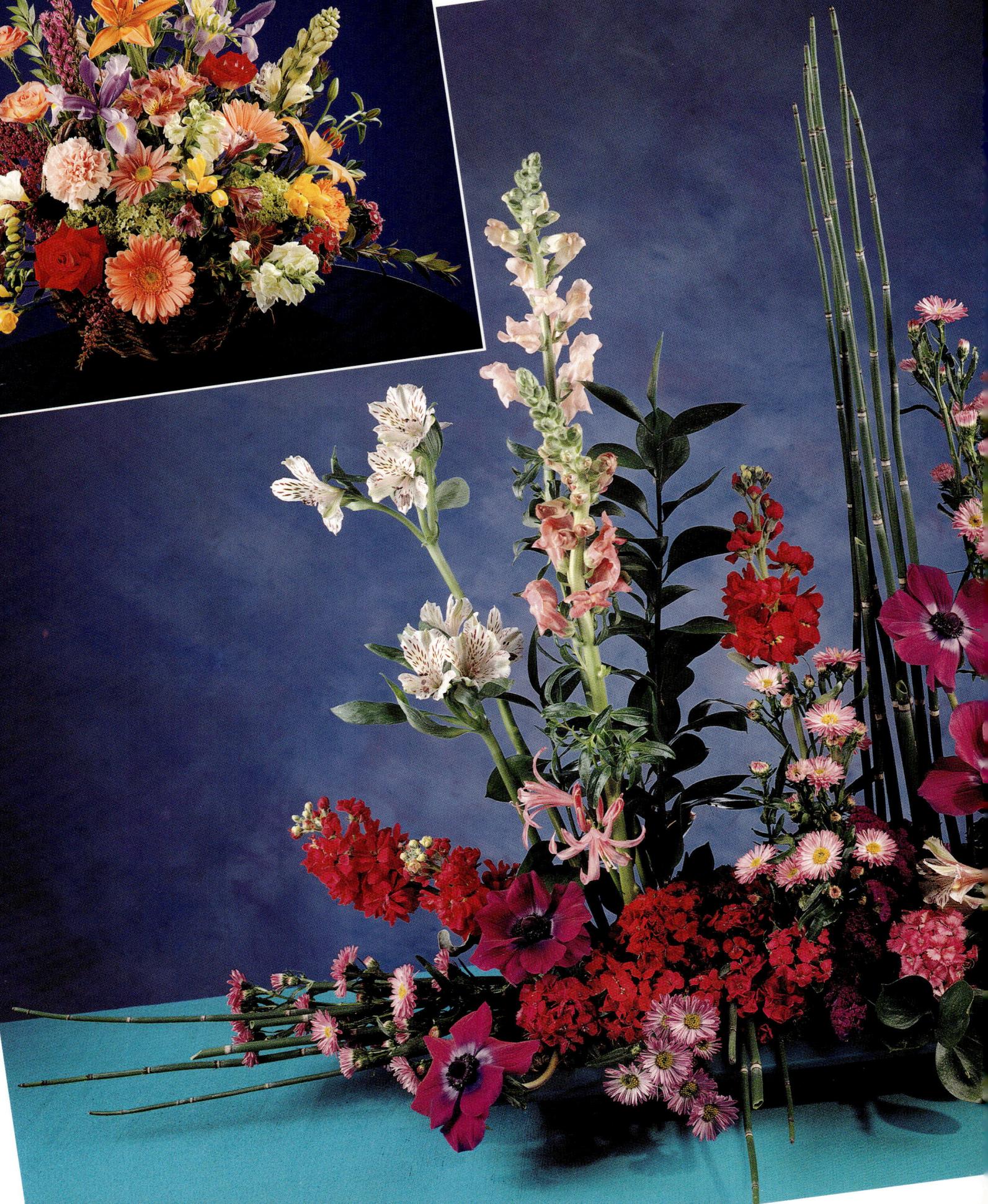

Excell in effortless Style

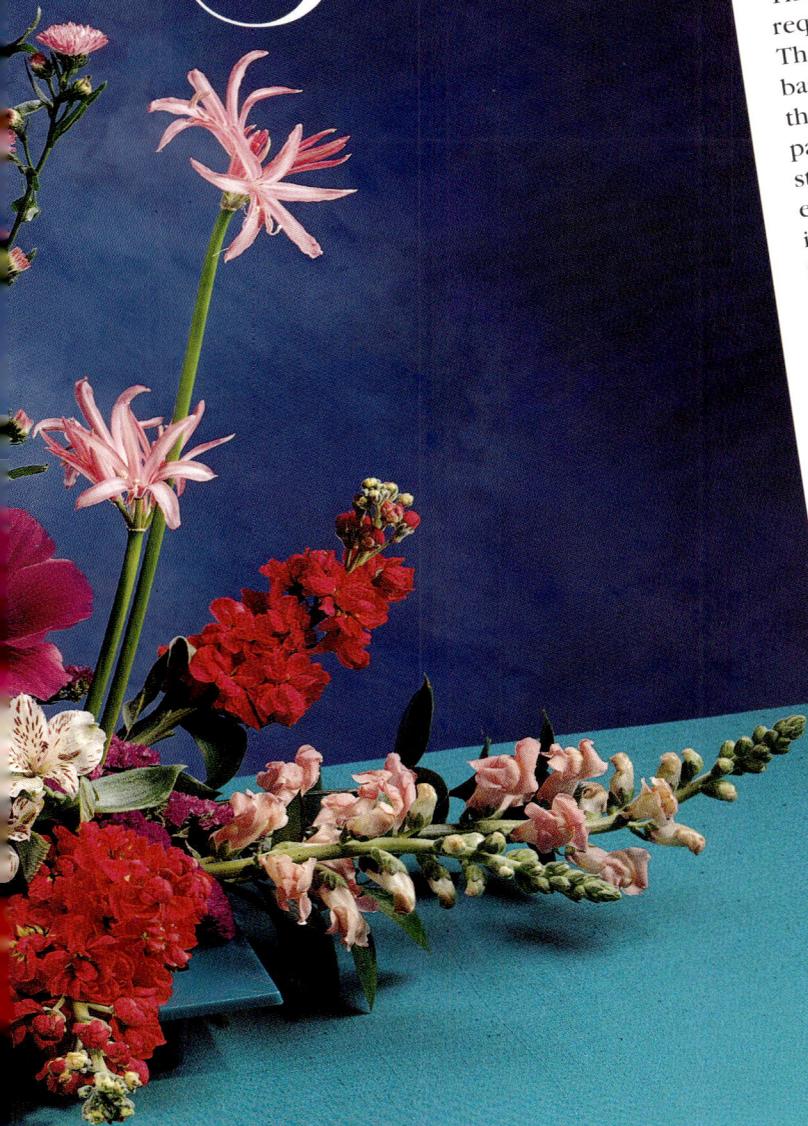

The current trend in floral design is away from "mechanical style." In all design forms, whether an equilateral triangle or the new convention, the approach is to achieve elegance in relaxed presentations of flowers. The true meaning of the "effortless style" is to play up the natural beauty of the materials and to downplay the mechanical arrangement process.

There are two distinct approaches to an effortless style.

The first is to present an array of informal materials within a traditional, formal form. The basket design of assorted flowers in an extended selection of forms, sizes and colors arranged in the more conventional equilateral triangular form, illustrates this approach to effortless style. Even though the composition is structured, it conveys the feeling of informal elegance. It has effortless style.

The second approach to effortless style is to relax the actual structure of a design. The new convention composition pictured exemplifies this technique. The composition contains all the requirements of the new convention style. There are parallel groupings, horizontal base lines and reflective front lines. All of these characteristics are relaxed. The parallel groupings are not precisely structured. The horizontal base lines are easy, the front reflective lines casual. This is effortless style with relax-structured form.

Perhaps you are asking, "How do I develop the skill to be idea-centered in my creative efforts?" Psychologists who have studied the phenomena of ideas as it applies to art, state there are three sources for ideas.

1. Imitation—copying an existing idea and doing it as well as the original. The standardization that the industry has imposed on floral design causes more and more floral designs today to be imitations. An imitation can be purchased anywhere there is a designer who can copy.

2. Innovation—taking an existing idea and adding something new or different to make it better. Many floral designs come from innovation—adapting by adding, subtracting or changing. Innovation introduces limited creativity. The idea of the design is not original. Sometimes, however, the modification gives the composition the appearance of an original.

3. Imagination—developing a new idea or concept through visualization—seeing the materials in an original and unique composition.

When an artist visualizes how to configure materials in a composition without the aid of instructions, pictures or previous design ideas, he is using his imagination to the fullest. The word imagination means "a mental image of something not present to the senses—a creation of the mind."

The two designs presented are examples of innovation. The forms of the designs—the equilateral triangle and the new convention—are well-established. Through innovation, the artist added his personal creativity by changing the usual and the accepted.

THE DESIGN PROCESS

IDEA

Franklin China Eurotray No. M-7019, Knud Nielsen mood moss, and Oasis® floral foam available from your local wholesaler.

Stackable container No. M1, from Midamco, 6630 N. Kostner, Lincolnwood, IL 60646. Knud Nielsen reindeer moss available from your local wholesaler.

In the commercial world of floral design, an idea isn't creative unless it sells. The singular purpose of any idea in floral design is to produce a composition that sells, satisfies the customer and produces a worthwhile profit for the flower shop.

critical choices: creativity & practicality

As a creative floral artist, you can judge a design only from the viewpoint of your own circumstances. There are no universal judgments. What is creative and practical in one flower shop may be totally off the wall in another, and boring, mundane and unacceptable to another shop. In every idea presented there is a kernel of creativity that can be learned and adapted in any flower shop.

The creative design pictured is innovative. The idea originated in the designer's mind—it was not copied or adapted from another composition. And, the artist used the available leucadendron, heather, flax, galax and maranta foliages.

A designer might create this same idea with a stem of yellow gladiolus, two gladioli leaves, a yellow glamellia in the center and foliages at the base. Another designer might look at this idea and visualize a center, vertical grouping of pink snapdragons, a pink gerbera at the base and an arched structure of maroon flax.

Many floral designers maintain that they do not visualize a completed design. For these artists, a composition emerges as they work on it. This is a misconception about the creative process. A floral artist can start a composition without visualizing the completed design. As any composition takes form, the designer's imagination goes to work subconsciously. The idea of the finished design crystallizes in his mind.

To create the composition pictured, start with the arched foliages to establish the height limitation. Slit the one leaf and insert the second leaf. Use Oasis® glue on the back side of the leaf to hold the leaves together where they join.

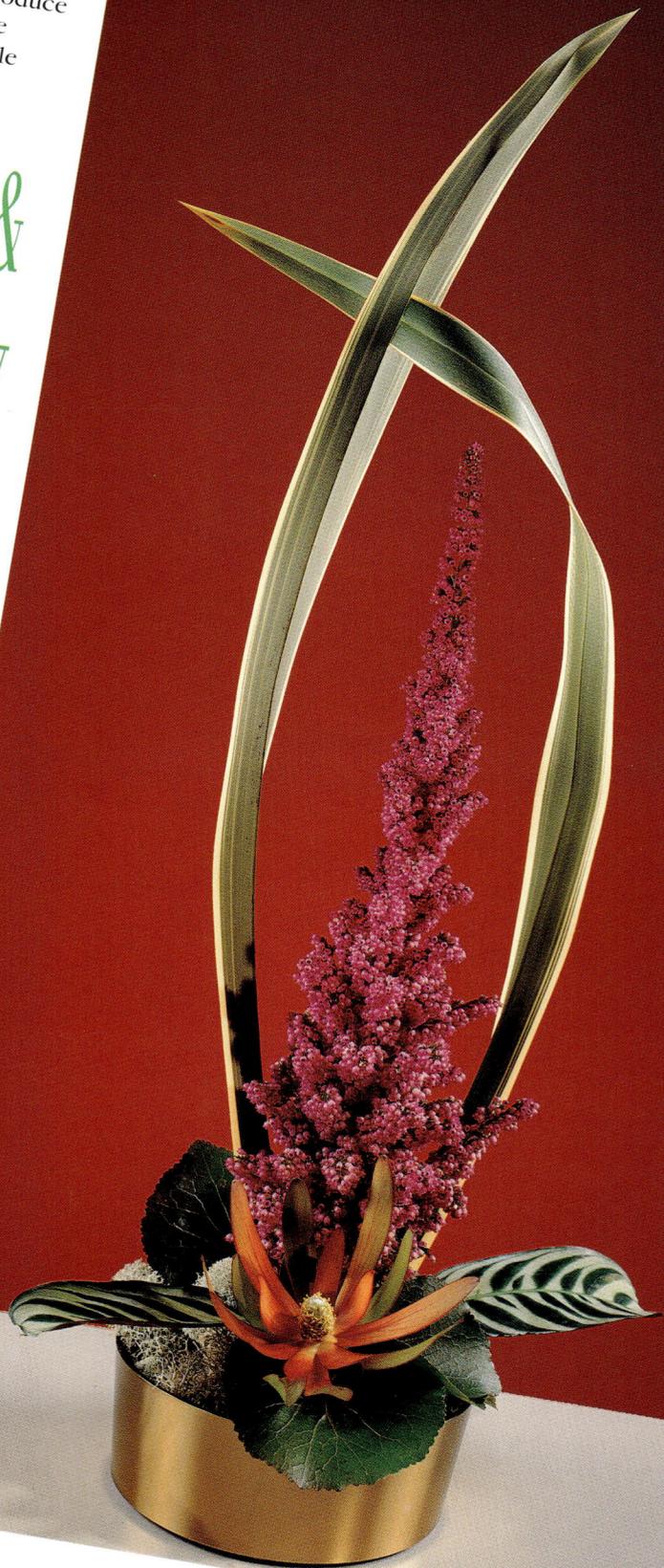

In floral design, we use the term "design" as a noun to identify a completed composition. As a verb, the same word implies the process of placing materials in a composition.

To understand how The Design Process functions for a floral artist, it's necessary to forget both of these definitions and look at what the word design means.

A design is a plan to make something. It is first an idea. The Design Process is the procedure of moving an idea from the planning stage in the mind to the actual, completed composition.

The creative composition pictured is an outstanding example of The Design Process. The idea is distinctive. It communicates. The idea moves from the idea stage into form—a trellised basket container and an elongated oval composition. The artist uses balance, unity, line, emphasis and contrast in presenting the blossoms.

To construct the garden trellis use Alder branches in two vertical and three crossbar positions. Construct the trellis in the basket after filling it with saturated floral foam, and before inserting flowers and foliages.

The designer presents the blossoms in relaxed groupings—four roses, four freesia, three sweet William, one stem of statice and one stem of heather separated into two pieces. The fresh ruscus foliage is an intriguing vertical accent. The fern fronds and calathea leaves contribute an interesting contrast at the base of the design.

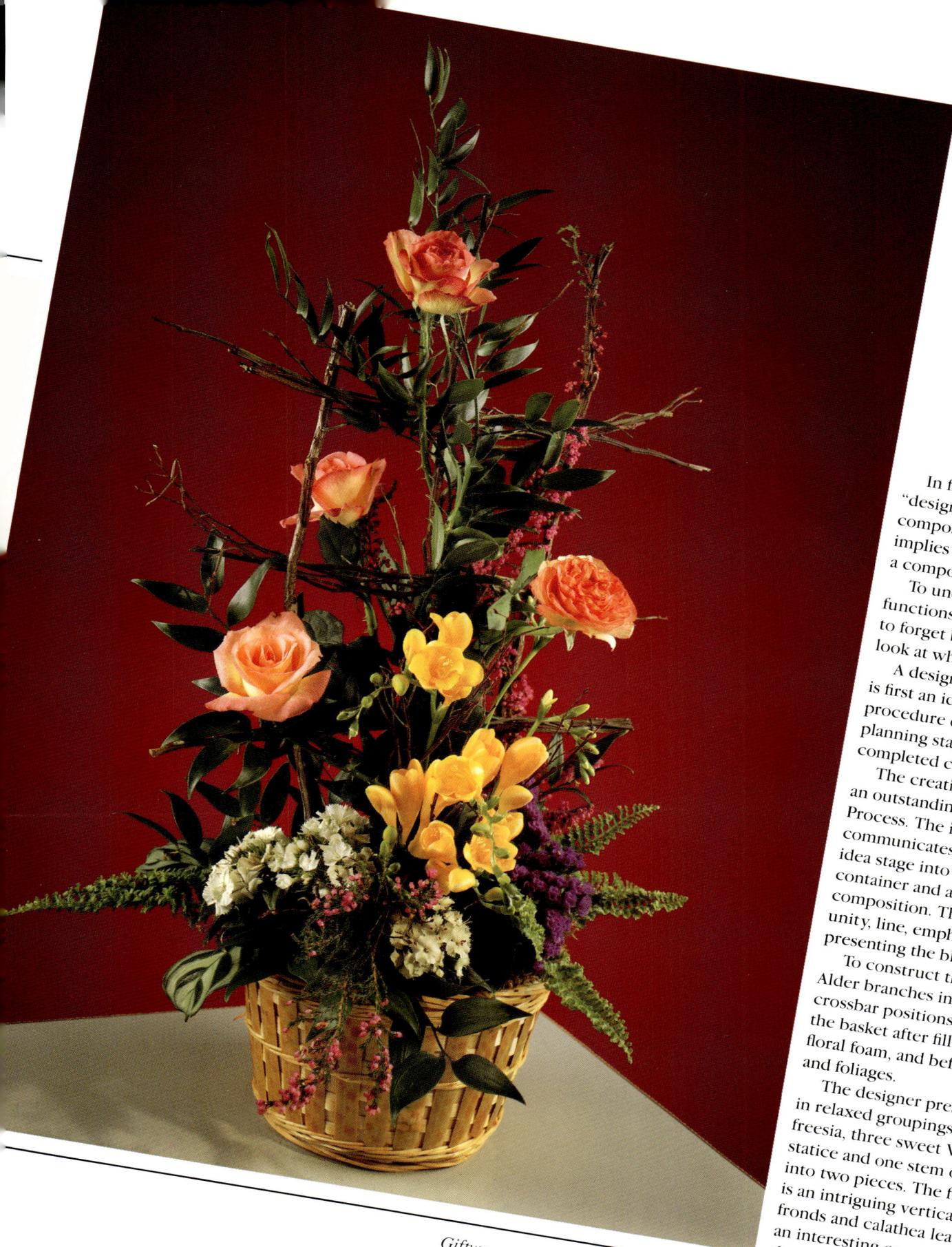

Giftwares basket No. 010261 distributed by Pete Garcia Co. and available from your local wholesaler. Fresh Alder branches from HOH Grown, P.O. Box 2135, Forks, WA 98331.

THE DESIGN PROCESS

IDEA

Glass compote lined with Highland Supply white plant foil and McGinley Mills tulle No. 1620 available from your local wholesaler.

The idea for this exquisite composition comes from the current interest in Victorian influenced design. Some say that the phenomenal success of the new consumer magazine *Victoria* has created a revival for Victorian elegance in all areas of home decor. The creative floral designer draws his ideas from everything around him.

The composition pictured is a combination of the French and the Biedermeier influence. According to Angus Wilkie, in his book Biedermeier, "The Biedermeier style originated in Austria and Germany during the postwar years 1815-1848. It was a style which owed a significant debt to French Empire and English Regency designs."

In floral design, Biedermeier style is best known as the circular bouquet with concentric circles of flowers. The placement of the carnations, sweet William and roses in this composition exemplifies the Biedermeier style.

The nosegay was a popular form of floral presentation in the Victorian Era. And, the typical Victorian nosegay bouquet was a conical, round form rather than a flatter circular design.

Add your own innovation to adapt this style of bouquet to whatever is appropriate for your shop. Do it in miniature with small, delicate flowers. Or, create a large impressive display with sizable flowers.

The Victorian influence is now. Follow this idea through The Design Process. First, the idea. Second, the form in which you present the idea. Then, incorporate balance, unity, line, emphasis and contrast in your composition.

The fine art of Elegance

What could be more elegant, more Victorian and more fashionable than a marvelous Victorian bouquet created in a simulated silver tussie mussie holder. Suggest it for a prom or wedding bouquet. The idea is brilliant. How you adapt it to your own shop depends on your ability to visualize possibilities.

Visualization is the result of an idea. It is not an idea in itself. Ideas are thoughts. How the ideas are expressed is visualization.

As you explore the possibilities of this Victorian nosegay in a bouquet holder, you visualize how you can use innovation to adapt the idea. How can you change it, make it larger, make it smaller, embellish it, simplify it and make it desirable to your customers and your market?

This brand new bouquet holder comes with a floral foam attachment. You can create a design quickly with labor efficiency. And, the flowers will be in moisture and provide extended customer satisfaction.

The style of this nosegay represents the French styling with an assortment of flowers in freeform placement. There should be no organized pattern of placement. This style is distinctly different from the Biedermeier styling where blossoms are presented in precise circles.

THE DESIGN PROCESS

IDEA

Creative Marketing Concepts tussie mussie holder No. XJM94373 and McGinley Mills lace No. 5999 available from your local wholesaler. (If you have difficulty finding this new bouquet holder, call CMC at 800-262-2100 and ask for your nearest source.)

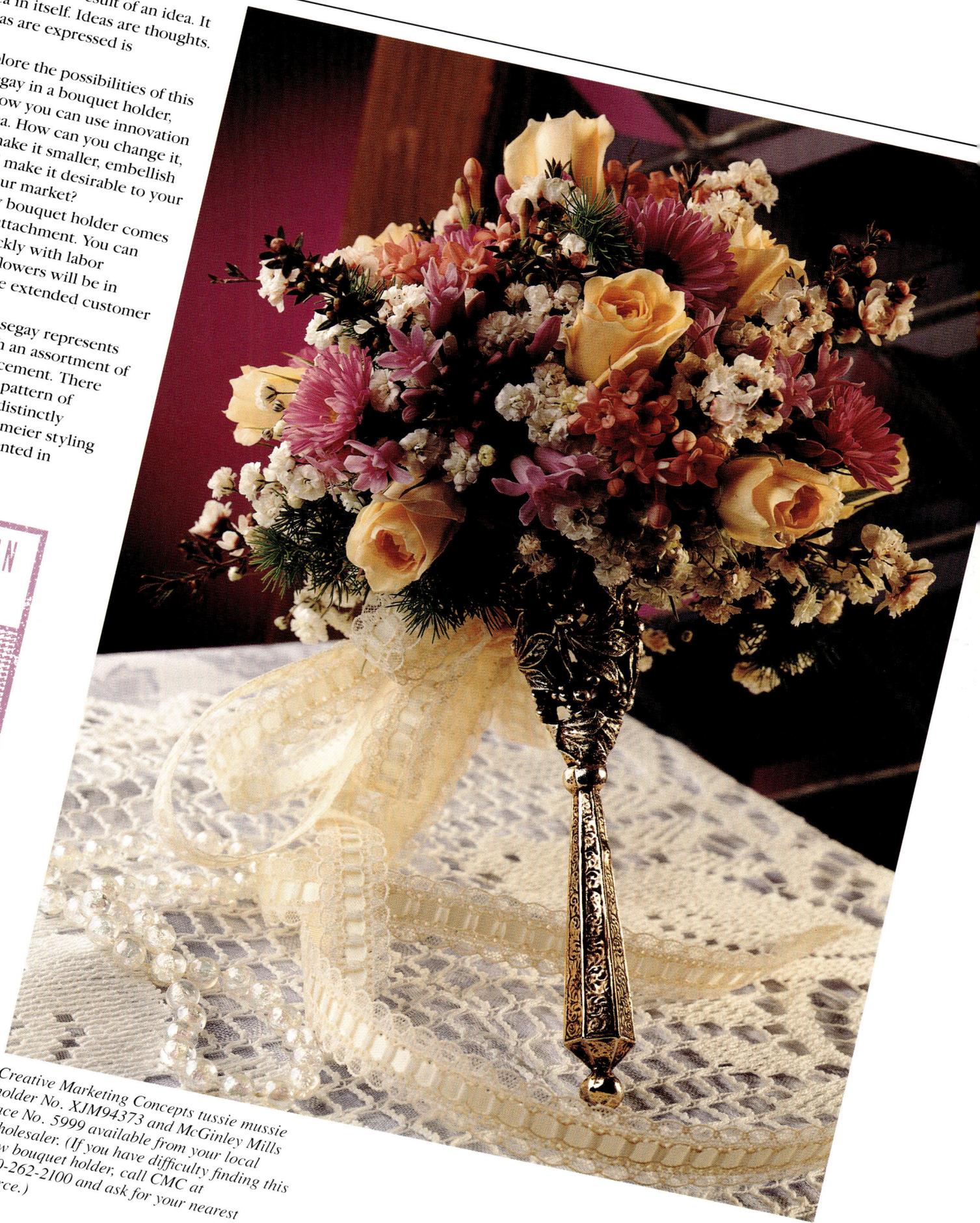

THE FINISHING TOUCH TO

MATCH THE MOOD

E. O. Brody etched European glass vase No. 4032 used for the fresh flowers, No. 4035 for silks. Creative Marketing Concepts peruvian lily No. RF-50723; hydrangea No. XAF-45384; Italian roses Nos. MF-69904, 69905; cabbage rose No. BF-61220; freesia No. RF-50745; galax leaf No. CF-63186; gerbera No. RF-50734; statice No. AF-45804; aralia No. AF-45780. All items available from your local wholesaler.

Silk flowers in an equilateral triangle with relaxed triangular structure. The eased structure gives a more casual feeling than the structured triangular form used for the fresh flower design.

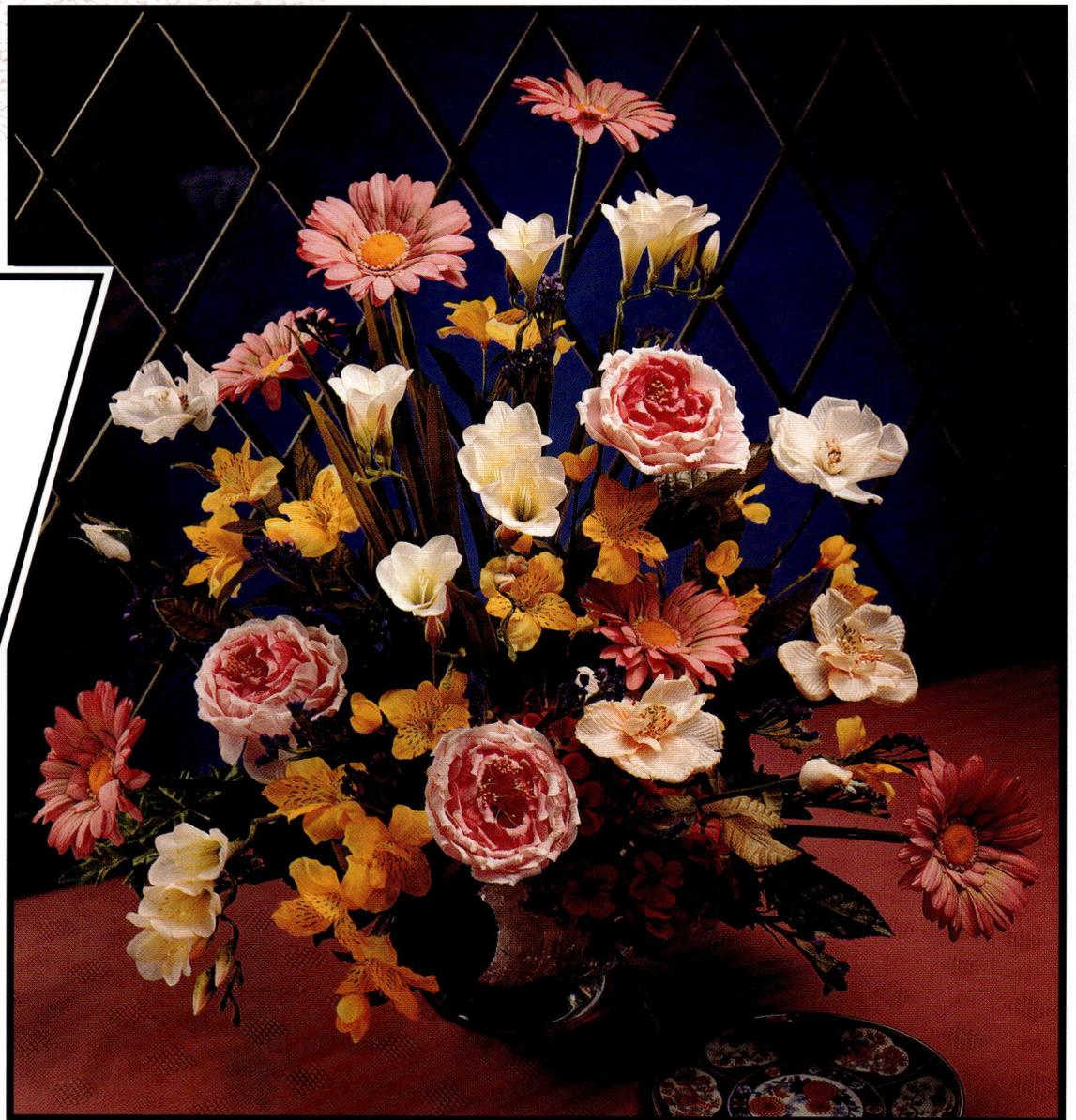

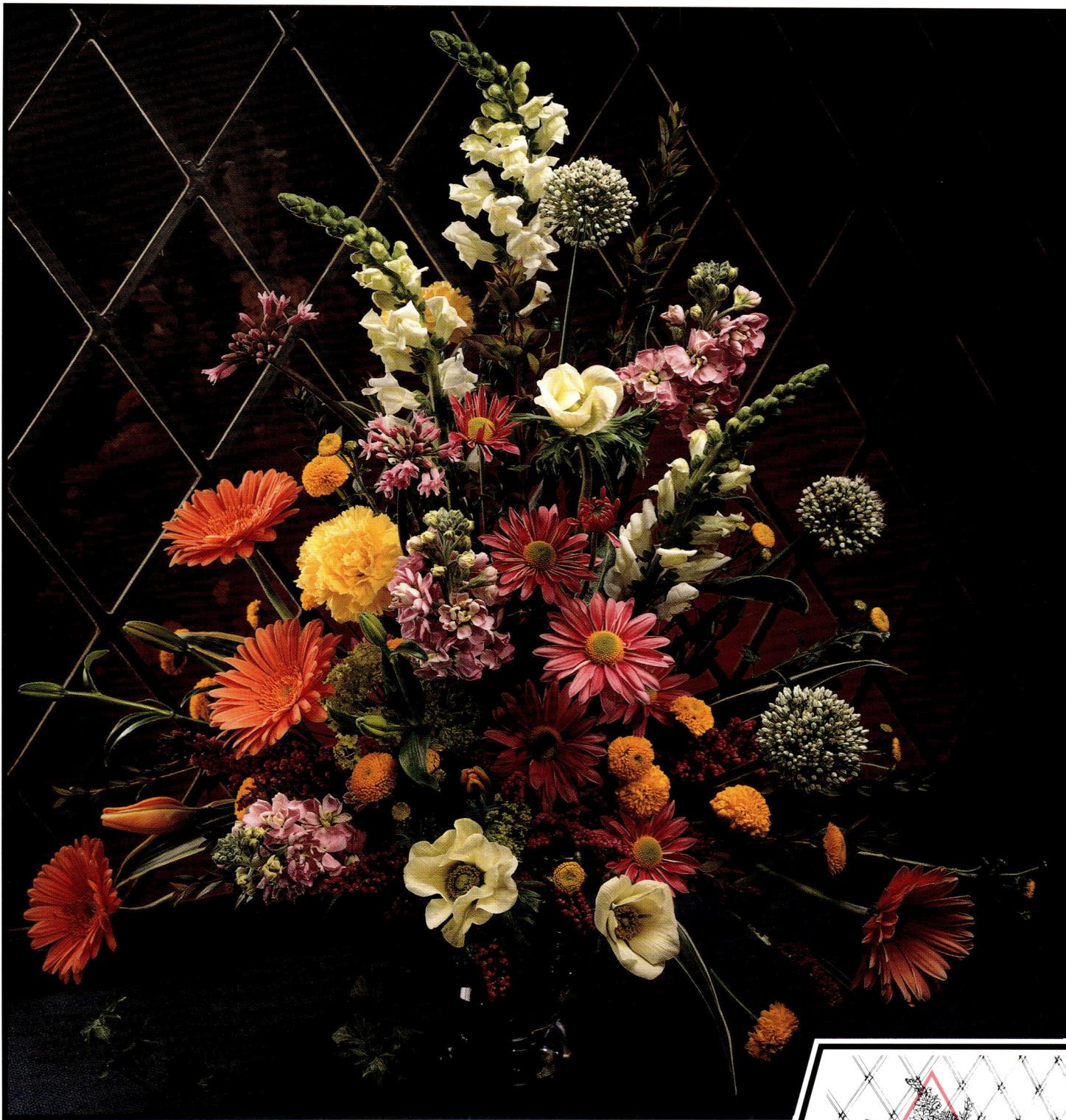

Form is the second component of The Design Process. After conceiving and envisioning an idea, a designer expresses it in form.

"The form of any design is the combination of the three-dimensional structural characteristics that creates its individual, physical identity. Form is either decided by choice or it appears by chance as a design is created. Form is expressed in three-dimensional triangles, circles, ovals, horizontal and vertical rectangles and squares."

In floral design, the conventional, triangular form is the most popular form. It has definite linear structure which establishes visual stability and a feeling of formality.

Floral designers work with three triangular forms. (1) Equilateral triangle form with all three sides of equal length. (2) Isosceles triangle form with two sides of equal length. Traditionally, the two upright sides of the isosceles arrangement are of equal length and the horizontal base line a shorter length. (3) Right-angle triangle form with the vertical and horizontal lines forming a right angle. Technically, these two lines are the same length. In practice, most designers exaggerate the height line and shorten the horizontal base line.

The arrangements pictured illustrate two triangular forms. In the fresh flower design, the artist consciously confines materials within a structured isosceles triangular form. The silk flower design expresses a relaxed, equilateral triangular form.

Fresh flowers in a structured triangular form. It emphasizes the favored isosceles triangle with exaggerated height. This conscious, gentle extension of height adds elegance to the triangular form.

SMART!

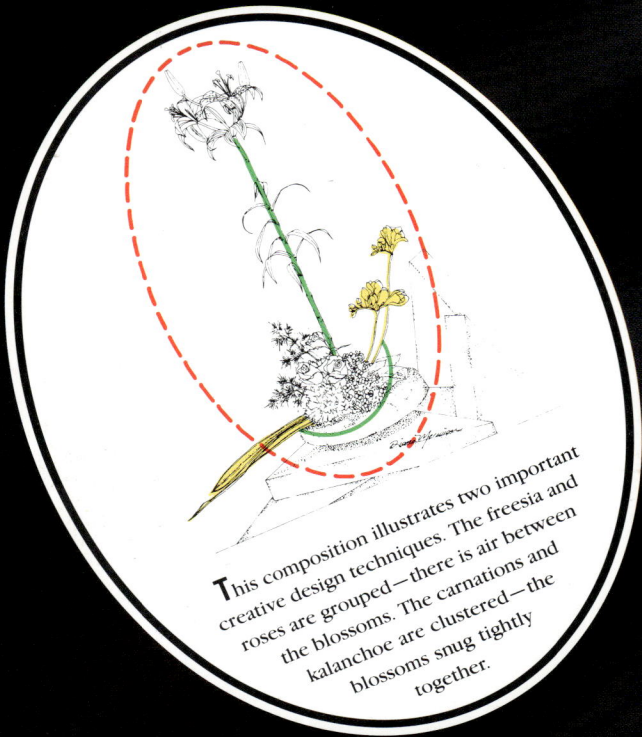

This composition illustrates two important creative design techniques. The freesia and roses are grouped—there is air between the blossoms. The carnations and kalanchoe are clustered—the blossoms snug tightly together.

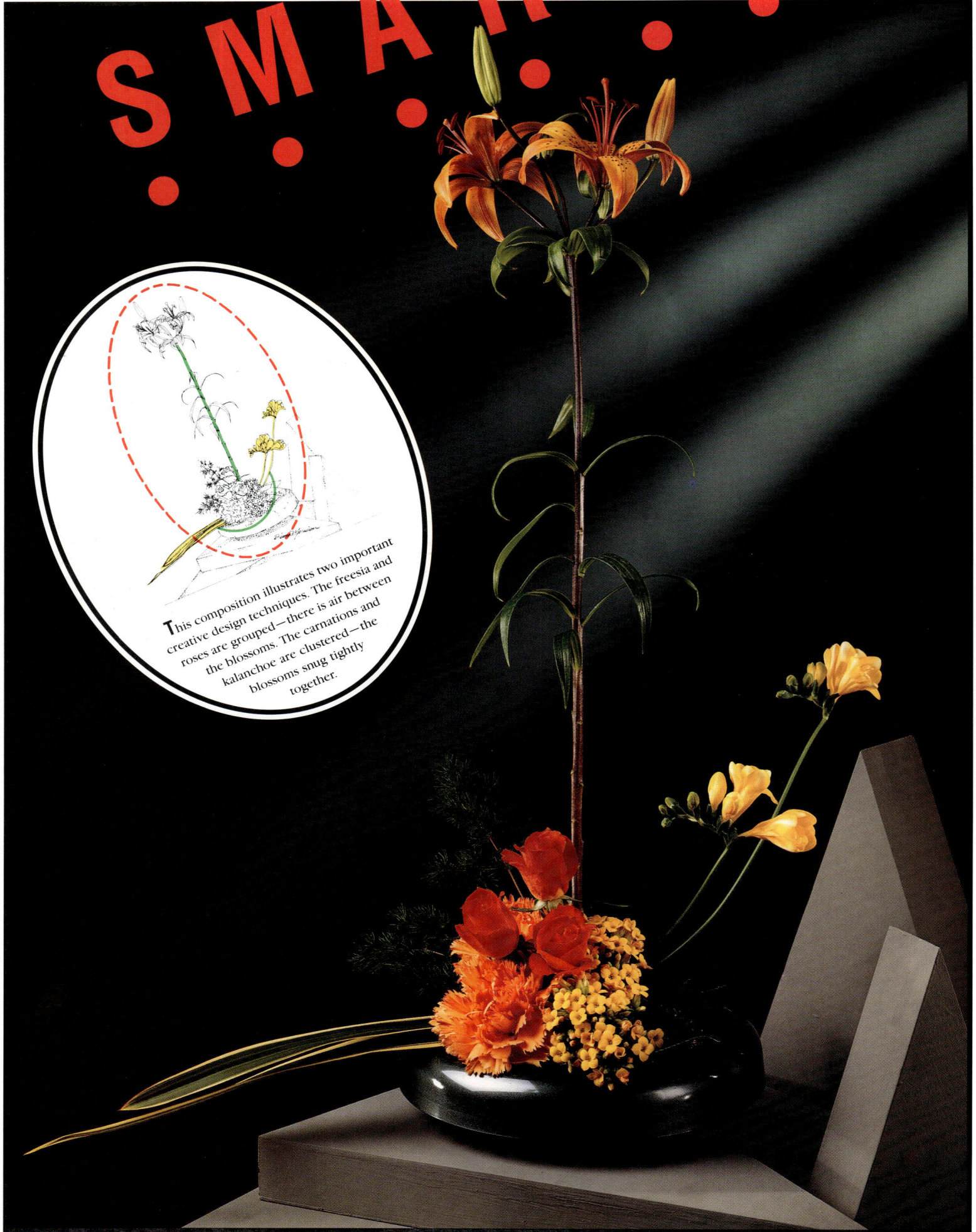

Professional floral artists incorporate many interesting circular and oval forms into their designs. Two interesting, contemporary methods provide exciting, creative possibilities for using these round forms.

The first method is "repeated line extension." Within a round or oval arrangement format, the artist introduces line extension. Some of these extended lines break out of the format.

The arrangement pictured to the left illustrates the repeated line extension method with bold, creative genius. The single stem of lilies extends far above the base visual emphasis area of the composition with exaggerated flair. Two stems of freesia extend to the right and two flax leaves extend to the left. The artist places all linear materials with striking overstatement. And, positions the flax to break out of the oval format of the composition.

Another interesting method for working with round forms in floral design is "form within form." The smart, stylish composition to the right pictures this pattern.

The entire composition falls within an oval format. The cluster of carnations at the top implies a circular form. At the bottom of the design, the artist circles the composition with camellia foliage and sweet William on natural stems.

> **" The Element Of Surprise.**
> **Impressive, distinctive floral design is based on the simple premise that the designer's job isn't to give the customer what he or she wants, but to create something unexpected—and in retrospect what the buyer really needed. "**

THE DESIGN PROCESS

FORM

Insert the carnations in the center to form the upper circular cluster. Tie together with ribbon—a banding technique. Circle the base with camellia leaves and sweet William—all on natural stems.

VIVID!

Verdi green pearlescent Lomey series 49 dish and Pete Garcia's Plus One Ribbons available from your local wholesaler. Red container to the right No. M1 from Midamco, 6630 N. Kostner, Lincolnwood, IL 60506.

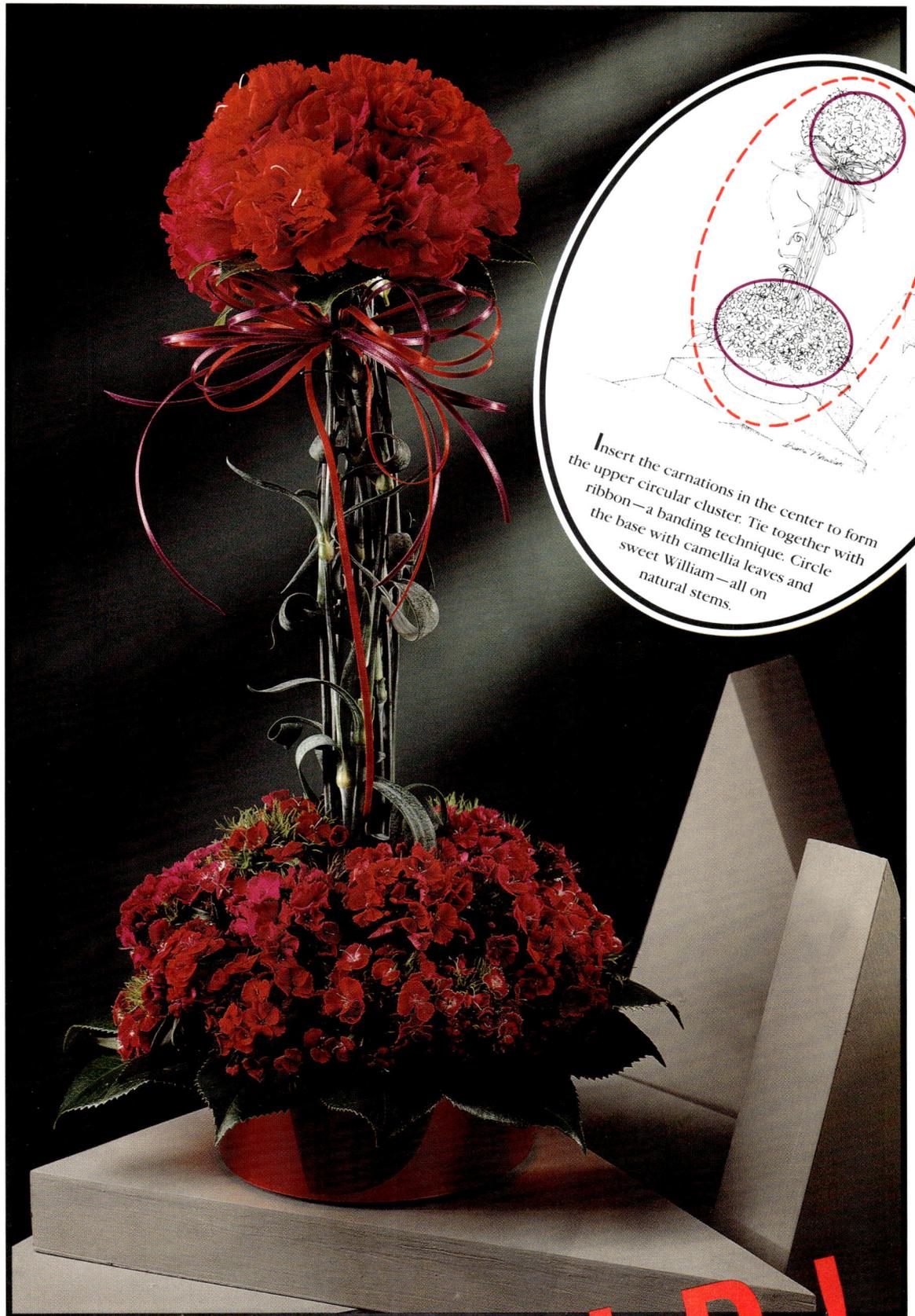

ELEGANT, EXPRESSIVE

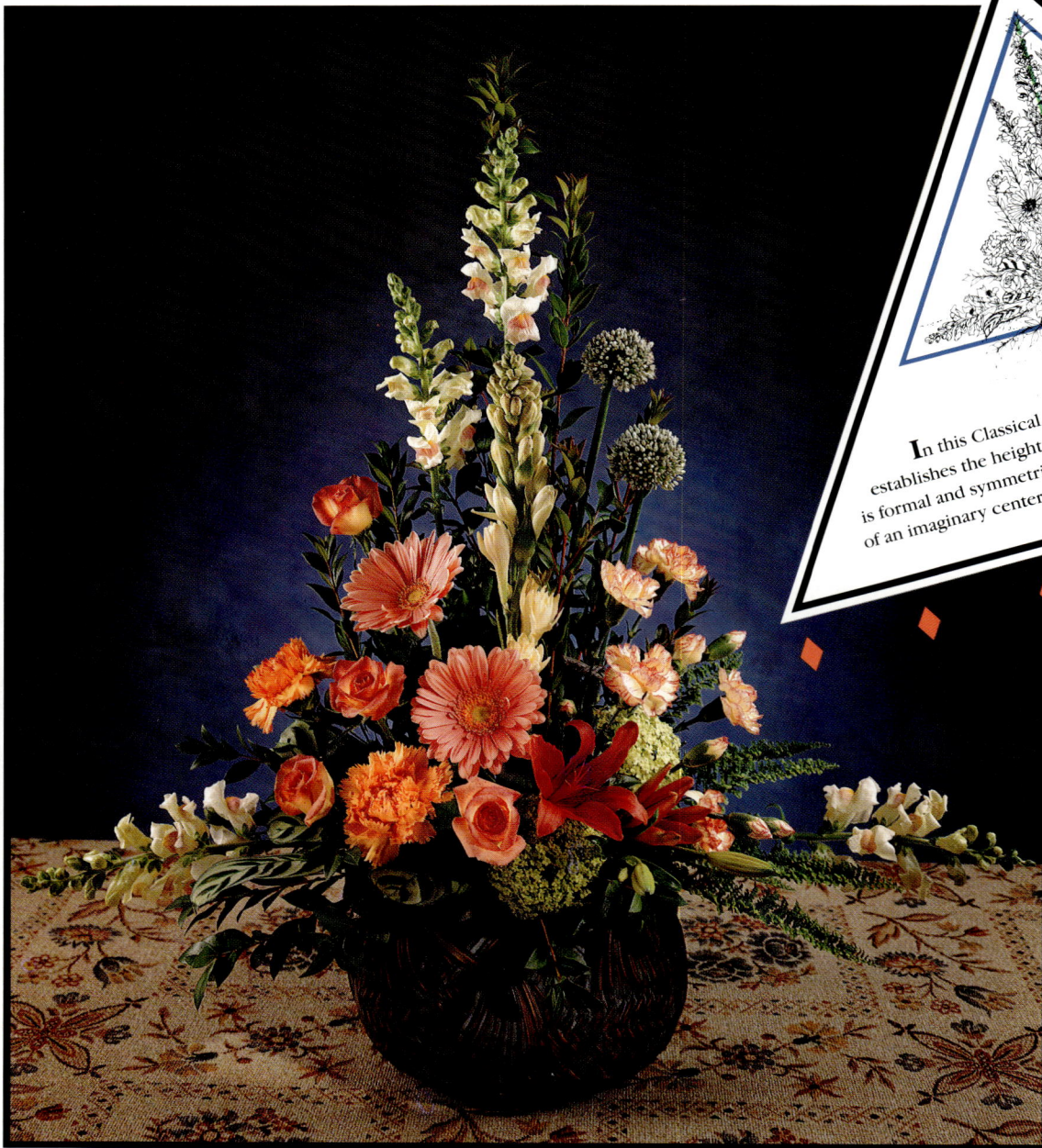

In this Classical equilateral triangular design, the artist establishes the height and width with snapdragons. The balance is formal and symmetrical. There is equal visual weight on either side of an imaginary center line bisecting the composition.

Basket No. JB-1038 from Vintage Basket Imports, P.O. Box 693, St. Helena, CA 94574. Oasis® floral foam available from your local wholesaler.

Professional floral design has a rich heritage in Classical forms. The term Classical dates back to the art and architecture of ancient Greece and Rome in the 5th and 4th Centuries B.C. The art definition of Classical states, "Art which aspires to a state of emotional and physical equilibrium, and is rationally rather than intuitively constructed."

All Classical forms are structured forms. They are associated more often with linear forms than curved forms. In floral design, the Classical Triangle, the Classical Horizontal, the Classical Vertical and the Classical Asymmetrical are the primary Classical forms.

Floral design is an expressive, interpretative art. In using Classical form in The Design Process, an artist has the

CLASSICAL DESIGN

A traditional floral composition that follows the esthetic principles of simplicity, restraint, balance, dignity and formality.

prerogative to express Classical form in any design that reflects simplicity, restraint, balance, dignity and formality.

In the composition pictured above, the artist expresses the present-day interpretation of the Classical Triangle form. The arrangement is structured with rational attention to form and balance.

&TIMELESS

In pure form, the Classical Horizontal features a strong central focal point. Lines extend on either side to achieve exacting symmetrical balance. From a practical point of view, a floral designer creates very few Classical Horizontal compositions. Today, most contemporary horizontal designs are used as table decorations. Like all other Classical forms, the horizontal is an expression of the artist's interpretation. As long as the finished composition meets the requirements of simplicity, restraint, balance, dignity and formality, it can be correctly called Classical.

The arrangement pictured below is a Classical Horizontal form many florists use today. The floral arrangement itself is an excellent example of a present-day Classical Horizontal form. The introduction of candles moves the form from horizontal to Classical Triangle.

For an authentic Classical composition, a designer would use only formal flowers—lilies, roses, carnations, gladioli standard chrysanthemums and other traditional blossoms with distinct, formal forms. In practice, however, a designer uses a wide range of blossoms and emphasizes the Classical arrangement form.

Basket No. JB-1051 from Vintage Basket Imports, P.O. Box 693, St. Helena, CA 94574. Candles from Creative Candles, P.O. Box 19514, Kansas City, MO 64141. McGinley Mills moire ribbon No. 242 available from your local wholesaler.

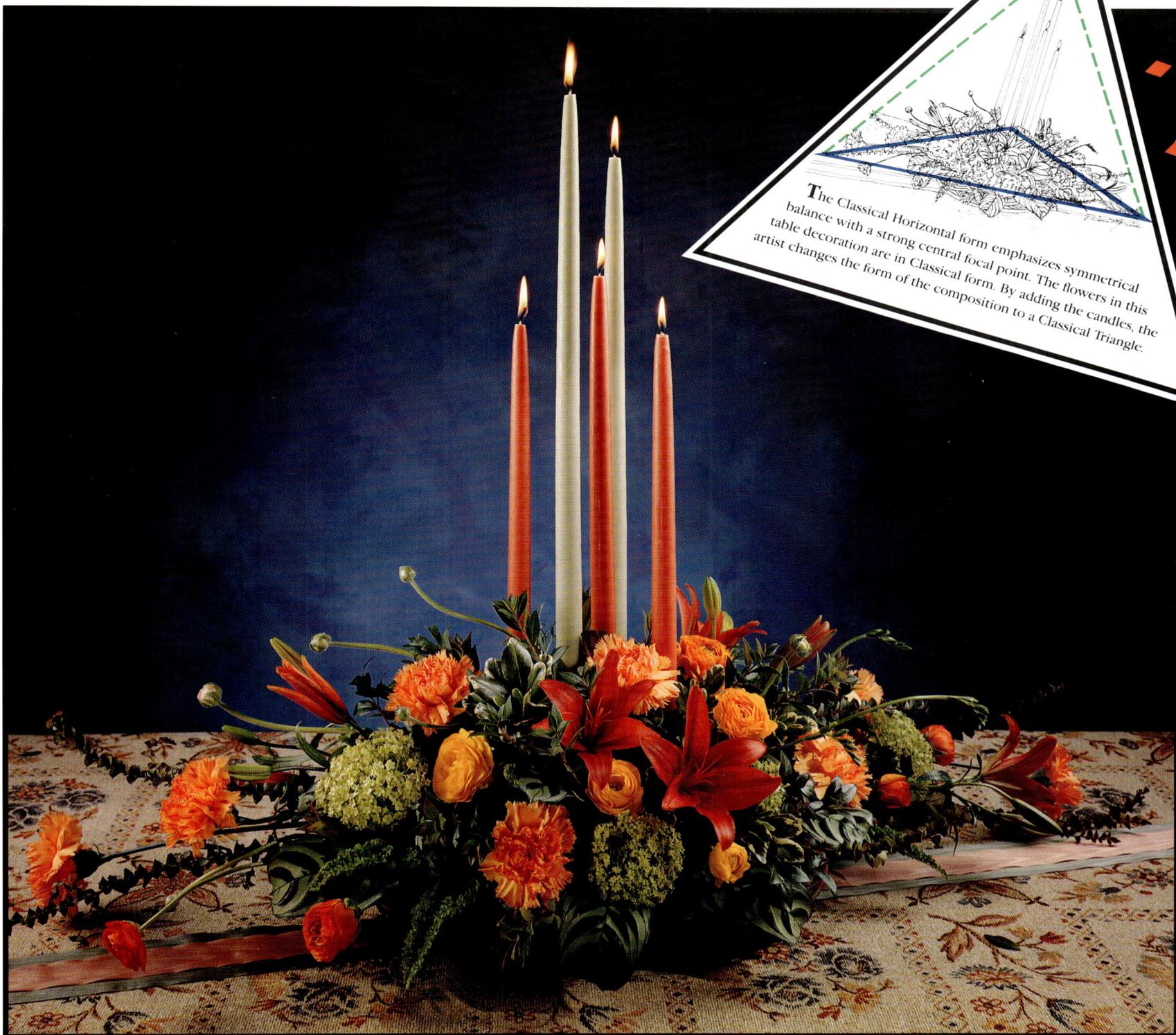

THE DESIGN PROCESS
FORM

The Classical Horizontal form emphasizes symmetrical balance with a strong central focal point. The flowers in this table decoration are in Classical form. By adding the candles, the artist changes the form of the composition to a Classical Triangle.

Popular in the 1950's and 1960's, the highly structured Classical Asymmetrical is an outdated form. The Western Line, with a graceful, high-right to low-left curving and flowing line, became popular in the 1970's as an adaptation of the Classical Asymmetrical. Today, designers use many different styles to express asymmetrical form.

In the composition below, the two gerbera assertively announce the primary statement of asymmetrical form. Three dracaena leaves reinforce asymmetrical line movement. Green viburnum blossoms and myrtle foliage carry this line through the composition.

The design pictured to the right is a dramatic and impressive portrayal of a modified new convention style. The form of this design is highly structured with two vertical groupings of foliages. The artist uses foliages with interesting and contrasting textures to create these perpendicular groupings.

Gerbera, strong in form and color, create the horizontal line movement. These blossoms do not connect for a line pattern. Yet, the artist achieves definite horizontal line movement through implied line.

Within the forms of these compositions, the artist illustrates many important techniques. The two white gerbera are isolated in a zone and demand strong visual emphasis. The artist uses the basing technique in the placement of carnations, pompons, viburnum, reindeer moss and galax leaves. This base treatment is an arrangement form from which the gerbera and dracaena leaves emerge. The grouping of foliages in the modified new convention design illustrate parallelism. The designer uses the clustering technique in placing the two central gerbera and the viburnum.

The white container No. P389 from Franklin China's Finesse Collection, the Franklin China's terra cotta Eurotray No. M7019 and Knud Nielsen's reindeer moss are available from your local wholesaler.

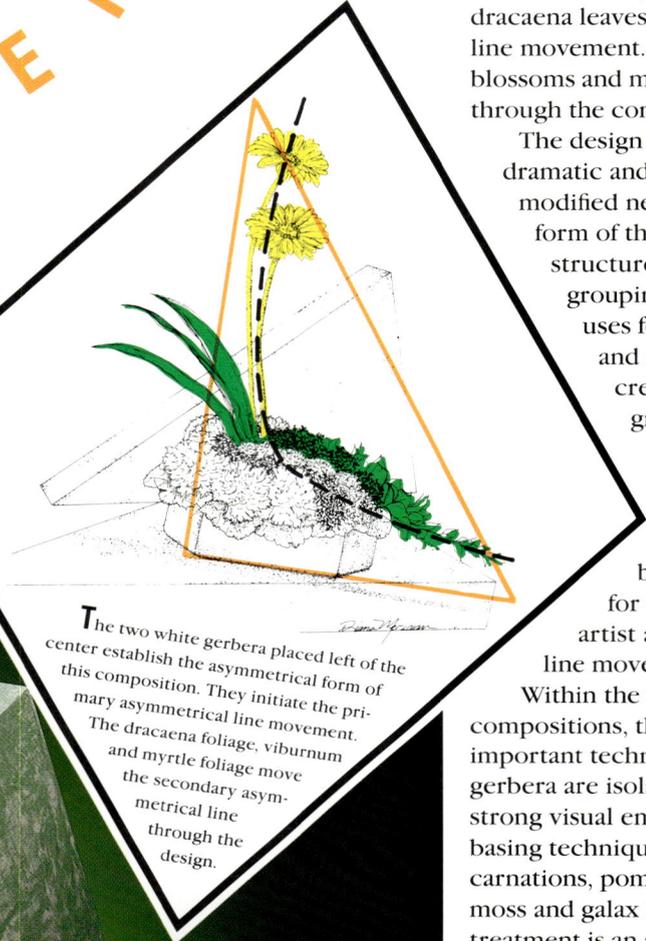

The two white gerbera placed left of the center establish the asymmetrical form of this composition. They initiate the primary asymmetrical line movement. The dracaena foliage, viburnum and myrtle foliage move the secondary asymmetrical line through the design.

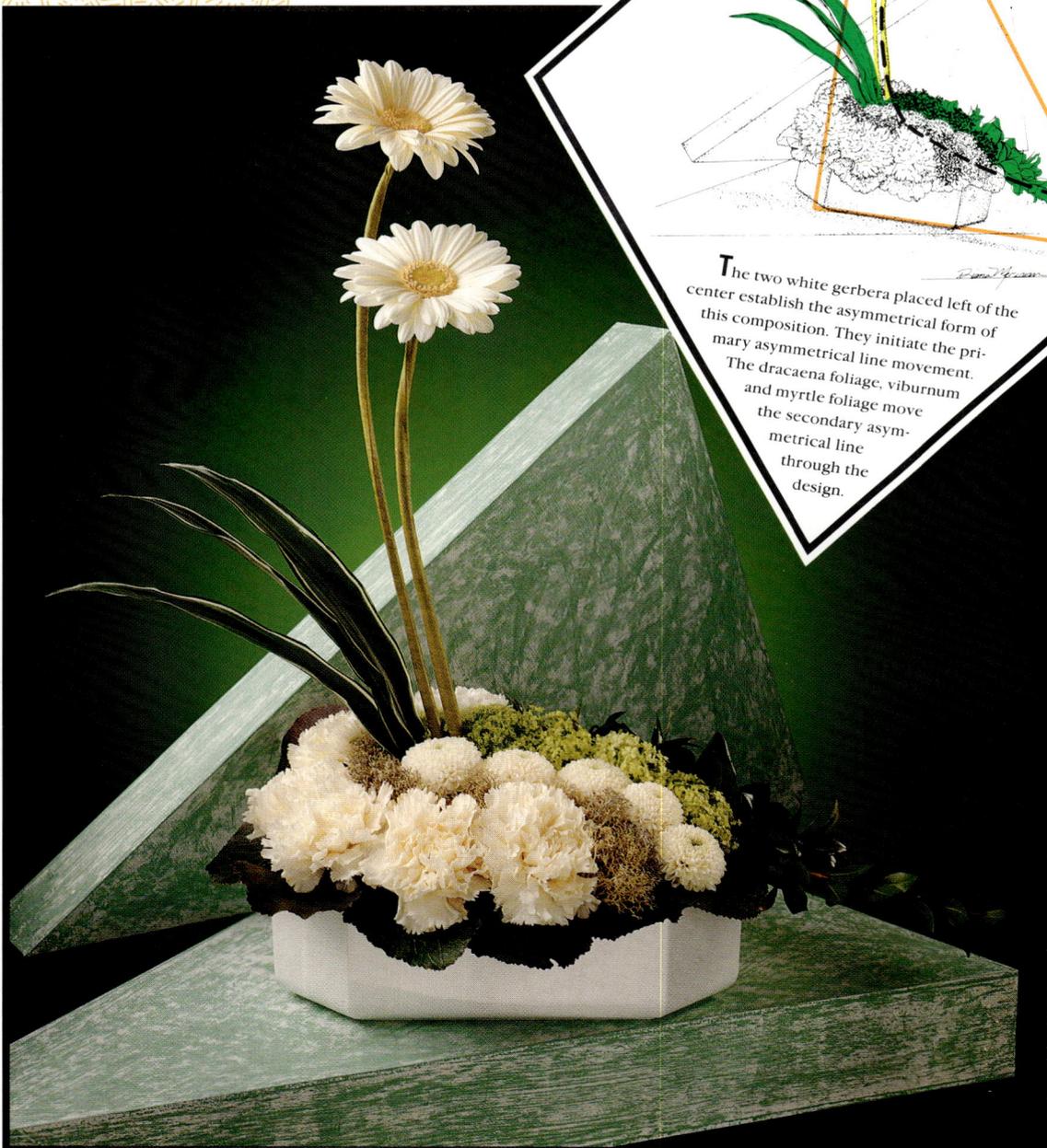

THE DESIGN PROCESS
FORM

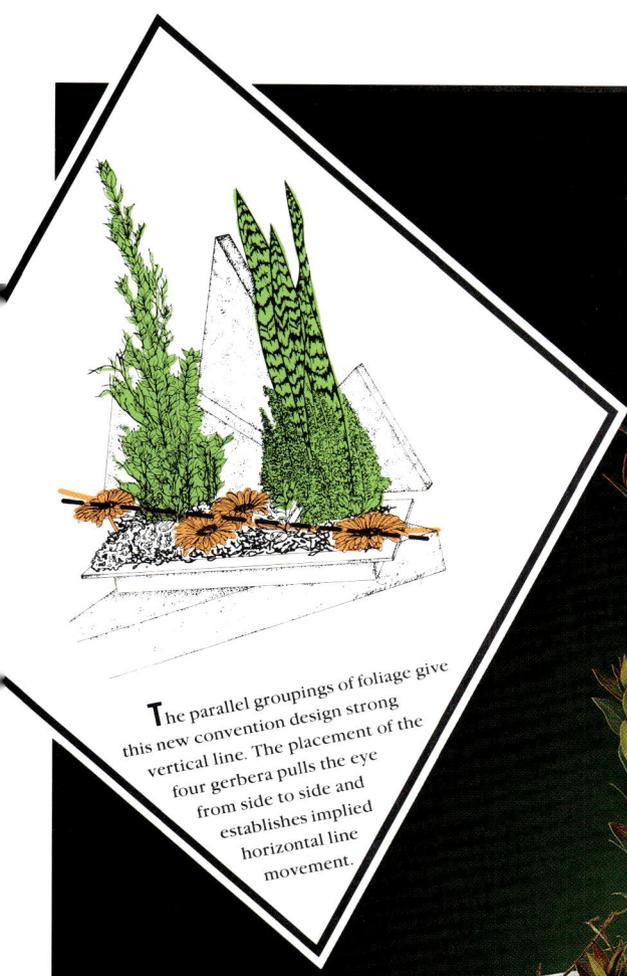

The parallel groupings of foliage give this new convention design strong vertical line. The placement of the four gerbera pulls the eye from side to side and establishes implied horizontal line movement.

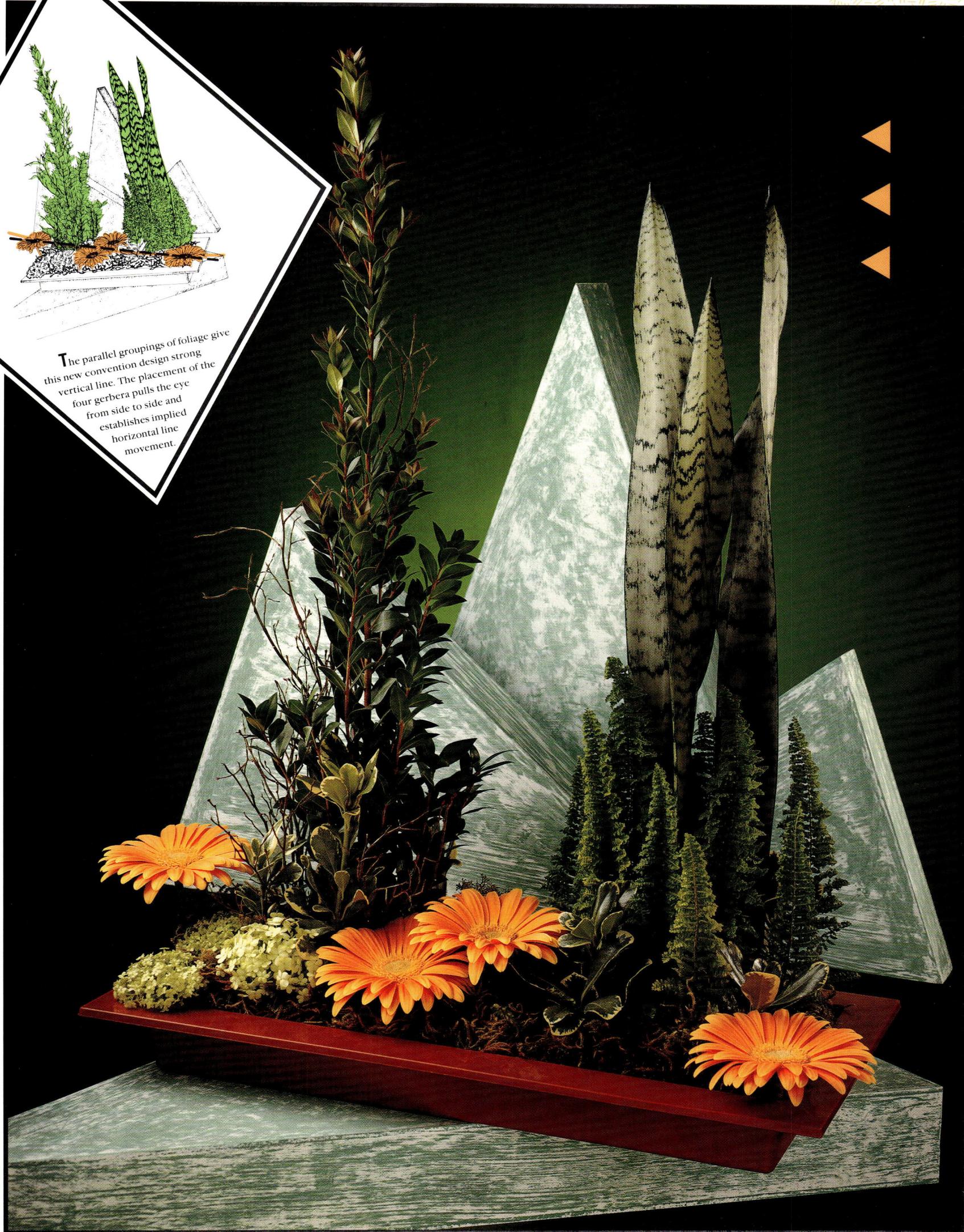

Casual. What is it? Is it a form of design or a style of design? It's both. Casual is an unstructured look. There are two creative approaches to casual. First, a casual presentation of flowers within a structured form. Casual becomes a style. Second, an unexpected, perhaps even unplanned presentation of blossoms. Casual becomes a form.

In the composition pictured below, the artist presents a random array of blossoms and colors within a structured triangular form. The style would be appropriately labeled "casual." The form of the design is planned. In contrast, the presentation of the flowers is carefree and effortless.

In contrast to structured form, the artist presents a grouping of ranunculus in a casual form in the composition pictured to the right. The blossoms appear to be laid casually in the vase. Even the wonderful ring of raffia bowed at the corner of the vase adds a casual emphasis.

The designer crisscrossed narrow arrangement tape on the top of the containers to form a mesh to hold the blossoms. For the triangular composition, the artist placed arrangement tape in both the width and length dimensions of the container to form a mesh-like web. For the ranunculus composition, the designer placed arrangement tape only in the width dimension to hold the stems in a diagonal position.

Casual arrangements in glass containers are time consuming, even frustrating to design. They require extra attention in securing stems in tight position and adequate packing for satisfactory delivery. This often merits an increased labor charge since this style of casual design requires additional creative time.

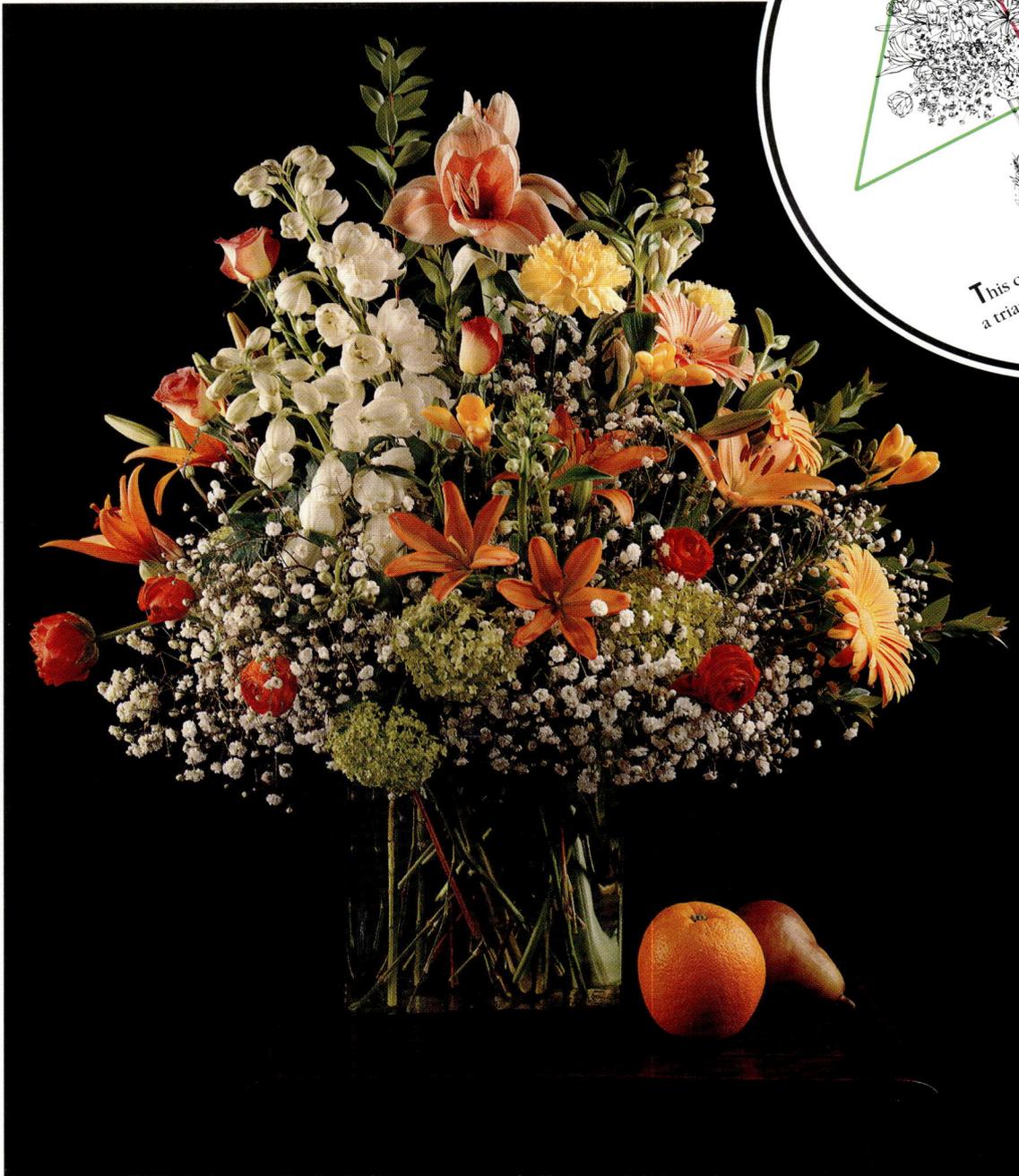

This casual composition falls within the frame of a triangular form—a formal composition form. Yet, the artist presents a diverse selection of blossoms in an unplanned, casual style.

"Floral design that communicates impressively to the recipient, creates pleasant surprises that draw visual attention to the unique characteristics of the flower composition. Expressive design must venture beyond the ordinary and the expected to create the element of pleasant surprise."

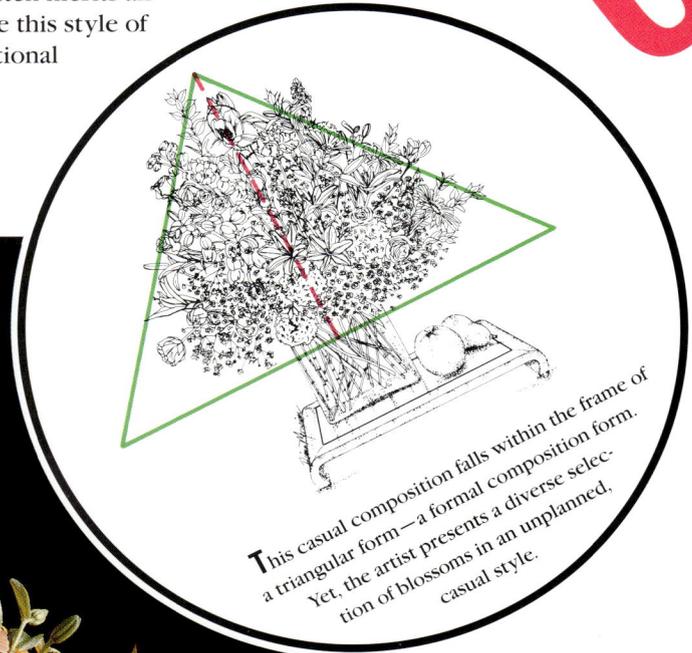

THE DESIGN PROCESS

FORM

E. O. Brody square block glass vase No. 4025 available from your local wholesaler.

SUAL.

GET A TASTE OF IT!

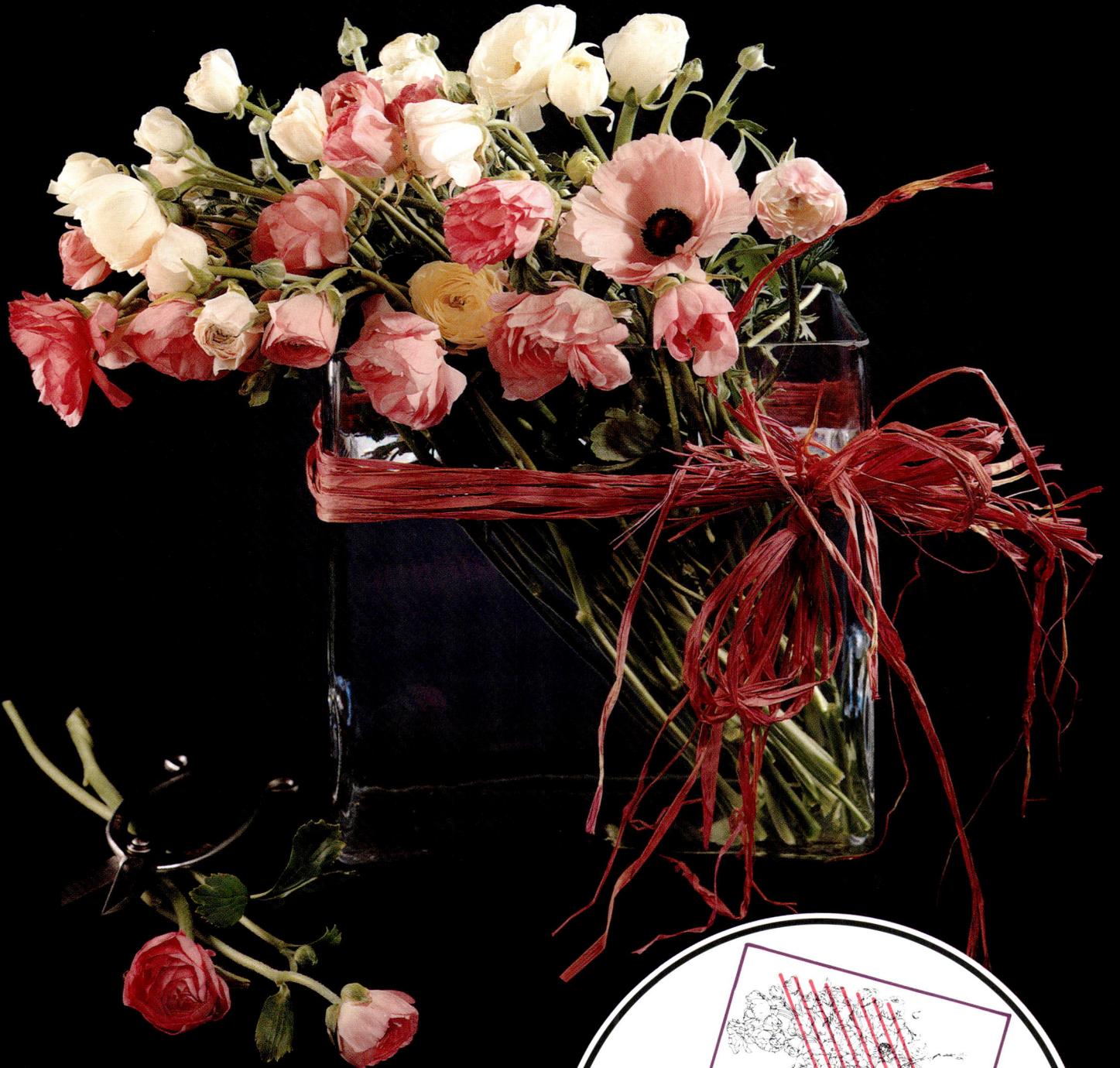

E. O. Brody square block vase No. 4020 and Knud Nielsen colored raffia available from your local wholesaler.

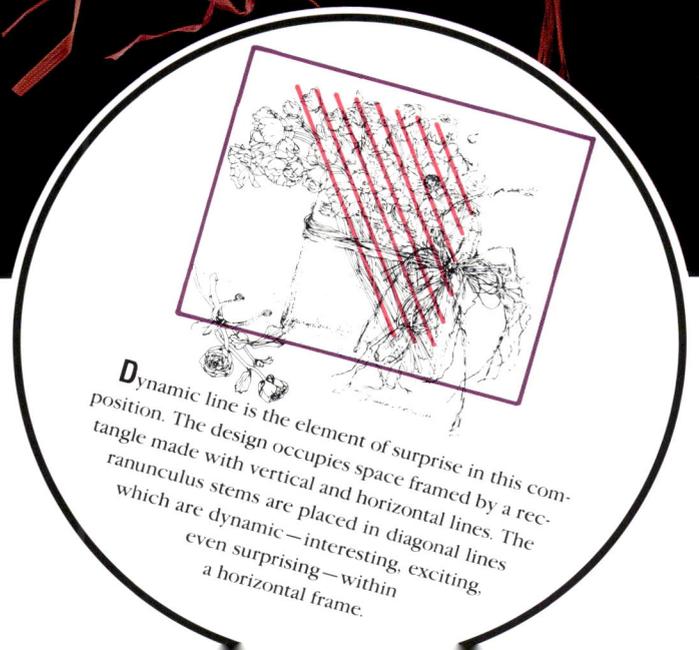

Dynamic line is the element of surprise in this composition. The design occupies space framed by a rectangle made with vertical and horizontal lines. The ranunculus stems are placed in diagonal lines which are dynamic—interesting, exciting, even surprising—within a horizontal frame.

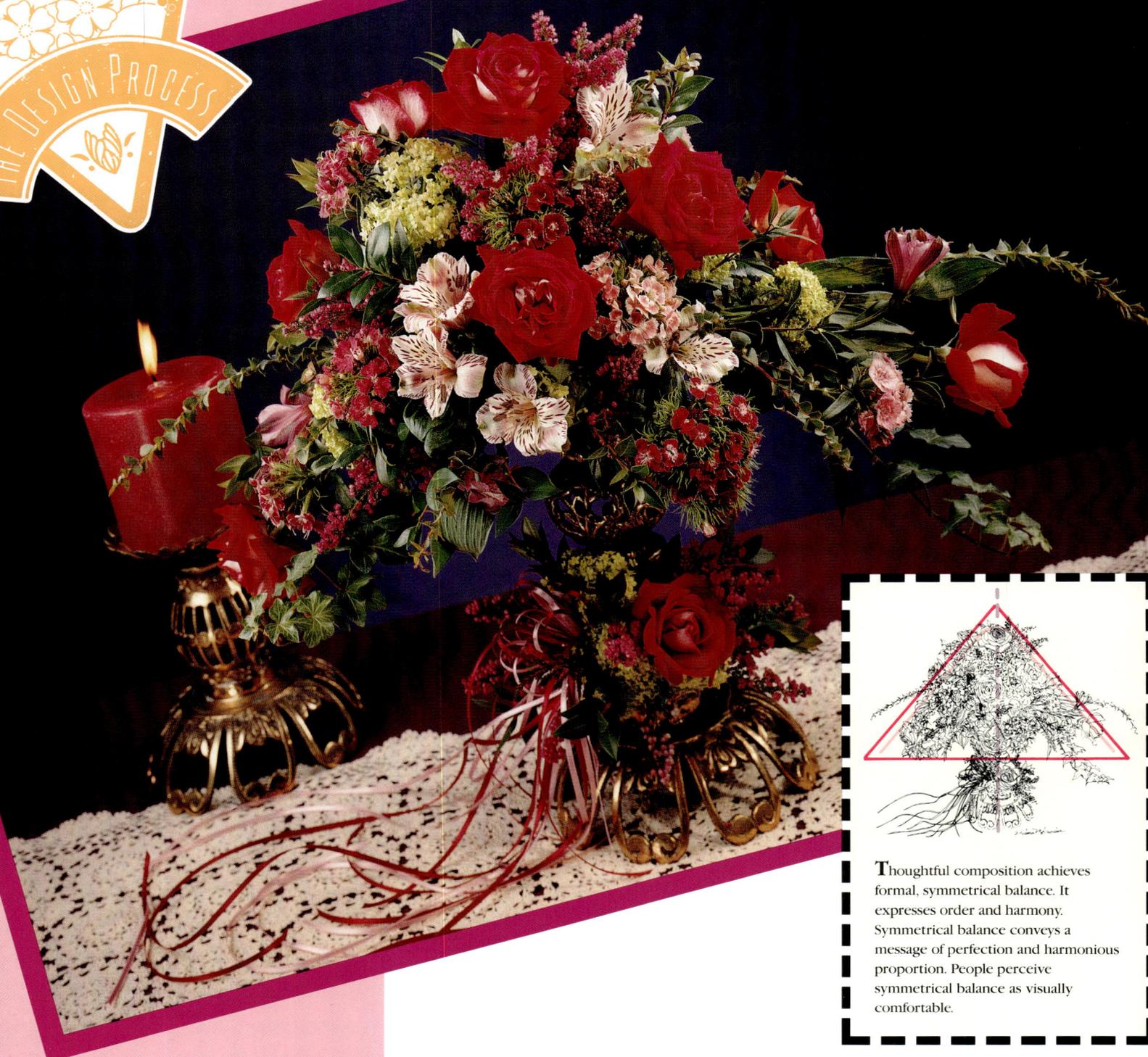

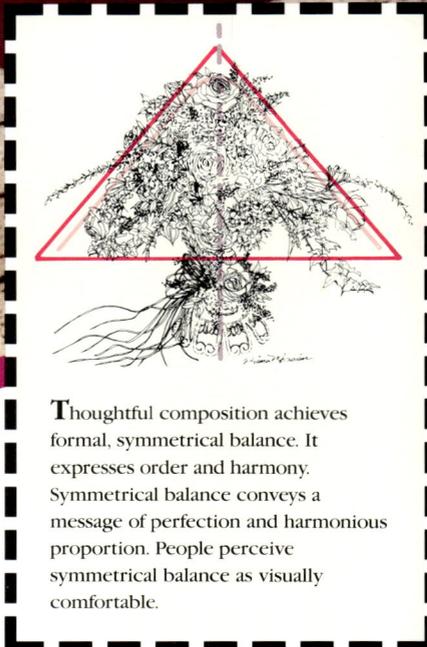

Thoughtful composition achieves formal, symmetrical balance. It expresses order and harmony. Symmetrical balance conveys a message of perfection and harmonious proportion. People perceive symmetrical balance as visually comfortable.

The Appealing Symmetry Of The *Contemporary*

BALANCE IS VISUAL AND PHYSICAL STABILITY. FLORAL DESIGNERS USE THREE TYPES OF BALANCE. SYMMETRICAL BALANCE—FORMAL BALANCE WITH EQUAL VISUAL WEIGHT ON EITHER SIDE OF A CENTRAL VERTICAL AXIS. ASYMMETRICAL BALANCE—INFORMAL BALANCE WITH UNEQUAL BALANCE ON EITHER SIDE OF A CENTRAL VERTICAL AXIS. OPEN BALANCE—A RELAXED, CASUAL AND SPONTANEOUS BALANCE.

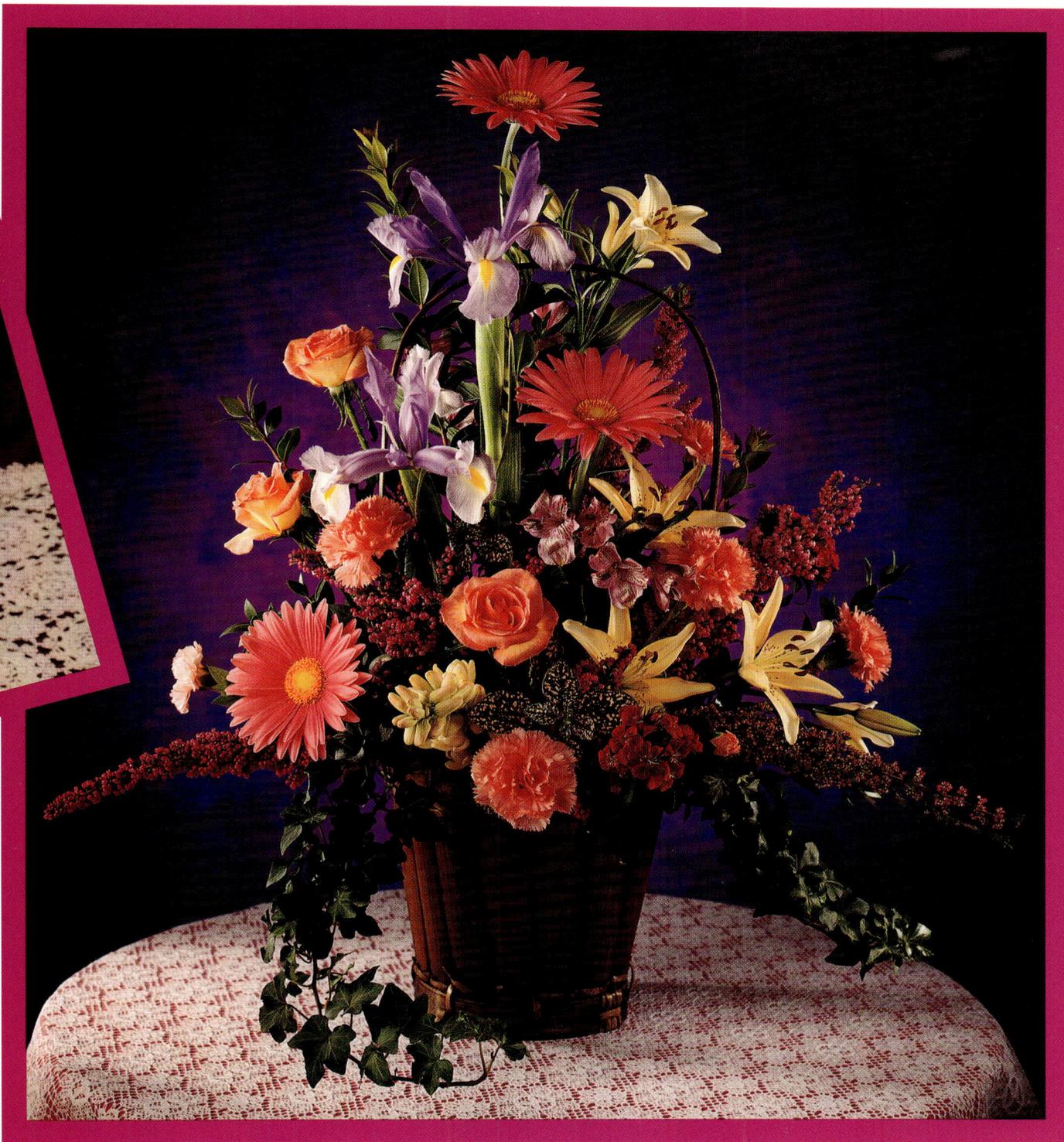

Symmetrical balance is balance through order and likeness. It is appropriate whenever traditional design is preferred.

Most designers think symmetry and create symmetrical designs subconsciously. For the conventional designer, experiencing different styles and balances requires conscious discipline.

The beauty of a symmetrical design is not in form and balance. Instead, the composition features interesting contrasts in forms, textures and colors of materials.

Both of the designs pictured illustrate

symmetrical balance. The formal Victorian Classical Horizontal is an elegant example of symmetrical balance. The rich colors and the exquisite contrasts in the forms and textures of the materials create a striking, regal composition.

The basket design is informal yet structurally composed with symmetrical balance. The placement of materials is irregular and spontaneous. Yet, there is equal visual weight on either side of a central, vertical axis.

Both designs exemplify symmetrical

balance. Each has a distinctly different appearance achieved through the selection of the flowers, foliages and the presentation of these materials.

Oriental brass candlesticks and Pete Garcia's Plus One double faced 1/8" satin available from your local wholesaler. Bluegate plum pillar candle from San Francisco Candle Co., 1825 S. Grant St., Suite 640, San Mateo, CA 94402. Satin bamboo basket No. R407 from Davidson-Uphoff, P.O. Box 184, Clarendon Hills, IL 60514.

The Design Process: Balance

Perfect

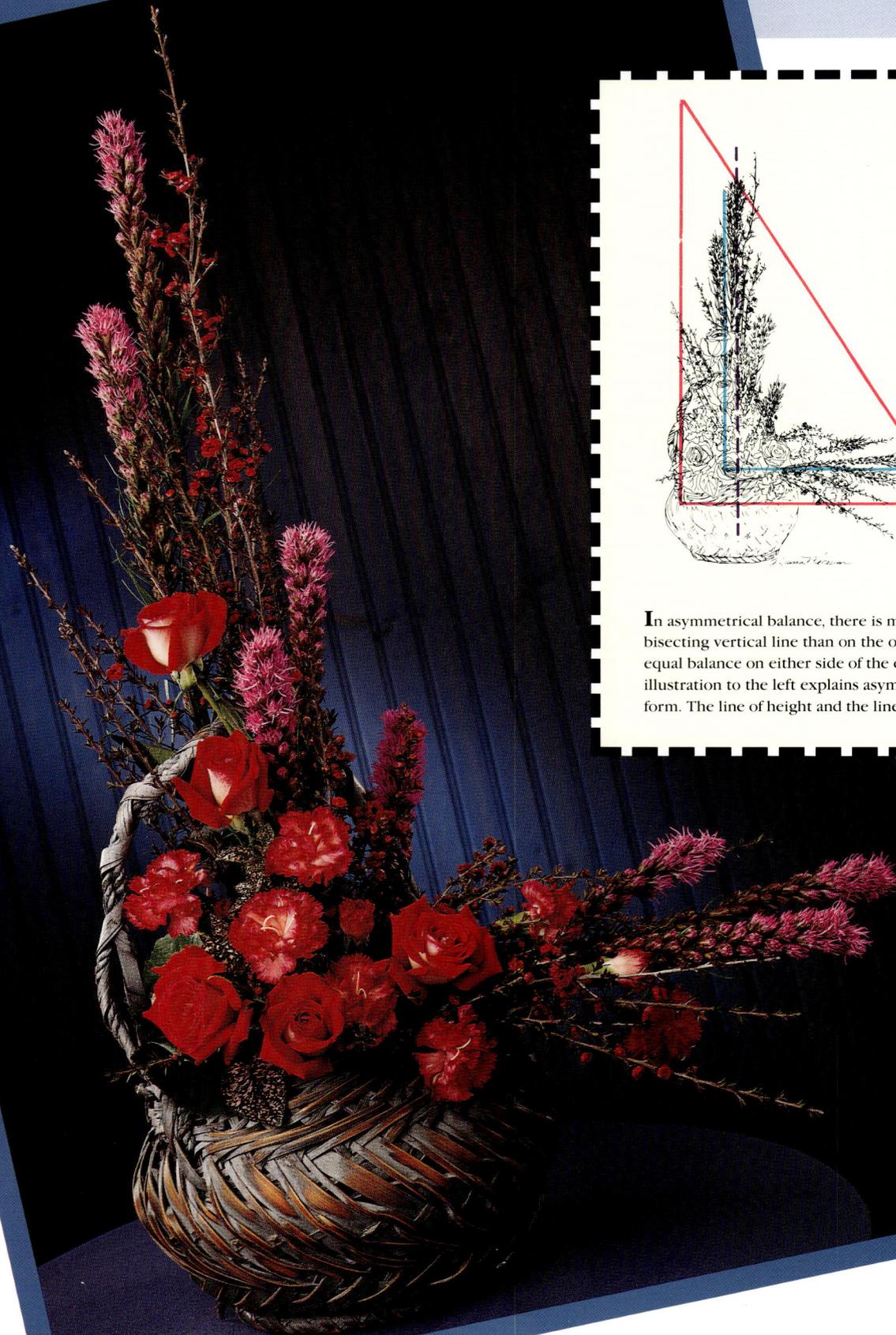

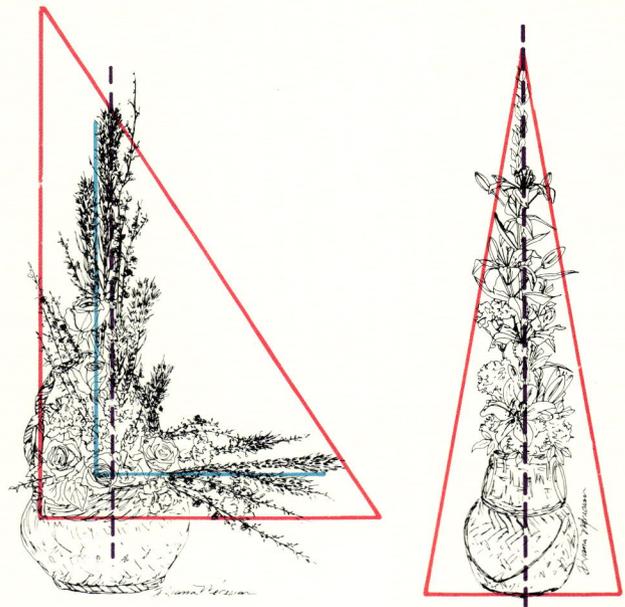

In asymmetrical balance, there is more visual weight on one side of the bisecting vertical line than on the other. In symmetrical balance, there is equal balance on either side of the center, vertical bisecting line. The illustration to the left explains asymmetrical balance and asymmetrical form. The line of height and the line of width join, forming a right angle.

Basket No. JB1049 from Vintage Basket Imports, P.O. Box 693, St. Helena, CA 94574.

tall
ion Is A Order

The glorious asymmetrical basket design featuring liatris, roses and miniature carnations is a superb example of a contemporary Classical Asymmetrical. The basket is unexpected and marvelous. It adds the element of creative surprise that distinguishes the composition. This design meets all the requirements of Classical design. It is simple, restrained, balanced, dignified, formal—and beautiful!

In creating this composition, the artist impeccably incorporates the fundamentals of asymmetrical form. There is more visual weight on the right side of the center liatris line, bisecting the design vertically, than on the left. The height line and the width line join at the central focal point in a strong right angle. There is depth—front to back movement of materials through the focal area. The line of motion emphasizes the height and flows comfortably from high left to low right.

The design techniques used in this composition are worthy of special attention. Liatris state the primary asymmetrical line movement. This dominant height and width line is reinforced with leptospermum. Then three roses again strengthen the asymmetrical line in a high left to low right movement. Every flower in this composition is placed with precision to fortify the asymmetrical form.

"Symmetry is balance through likeness. Asymmetry is balance through contrast."

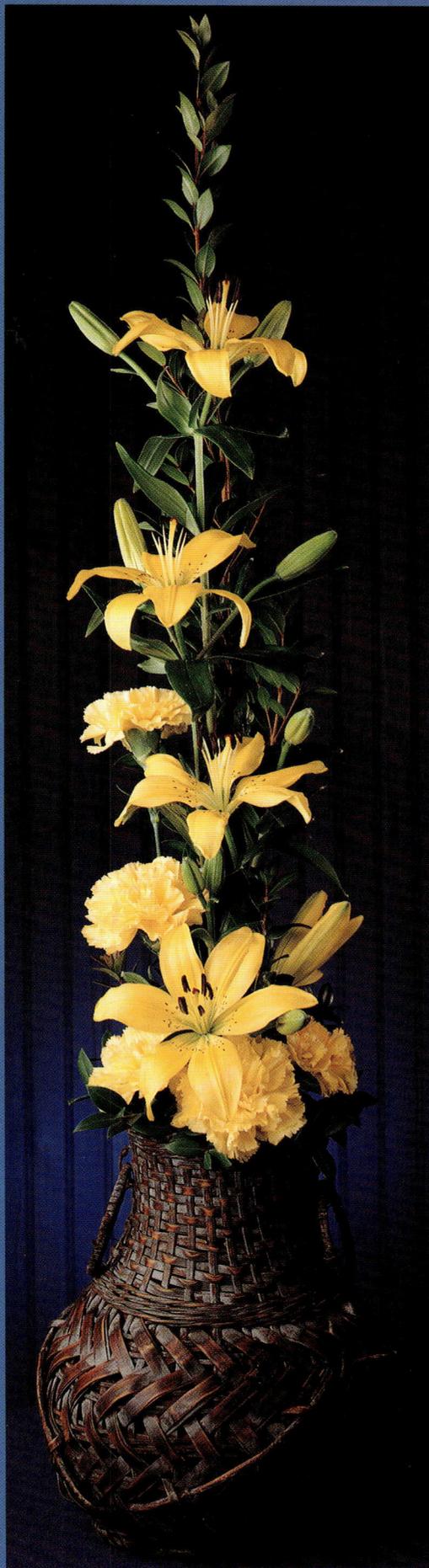

There's a very special, extraordinary countenance in a Classical Vertical composition. Technically, the materials in a pure form Classical Vertical should not extend over the rim of the container. Nevertheless, this monochromatic yellow, majestic vertical is Classical in every sense of the word. It is elegantly simple. The artist uses artistic restraint in materials. The composition is beautifully balanced. It is dignified. And it is formal. This composition illustrates symmetrical balance. The extended vertical stem of myrtle bisects the composition. There is equal visual weight on either side of this bisecting line. And, the contrasts in the textures of the flowers, greens and basket add important visual interest.

The choice of basket for this design is a stroke of creative genius. It relaxes the stereotyped formality with a spark of surprise—the element that makes a composition stand out, be noticed and remembered.

BALANCE
THE DESIGN PROCESS

Basket No. JB1038 (set of 2) from Vintage Basket Imports, P.O. Box 693., St. Helena, CA 94574.

The *Hidden* Assets Of The

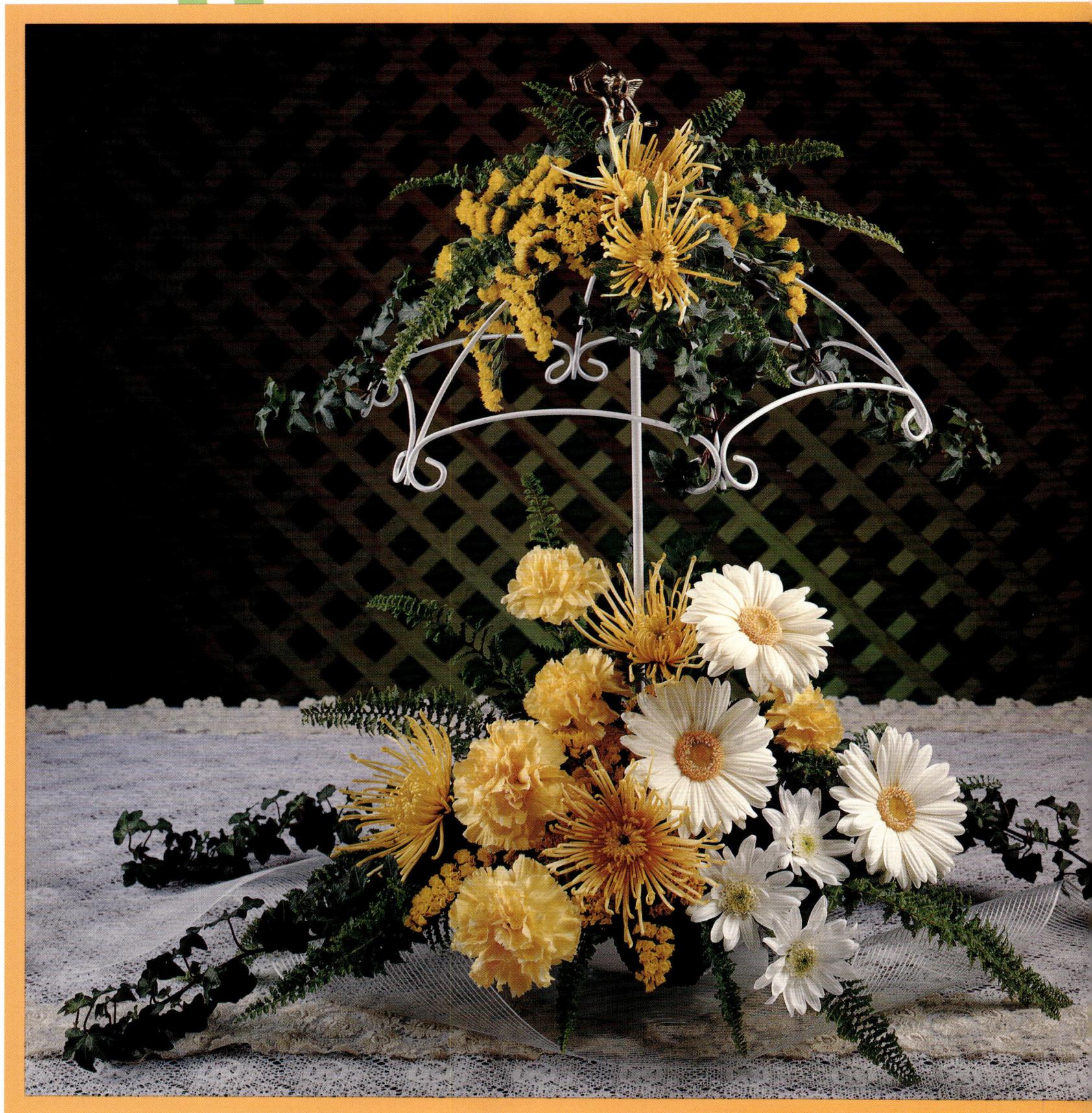

White parasol container No. 21000-23 and black nine-light astaire No. 59 from Davidson-Uphoff, Inc., P.O. Box 184, Clarendon Hills, IL 60559. Knud Nielsen sea grape leaves and Phoenix palm; and Lomey caged floral foam available from your local wholesaler. Votive candles from Creative Candles.

Imagination

BALANCE
THE DESIGN PROCESS

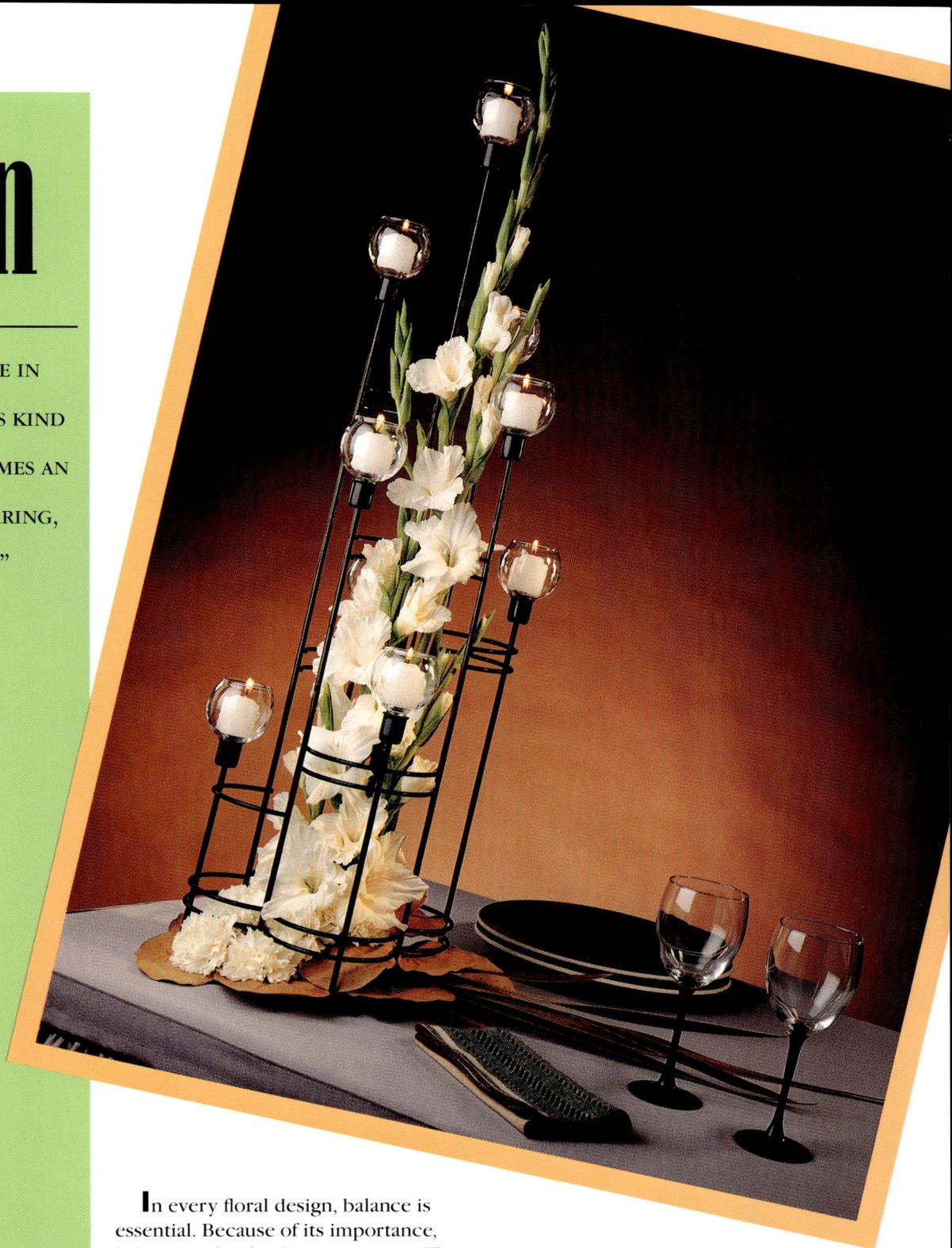

In every floral design, balance is essential. Because of its importance, balance is the third component in The Design Process. First is the idea. Then, the form in which the designer chooses to express the idea. Third is balance.

Balance affects how viewers perceive a floral composition. Lack of balance irritates viewers. Imbalance keeps them from appreciating the beauty and the intended message of the flowers. When a floral composition is visually and physically unbalanced, the eye becomes confused. It shifts from element to element wanting to move things to bring the design into comfortable balance.

The placement of materials in a floral composition accomplishes both physical and visual balance. A designer uses three different placement techniques. (1) Radiation—all materials flow into and out of a central focal area. (2) Parallelism—materials flow in vertical lines or vertical groupings. (3) Random—irregular placement of materials without concern for radiation or parallelism.

The white and yellow parasol table decoration is an attractive, symmetrical design. The center pole of the parasol container bisects the design with equal visual weight on either side. All of the materials radiate out of a central focal area. The designer groups flowers and colors for maximum visual impact.

The striking white, black, tan and grey table decoration features asymmetrical balance with major physical and visual weight on the left. Fresh flowers declare vertical line with outspoken exclamation. Dried Phoenix palm and sea grape leaves state the horizontal line with quiet, reserved dignity. This extreme contrast in materials and placement gives the composition a smart presence of contemporary styling.

A (SUBTLE) Standing Ovation

In floral design, no amount of learning replaces how you see things. The different ways you see materials in finished compositions determine how you express your creative talents in floral design. You can attend endless design schools, read all the books and have your head filled with all the important knowledge, however, until you put your learning into practice and express your individual creativity, what you learn has little growth value.

Achieving pleasing, comfortable balance in your designs is partly mechanical—how you place the materials based on accepted techniques. Even more important, however, is your eye—how you see things. Visual balance is in the eyes—both yours and the viewer's.

This luxurious silk flower arrangement illustrates open balance. Open balance is a relaxed, casual and spontaneous balance. Some artists call it informal balance. Technically, we classify balance as structured balance and unstructured balance. Symmetrical and asymmetrical balance are structured balance. Open balance is unstructured balance. The important understanding about open balance is that the designer is not limited to creating within a structured balance. A design with open balance is neither precisely symmetrical or asymmetrical—but it is balanced. It has a comfortable and pleasing visual feeling.

In open balance all stems flow into and out of one central axis. This central point of line movement can be anywhere in the composition—whatever looks comfortable and pleasing. Sometimes, this axis becomes a visually strong focal area. Other times, it is no more than the point from which all stems emerge.

Regardless of the size of the composition or the amount of materials available for the design, open balance gives the artist freedom to express. Perhaps the finished design might look "almost like" a symmetrically or an asymmetrically balanced composition. Nevertheless, the artist's creativity is not inhibited by structure. He has articulated his or her creative freedom to see things differently.

BALANCE
THE DESIGN PROCESS

Basket No. JB1051 from Vintage Basket Imports. Creative Marketing Concepts' (CMC) silk stock No. RF-50746, lily No. ZF-02582, statice No. AF-45806, mini carnation No. RF-50717 and birch spray No. MF-69689; Iris No. K900 from K&D Export Co. and Sahara ® foam available from local wholesalers.

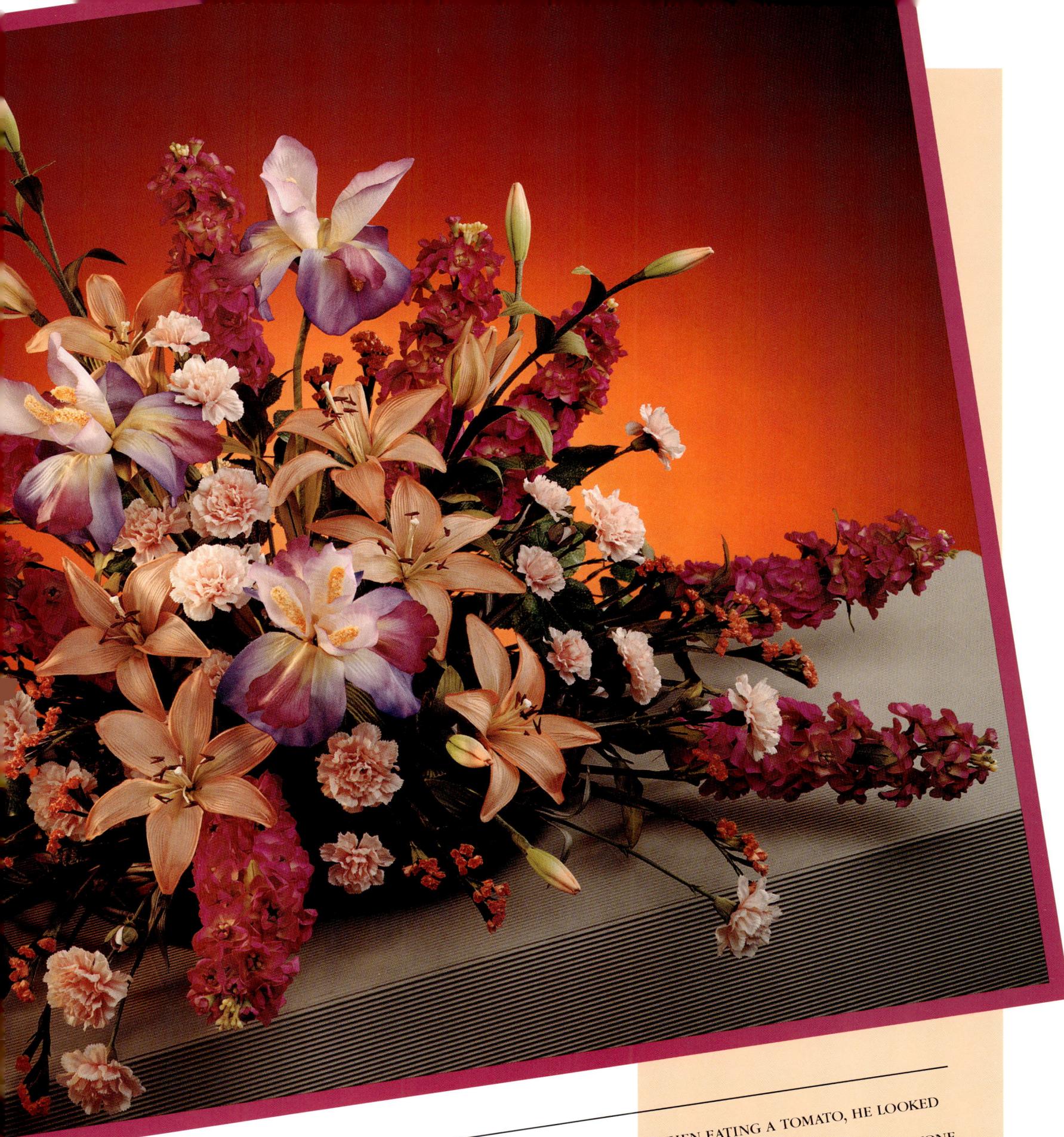

GERTRUDE STEIN ASKED THE FRENCH ARTIST HENRI MATISSE WHETHER, WHEN EATING A TOMATO, HE LOOKED AT IT THE WAY AN ARTIST WOULD. MATISSE REPLIED: "NO, WHEN I EAT A TOMATO I LOOK AT IT THE WAY ANYONE ELSE WOULD. BUT WHEN I PAINT A TOMATO, THEN I SEE IT DIFFERENTLY."

Hands-on Experience

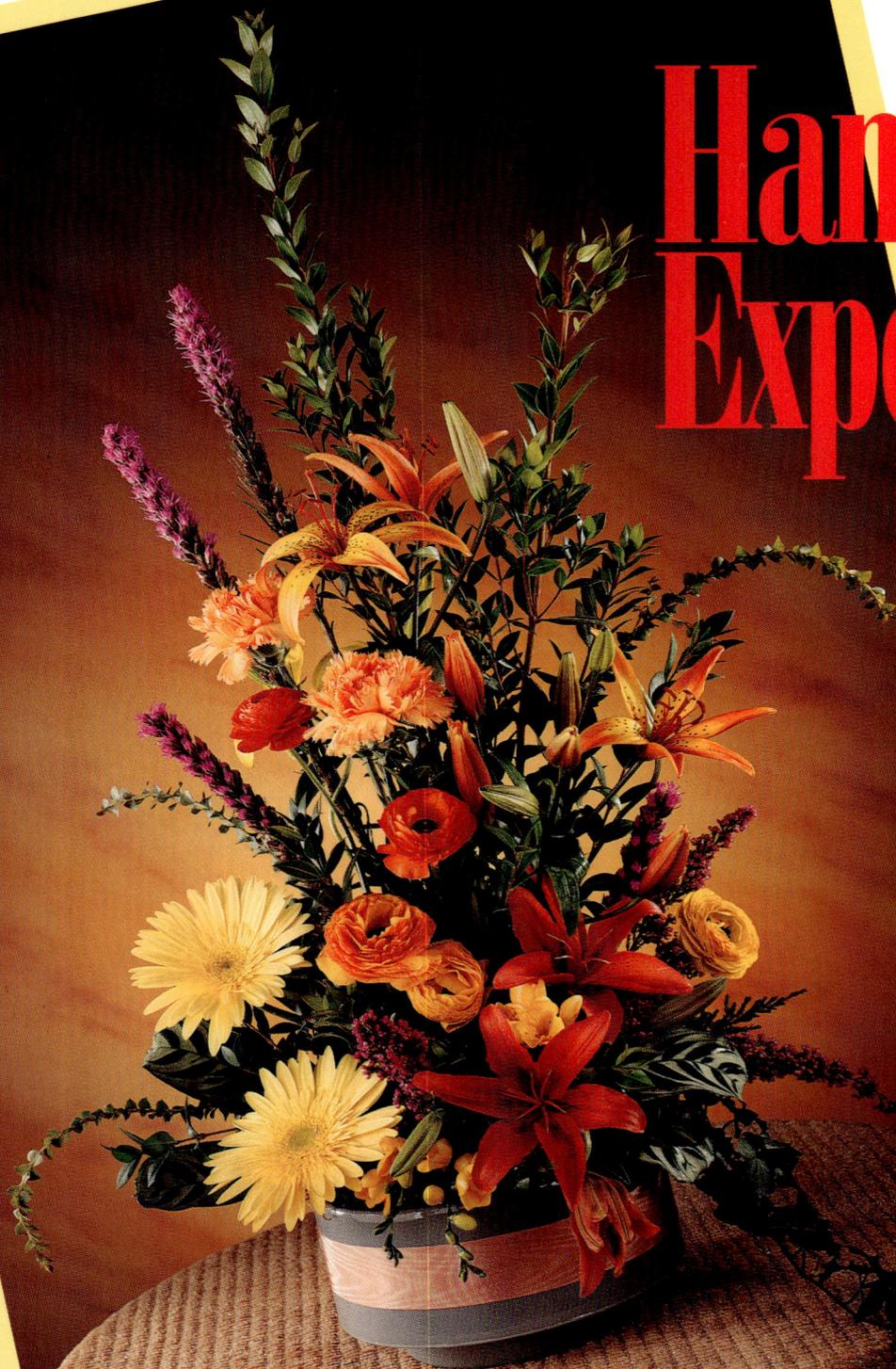

Prima compote No. PR5 from Excelsior Plastics Industries, Inc., 808 High Dr., Excelsior Springs, MI 64024. McGinley Mills moire ribbon No. 242 available from your local wholesaler.

"A FLORAL DESIGNER USES MATERIALS, COLORS AND LINES AND ORGANIZES THEM INTO A BALANCE, A HARMONY AND A RHYTHM STRONGLY INFLUENCED WITH FEELINGS. WITH HANDS-ON EXPERIENCE, HE RECOGNIZES THAT HIS WORK IS AN EXPRESSION OF HIS BELIEFS AND ATTITUDES AS WELL AS HIS ABILITIES."

BALANCE

THE DESIGN PROCESS

All floral art must have function. In the commercial world, a design must have customer appeal, quality, beauty and desirable, lasting characteristics. It must also produce a responsible profit for the flower shop. Otherwise, there is no future for either the flower shop or the designer.

The compositions pictured are practical expressions exemplifying traditional balance. Professional, quality conscious floral designers create and sell these design styles every day. They please customers.

The design on the opposite page is smartly symmetrical. The composition has high visual appeal. It is an example of quality floral design.

The three designs below are down-to-earth salable. In the upper left, the floral artist shows a symmetrically balanced composition with vertical emphasis. The design to the right is a traditional triangular form with symmetrical balance. And, the horizontal design incorporates asymmetrical balance. There is more visual weight on the right side of the handle than on the left.

Balance is explicit in every composition. Whether the design includes only a single blossom or an unlimited quantity of flowers, how the designer places these materials in the composition determines the balance. A qualified artist is balance conscious. He knows that for any design to be visually pleasing and comfortable, it must be balanced.

Set of three baskets No. JB1033 from Vintage Basket Imports, P.O. Box 693, St. Helena, CA 94574.

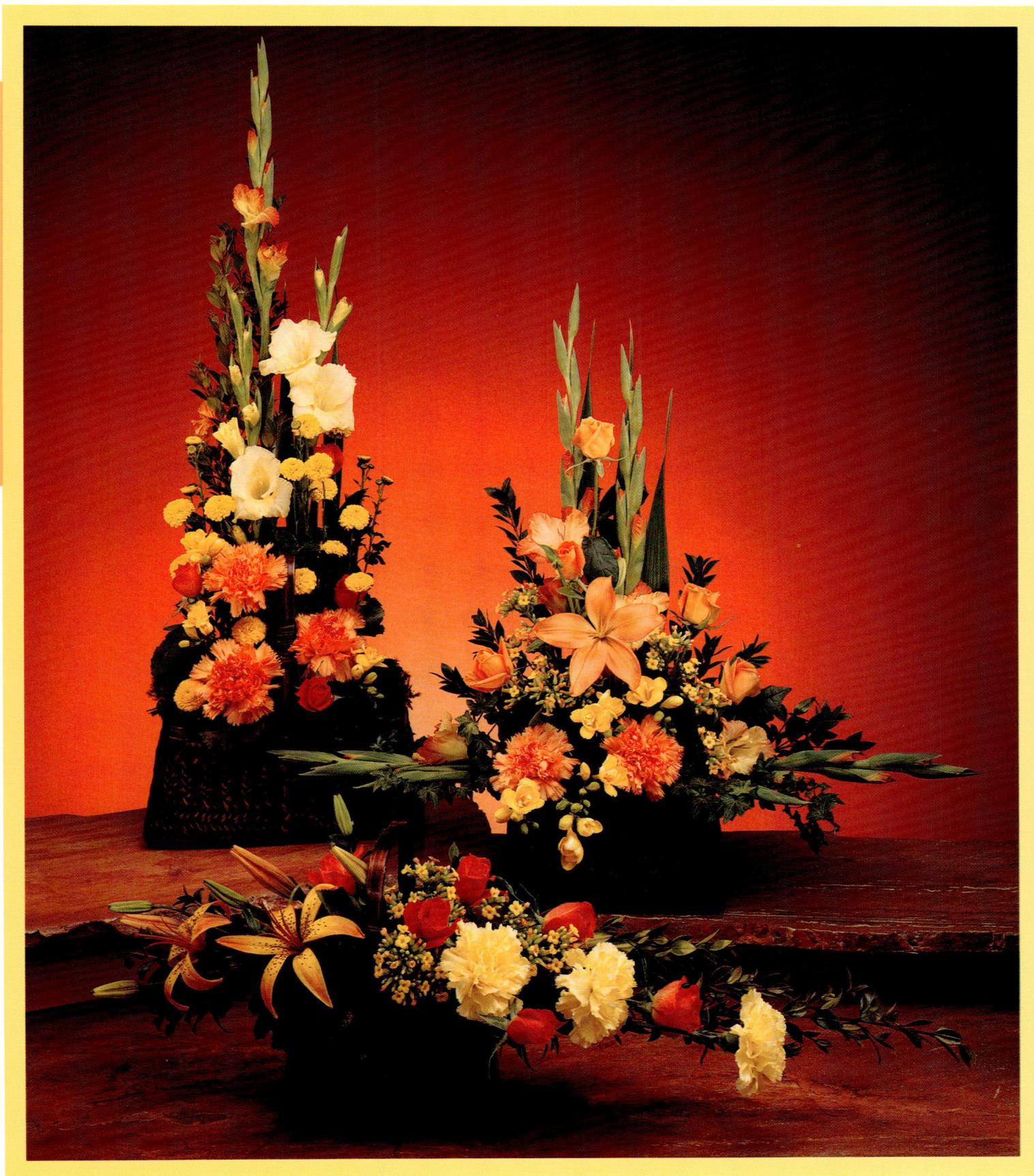

SOME DESIGNS
START TRENDS
OTHERS
CREATE LEGENDS

David Lauer, College of Alameda, Alameda, CA states: "Unity implies that a congruity or agreement exists among the elements in a design; they look as if they belong together, as though some visual connection beyond mere chance has caused them to come together."

In The Design Process, unity is achieved when everything in a composition—flowers, foliages, container and accessories—joins in a pleasing visual relationship. Unity conveys a oneness of purpose, thought, creative spirit and style.

The two compositions pictured are exquisite examples of design unity. Within each design, the materials connect to one another in a concordant relationship.

In the distinctive, innovative silk and dried materials design pictured to the left, the artist first inserts silverwood branches into the floral foam and entwines them into a circular form. Some branches move freely from side to side in the

Container No. 5202 from Chimes, Inc. Accents Collection. Columbine No. K358 and alstroemeria No. K136 from K&D Export Import Co. Queen Anne's lace No. 2036 from Dark's Silk Flowers. Knud Nielsen dried materials available from your local wholesaler.

composition. Then, he creates an impressive design with silk flowers, dried materials and fruits. The line of silk alstroemeria moves from high-center to low-left in graceful, flowing movement.

The repetition of round forms—the vase, the peaches and the circular formation of silverwood twigs—achieve a unity of form. There is contrast of size scale between the small peach, the larger vase and the still larger circle of twigs. This progression in form accents the circular emphasis of the composition. The texture of the vase and the silverwood is another form of repetition.

The composition featuring dried larkspur, stirlingia, Australian daisy, lavender, and Watercolors™ rye is another superlative study in unity. In creating this magnificent design, the artist uses the grouping technique. All materials are in distinct groups. Even the color pattern on the vase reinforces the grouping style of the composition. The stirlingia and Australian daisies move through the center focal area in a distinct, diagonal line pattern. The isosceles triangular form of this composition suggests elegance and formality. Everything in the design—container, materials and design form join for beautiful, striking composition unity.

Vase No. 12016 from Chimes, Inc. Mirage Collection. Knud Nielsen dried materials available from your local wholesaler.

NOTHING NEUTRAL ABO

White is simple. Elegant. And, white is pure sophistication. White is high fashion. And, white is elegantly right—always.

Many floral artists express unity through color. The two sympathy compositions pictured suggest the quiet and dignified unity that white gracefully expresses.

Often the terms unity and harmony are interchanged. In The Design Process, unity is one of the seven composition essentials.

Harmony is a design technique that relates to the proper relationship between the various elements in a composition. Where there is visual closeness or blend of materials, colors, textures, lines or forms, there is harmony.

When the materials in a composition are not harmonious, they appear separate and unrelated. In some designs, the artist achieves unity in the total composition. Nevertheless, within the composition there is a conscious dissonance of materials.

In the wreath of white flowers, there is dissonance, not harmony between the forest wreath and the exquisite lilies. The white statice is a bridge between the rough texture of the wreath and the smooth texture of the lilies. In creating this design, the artist plays on repetition by repeating the upper lily cluster in the lower area of the wreath. When the artist planned this composition,

he decided to use the techniques of dissonance, bridging and repetition. They did not happen by chance or accident.

After adding moss to the forest wreath, the designer glued and wired saturated Lomey BHO bouquet holders—with half the handle cut off — to the wreath to hold the flowers and greens.

Color unifies the distinguished basket of white flowers. This composition combines the techniques of framing and grouping. The designer presents miniature allium, gerbera, snapdragons and delphinium each in a distinct group. The allium on the right and the delphinium and myrtle foliage on the left, frame the composition. The inward movement of these materials pulls the eye into the composition.

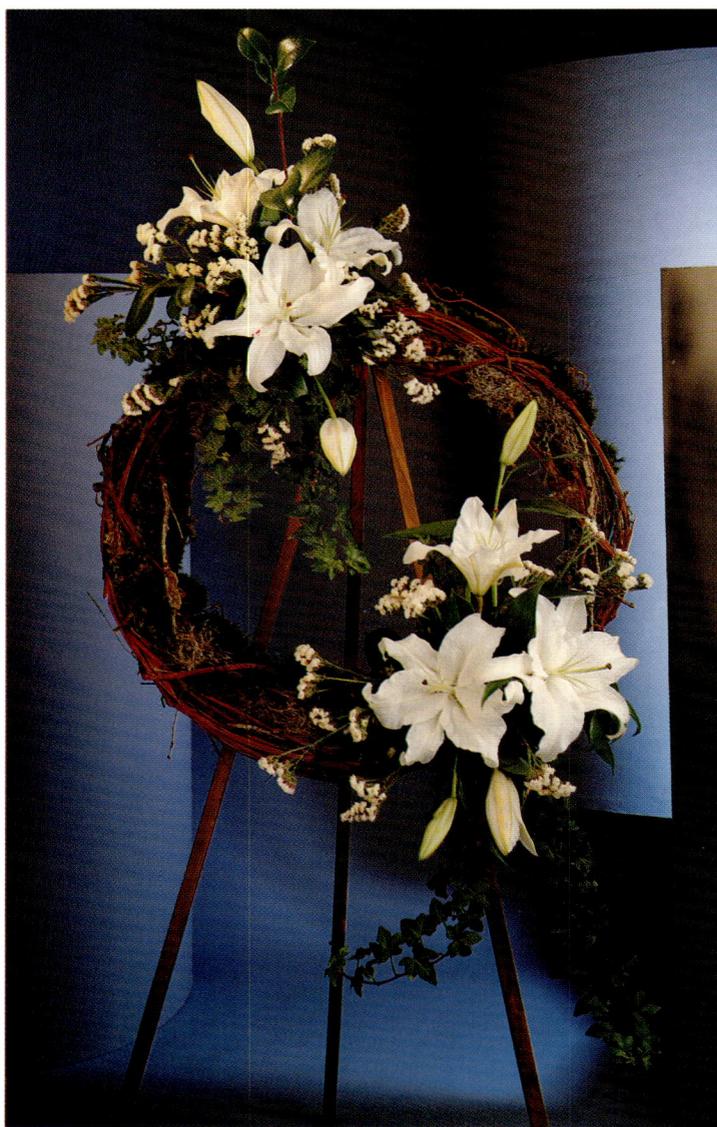

Knud Nielsen forest wreath, Design Master Color Tool to spray easel and Lomey BHO bouquet holders available from your local wholesaler.

UT WHITE

Giftwares Basket No. 010090 distributed by Pete Garcia, Knud Nielsen paper ribbon and mood moss available from your local wholesaler.

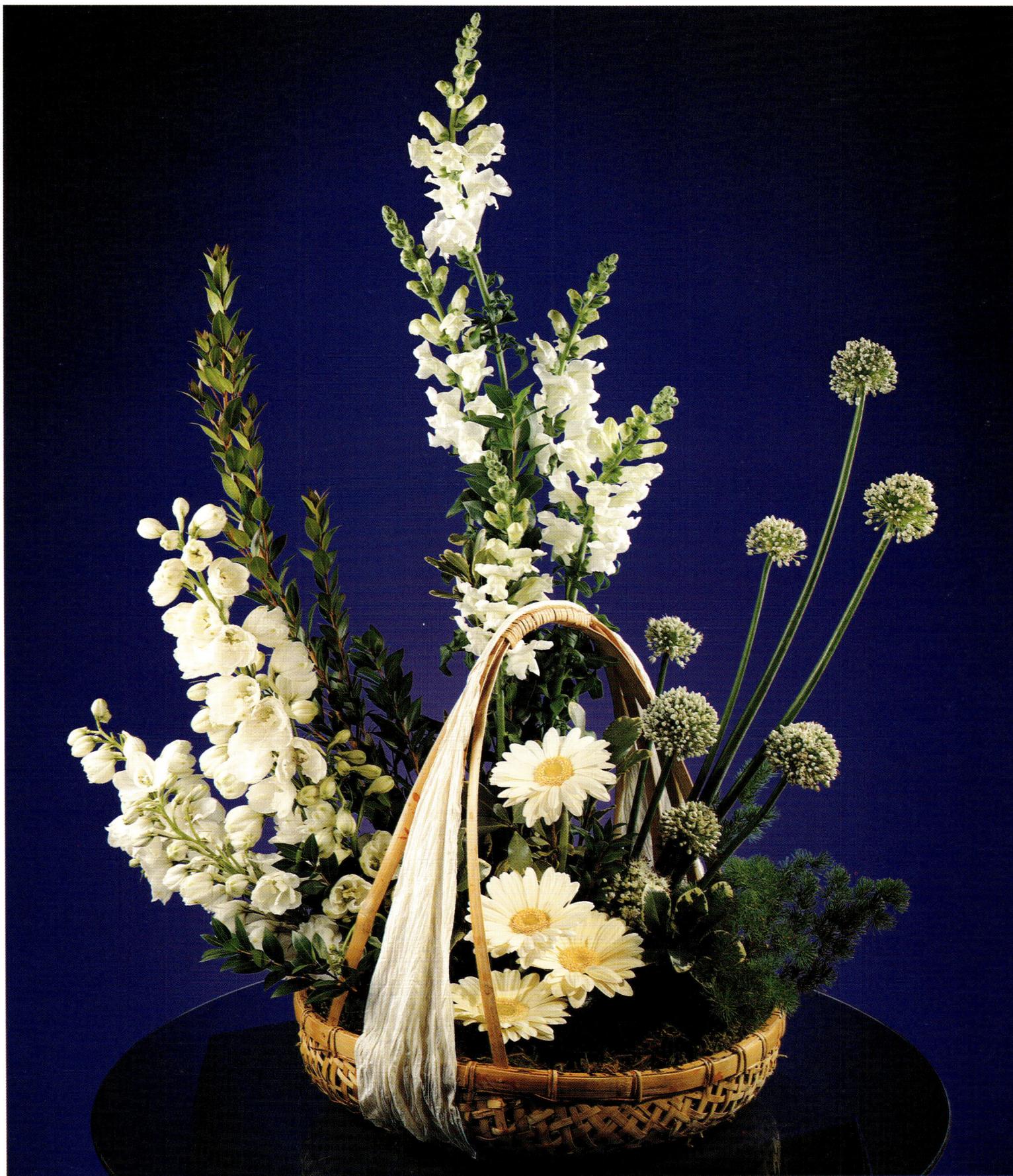

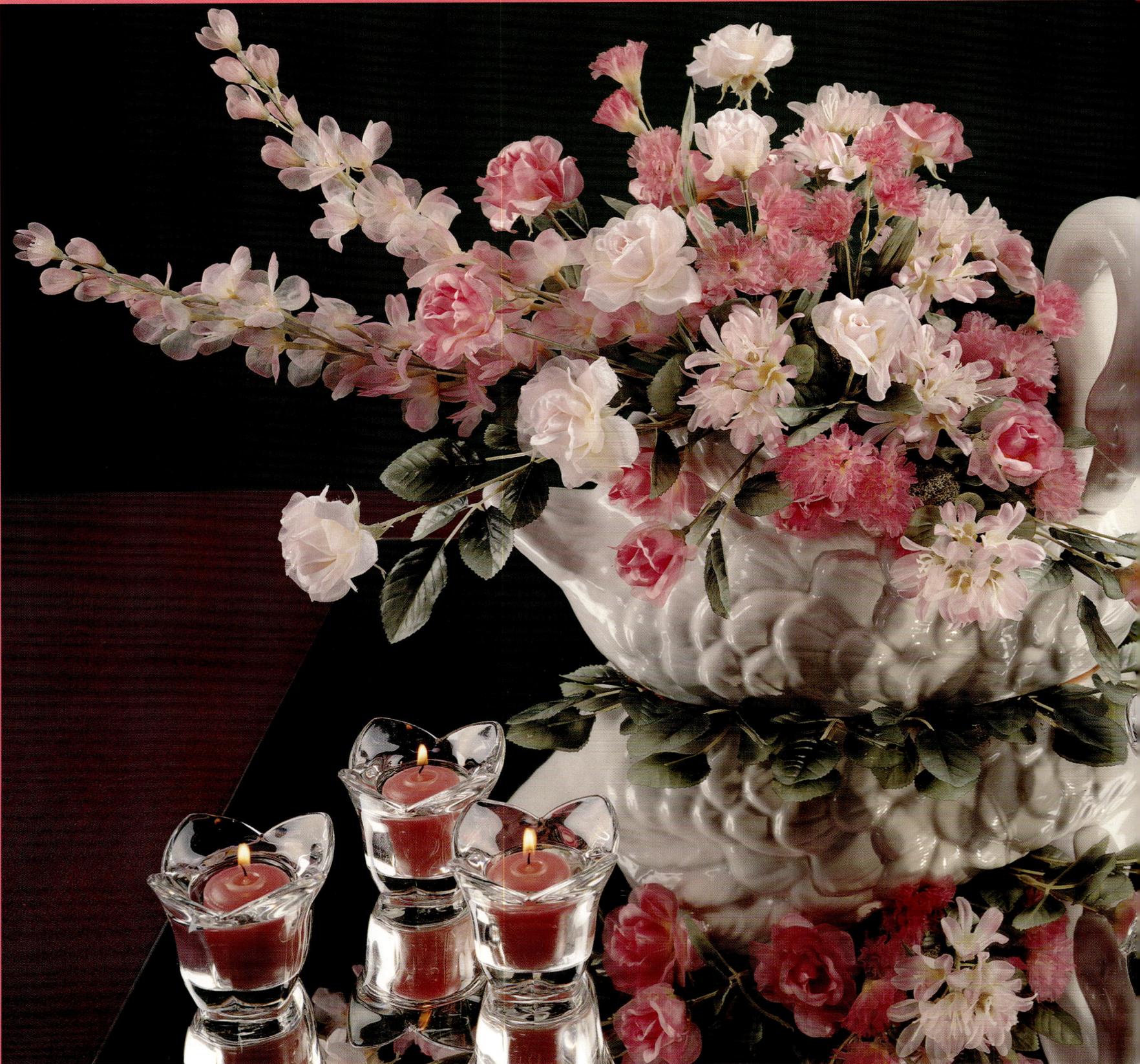

The significant concept in unity is that the whole must be predominant over the individual parts. The viewer must see a floral design as a whole, not a combination of individual parts.

There is a difference between intellectual unity and visual unity. Intellectual unity is a logical, rational approach of commonalty. For example, logically all yellow flowers should achieve unity because they are the same color.

Visual unity is a sensitive approach. It is not logical. Visual unity denotes harmony or agreement between all the materials in a composition that is apparent to the eye.

In the swan composition, the artist achieves visual unity through expressing a consistent, elegant, romantic look.

The high gloss ceramic swan, the composition of ballet silk flowers and the presentation with votive candles on the mirrored base creates pleasing and impressive visual unity.

In the candlestick composition, the artist achieves unity through color. The many divergent forms and textures in candlesticks, dried and preserved "For Keeps" natural carnations and roses, raffia, ribbons and silk foliages all conjoin with color.

THE • DESIGN • PROCESS
UNITY

THE OBVIOUS CHOICE FOR

INFINITE INDIVIDUALITY

Swan No. 11100-G from Chimes, Inc. Ballet azalea No. B-220, delphinium No. B-214, mini camellia No. B-219, mini carnation No. B-216 and French rose No. B-213 from Mafco Imports Ltd., 5955 Guide Meridian Rd., Bellingham, WA 98226. Tulip votives No. 590027 from Toscany Imports, Ltd., 386 Park Ave. S., New York, NY. Votive candles from Candle-lite.

Verdigris candlesticks Nos. 0991, 0992, and 0993 from Jim Marvin Enterprises. "For Keeps" dried and preserved roses and carnations from Mafco Imports. Plus One wide sheer ribbon No. 1620; McGinley Mills moire ribbon No. 242 and velvet ribbon No. 9045; CMC maidenhair fern No. GF-56104 and aralia No. AF-45780; Nouvette ivy No. LH1029; and Knud Nielsen colored raffia available from your local wholesaler. Candles from Creative Candles.

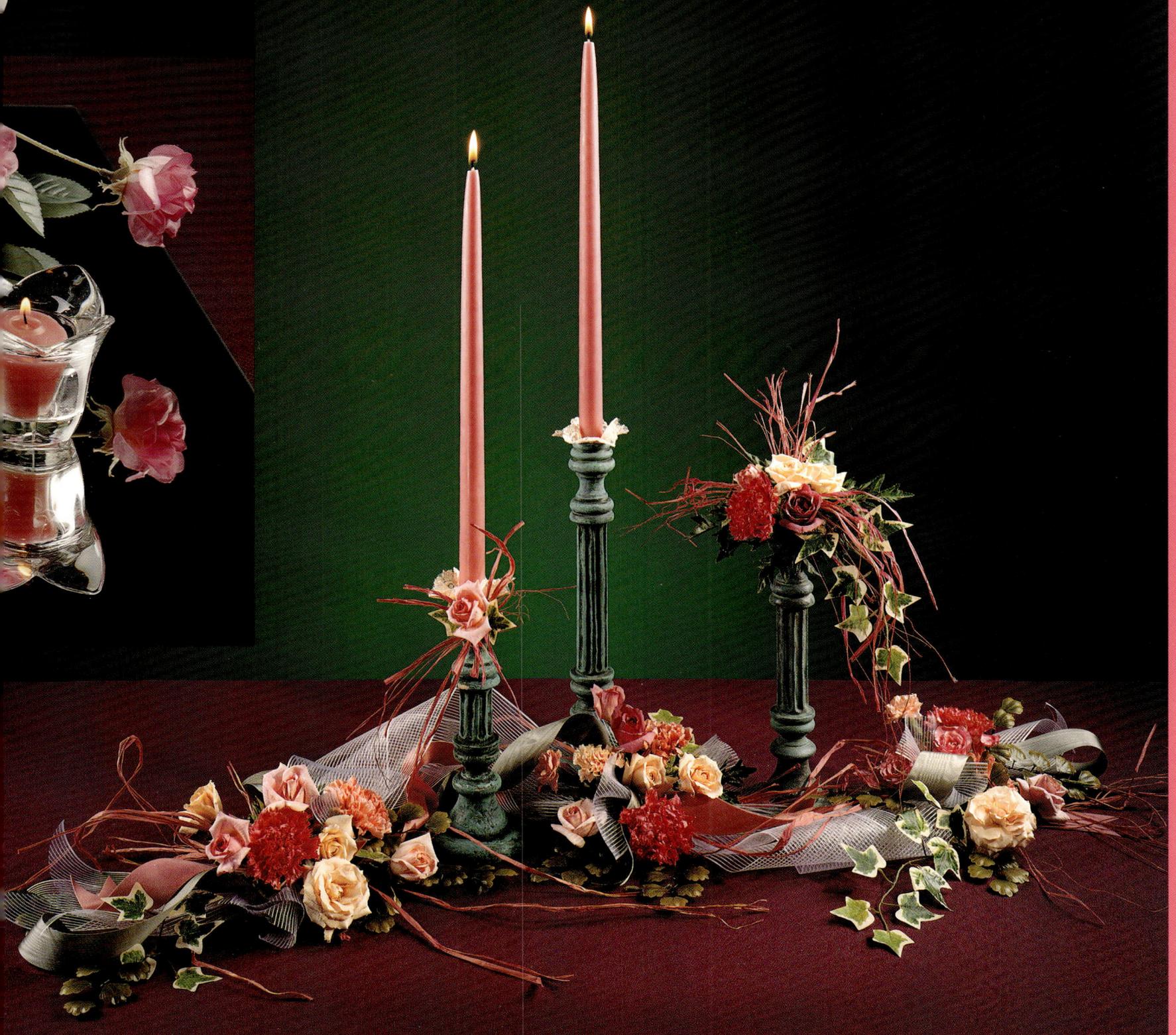

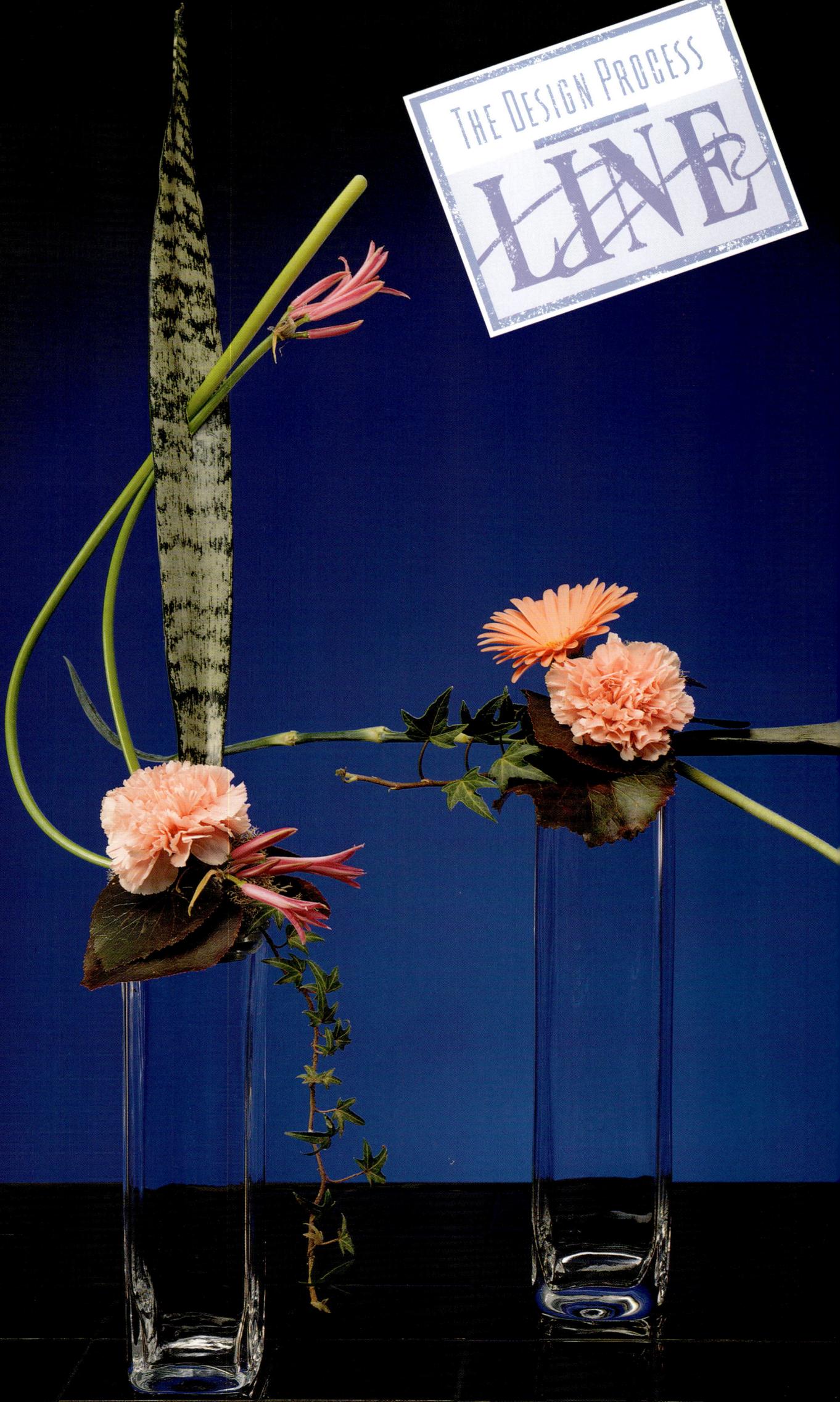

ACCEPT NO LIMITATIONS

THE DESIGN PROCESS

LINE

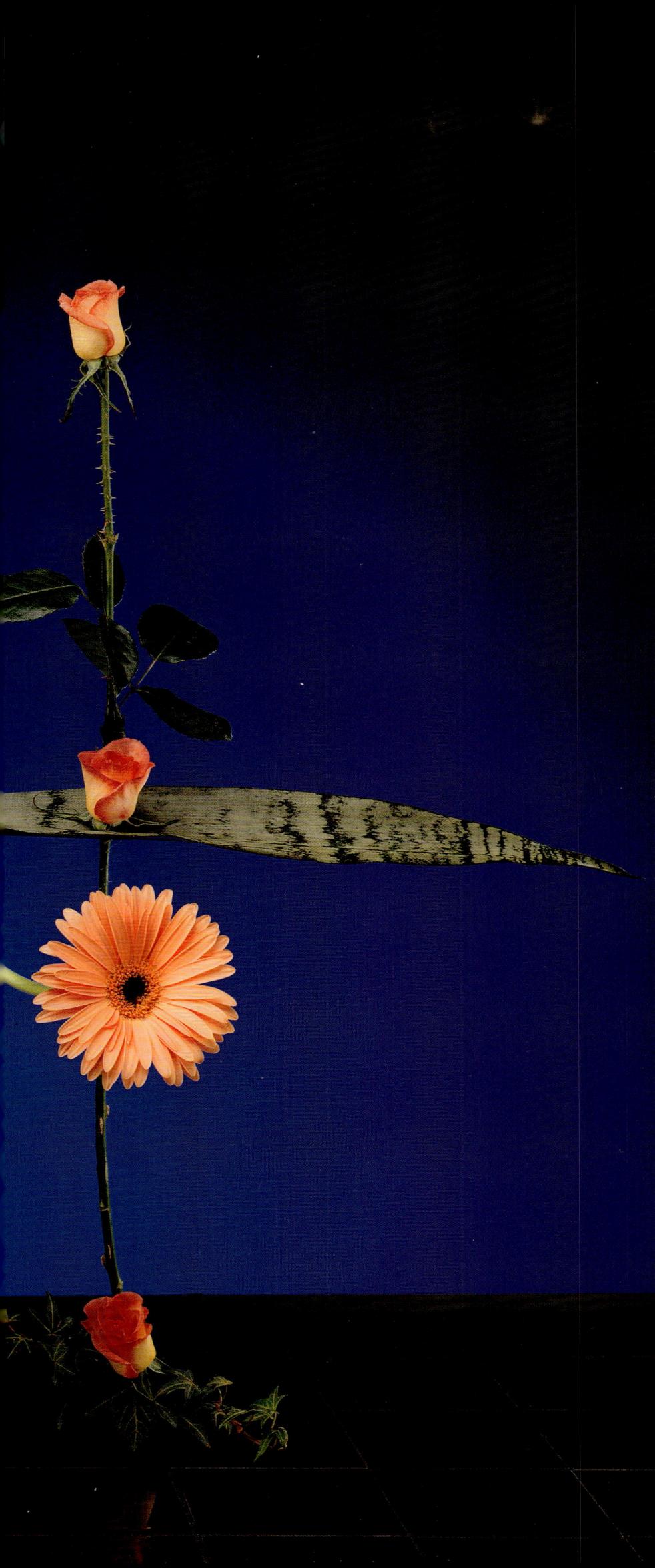

Line is the floral designer's medium of expression. Line creates form, generates movement and energy and spawns personality as it voices mood. Line can be classified into four patterns: vertical, horizontal, diagonal and curving lines.

Lines have energy. The visual dynamics of tension between lines create energy. This is the difference between static and dynamic line. Dynamic lines express motion and create visual excitement. Unless exaggerated in some manner, static lines are inert, even boring. They lack visual energy. Line opposition, dynamic lines, bring strength and vibrancy to a design.

The composition pictured is a striking, contemporary, abstract design suggested for a table decoration. In this setting, the artist skillfully introduces visual energy by creating tension between vertical, horizontal, diagonal and curving lines.

Visually frame the design in an elongated horizontal rectangle. Horizontal and vertical lines make up this imaginary frame. The glass containers repeat the vertical and horizontal lines of the frame. They are static. The curving lines of the nerine and the diagonal gerbera stem are dynamic—they are counterpoint to the vertical and horizontal lines.

Vertical and horizontal lines within a square or rectangular frame are static. Curving and diagonal lines are dynamic.

"The fact that a floral design can be revolutionary, responsible and functional at the same time should be no surprise at all."

In a circle or oval frame, curving lines are static, vertical and horizontal lines are dynamic.

As a line thickens and is exaggerated, it becomes dynamic. The vertical and horizontal sansevieria leaves become visually dynamic because of the change in thickness.

For the composition, the designer glued dry Lomey caged floral foam to the tops of the vases and then submerged the attached foam to saturate it. The roses and gerbera to the right are arranged in a Lomey caged floral foam.

E. O. Brody tall square crystal vases No. 4028 and Lomey caged floral foam available from your local wholesaler.

The Design Process: Line

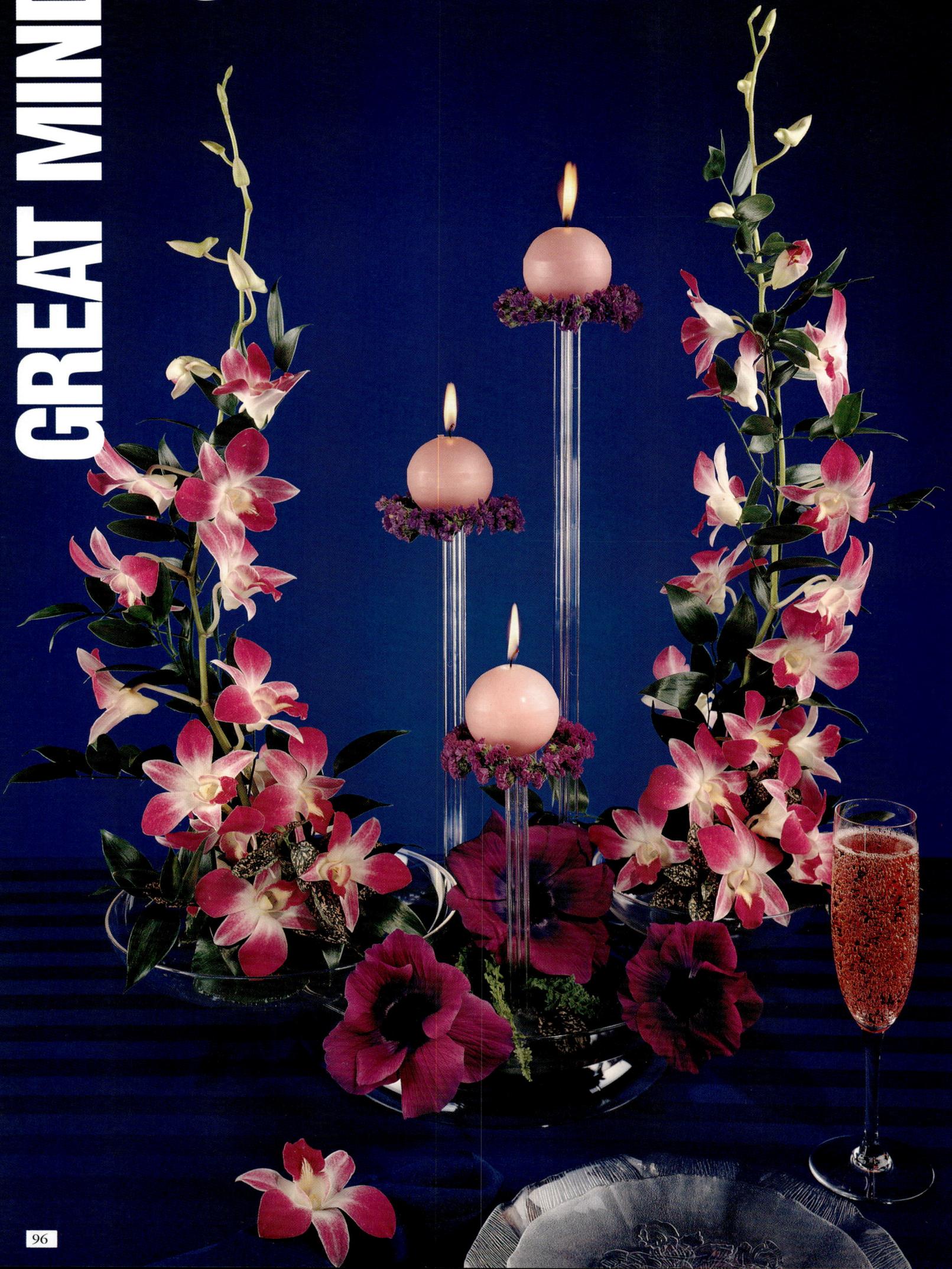

All of the lines in this composition are dynamic. They are counterpoint, in opposition to the straight vertical and rectangular lines that frame the design. Even the diagonal lines of the container are dynamic.

ine functions in every floral composition. When a floral designer understands the importance of line and how to use it to individualize and distinguish his compositions, he controls line to enhance compositions. Otherwise, lines are accidents which can destroy the beauty of the design.

The sensational design of dendrobiums and anemones is dramatic because of lines. The dendrobium orchids curve into the design and frame it, pulling the eye into the composition.

This design requires one 11-inch, two 9-inch and one 6-inch Lomey designer dishes; two 14-inch and one 21-inch Lomey pedestals and two Lomey rim pads. Invert the 6-inch designer dish and glue the 11-inch dish on top. Glue rim pads to the edge of the 11-inch dish and glue on 6-inch and 9-inch dishes. Cut one 14-inch pedestal to 8 inches. Glue on the pedestal ends and glue into bottom of designer dish. Use Oasis® glue to attach candles to top of pedestals.

Counterpoint is another important characteristic of line energy. Counterpoint is an opposing line force, a contrasting line.

The design with alstroemeria, gerbera and viburnum occupies space enclosed in an elongated vertical format. All of the materials in this composition are dynamic—counterpoint to the frame. Even the vertical line of alstroemeria is dynamic because of the round forms of the blossoms. The bold, round forms of the gerbera make the most dominant, dynamic line statement. Even in visual dynamics, there are degrees of energy depending on how lines interact in a design.

This composition occupies space framed by an oval. The curving lines of the dendrobium orchids and the round lines of the candles and anemones are static. The straight lines of the Lomey pedestals are dynamic. They are counterpoint — they have opposing energy to the curving lines.

Basket No. JB1035 from Vintage Basket Imports, P.O. Box 693, St. Helena, CA 94574. Silk dogwood No. K406 from K&D Export Import Co. Dutch freesia No. RF-50745 from Creative Marketing Concepts. Nouvette silk needlepoint ivy No. LH1029 available from your local wholesaler. Alder branches from Hoh Grown, P.O. Box 2135, Forks, WA 98331.

THE ART OF

Line in some form is inherent in every floral composition. The professional designer understands line and knows how to use it to distinguish his compositions.

Vertical and horizontal lines are stable. They remind us of our own bodies, architecture, furniture and other elements we live with every day that we consider to be solid and secure.

Diagonal lines are dynamic and forceful. They are poised for movement. Diagonal lines express motion—even tension—and seem in a state of flux.

Curved lines are less terse and often more comfortable visually. They bring a softer movement to a composition than crisp, precise diagonal lines.

Using line to introduce pleasing tension is an important consideration in creating a floral composition. Line tension like human stress has two different connotations. Helpful stress makes life interesting, exciting and meaningful. Too much, or the wrong kind of stress is a killer. In floral design, interesting and proper line tension brings a distinctive, differentiating look to a composition. Excessive line tension destroys the composition and confuses the viewer.

This composition of silk flowers is an outstanding example of line presentation. There are two zones of lines. The upper zone focuses on a carefree arrangement of alder branches. Silk freesia solidify weight without creating a pattern or a line. In contrast, the silk dogwood and ivy at the bottom of the line flow in a distinct curving line. The repetition of the three dogwood blossoms establishes a visual beat, a cadence that keeps the line moving.

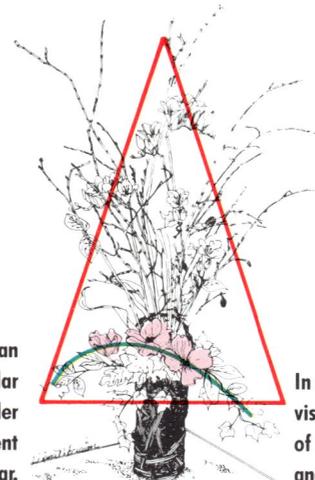

This composition falls within an elongated vertical triangular format. The lines of the alder and freesia are independent and irregular.

In contrast, to create interesting visual tension, the curving line of dogwood and ivy is controlled and precise.

VERSATILITY

E. O. Brody painted glass vase with grid lock stem holder No. G300 available from your local wholesaler.

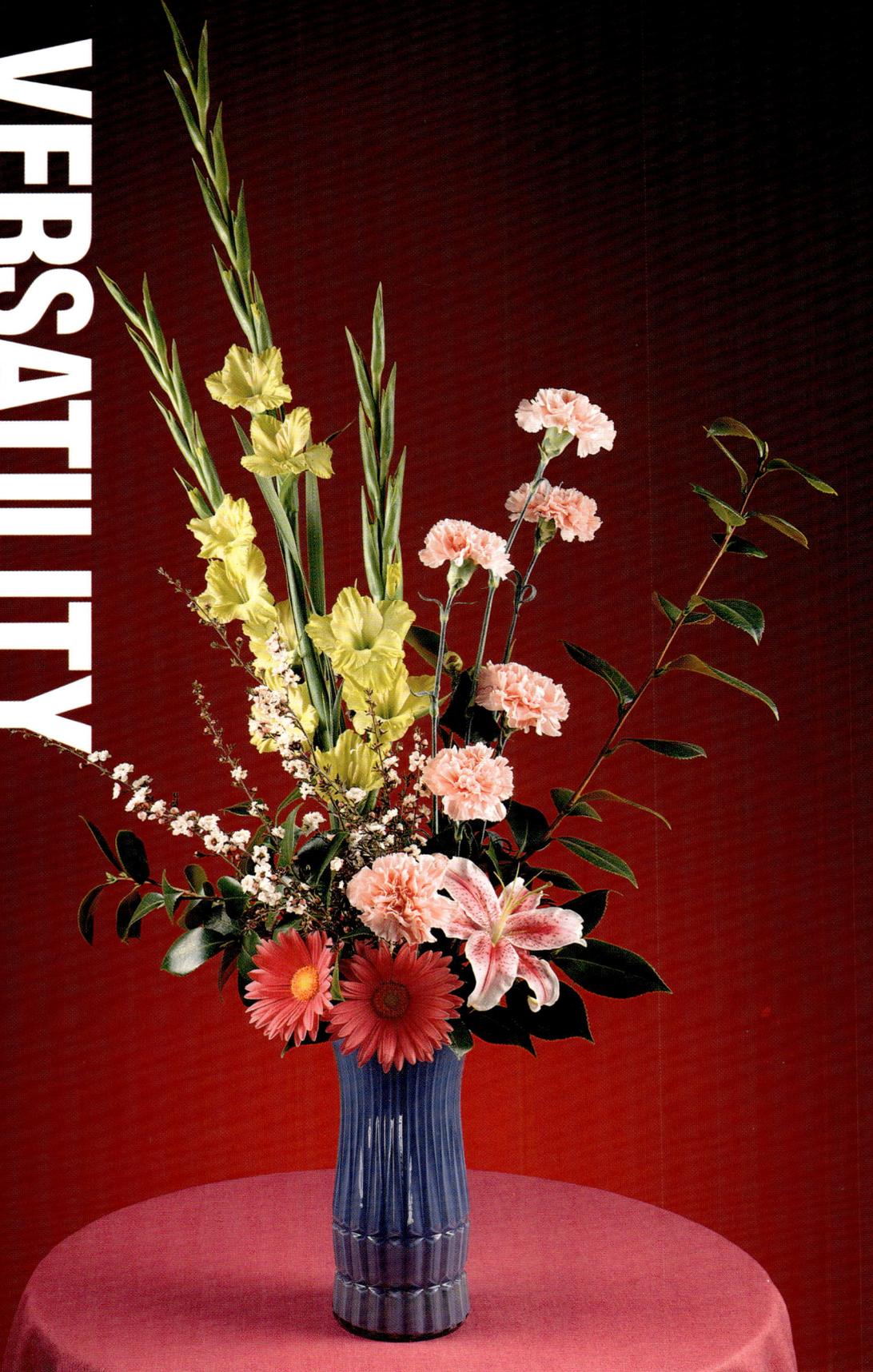

This composition combines the technique of grouping with line dynamics for a smart, conspicuous look. Line is strong, definite and directional. The designer places only one gladiolus in the straight, vertical position. He positions all other materials in dynamic, diagonal lines.

The presentation of line in this design illustrates an interesting and effective technique. The designer presents the major flowers—the gladioli and the carnations—in definite groupings that create strong, diagonal line emphasis.

The three upper carnations in an irregular diagonal line pattern contrast to the three lower carnations in an explicit diagonal line. The grouping of three green gladioli moves in an opposite diagonal line pattern.

The secondary materials—the leptospermum on the left and the camellia foliage on the right—move into the composition in diagonal line formation.

All of the stems in this composition radiate into and out of a central focal area created with the lower carnation, the two gerbera and the lily blossom.

The designer uses E. O. Brody's new grid lock stem holder on the top of the container to hold the flowers. This is a new plastic grid that clamps on top of certain E. O. Brody containers and holds the stems. The grid lock stem holder replaces floral foam and other fillers. It is especially effective for clear glass containers.

THE DESIGN PROCESS
LINE

The line energy in this composition is created by the diagonal movement of the materials.

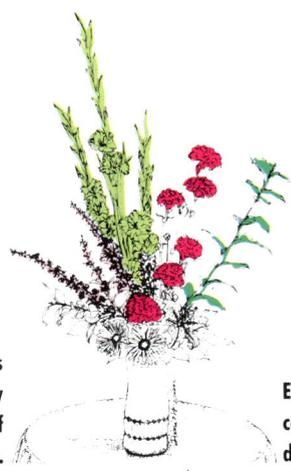

Each grouping moves into the central focal area in a distinct, diagonal line pattern.

DON'T SETTLE FOR SIMMER

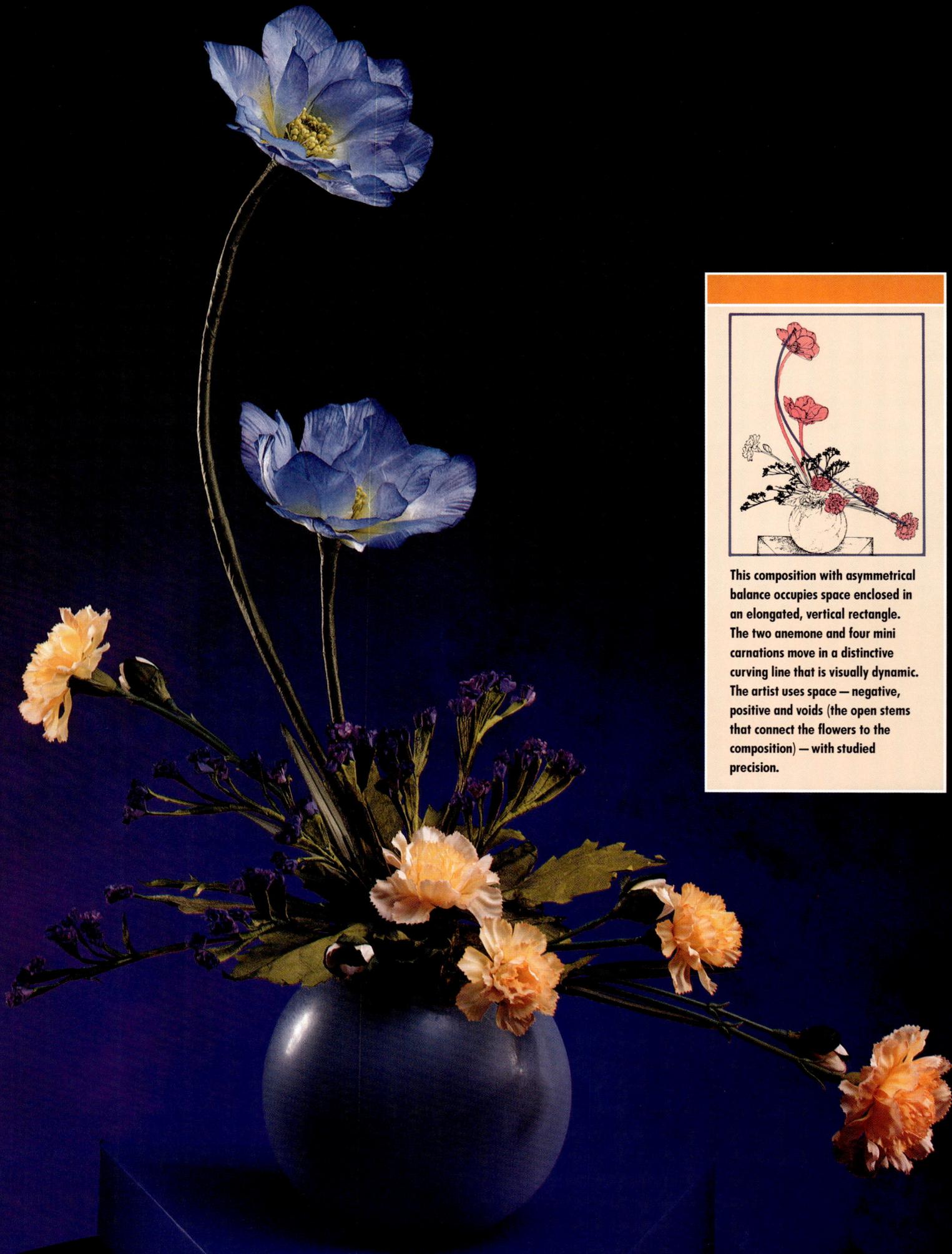

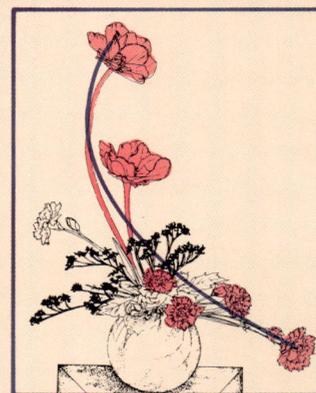

This composition with asymmetrical balance occupies space enclosed in an elongated, vertical rectangle. The two anemone and four mini carnations move in a distinctive curving line that is visually dynamic. The artist uses space — negative, positive and voids (the open stems that connect the flowers to the composition) — with studied precision.

...MAKE IT SIZZLE!

Don't settle for watered-down line. It's not the style that distinguishes your floral designs. Select hot lines—sizzling lines that move, have personality and are worthy of recognition and praise.

Line is not just an esthetic consideration. Often it's dollars and cents. The use of line in floral compositions becomes influential in designs with a restricted quantity of materials. Line, properly introduced in a composition, amplifies the visual value of the materials used.

In the silk flower design, the two anemones introduce a curving line that joins with the four lower miniature carnations. This high-left, low-right line movement composes the major line emphasis. It fortifies the asymmetrical balance of the composition.

The table setting with an impressive, interpretative design of fresh gladioli, gerbera, allium and ranunculus presents an intriguing contrast between line movement and flower form. This technique of highlighting line through form contrast works exceptionally well with limited materials. The strong vertical lines of the gladioli and the vertical direction of the ranunculus play against the definitive round form of the gerbera, allium and ranunculus.

THE DESIGN PROCESS
LINE

Blue container No. R306 from A. L. Randall. CMC's paper anemone No. 2F-25627 and statice No. AF-45804 and silk mini carnations No. RF-50714; Sahara® foam; and E. O. Brody's glass vases Nos. 4022, 4023 and 4024 available from your local wholesaler.

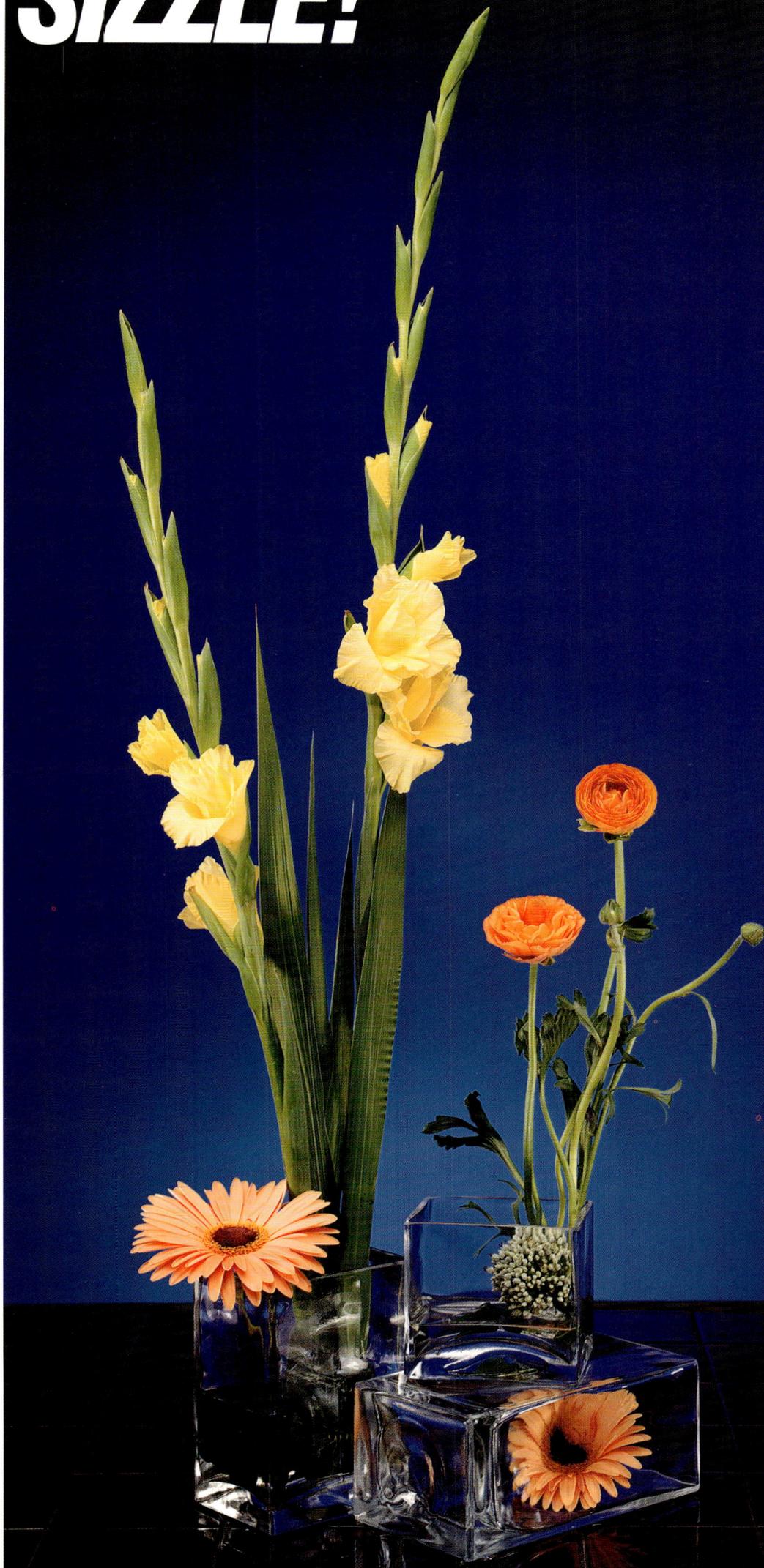

Vase D'Lite cylinders No. 1544; Knud Nielsen Watercolors™ bell cups, sabel palm, cut palmetto, sea grape, lotus pods, palino and preserved galax leaves; and McGinley Mills moire ribbon No. 242 and velvet ribbon No. 9045 available from your local wholesaler. Candles from Creative Candles, P.O. Box 19514, Kansas City, MO 64141.

USING LINE

Line gives a floral composition personality. If a design has no individual character, it lacks the special look that elevates it beyond the ordinary.

Without a distinguishing personality, a design looks like every other design. And, the consumer market for the run-of-the-mill, the unexceptional, is becoming more limited every day.

The composition of dried materials created for a table decoration exemplifies how line sets a design apart from the typical. Exaggerated vertical lines with sabel palm, lotus pods, palino and candles emphasize parallelism. The repetition of the vertical line emphasis gives the design an important linear pattern—"the special look" of distinction.

"In floral design, that nervous pandering to the imagined perimeters of what customers and recipients will like involves a great risk — that of being totally inconspicuous."

When a designer repeats one type of line in a composition, this repetition amplifies the visual impact of the line. As illustrated in the dried composition, line is more dominant when repeated in a range of linear forms—sleek, slender candles, broad sabel palm, delicate palino and coarser lotus pods. In contrast, the materials forming the horizontal line are round or fan-shaped.

The artist uses four Vase D'Lite cylinders for the composition. The container to the far left includes cut palmetto and three bell cups. The container to the immediate right features the vertical line of lotus pods. Behind and to the far right are containers with candles and preserved galax leaves. The cut palmetto with the bell cup used as a container to hold the palino, sets flat on the table.

The fresh flower design is a contemporary interpretation of Traditional Triangular form. To add visual impact to the vertical line, the artist broadens the line by the parallel placement of gladioli and gerbera. This is the primary, the most

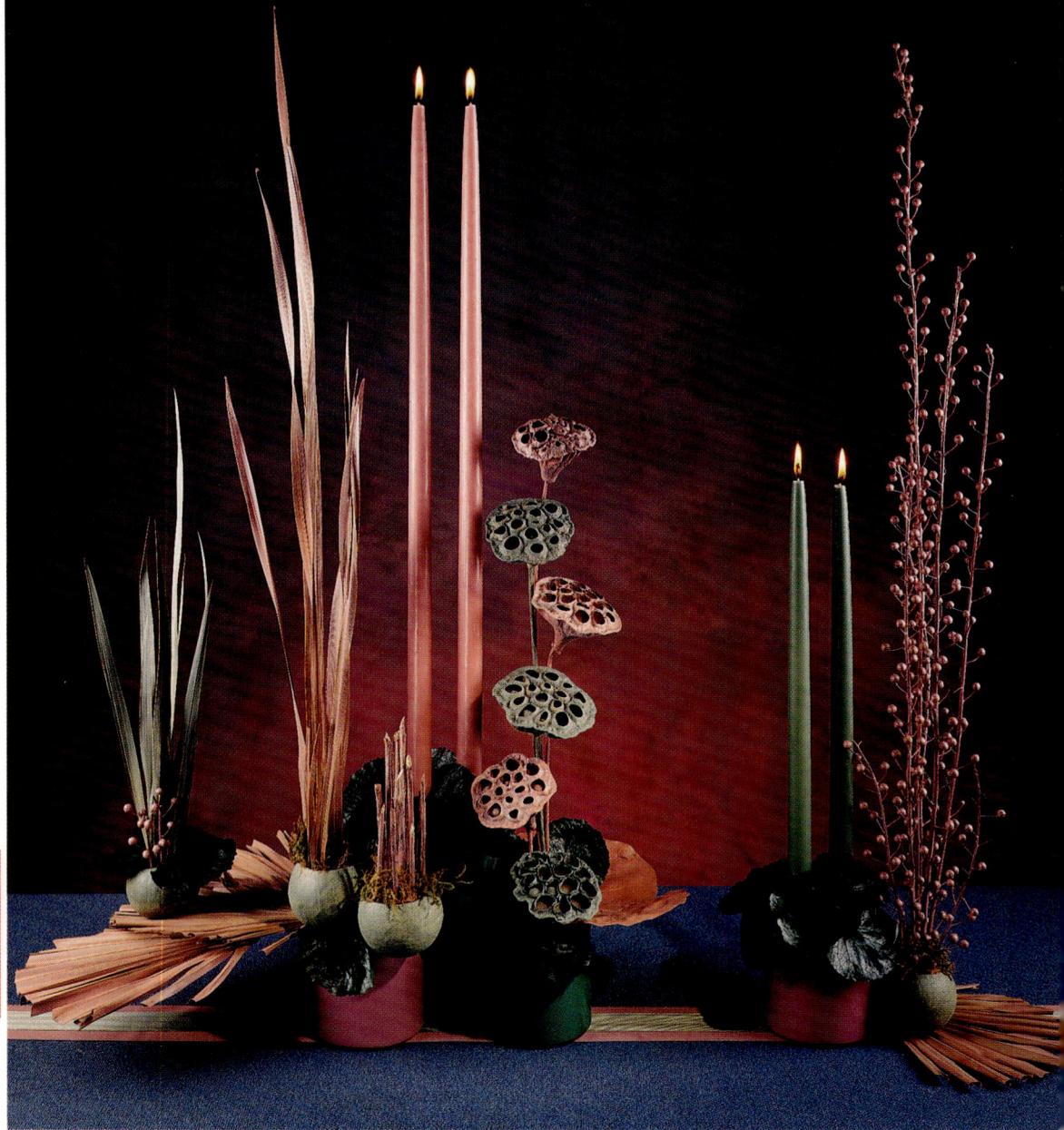

important visual line in the design. Normally, a vertical line is static in this format. The exaggerated width of the vertical line, makes it dynamic—it has visual energy.

The secondary horizontal line created with carnations, gladioli and a gerbera, moves across the base of the composition with low-key visual emphasis.

THE DESIGN PROCESS
LINE

Finesse octagon container No. P380 from Franklin China, available from your local wholesaler.

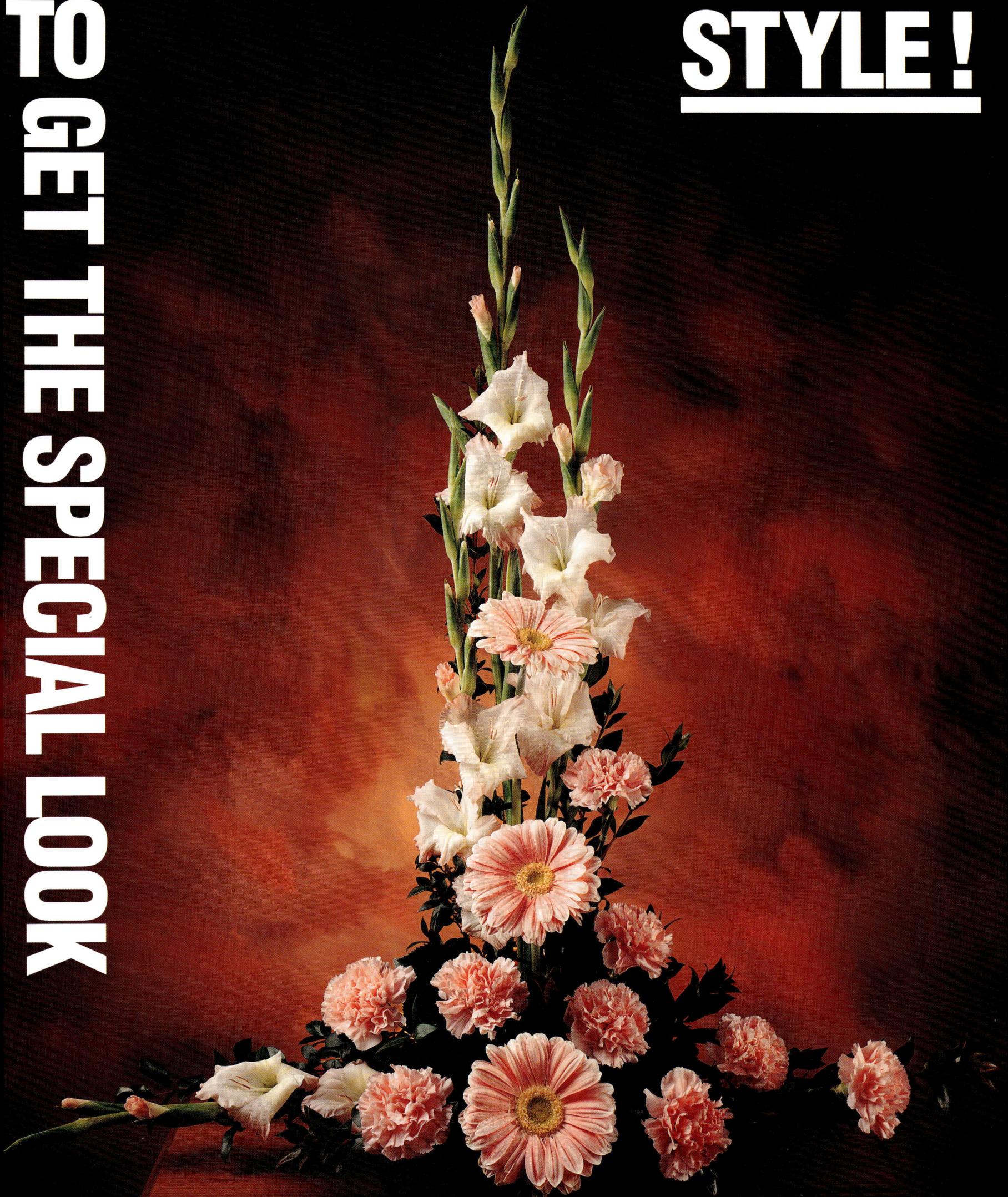

STYLE !

TO GET THE SPECIAL LOOK

AN ANTHOLOGY OF

Style

Emphasis is the process by which the visual components in a composition are tied together through dominance and subordination. Through emphasis, the artist attempts to control the sequence in which visual events are observed or the amount of attention paid to them. *Joseph A. Gatto*

Emphasis establishes style. In traditional floral design, the point of emphasis is the focal point or the focal area. In The Design Process, the point of emphasis can appear anywhere in the composition as long as the design is visually balanced.

The three designs pictured, illustrate three different ways to achieve emphasis.

In the composition featuring yellow lilies, these blossoms are the emphasis. This design expresses the traditional process of placing major visual emphasis in the focal point with all stems moving into and out of this central point. Emphasis is created by the central location of the dominant materials.

Outside bowl, Franklin China Finesse bowl No. P365, inside bowl No. P368; and Knud Nielsen mood moss available from your local wholesaler.

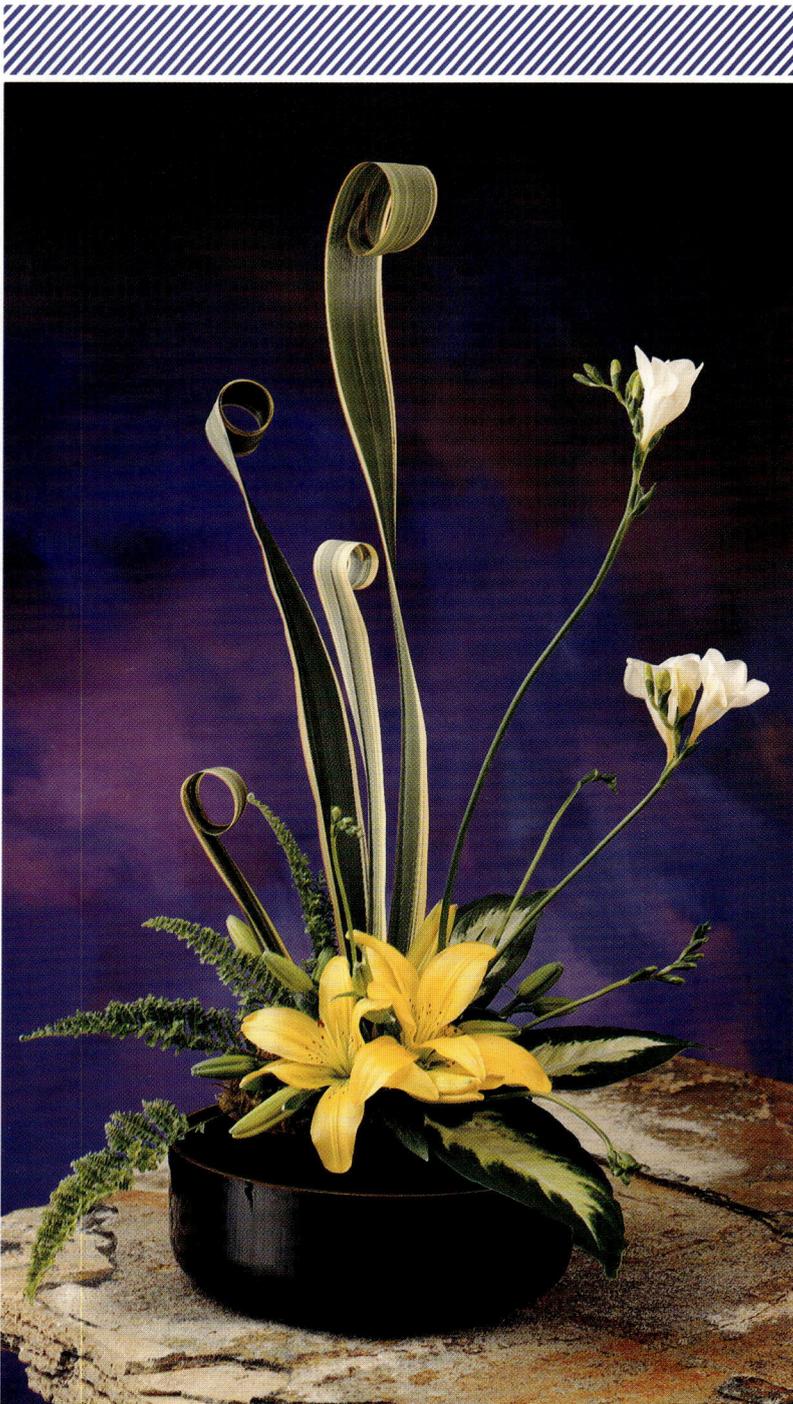

The design with lavender liatris and pompons accentuates two roses. Because of the color and the form of the roses, they become the point of visual emphasis in the composition.

The contemporary design with groupings of iris and delphinium illustrates emphasis through isolation. The upward, slightly diagonal position of the iris gives these blossoms the dominant position, the primary point of visual emphasis in the composition. The white delphinium is the secondary emphasis and the dieffenbachia leaves the tertiary emphasis.

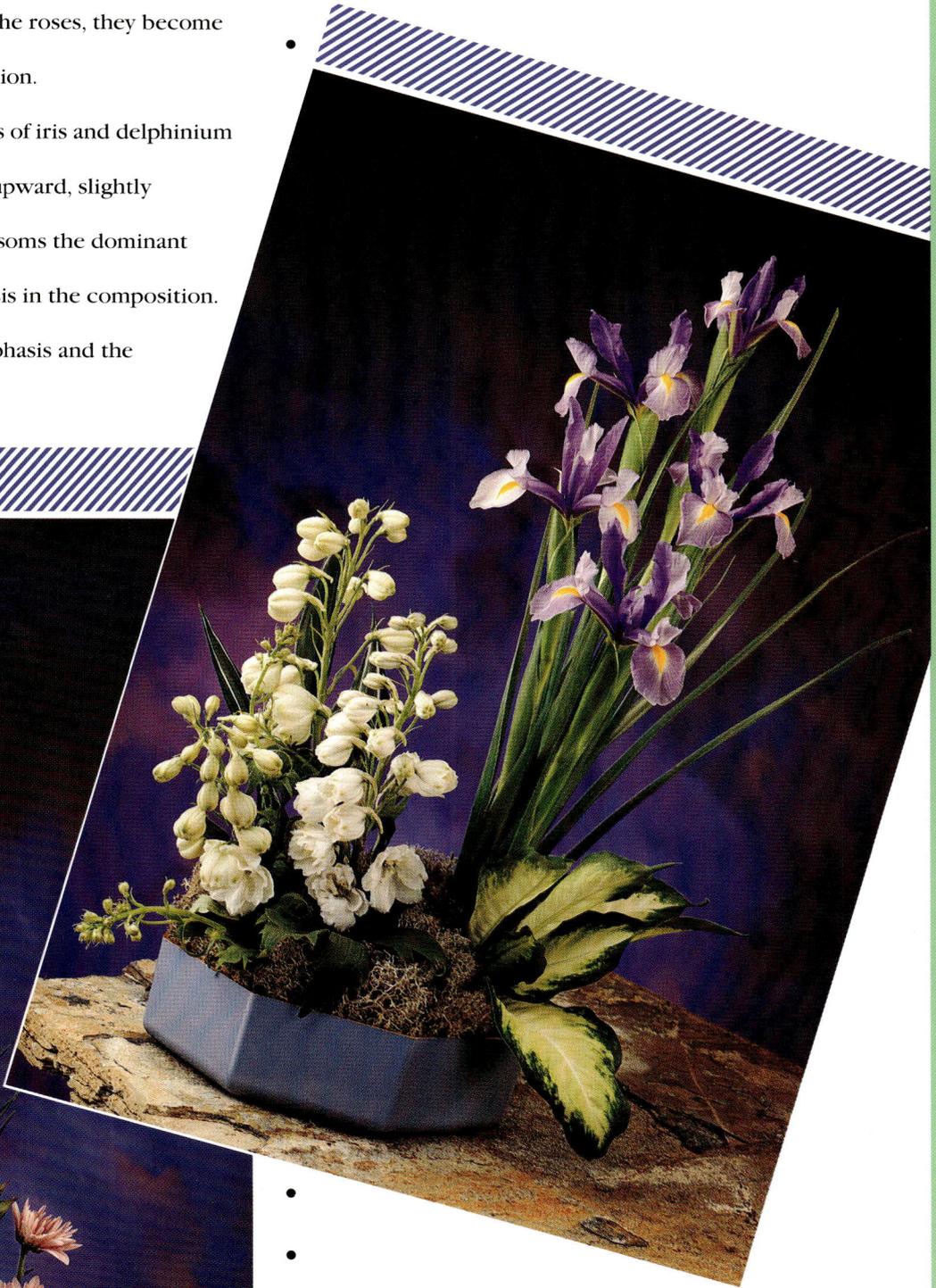

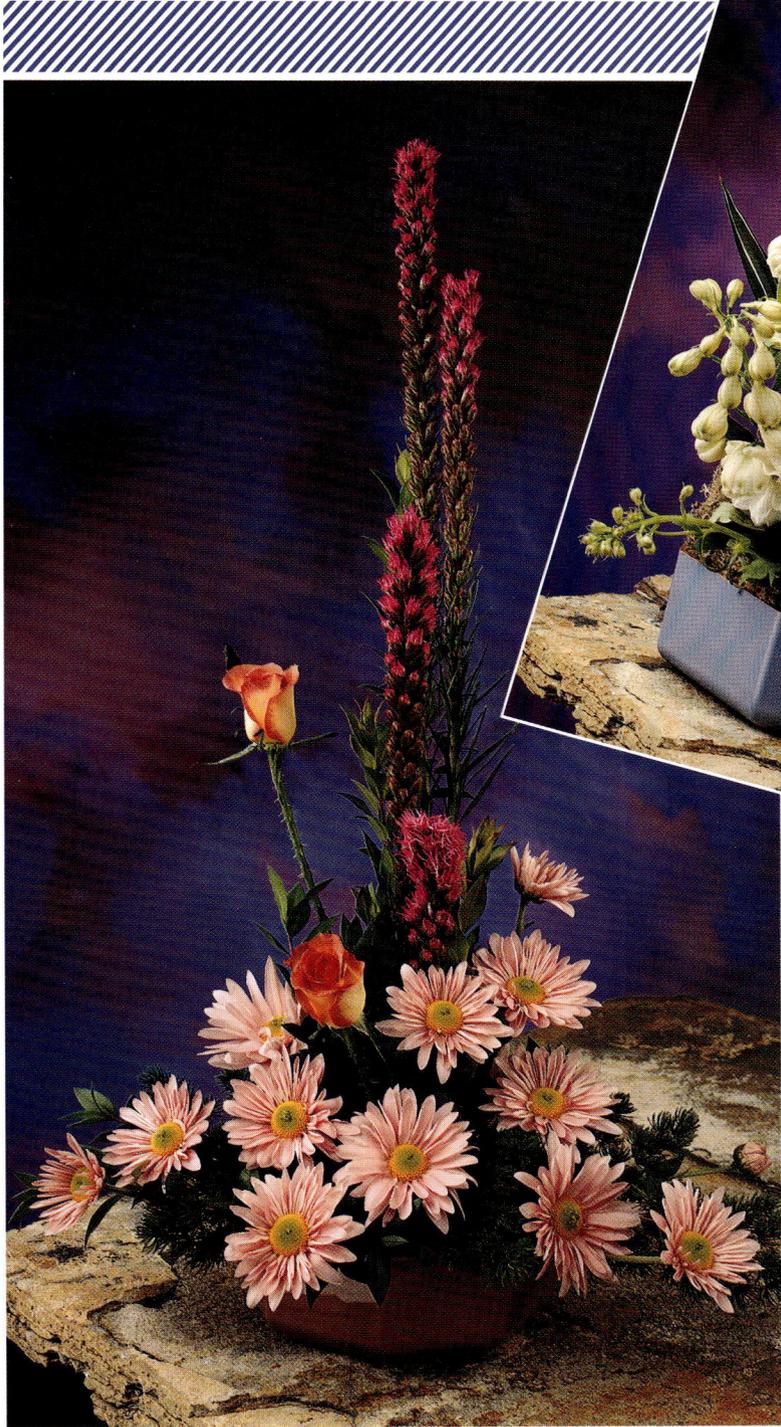

Containers on this page, Franklin China Finesse octagon No. P385 and Oasis® floral foam available from your local wholesaler.

The Design Process: Emphasis

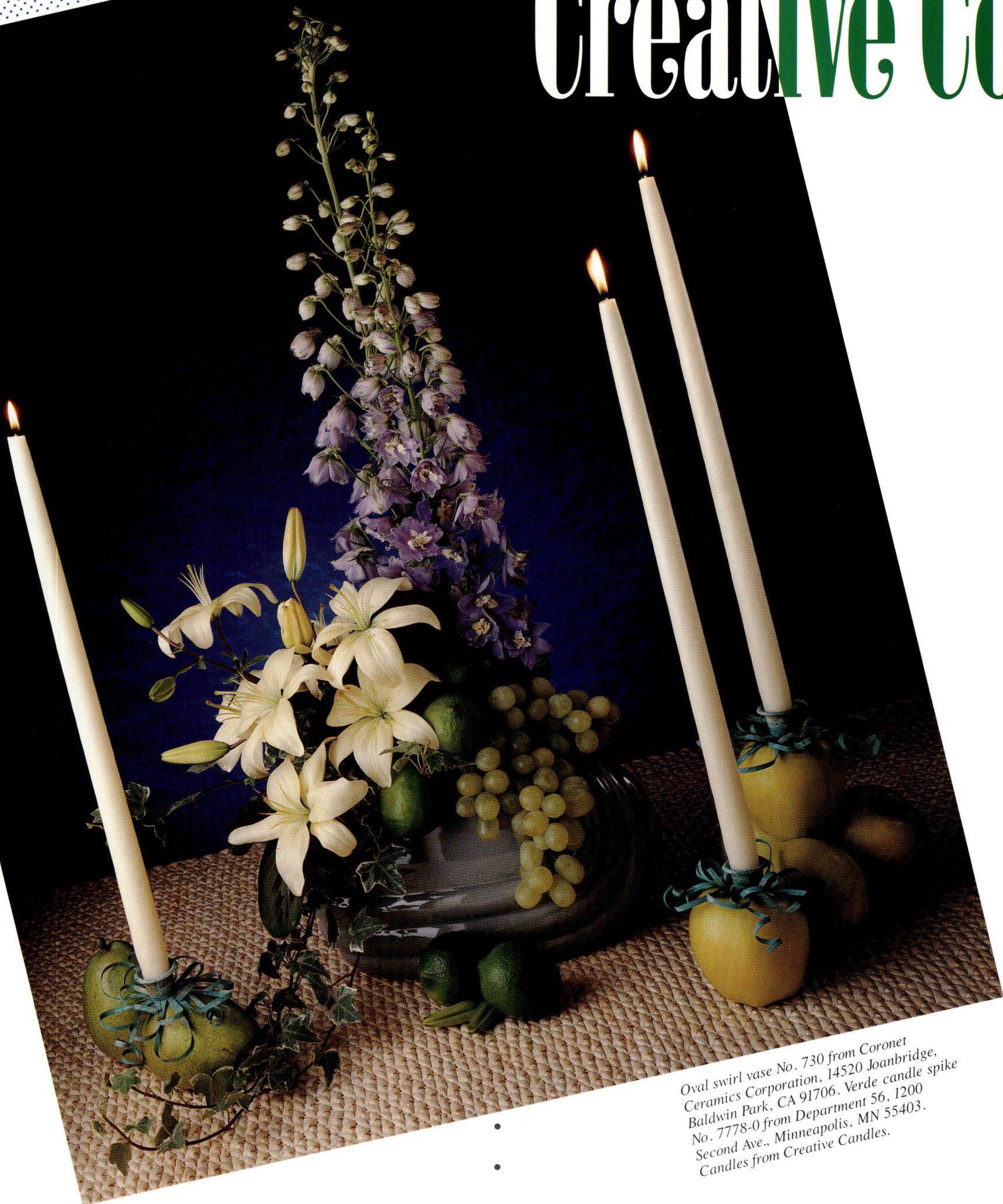

Oval swirl vase No. 730 from Coronet Ceramics Corporation, 14520 Joanbridge, Baldwin Park, CA 91706. Verde candle spike No. 7778-0 from Department 56, 1200 Second Ave., Minneapolis, MN 55403. Candles from Creative Candles.

unterpoint

Counterpoint in music is the art of playing more than one melody at a time, related to but independent from a theme. In both compositions pictured, the designer uses creative counterpoint by combining flowers with novel accessories.

Often, a designer must ask, "What is the right design to achieve the purpose?" Once he makes this decision, the next judgment is the selection of materials. Then, the artist determines how to present the materials. At this point he resolves the major focus of the work. This is the role of emphasis—to identify specific materials as the paramount visual focus.

In the table setting composition of fruit and flowers, the cream colored lilies and the ivory candles visually advance. The lilies are the dominant visual emphasis and the candles the secondary emphasis. The delphinium and the fruit recede allowing the lilies and candles to advance. This is an important technique in achieving visual emphasis, especially when there are novel items in the composition. Some materials must advance and others recede.

In the white and silver composition, the balloons speak out with visual dominance. They are the point of emphasis because of their exaggerated size and commanding placement. The communication is clear and direct— "Let's celebrate!"

Each of these compositions has a distinct personality. The fruit and flowers speak with soft elegance. The balloon design communicates with spirited vitality.

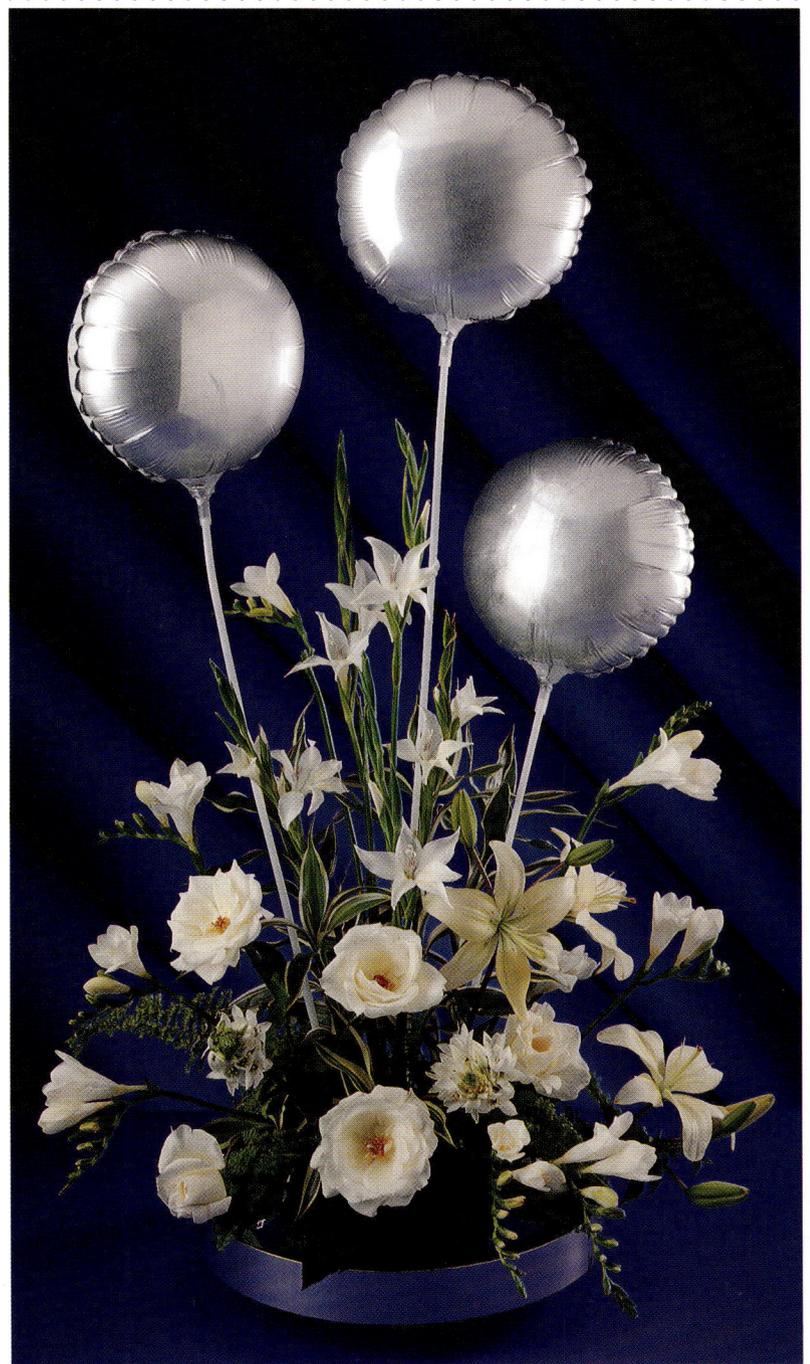

THE DESIGN PROCESS
EMPHASIS

Syndicate Sales' designer tray No. 30 available from your local wholesaler. Inflated 9″ balloons and stems available from CTI Industries Corp., 22160 N. Pepper Rd., Barrington, IL 60010.

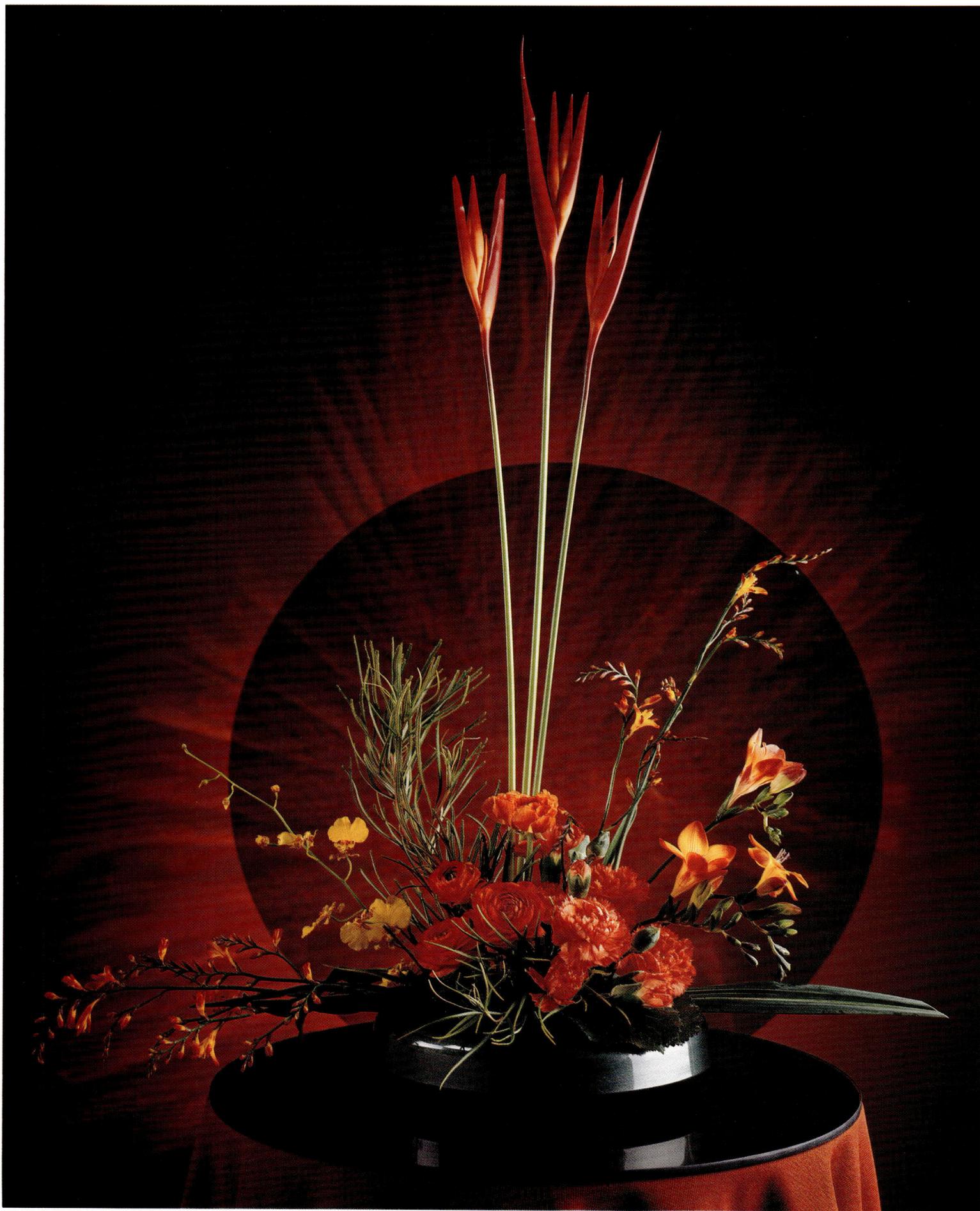

Lomey series 49 dish available from your local wholesaler.

DESIGNS THAT
Dazzle
Loud & Clear

Emphasis is the fine art of saying, "I'm important, look at me." Or, "I'm expensive, be sure and notice me."

The role of emphasis is to identify specific materials in a composition as the most important. These items require visual accent to make the design effective or to establish appropriate visual value.

Visual value is an essential consideration in any floral composition. Does it look the value? This does not mean large size. Visual value is not always associated with size.

Instead, attention must be centered on giving the expensive materials visual emphasis. For example, higher-priced items should not be buried where they will not receive important visual value.

Another aspect of emphasis is to call attention to the entire composition. This is accomplished by any technique that compels attention to remain with the design. Unless something attracts and holds attention, visual attention span is short, even in viewing beautiful floral compositions.

In the design featuring miniature heliconia, the three heliconia blossoms stand out with major visual dominance. They literally stand out and say, "I'm important, look at me." The artist achieves this visual dominance by extending the heliconia in exaggerated height over the base of the design. This dramatic contrast allows the heliconia to take center stage.

The mass composition on this page demands attention because of the style. There are no specific materials that stand out with differentiating dominance. Nevertheless, the stems of pussy willow frame the design, pull the eye into the composition and command attention.

The Design Process
EMPHASIS

Lomey 9-inch designer dish available from your local wholesaler.

Impact! Impact! Impact!

Prism vases Nos. 1-1326, 1329 and 1339 and diamond table lights Nos. 1-285, 286, 287, 288 and 289 from Firelight Glass, 1000 42nd St., Emeryville, CA 94508.

Impact!

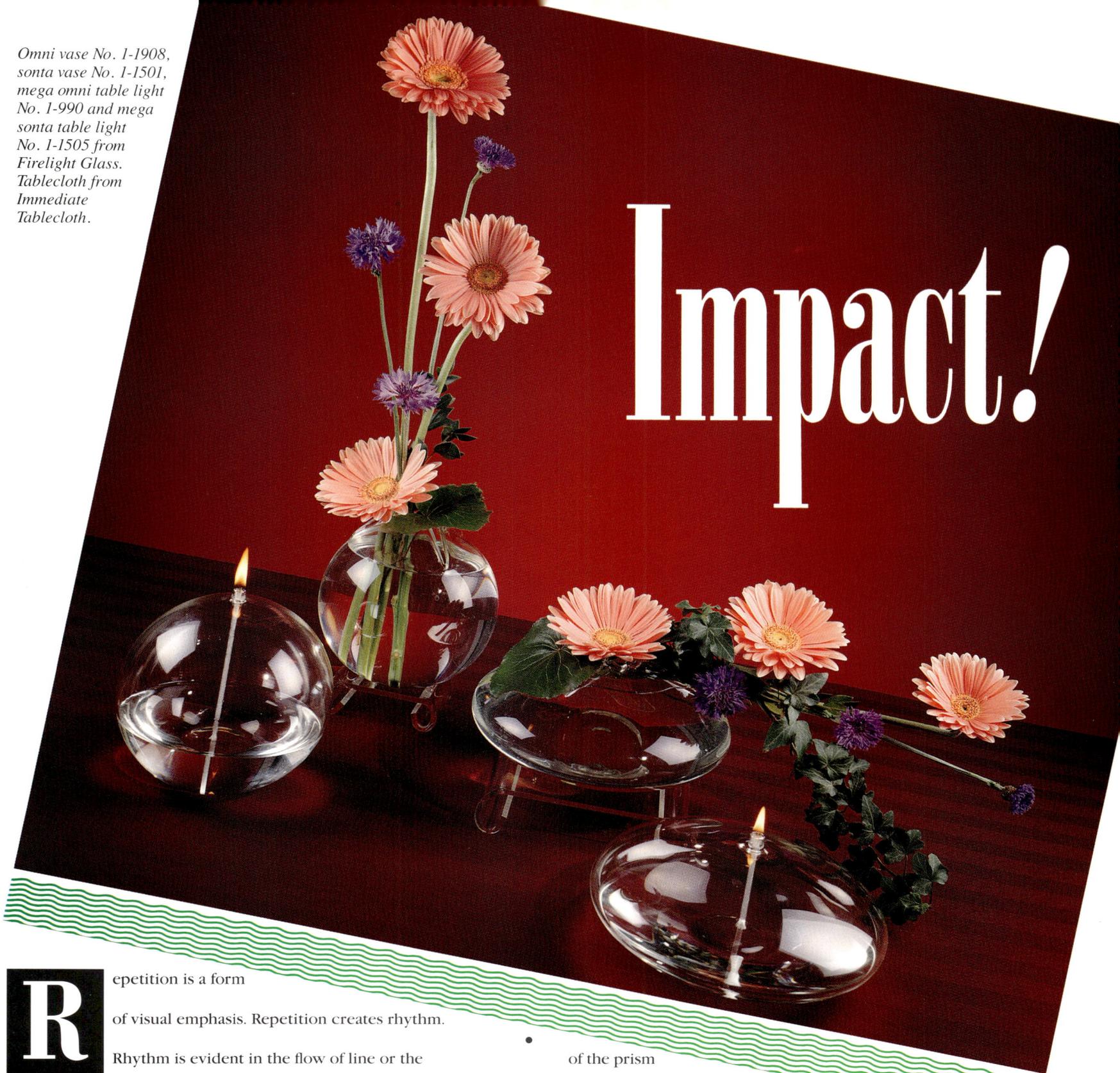

Repetition is a form of visual emphasis. Repetition creates rhythm. Rhythm is evident in the flow of line or the repetition of form or color. This repetition creates a visual cadence. The resulting rhythm is an important creative expression in the design.

Similar to music, the accents and pauses in a composition establish rhythm. Without repetition, there is no rhythm. Some rhythm is sharp and pulsating. Other rhythm is staccato or lazy and languorous. Patterns of rhythm create visual emphasis.

The form of the Firelight vertical prism vases and diamond table lights set up the repetition for the white table composition. There is a specific visual cadence in this design achieved by the repetition of the prism forms. Then, the arrangement in descending height establishes another rhythmic pattern. The white flowers emphasize the vertical emphasis of the design.

The pink table setting features round forms in Firelight vases and table lights. In this composition, the designer achieves repetition and rhythm by using gerbera to repeat the round forms of the containers and table lights. This rhythm pattern is important, but not as regimented as in the vertical design.

Master Composer

● OPPOSITION

Contrast is the final component of The Design Process. First, a designer generates an idea. Then, he determines the form in which he will present the idea. Within this form, the presentation includes balance, unity, line, emphasis and contrast. A floral composition that stands out with distinction expresses all seven of these components.

A designer produces contrast in a composition by intentionally introducing opposition—differences. There cannot be contrast unless there are opposing forces in a design. Contrast can be expressed in scale, shape, volume, direction, color and color value, texture and depth dimension.

Visual and emotional contrasts fill our lives. Contrast is a natural part of everyday living. We move from experiences of exhilarated joy and happiness to moments of peace and solitude to times of intense sadness.

In nature, there are contrasts all around us—in trees, flowers and animals. There are contrasts in buildings, in automobiles, in the clothes people wear and in the food we eat.

Life needs contrasts. Otherwise, living would be dull, boring and without meaning. Likewise, an exciting floral composition requires contrasts to be interesting and distinctive.

The composition of silk flowers, dried materials, grapes and berry clusters illustrates many contrasts. Study this distinctive design and identify how contrasts give it individuality and visual prominence.

● DIFFERENCES

The woven texture of the basket is in opposition and contrasts with the smooth textured flowers. The round forms of the

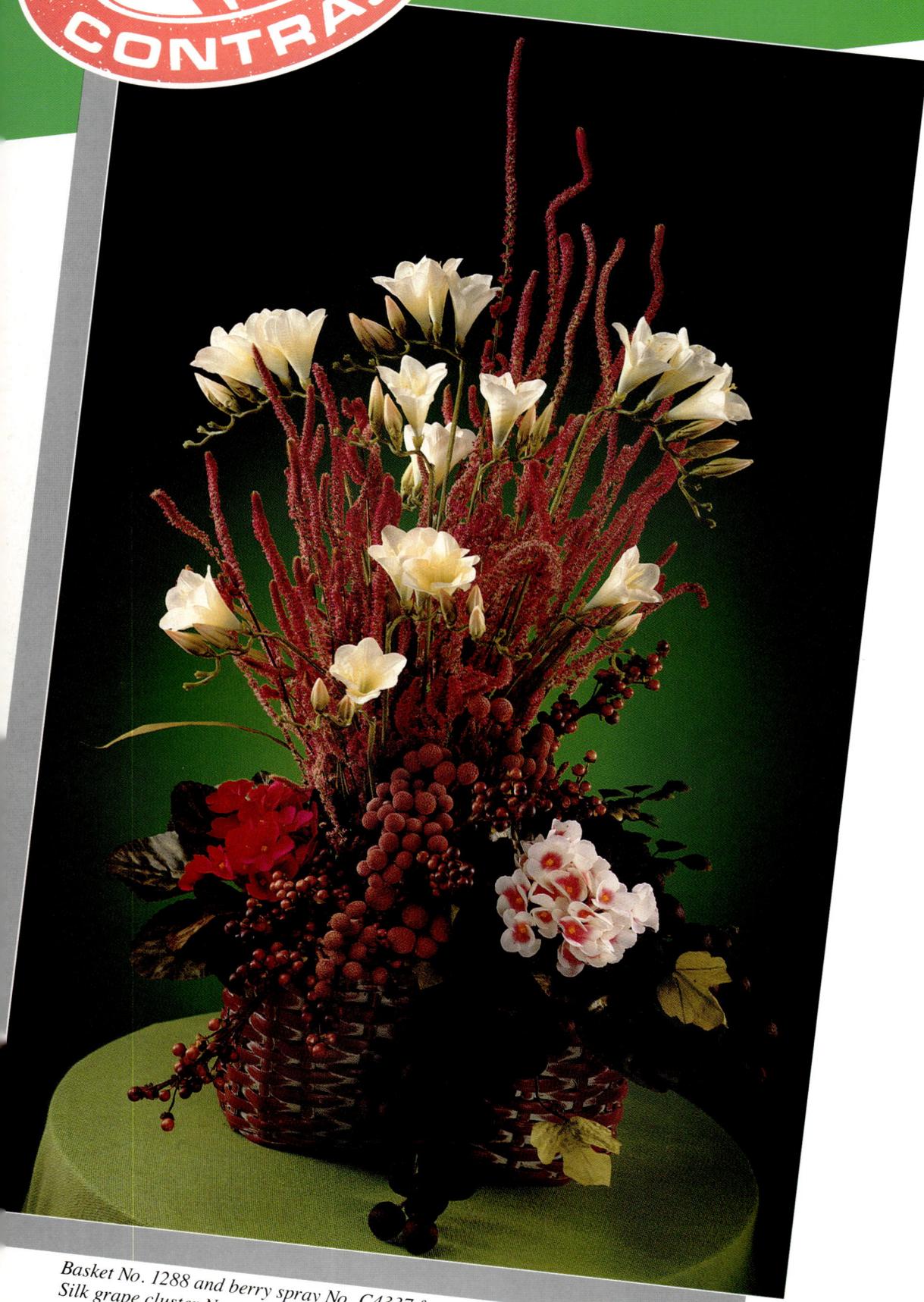

Basket No. 1288 and berry spray No. C4337 from Jim Marvin Enterprises, Ltd. Silk grape cluster No. K607 from K&D Export Import, CMC silk freesia No. RF-50745, violet plant No. AF-45924 and maidenhair fern No. GF-56104 and Knud Nielsen suveronia and bruneia available from local wholesalers.

grapes and berries are different from the shapes of the freesia and the suveronia. This difference creates contrast.

The cream color of the freesia contrasts with the red-lavender color of the other materials. There is contrast in color value. The red-lavender materials across the focal area move from deep shades to tones and tints.

This intermingling of contrasts gives the composition a distinctive personality. Yet, the composition is a perfectly orchestrated symphony of interesting forms and colors that join in perfect visual unity.

The elegant arrangement of silk flowers is distinctive because of contrasts. Scale is the most dominant contrast. Scale is a relationship between sizes. There are four distinct sizes of flowers—the large cabbage roses, the intermediate Italian roses, the wild roses and the bouvardia. Contrasts in texture, the real and implied surface quality—the visual touch—of materials, function quietly but emphatically in this composition. The basket expresses a woven texture; the flowers, different impressions of surface characteristics.

The way the artist expresses line in this composition is a differentiating point of design creativity. The line of pink roses starts at the top center with a spray of wild roses. It moves down through the design with Italian roses, a cabbage rose in the central focal point, and it concludes with wild roses in the right front. The white bouvardia move across the composition with horizontal line emphasis.

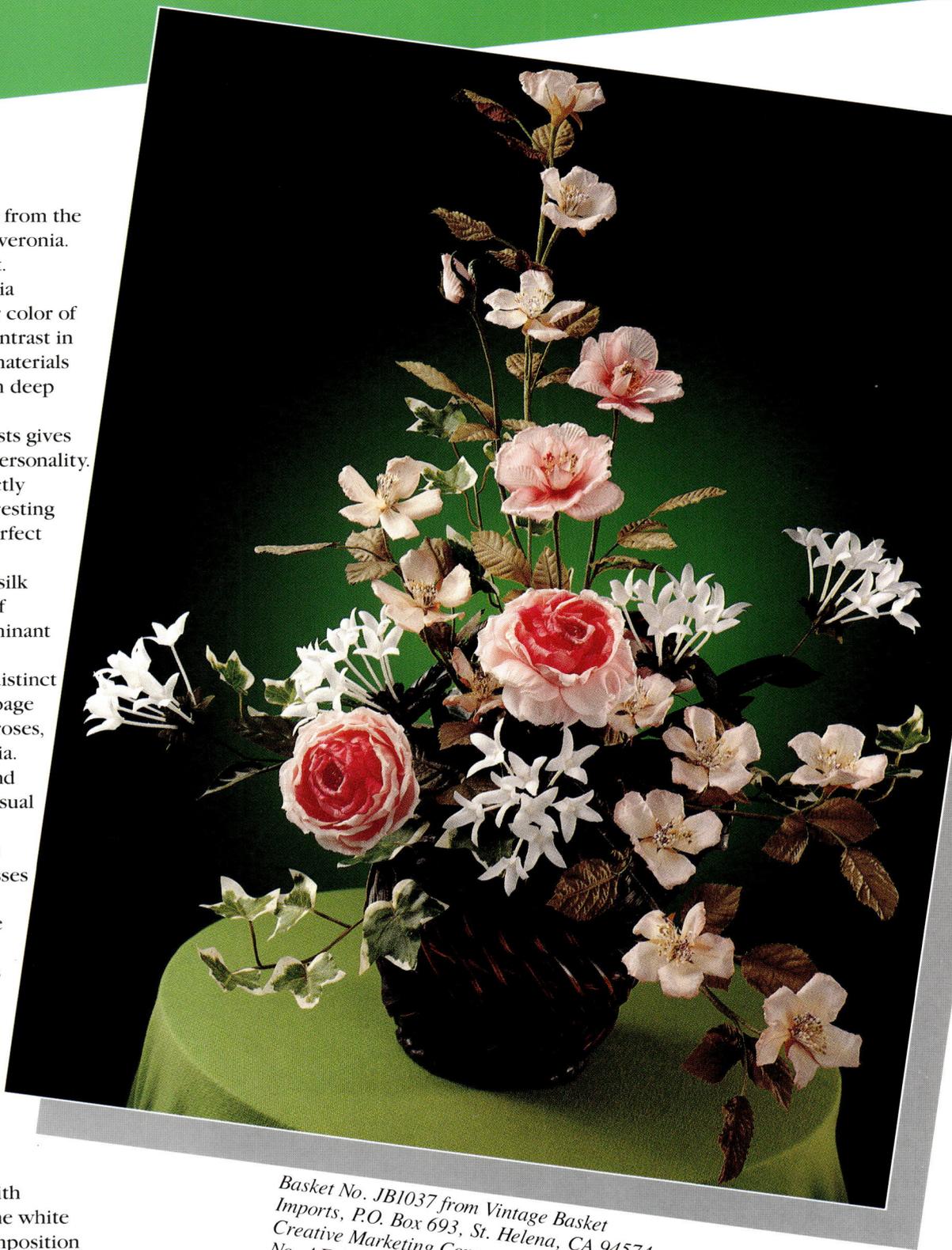

Basket No. JB1037 from Vintage Basket Imports, P.O. Box 693, St. Helena, CA 94574. Creative Marketing Concepts (CMC) silk ivy No. AF-45735, wild rose spray No. AF-455816, bouvardia No. BF-61224, cabbage rose No. BF-61220, Italian rose No. MF-69901 and galax leaf No. CF-63186; and Sahara® foam available from your local wholesaler.

The Design Process: Contrast

● contrast ● opposition ● difference

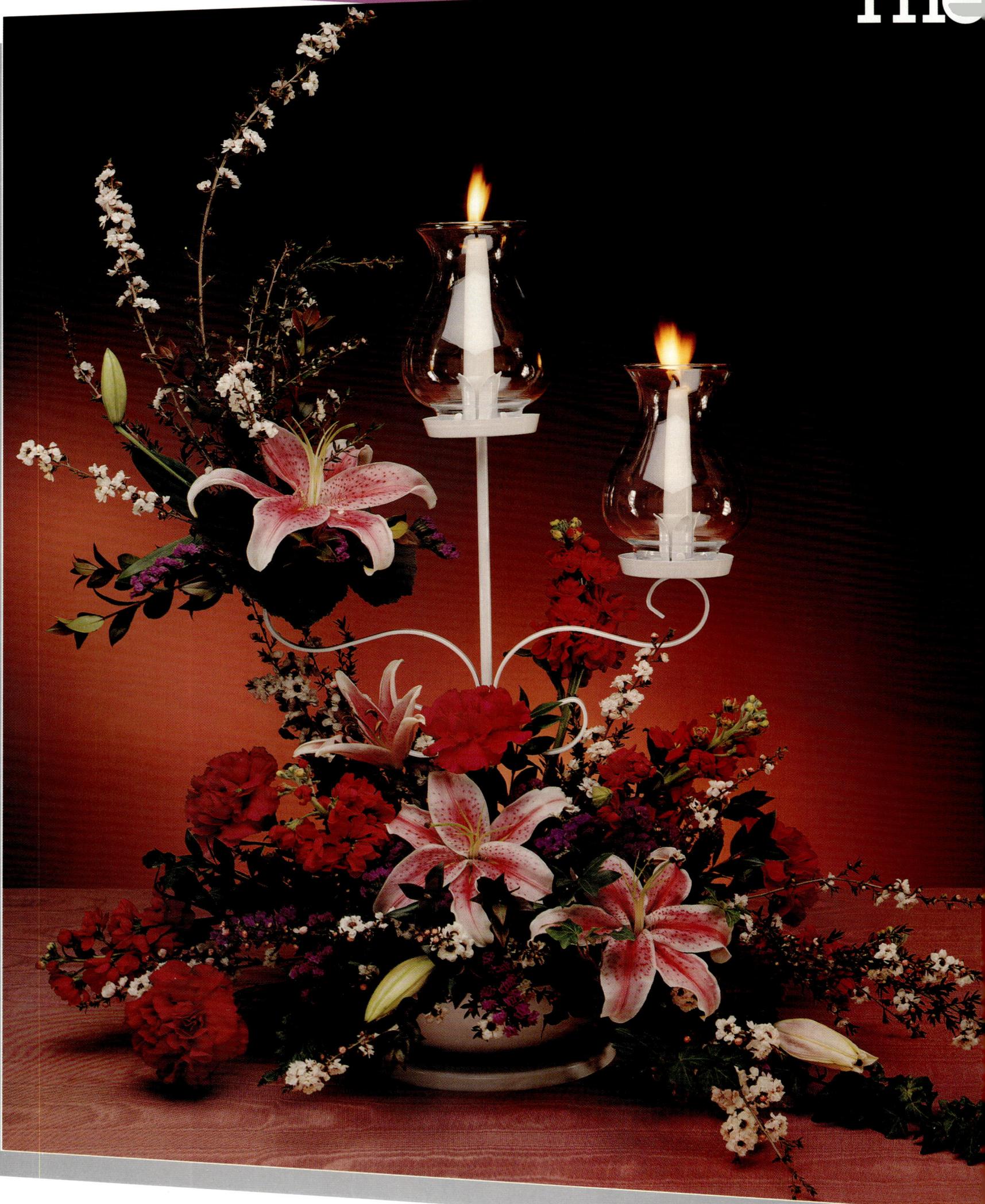

Expanded Dimension

● BALANCE

the knowledgeable designer who understands the methods for achieving contrast in his compositions can use this expanded dimension to differentiate his designs. This insight for applying contrast is an expression of creativity.

Many different contrasts appear in this beautiful hurricane table decoration. The dominant contrast is balance. The center hurricane bisects this design. In this asymmetrical design, there is more visual weight on the left than on the right. Asymmetry is balance through contrast.

There are two considerations in creating asymmetrical balance: weight and direction. Weight is the strength of dominance of the key visual materials. Direction is the path the eye follows through the composition.

This floral composition illustrates Western Line style. Western Line is an interpretation of asymmetrical. The asymmetrical line curves from high-left to low-right. The important characteristic of the Western Line style is the curving line instead of the structured vertical and horizontal lines of the Traditional Asymmetrical.

● LINE DIRECTION

The line direction in this composition starts with the upper curved tip of leptospermum that connects with the top rubrum lily. The relaxed line flow continues with the three lower rubrums and concludes with the lower right line of leptospermum.

There are three statements of weight in this composition. The single rubrum arranged on the left hurricane holder; the three rubrum lilies in the center; and, the single rubrum in the hurricane to the right. Because of their size and distinctive form, the rubrums make the dominant weight statement.

The contrast of spatial depth in this composition creates another significant contrast. Spatial depth is the third dimension that moves from the front to the back of the design. Depth is an important contrast. It gives the design a rich feeling of body. In constructing an all-front, one-sided design, the designer achieves depth by placing some blossoms behind other flowers. Spatial depth, however, is a third dimension that moves through the arrangement from front to back.

There are three distinct flower forms in this composition that are in opposition. The open lily; the round, compact carnation; and, the elongated spike-like leptospermum and stock.

Form of design style is another contrast in this composition. The bottom area of the arrangement moves in a flowing left-to-right horizontal format. (We read from left to right. Therefore, the eye records most formats from left to right.) The artist allows open, negative space between the lower portion of the composition and the upper area that initiates the flowing Western Line. Nevertheless, the eye connects the upper and lower areas and follows the asymmetrical line movement. This line pattern didn't happen by accident. The designer planned this pleasing flow of materials to give the composition distinct individuality.

This composition illustrates the Western Line style. The asymmetrical line flows through the design from high-left to low-right with a graceful, pleasing curve.

Hurricane centerpiece Nos. 900 and 903 from Davidson-Uphoff, Inc. P.O. Box 184, Clarendon Hills, IL 60514. Lomey caged floral foam used for the upper hurricane arrangement available from your local wholesaler.

THE DESIGN PROCESS
CONTRAST

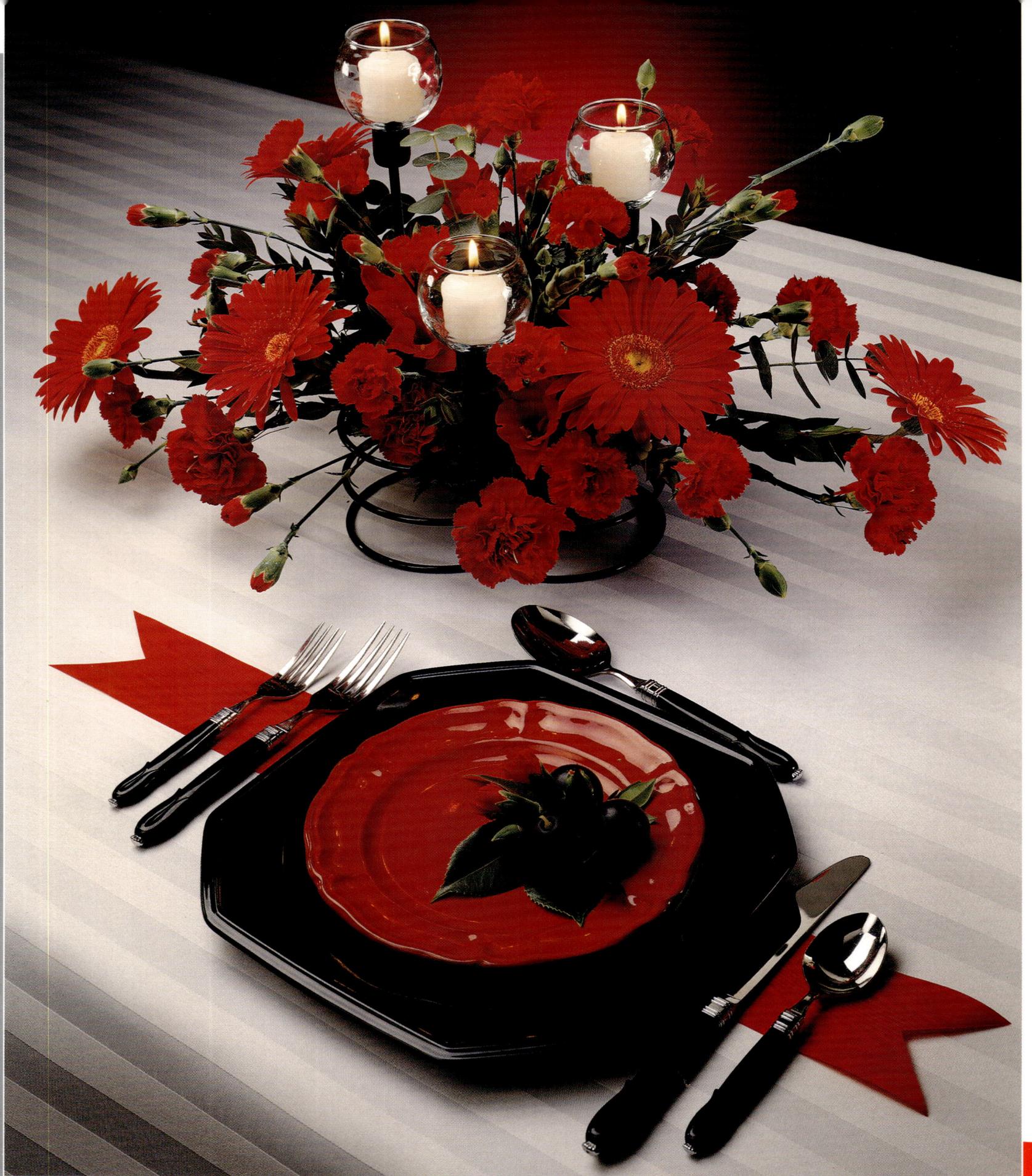

When The Same Worn-Out Choice Won't Fly

The Ritz centerpiece No. 53V from Davidson-Uphoff, Inc. Tablecloth from Immediate Tablecloth, 40–44 Austin St., Newark, NJ, 07114. McGinley Mills moire ribbon No. 242 available from your local wholesaler.

● CREATIVE SPIRIT

"The beauty of floral design goes beyond mere flowers and arrangement forms to make us aware of the boundless thought and spirit behind it."

Attracting and keeping customers means drawing attention to your individuality and creativity. The purpose of floral design is to fulfill a need. Many flower users have a need for the different, the unique, the distinctive and the original.

A black and red table decoration is the finishing touch to match the mood of an upbeat, contemporary dinner party. It doesn't matter whether the guest list is four, forty or four hundred, this red and black composition demands attention and draws compliments from everyone.

When working with a monochromatic color harmony, especially when flowers are in close color values, the point of contrast must be scale and texture. In the composition pictured, the form is a Traditional Horizontal. To give this design spirit and distinction, the artist uses miniature and standard carnations with gerbera. The contrast in size, flower form, and soft texture opposition creates the look to match the mood.

● PROVOCATIVE DESIGN

The table composition to the right suggests how to use your innovative ability to turn new corners, while giving you the freedom to create provocative new designs.

There are many themes of contrast in this table decoration. The most dominant are contrasts in structure. To introduce pointed contrast, the designer ties equisetum around one of the candle holders. This changes the structure and creates opposition—contrast—with the other two candle holders. For a mark of distinction, the designer ties one stem of pink nerine in the equisetum with pink raffia.

The base composition of flowers is a Traditional Horizontal form. Traditionalism ends here. The pink and orange color harmony generates a subtle dissonance and excitement in color contrast. It's a refreshing and fashionable look for any table where distinction and uniqueness are desirable and expected.

THE DESIGN PROCESS
CONTRAST

Lido 3-light tower No. 530 from Davidson-Uphoff, Inc., P.O. Box 184, Clarendon Hills, IL 60514. Votive candles from Creative Candles.

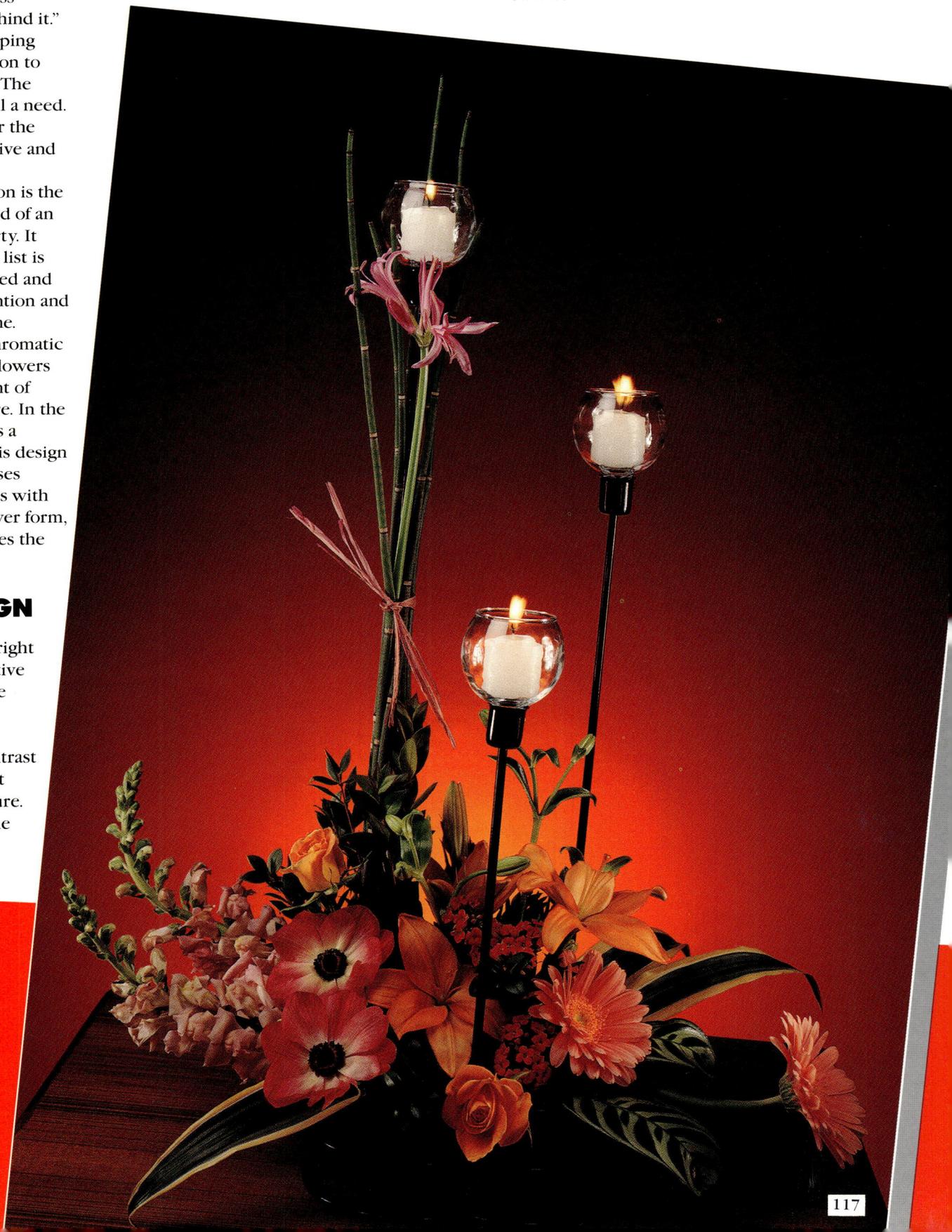

Basket No. JBI038 from Vintage Basket Imports, P.O. Box 693, South Helena, CA 94574. Knud Nielsen dried lavender, globe thistle, ming moss and reindeer moss; and Sahara® foam available from your local wholesaler.

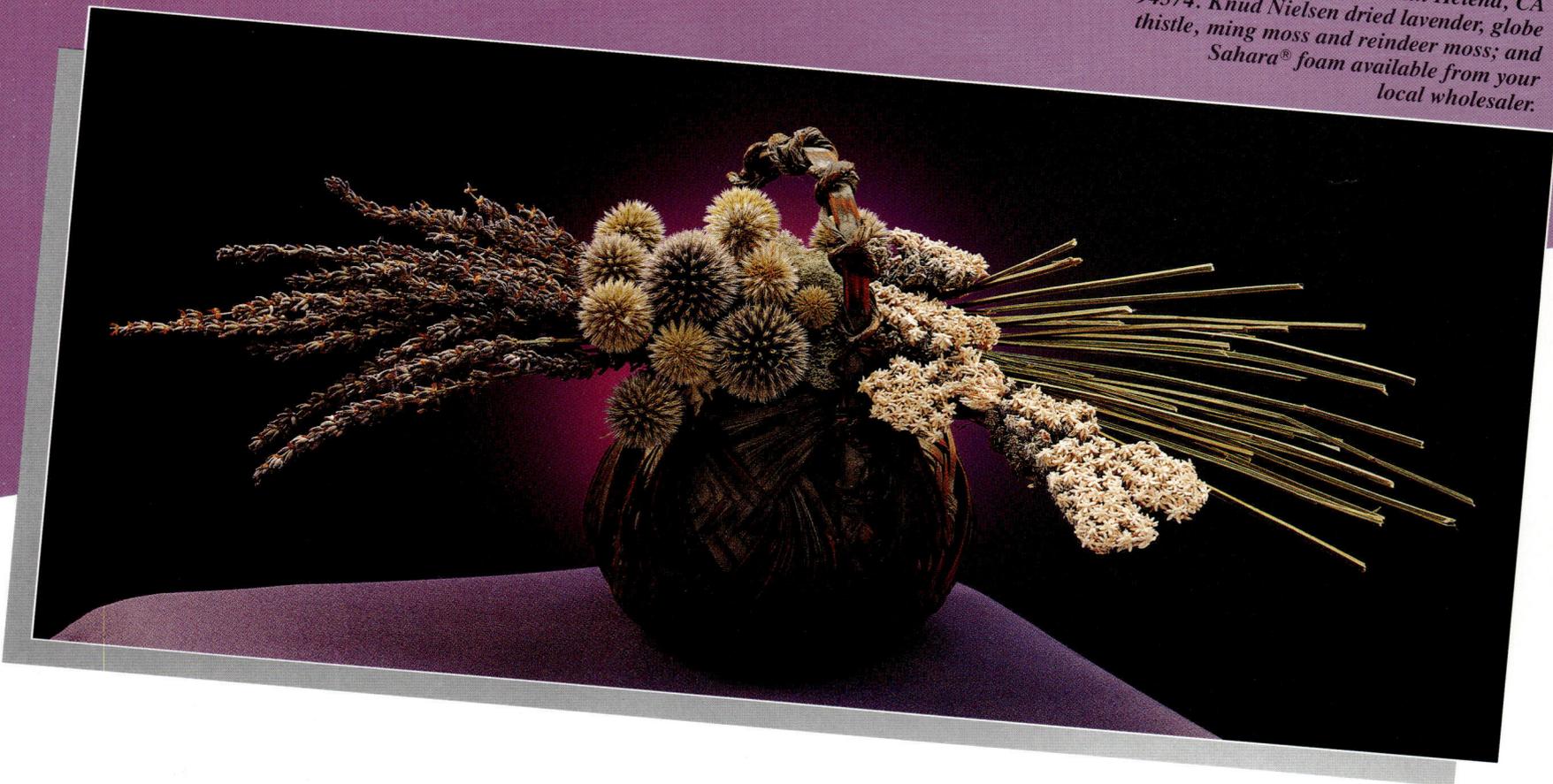

Blowing Away

The Cobwebs Of Conformity

● VISUAL DESIGN

the Design Process identifies floral design as visual esthetic design. Design is a general term used in planning the houses we live in, the automobiles we drive, the airplanes we fly in, the couches and chairs we sit in, the clothes we wear and even the dishes from which we eat.

Visual esthetic design is defined as "the kinds of objects which are primarily made to look at." Floral designs, paintings and decorative accessories all fall into this category. The same process of design applies to all three. Within each field of specialization, there are unique applications. Nevertheless, the basic art knowledge and techniques of the creative design process are much alike.

There is an appropriate niche for conformity in floral design. Sometimes, the same composition needs to be manufactured in quantity. When a design must be created for production-line assembly, there are specific guidelines to be observed and followed without deviation. Nevertheless, even the most standard, mass produced floral design starts with a creative idea. At the point of idea creation, nonconformity is an essential.

The magnificent, horizontal composition designed with intriguing dried materials exemplifies creative nonconformity. The composition style, the basket container and the selection of materials break away from the expected and the usual.

● VISUAL EMPHASIS

For visual emphasis, the designer clusters each material in a clearly defined area. There is no negative space between the materials in each cluster. And, each cluster functions as a single, unified visual unit.

Contrast—differences and opposition between materials—is the primary characteristic of this composition. The elegant dried lavender clustered to one end of the horizontal line with natural stems at the opposite end establish the line movement of this composition. The texture and form of the round globe thistle contrasts with both the lavender and the irregular shaped ming moss.

Harding Floral Co. container No. 930; and Knud Nielsen star flowers, dried kiwi vine, poppy heads, globe amaranth and hydrangea available from your local wholesaler. Deciduous huckleberry branches from Hoh Grown.

● POSSIBILITIES

By escaping the boundaries and limitations of conformity, a floral designer allows the possibility of new ideas to invade his thinking. Nonconformity is an attractive and desirable quality. All originality is born in an environment of nonconformity.

The wonderful dried materials topiary is a smashing example of nonconformity. The interesting point about both of the designs pictured is that the idea process—the point of creativity—represents nonconformity. Yet, both of these compositions could be duplicated on a production line for multiple units. In all floral design, there is a time and place for nonconformity and other periods when only conformity is appropriate.

● CONSTRUCTION

The construction of this distinctive topiary begins by inserting one bunch of star flowers into Sahara® foam. Before inserting these star flowers, the artist loosened the flower heads and pulled some up and out for an irregular mound. Then, he banded the bunch near the top and glued on the dried kiwi vine, wild huckleberry branches, globe amaranth, poppy pods and florets from dried hydrangea blossoms.

At the mossed base of the composition, the designer positioned concentric rings of dried hydrangea florets, poppy pods and globe amaranth to repeat the round form of the star flower topiary cluster. To complete the design, the artist hot glued kiwi vine, hydrangea florets and globe amaranth blossoms to the container.

Another opportunity for nonconformity. There are at least 16 different colors of star flowers. So, this same idea can be repeated in many different color presentations.

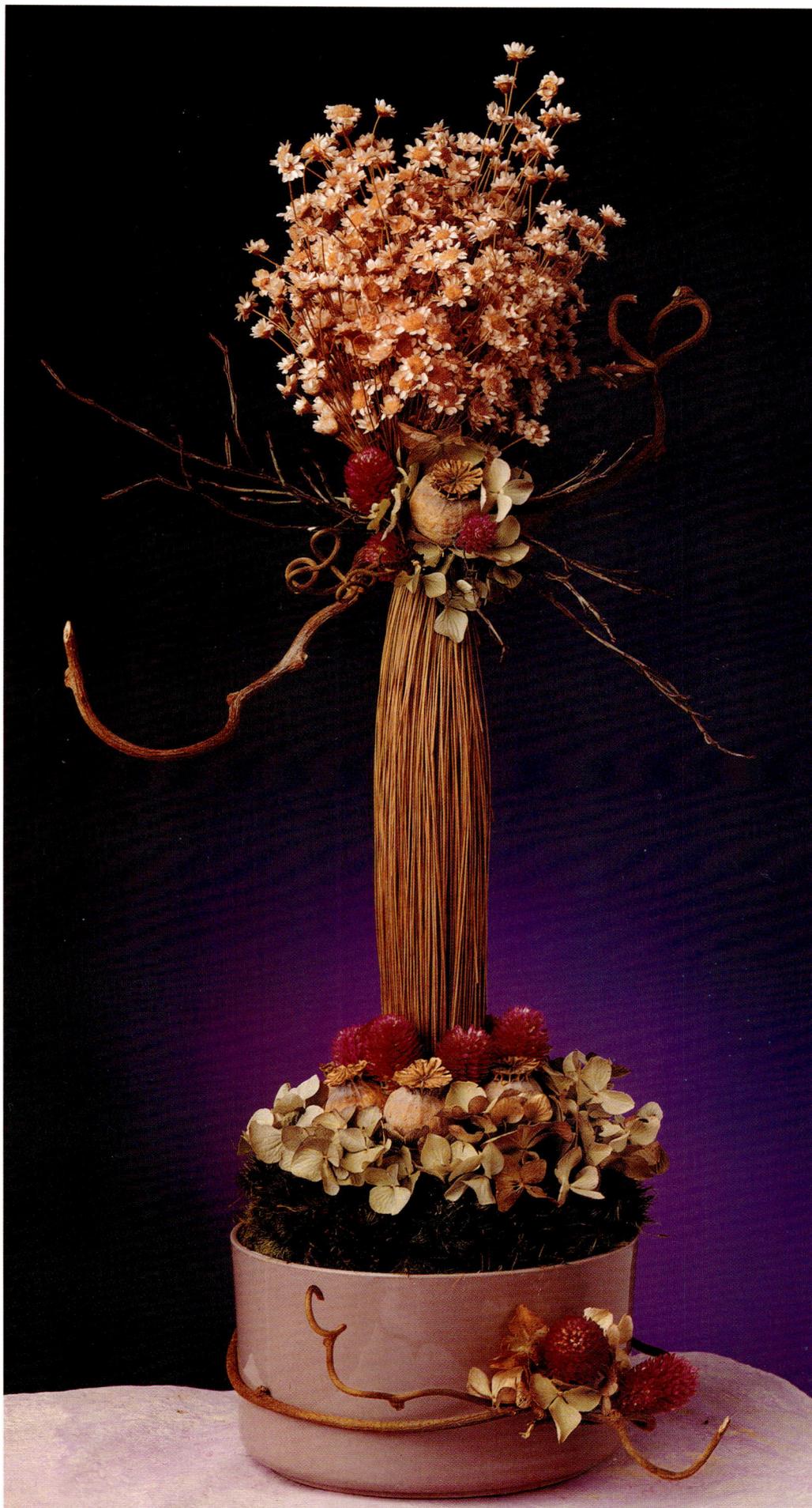

THE DESIGN PROCESS
CONTRAST

A GREET LOOK!

a b c d e f g h i j k l m n o p q u r s t u v w x y z

At your public library, you'll find these 26 letters arranged in voluminous ways. They can make you cry, giggle, love, hate, wonder, ponder, question, understand and learn.

It's astonishing what these 26 letters can do. In Shakespeare's hands, they became *Hamlet*. Mark Twain wound them into *Huckleberry Finn*. Through the creativity of James Michener, they appeared as *Hawaii*. Gibbon pondered them in *The Decline and Fall of the Roman Empire*. Milton shaped them into *Paradise Lost*. These famous authors worked with the same 26 letters. Yet, the manner in which they shaped them and presented them made each of their works totally different and unique. Each author used a personal way . . . a style . . . to express his creativity.

In floral design, creating style means using everyday flowers, greens and other materials and presenting them in a design that stands out with distinction. Too often, designers associate style only with high price tags and exotic blossoms and greens. Style is not what you have or how much it sells for, but what you do with what you have.

Style is a search for responsible creativity that fulfills a purpose, commands attention, distinguishes both the user and the creator and satisfies a customer. In the world of business, style also must have an economic value.

Smart, brilliant style speaks out with excellence in this composition featured on the cover. What gives this table decoration style? What makes it stand out with distinction?

The unique presentation of the flowers and foliages expresses a distinguishing style. The designer presents the same flowers in different ways to introduce, accent, repeat and emphasize.

Visually arousing color reinforces the vibrant style of this design. One hue in flowers and candles dominates. The white snapdragons and ornithogalum echo the white edges of the lilies for an assertive color counterpoint. The variegated dieffenbachia foliage adds a quiet, complementary color accent. And, the candles repeat the vertical line emphasis of the tallest design.

Style is in the mind and the hands of the designer. Style does not happen by accident. The sytle-conscious designer studies, experiences and works hard to distinguish his work.

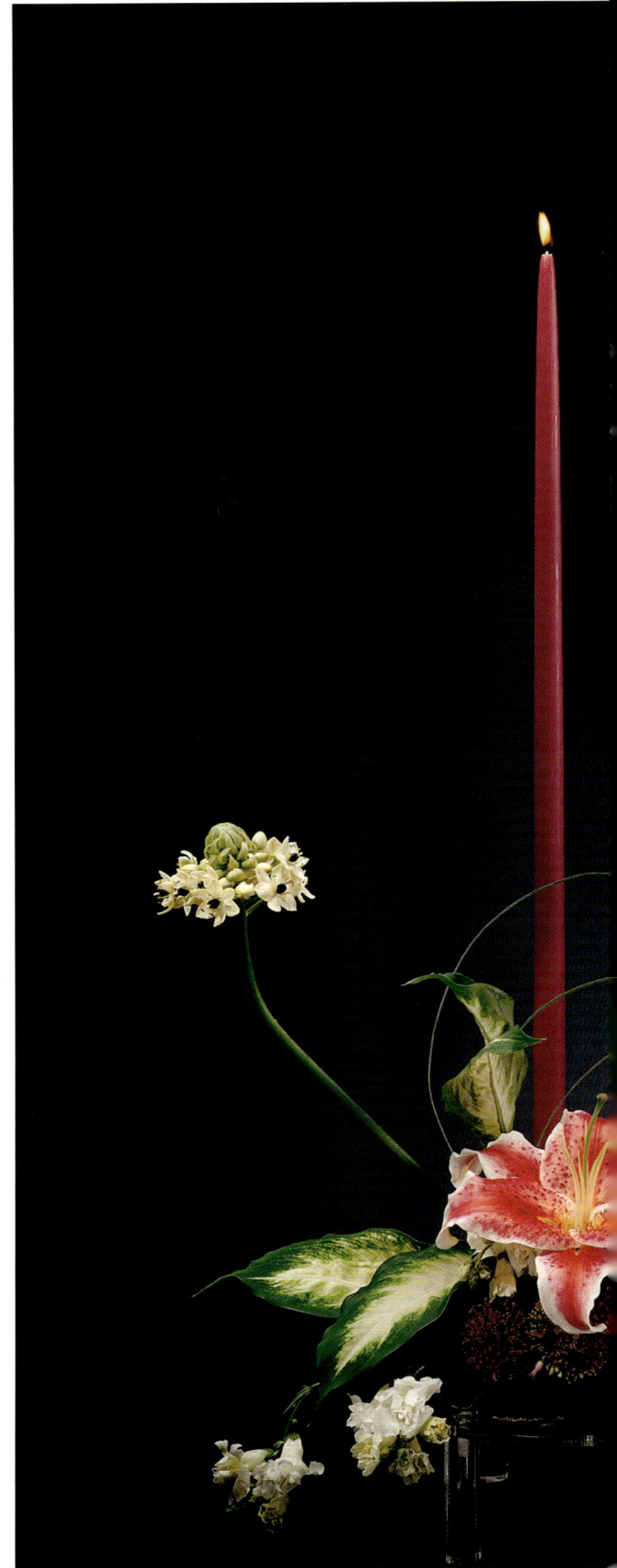

Tall No. 276 acrylic igloo opening base riser and Nos. 260, 261 and 262 (6", 8", 10" acrylic risers) from Van Horn Hayward, P.O. Box 903, Bellaire, TX 77402. Lomey caged floral foam used to hold flowers available from your local wholesaler. Candles and glass candleholders from Creative Candles, P.O. Box 19514, Kansas City, MO 64141.

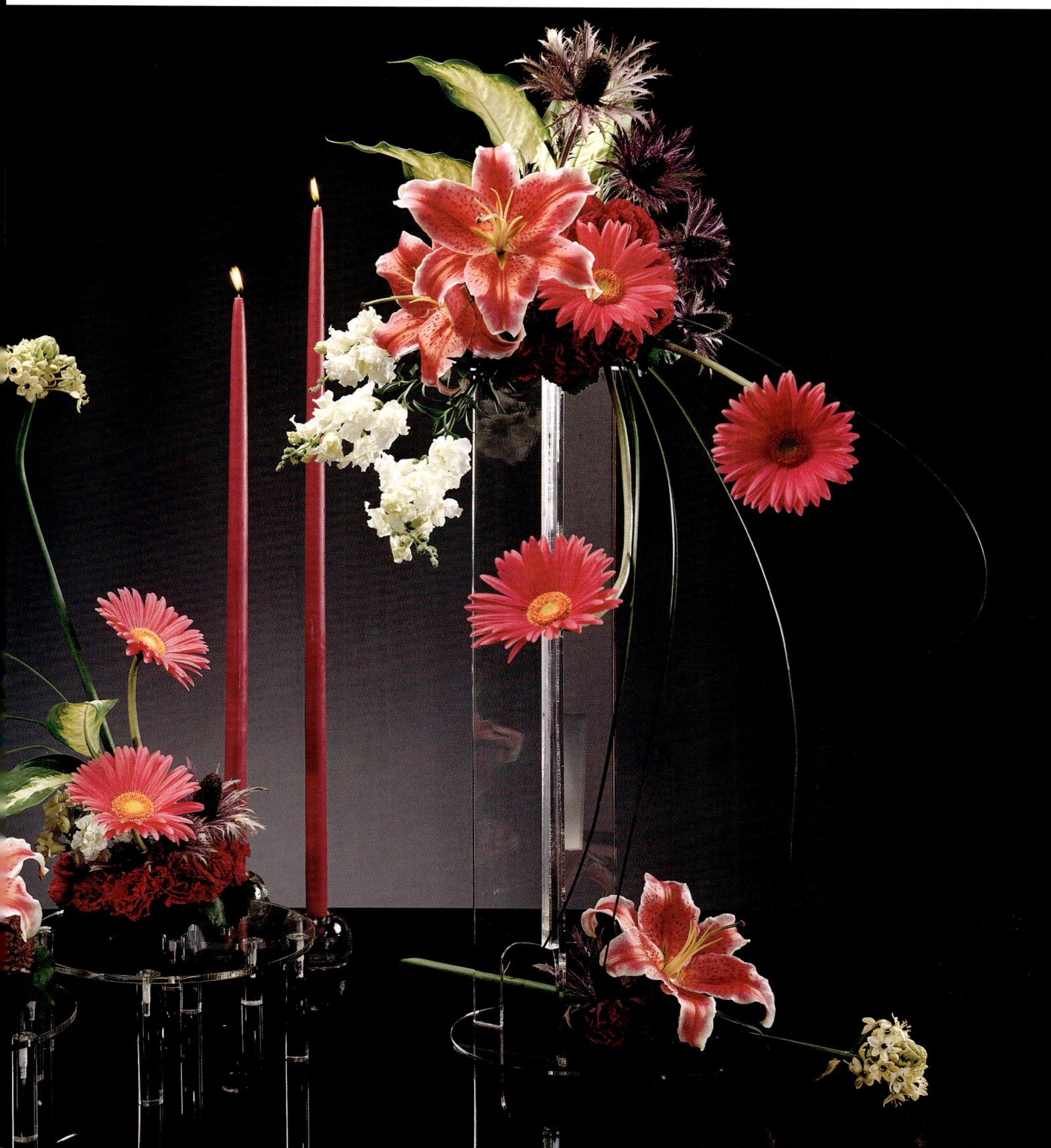

" STYLE . . . THAT VERY SPECIAL
AND UNIQUE APPROACH TO
CREATIVITY THAT ENCOURAGES A
DESIGNER TO TAKE EVERYDAY
MATERIALS AND TURN THEM
INTO THE EXTRAORDINARY,
THE DISTINCTIVE. "

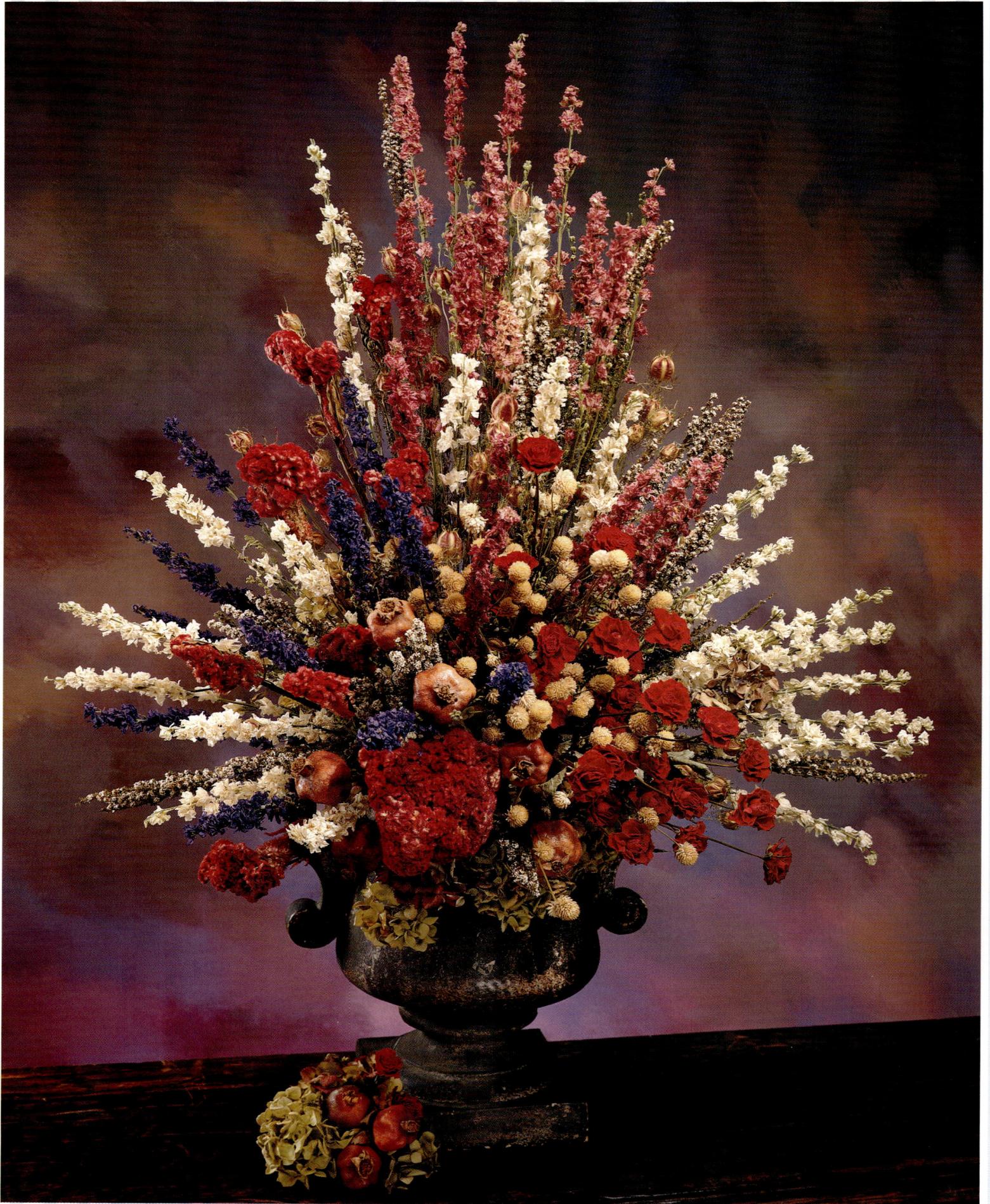

> "CREATING STYLE IS MAKING
> A GRAND ENTRANCE BY
> MAXIMIZING THE POTENTIAL OF
> COLOR, SHAPE AND TEXTURE."

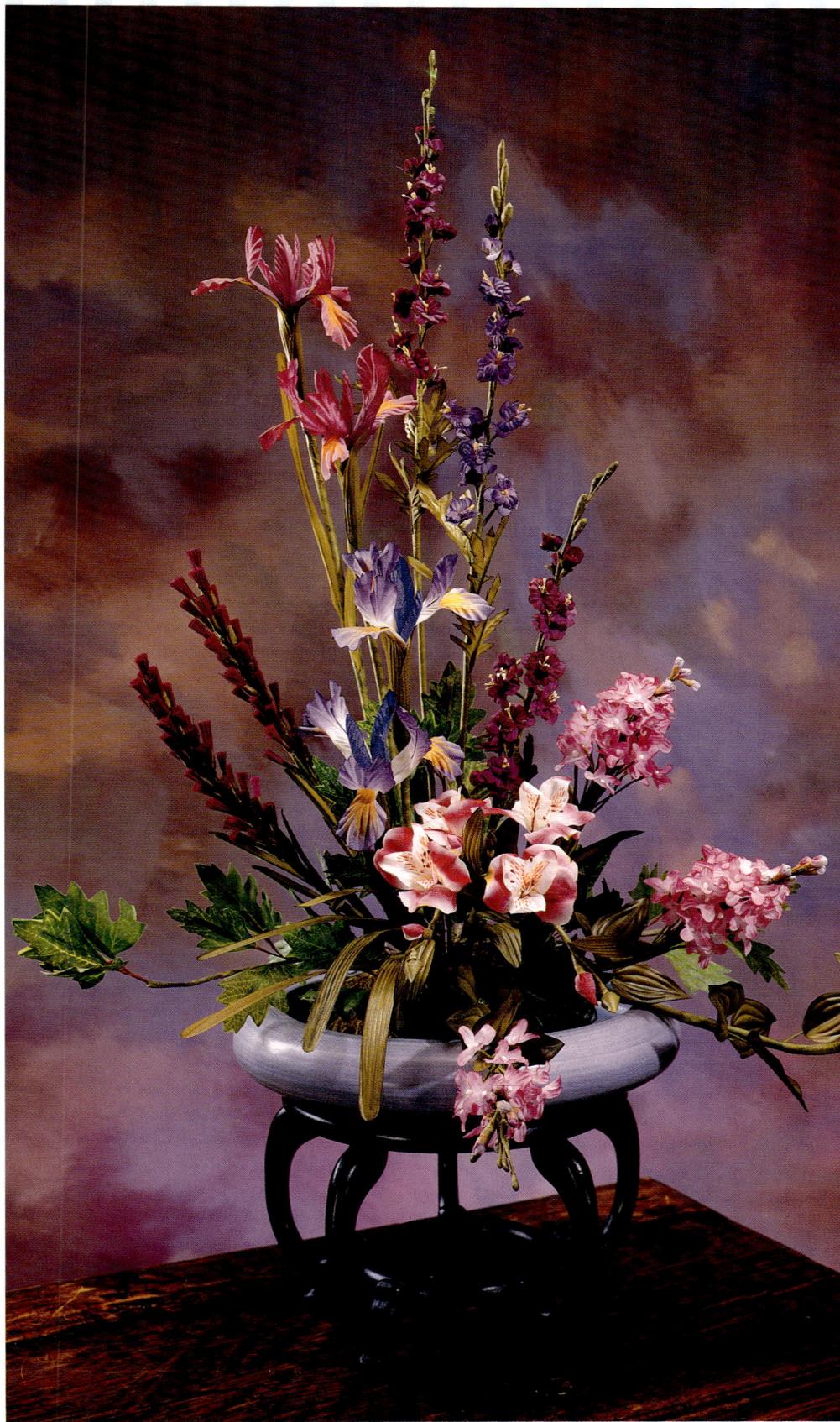

Silk larkspur No. 2608; Dutch iris No. 2612, lilac No. 2610 and alstroemeria No. 2616 from Magicsilk's Signature line; and Sahara™ arrangement foam available from your local wholesaler. Dankia foliage No. K1284 from K&D Export Import Co., 225 Fifth Ave., New York, NY 10010. Mobach pottery container No. 928. Stand No. 12-3020 from Toyo Trading Co., 13000 S. Spring St., Los Angeles, CA 90061.

Developing style is a process of looking actively. A sensitive floral designer observes what he or she sees and asks, "What am I really seeing? What do I think about it?"

You must form opinions. Avoid being confused by the clutter of choice. When you view a flower arrangement, a painting, a tastefully decorated room or the wonders of Mother Nature, mentally question what you are seeing. Then form an opinion.

Good taste, the basis of style, goes hand-in-hand with discipline. No artist is born with "natural style." Developing and fine-tuning style is a constant process of pursuing the four essential elements of style: (1) exposure, (2) experience, (3) decision and (4) practice.

Discipline yourself to look for the new. Experience what you see. This demands more than looking. From experiencing the new, make a decision about what you want to learn from this experience. Finally, practice what you learn to bring the influence of any new experience into your own personal style.

Both of the compositions pictured make a grand entrance with "classical style." One is traditional classical; the other, contemporary classical.

"Classical style is design that aspires to a state of emotional and physical equilibrium, and is rationally rather than intuitively constructed." The magnificent symmetrical composition of natural dried flowers is traditional classical, formal, triangular style. The exceptional design of silk flowers influenced with asymmetrical line movement is contemporary classical.

In each composition, the designer uses rational construction. There is a central focal area. All stems flow into and out of this axis in a radiating pattern. Each composition reflects a distinctive style. Yet, the artist achieves a state of emotional and physical equilibrium with structured construction techniques.

This classical arrangement of natural dried flowers features Knud Nielsen larkspur, red roses, hydrangea, nigella, ti tree, globe amaranth, celosia and pomegranates - all available from your local wholesaler.

The Elements Of Style

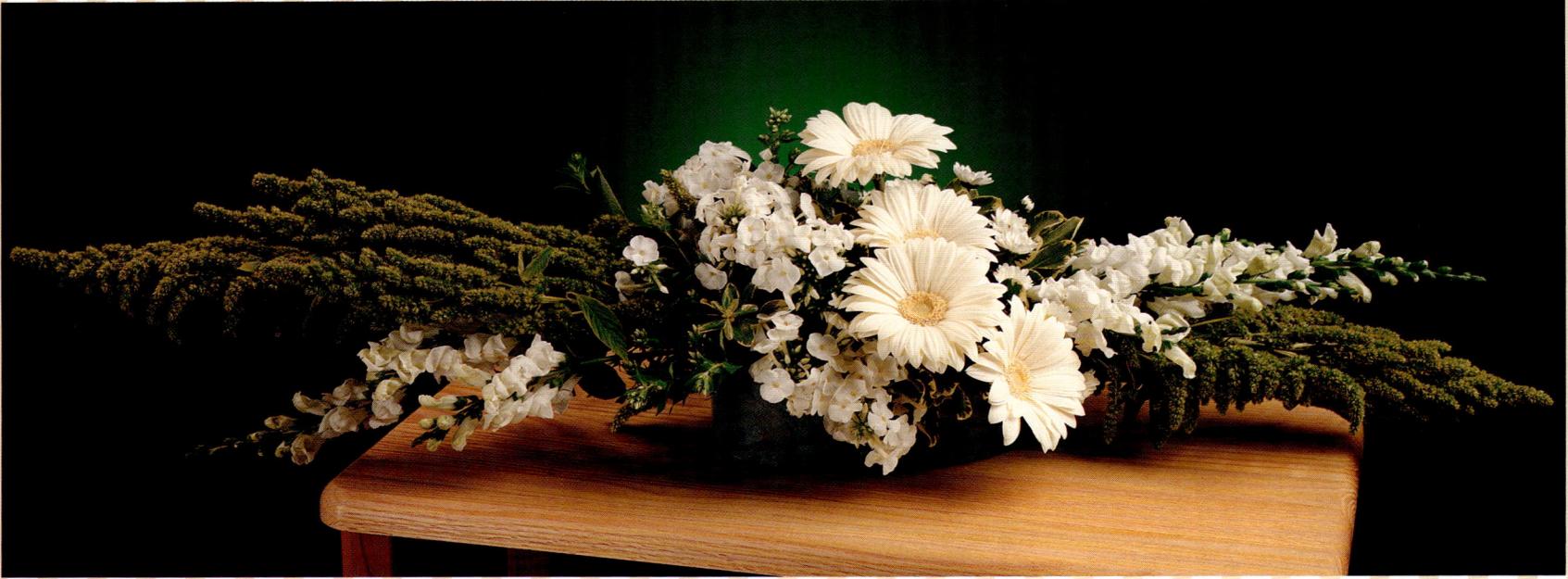

STYLE.

TWEAKING
THE
TRADITIONAL

Form is the strongest signature of traditional styling. The conventional horizontal, triangle and vertical forms are the basics in Western American floral design.

Art authorities knowledgeable in the influential periods in the history of floral design state that structured form is the strongest characteristic of American floral design. Most American floral designers focus on form (structure) compared to those who concentrate on the expressiveness of the materials.

There is a distinct difference in these two approaches to style. The form-oriented designer commences design from the viewpoint of conforming the materials to a specific design form - triangular, round, horizontal or vertical. In contrast, the expressive artist looks at the material and allows the material to dictate form.

In the horizontal composition above, the designer uses a distinctive technique in presenting the white gerbera, phlox, snapdragons and fresh amaranthus. The gerbera and phlox move in diagonal line patterns through the central focal area. In contrast, the snapdragons and amaranthus establish strong horizontal lines. This unusual presentation gives the composition unique style.

The triangular design projects color exuberance and vibrant, visual vitality.

Within a structured triangular form, the designer introduces placement spontaneity with the free-floating tulips and snapdragons on the sides of the composition. This technique relaxes the formal structure, giving the composition distinctive style.

To bring distinguishing style to the vertical design, the artist places the upper stems of gladioli, lily buds and open lily blossoms in a composite, dynamic diagonal line pattern. The casual placement of the gladiolus to the lower left, and the diagonal line of papyrus eases the formality and structure of this elegant composition. The presentation of the materials in the design gives it a distinguishing mark of style.

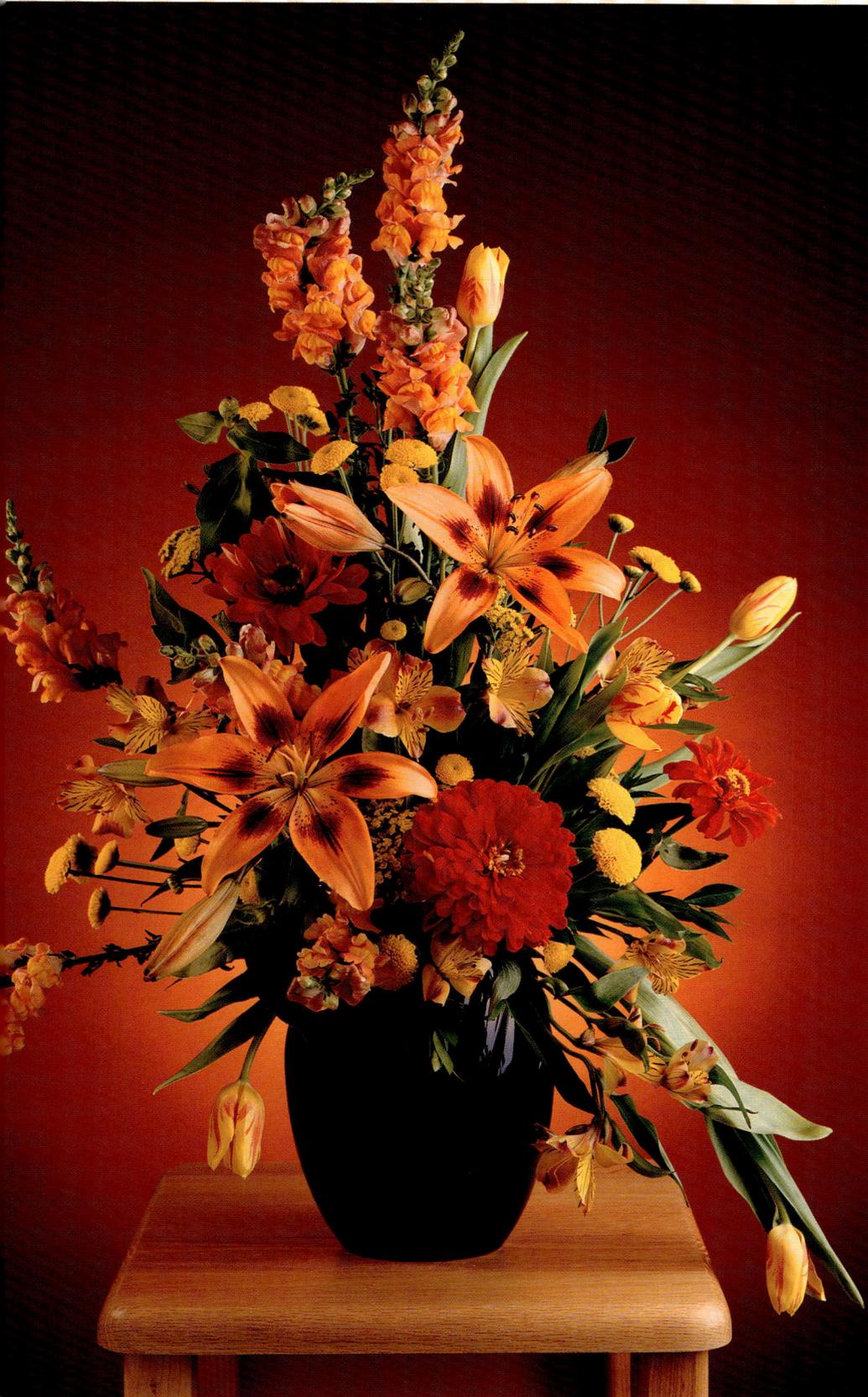

Container for horizontal arrangement, Syndicate Sales No. 505 oval in patina finish. Pottery container for triangular arrangement, Giftwares No. T13603, distributed by Pete Garcia Co. Both containers and Oasis floral foam available from your local wholesaler.

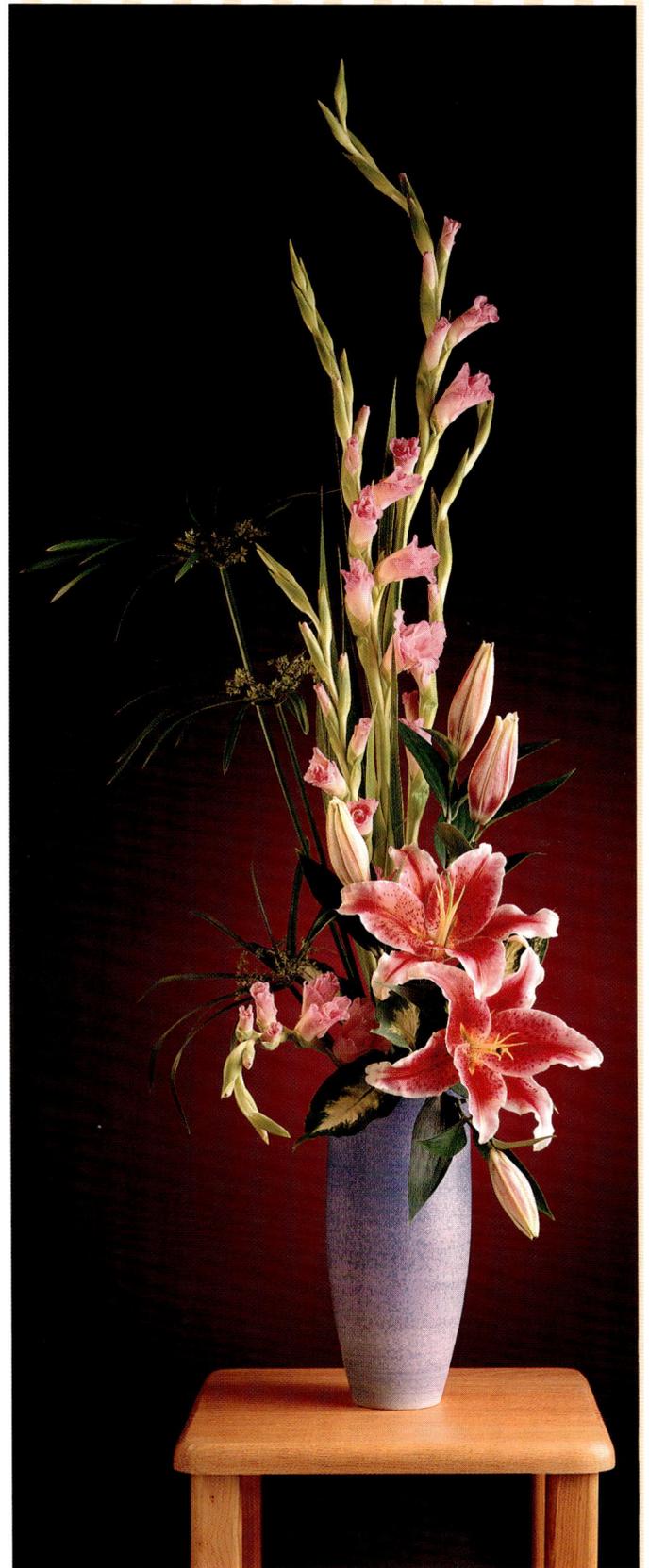

Mobach Pottery vase No. 945. You can order Mobach Pottery direct from the manufacturer in Holland. Mobach Pottery, Kanaalweg 24, Utrecht, The Netherlands.

Personality. Taste. Style

IS MORE THAN A LOOK!

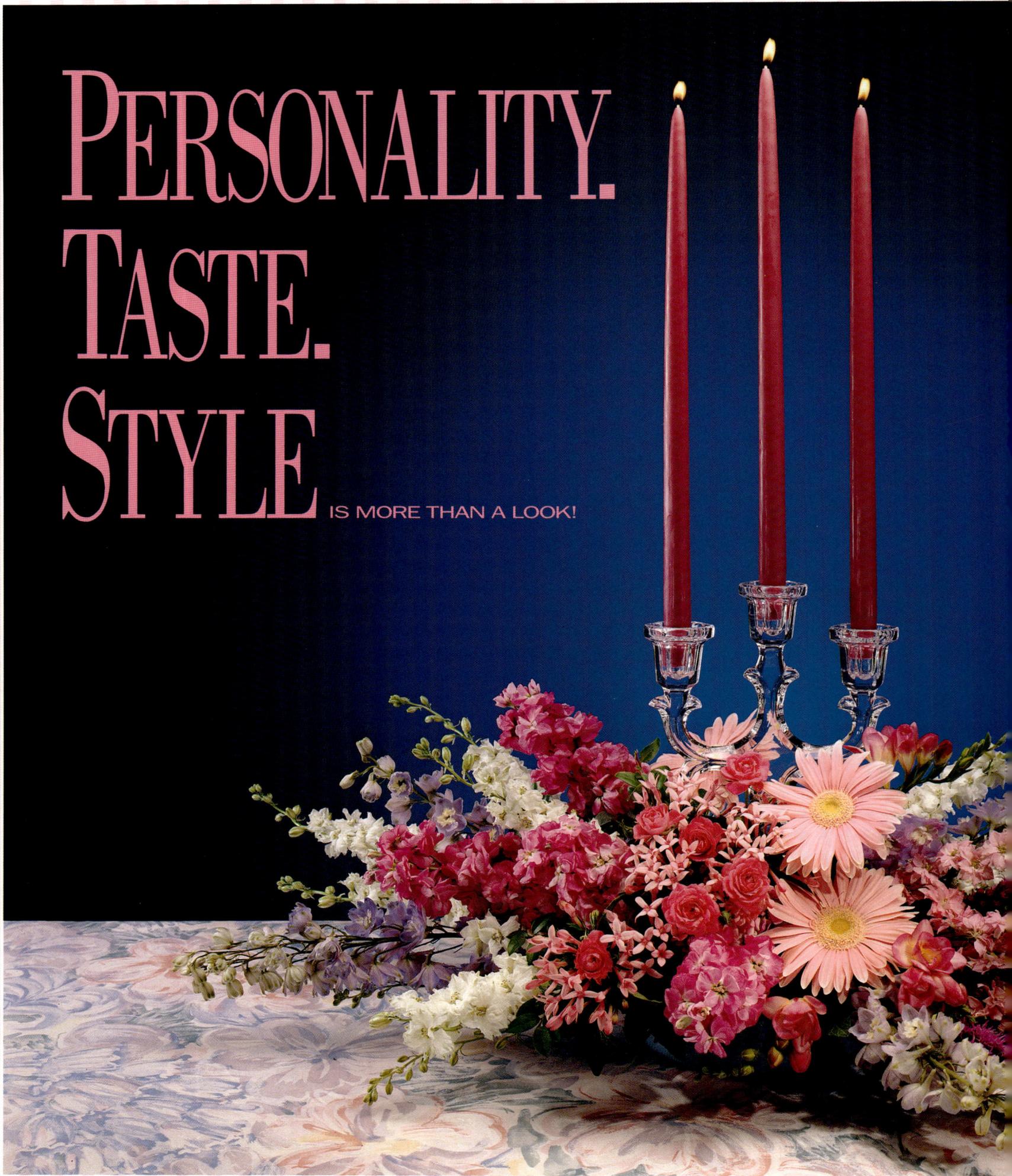

Franklin China's 8″ Finesse round bowl in Williamsburg blue available from your local wholesaler. Three-branch crystal candelabra No. 5209-9 1/2 from Sullivan, Inc., Box 1661, Sioux Falls, SD 57101. Phone 800-843-6827. Candles from Creative Candles, P.O. Box 19514, Kansas City, MO 64141.

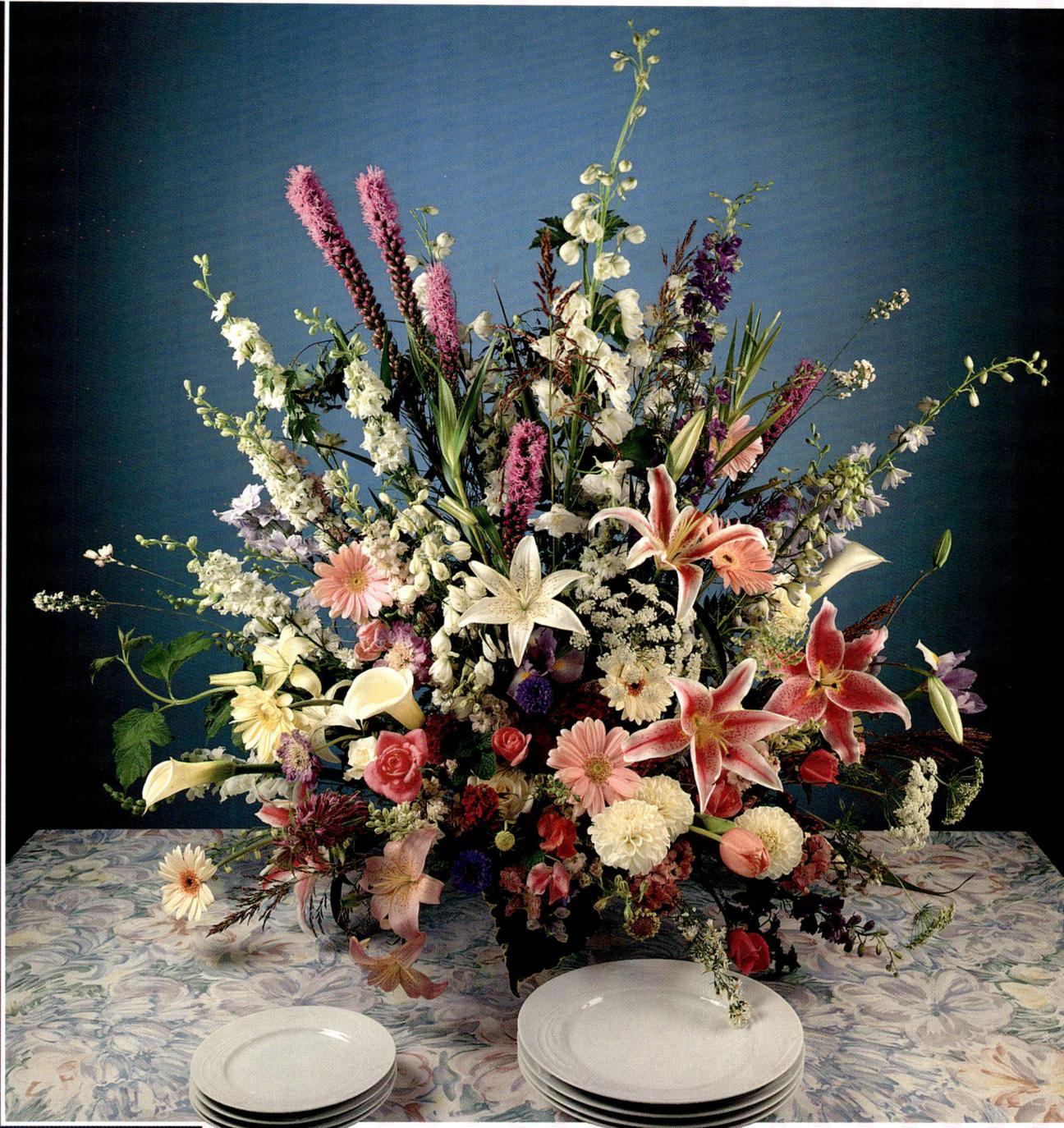

tyle is an ambivalent word. It connotes a different meaning to every individual. *The Northlight Dictionary of Art Terms* defines style as ''the artist's individual manner of working.''

Style is a personal expression of the floral designer. It is a composite of different characteristics which reflect the personality of a floral composition.

The personality of a human being expresses personal identity and unique individuality. The distinguishing identity and the individuality of a floral composition are visually apparent in the personality of the design. Style reflects uniqueness and distinction.

Another aspect of style is taste. What is taste? From an art and design perspective, taste is ''the ability to notice, appreciate and judge what is beautiful, appropriate or harmonious, or aesthetically pleasing.''

Style is in the eyes, mind and hands of the floral artist. And, it is in the eyes and the mind of the viewer. Nevertheless, style is an absolute characteristic in every floral design.

The lovely centerpiece illustrates a structured style with flower types and colors carefully organized. The groupings of roses, bouvardia and gerbera are a forceful statement in design structure which influences the style.

(Construction tip. Anchor the crystal candlestick on top of the floral foam before arranging the flowers.)

The outstanding design above is an open, unstructured, free-spirited style. Compare the two compositions pictured. Note the two distinctly different personalities expressed.

The same floral artist created both of these compositions. A competent, experienced floral designer develops the ability to create many different styles.

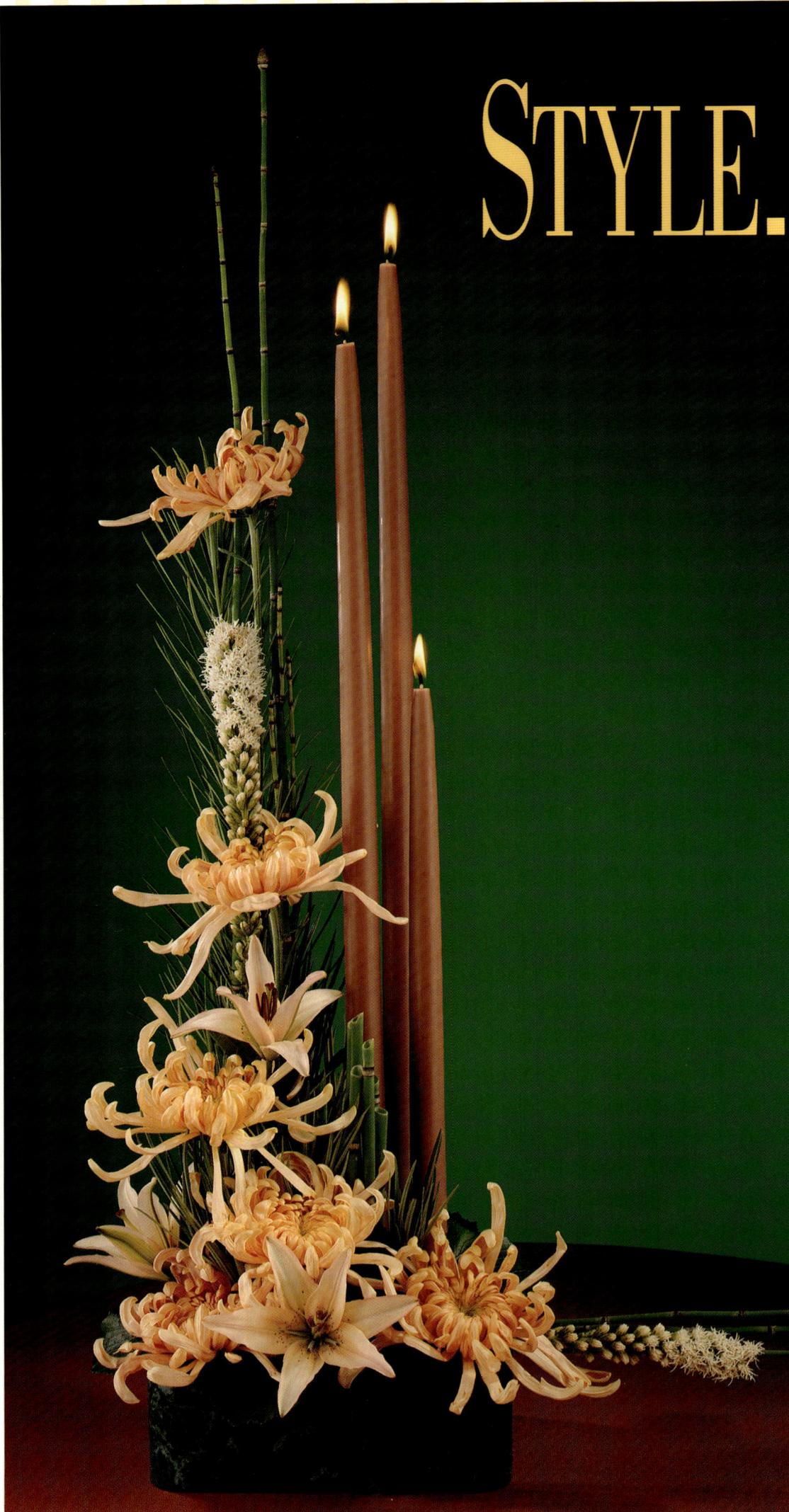

Styles change. But style does not. There is a timelessness about smart style which pervades a design. Call it a sense of scale, proportion, color, individualism - or whatever distinguishes the composition. The point is that the design stands out with a look of beauty, harmony and excellence. It is appropriate and pleasing.

The two magnificent designs pictured have style - unique, distinctive personalities. Both are formal, structured styles which express elegance and creative excellence.

In the asymmetrical design, the artist emphasizes vertical line with parallelism. The equisetum, spider chrysanthemums and liatris introduce the vertical line which is repeated with the candles. The strong angular lines of this design give it a feeling of comfortable, updated contemporary style.

The composition to the right is structured within a formal triangular form. It expresses a sense of Old World style updated with clear, clean lines. The artist keeps the eremurus, roses and alstroemeria within the framework of the candles. Only the strands of ivy flow in free-form lines at the base of the composition.

Container for the asymmetrical design: Syndicate Sales Trendsetter No. 506 (set of 3) in malachite finish available from your local wholesaler. Birds on Branches Centerpiece container (celedon bowl, semi-circular wrought iron branches and candle cups in bronze finish and birds and leaves in verdigris finish) No. 1125 from Great City Traders, 537 Stevenson, San Francisco, CA 94103-1636. Candles from Creative Candles.

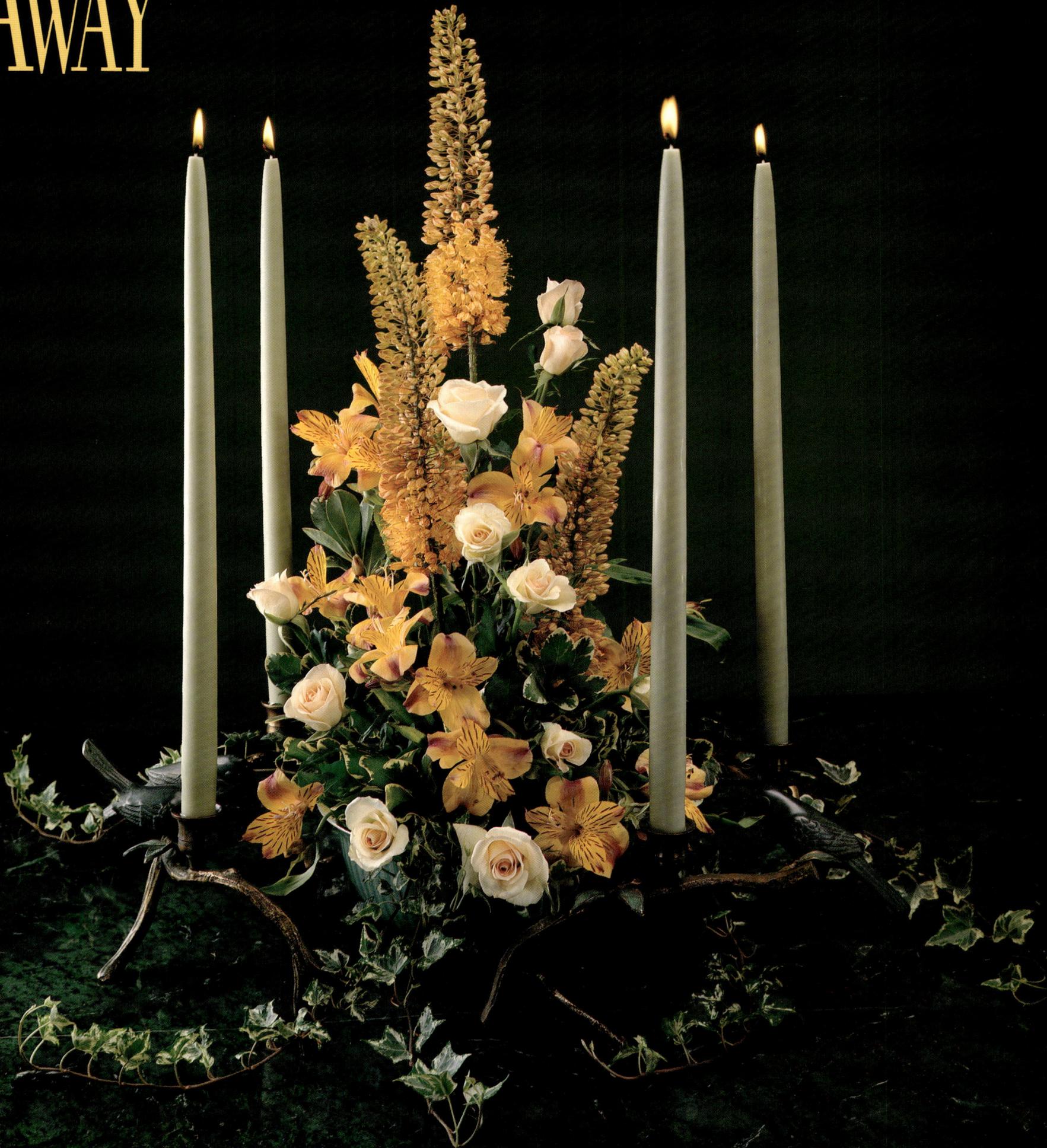

AWAY FROM THE ORDINARY.

PERSONAL STYLE

BEING THE

CAPTAIN

OF YOUR OWN

SHIP.

A designer displays the spirit and character of style in many ways. One is by attention to details that move a floral composition away from the masses of the boring designs which inundate the world of floral design today.

Far too many designers live in a copy-artist world. There is little room for creative style. The opportunity to create is restricted to reproducing what someone has done and imitating what everyone else is doing.

It is true that there is little in floral design that is totally original. Style does come from exposure to someone else's ideas which a designer interprets into his own style.

Style is influenced by advice. A growing designer - and every floral designer should be in a growth pattern - comes from listening to the observations of others. But advice must be evaluated, not applied without conscious appraisal.

Style arises from inspiration. A floral designer finds inspiration in the pages of books, from listening to music, by studying art, from learning the techniques of interior design, through experiencing brooks, oceans, deserts and forests - and often from quiet contemplation. A style-conscious floral artist knows the sources which inspire and constantly seeks them out.

Style emerges from imagination. This is the inward source of style. Ideas, advice and inspiration originate in your outer world. But imagination comes from inside, after you have processed ideas, advice and inspiration. Your personal style springs up from your imagination.

The extraordinary table setting pictured is a marvelous example of style. The composition is actually split into two distinct points of accent. The extended branch of camellia foliage on the right flows into the design and moves into the grouping of yellow lilies. On the opposite side of center, flax leaves and ornithogalum fan into vertical emphasis and unify into the single center lily.

The three stems of yellow snapdragons on the lower right complete an implied diagonal line initiated by the ornithogalum. And, the two isolated gerbera to the left give the composition a feeling of sweeping horizontal line emphasis.

Square bowl No. 51-7462, companion candlesticks No. 24-2751 and gold iron quail No. 19-3941 from Toyo Trading Co., 13000 S. Spring St., Los Angeles, CA 90061. Candles from Creative Candles.

CREATIVE AUTHORITY

A modern approach to simple forms and uncomplicated designs created with minimum materials introduces an important statement in style. Line advances as the dominant, the most apparent detail of design authority in the three designs pictured.

In the anthurium composition, the artist presents two anthurium blossoms with dominant visual emphasis and then repeats this pairing with the two Silver Queen aglaonema and two galax leaves. This pairing stair-steps down from the anthurium to the aglaonema to the galax. The bear grass tied to the upper anthurium introduces dynamic counterpoint line.

Static vertical and dynamic counterpoint lines create exciting visual tension in the arrangement featuring miniature heliconia and variegated flax leaves. The two flax leaves repeat with strong visual drama the open spaces (voids) on the two heliconia stems that connect the blossoms to the arrangement. (Cut each flax leaf into two pieces and insert the upper and lower portion separately).

The composition with gerbera and leucadendron is a flawless example of line authority. Two stems of leucadendron stand out with commanding diagonal line positions. Four gerbera move through the base of the composition with dominant, curving horizontal line authority. The fanned line of leucadendron foliage behind the gerbera brings visual unity to the composition.

Ceramic containers available from Reini Moser, Moser's Dried Flower Barn, 14065 Cleveland, Nunica, MI 49448. Anthurium and miniature heliconia from Hawaii Tropical Flowers, 431 Alamaha St., Kahului, Maui, HI 96732. Leucadendron from Silvermink Protea, 14111 Westfork Rd., Pauma Valley, CA 92061.

QUALITY.
VALUE.
THAT'S &STYLE!

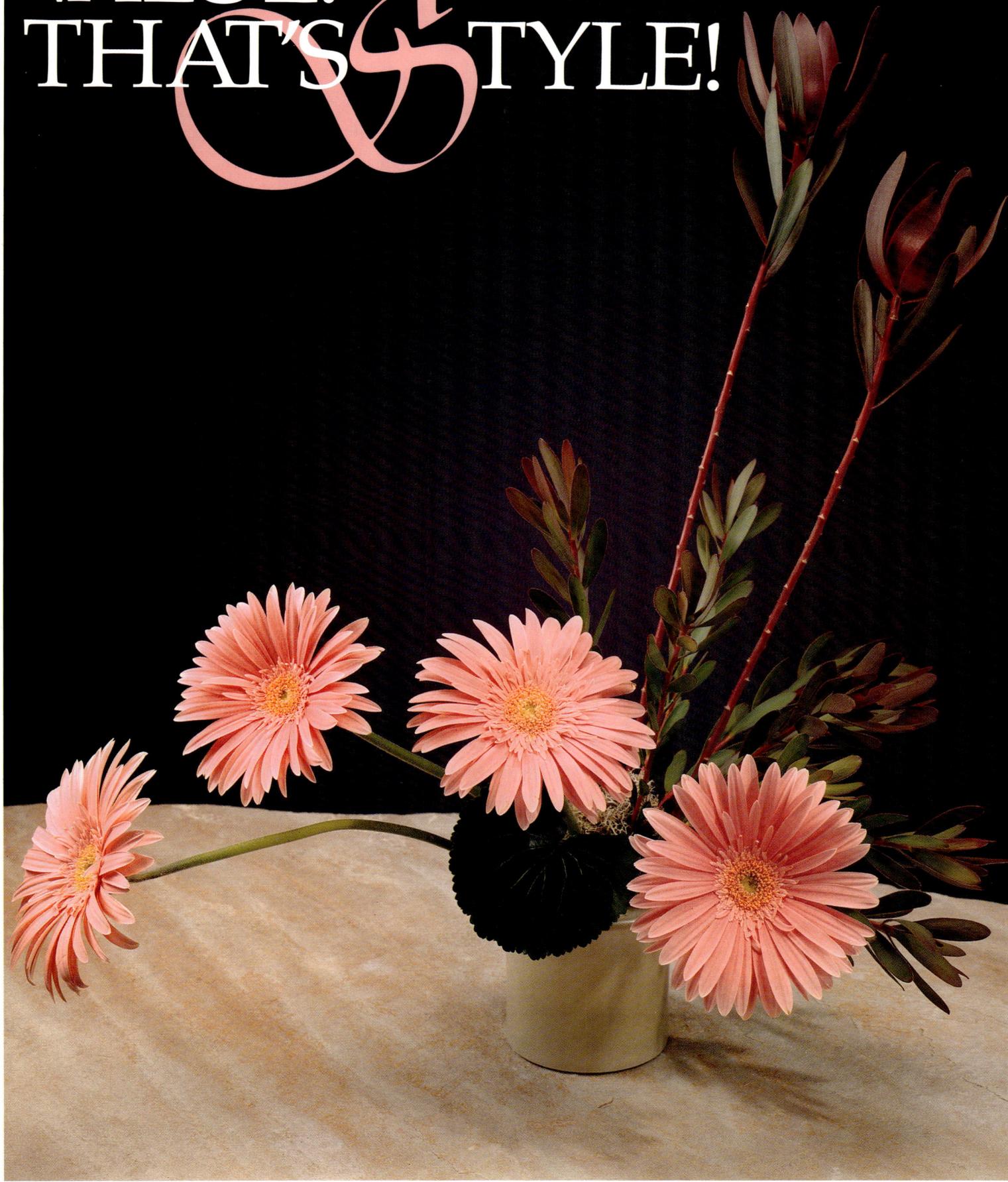

BASIC GEOMETRY

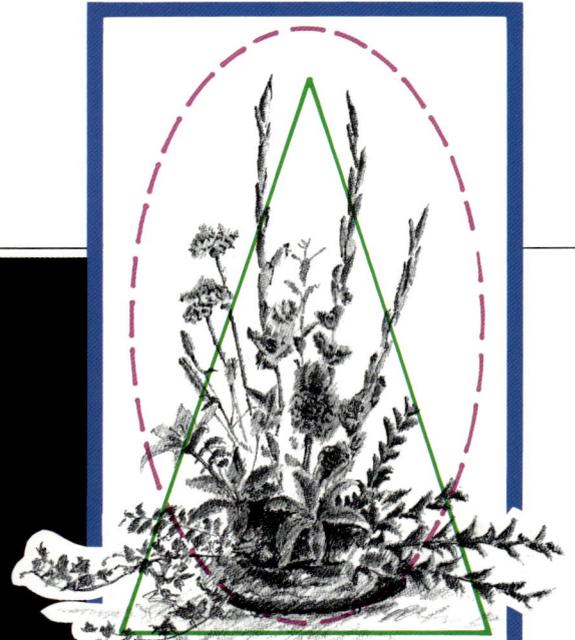

The primary geometric form of this design is a triangle because the ligustrum and ivy extend the base line of the composition. From another point of view, the flowers fall within an oval form. This is implied visual form since the viewer decides whether he sees the design as a triangle or an oval.

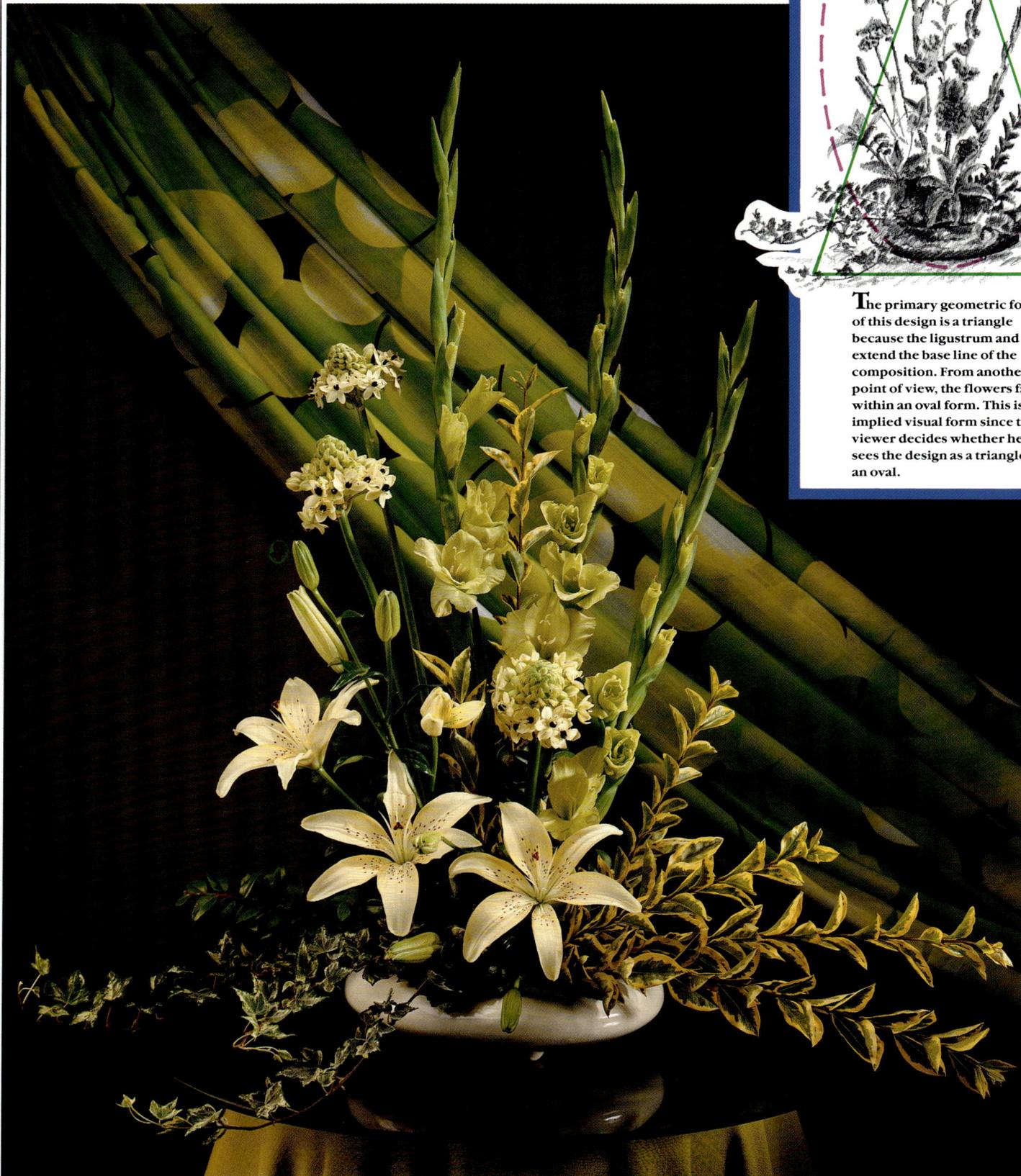

AN

Sources: White ceramic containers from L. A. Floral Supply, Wall St., Los Angeles, CA. Lilies from Sun Valley Farms, 1789 27th St., Arcata, CA 95521. Anthurium from Hawaii Tropical Flowers, 431 Alamaha St., Kahului, Maui, HI 96732.

UNUSUAL TWIST TO STYLE

Floral designs that conform to strong geometric forms or imply enclosure by geometric forms introduce another approach to style. In geometric form design, the all-important consideration is maximizing the potential of a space and the materials it contains.

In 1913, Russian artist, Kazimir Malevich, introduced geometric in his paintings. He based his compositions on simple geometric forms - the square, circle and triangle. Malevich called this approach *suprematism* and saw his art as an expression of architecture. This architectonic technique led the way to constructivism which is the idea that art is construction, like architecture. Malevich's introduction of geometric form is thought to have made an important contribution to modern art.

The composition featuring gladioli, ornithogalum, lilies, variegated ligustrum and ivy strands might be identified as a triangle or an oval, depending on the point of view. Therefore, it shows implied geometric form.

In the striking contemporary design of green anthurium, yellow gerbera, equisetum and nephthytis, the designer maintains a clear-cut square form. The one stem of equisetum to the upper right with the tip bent back into the design establishes the upper line of the square format. The repetition of the equisetum on the opposite side fixes the outer limits of the square composition.

The parallel placement of the central group of six anthurium reinforces the vertical and horizontal lines that make up a square. The three upper blossoms move across the design in an authoritative horizontal line. The two lower anthurium and the single blossom at the base repeat this linear movement, strengthening the vertical and horizontal line structure of the composition.

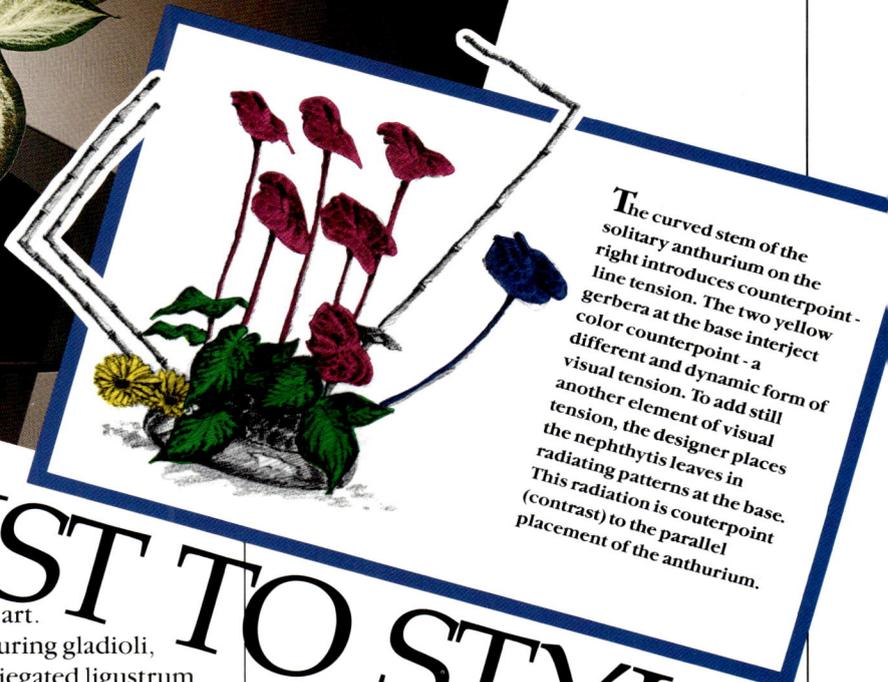

The curved stem of the solitary anthurium on the right introduces counterpoint - line tension. The two yellow gerbera at the base interject color counterpoint - a different and dynamic form of visual tension. To add still another element of visual tension, the designer places the nephthytis leaves in radiating patterns at the base. This radiation is couterpoint (contrast) to the parallel placement of the anthurium.

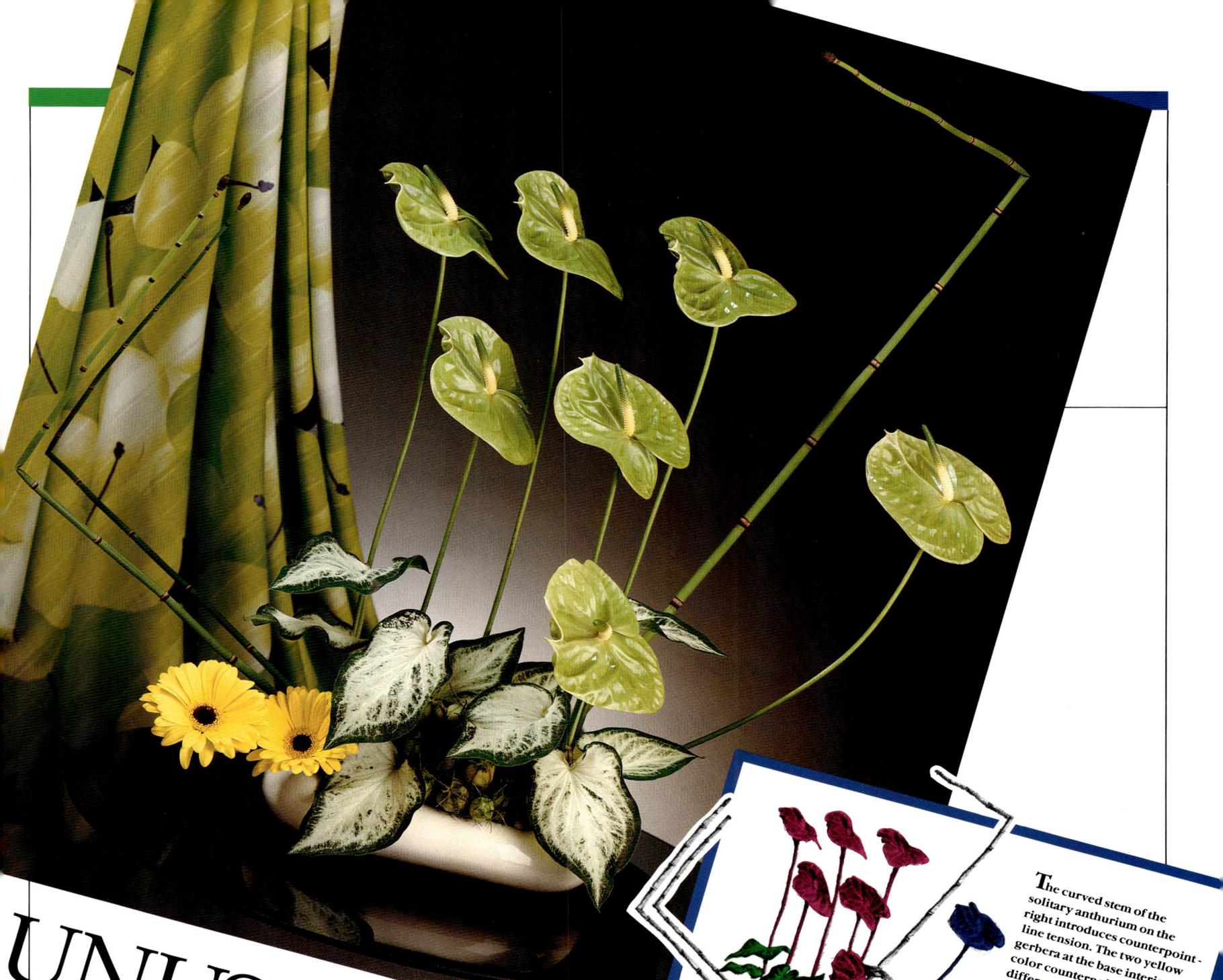

TAKE A SIMPLE IDEA

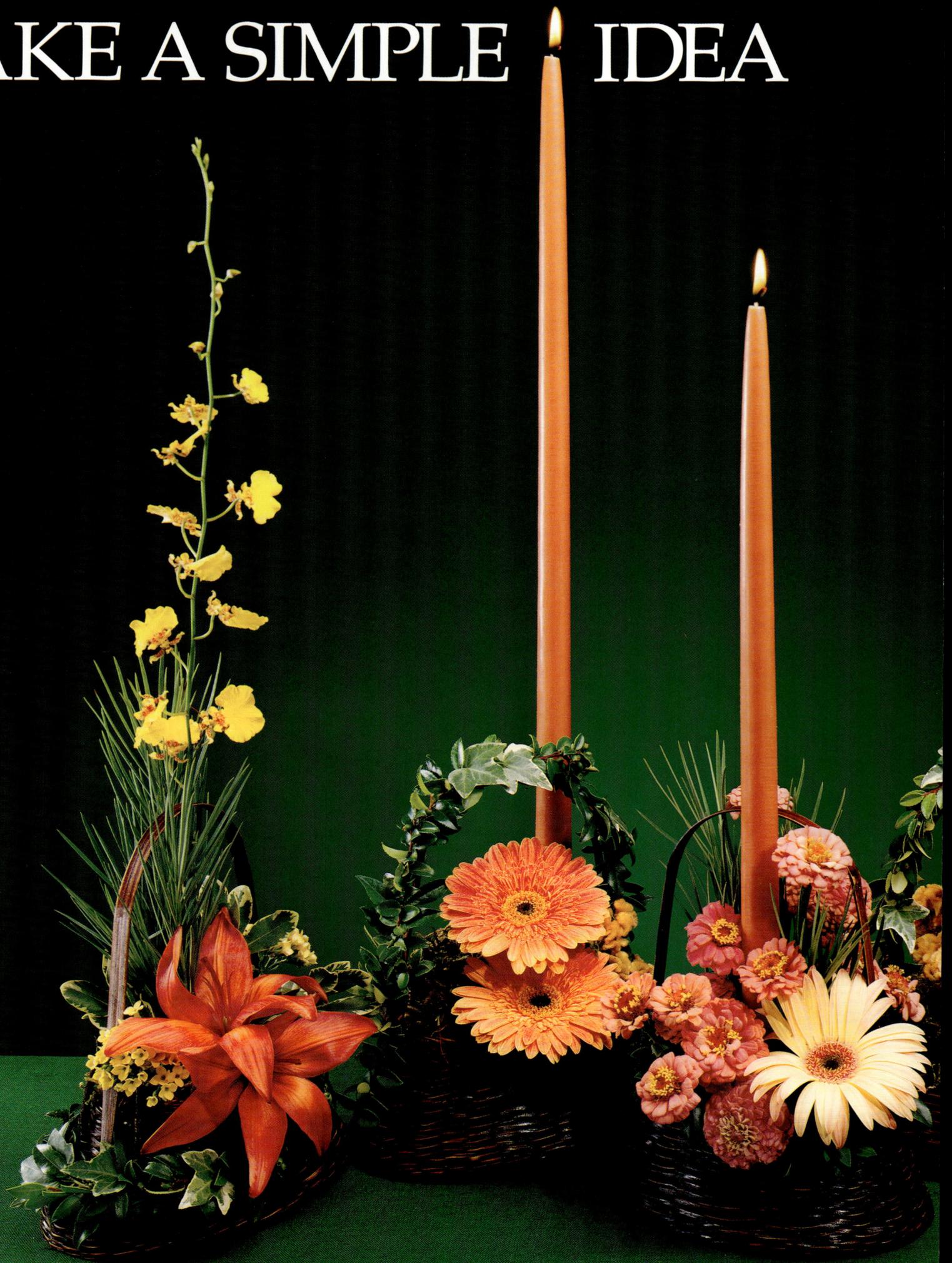

AND MAKE IT *U*NIQUE.

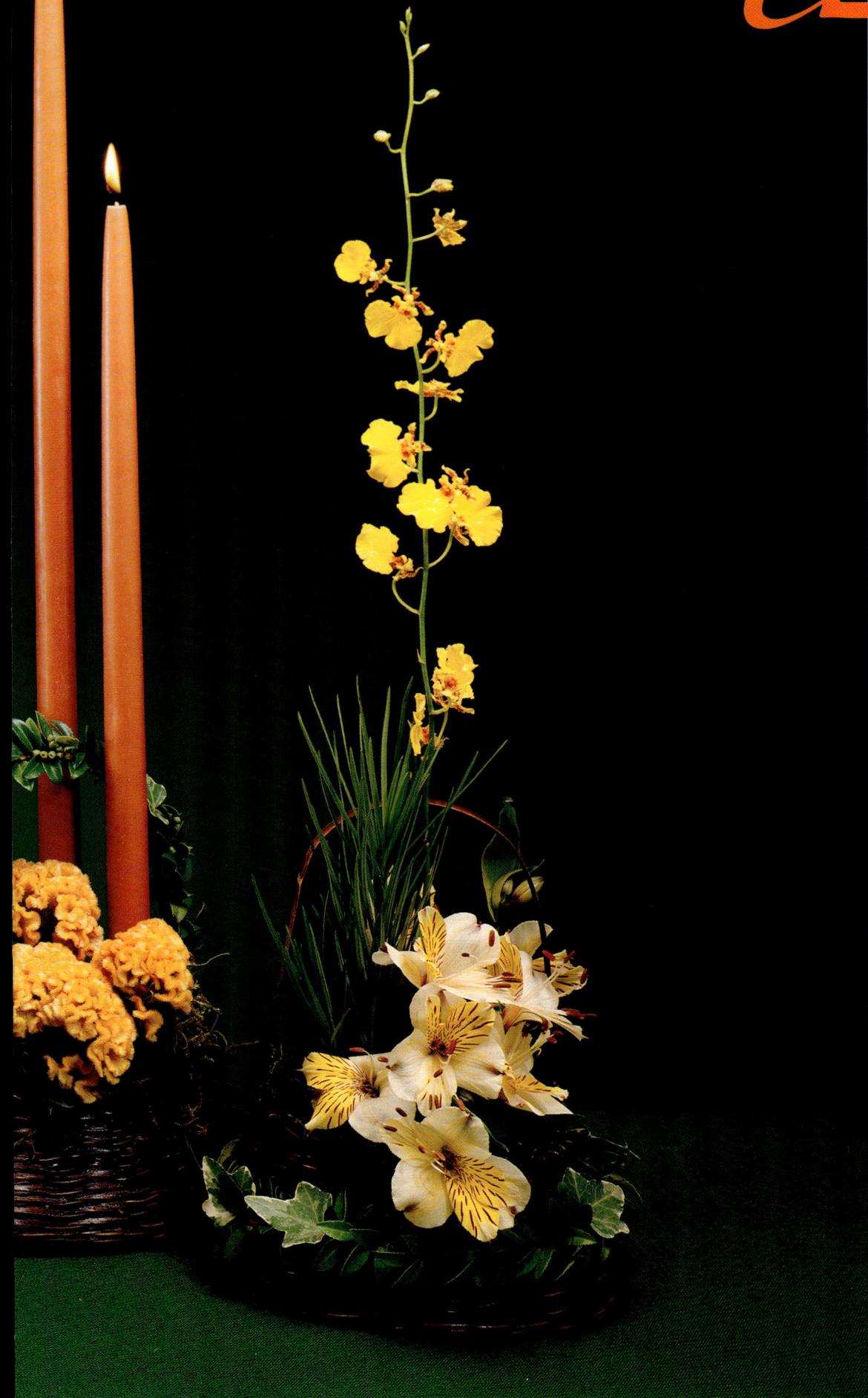

In this eye-catching table decoration, the artist illustrates how emphasis through repetition creates style. When used to its fullest advantage, repetition generates visual rhythm.

Art authority, Amy Arntson, states, "Life itself is based on rhythm. There is rhythm to the passing of days and seasons. The "tempo" of our days may be fast or slow. The growth and gradual decline of all natural life forms have a rhythm. Cities have particular pulsing rhythms. Different periods in our history have seemed to move to various beats."

Rhythm is a critical component in exciting, visually stimulating floral compositions that speak out with distinctive style. A floral designer achieves visual rhythm with repetition of shapes, colors, values, lines, textures and space. The composition pictured is an outstanding example of the use of repetition to accomplish rhythm.

The vertical lines of the oncidium orchids and candles are the major elements of repetition which create a repeating beat, a rhythm. The cadence of this rhythm pattern is irregular, alive and interesting.

The colors and color values of the flowers move across the base of the arrangement from red-orange through the analagous neighbors to the light yellow alstroemeria. The repetition of the baskets and the huckleberry and ivy trim on the handles and rims of the baskets is another mark of unique personality, a differentiating style.

Baskets No. C1440 from Jim Marvin Enterprises, Ltd., Route 7, Box 44, Dickson, TN 37055. Tablecloth from Immediate Table Cloth, 40-44 Austin St., Newark, NJ 07114. Candles from Creative Candles. Lomey candlestakes available from your local wholesaler.

LYRICAL &

Container above No. 3607 from Zanesville
Stoneware Co., 309 Pershing Rd., Zanesville,
OH 43701. Order curly pussy willow from
Rosemary's Ranch, 218 N. Loyalsock Ave.,
Montoursville, PA 17754. Container with dried
materials, No. 8923 from Haeger Gardenhouse
line, The Haeger Potteries of Macomb, Inc.,
P.O. Box 558, Macomb, IL 61455-0558. All
bleached Holland dried materials available
from Moser's Dried Flower Barn, 14065
Cleveland Ave., Nunica, MI 49448.

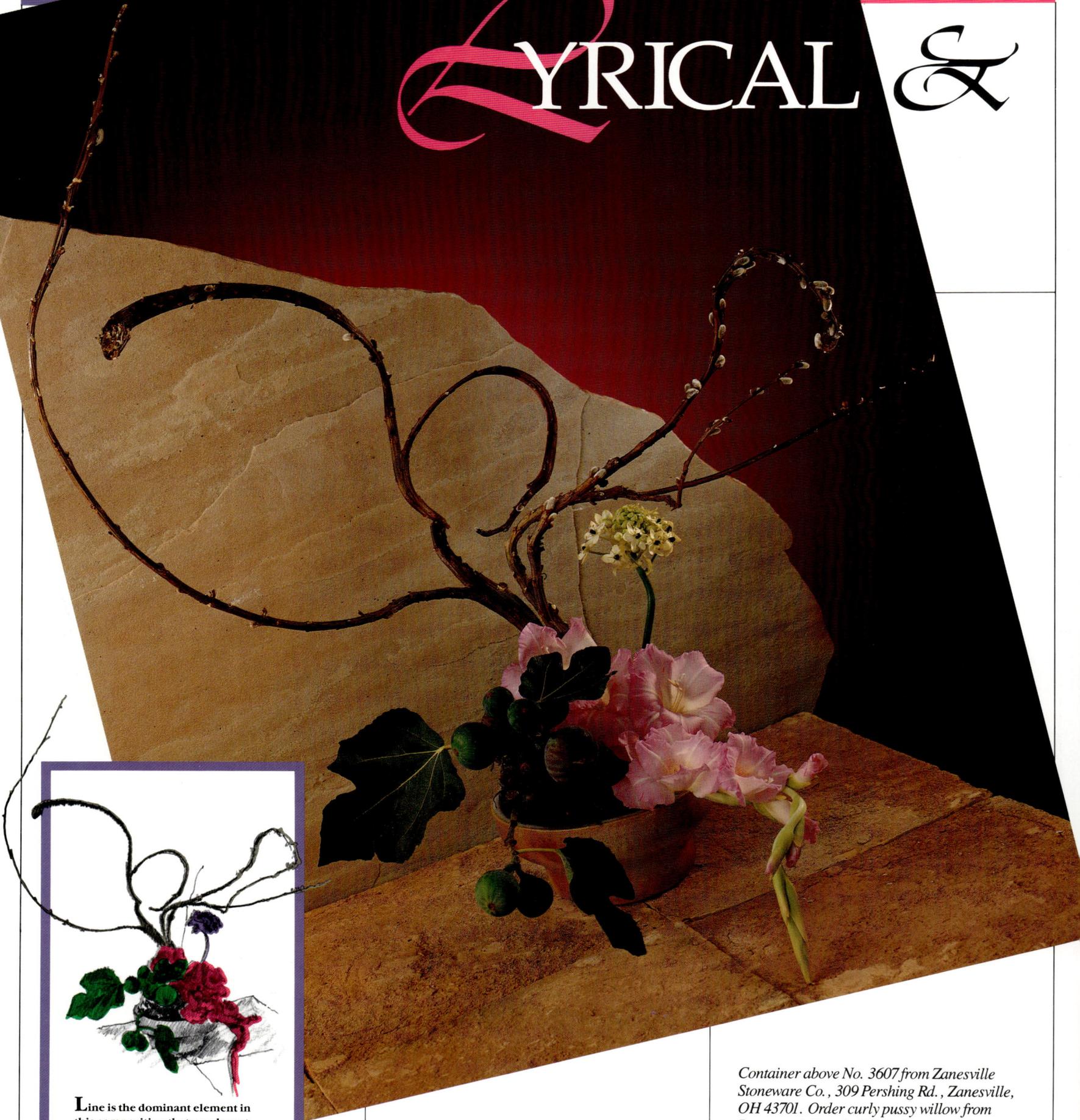

Line is the dominant element in
this composition that speaks out
with a statement about style. The
curving, circular lines of the willow
move in and out of the design. There
is no beginning, no ending, no
definite direction. The
ornithogalum, gladiolus and fig
branch introduce additional
curving lines plus contrast in the
forms of the materials.

POWERFUL LINES

The Design Process is a very important approach to floral design education. (See the May-June 1989 issue of Design With Flowers.) It integrates seven essential components: the idea, form, balance, unity, line, emphasis and contrast. Each ingredient influences the style of a floral composition.

The two designs pictured illustrate how line gives a floral composition a distinctive personality - a style. Understand and master these essential characteristics of line.

Horizontal and vertical lines are stable. Most of the environment in which we live consists of vertical bodies on horizontal earth. For this reason, horizontal and vertical lines are visually safe and comfortable.

Diagonal lines are dynamic. They are active, vigorous and lively. Diagonal lines are in a state of flux. They are poised for movement toward the more stable horizontal and vertical. A diagonal line is one of the quickest, most effective ways to introduce interesting visual tension into a composition.

Curving lines are moving lines. Horizontal, vertical and diagonal lines have absolute direction. They pull the eye immediately from one point to another. In contrast, a curving line implies movement but often leads the eye off into space.

People in Western cultures read from left to right. This experience influences the way most individuals look for balance between the two sides of a composition. The left side is more important because attention subsconsciously goes there first. Flower designs that move from left to right are more comfortable to view.

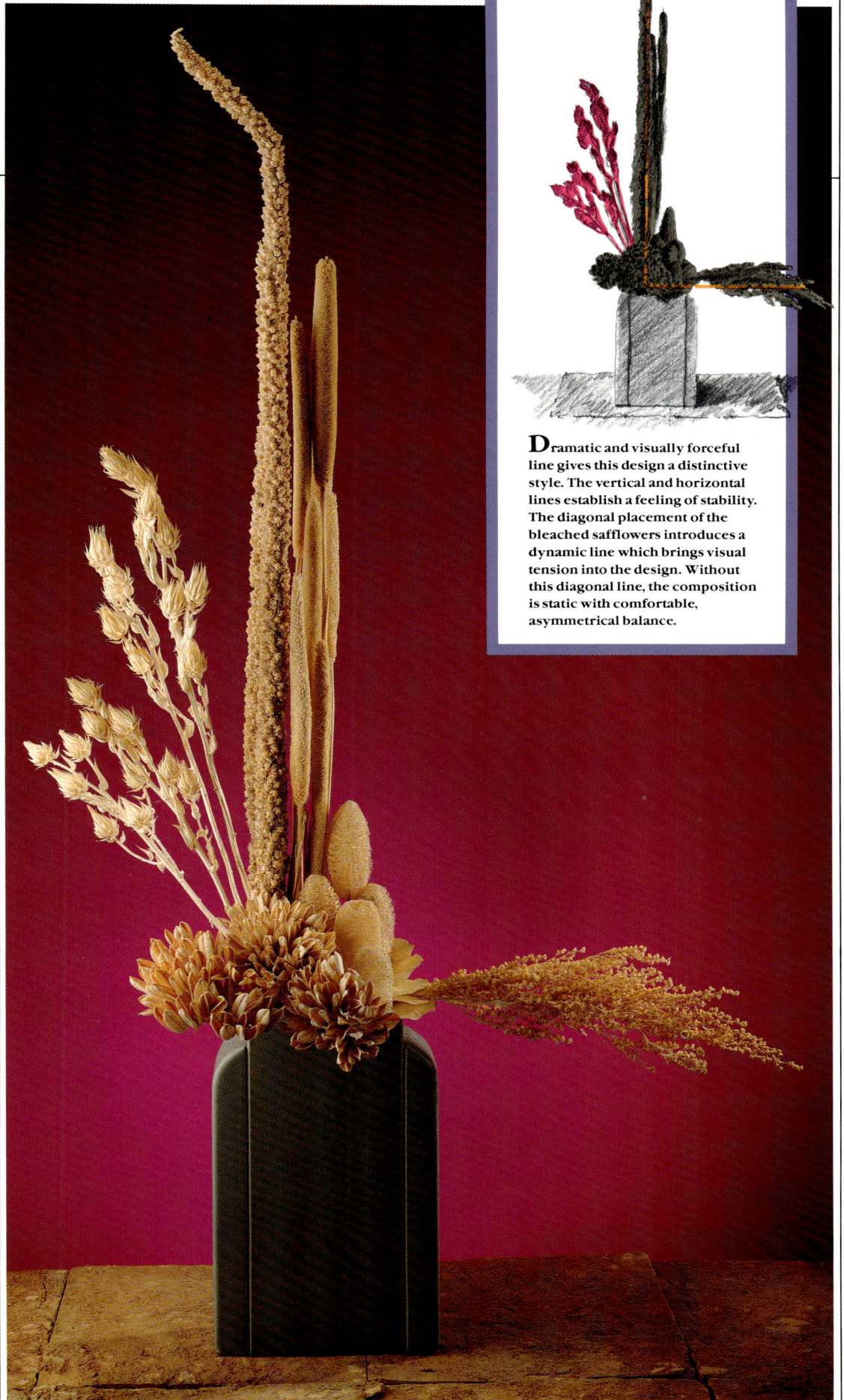

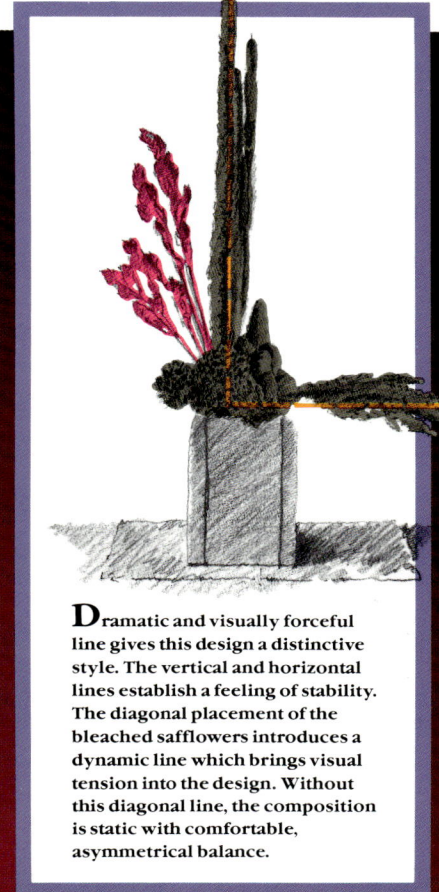

Dramatic and visually forceful line gives this design a distinctive style. The vertical and horizontal lines establish a feeling of stability. The diagonal placement of the bleached safflowers introduces a dynamic line which brings visual tension into the design. Without this diagonal line, the composition is static with comfortable, asymmetrical balance.

A SYNTHESIS OF KNOW HOW

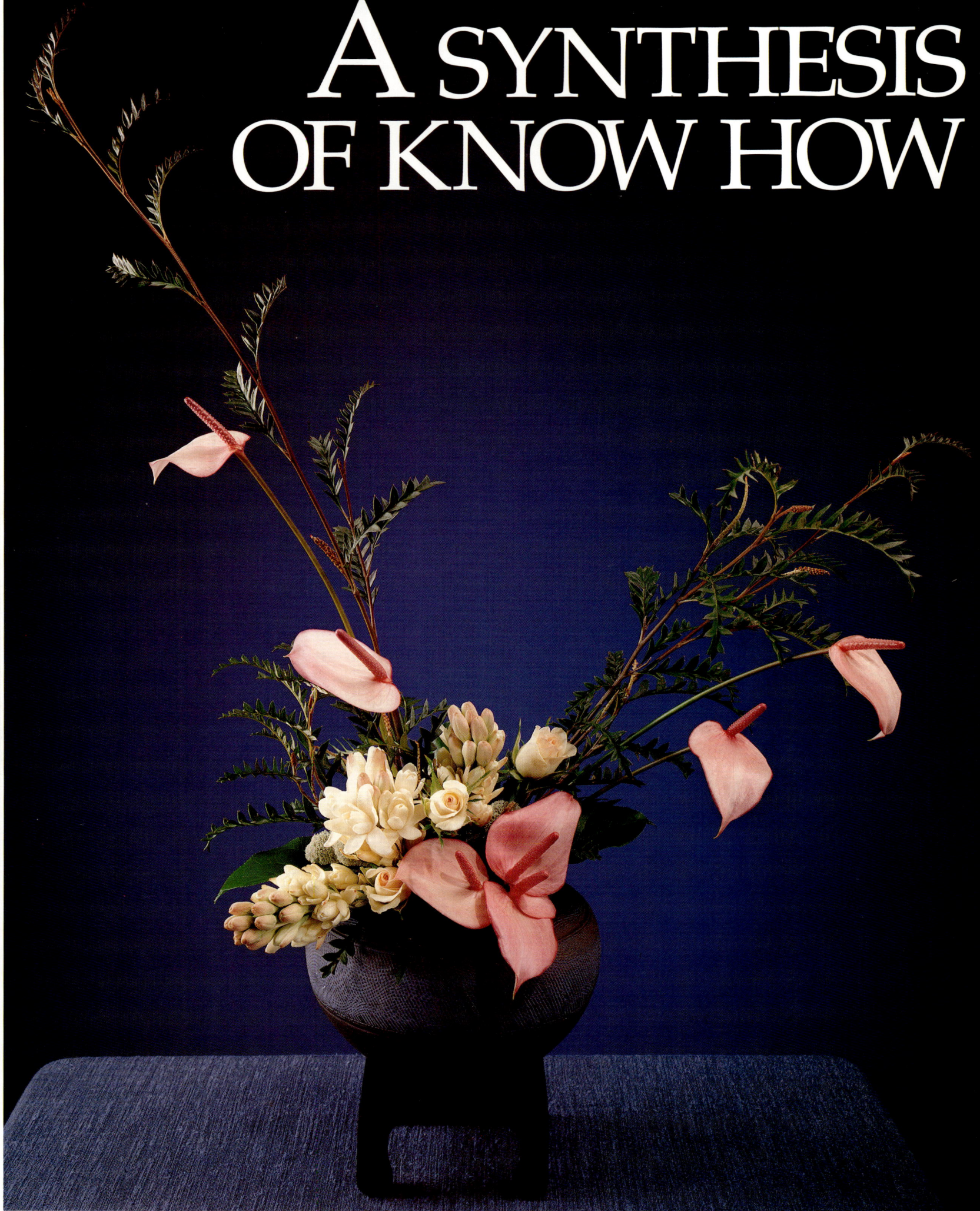

AND _I_MAGINATION.

A poet invents new sequences of words and phrases to convey a new experience to the reader. An inventor rearranges known properties to produce new results. The artist presents elementary form, color and texture in new ways to capture the aesthetic sense of viewers. The poet's words, the inventor's properties, the artist's basics are not unusual possessions. These same things are available everyday to almost everyone. The difference is how the poet, the inventor and the artist work with these fundamentals to create uniqueness. The ability to take the ordinary and transform it into the exceptional requires both know-how and imagination.

The distinctive composition featuring miniature anthurium, roses and tuberoses is an imaginative interpretation of a line design. Instead of one central vertical line, the artist separated the typical, singular linear accent with two diagonal lines. All materials move into and out of the composition with dynamic line movement.

Even though the sabel palm leaves in the dried composition express line emphasis, the design is a mass composition. Hydrangea, salignum, canella, poppy heads, lotus pods and a tree conk cluster close together with no space in-between.

The mark of style is not the uniqueness of materials used, but the distinguishing manner in which the artist presents the materials.

Container for fresh design No. 130, container for dried composition No. 120 from Pittsburg Pottery, Box 8621, Fort Worth, TX 76124. (Container for fresh flowers lined with inexpensive plastic container - Pittsburg Pottery is not water tight.) Stand for No. 130 from Toyo Trading Co. All dried materials from Knud Nielsen, available from your local wholesaler. Tree conk from Hoh Grown, P.O. Box 2135, Forks, WA 98331.

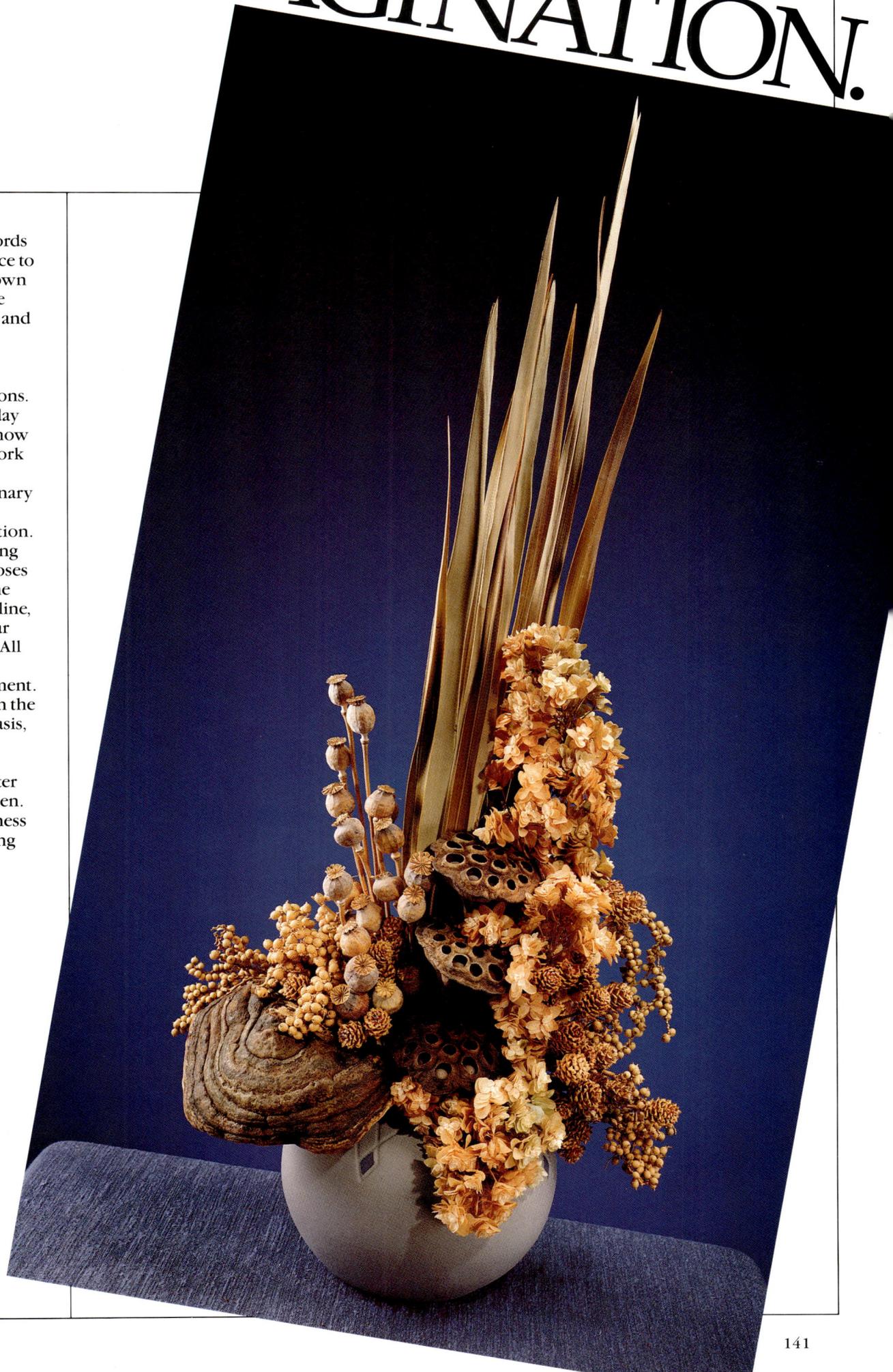

An Inspired Definition Of Style

''What the artist discovers, isolates and concentrates, he usually becomes conscious of and expresses in an entirely different context from that in which he first sighted it.'' *David Pye*

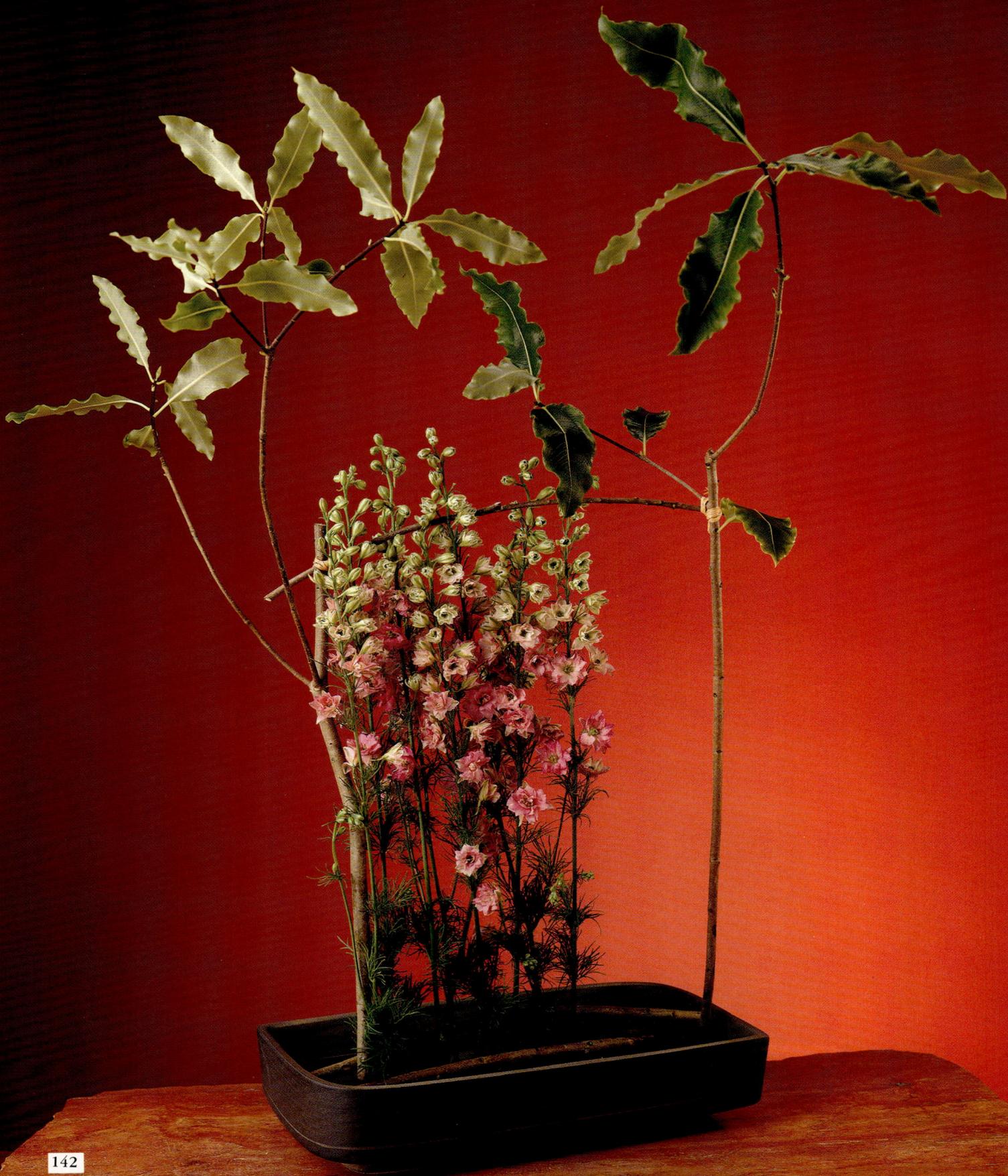

After wedging branches into the base of the low container to hold the stems, Keita creates a framework of laurel branches tied together with raffia. Then he places stems of larkspur in parallel formation.

Keita entwines willow down in the glass container and at the top to hold the tulip blossoms in place. In this style, there is no attempt to structure the composition. Instead, both the willow and tulips move in a natural, freeform style.

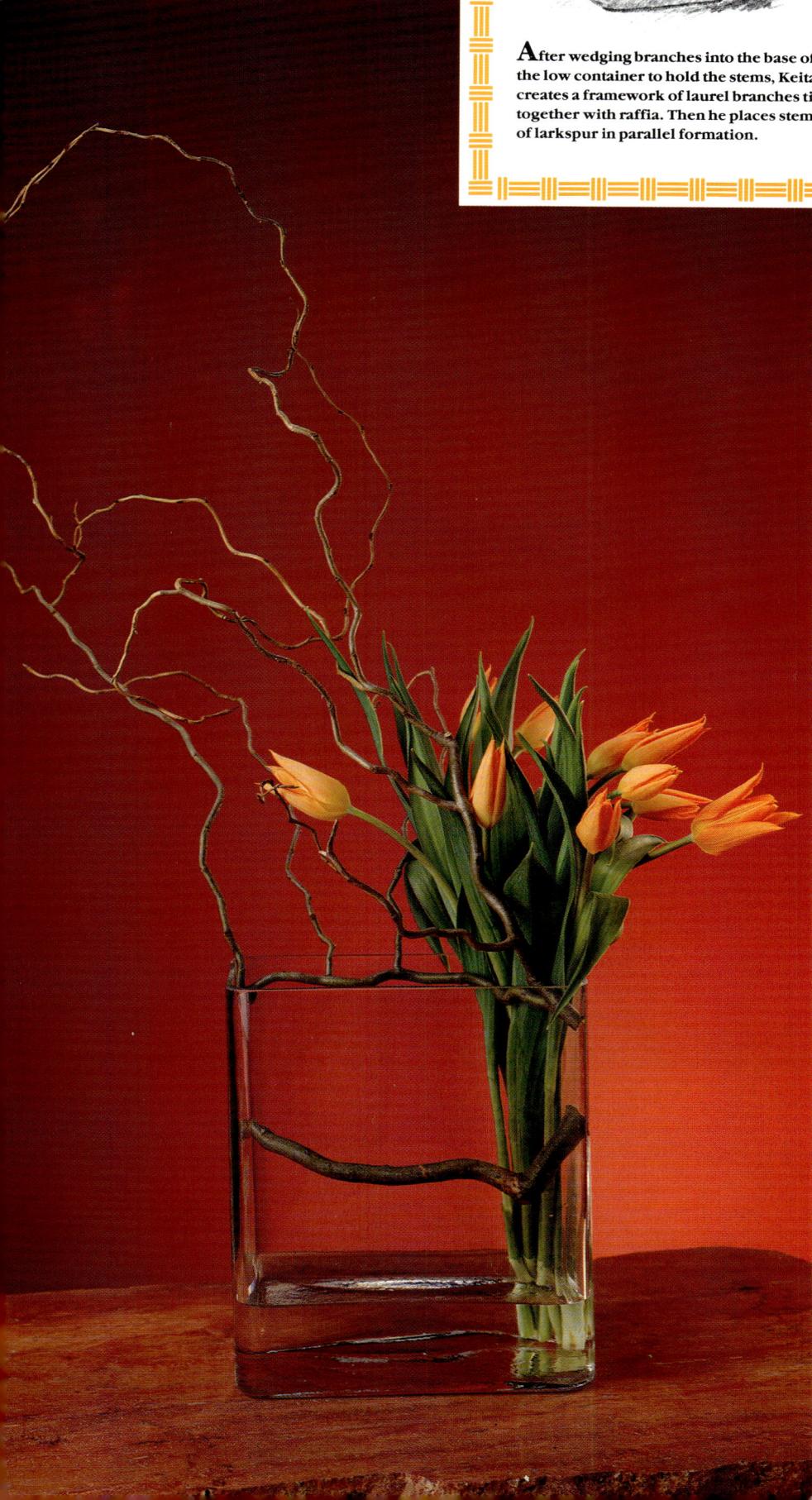

J apanese flower arrangement is moving through a transformation from the old to the new. Ikebana with the traditional Moribana and Nageire styles is becoming obsolete. Young designers prefer the newer, more expressive and less structured compositions.

So you could experience the newest trends in Japanese flower arrangement, Design With Flowers brought Keita Kawasaki to the United States to create the arrangements in this section and to teach us about 20th Century Japanese flower arrangement.

Keita's excitement for flower arrangement is evident in his philosophy about design. ''You must give up your fixed ideas about Japanese flower arrangement. Forget the traditional rules. Learn to express yourself through the materials you work with. The flowers and branches are the art. You are the presentor of the wonderful beauty of nature.''

In the lovely composition with pink larkspur, Keita presents a naturalistic design style. In nature, larkspur grows in a structured formation while laurel grows in graceful branches. The contrast between the structured, framed presentation of the larkspur and the free-floating laurel branches give this composition a character of distinctive, original style. It expresses the contrast of these materials in nature.

The composition with curly willow and tulips is another expression of natural style. In this arrangement, Keita presents tulips in a composition suggesting that the blossoms were arranged in the hand as they were picked and then slipped into the container.

Low container No. 39-2602 from Toyo Trading Co., 13000 S. Spring St., Los Angeles, CA 90061. Brody rectangular glass container No. 4025 available from your local wholesaler.

● A Revolution

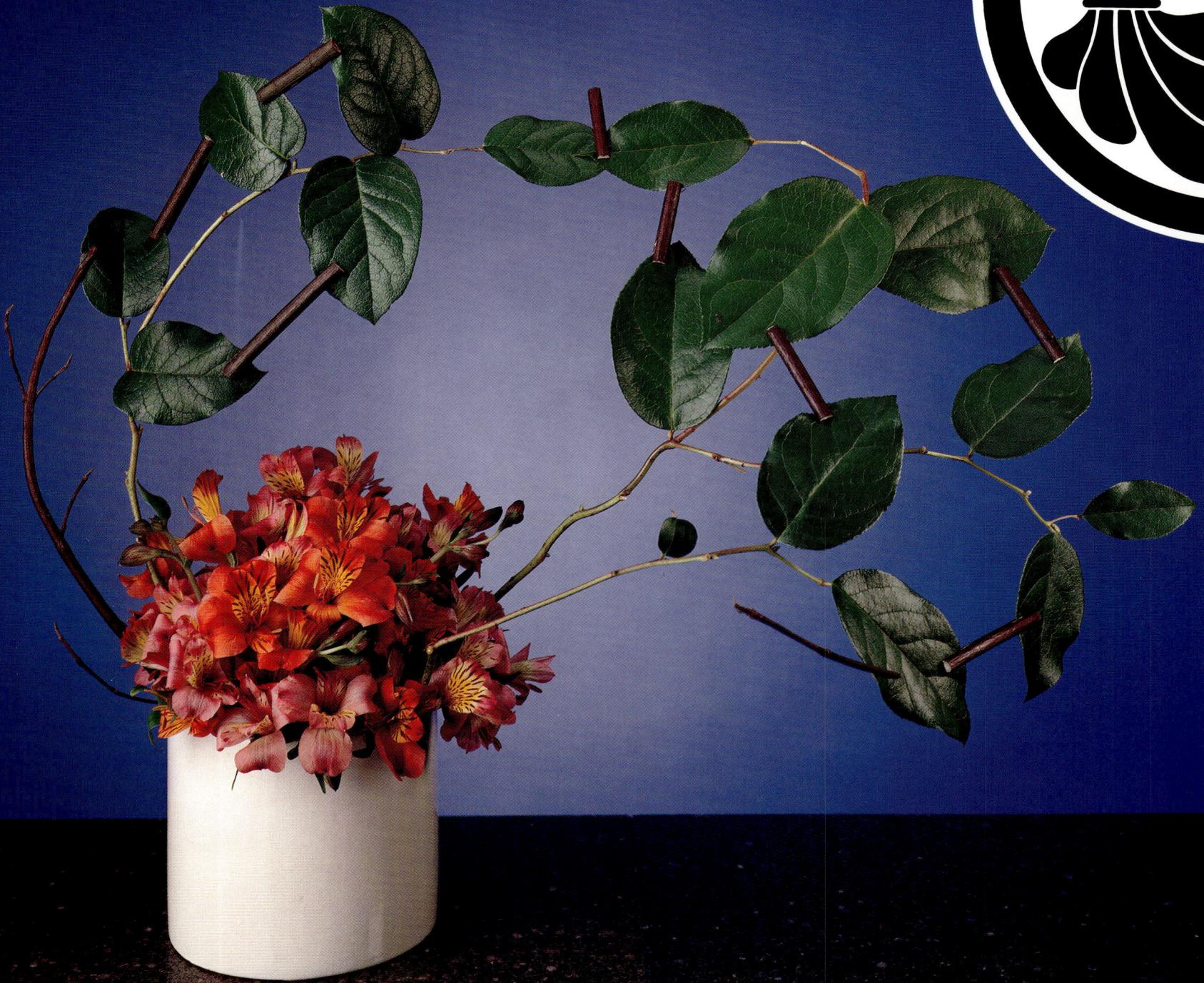

Giftwares white pottery container No. T13474 and E. O. Brody vase No. 4024 available from your local wholesaler.

固 定 観 念

A FIXED IDEA
''GIVE UP FIXED IDEAS. BE CONFIDENT
IN EXPRESSING YOURSELF THROUGH THE
BEAUTY OF NATURE.'' *Keita Kawasaki*

144

In Style

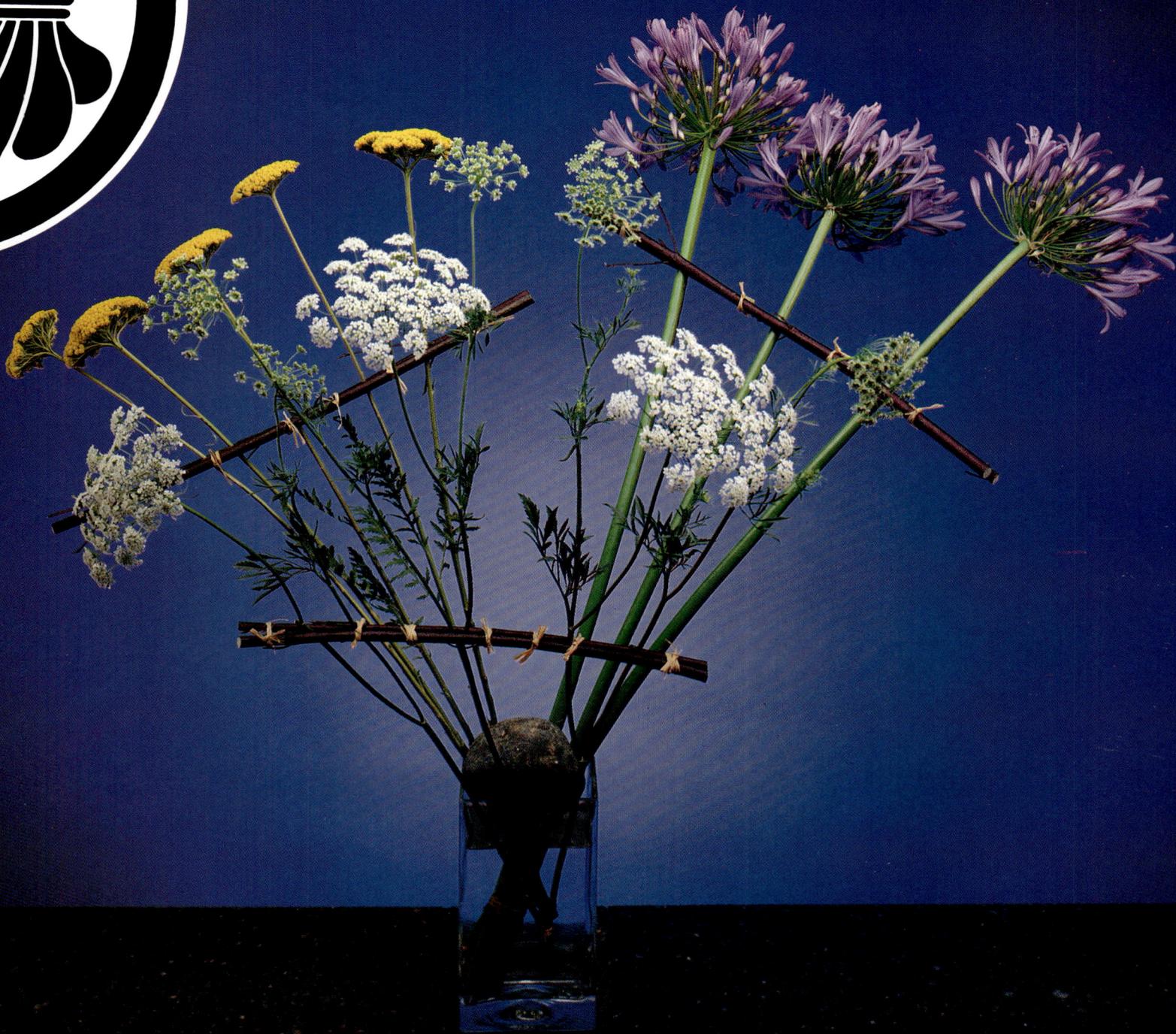

In the composition of alstroemeria and salal leaves, Keita conveys the connectiveness of life. We all spring from a rich heritage, a closely knit background of family and other significant people. As we branch out in life, we stretch and move in many different directions. In this growth, we remain connected to others.

To create this design he calls ''Everlasting Connection,'' Keita prunes leaves from stems of salal. The resulting graceful, uncomplicated branches suggest that a happy life has a flow, a rhythm of simplicity. Keita connects the salal leaves with sections of dogwood branch which he notches at the ends and then inserts the edges of the leaves into the notches. As demonstrated in this composition, Keita uses flower foam for many of his designs.

In the composition above, Keita shows the technique of banding in 20th Century Japanese flower arrangement. There are three ''bandings'' of flowers in the design - one banding with three agapanthus, one with five yarrow and one with three Queen Anne's lace.

For each banding, Keita places the stems on top of a section of dogwood or another branch. Then he lays another branch over the blossoms and ties the branches together with raffia. After inserting the banded stems into a clear glass vase, he secures them by placing a rock at the top of the vase.

You can create this same design in a less natural style by inserting the stems into a container filled with floral foam.

"The Material"

In teaching and critiquing floral design, we often state that lines should not cross. In 20th Century Japanese flower arrangement, crossing lines are not only acceptable but even desirable.

In the arrangement of equisetum and anemones, Keita illustrates how crossing stems convey a feeling of nature. "Crossing stems is a very natural use of materials," Keita states. "When you think you must keep all stems straight and organized, you lose the naturalness of nature."

To create this composition, Keita glued nails to a Lomey Designer Dish and then pushed the stems over the nails. The opposing, crossing lines of the equisetum create positive tension and stimulate attention.

In the basket composition, Keita combines curved and straight stems. "To make the strongest contrast," Keita comments, "create forceful opposition. Make a sharp visual difference between the strength of the curving stems and the energy of the straight stems."

A dynamic contrast in weight balance is another distinguishing feature in this design. The visual weight of the snapdragons and thistles at the top is balanced by the expansiveness of the curling branches. In contrast to create a sharp visual difference, Keita uses minimum weight balance at the bottom of the design.

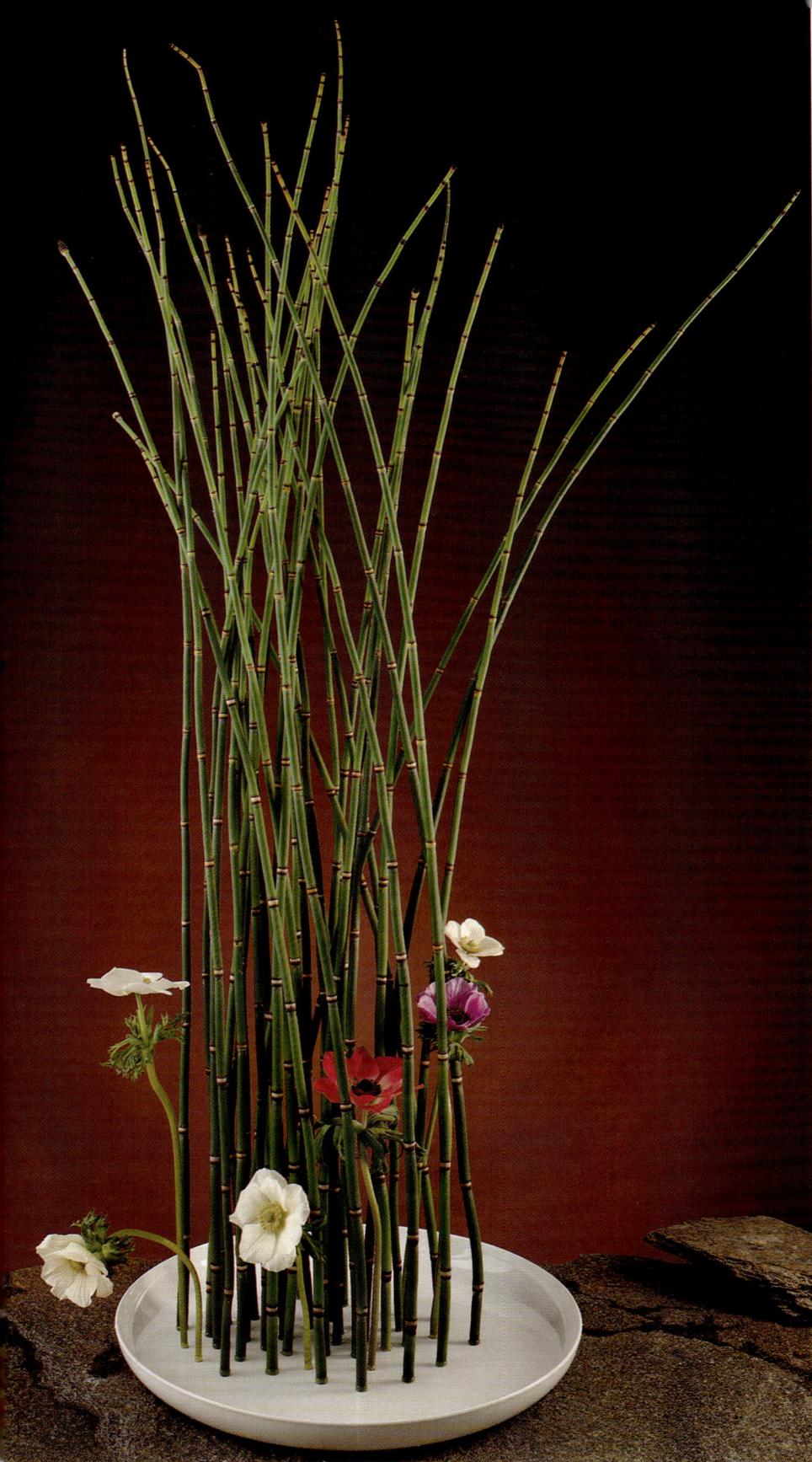

固 定 観 念

A FIXED IDEA
"FIXED IDEAS LIMIT YOUR CREATIVITY.
YOU CANNOT DESIGN BEAUTIFUL FLOWER
ARRANGEMENTS IF YOU REFUSE TO BREAK
AWAY FROM WHAT EVERYONE ELSE DOES."

Keita Kawasaki

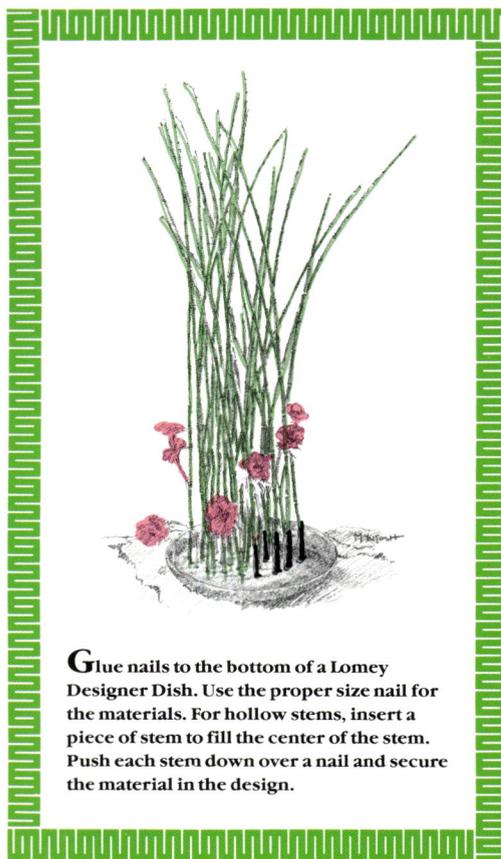

Glue nails to the bottom of a Lomey Designer Dish. Use the proper size nail for the materials. For hollow stems, insert a piece of stem to fill the center of the stem. Push each stem down over a nail and secure the material in the design.

Is The Art. You Are The Presentor."

KEITA KAWASAKI

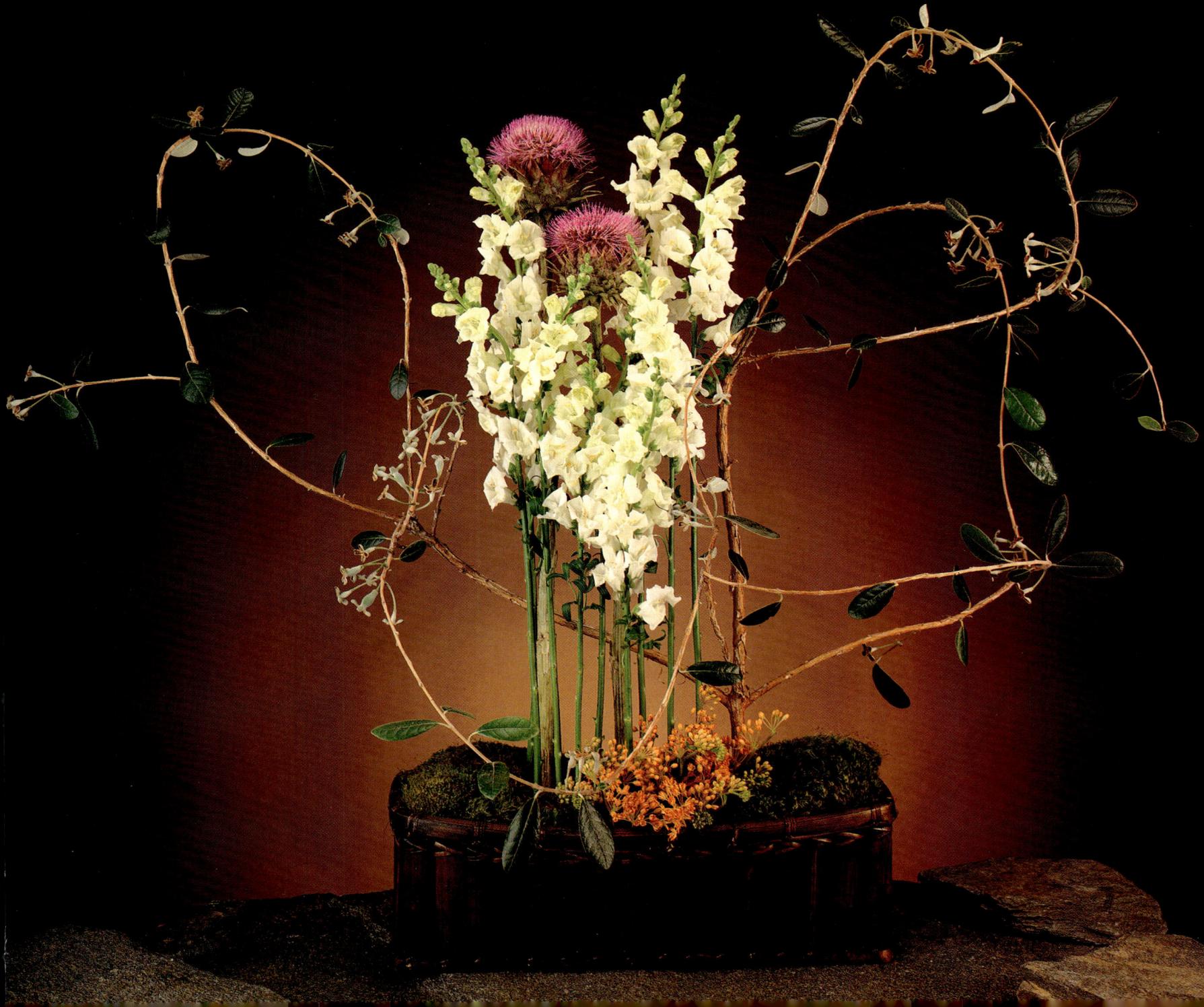

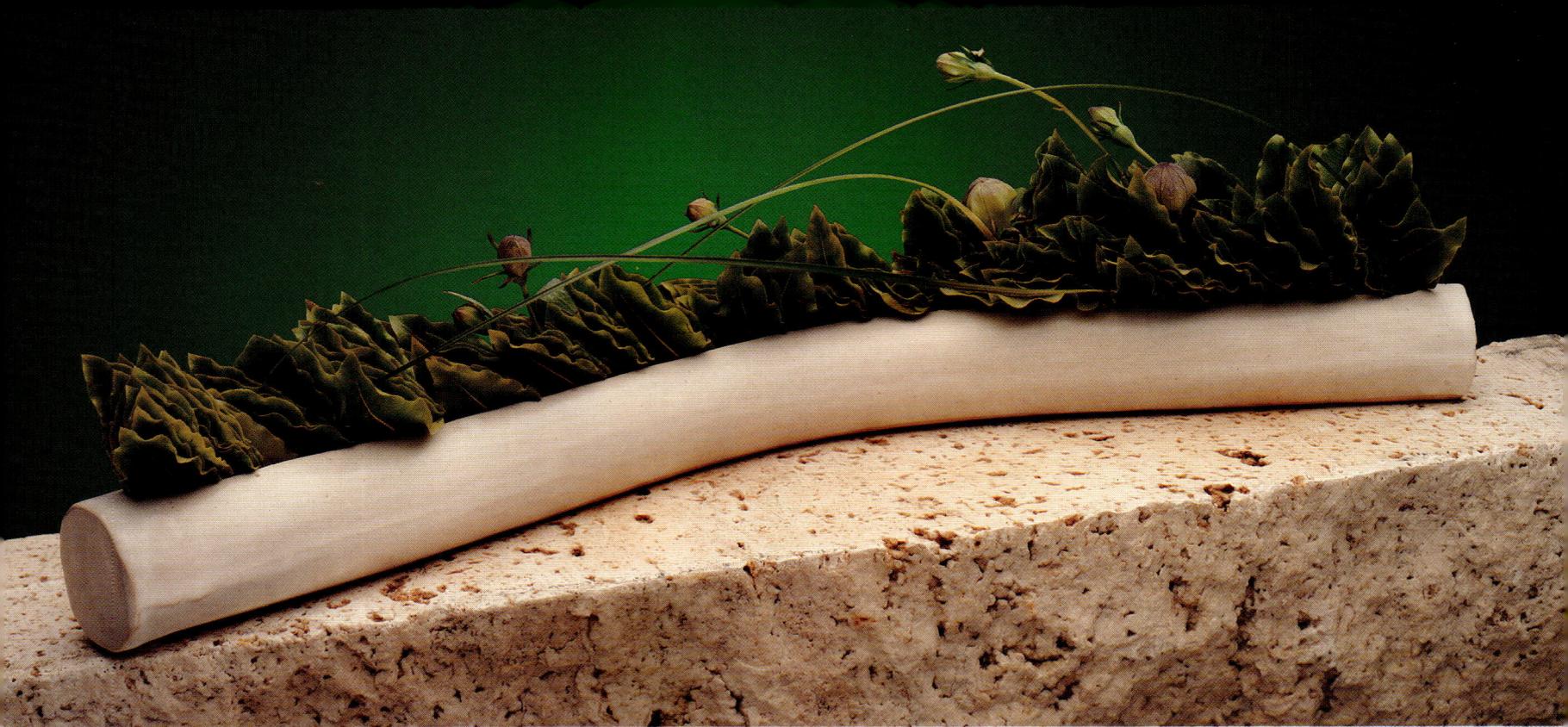

Imagination Without Limits
(That's where style comes from.)

Kimberley Reynolds, an authority in the terms and techniques of art, defines style as, "The complex of characteristics which identify works of art with a particular artist, school, movement, period or geographical region. In painting, for example, these features include such elements as brushwork, use of tone and color, and choice of different motifs, and they reflect the artist's training and background as well as his own personality."

Even though Reynolds defines style from a fine artist's perspective, the same characteristics hold true in floral design. How a designer presents materials in a composition, his understanding and use of color, and his training, background and unique personality - all contribute to the styles of composition he creates.

In reviewing Reynolds' definition of style, pay close attention to the fact that a designer must have training plus background (experience). By learning the basics of floral design, and then using, adapting and releasing these principles through experience, a designer develops style.

Imagination is the picturing process of the mind. Properly defined, "Imagination is the act or power of forming mental images of what is not actually present."

Imagination is a process of synthesis. A creative person takes in and experiences everything he sees, reads and hears. From this accumulation of experiences, he uses his imagination to form the pictures in his mind of compositions to create.

Keita Kawasaki is a master potter, as well as a floral artist, who refuses to limit his creative imagination. The containers for the two compositions pictured are Keita's original design.

In the composition above, Keita places tight clusters of pittosporum foliage to fill the shallow curving container. The fine lines of the bear grass and bellflower buds introduce a soft, thoughtful line movement. The contrast between the composite structure of the pittosporum leaves and the unstructured, free-flowing movement of the bear grass and bellflower buds is an important style characteristic of this design. The design on the opposite page is another imaginative approach to creating style. Line opposition and the grouping of materials are the fundamental characteristics of this composition which set the style.

固定観念

A FIXED IDEA

''A qualified practitioner in any field of art must study and learn the fundamentals. These basics must not become fixed ideas. They are only the foundation on which an artist develops his own unique talents, skills and style. A floral designer with fixed ideas never moves away from the standard - he never uses his imagination.

If a flower designer wants to express his unique individuality in his art, he must go beyond learning and understand what it means to experience. A designer can learn about nature. Experiencing nature is entirely different. A flower artist can master the principles of color. Experiencing color means that a designer interacts personally with color. Rules are made for people who cannot think. A designer must think to inspire his imagination.''

Keita Kawasaki

The beauty, inspiration and style of this design results from counterpoint, the contrast between the straight, dominant lines of the iris, the delicate flow of the curving line of Japanese maple, and the sturdy curving line of the container. The parallel repetition of the iris achieves a left-to-right rhythm: one blue iris, two clusters of two iris, another single blue iris and then a grouping of two yellow iris buds placed in taller positions.

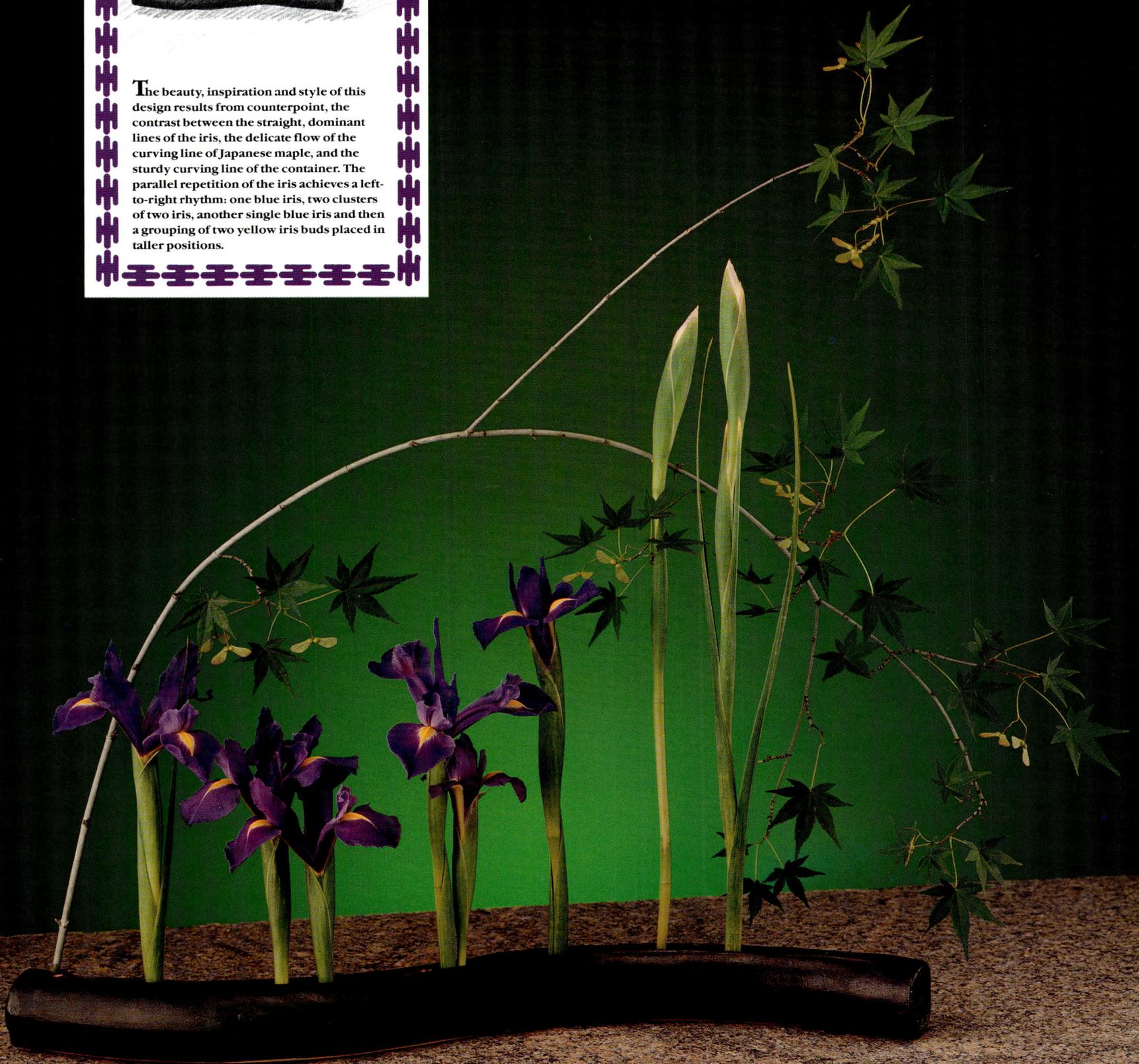

A Commitment To Innovative Style.

A Commitment To Innovative Style.

In the compositions pictured, Keita illustrates the difference between visual and physical balance. He believes that a floral designer must experience both forms of balance.

Visual balance is the impression of equilibrium in a composition. A design must look balanced to be pleasing to the viewer. The composition of banksia pictured to the immediate right illustrates visual balance.

Physical balance is essential for a composition to remain upright. A design must be structured for both tangible and sensual balance. The banksia composition pictured to the far right shows a method of physical balance in a 20th Century Japanese flower arrangement.

In any properly constructed composition, the designer achieves both physical and visual balance by the placement of materials.

Terra cotta rectangular container with inside glaze available from Adams Ceramics, 14041 Vancouver St., No. 290, Van Nuys, CA 91405. Low, round bowl No. 2710 from Zanesville Stoneware Co. Leucadendron and Banksia from Silvermink Protea, 14111 Westfork Rd. Pauma Valley, CA 92061.

The upper grouping of banksia makes a visually stable vertical accent. The lower banksia in horizontal position brings visual weight to the bottom of the design. It demands visual attention, but recedes allowing the upper grouping of banksia to be dominant.

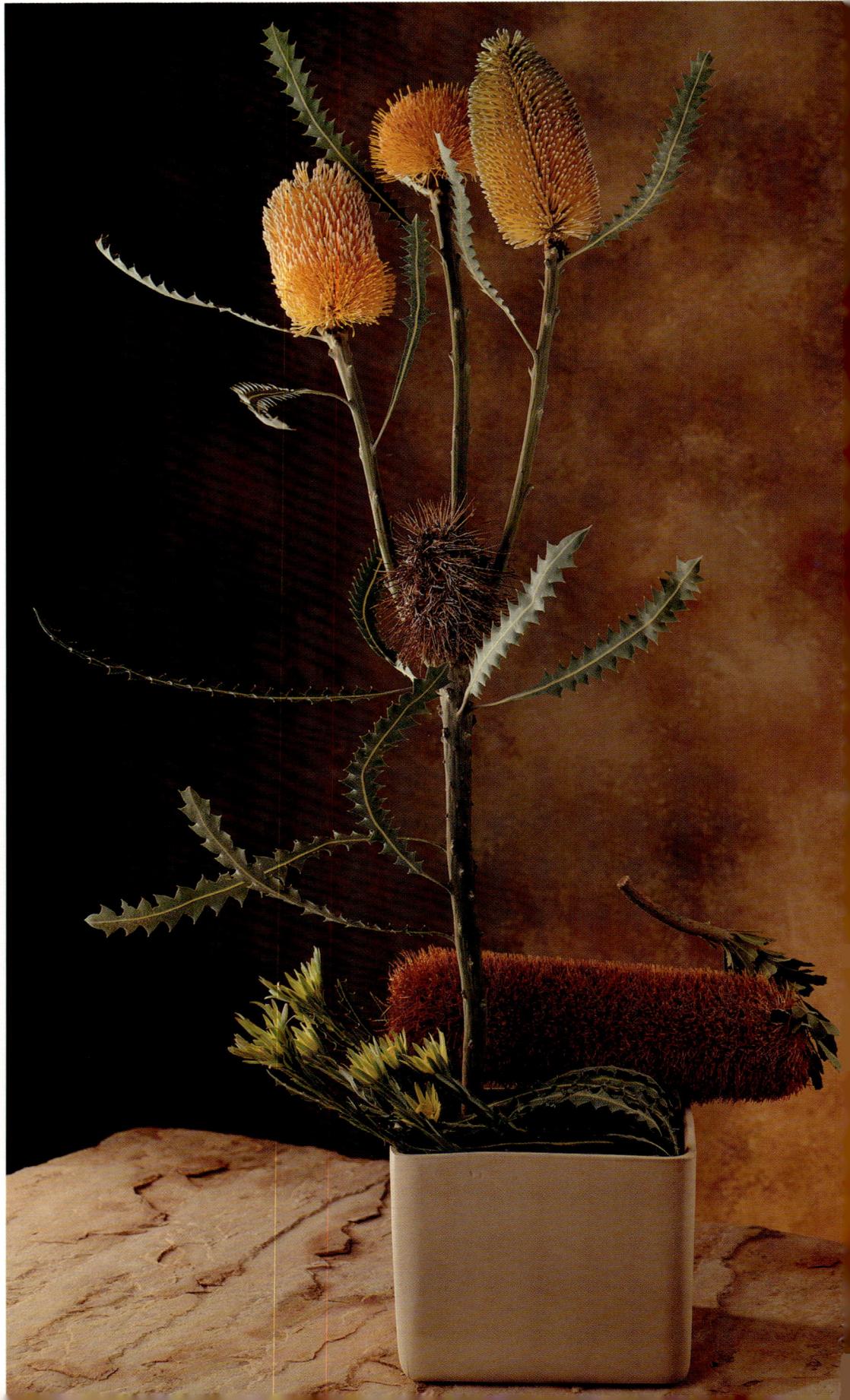

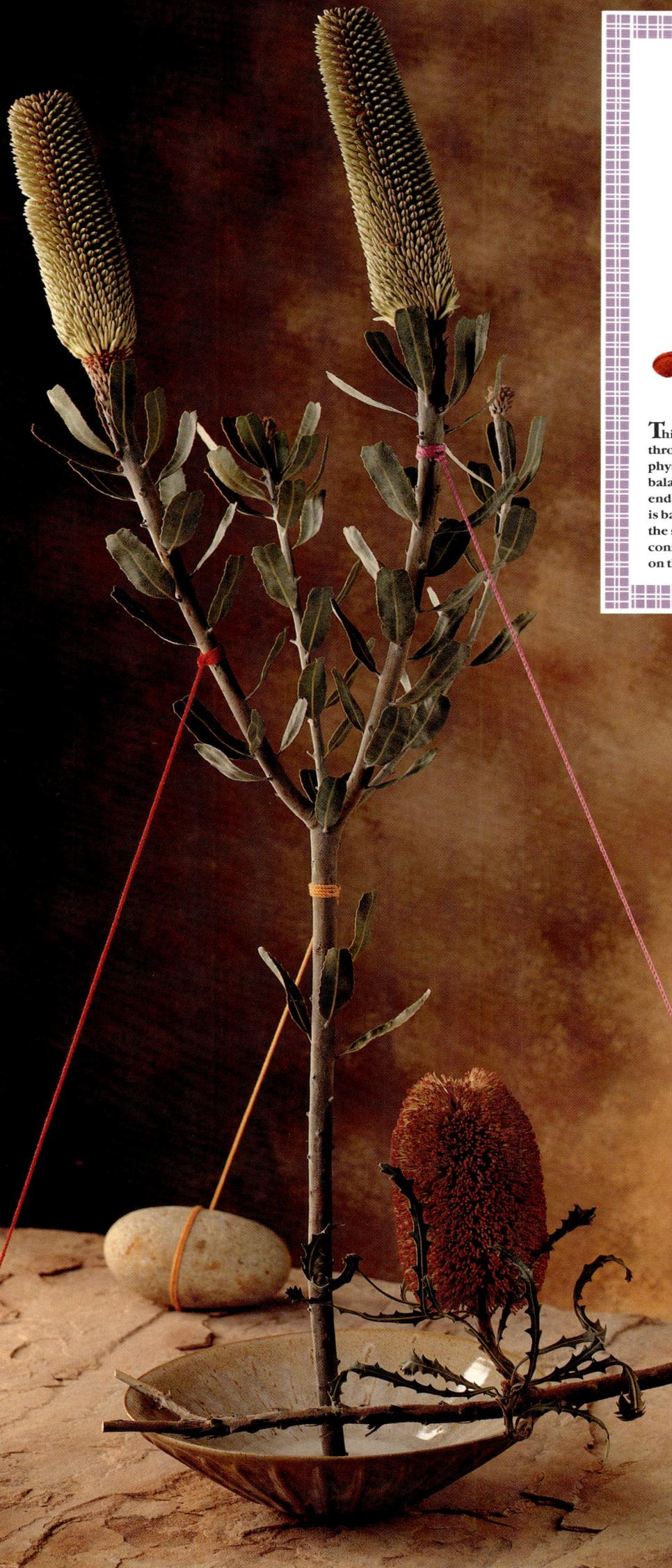

This composition illustrates a process through which a designer can experience physical balance. The banksia at the bottom balances naturally with the branch at the end of the stem. The upper stem of banksia is balanced with three rocks connected to the stem with colored yarn. The yarn connects at three different balance points on the stem.

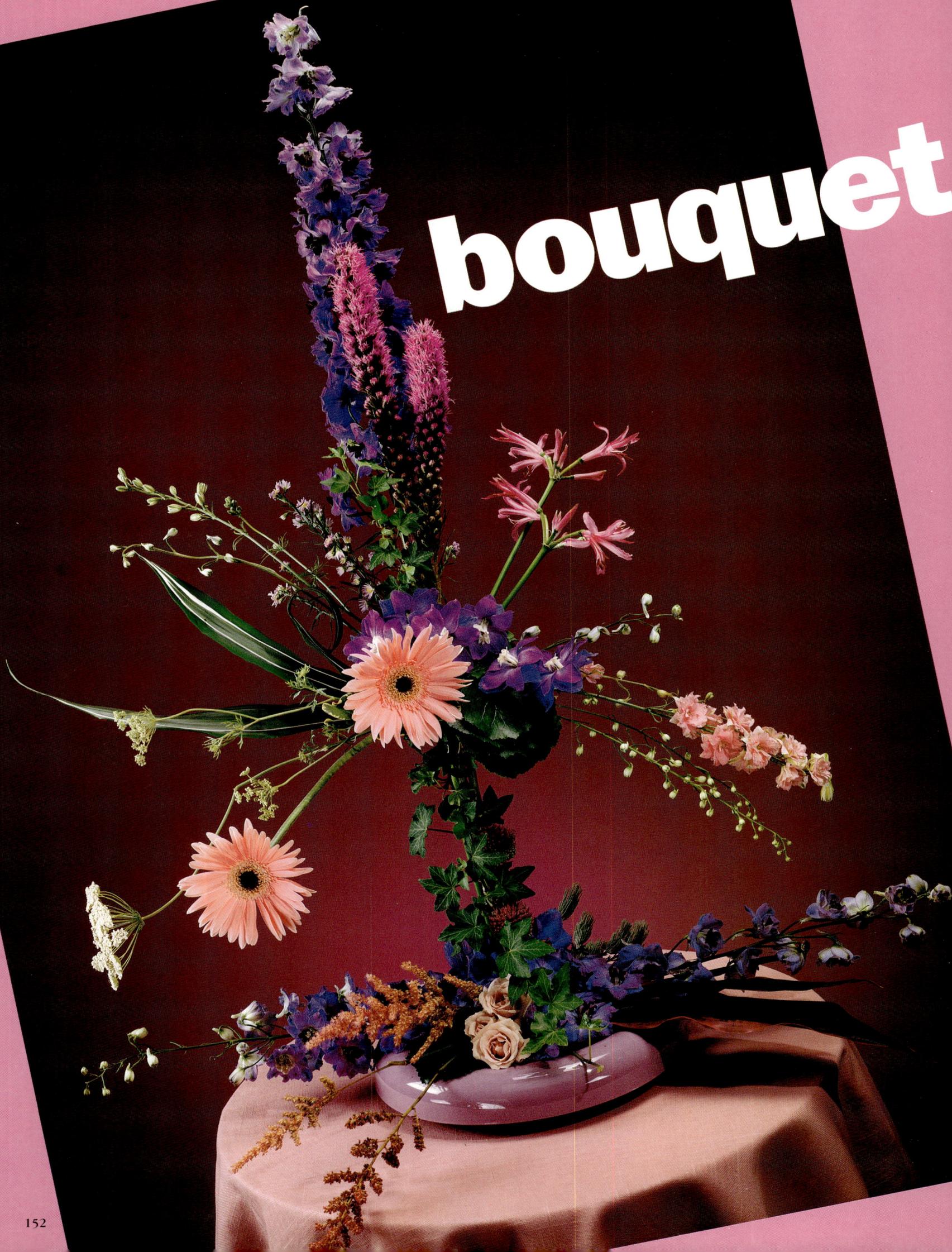

bouquet

fantasia.
a fantastic new style.

New ideas come from exposure to other floral designers. Mitsuyo Sakai, a teacher at Mami Flower School in Tokyo, came to the United States with Keita Kawasaki. She showed us a new style of bouquet used for decorations in Japan called "Bouquet Fantasia." As used in Tokyo, the bouquet stands on natural stems.

The design sparked an idea for a table decoration. We adapted the bouquet style to share with you and designed it in a container so the stems could be in water. Don't let the selection of flowers pictured discourage using the idea. It can be created with many different flowers.

This is the important attitude about experiencing any new idea. When you experience an idea rather than just look at it, you do not judge it quickly. Instead, you examine the idea with an open mind for adaptation. Go beyond trying to make an exact copy of the idea.

The essential question is, "How can I alter, incorporate or expand the idea and make it part of my style repertoire? In every idea, no matter how far out or how earthy it might be, there is always a seed for something new. Creative designers look for the seed that germinates and inspires their imagination.

Insert the larkspur, nerine lilies, gerbera, Queen Anne's lace, Monto Casino asters, delphinium, galax and dracaena leaves in the center area of the bouquet. Allow the flowers to flow out in luxurious horizontal and diagonal line movement.

2. Create the upper area.

Insert strands of ivy into the base foam and entwine up the stems to finish the bouquet. Add one or two pieces of ivy in the center area to carry the foliage up into the design. Finish the bouquet on both sides for all-around viewing.

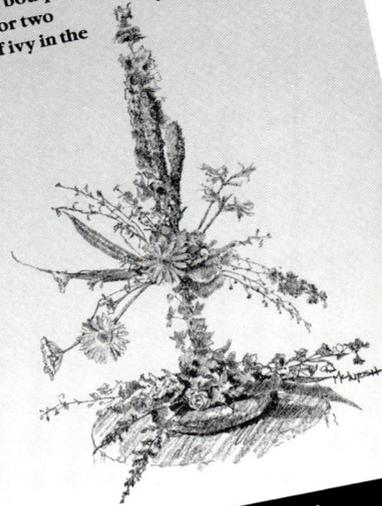

4. Finish the design.

Lomey Series 48 container and caged floral foam available from your local wholesaler.

Add the delphinium, roses and astilbe at the base of the design. Extend the horizontal base line slightly beyond the length of the flowers in the upper area. This repetition of horzonital line is an important characteristic in this style.

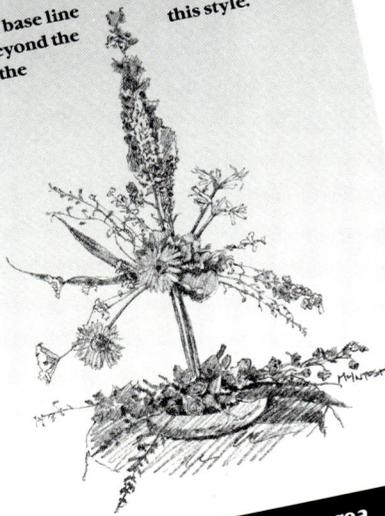

3. Design the bottom area.

Glue a dry, large Lomey caged floral foam in a Lomey Series 48 container. Submerge the container to saturate the foam. Saturate another large caged floral foam and cut off the solid bottom piece. Hold this caged foam with the plastic down and insert the stem of delphinium and the two stems of liatris. Wire or tape the caged foam securely to the stems, then insert the stems into the container.

1. Establish the framework.

Style—The Spirit Of Eclecticism

tough-minded style.

back to the basics.

In floral design, there are two prominent styles of composition, often called the basics. One is the triangular form, the other the fan-shaped form. Even though these are traditional forms, there is still every opportunity for a creative designer to move out from the typical. There is no reason to limit style simply because the design is in a traditional form.

The design featuring green fuji chrysanthemums is an interpretation of the conventional triangular form. Yet it has a smart, bright, upbeat style.

There is no more overworked and overused style than the typical fan design. Nevertheless, a style-conscious designer does not hesitate to present this form creatively avoiding the commonplace and boring. In the white and green fan composition, the designer shows a refreshing and sparkling interpretation that speaks out with casual, yet sophisticated style.

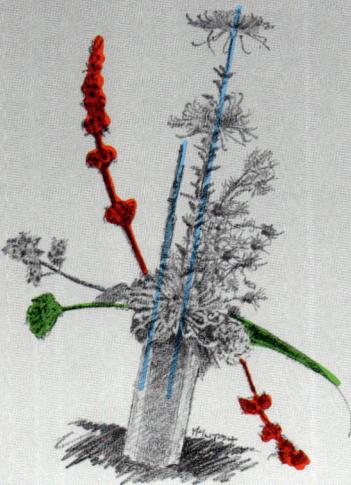

The basic form of this design is a triangle. Within this traditional form, the designer uses smart, contemporary techniques - parallel lines, sweeping diagonal lines and curving horizontal lines.

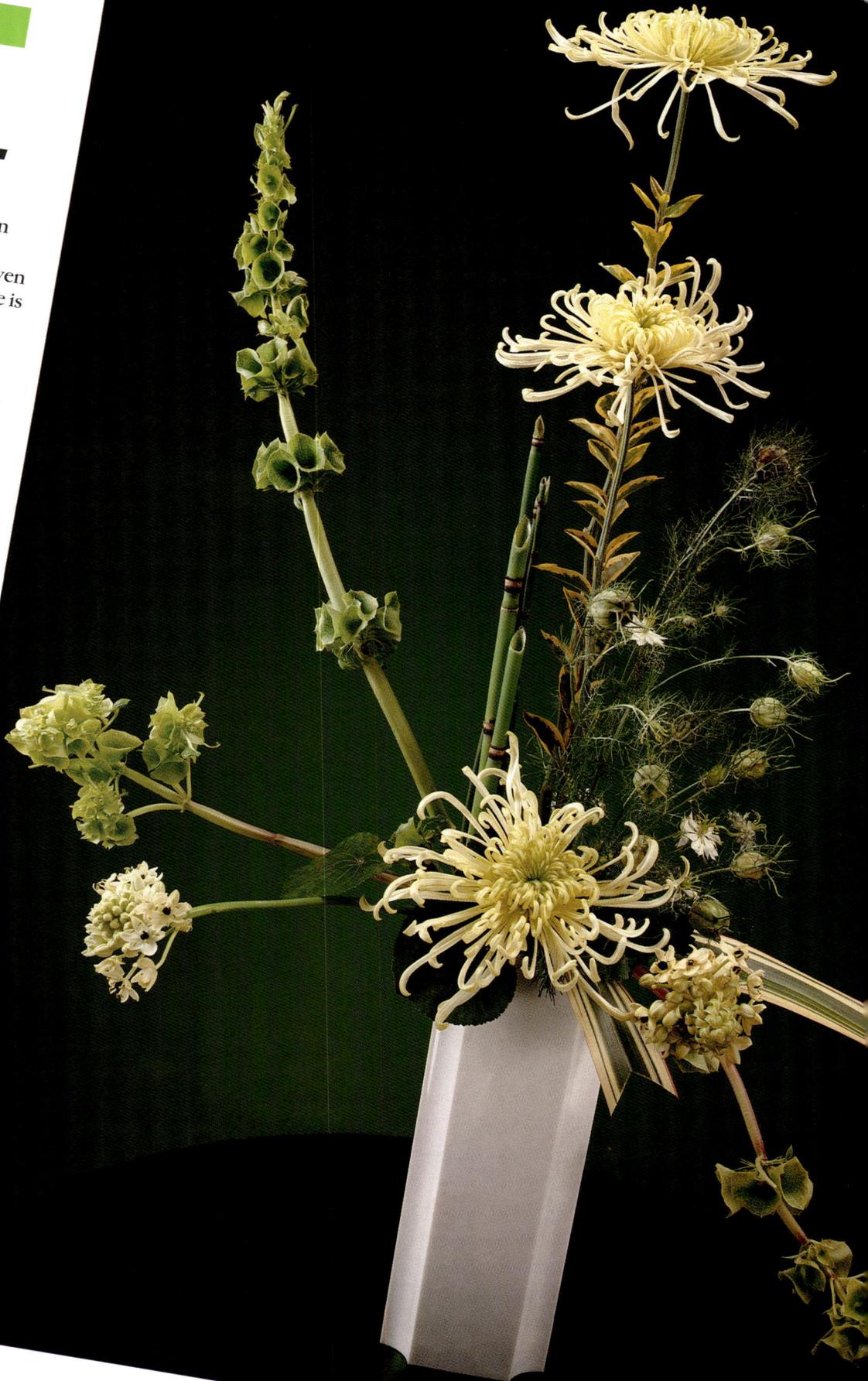

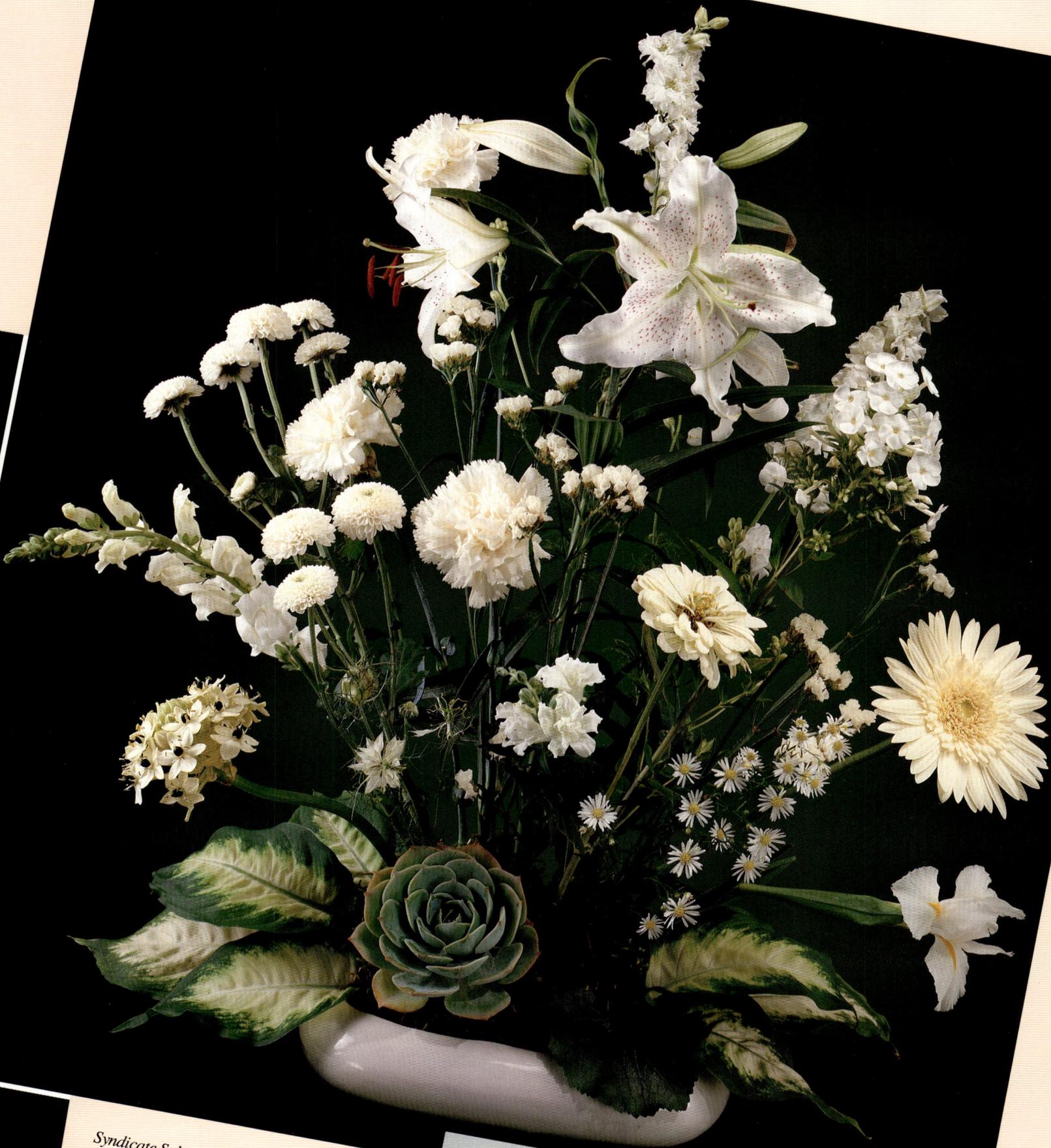

Syndicate Sales No. 15, 10" French rose vase in white and Oasis® floral foam available from your local wholesaler. White pottery container from L. A. Floral Supply, Wall St., Los Angeles, CA.

This fan-shaped design suggests a free-form composition. Flower stems do move into a central area. Yet there is a flamboyance of presentation. The unexpected horizontal groupings of dieffenbachia foliage, the single galax leaf and the succulent give a mark of individual style.

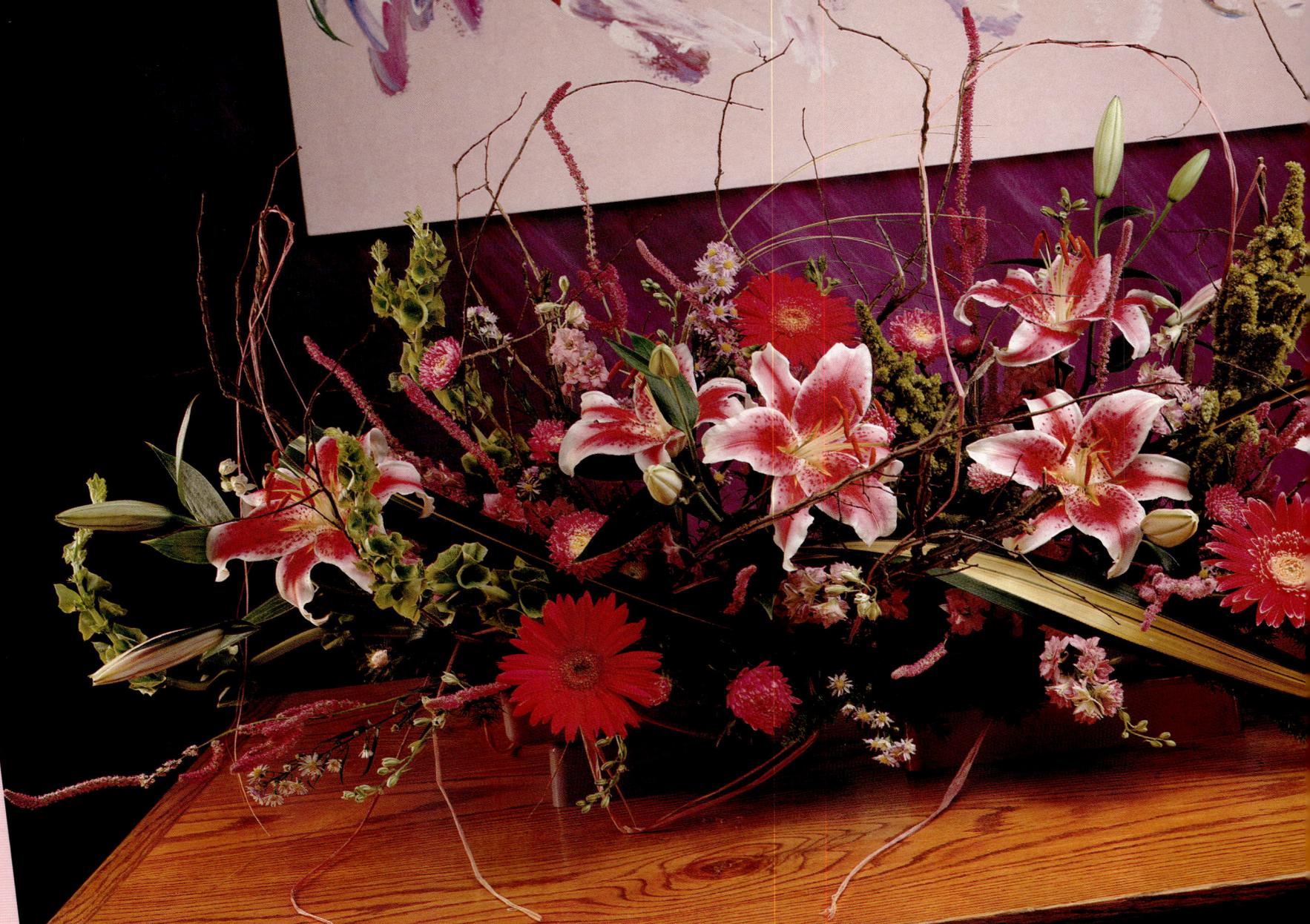

the fine art of creating style.

There is a direct relationship between painting and floral design. In its most practical application, art must be an integral part of floral design. Otherwise, it is no more than a mechanical process of sticking flowers into a vase.

To expand his understanding of style and his ability to create style, a designer studies art and relates what he experiences to floral design. The principles, elements and techniques of floral design are the same as in any form of art.

Through study and experience, a contemporary fine artist learns to combine form, color, texture and line movement to create a painting. His tools are a canvas, tubes of paints, brushes and palette knives. These are the necessary mechanics. Every painting starts with an idea in the mind of the artist. The mechanics are merely the ingredients that enable him to express his idea. His vehicle of expression is a painting.

A floral designer, like the painter, works with form, color, texture and line movement. His tools are a container, flowers, foliages, twigs, branches and other accessories. Like the artist, every flower composition starts with an idea. The container, the flowers and foliages, the twigs and branches and the accessories are the ingredients which enable him to transform his idea into reality - a floral design.

In the composition pictured, two artists express two different forms of art. Yet, each illustrates how form, color, texture and line movement interact to create style - a unique, personal expression of the artist.

clean, clear lines.

In studying and developing style, a floral designer deliberately looks for ways to bring synergism into his compositions. When contrasts in line, texture and form of materials interact vividly, the design expresses a stronger visual style than one in which line, texture and form are bland.

The interaction of materials and techniques in a floral composition is known as synergism. Synergism occurs when the visual emphasis of the composition multiplies because of this interaction between the materials and the presentation techniques. When a designer combines materials with distinct characteristics, or when he presents common materials in distinctly different and unexpected ways, the visual impact compounds. This compounding is synergism. It creates a more identifiable, distinctive style.

This composition featuring ginger, a tree conk, curly protea flats, lotus pods, variegated flax, galax and ivy is an excellent example of synergism. Each material has distinct form and texture characteristics which interact visually to strengthen the style of the design. The combination of straight lines, curving and diagonal lines results in synergism that creates a more unique style.

The repetition of two ginger, two vertical pieces of flax and two horizontal pieces of flax on either side of the design reinforce visual emphasis. The combination of materials with distinctly different forms and textures and the techniques of presentation interact together (achieve synergism) to create a unique style of design.

Round marbleized black container from Midamco, 6630 N. Kostner, Lincolnwood, IL 60646. Ginger from Hawaii Tropical Flowers, 431 Alamaha St., Kahului, Maui, HI 96732. Tree conk from Hoh Grown, P.O. Box 2135, Forks, WA 98331.

When a designer exaggerates the differences in materials or techniques, the style of a composition becomes more distinct. Many floral designs have little, if any, differentiating style. One design looks like the next, except the color might be different. Or, the style is typical of designs found everywhere. This lack of distinctiveness is a style. It can be labeled as ordinary, mundane, common, run-of-the-mill or whatever term defines a style void of personality.

Style does not mean expensive. One lovely blossom presented with distinction has style. Style is created when materials and method of presentation interact (attains synergy) to differentiate the design.

The composition of liatris and miniature carnations includes only a few commonly used flowers. Yet, the method of presentation illustrates synergism that makes this design stand out with distinct style. Exaggeration is a method of synergism. In creating this design, the artist exaggerates the techniques to make the style more individual.

Black stackable container from Midamco, 6630 N. Kostner, Lincolnwood, IL 60646.

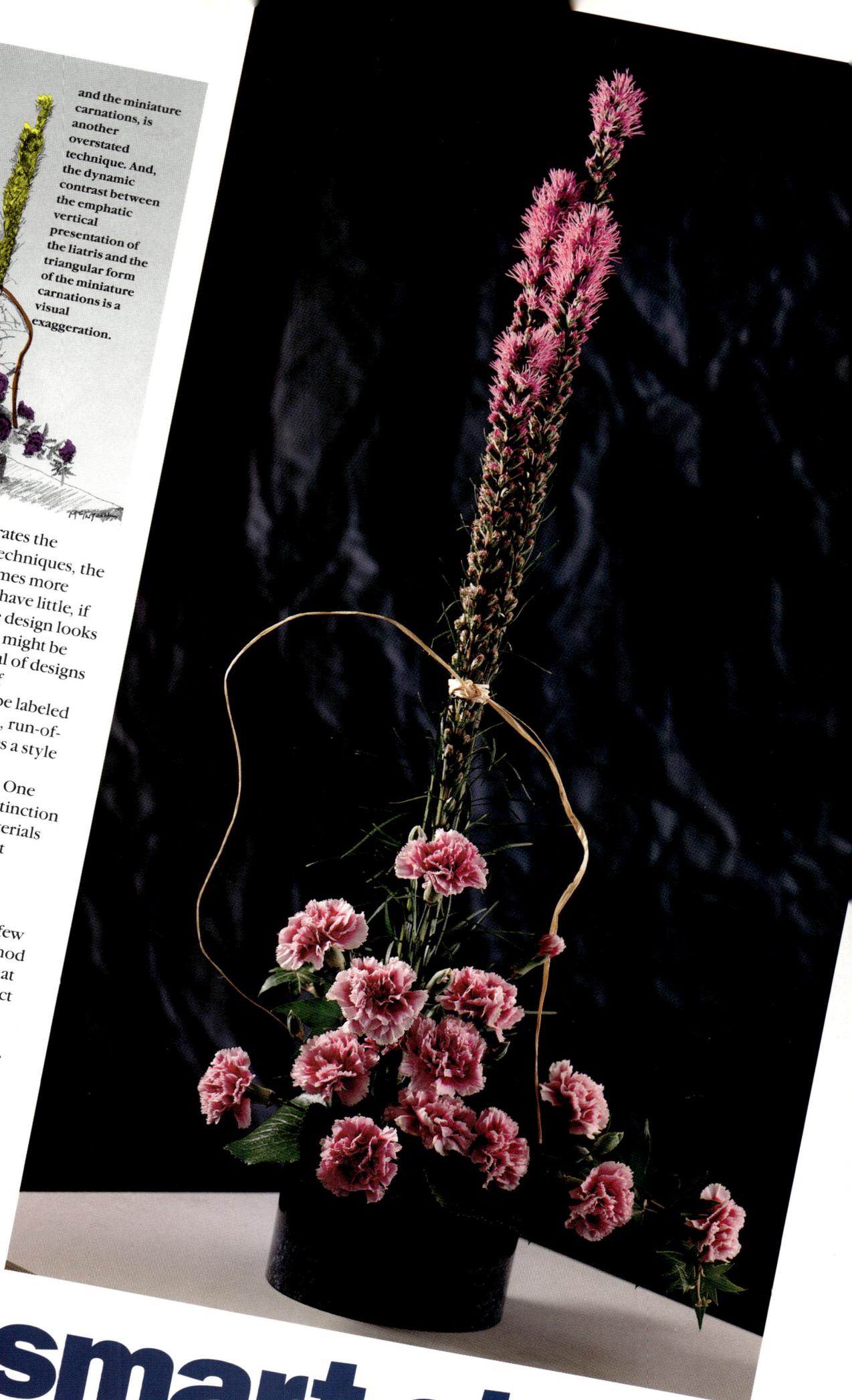

very smart style.

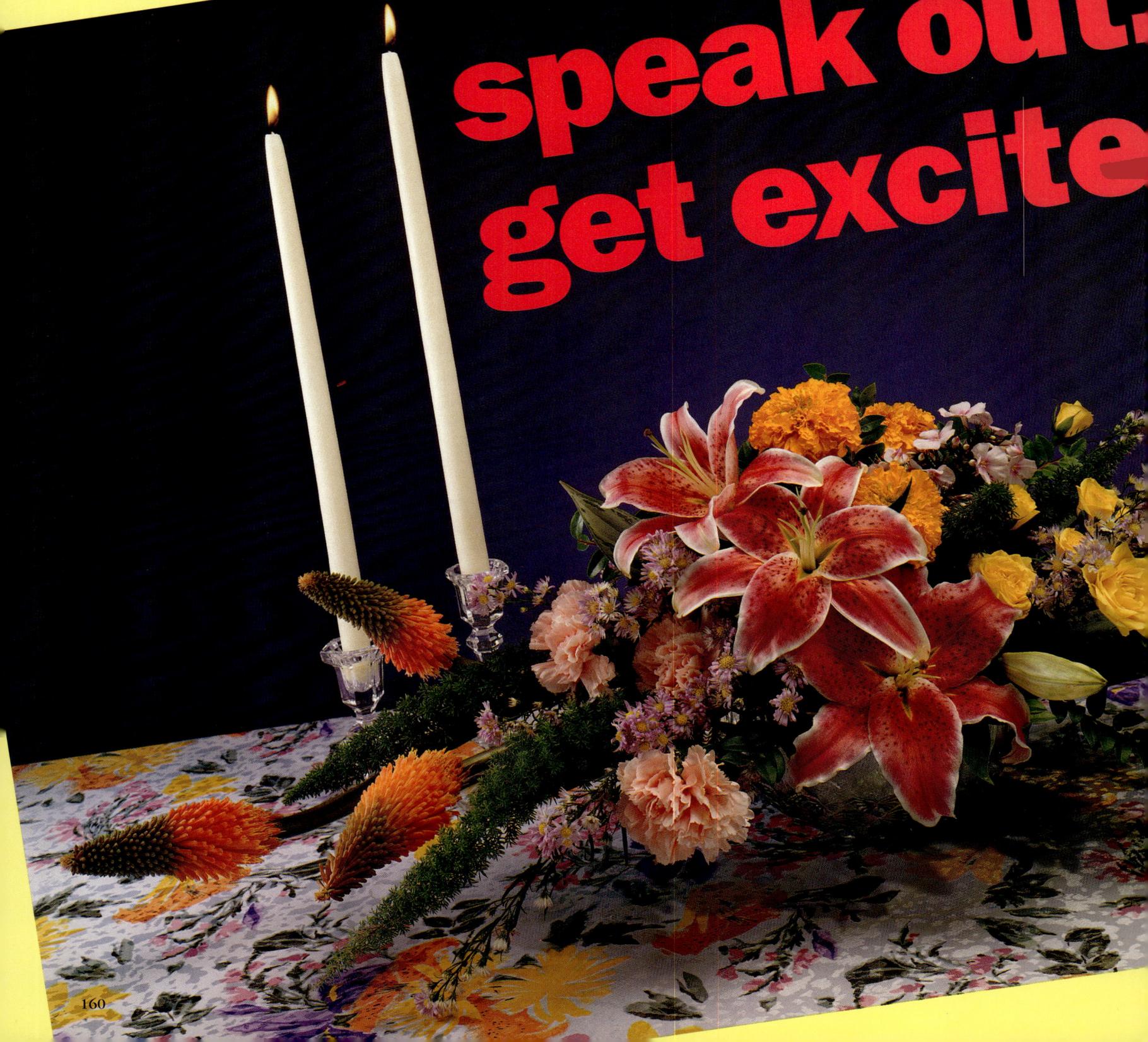

Many attempt to set up reliable ways to build aesthetic quality into the design process. Rules about symmetry, balance, proportion and color, as important as they are in design training, are not trustworthy formulae which make a beautiful comprehensible concept. Beauty is not an absolute value. It is relative. "It is beautiful" has no deeper meaning than "I like it." Therefore, the question, "What is beautiful?" must be translated into the question, "What do I like?" The majority cannot rule in aesthetics. In the commercial world of floral design, beauty is a unique understanding, a relationship between the customer who buys and the designer who creates.

declare sty

let go.

speak out.

get excite

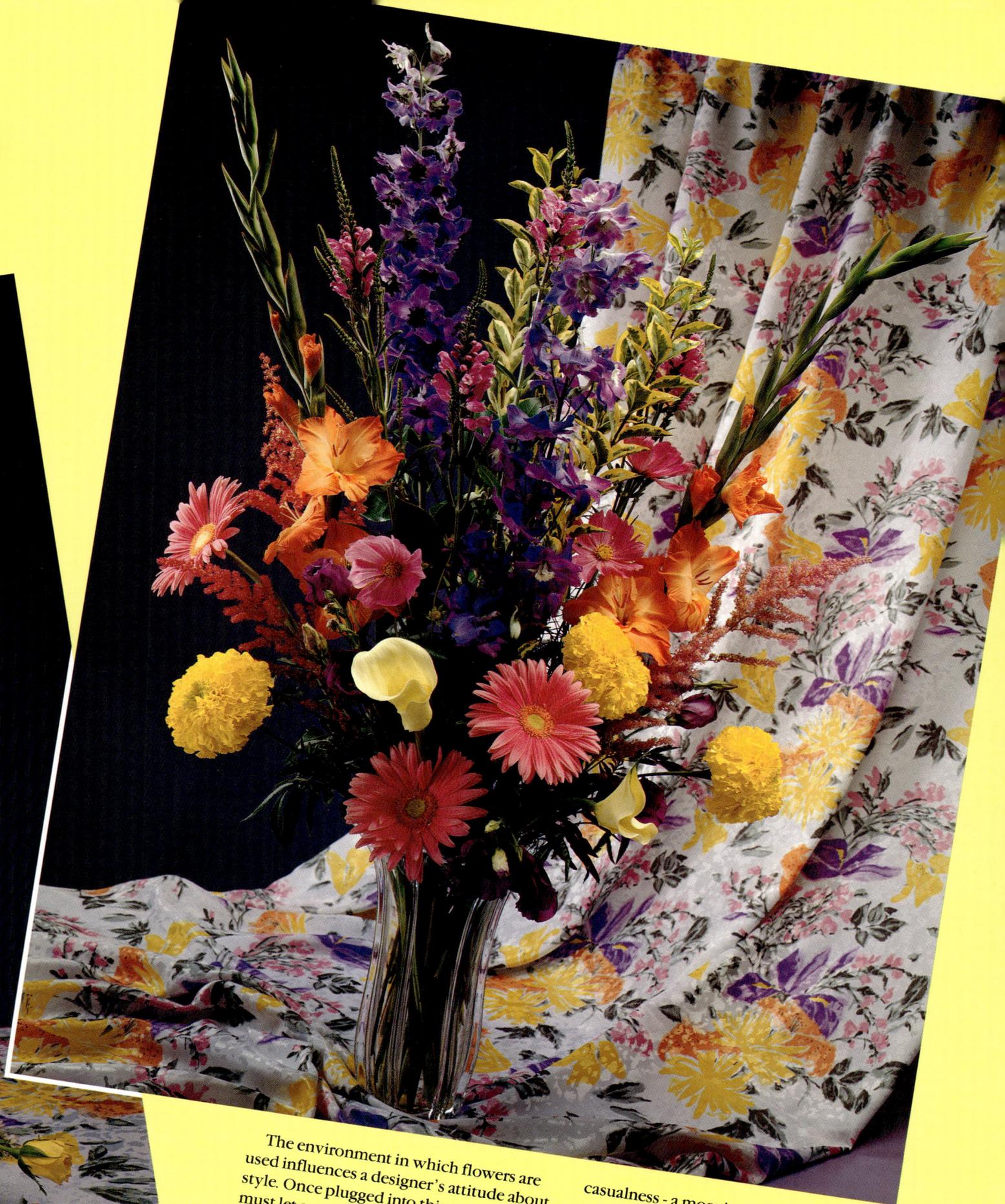

The environment in which flowers are used influences a designer's attitude about style. Once plugged into this sensitivity, he must let go, get excited, speak out and declare a style.

Both of these designs are appropriate in the surroundings. The centerpiece suggests formality. The design is structured with each type and color of flower presented in distinct areas. Even though the design combines formal and informal flowers, the look of the composition communicates formality.

The vase bouquet suggests a more informal setting. The composition is somewhat structured, yet it expresses a casualness - a more impromptu presentation of the flowers.

Do these compositions have style? Of course! Each design is distinctly different with a unique, differentiating presentation of the flowers. Are the compositions beautiful? That all depends on your own definition of beauty. We think they are wonderfully beautiful!

Centerpiece in 9-inch crystal bowl No. 5101; crystal candlesticks Nos. 509, 510 and 511; crystal vase No. 5401 - all from Sullivan, Inc., 405 E. 18th St., Sioux Falls, SD 57101. Candles from Creative Candles.

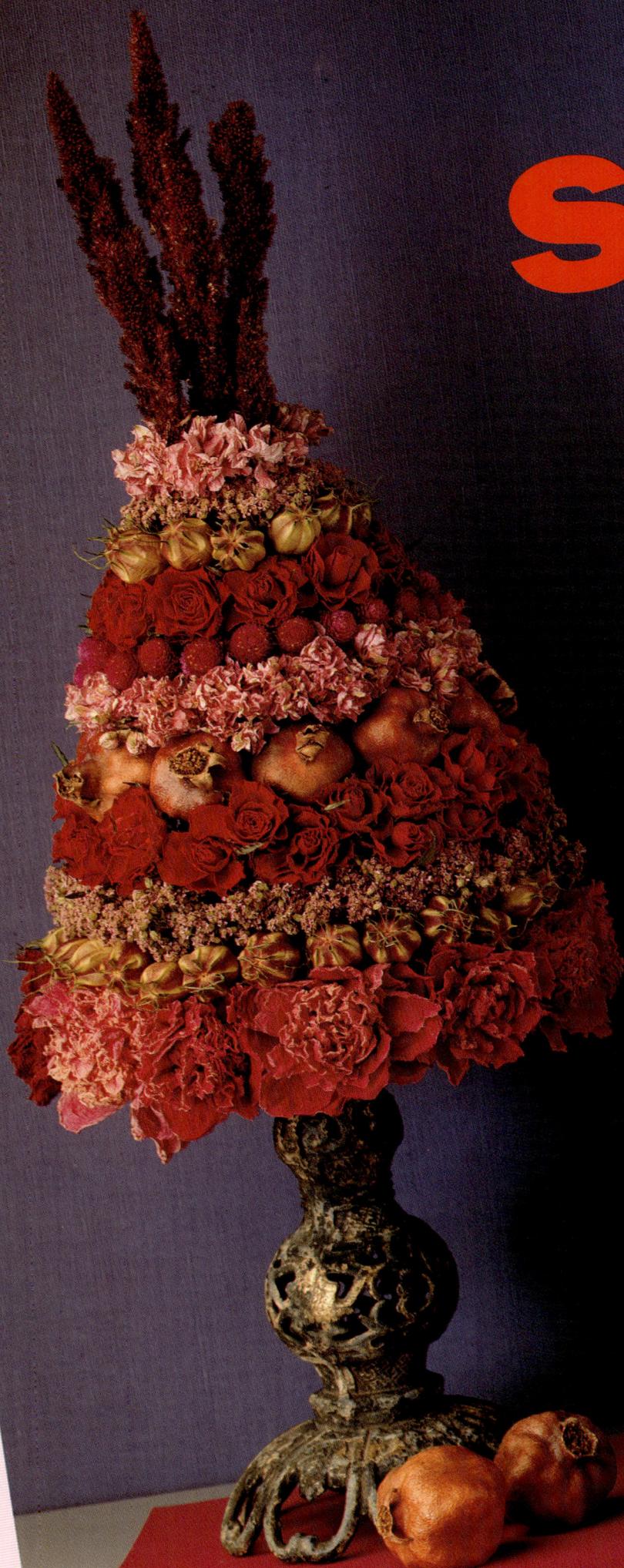
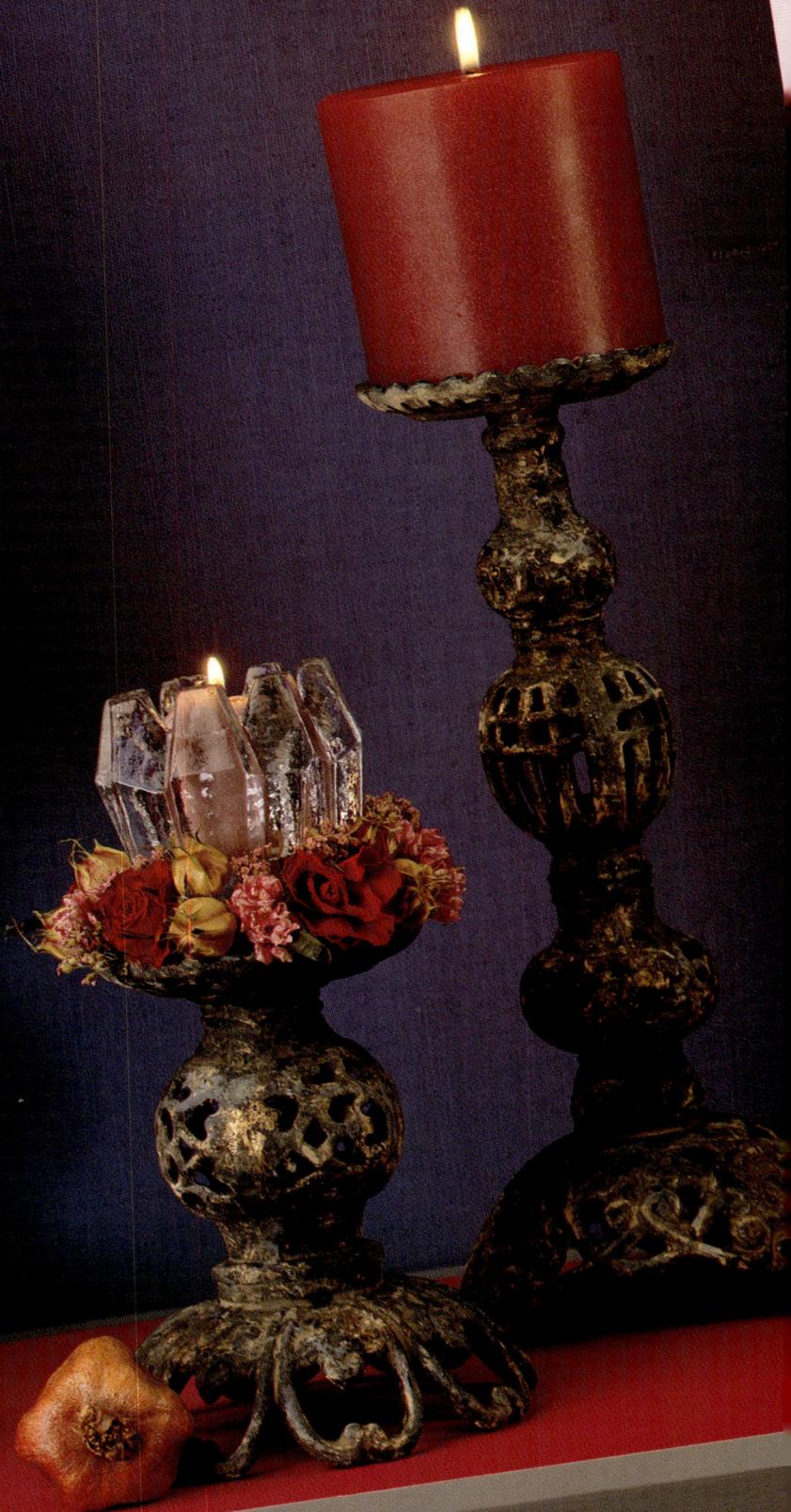

style

the glow of distinction in custom design.

A designer who strives to develop a complete repertoire of styles looks to history to influence his designs. Each historical period offers unique characteristics that can be incorporated into floral design. The two compositions pictured combine the influences of several periods in history.

Often Biedermeier is identified as a style. There is no one distinctive style that emerged from this period of history (1815-48). Instead, there are only influences from decorative accessories. Architectural simplicity is the one characteristic that might define the Biedermeier period. This simplicity was evident in furniture, accessories and paintings.

The elegant cone-shaped composition is often identified as a Biedermeier design. The banding technique with the materials presented in concentric rings is a design influence used in furniture in the Biedermeier period. Bands of ebony and maple inlays contrasted the light colored fruitwood Biedermeier furniture.

The rich, red colors in this composition suggest the Victorian period more than Biedermeier. A creative designer brings a combination of historical influences into his design work.

In history, the topiary as pictured to the right precedes the Biedermeier period. And, the artist presents this design with a feeling of Victorian Old World elegance.

Iron candleholders Nos. 24-2501, 24-2502 and 24-2503, handled container for the topiary No. 33-2081 and leaf dish accessory No. 33-2051 from Toyo Trading Co., 1300 S. Spring St., Los Angeles, CA 90061. Pillar candle from San Francisco Candle Co., 1825 S. Grant St., Suite 640, San Francisco, CA 94402. Crystal votive holder and candle from Creative Candles.

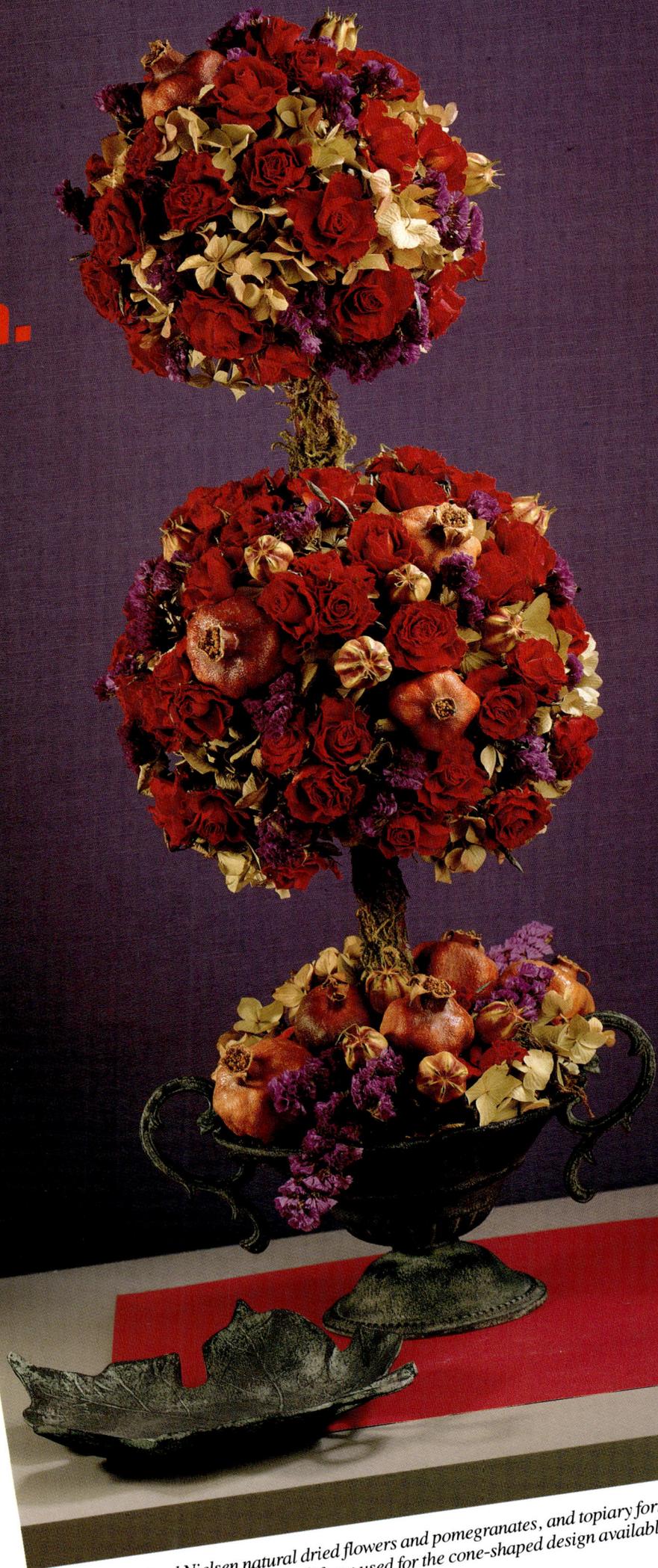

Knud Nielsen natural dried flowers and pomegranates, and topiary form No. TT18; and Sahara® foam used for the cone-shaped design available from your local wholesaler.

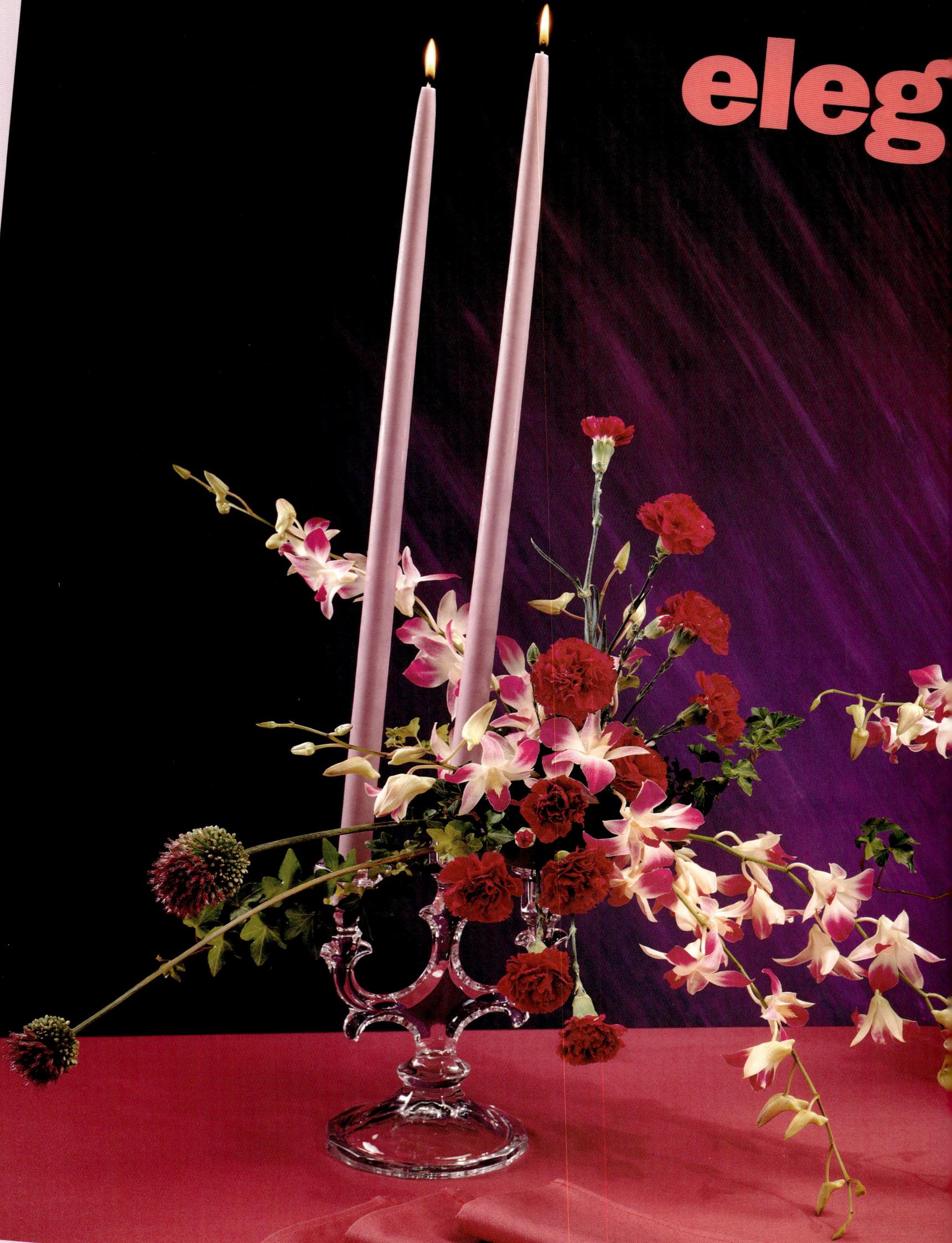

ant style is never out of fashion

Study, experience this outstanding table decoration. Ask this important question: What makes this design so exceptional, so visually captivating? Isolating the key differentiating features identifies the characteristics that give the composition style.

Creating style is an ordering process. Everything in a composition that contributes to style cannot be dominant. Instead, there must be first, second, third and fourth order of visual emphasis. This ordering technique is a conscious decision of presenting the various characteristics of a composition in visual priority order.

In this table setting, color is the dominant, primary characteristic. The monochromatic red-lavender color harmony with this single hue presented in different dark to light values commands attention.

Line is the second order of visual priority. The vertical strength of the candles contrasted to the dynamic energy of the diagonal lines of the dendrobium creates visual tension - a counterpoint in the design.

The third order of visual importance is texture contrast. Texture moves from the smooth dendrobium orchids to the ruffled carnations to the coarser allium.

The ordering process in creative design must be planned. First, know-how makes the difference in planning. A designer can't work with color, line and texture if he doesn't know what color, line and texture are all about. Some few outstanding designs emerge by accident. Most are accomplished by a conscious plan that enables the artist to translate the idea in his head into an exceptional floral composition.

Nine-inch crystal candleholders No. 5209 from Sullivan, Inc., 405 E. 18th St., Sioux Falls, SD 57101. Oasis O'Dapter® used for the flower arrangements in the candleholders available from your local wholesaler. Candles from Creative Candles, P.O. Box 19514, Kansas City, MO 64141.

Roy Behrens, a well-known art instructor states that creating a style is a struggle between difference and similarity.

Behrens compares art to life. "When there is nothing new and exciting, time drags on. Life is 'humdrum' (extreme similarity). Sometimes life is overwhelming with too many things happening. Life is like a hodgepodge (extreme difference).

"Humdrum forms of living are unity without variety. Hodgepodge forms are variety without unity. When we are composed in life, our pattern of experiences is a mixture of regularity and change, of harmony and discord. It is aesthetic living. It is unity with variety."

In the silk flower design, the artist combines soft, retreating colors with expansive lines and diagonal line movement. It incorporates variety and achieves design unity.

The analogous color composition with eremurus, spray roses and gerbera emphasizes strong vertical form and features differences in form and texture. These extreme similarities and differences interact for variety and design unity.

Candlestick No. 24-5071 from Toyo Trading Co., 13000 S. Spring St., Los Angeles, CA 90061 used for both arrangements. Dark silk Aztec lotus No. 953, budding branch No. 781 and crown imperial No. 960 from Seville Industries, P.O. Box 8621, Fort Worth, TX 76124-0621. Lomey caged fresh flower foam and caged dry foam used for the designs available from your local wholesaler.

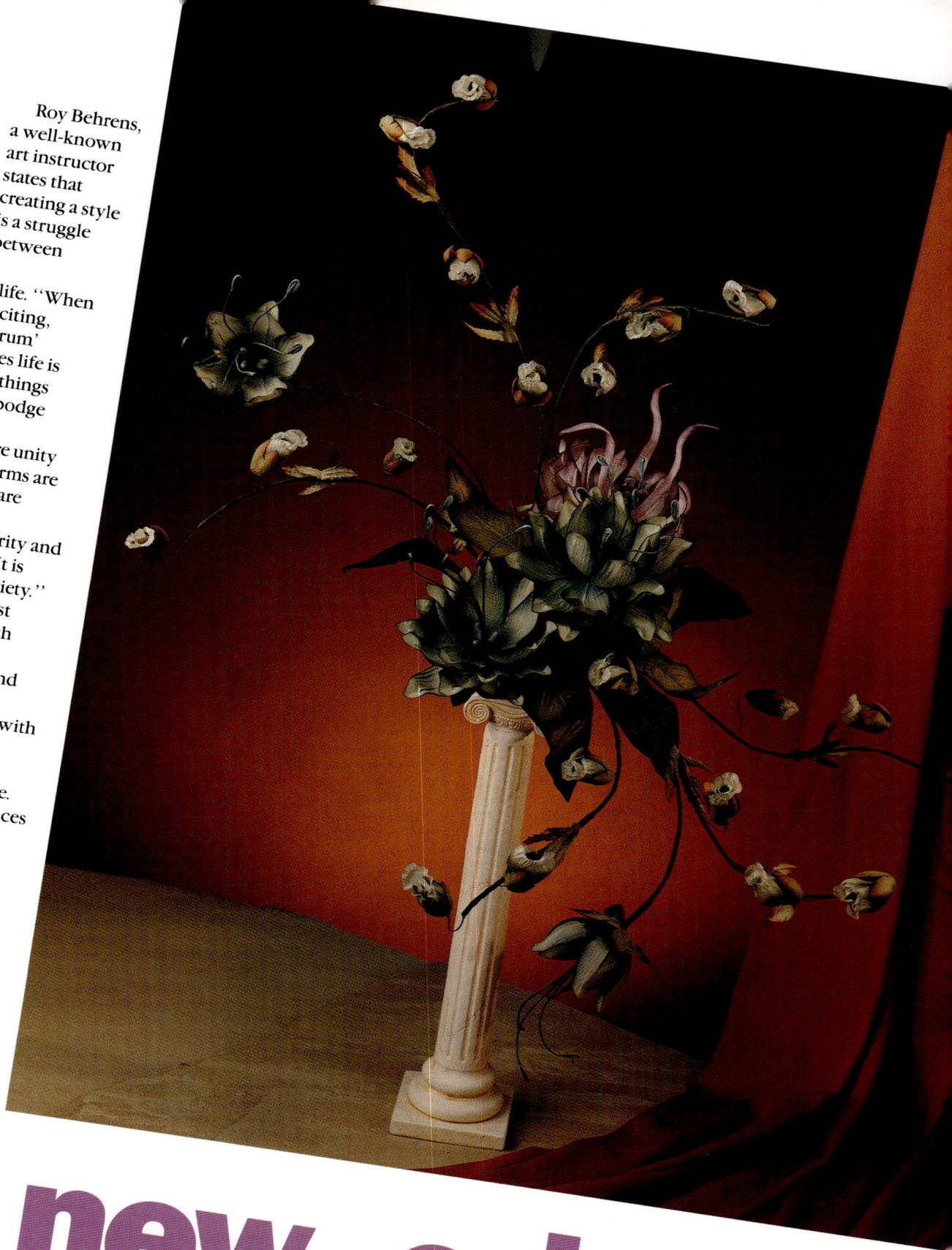

new, original variations on style.

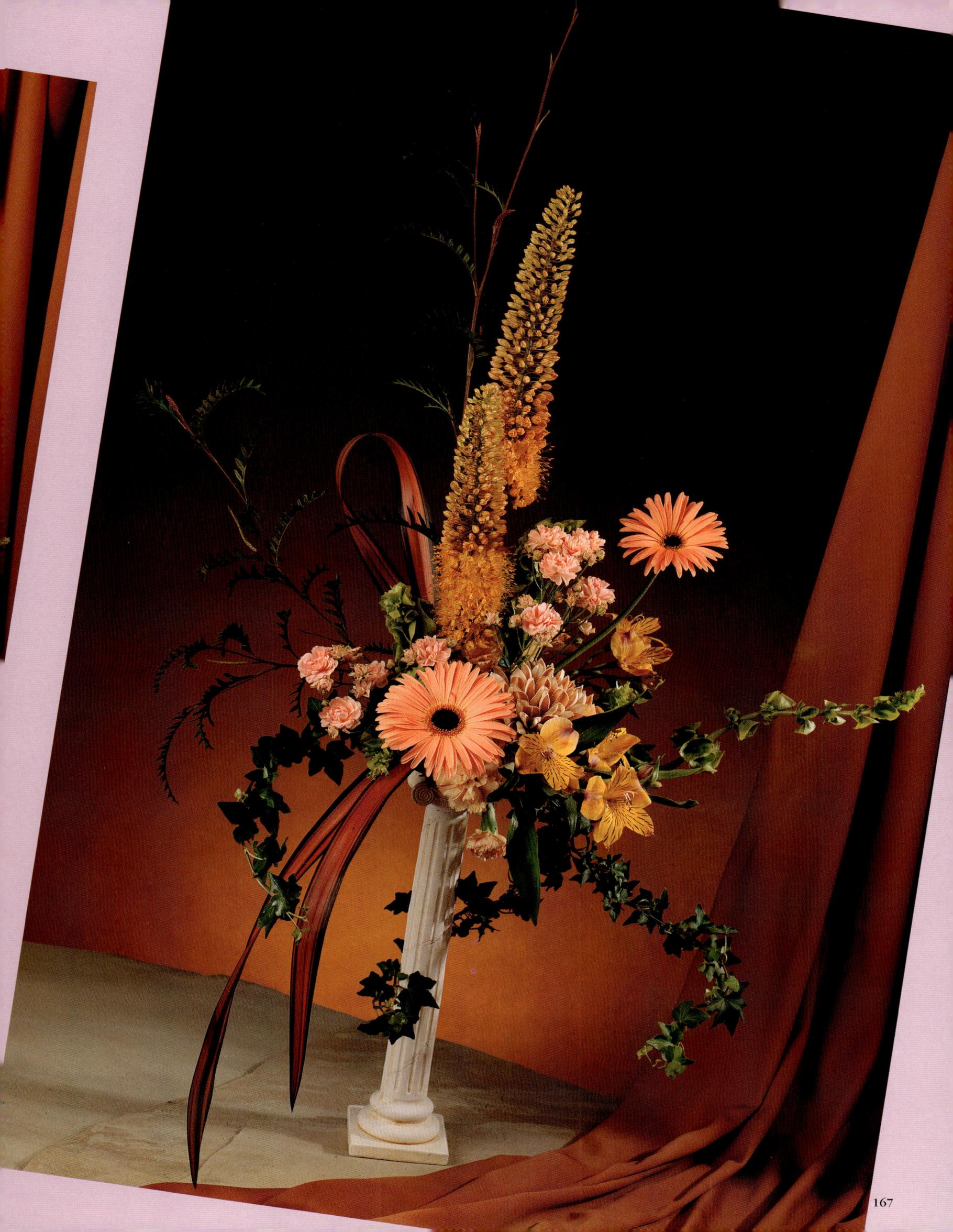

unmistakable personality

well-defined shapes

brilliant style!

In creating distinctive, distinguishing style, a sensitive floral designer recognizes the many ways to introduce similarity and variety into a composition. Unity results from similarity. Things which look alike appear to belong together. Variety results from differences. Things which do not look alike belong apart. This logical classification based on similarity dates back more than 2400 years to Aristotle.

In the all white design, the artist illustrates this theory of logical classification. The lilies and the gerbera do not look alike. Therefore, the designer presents them in separate areas in the composition. Even the line movement of the flowers is different and separated. The lilies flow in a vertical line; the gerbera move in a diagonal line. There is variety in flower form and line movement. The white color is the one similar characteristic which unifies the design. Even the difference in the background and the container unify because of color similarity. The total design is aesthetically pleasing, because it has unity with variety.

The high-spirited composition with red gladioli and gerbera is a different approach to similarity and difference. The vertical and horizontal lines are structured and expected. These lines are static - they have little motion. Only the single stem of gladiolus on the right and the looped dracaena leaves add dynamic line movement. The difference in the shapes of the materials and the similarity of the color interact and resolve into a unified design.

Black Horizon vase No. 8907 and white architectural vase No. 8921 from Gardenhouse™ collection, available from The Haeger Potteries of McComb, Inc., P.O. Box 558, McComb, IL 61455. Lilies from Sun Valley Farms, 1780 27th St., Arcata, CA 95521.

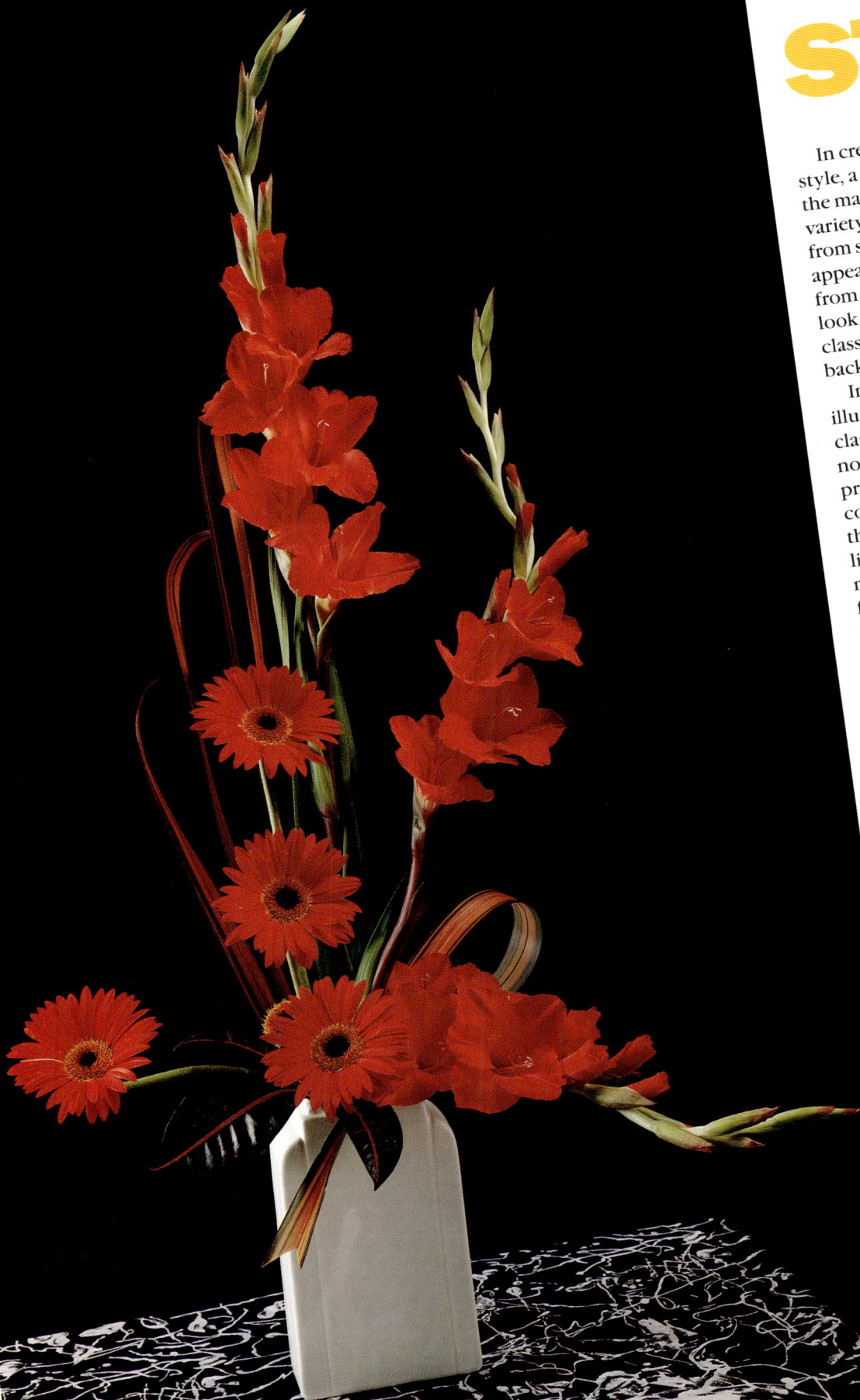

Creative, Fearless Style.

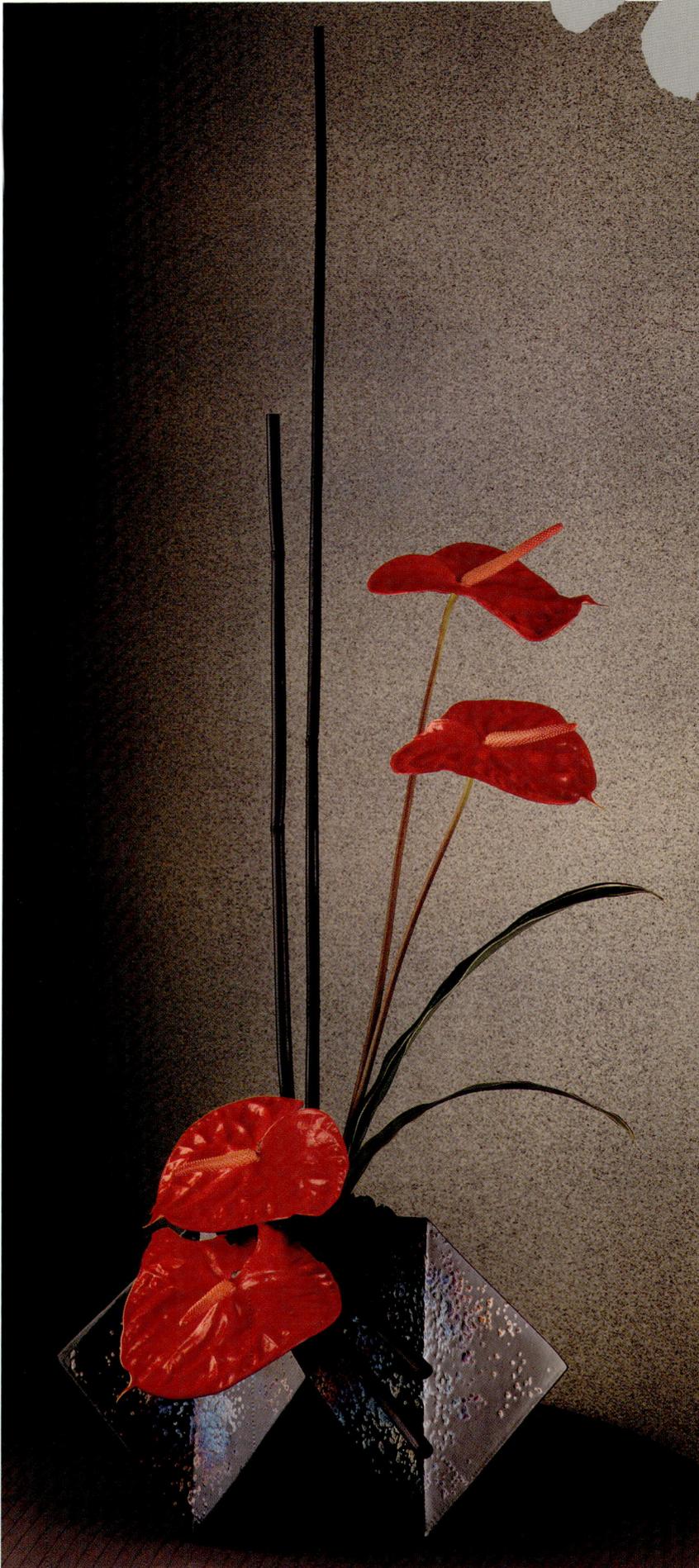

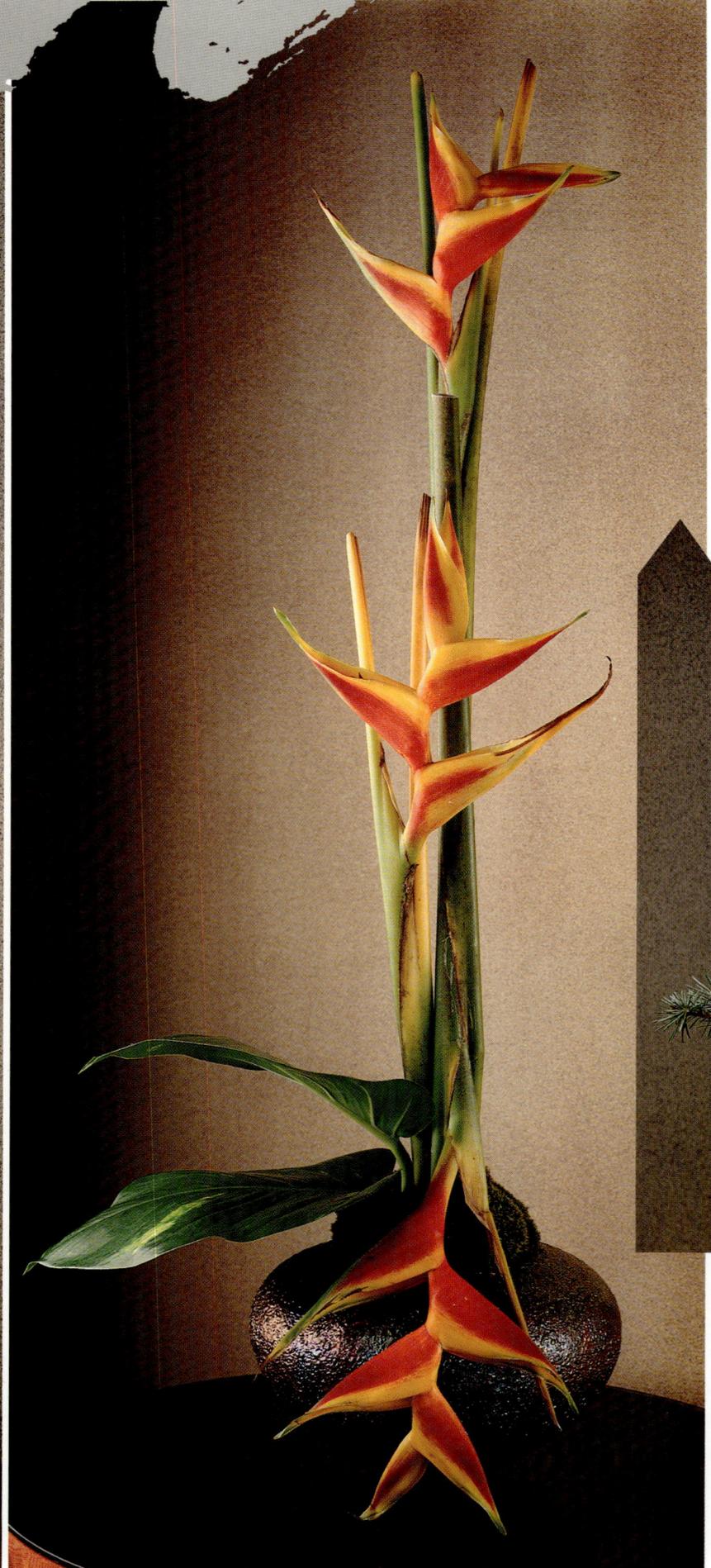

Repetition is a method of creating style. Forest Wilson, a respected teacher in design perception, states, "A recurring stimulus (repetition) has more attention-getting value than a constant stimulus of the same magnitude."

In the anthurium design, repetition occurs in pairs: two black river cane, two dracaena leaves and two groups of two anthurium. There is space - pauses - between each group. Based on Wilson's perception theory, this design draws more visual attention because the pairing of different materials with space between is a recurring visual stimulus.

The composition of heliconia presents another form of repetition with recurring stimulus. The two upper vertical heliconia, the two lower philodendron leaves and a single inverted heliconia repeat the form of the upper blossoms.

The red ginger is still another form of recurring repetition. The same form repeats in different groupings with exaggerated pauses in between. To introduce variety, the artist interrupts the striking horizontal format with a diagonal line of larch foliage.

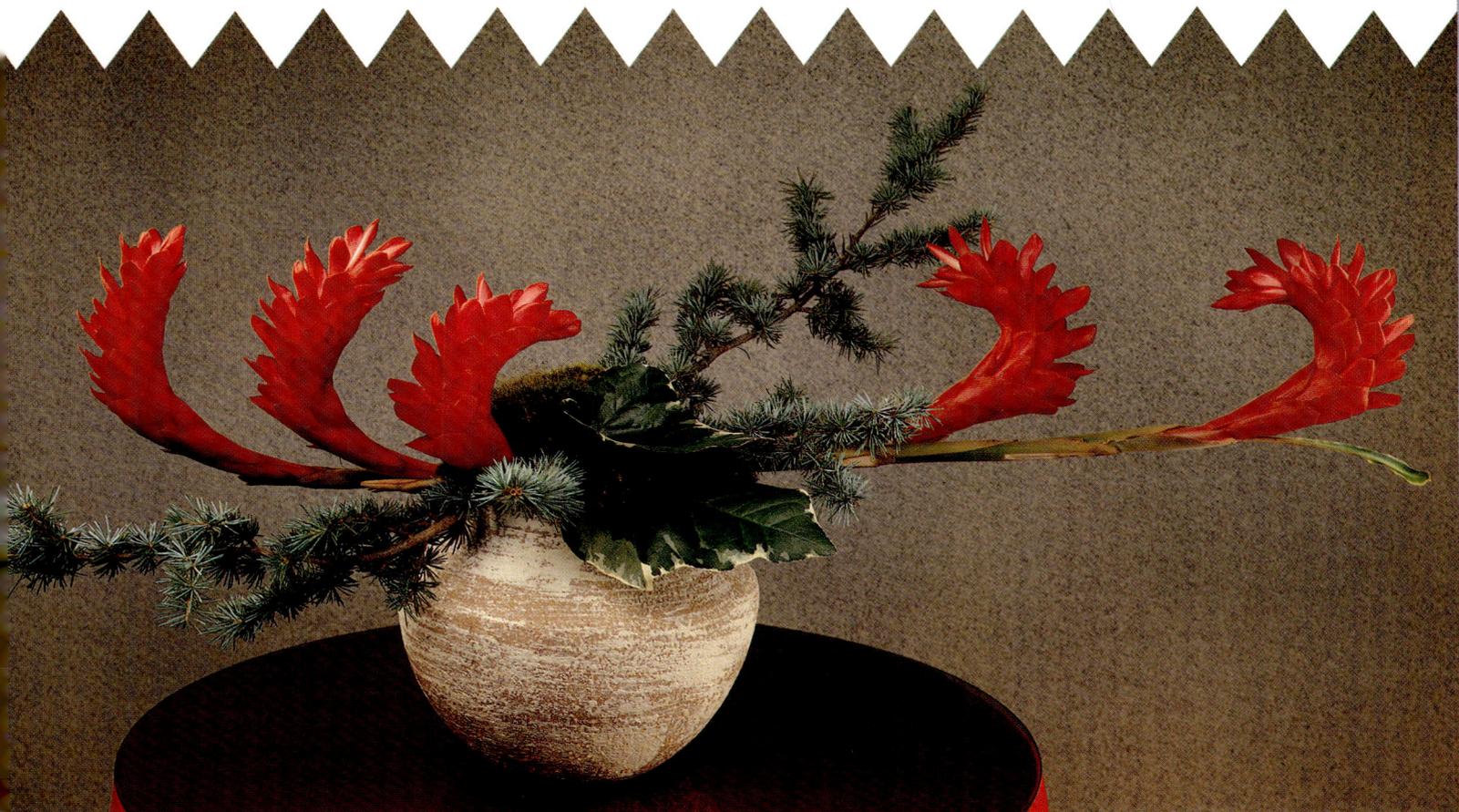

> **"Repetition is what holds life together. A composition in which no line, no shape, no color, no size, no direction and no movement is in anyway ever repeated is complete disorder."**
>
> **Arthur B. Fallico**

Anthurium, ginger and heliconia from Hawaii Tropical Flowers, 431 Alamaha St., Kahului, HI 96732.

Chimes black orgami container No. 001 CBL from Evans Ceramics, Inc., P.O. Box 1212, Healdsburg, CA 95448. Textured flame container No. 12012 T and sunwashed container No. 5004 from Chimes, Inc., P.O. Box 444, Oswego, KS 67356.

Style—The Art Of Getting Noticed

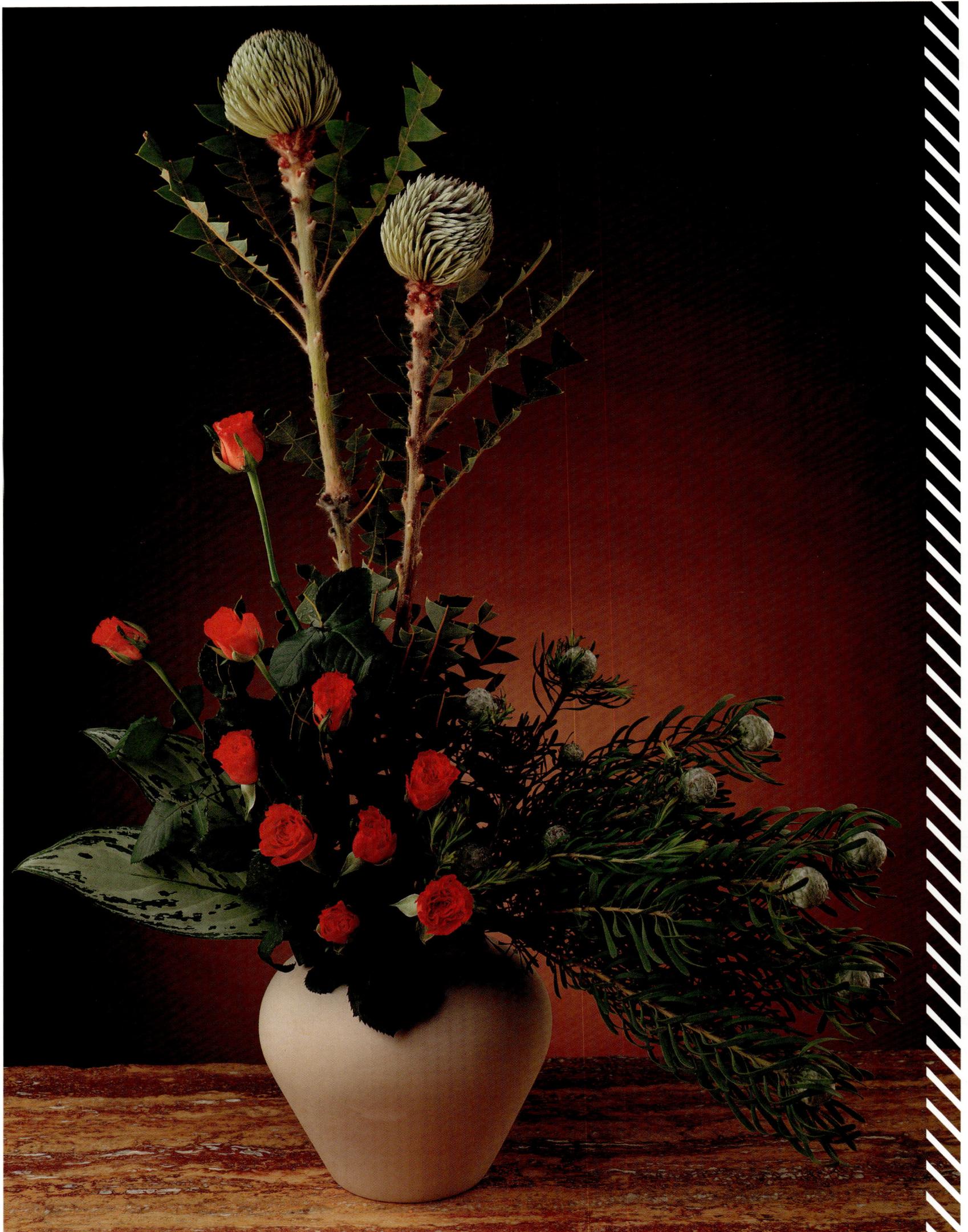

Style.

Rearranging the Cobwebs In Your Mind.

There are two basic approaches to presenting materials in any composition. One is ordered and systematized; the other, spontaneous. Both create style.

In the design of banksia, leucadendron and roses, the ordering of the materials is precisely organized with each grouping confined to an absolute area. There is no merging or intermixing. Each of the three materials makes a distinct line direction statement. The two banksia are in visually prominent vertical positions. The roses move through the base of the design in a secondary diagonal position. And, the leucadendron move out in horizontal direction in a tertiary position.

The composition with the vibrant red gerbera shows another form of ordering through grouping. To reinforce this ordering, the designer arranges each material in a separate container which join for a total composition.

Each of these compositions reflects a definite style. The pivotal consideration that determines style is how a designer presents the materials.

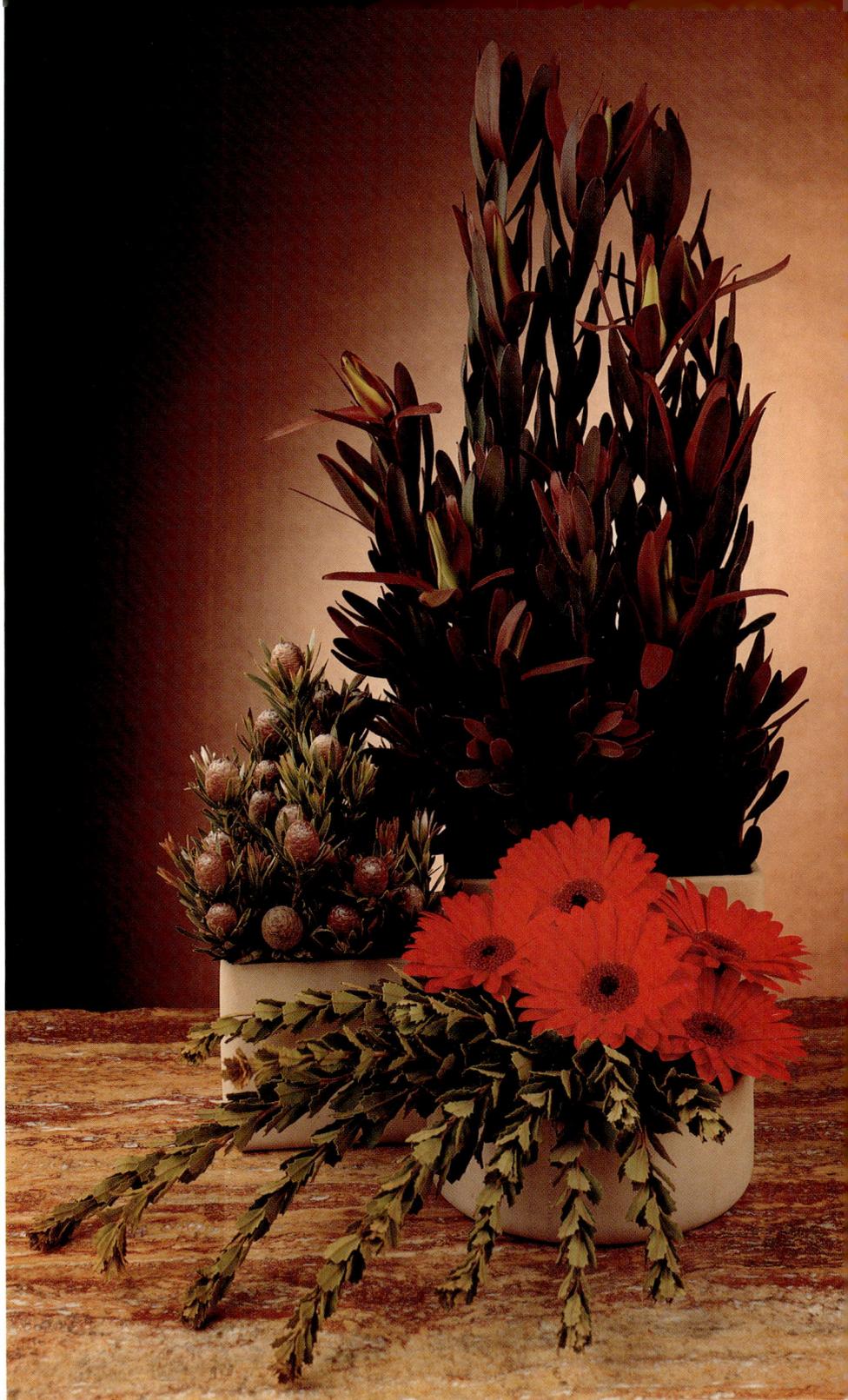

"Design is a means of ordering visual and emotional experience to give unity and consistency to a work. Design is essentially visual control."

All waterproof terra-cotta containers used for these arrangements from Adams Ceramics, 14041 Vanowen St., Suite 290, Van Nuys, CA 91405. Banksia and leucadendron from Silvermink Protea, 14111 Westfork Rd., Pauma Valley, CA 92061. Oasis® floral foam available from your local wholesaler.

Studied Simplicity. Eloquent Style.

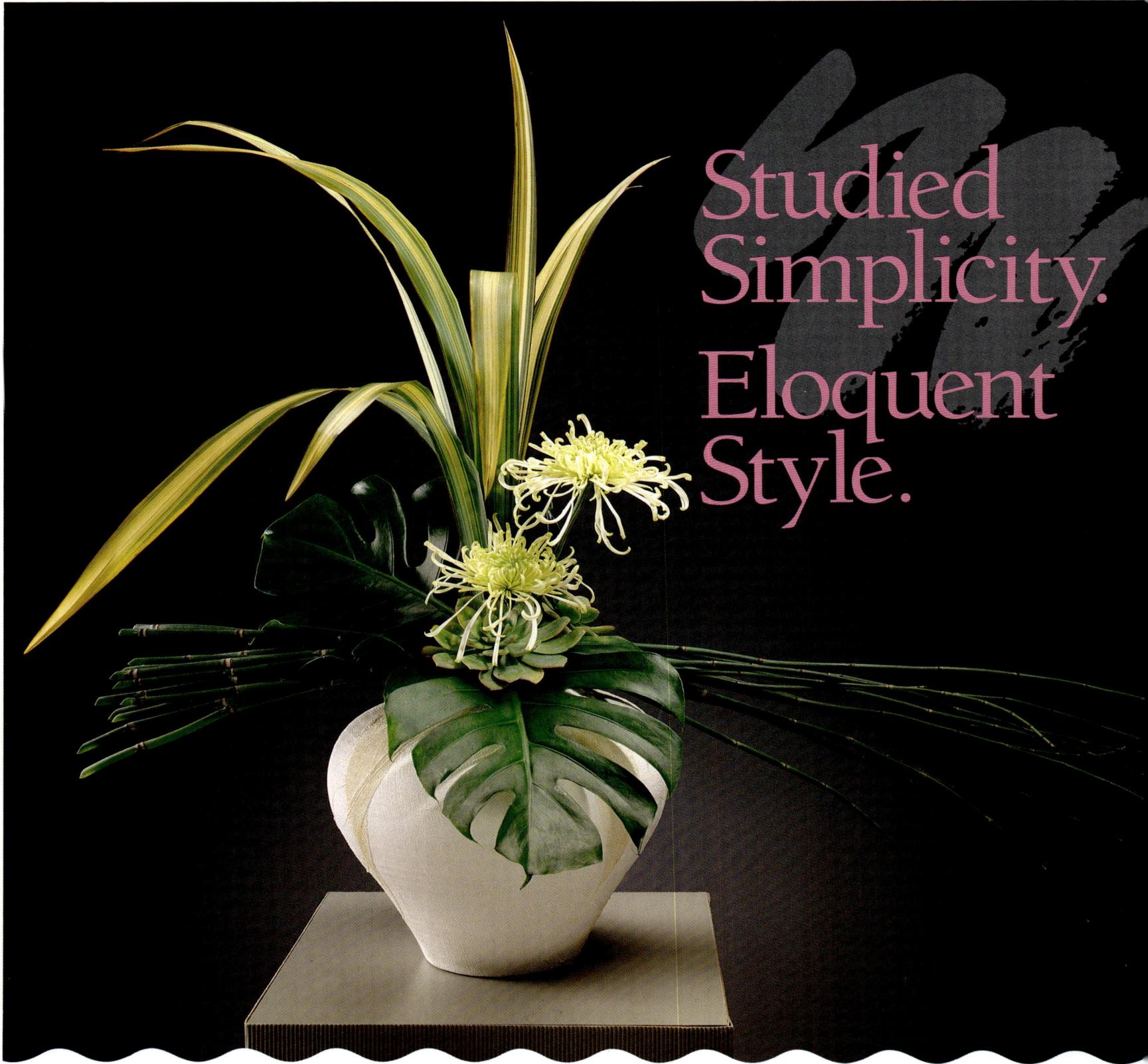

Accent containers with French gauze glaze Nos. 5201 and 5025 available from Chimes, Inc., P.O. Box 444, Oswego, KS 67356. Grey pedestals from Flute, Inc., 1500 S. Western, Chicago, IL 60608.

"Style is how you turn unembellished materials into a drama of your own."

The compositions pictured illustrate distinctly different styles. The design above presents complex materials in a range of sizes, forms and textures. The composition to the right makes an intensely dramatic statement with one stem of lilies, one jet-streak (rhodospatha) leaf and one flax.

The design with green fuji integrates a method of ordering: two fuji, two monstera leaves and two accents of equisetum. The flax emerges from the design. The succulent solidifies the focal area.

The lily composition is a studied, yet spontaneous design. The flax laces through the jet-streak leaf joining the lily stem to the leaf. The open stem area at the bottom of the design is an important characteristic of this freeform style.

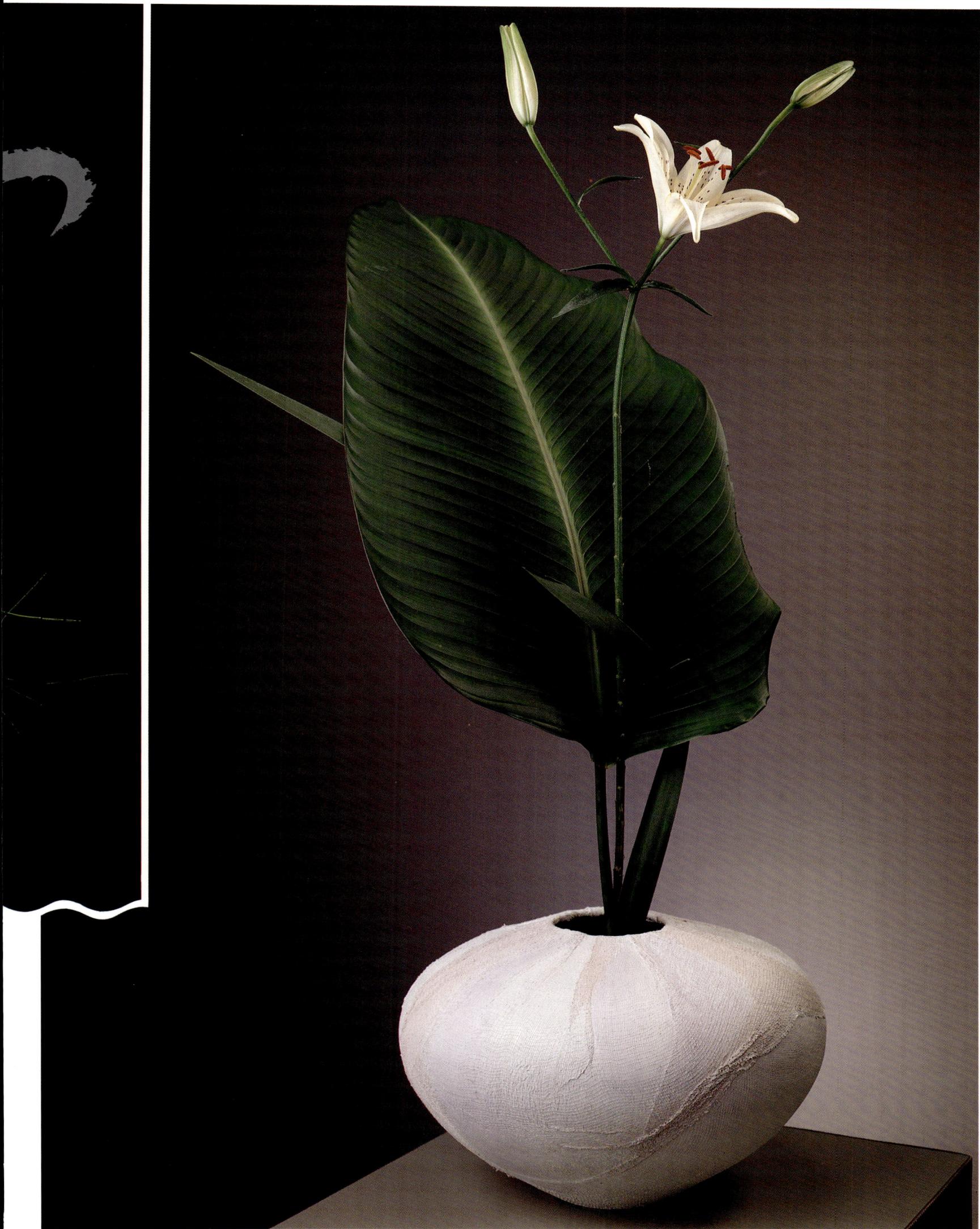

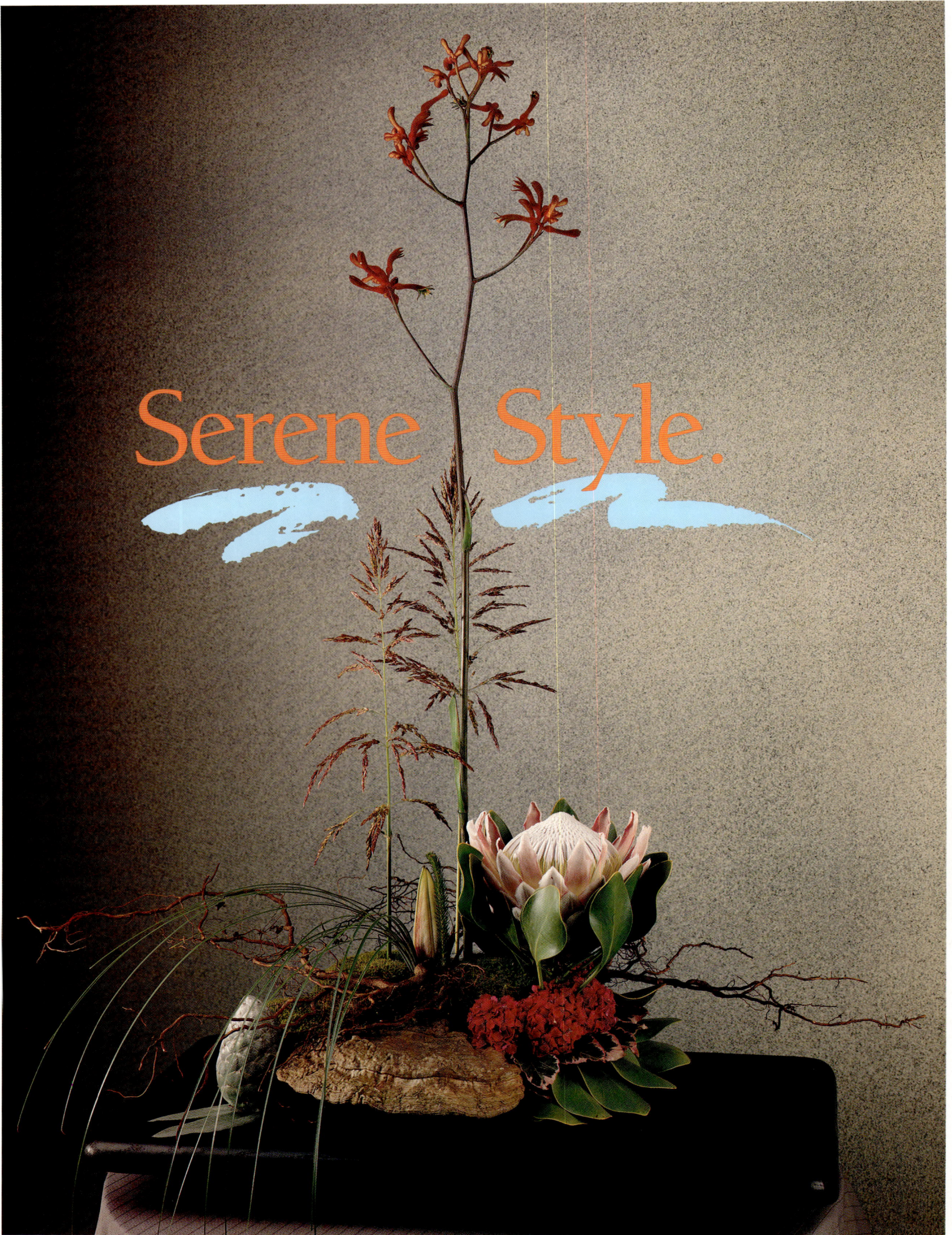

Serene Style.

"Design is firmly based in nature. Nature is an artist's most reliable source of ideas and inspiration, and even for understanding form, color, line and texture."

The protea design suggests a more natural style with king protea, kangaroo paw, grasses, foliages, a conk and roots. The design, however, is a contemporary presentation of nature. The stem of kangaroo pod, the two stems of grass, the king protea, the silver tree protea bud and the lily bud are in parallel positions. They pull the eye through the design. The king protea is the accent point of the composition and all other materials subordinate. The design featuring oncidium orchids is a unique approach to presenting nature. The birch branch, the bamboo, galax and croton leaves flow in a diagonal, angular line pattern. The oncidium orchids initiate another diagonal line. It moves into the center area of the composition and pulls the eye into the yellow roses. The oncidium orchids and birch branches split the composition vertically. The diagonal repetition of the yellow color is an important technique in this style.

The Ingenious Presentation Of Nature.

Lomey 11" designer dish used for the protea design; Knud Nielsen giant reindeer moss; and Oasis® floral foam available from your local wholesaler. Oncidium design in low dish No. 39-2602 from Toyo Trading Co., 13000 S. Spring St., Los Angeles, CA 90061. Protea from Silvermink Protea, 14111 Westfork Rd., Pauma Valley, CA 92061. Conk, roots and birch branches from Hoh Grown, P.O. Box 2135, Forks, WA 98331. Roses from Groen Rose Co., Inc., 754 Wall St., Los Angeles, CA 90014.

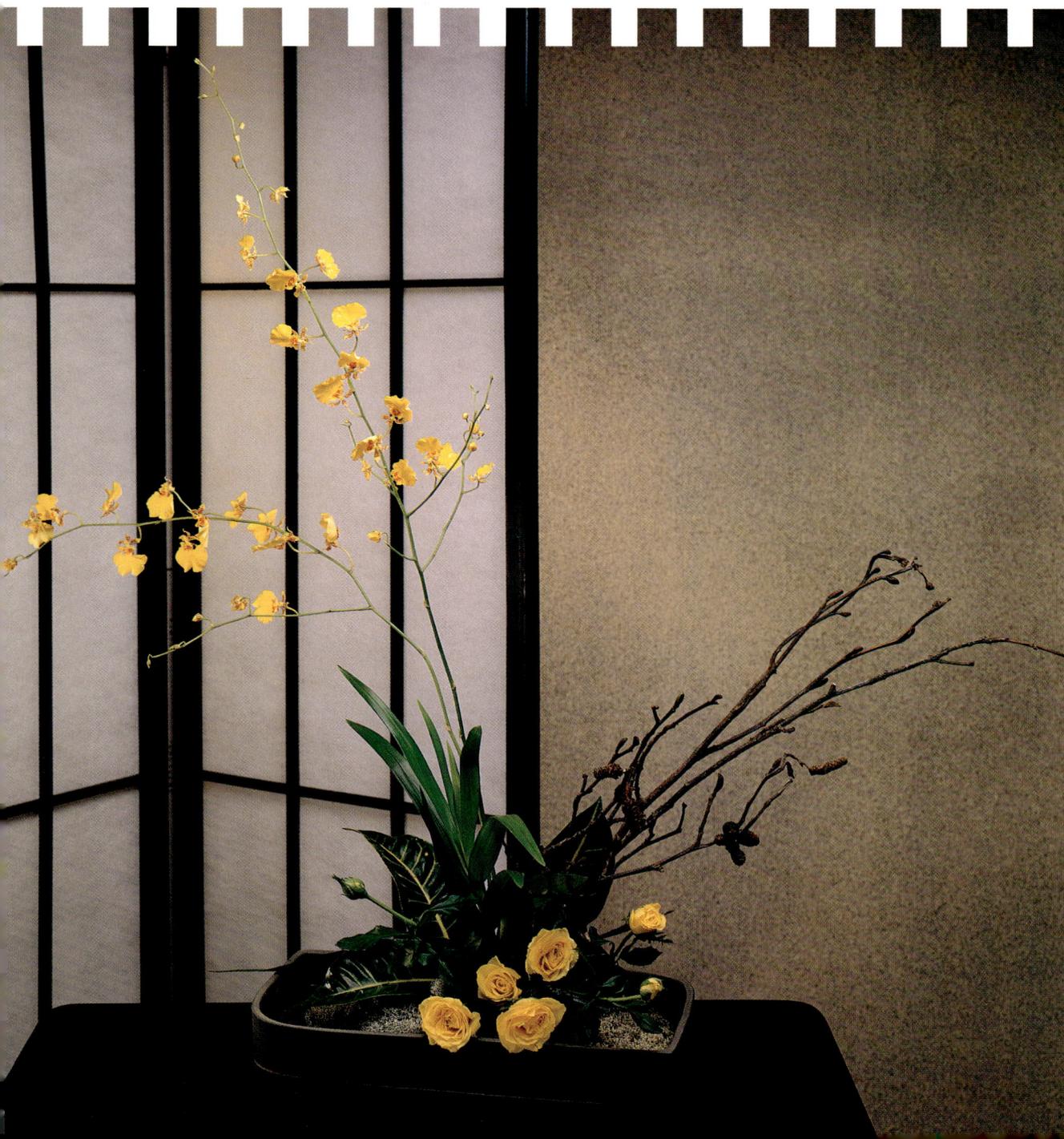

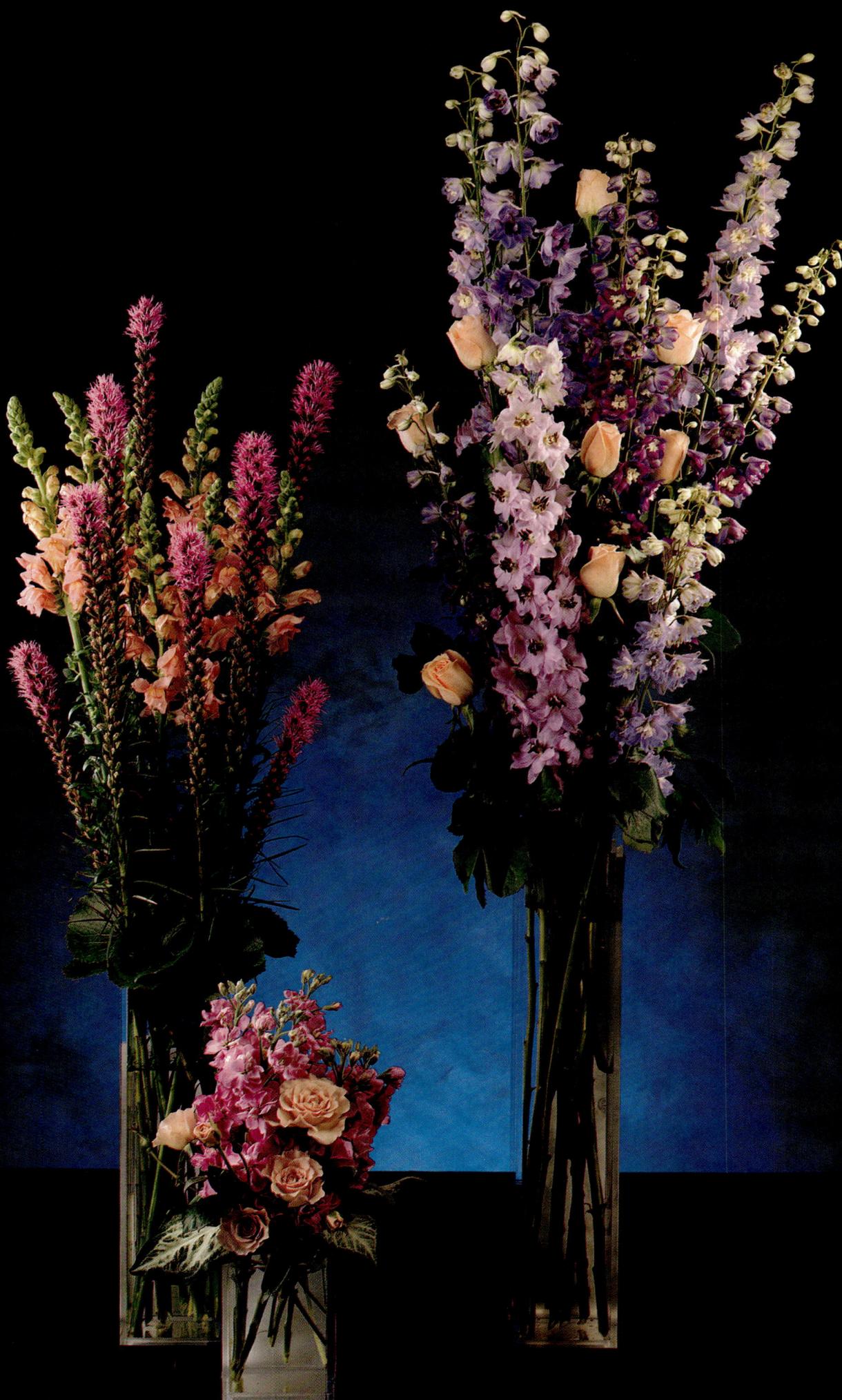

In floral design, often the terms contemporary and abstract are confused. Contemporary design is any type of floral composition used today. Art dictionaries state that contemporary means ''art of our era.''

Abstract design focuses all emphasis on the design with little or no attempt to present forms and subject matter in traditional arrangement forms.

The grouping of fresh flowers is contemporary design. It has a definite style. The designer makes no attempt to arrange the blossoms into any distinct design form. Nor does he rely on typical design techniques. The goal is to present the blossoms with full, exquisite beauty. The style is upbeat and 20th Century contemporary.

In the composition of silk flowers, the designer creates a striking contemporary style by following traditional techniques. There are exacting lines and a dominant line movement. The form of the design is planned and controlled. And, there are strong contrasts in color and texture.

Both of these compositions are contemporary. Yet each has different and distinctly unique character - a differentiating style.

Silk flowers from Karisma Signature Collection, available from your local wholesaler: No. 2612 Dutch iris, No. 2602 open rose, No. 2608 larkspur, No. 2603 medium rose bud, No. 2601 anemone, No. 2614 freesia and No. 2618 mini carnation spray. Acrylic vases available from Design With Flowers, 234 E. 17th St., Suite 202, Costa Mesa, CA 92627, in sets of three: 20", 14" and 6" tall × 3½" wide and 3½" deep and 20", 14" and 6" tall × 7" wide and 3¼" deep.

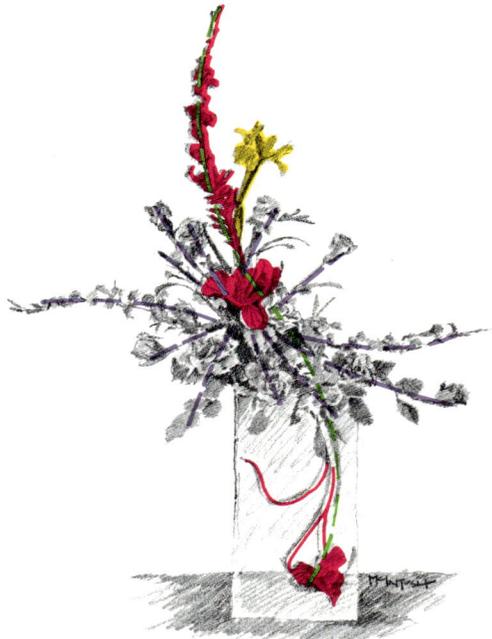

Secure a piece of Sahara™ foam in the top left corner of the container. Then place the iris that extends down inside the vase. Establish the lazy ''S'' line that starts with the upper larkspur, connects with the center iris and then moves down to the iris in the container. The upper right iris moves into this line. These are the dominant line placements. All other flowers move into the central focal area maintaining a strong asymmetrical balance.

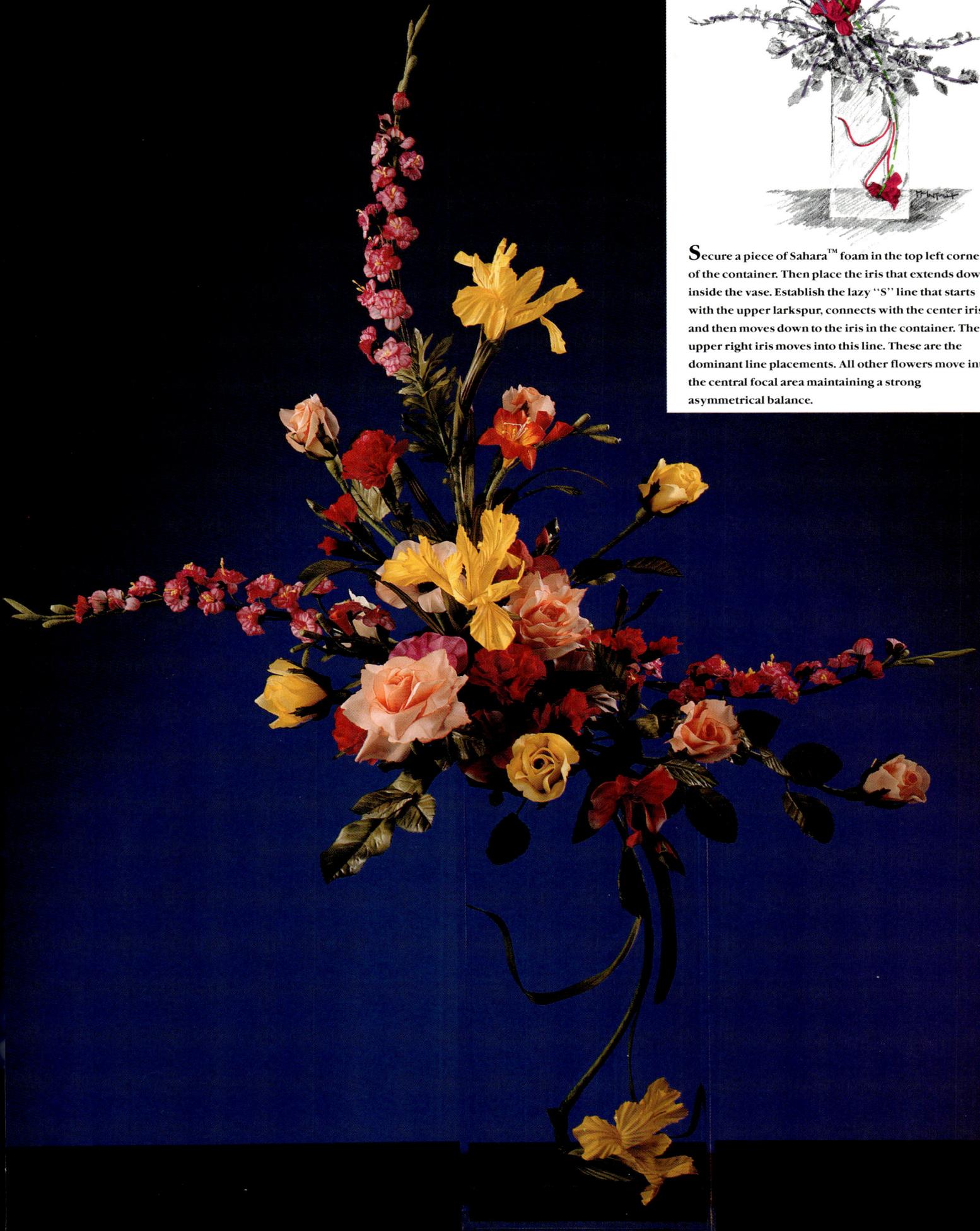

Visions In Contemporary Style

Many styles of art become part of floral design subliminally. A book, a magazine, a poster or another source of art inspires a designer. Without conscious effort, he records the experience and incorporates this influence into his floral work.

The two compositions pictured are examples of abstract expressionism. In art, abstract expressionism is an aspect of abstract art in which the approach is totally emotional or intellectual. The artist expresses a feeling or an idea solely by form, line or color without direct reference to subject matter. Abstract expressionism is a style.

To create the composition with gladioli, gerbera, dahlias and equisetum, the artist anchored Lomey caged floral foam on top of three different sizes of acrylic vases. The placement of all materials in this exceptional abstract design emphasize line, form and color.

The composition on the opposite page is another example of abstract expressionism conveyed with flowers. Created in acrylic vases, the design presents materials to accentuate color, line and form.

Set of three acrylic vases, 20", 14" and 6" tall, 7" wide and 3¼" deep available from Design With Flowers, 234 E. l7th St., Suite 202, Costa Mesa, CA 92627. Lomey caged floral foam available from your local wholesaler.

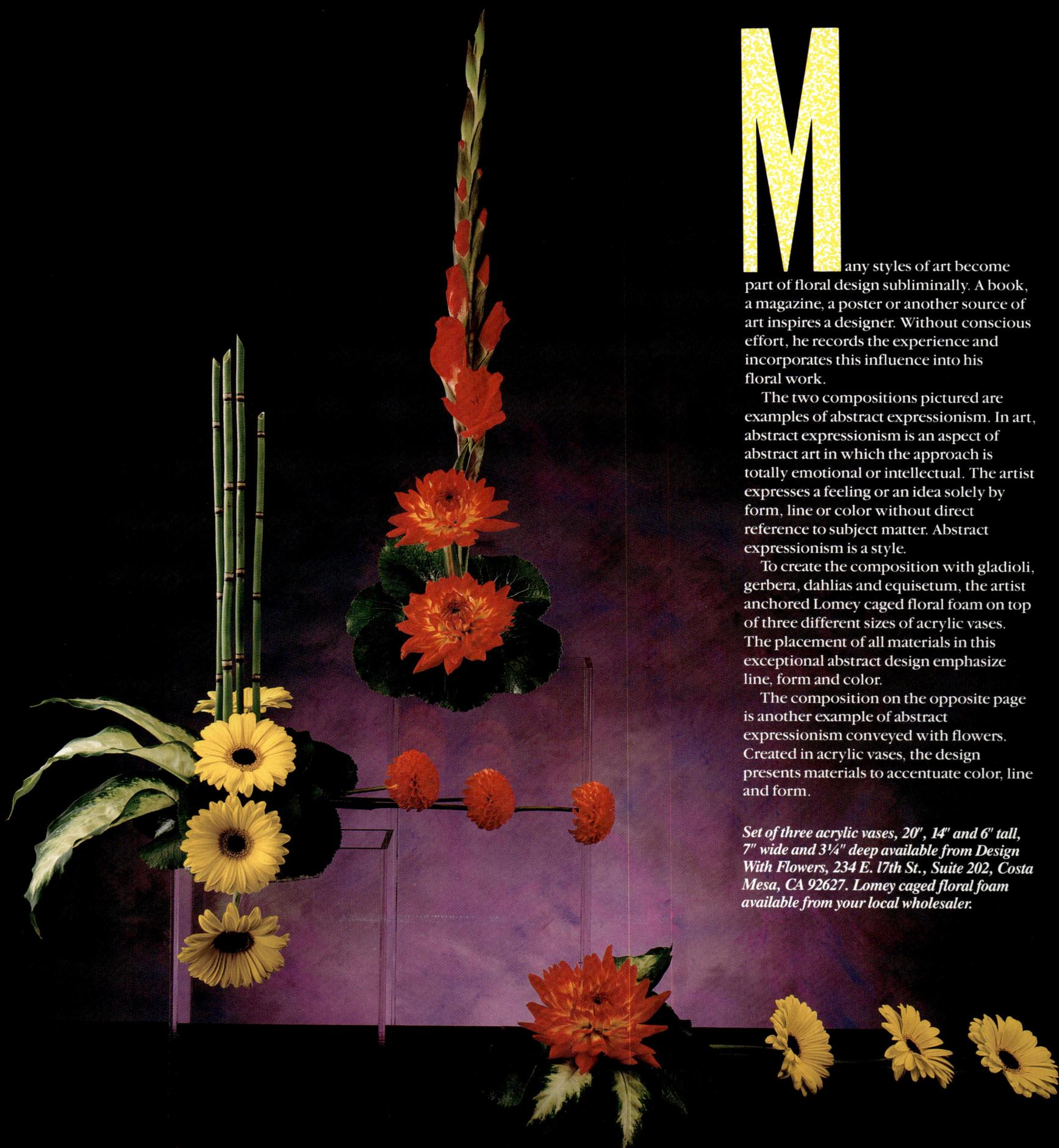

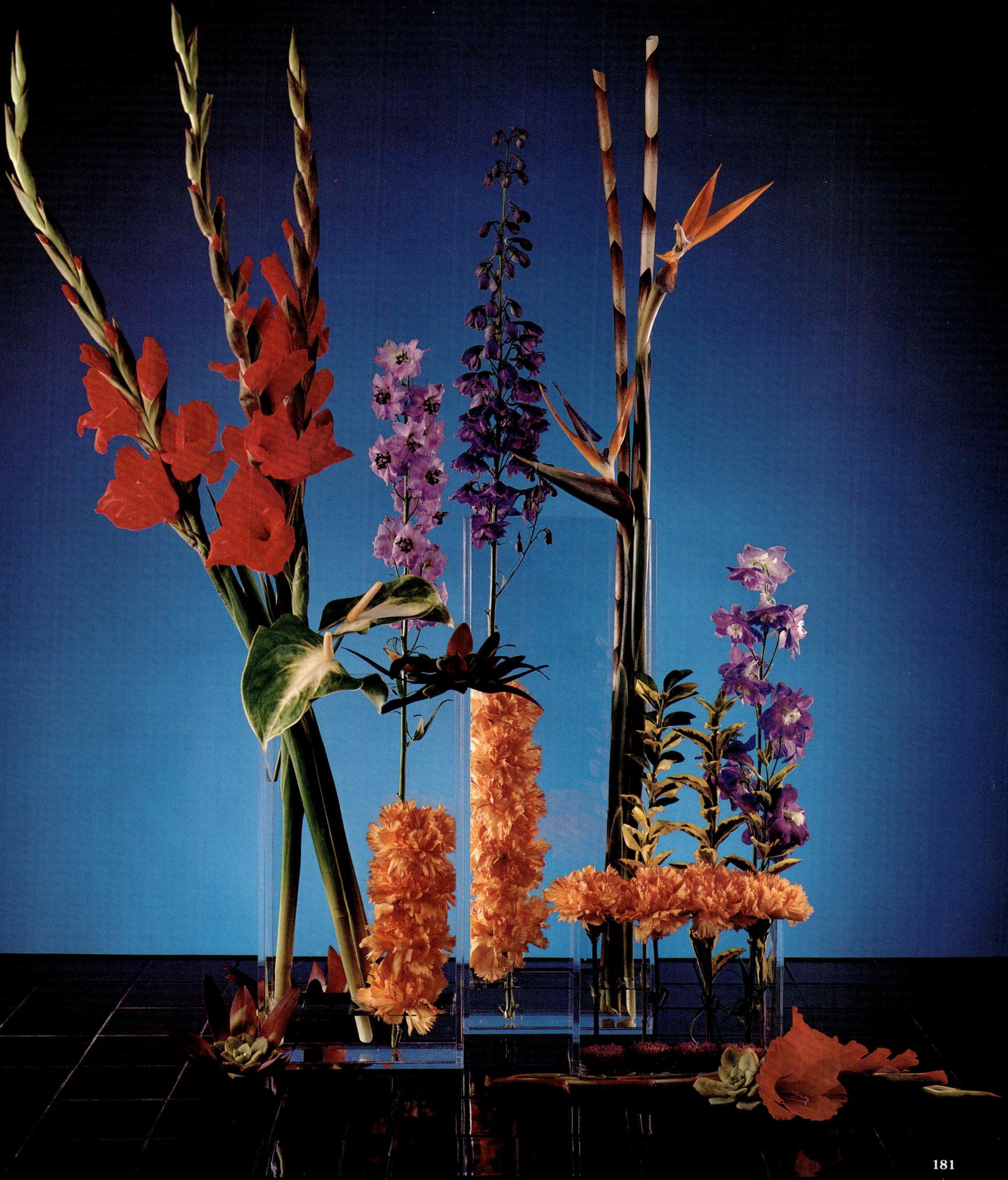

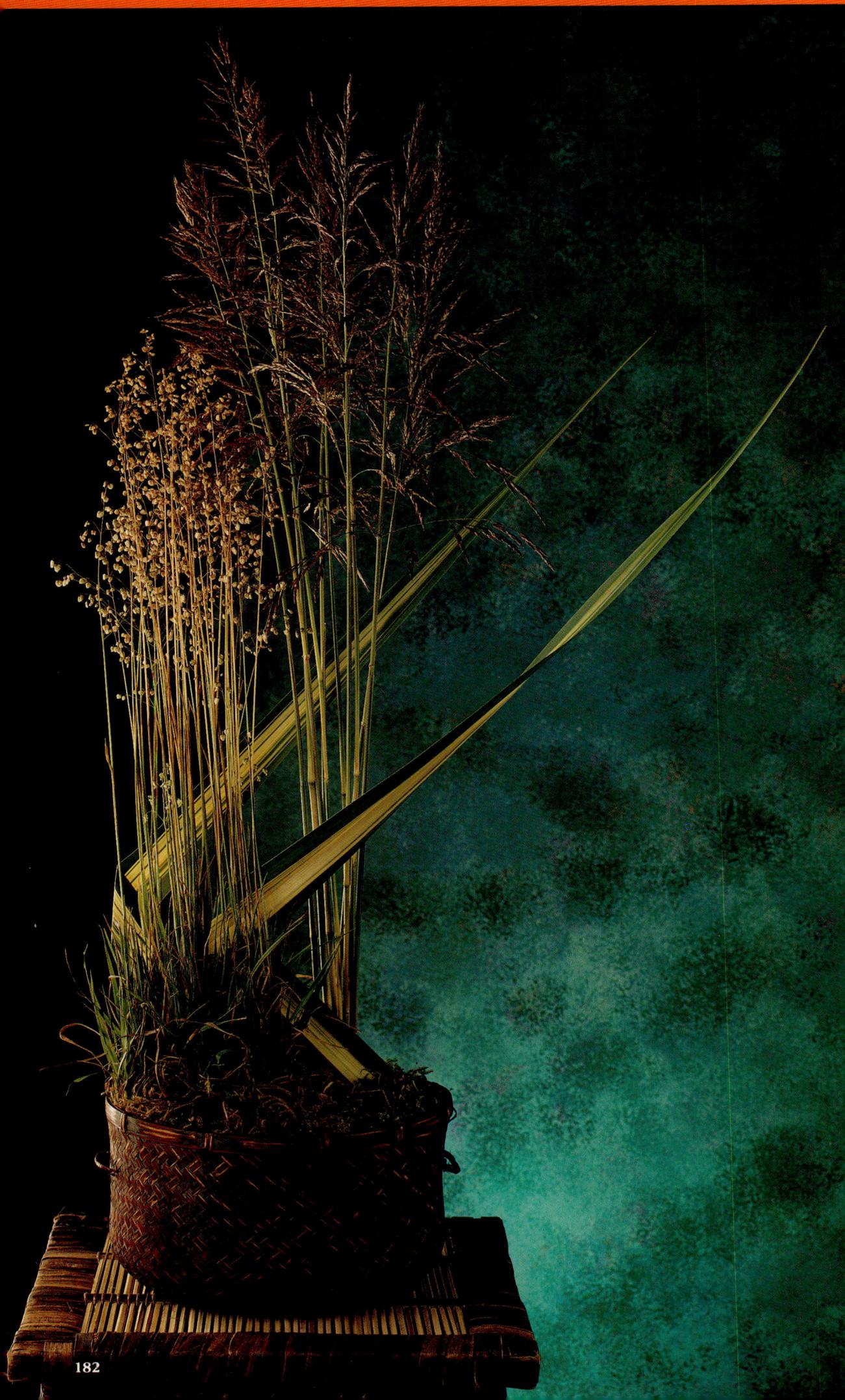

A great deal can be studied about style. But no one can teach style. The artist must find it for himself.''

The word eclecticism is an everyday word in almost any field of art. Today, people have a desire to have the best of everything. All together. All at once.

In floral design, eclecticism reflects a well-designed complement of traditional and contemporary styles blended together. This merging of styles creates a composition that speaks out with distinction. An eclectic design stands uniquely on its own with a distinguishing statement of style.

All three of the designs pictured combine the contemporary with influences of the traditional. Each composition expresses a totally different feeling of style.

The superb composition with grasses and flax combines the tradition of nature with dramatic, contemporary line accents. All three grasses are found in nature (and at your local garden center). The designer presents them in a natural setting. The angular, diagonal outbursts of flax foliage in parallel formation create dynamic line tension. The combination of the natural grasses with the unexpected linear accent of the flax gives this composition smart, spirited style.

Parallel grouping, framing and exaggerated vertical accent give the yellow and orange composition a showy flair of the contemporary. The flowers are quite traditional, but the modern presentation brings the spirit of eclecticism into the composition. By keeping the flowers in

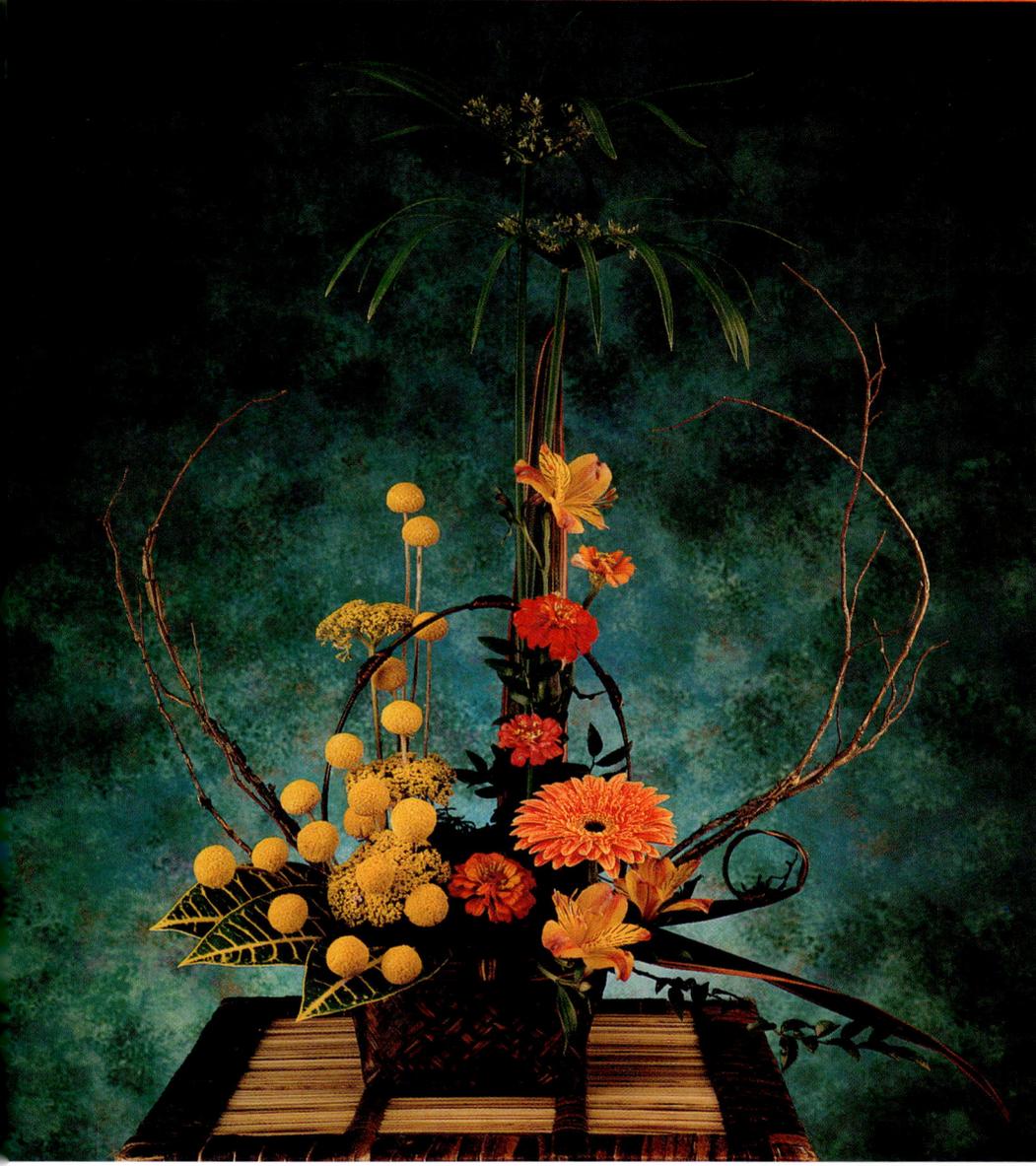

distinct color groupings, the designer intensifies the importance of color in the design. The birch branches frame the composition and keep the eyes contained within the design. And, the tall papyrus interrupts the composition with an expected accent of counterpoint. This design expresses a lively, imaginative style.

The basket with blue iris and succulents is more traditional in style simply because it conveys a feeling of restraint. By subtly pairing the two iris at the top, the two succulents which move into the focal area and the two smaller succulents glued on the basket, the designer creates an implied, effortless ''S'' line. This undeclared line pulls the eye through the composition in an unstudied manner. The design communicates a style of casual sophistication.

Basket C-1600 (set of 4) for the grass design, C-1441 (set of 3) for the yellow and orange composition and C-1161 for the iris and succulent design available from Jim Marvin Enterprises, Ltd., Rte 7, Box 44, Dickson, TN. Branches from Hoh Grown. Knud Nielsen billy buttons available from your local wholesaler.

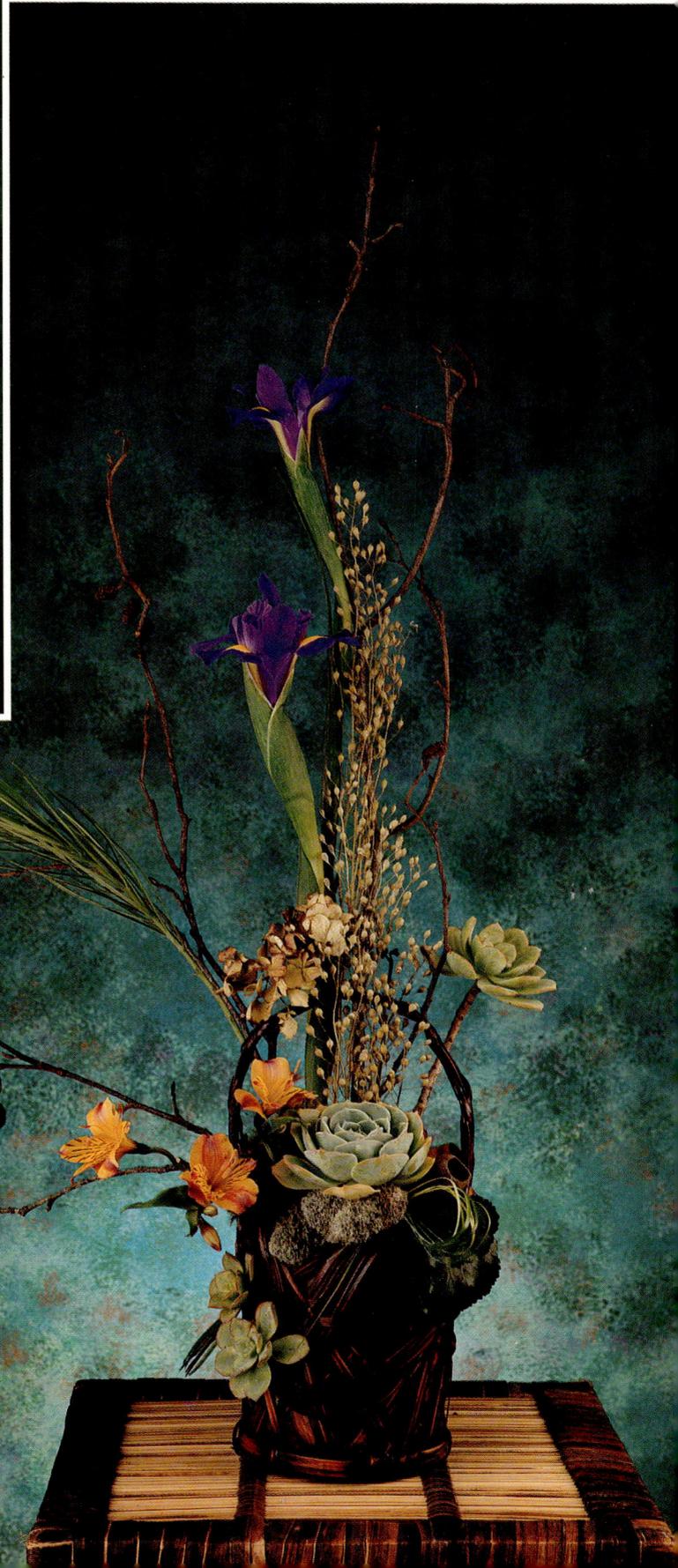

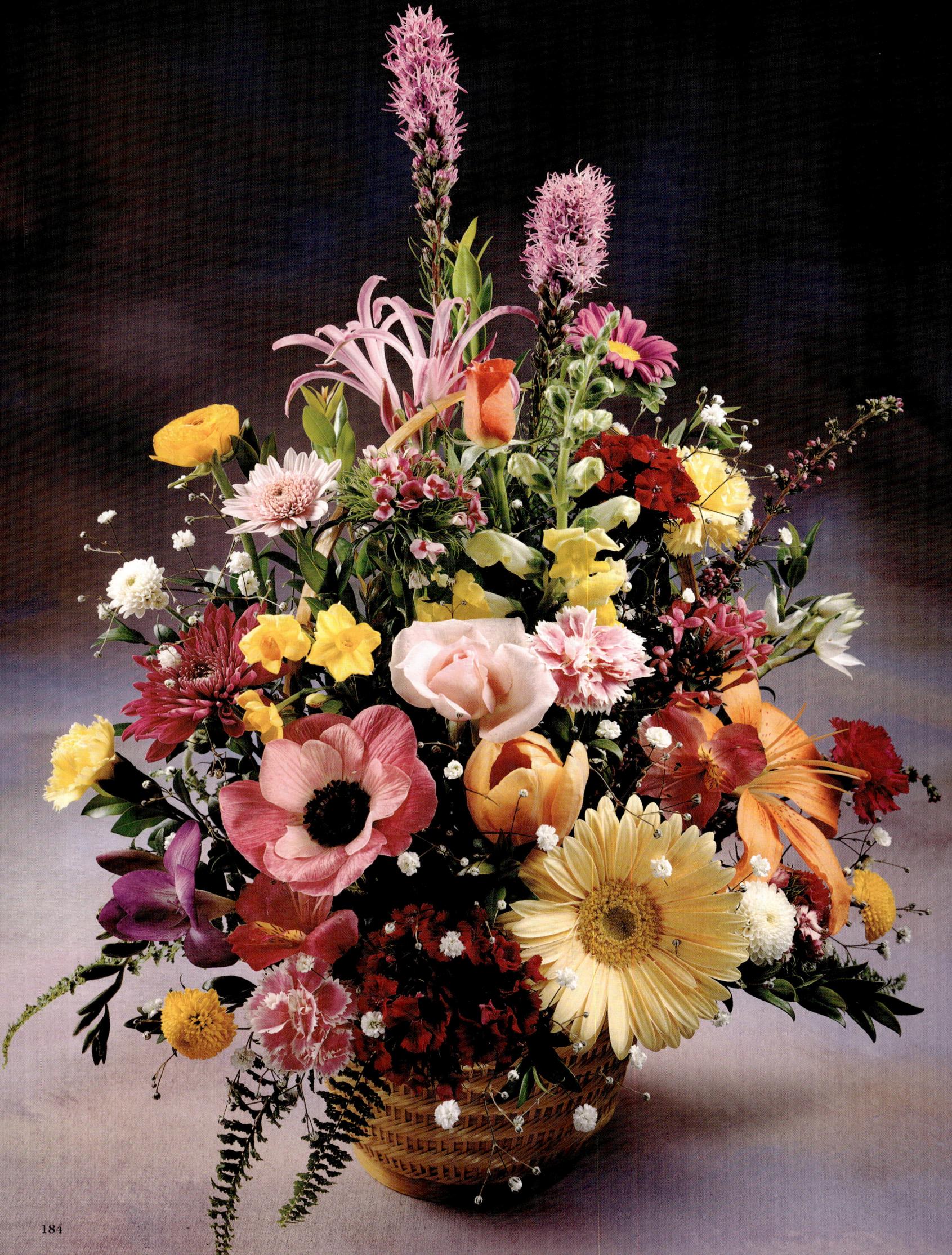

It's Always
Been Smart.

Now it's beautiful!

•

Mille-Fleurs Styles

Floral design is a spirit of color, form and texture. Often, the beauty of any art is found in the spontaneous--the urge of unplanned inspiration that brings the unexpected together with innocent, exploited beauty.

Sometimes our knowledge controls us. We study to learn the rules. We practice to mature our skills. Suddenly, almost without conscious understanding, we become locked into methods. Knowledge and methods are essential in floral design. When they become the control instead of the foundation for individual, creative expression, they lead to the dead end of mediocrity.

In this section, we show three interpretations of mille-fleurs styles. Each design presents a variety of flower forms, colors and textures. The forms of the compositions are structured. These designs suggest only one approach--the "more educated, the controlled" style of mille-fleurs.

I threw my brushes aside; they were too small for the work at hand. I squeezed out big chunks of pure, moist color and, taking my palate knife, I laid on blue, green, white, and brown in great sweeping strokes. As I worked, I saw that it was good and clean and strong. I saw nature springing to life upon my dead canvas.

— Albert Ryder, an early twentieth century American painter.

Often, the most expressive and interesting approach to mille-fleurs is placing stems in an open vase without a foundation or attempt to control flower position. As the great American artist, Albert Ryder, implies in the quotation above, place stems of flowers in a vase as you would squeeze out chunks of paint on a canvas.

The first stems placed in a vase will fall into uncontrolled, totally unorganized placement. Avoid the urge to dictate, to superimpose creative judgment. Let the natural movement of the stems take the flowers wherever they may go in the design. As the vase fills with flowers, one stem secures the other and placement becomes more definite.

Finishing the spontaneous mille-fleurs design is similar to the artist who uses his palate knife to spread, merge and disperse color on a canvas. The final flowers are calculated placements to add the forms, the colors and the textures that encourage nature to spring to life.

TRADITIONAL

The traditional mille-fleurs bouquet was simply a grouping of flowers with little style or organized design appearance. It was a grouping of flowers appearing as if they had been cut from the garden and placed in a container. Historically, if someone went into the garden, picked an assortment of many different blossoms and then slipped the stems into a vase, the bouquet would be called "mille-fleurs."

The joyous composition pictured to the left with many varieties of brightly colored flowers is an expression of the more traditional mille-fleurs bouquet.

Mille-Fleurs Styles

The term mille-fleurs
(thousands-flowers) dates back
to the 15th and 16th Centuries
when medieval tapestries were
designed with figures appearing
against a background thickly
scattered with flowers.

Historically, the mille-fleurs
bouquet was round, old-fashioned
and generously filled with an
abundance of flowers in every
variety and color.

Today, the mille-fleurs approach
in contemporary, professional
design includes any style
of design that includes an
assortment of flowers.

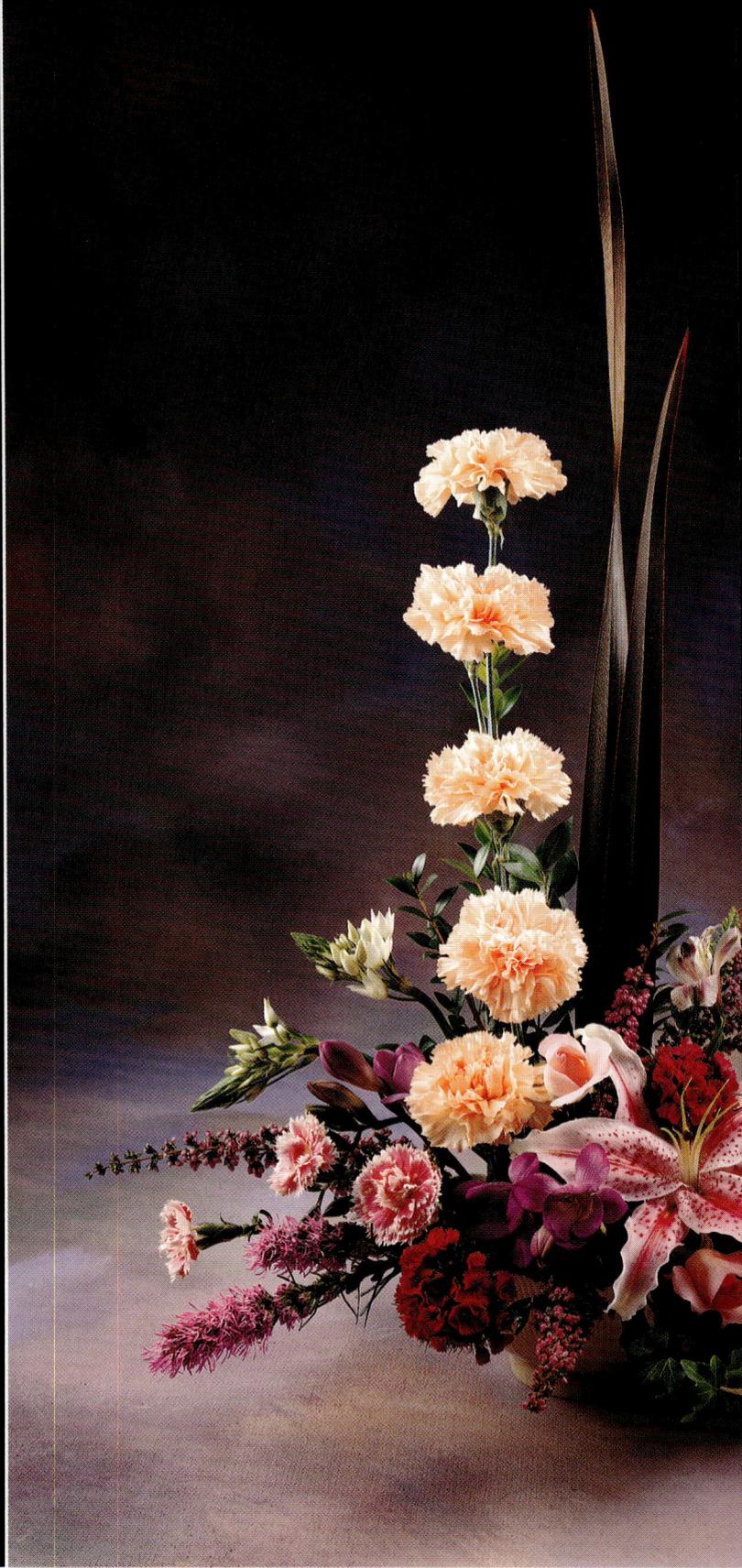

CONTEMPORARY

Every work of art, including a
flower arrangement is the artist's
expression of his own interpretation
of a design style. The term mille-fleurs
comes from art. It's original meaning
did not refer to a flower arrangement.
So, if a designer chooses to call an
arrangement with several different
flowers a mille-fleurs composition,
it is his prerogative. After all, he is
the artist.

The composition pictured above is
an interpretation of mille-fleurs in
20th Century idiom. Those who want
to preserve the Old-World style of
mille-fleurs might argue with this
presentation. If every artist had the

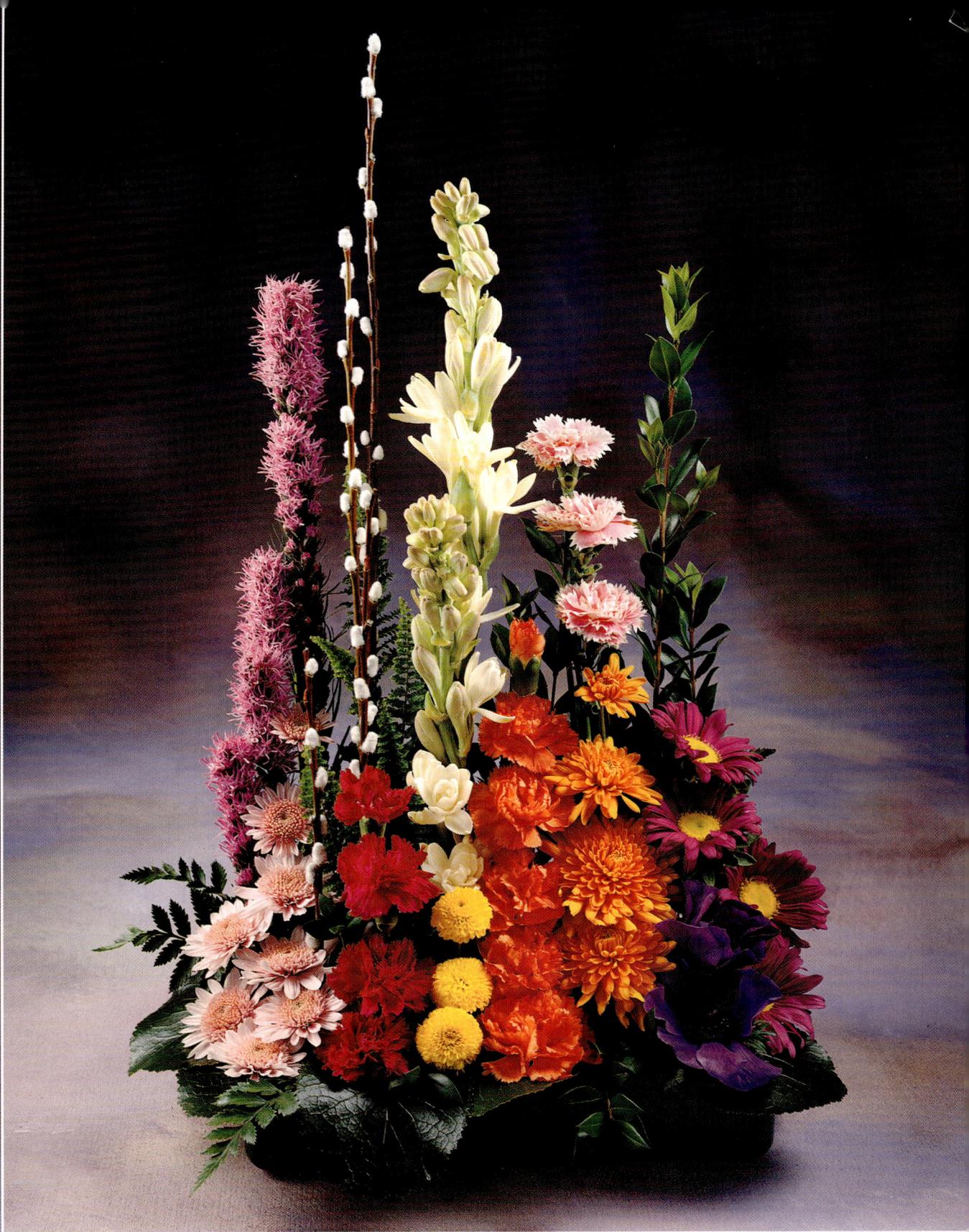

same idea about every arrangement, we would have only boring flower arrangements without creative originality.

As you study this interesting composition, note how the artist establishes both a primary and secondary vertical line in the composition. The linear grouping of carnations makes the dominant vertical line statement; the flax foliage repeats this same line movement. This distinctive repetition brings a flair to the composition that speaks out with creative originality.

MODERNISTIC

"Can a parallel systems arrangement be mille-fleurs?" you ask. Why not? As long as it contains many different flowers it could be a parallel systems mille-fleurs. If we lock our minds into only one way of doing things, there is little room for growth and new ideas. As you view the three mille-fleurs compositions presented, you will recognize there are many ways to say the same thing. Even if you are more traditional than you are contemporary, or more contemporary than you are modernistic, don't be afraid to expand your own style by going modernistic once in a while.

Giftwares basket No. 010075 used for the traditional mille-fleurs arrangement pictured on page 56 is distributed by Pete Garcia and available from your local wholesaler. Franklin China's container No. P518 used for the contemporary mille-fleurs arrangement and Lomey classic rectangular bowl No. 2 used for the modernistic mille-fleurs and Oasis® floral foam available from your local wholesaler.

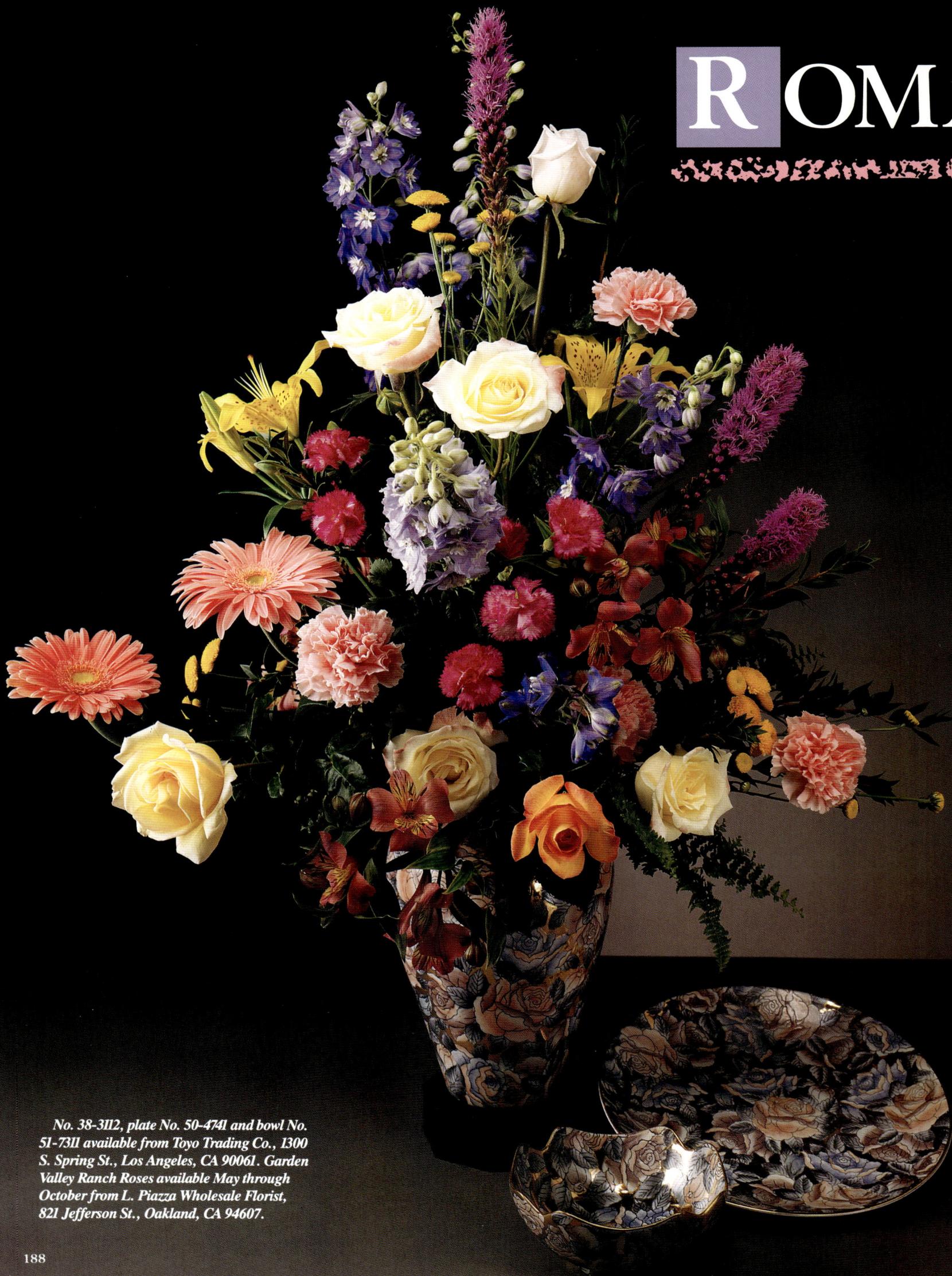

No. 38-3112, plate No. 50-4741 and bowl No. 51-7311 available from Toyo Trading Co., 1300 S. Spring St., Los Angeles, CA 90061. *Garden Valley Ranch Roses available May through October from L. Piazza Wholesale Florist, 821 Jefferson St., Oakland, CA 94607.*

NCE RETURNS

Everything is coming up romance! In all areas of decorative arts people talk about the "return to romance." These words sound beautiful, soft and wonderful. What does "returning to romance" mean? And, even more explicitly, how does this return to the romantic look effect professional floral design?

The History Of Romance

Romanticism as an expression in art was a profound revolution in human spirit. It emerged in the late 18th century and became an important approach to art in the 19th century. The Romanticism period of art stretches from 1790 through 1840. Historians identify this period as "an inevitable manifestation of the revolutionary spirit of the age."

Four important creative forces emerged during the Romanticism period: (1) Emphasis on emotion; (2) the unique expression of an individual; (3) spontaneous overflow of powerful feeling; (4) concentration on the imaginative powers of the artist.

Painting of landscapes became a favored vehicle for the expression of the liberated Romanticism artist. This interest in nature spilled over to flowers. The abundant floral paintings of the famous Dutch and Flemish artists reflect the influence of Romanticism on art.

Romanticism as an artistic style left little identifiable mark on history. Since each artist approached Romanticism with a free spirit of creativity, there are few consistent characteristics identifying Romanticism as a specific style of art. Whatever an artist chose to label as "romantic" was indeed romantic. It was a romantic, personal expression of the artist.

Romanticism In Flowers

In floral design, it is difficult to categorize a "romantic" composition of flowers. When we talk about "the return to romance," we suggest that the artist expresses a feeling or emotion in his design. There are, however, two universal characteristics of Romanticism that most floral artists associate with a romantic design.

1. Formality. The creative approach to Romanticism includes design structure even though the approach might be somewhat relaxed, perhaps free style in nature. A romantic floral composition always places more focus on the artist's interpretation than on absolute structure. Since spontaneity is a distinction of Romanticism, design structure is a technique for expression, not a mechanical discipline.

2. Elegance. According to one dictionary, tasteful grace and refinement identifies elegance. Another commentary uses "classical simplicity" to define elegance. Elegance does not connote an abundance of materials. Elegance reflects presentation - how the artist uses materials in a composition. A single flower in a brilliant composition might communicate elegance. And, a vase filled with a bounty of materials, variety and color might be elegant.

Romanticism is an approach to design. It is not a style. When a composition speaks out with expression and emotion, it is romantic. It can be achieved through color, through materials and through the total look of a design.

Romanticism Illustrated

The magnificent composition pictured is an expression of Romanticism. The design is somewhat formal. It is structured. The form is an interpretation of the Classical Triangle. In interpreting the Classical Triangular form, the artist relaxes the formality through the spontaneous placement of materials. All stems flow into and out of a central axis. Yet, there is no identifiable, dominant focal point or focal area. Spontaneity is evident in flower form, in colors and in placement.

Elegance is a primary characteristic of this romantic composition. The look of elegance begins with the container. The flowers selected for the design communicate elegance. Color in the composition conveys elegance. And, the total visual impression of the design and accessories speaks out with romantic elegance.

The Rose Story

What is more romantic than a rose? The roses in this wonderful composition are special outdoor varieties grown for commercial production. Rayford Clayton Reddell, one of America's premier rosarians, owns Garden Valley Ranch in Petaluma, California.

REKINDLE THE ROMANCE

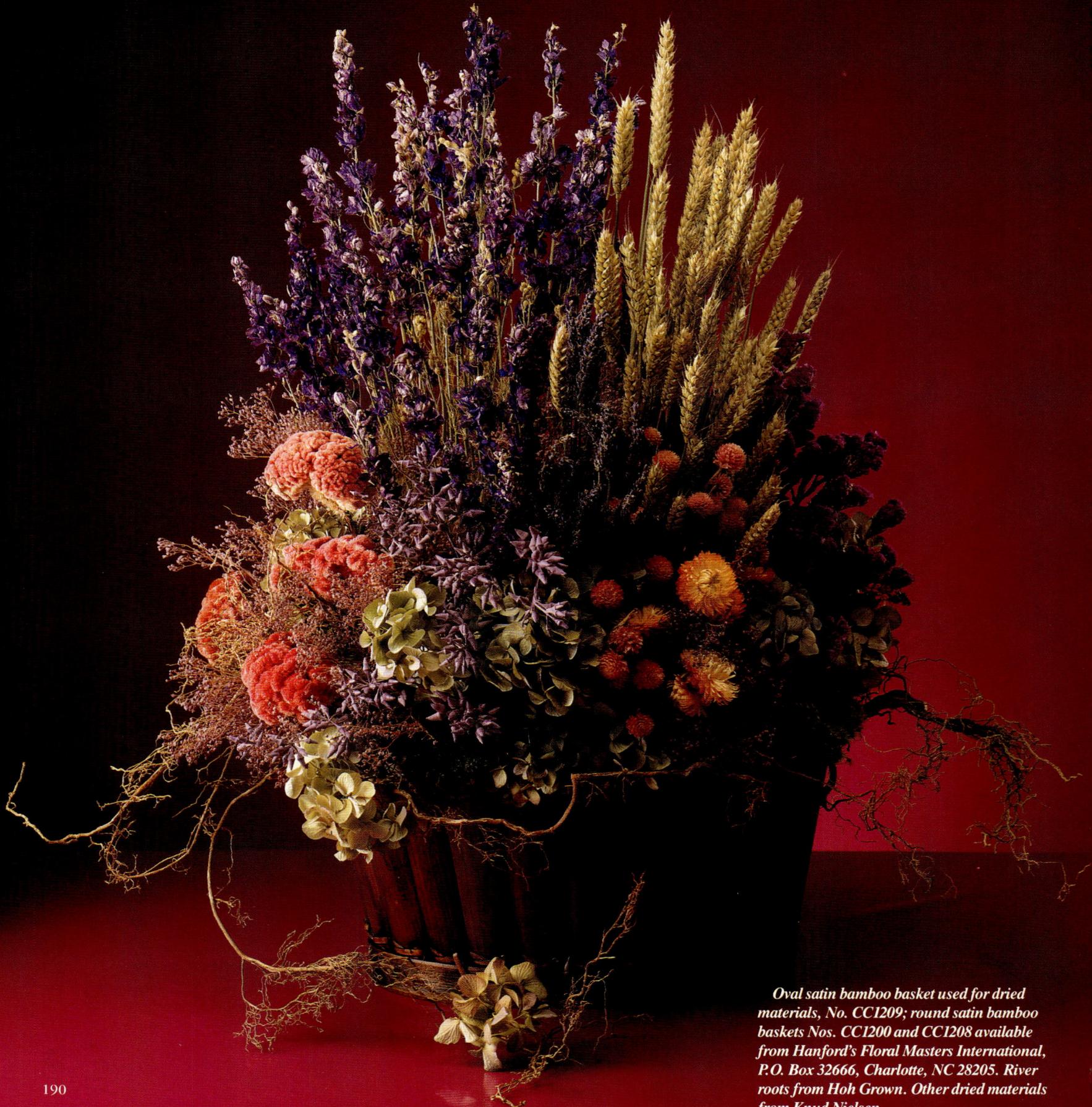

Oval satin bamboo basket used for dried materials, No. CC1209; round satin bamboo baskets Nos. CC1200 and CC1208 available from Hanford's Floral Masters International, P.O. Box 32666, Charlotte, NC 28205. River roots from Hoh Grown. Other dried materials from Knud Nielsen.

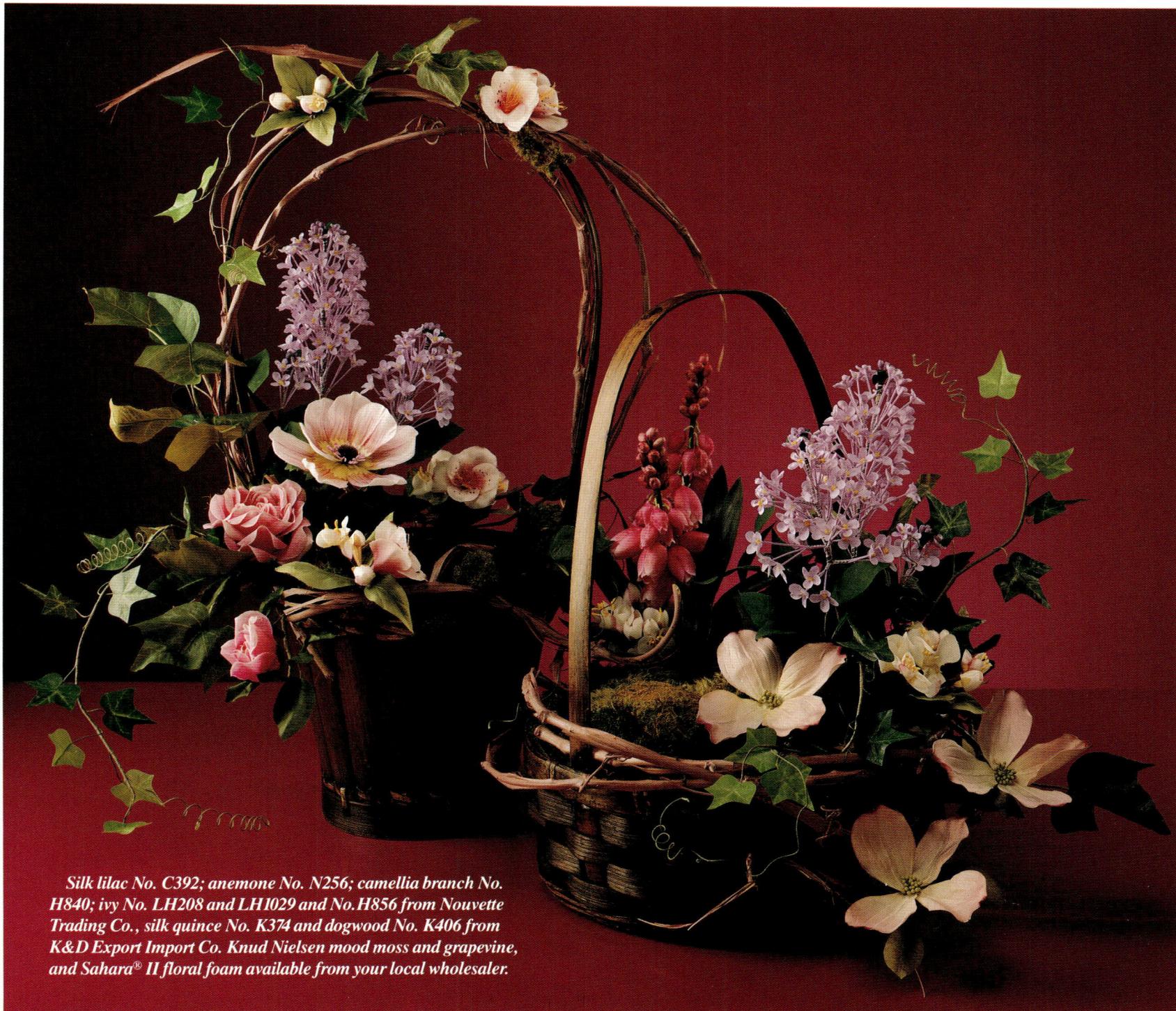

Silk lilac No. C392; anemone No. N256; camellia branch No. H840; ivy No. LH208 and LH1029 and No. H856 from Nouvette Trading Co., silk quince No. K374 and dogwood No. K406 from K&D Export Import Co. Knud Nielsen mood moss and grapevine, and Sahara® II floral foam available from your local wholesaler.

*I*n floral design, materials do not limit the expression of romance. Since the romantic look is the result of the presentation, this emotional approach to design creativity is effective with dried materials and silk flowers.

Flower Garden Naturals

The romantic composition with Knud Nielsen naturally dried flowers emotes elegance and classic beauty. Larkspur, celosia, hydrangea, statice, straw flowers, clover, rye and gypsophila unite with impressive color and perspicuous style. Each color speaks out with sensitivity and then merges into the wholeness of the composition. Flower forms are distinct and individual. Yet, all merge into amorous unity. This composition of dried flowers and grain is clearly structured. The river roots depart from structure with graceful and intriguing spontaneity.

Romance In Silks

The delightful composition of silk flowers is struck with romantic wanderlust. Design structure is softly whispered, then abandoned to experience freedom of creative expression. Each silk blossom is a distinct entity. Even in this statement of individuality, each flower form and color moves in pleasing harmony for a wonderful countenance of romance.

YOUR PERSONAL
EXPRESSION OF ROMANTIC
DESIGN CAN BE INFINITELY
INDIVIDUAL.
ROMANTICISM COMES IN
EVERY SHAPE, STYLE AND
FORM OF CREATIVE FLORAL
DESIGN. WHATEVER YOU
FEEL IS ROMANTIC, IS
ROMANTIC. ROMANTICISM
IN PROFESSIONAL FLORAL
DESIGN CREATES
ELEGANCE THROUGH
IMPECCABLE STYLING AND
EXQUISITE USE OF
MATERIALS.

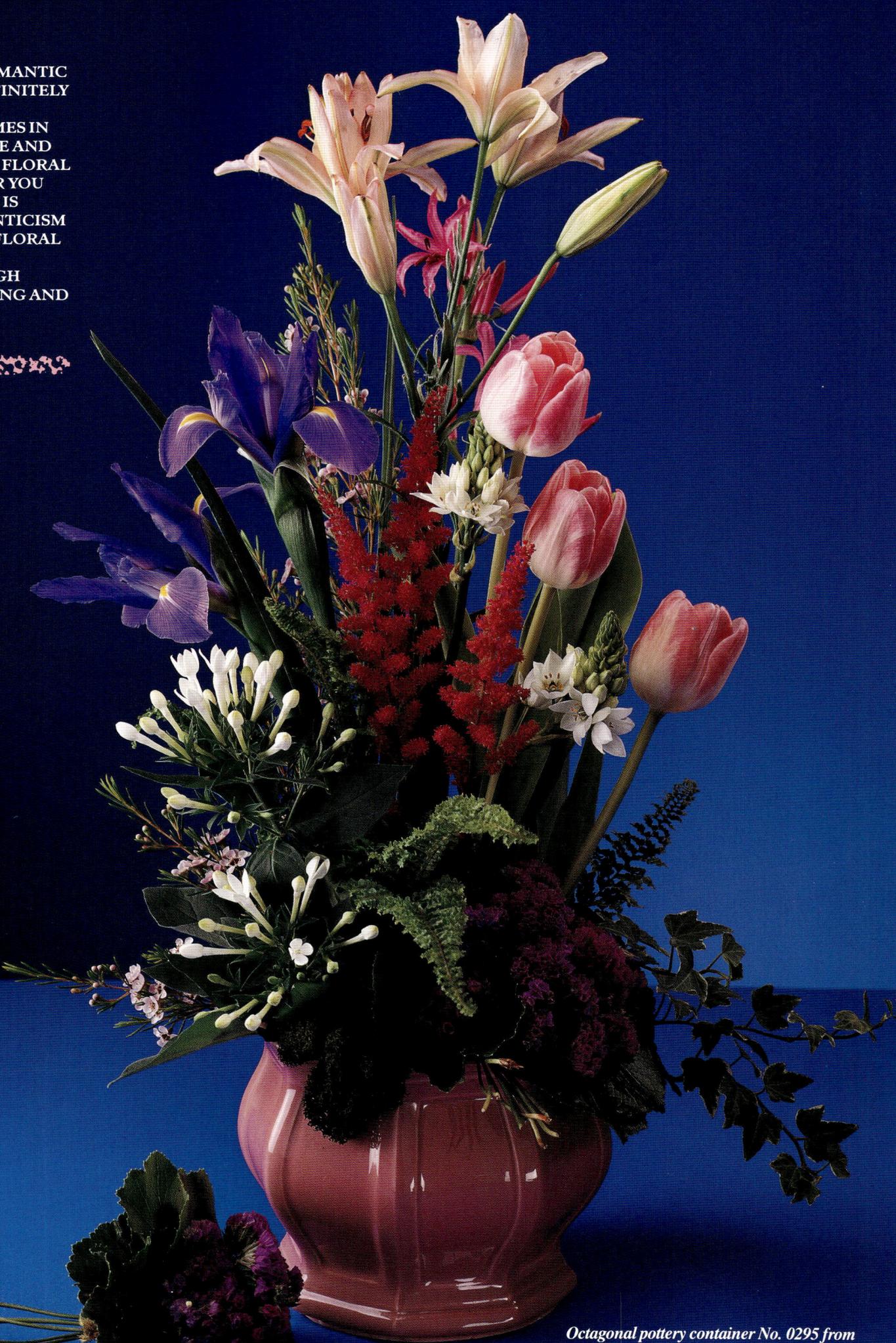

*Octagonal pottery container No. 0295 from
Designer Accents by Roseville Floraline, 451
Gordon St., Roseville, OH 43777.*

STRETCHING THE LIMITS

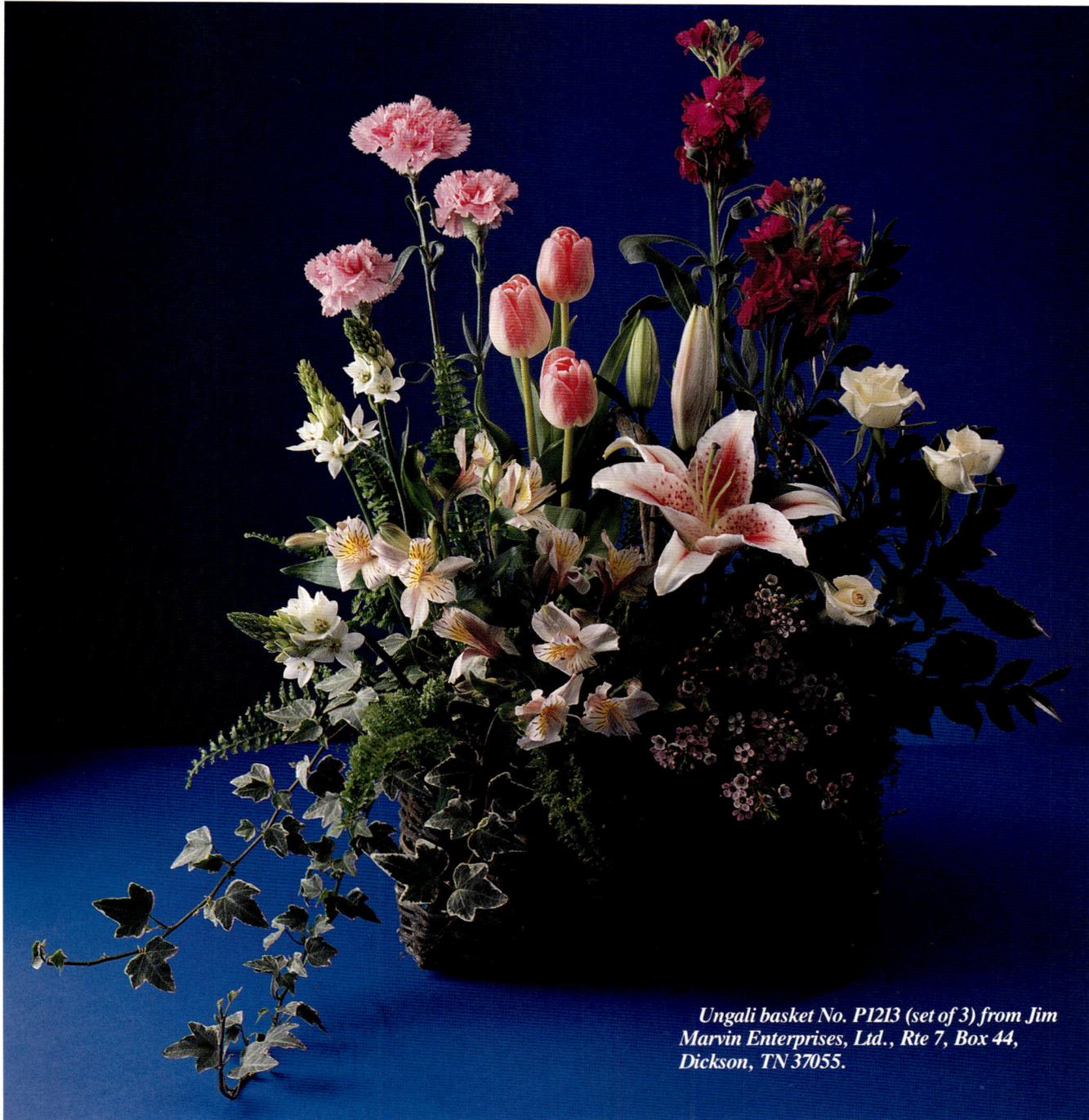

Ungali basket No. P1213 (set of 3) from Jim Marvin Enterprises, Ltd., Rte 7, Box 44, Dickson, TN 37055.

OF ROMANTICISM

The concept of romanticism obliterates all boundaries. Romanticism is a look within a style. Romanticism is Old World. Romanticism is contemporary. Romanticism is what you want it to be, expressed as you want to express it.

Romanticism is rooted in the old but expressed in the contemporary.

In the romantic composition to the left, the artist concentrates on the contemporary grouping technique. Even though each flower variety occupies a distinct, defined space, there is a sense of creative harmony.

The form of this romantic composition is structured. All of the materials would fall within the framing of an elongated oval. The extended height with controlled width brings a majestic vertical line emphasis to the composition.

You might not expect a design constructed with parallel influence to be romantic. The striking romantic composition above demonstrates that any floral design can express Romanticism.

In this expression of Romanticism, the artist places each grouping of flowers in a controlled area with definite parallel line movement. The harshness of the parallel lines is abated with soft foliages and wax flower. This superb composition is an outstanding example illustrating how the look of romance can be introduced into any style of floral design.

193

EVOCATIVE ROMANTIC DESIGN

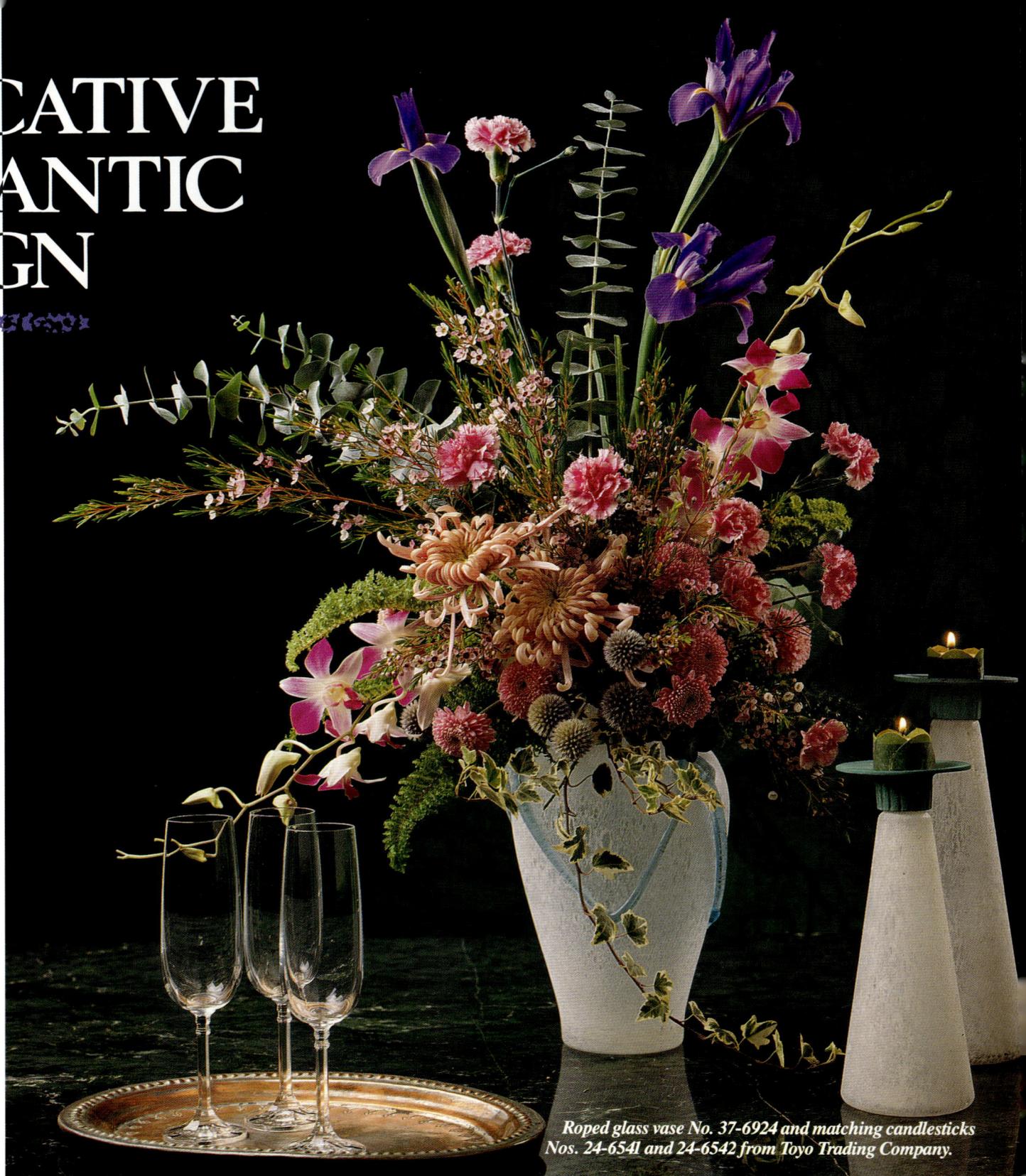

Roped glass vase No. 37-6924 and matching candlesticks Nos. 24-6541 and 24-6542 from Toyo Trading Company.

*S*uperlative beauty is a characteristic of Romanticism in floral compositions. Beauty is an elusive word. Perhaps the only terms describing beauty that receive universal affirmation are ''special grace or charm.'' Anything symbolizing beauty would exhibit grace and charm.

This radiant floral composition expresses Romanticism in the contemporary idiom. The vertical emphasis of the design moves to either side of the central stem of eucalyptus which bisects the design. This openness in the center of a composition is a contemporary approach to creative styling. Nevertheless, the composition is not starkly contemporary but abundantly romantic. And, in its romance it expresses a special grace and charm. It creates mood, a feeling, an emotion.

In achieving this distinctive design style, the artist masses flowers at the bottom of the composition. These blossoms, many of which are round forms, establish a triangle. The base of this triangle is extended with the diagonal line of dendrobium orchids. In contrast to the massing of flowers at the base, the artist uses generous negative space and voids to create an openness at the top of the composition.

The elegant roped glass vase and the matching pair of candleholders accessorize the floral design with more romantic elegance. Expressing Romanticism in floral design does not require decorative containers and accessories. When used, however, they must support the look of romance communicated with the flowers. A container and accessories are a support system to the mood the floral design establishes.

TRADITIONAL ROMANTICISM

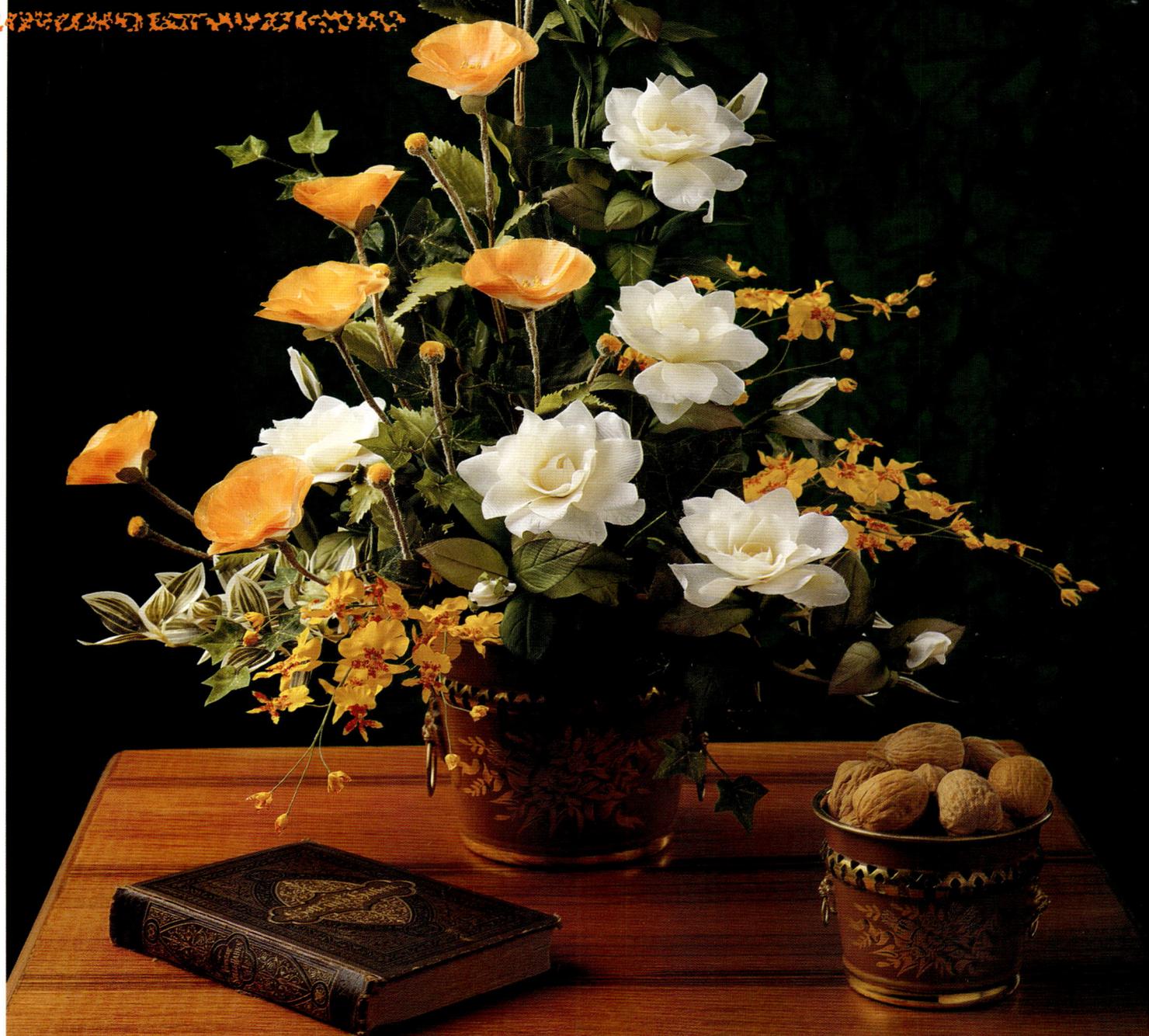

The Classical Triangle form with three equidistant sides is the most formal expression of romantic design. In this romantic composition, the artist interprets the Classical Triangle with elegant simplicity. In creating pure Classical form, the designer places emphasis on flowers with formal form and in the formal placement of the materials within the design.

In expressing the spirit of Romanticism in this composition, the artist maintains a relaxed Classical Triangular form. Some of the silk Iceland poppies and gardenias follow a pattern of formal line regimentation.

Since spontaneity is a characteristic of Romanticism, the artist placed one gardenia to the left behind the Iceland poppies. And, the spontaneous line movement of the silk oncidium orchids relaxes the formality of the design.

The elegant container with a reflective brass tole design complements the composition by basing it with a rich-valued hue. In this design, the container plays an important role in amplifying the reserved elegance of the composition.

Brass tole container No. 1325 (set of 3) from Hanford's Floral Masters International. Silk Iceland poppy No. H863, ivy leaf No. LH208 and needlepoint ivy No. LH1029 from Nouvette Trading Co., Ltd., available from selected wholesalers. Silk gardenia No. K751 and oncidium orchids No. K1500 from K&D Export Import Co., 225 Fifth Ave., New York, NY 10010. Wandering Jew foliage No. E765 from Supersilk, 1967 S. Third, W., Salt Lake City, UT 84115. Sahara Foam II available from your local wholesaler.

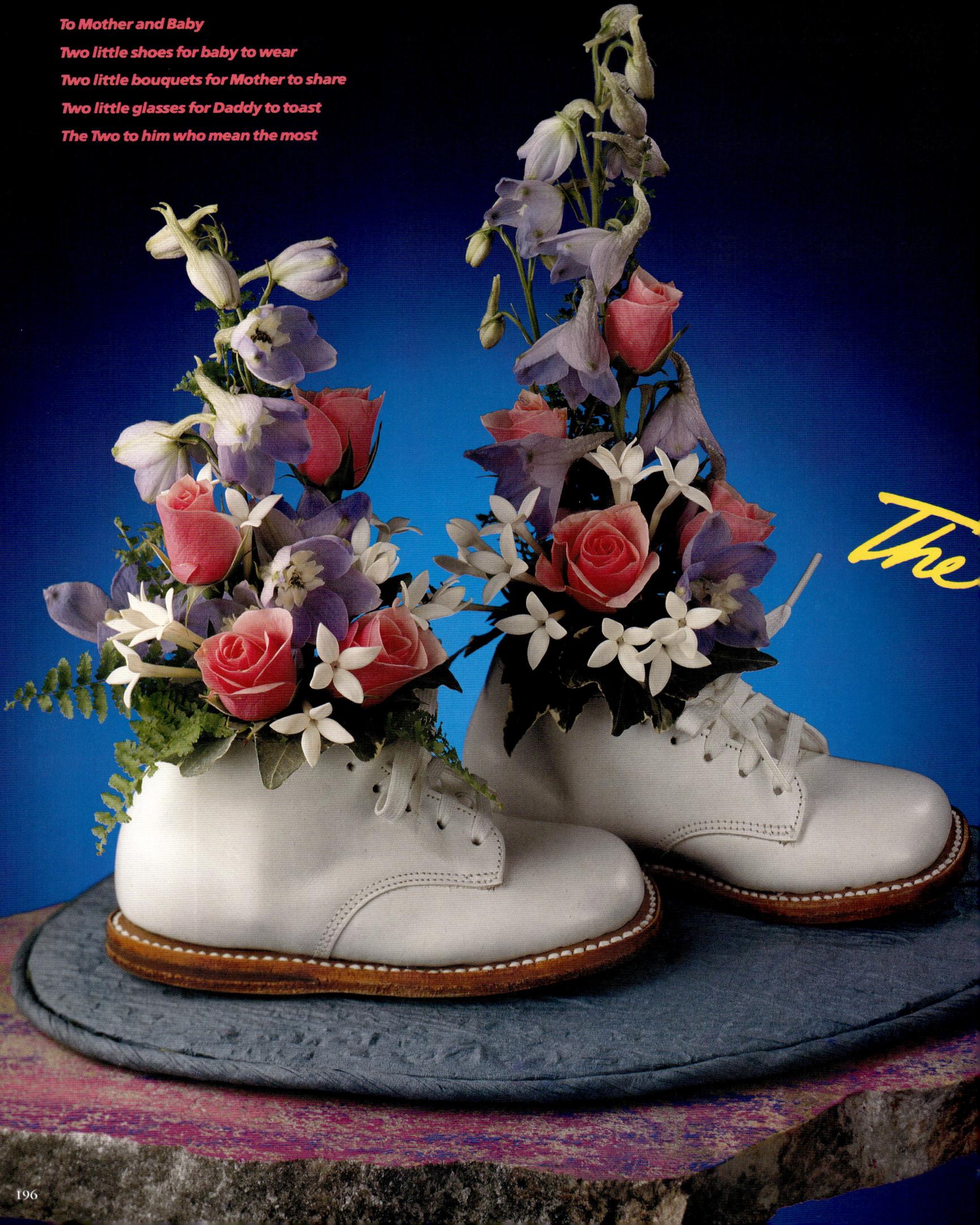

The

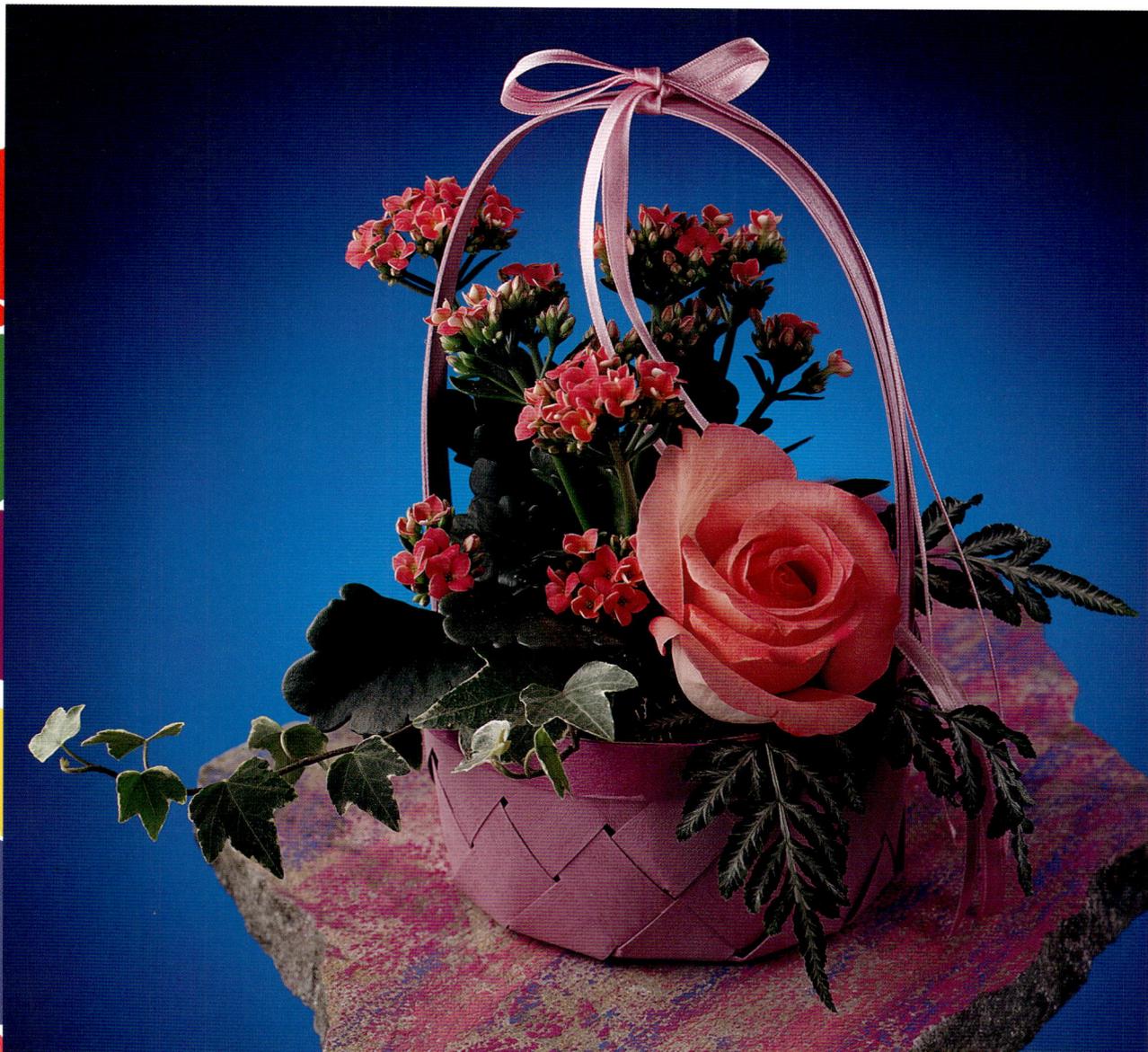

imagination over-flows

Linden, high walker baby shoes, from Buster Brown, Brown Shoe Co., St. Louis, MO. Knud Nielsen paper ribbon available from your local wholesaler.

When it comes to creative design in miniatures, put practicality aside. Go for the imaginative. In this world of bigness, big is not always better. Sometimes, the subtle beauty of something small, lovely and creative makes far more impact than the big and boisterous.

The baby shoe arrangement is an ingenious idea for the new arrival. Insert shot glass filled with saturated flower foam into the baby shoes. Anchor the shoes onto a piece of foam board covered with opened paper ribbon and banded with coiled paper ribbon. Then, create a lovely arrangement. This idea and poem came from Leroy Birkholz at Ranchview Floral and Interiors in Overland Park, KS. Ranchview advertises this composition regularly. It is one of their most successful promotions.

The miniature basket pictured above is another wonderful idea in miniature design. The basket, available from most local wholesalers, is inexpensive. In creating the design, the artist used one 4-inch kalanchoe plant and a single Touch of Class rose from Garden Valley Ranch. Three fronds of terrace fern and a strand of variegated ivy move through the focal area with grace and importance.

On being Sensational

The Two's Company double bamboo shoot base with two clear glass flower vases offers endless possibilities for miniature designs. In this composition, the artist chose to stay with a primary-intermediate statement of color. The yellow oncidium orchids announce a bright primary color while the red-orange kalanchoe blooms speak out with color independence.

What could be more sensational in diminutive form than the very, very chic arrangement with miniature anthurium, equisetum (horsetail), dracaena, galax and fern foliages? Note the creative detail in this composition. Dracaena leaves glued around the rim of the saucer and repeated in the foliage loops in the focal area. Dramatic diagonal lines with equisetum. This composition is primarily a foliage design jeweled with two miniature anthurium. The impressive red-green, complementary color harmony adds important visual brilliance.

In creating miniatures, you have a choice. Should you depend on a distinctive container like the baby shoes or bamboo holder? Or, should you go for the inexpensive container like the miniature basket or 6-inch clay saucer? It is a matter of price point and what the customer wants. If you want to feature miniature designs, you need to stock a variety of containers which enable you to create the sensational. After all, even in miniature your composition must be sensational!

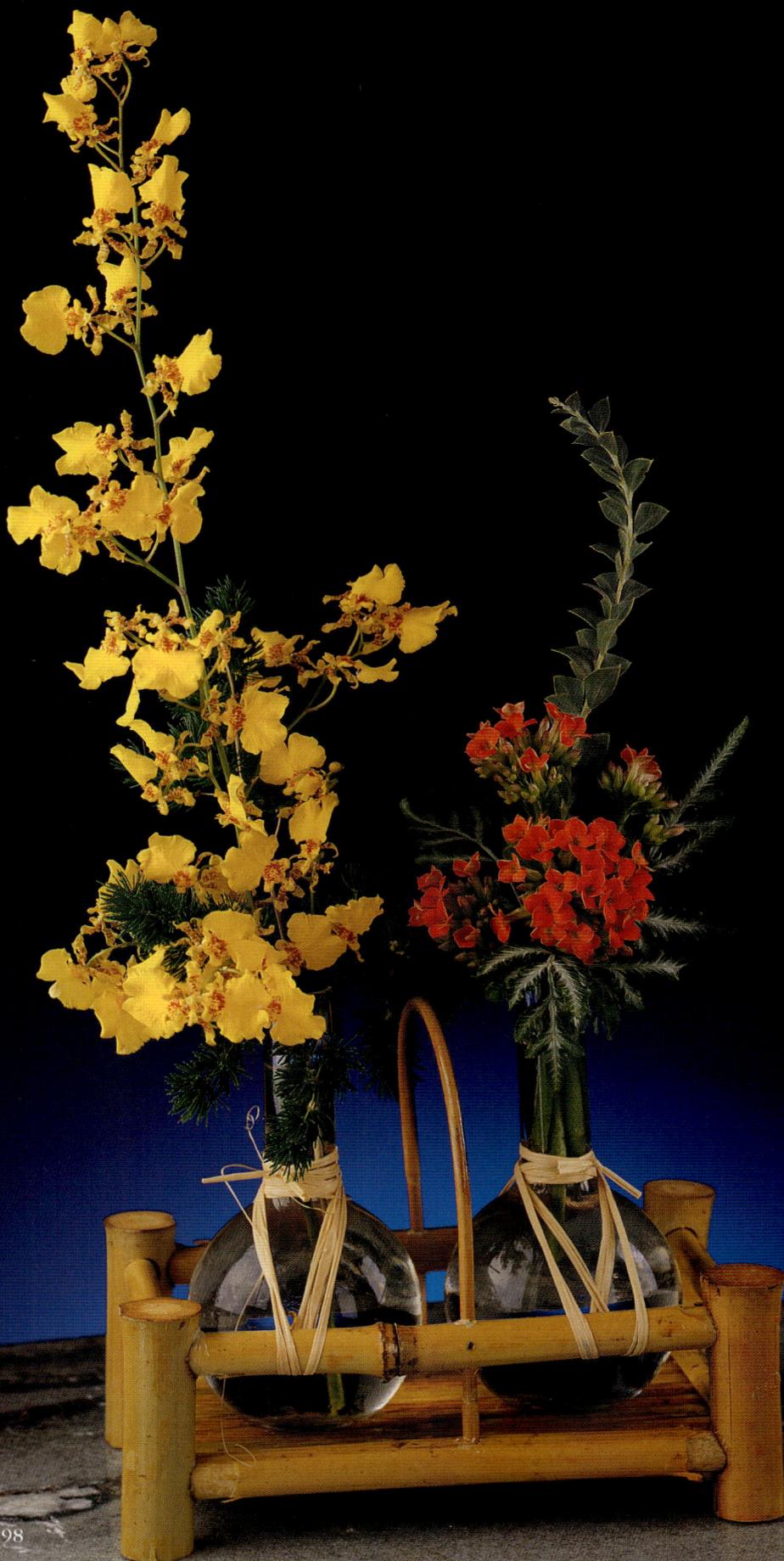

Being sensational doesn't mean being shocking. It's possible to be sensational in miniature. Just defy convention and know when to stop.

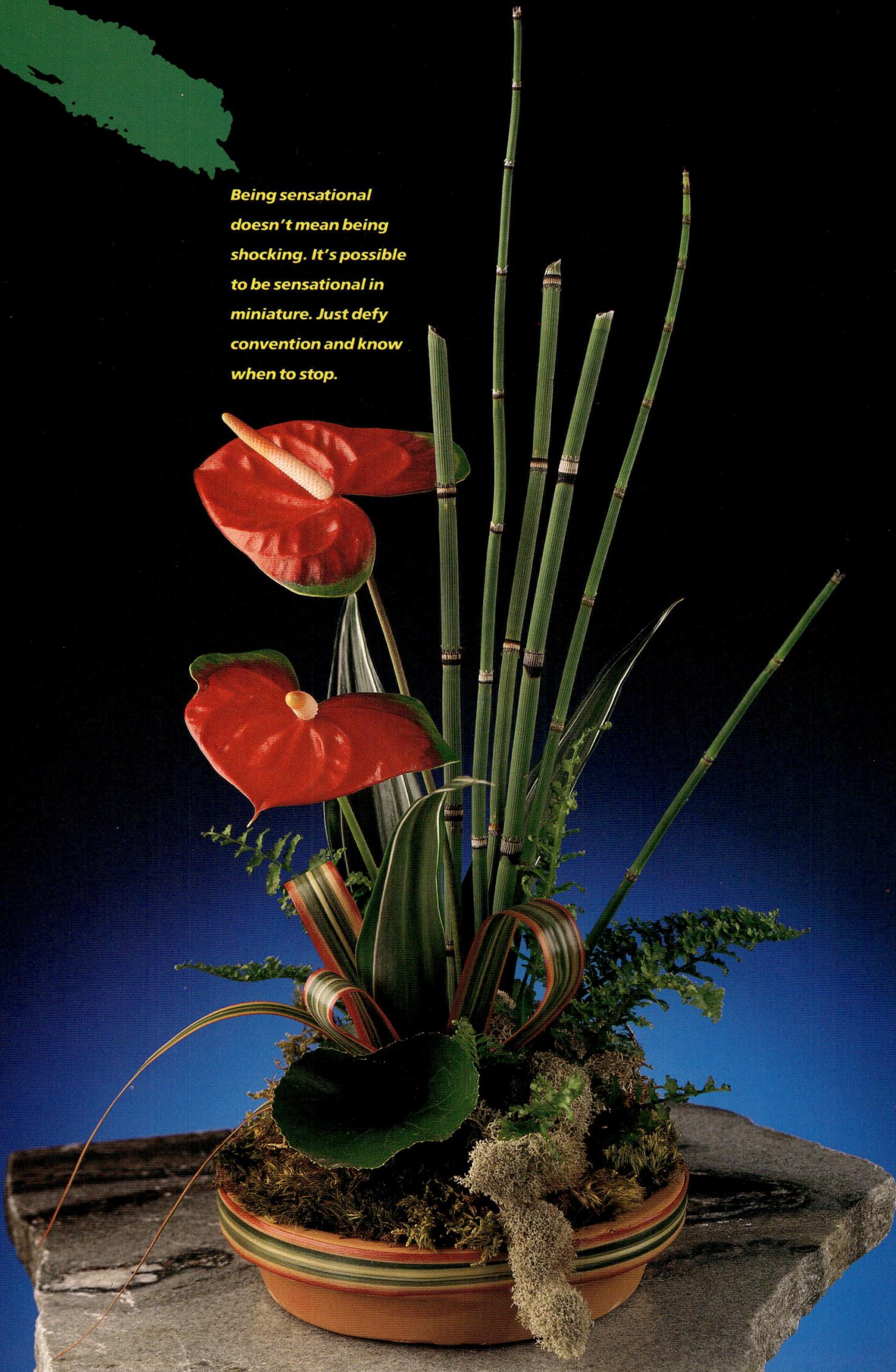

A Point Of

Construction Tips:
Slide a dry Lomey caged floral foam to the bottom of the Lomey Pedestal. Slide the second dry caged foam to the center position. Hot glue this caged foam securely in place. Then, anchor the top caged foam. Saturate foam thoroughly. Wrap the pedestal with moss and entwine with raffia.

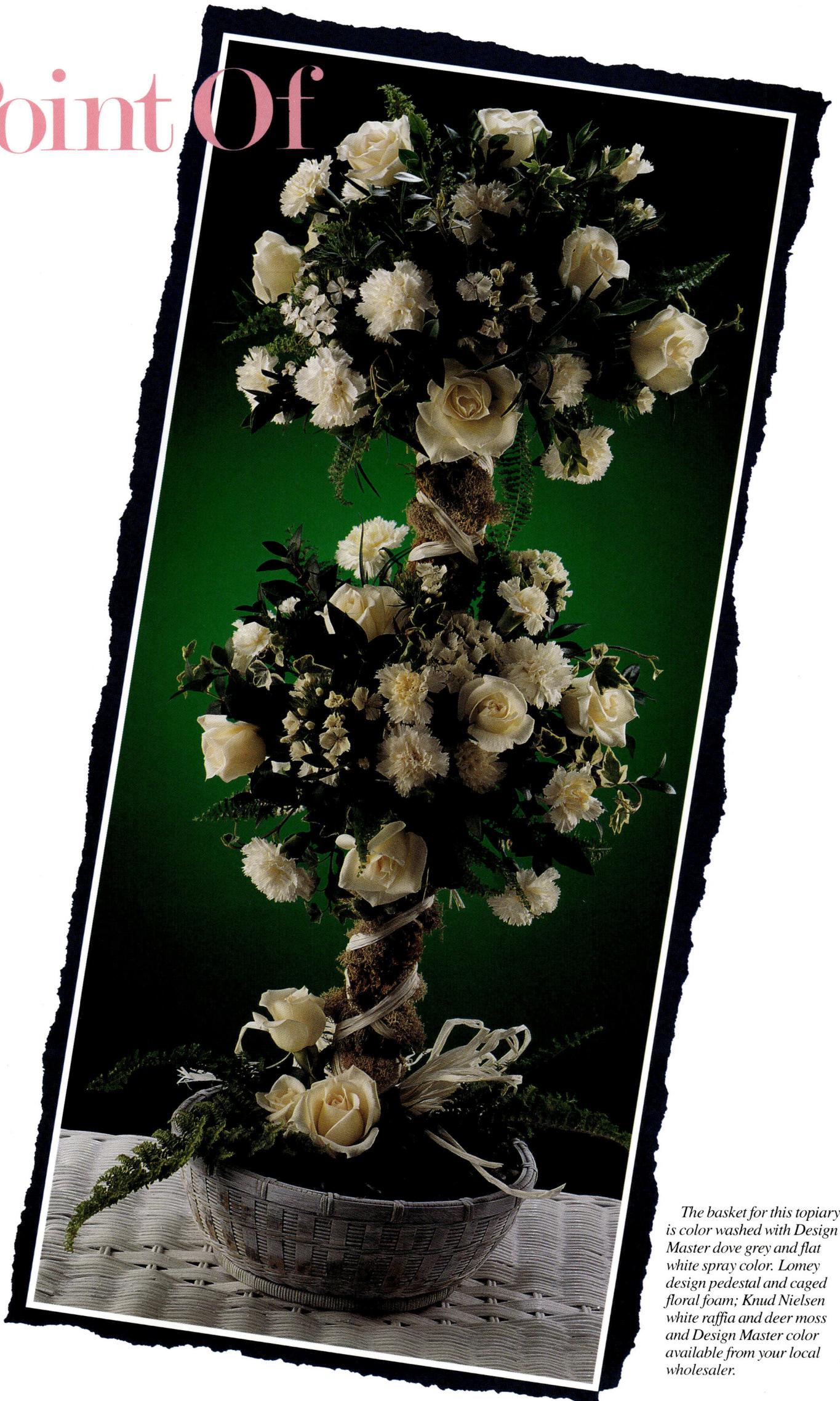

The basket for this topiary is color washed with Design Master dove grey and flat white spray color. Lomey design pedestal and caged floral foam; Knud Nielsen white raffia and deer moss and Design Master color available from your local wholesaler.

Dramatic Intensity

Topiaries are making a comeback. Silk design manufacturers reintroduced them over a year ago. They were an immediate success. Buyer interest remains strong. Don't miss this opportunity to create sales by featuring topiaries. And, topiaries are a smart, refreshing look in fresh flowers.

Historical Background

Topiaries date back to the thirteenth century when the rage for formal gardening in Holland was at its peak. Due to the scarcity of land in Holland, gardens were laid out with mathematical precision. Holland landscapers looked at ways to use plants effectively in restricted space. And from this need to conserve space, the topiary emerged as an ideal method of growing certain plants. In the *Book Of Topiary,* the historical record of topiaries, the authors state that Holland was the major source of supply, inspiration and technical knowledge for the English nurserymen and gardeners who popularized topiaries in the Golden Age of topiary in the sixteenth century.

At the end of the Nineteenth Century the art of topiary appeared in English gardens. Photographs of gardens during the late 1880s and early 1900s showed sophisticated gardens with box topiaries. By 1950, interest in topiaries declined because of the cost and the amount of time required in care. According to Geraldine Lacy, an English authority on the history of topiary, a renewed interest in the art of topiary began in the 1970s. "This happy return to topiary fashion comes at a time when the pleasure of gardening has reached an intensity which shows no signs of abating," states Lacy.

Flower Topiaries

Flower arrangement historians cannot identify when the art of topiary appeared in floral design. It is believed that fresh flower topiaries first appeared during the Victorian Era - mid 1880s. The Victorian nosegay, which is the first evidence of a composite flower arrangement, was popular during this period of history. Historians believe that this interest in nosegays led to composite topiaries with fresh flowers.

Topiaries Updated

Those who have researched the current topiary rage state that the enthusiasm for this classic, ornamental look is an indication that an "inevitable return to more formal interiors" is emerging. Decorative accessories specialists claim that interior design is moving away from the casual look of the Southwest and pastels to a more traditional formal feeling.

Style Of Design

Topiary is a controlled design. It has shape, form and definition. The table-top topiary is the major market for a flower shop. Nevertheless, the range of creative possibilities in table-top topiaries is unlimited. Fresh flowers, silks, dried natural materials, pods and cones - all are effective in topiary designs.

Fresh Flower Construction

For fresh flower topiaries, the floral artist must construct his own topiary form. For the magnificent white and green fresh flower topiary pictured, the artist used a 31-inch Lomey Pedestal and three large Lomey caged floral foams.

The distinctive beauty of this elegant all-white topiary is the relaxed style. The round forms of the two topiaries are distinct. Flowers are not compact. Instead, each blossom shows with individual recognition. The greens used with the flowers are an important material in achieving the elegant, but relaxed look.

The bottom caged floral foam holds the greens at the base of the design and the cluster of white roses.

In creating this all-around topiary, the artist used 25 Bridal White roses, one bunch of white miniature carnations, 9 stems of white Sweet William, 4 stems of myrtle and 2 four-inch pots each of fluffy ruffle fern and variegated ivy.

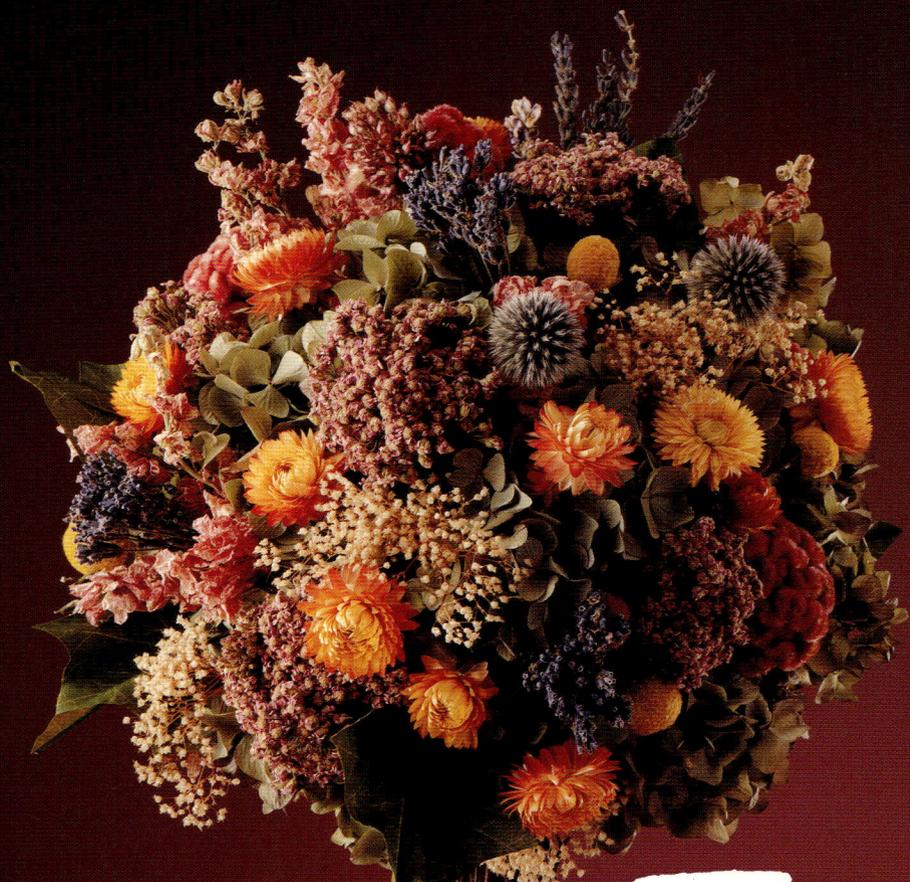

The shapes of these topiaries and the materials used are old friends. It's the bold, fresh attitude that makes them new and exciting.

Dried natural materials give this topiary the classic look of the Old World. The design and presentation in topiary form nourish the composition with an elegant contemporary look.

Construction Tips: Place sheet Styrofoam® in the basket and anchor in one of Knud Nielsen's wonderful, brand-new single topiary forms. Insert the ends of birch branches into the topiary ball and the Styrofoam® base to the topiary stem. Then, fill the topiary ball with an expansive assortment of natural, dried materials.

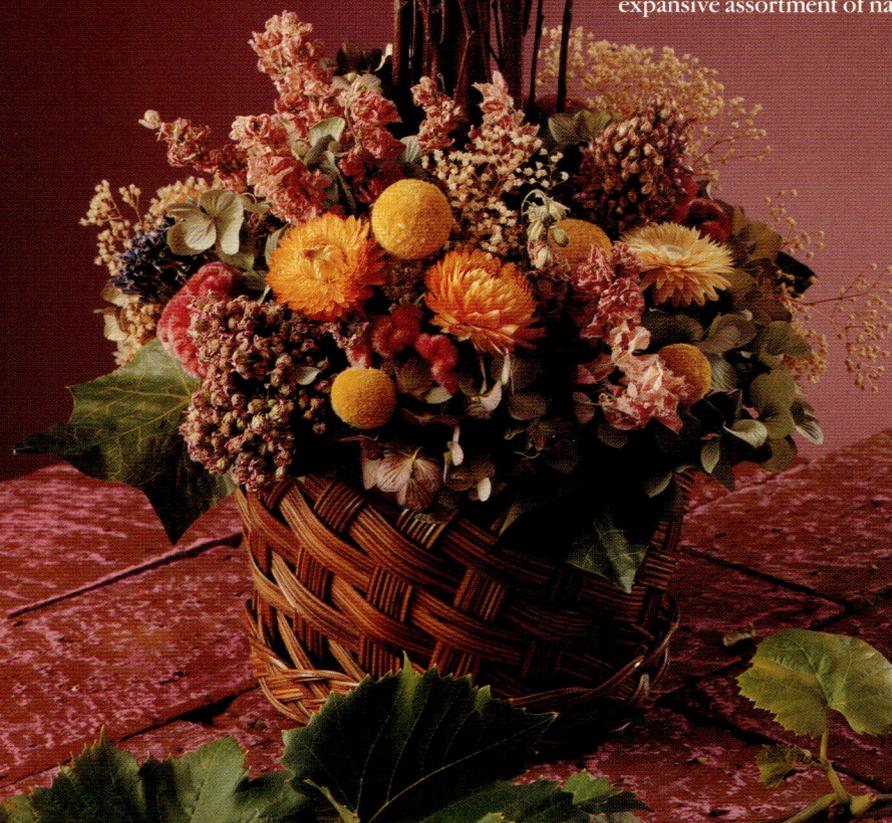

Knud Nielsen topiary forms, natural dried flowers, pickled pods and untwisted paper ribbon; Franklin China's P1606 garden pot; Nouvette's silk larkspur No. H43, anemone No. N256, Mt. Berry No. P240, ivy leaf No. LH208 and needlepoint ivy No. LH208; Design Master Color Sprays; Offray ribbon and, Sahara® II foam available from your local wholesaler. Silk quince No. K374 and Dogwood No. K406 from K & D Export Import Co., 225 Fifth Ave., New York, NY 10010. Silk rose No. P208 and variegated ivy No. E610 from Supersilk, 1967 S. Third, W., Salt Lake City, UT 84115.

An Aesthetic Statement–
A Dramatic Accent

The silk flower topiary looks like it came from the work room of Laura Ashley. It doesn't require a Laura Ashley environment or even English style surrounding to be effective and beautiful. The style of this topiary is more casual. The artist maintains the integrity of the round, topiary form in the design. Form, however, does not control. Instead, the unstudied placement of materials brings a feeling of fluent elegance.

Construction Tips: Anchor a Knud Nielsen single topiary form in a clay pot color washed with Design Master Glossy Woodtone and Blush Pink color. Surround with Sahara II™ foam to hold the materials at the base. Stem all materials with steel picks for efficient design labor. Complete the composition by swirling Offray rosy mauve ribbon through the topiary and the base.

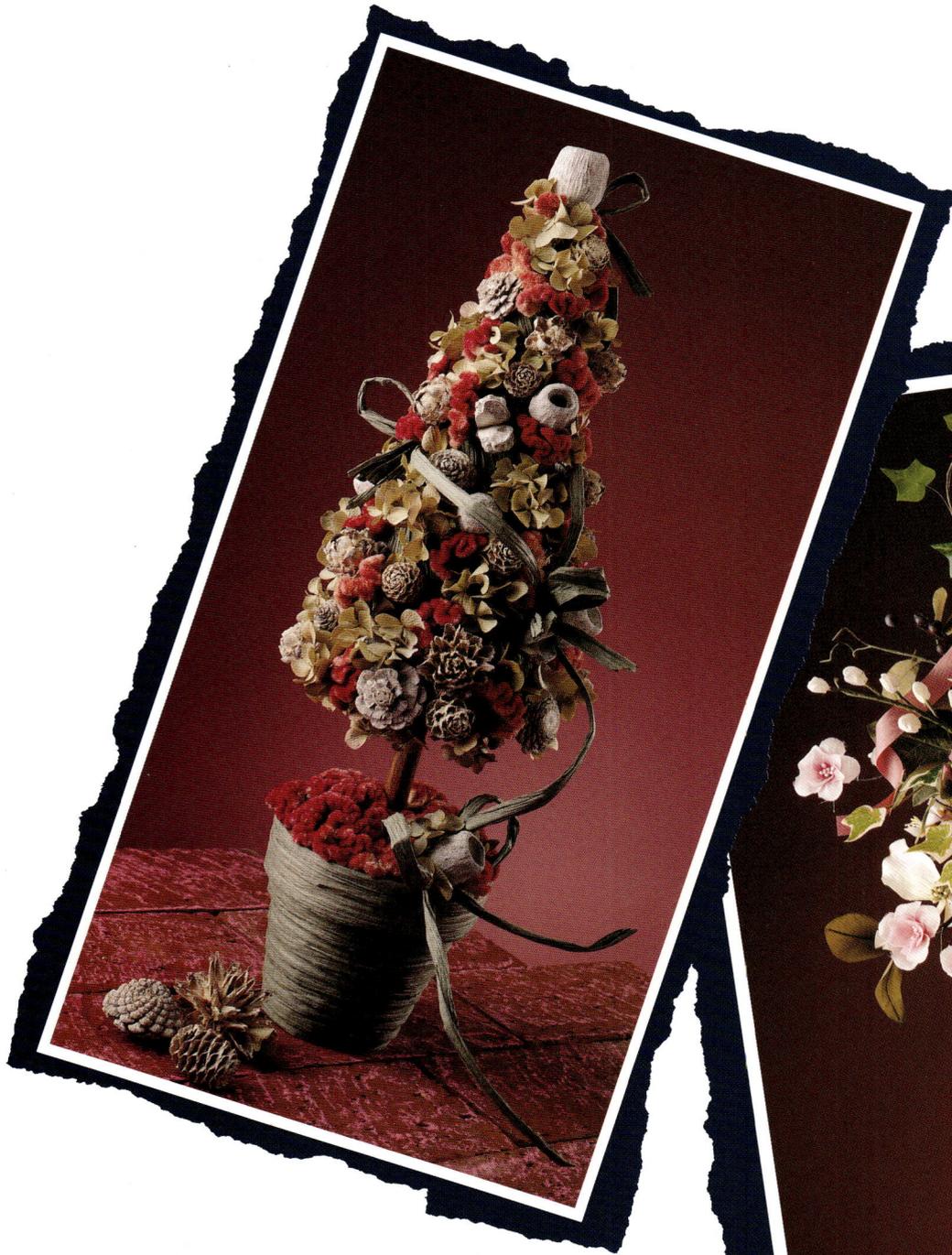

The pyramid-shaped topiary with pickled pods, dried hydrangea, celosia and paper ribbon projects a totally different look in topiary design. Controlled shape is important in this style. The Knud Nielsen cone-shaped topiary form and pickled pods on wooden picks makes this topiary style design efficient.

Construction Tips: Use a glue gun to attach Knud Nielsen untwisted paper ribbon to a clay pot. Securely anchor the topiary form in the pot. Then, create the topiary with the pods and dried materials. Place the clusters of celosia and hydrangea on steel picks for efficient design labor. Finish the design with Knud Nielsen untwisted paper ribbon.

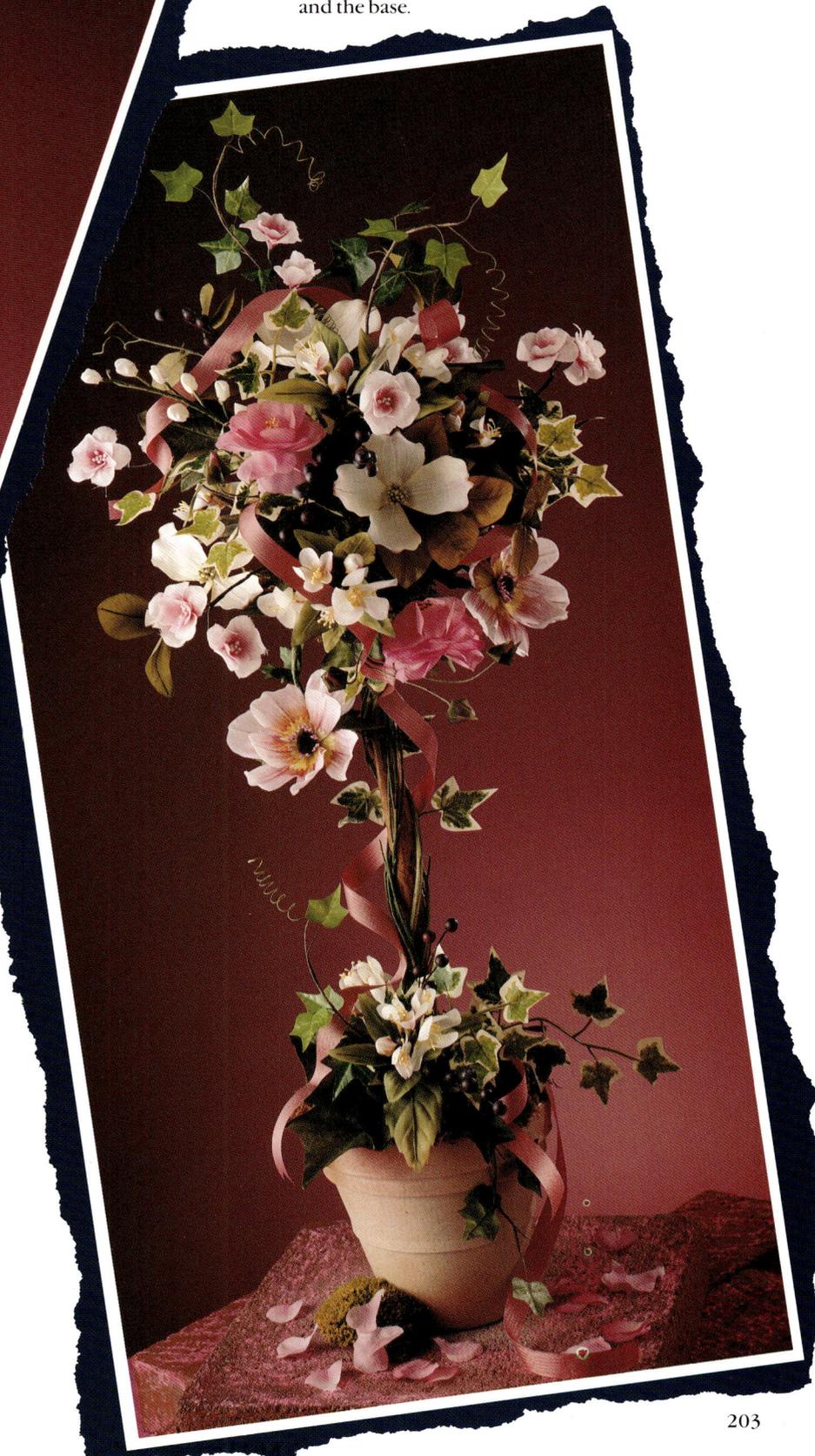

Knock Out Design — Knock Out Color

*I*t takes vision to be a successful professional floral designer. It takes imagination. And, it takes attention to the critical creative details that make a difference.

Vision, imagination and quality, creative workmanship. This topiary is a glowing example of how a qualified, professional floral artist puts together all of these critical creative details so they make a difference. The powerful, extended analogous color harmony includes all warm colors: yellow, yellow-orange, orange and red orange. This extraordinary topiary would be outstanding in a business environment for celebrating an important milestone. As a party decoration, it would stand out with incredible beauty and set the mood for a joyous celebration.

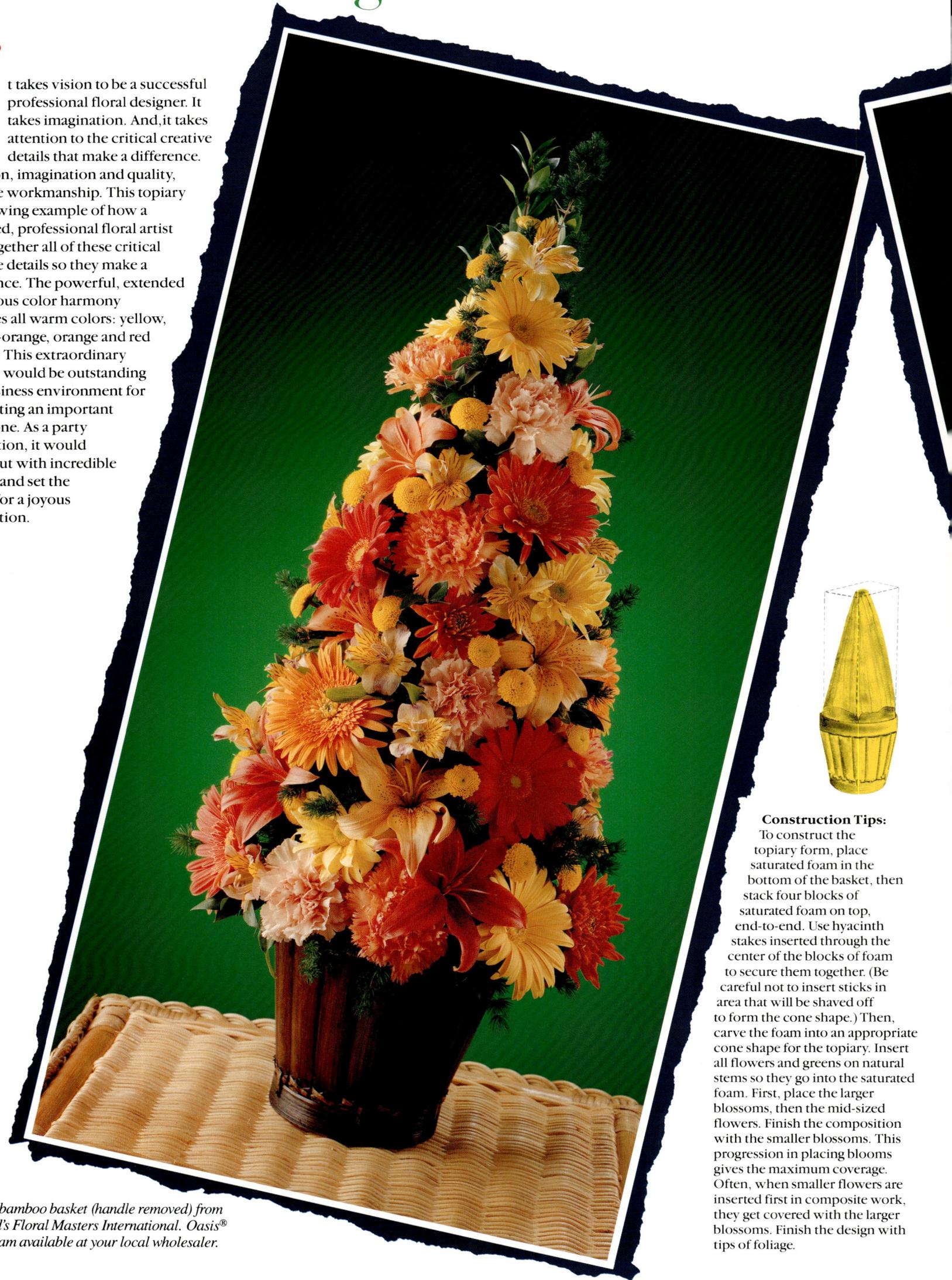

Satin bamboo basket (handle removed) from Hanford's Floral Masters International. Oasis® floral foam available at your local wholesaler.

Construction Tips:
To construct the topiary form, place saturated foam in the bottom of the basket, then stack four blocks of saturated foam on top, end-to-end. Use hyacinth stakes inserted through the center of the blocks of foam to secure them together. (Be careful not to insert sticks in area that will be shaved off to form the cone shape.) Then, carve the foam into an appropriate cone shape for the topiary. Insert all flowers and greens on natural stems so they go into the saturated foam. First, place the larger blossoms, then the mid-sized flowers. Finish the composition with the smaller blossoms. This progression in placing blooms gives the maximum coverage. Often, when smaller flowers are inserted first in composite work, they get covered with the larger blossoms. Finish the design with tips of foliage.

Innovation — Not Imitation

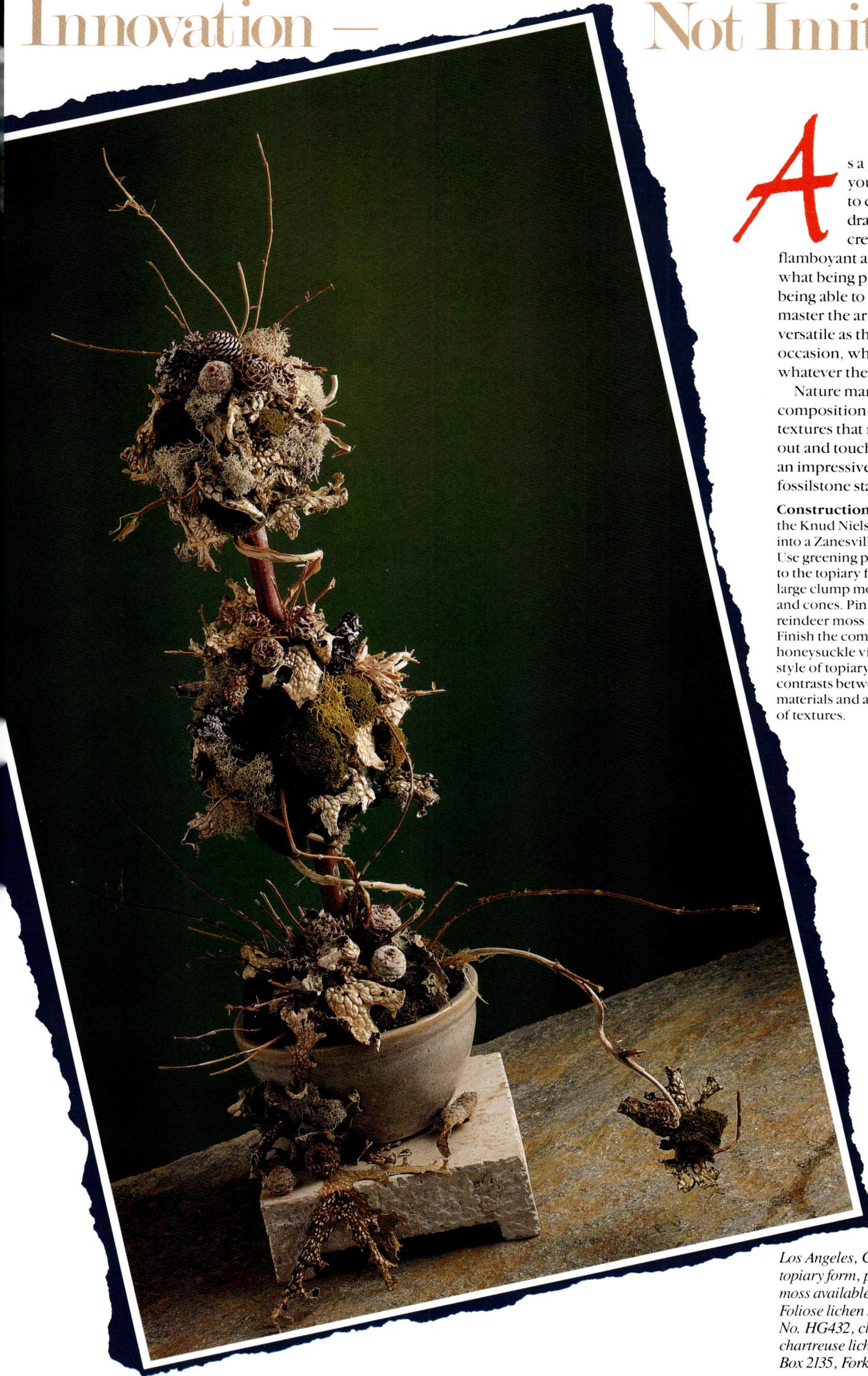

As a professional floral artist, you have the artistic license to create designs that are dramatic, exciting, intense, creative, theatrical, flamboyant and even a bit wild. That's what being professional is all about - being able to innovate. When you master the art of topiary, you can be as versatile as the demand. Whatever the occasion, whatever the mood, whatever the style - do it with a topiary.

Nature marks this striking topiary composition. Interesting materials, textures that make you want to reach out and touch, exquisite design, and an impressive presentation on a fossilstone stand.

Construction Tips: Securely anchor the Knud Nielsen double topiary form into a Zanesville Stoneware container. Use greening pins to attach green moss to the topiary forms. Next, pin in the large clump moss. Then, insert the pods and cones. Pin in the lichens. Attach the reindeer moss and the chartreuse moss. Finish the composition with the honeysuckle vines. In constructing this style of topiary, the objective is strong contrasts between light and dark materials and a wide variation of textures.

Planter bowl No. 9506 from Zanesville Stoneware Co., 309 Pershing Rd., Zanesville, OH 43701. Fossilstone stand No. 11-3022 from Toyo Trading Co., 13000 S. Spring St., Los Angeles, CA 90061. Knud Nielsen double topiary form, pickled pods, cones and reindeer moss available from your local wholesaler. Foliose lichen No. HG434, grey-black lichen No. HG432, clump moss No. HG204 and chartreuse lichen from HOH Grown, P.O. Box 2135, Forks, WA 98331.

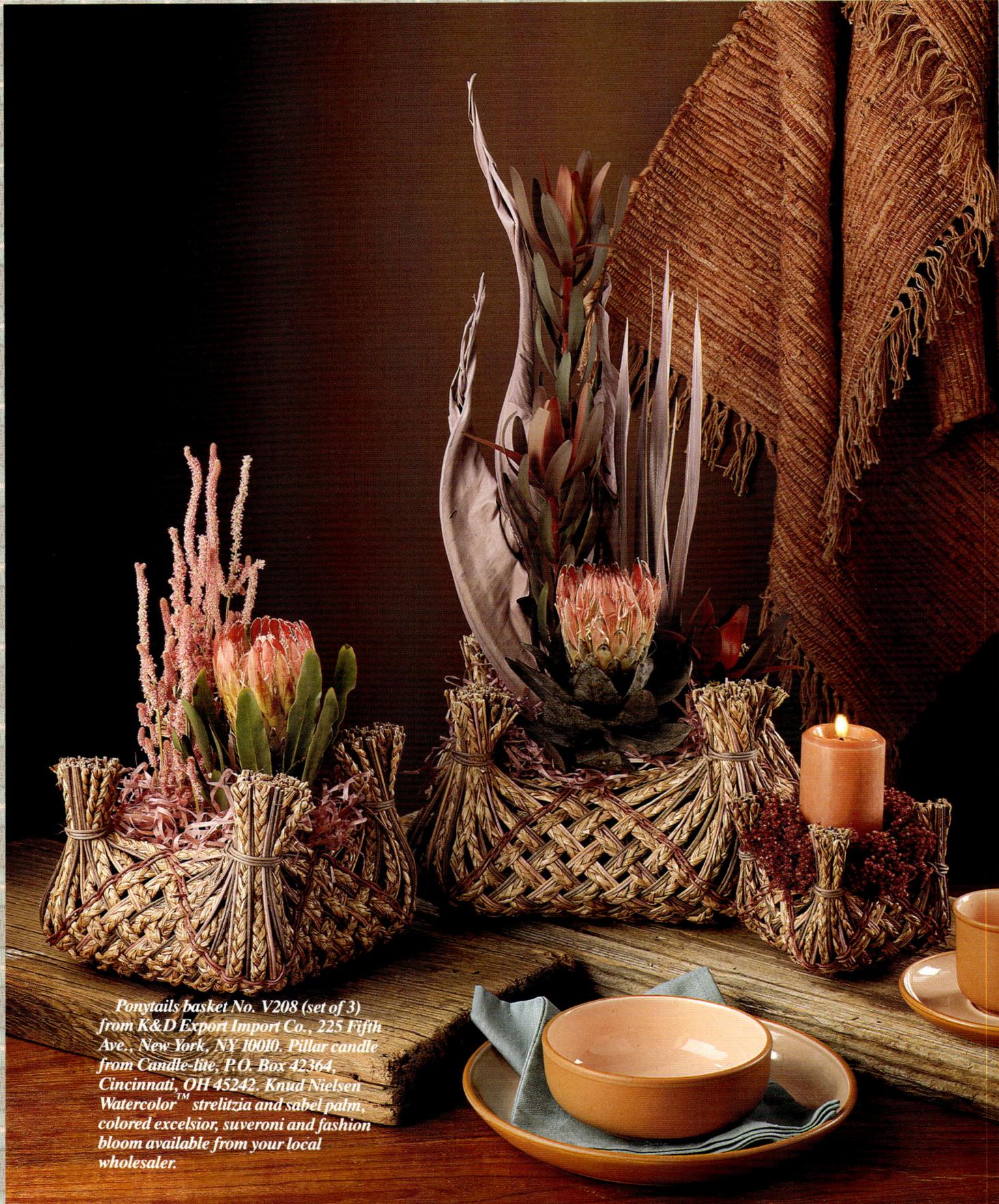

Ponytails basket No. V208 (set of 3) from K&D Export Import Co., 225 Fifth Ave., New York, NY 10010. Pillar candle from Candle-lite, P.O. Box 42364, Cincinnati, OH 45242. Knud Nielsen Watercolor™ strelitzia and sabel palm, colored excelsior, suveroni and fashion bloom available from your local wholesaler.

INTERPRETING THE SOUTHWEST LOOK

*New Mexico is the most authentic example
of the Desert Southwest. More than any other state,
New Mexico has held on and nurtured its historic roots.*

n 1846, the United States claimed New Mexico as a territory. As New Mexico developed and became a state, tourism developed. This influx of new people and new ideas caused concern about the loss of indigenous architecture and art. Taos and Santa Fe prospered as popular tourist cities and prompted the birth of the Pueblo Revival style of architecture. Buildings with rounded adobe walls, flat roofs and protruding vigas, or beams, became the characteristic architecture style.

In 1916, the Santa Fe Art Museum was built in this new mode of architecture. This initiated a rebirth of the Desert Southwest style. The allure of Santa Fe and Taos began to draw artists, writers and craftsmen from the East and Europe. Indian and Hispanic artists became popular and recognized. The Rio Grande and Taos schools of art developed. As artists moved to the Santa Fe area and reflected the Southwestern style in their works, the popularity of the Southwestern look expanded rapidly.

Southwestern Influence

Today, muted earth-related colors, mats and rugs, textured baskets, and pottery in many different forms reflect the Southwestern Influence. It is part of the contemporary eclectic look in decorating.

Southwestern Characteristics

In creative floral design, the Southwest Influence reflects color, texture and materials. Of these three characteristics, color is the most dominant. The earthy look with muted values of oranges, turquoises, purples and browns are among the most popular Southwestern colors.

Textured pottery, rustic adobe-like containers, heavy-weave baskets and braided and corded rugs and mats express the look of the Desert Southwest. Desert-like flowers, greens and plants are part of the Southwest look. Many other materials that are not indigenous to the desert, but look like the desert, are appropriate in Southwest designs.

No one style of floral design expresses the Desert Southwest. It is an influence in design, not a style. This Southwestern Influence appears in the rustic, the contemporary and the sophisticated.

Southwestern Composition

The composition pictured to the left combines the three main characteristics of the Southwestern Influence: (1) Earth-influenced, Southwest colors. (2) Texture. (3) Desert-like materials.

Fireside Basket

This fireside basket composition is another interpretation of the Southwestern Influence in floral design. The basket, the clay pots, the colors, the mat, the woven painted flax - all represent the characteristics of the Desert Southwest.

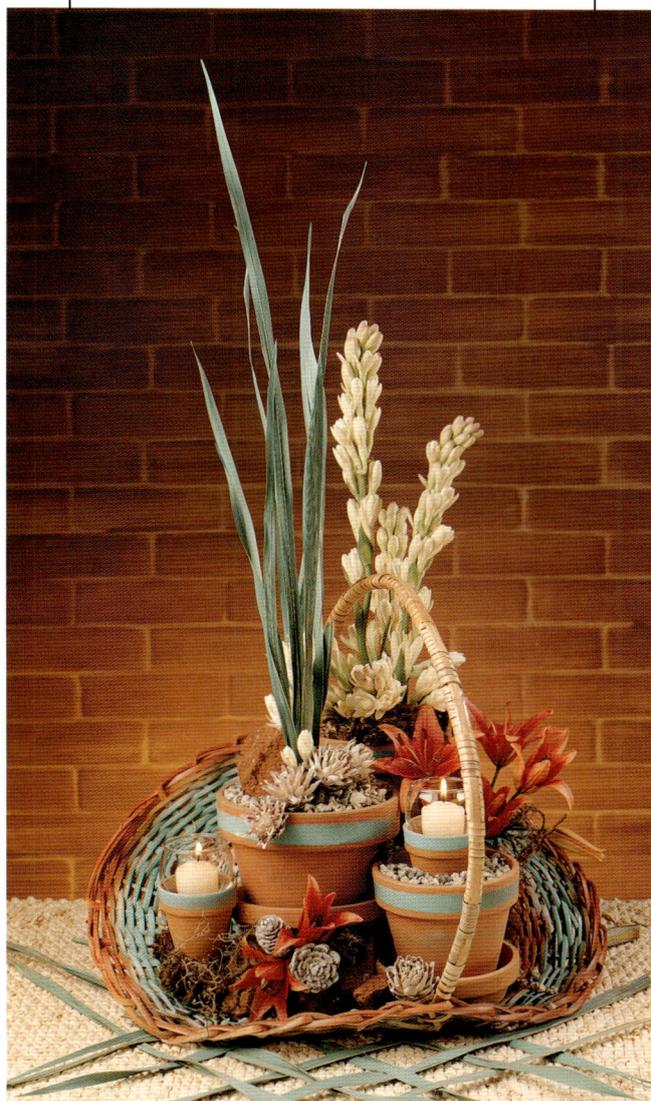

Fireside basket and clay planter pots spritzed with Design Master Color Tool; roly poly votive candles, and Knud Nielsen sabel palm, pickled pod assortment and mood moss, available from your local wholesaler.

The Southwestern Influence

Water jug No. C74 from the Village Ware Collection, Evans Ceramics, Inc., PO Box 1212, Healdsburg, CA 95448. Nouvette silk hibiscus No. N309 and lotus leaf No. LH203 and Knud Nielsen panchu spring and ti tree available from local wholesalers.

As the contemporary influence in architecture moved into the Desert Southwest a new Abstracted Traditional style emerged. This architectural style preserves the adobe-like look while incorporating the openness and expansiveness of the contemporary. The Abstracted Traditional is Southwest in feeling and modified with the grand style of elegance and comfortable sophistication.

This marvelous silk and dried composition reflects the grand style of the Desert Southwest. The colors are muted, elegant and sophisticated. The Evans container with the unique asymmetrical glaze texture sets the mood and style of the design. The materials are not indigenous to the Desert Southwest. Nevertheless, they introduce the grand, sophisticated style appropriate with the Abstracted Traditional.

The structuring techniques in this floral composition are important. One full bunch of Watercolor™ Panchu Spring bisects the design establishing symmetrical balance. Three hibiscus in a slightly curved line introduce a cadence repetition. The three lower silk lotus leaves repeat this same placement pattern. The three hibiscus make the primary visual statement, the three lotus leaves communicate the secondary visual statement.

All of the essential characteristics of Southwest design appear in this ingenious composition - color, texture and indigenous materials.

The Parcel basket from K&D's Southwest Collection is the ideal container. Wrap several thicknesses of cardboard (or a piece of foam board) with polyfoil and place in the bottom of the basket for support. Then, line with a thick sheet plastic. Cut part of the soil from the bottoms of two 6-inch *Pilocereus gounellei* cacti plants and position in the basket. Anchor the saturated floral foam in an inexpensive container and place in the basket to hold the fresh flowers. Fill the open basket area with soil and cover with moss. Glue the miniature pods in position. Then, arrange the fresh flowers. The framing position of the flax leaves is an essential characteristic of this design. Finish the composition with pieces of preserved plumosus.

THE SPIRITED

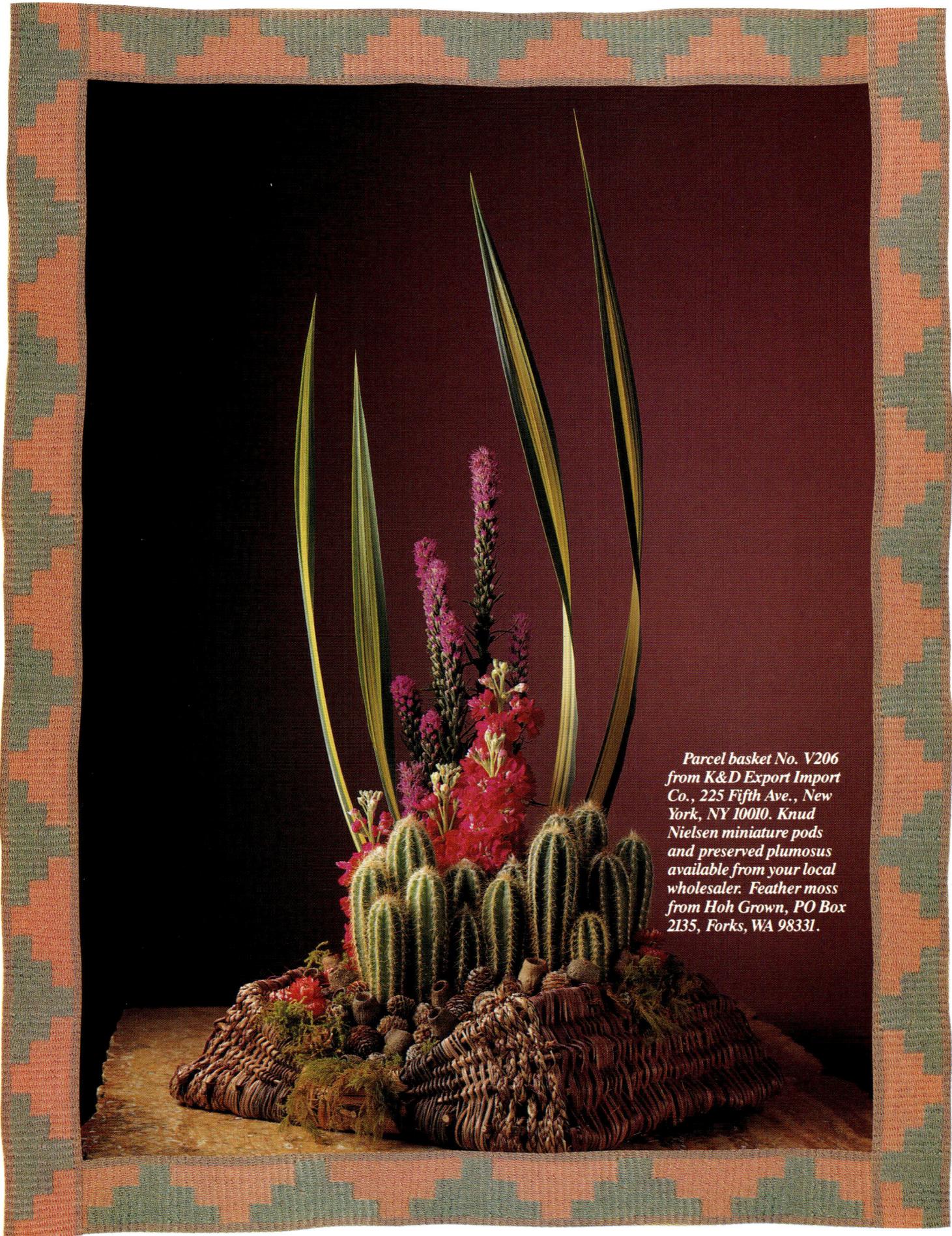

Parcel basket No. V206 from K&D Export Import Co., 225 Fifth Ave., New York, NY 10010. Knud Nielsen miniature pods and preserved plumosus available from your local wholesaler. Feather moss from Hoh Grown, PO Box 2135, Forks, WA 98331.

LOOK OF THE SOUTHWEST

SOUTHWEST SOLUTIONS

In a professional flower shop, no idea is worth much unless it can be interpreted into designs that sell. We believe that every idea presented in DESIGN WITH FLOWERS does have practical, profitable application. Some concepts must be modified. Few ideas can be copied exactly as presented. The purpose of any design idea is to spark your imagination to unlock your creativity.

The three compositions pictured above are down-to-earth, practical solutions for bringing the Southwest Influence into your own design work. First, they show interpretations of the Desert Southwest colors. Second, each design focuses on texture and the interplay of different textures. And, third, the compositions feature or include desert-like materials. These suggestions are simply starting points to nudge your own creativity. For example, using cacti plants in any size and form is a way to create a distinctive fresh flower design that picks up the influence of the Desert Southwest.

The composition to the right suggests a decoration for a serving table. It highlights the Desert Southwest colors, texture and indigenous materials. In analyzing the design, capture the placement pattern: Cacti and aloe to the right, bright fresh flower color in the center and bush-like materials to the left. Arranging the materials in this matter creates a feeling of simple, natural design.

To create the candle accent, the artist anchored gray, apricot, peach sherbet and aqua mist tapers in a piece of Styrofoam® attached in an inexpensive container. Then, he glued natural cork pieces to cover the Styrofoam® and the container.

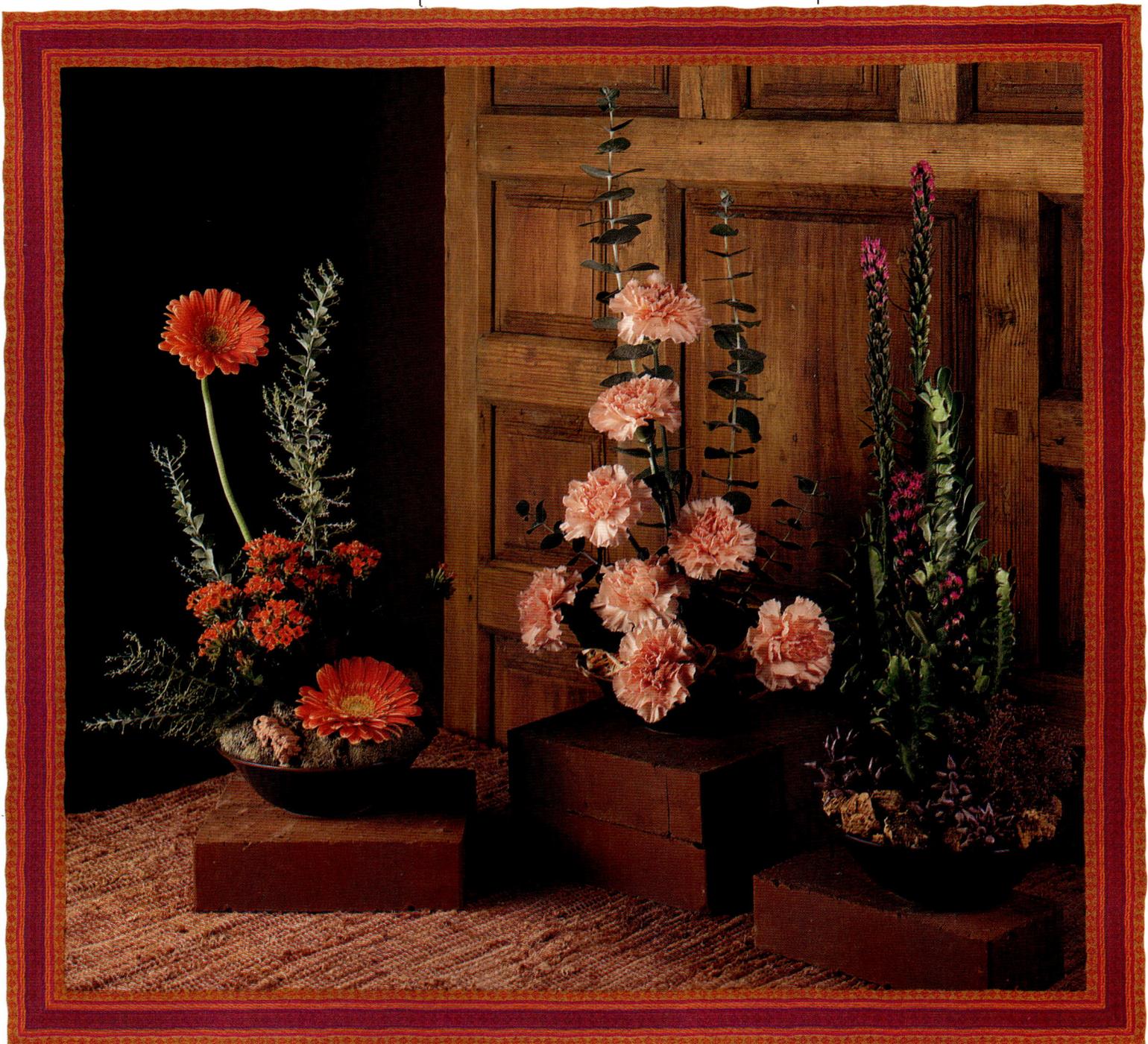

Knud Nielsen mini euk fruit, Watercolor™ gyp, deer moss and colored paper excelsior available from your local wholesaler. Ceramic oval lily bowl No. L-7 from Coronet Ceramics, 14520 Joanbridge, Baldwin Park, CA 91706. Candles from Creative Candles, P.O. Box 19514, Kansas City, MO 64141. Rainbow cork from A. L. Randall Co., Aptakisic Road, PO Box 82, Prairie View, IL 60069.

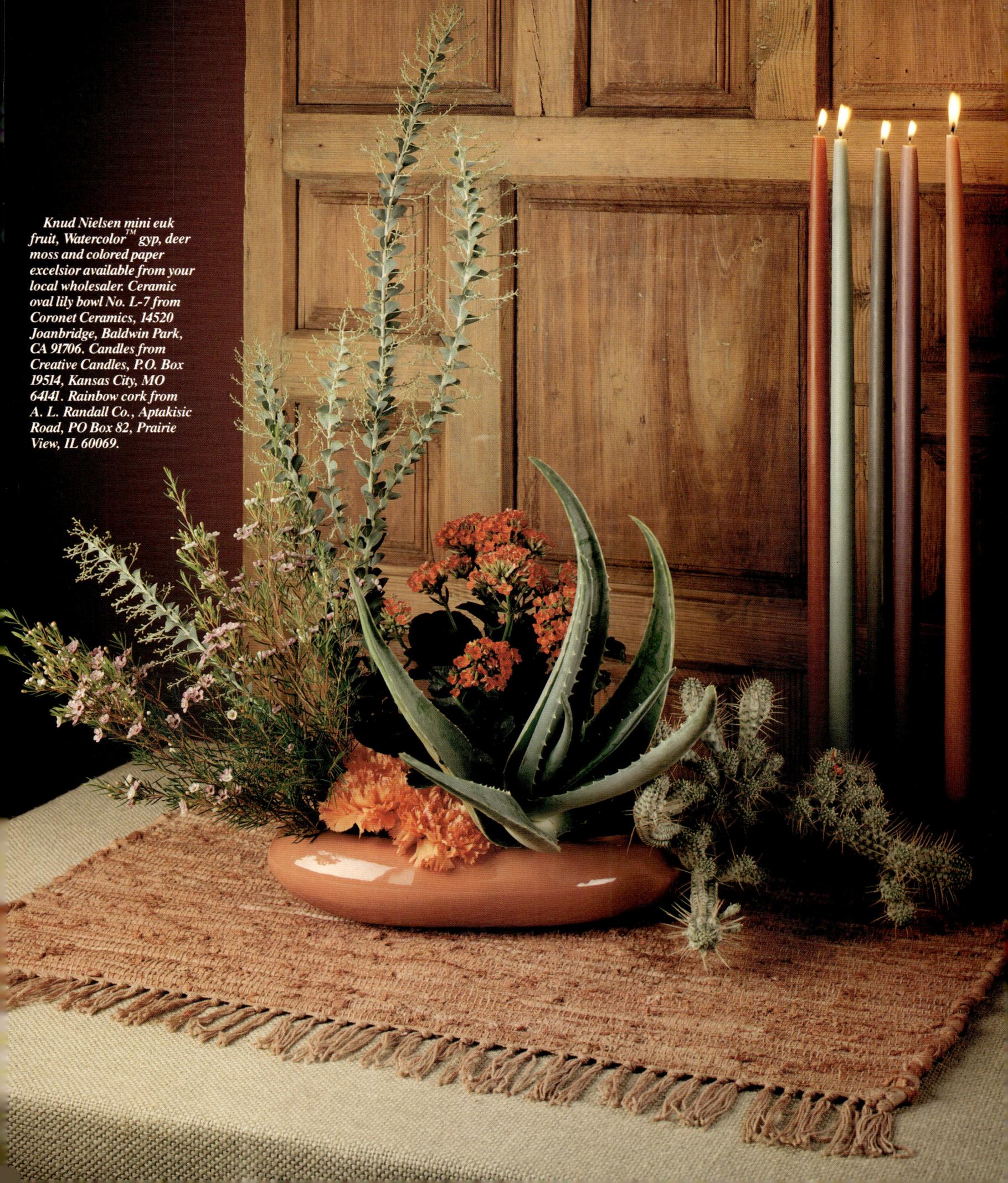

LINEAR DESIGN— A LEGEND IN EX...

Historians suggest that linear design dates back to the 15th century when Soami, the great Japanese painter created masterpieces featuring the three specific lines - heaven, earth and man. Before this focus on line, flower arrangements were more massive and less linear.

The art of linear design has progressed through many phases in flower arrangement history. Contemporary linear design reigned in the post World War II 1940's, through the 1950's and into the early 1960's. During this 20 year span, flower arrangements became very structured based on line. The one-sided, show-it-all-up-front arrangement came into vogue and dominated the scene for many years.

Regardless of how line is expressed, it remains an important influence on contemporary floral art. As the price of flowers increased and the costs of operating a flower shop escalated, more and more emphasis was placed on doing more with fewer flowers. This encouraged the proliferation of linear design.

In floral design, there are two popular lines - vertical and horizontal. In most compositions, one line dominates while the other subordinates. This method of line presentation comes from the art theory teaching that one major line should advance while the secondary line recedes.

The inspiring horizontal arrangement pictured is a beautiful example of advancing and receding lines. In the taller right design of the composition, the horizontal line advances. This line dominates because of the chroma of the yellow flowers. The blues and purples establish a receding vertical line. In the left, shorter design, the vertical line advances. Again, the brilliance of the yellow flowers makes the vertical line dominant. And, the color dominance of this line pulls it through the receding blue vase. This composition could be framed in an elongated horizontal rectangle. Therefore, the horizontal emphasis is dominant, the vertical line emphasis is secondary.

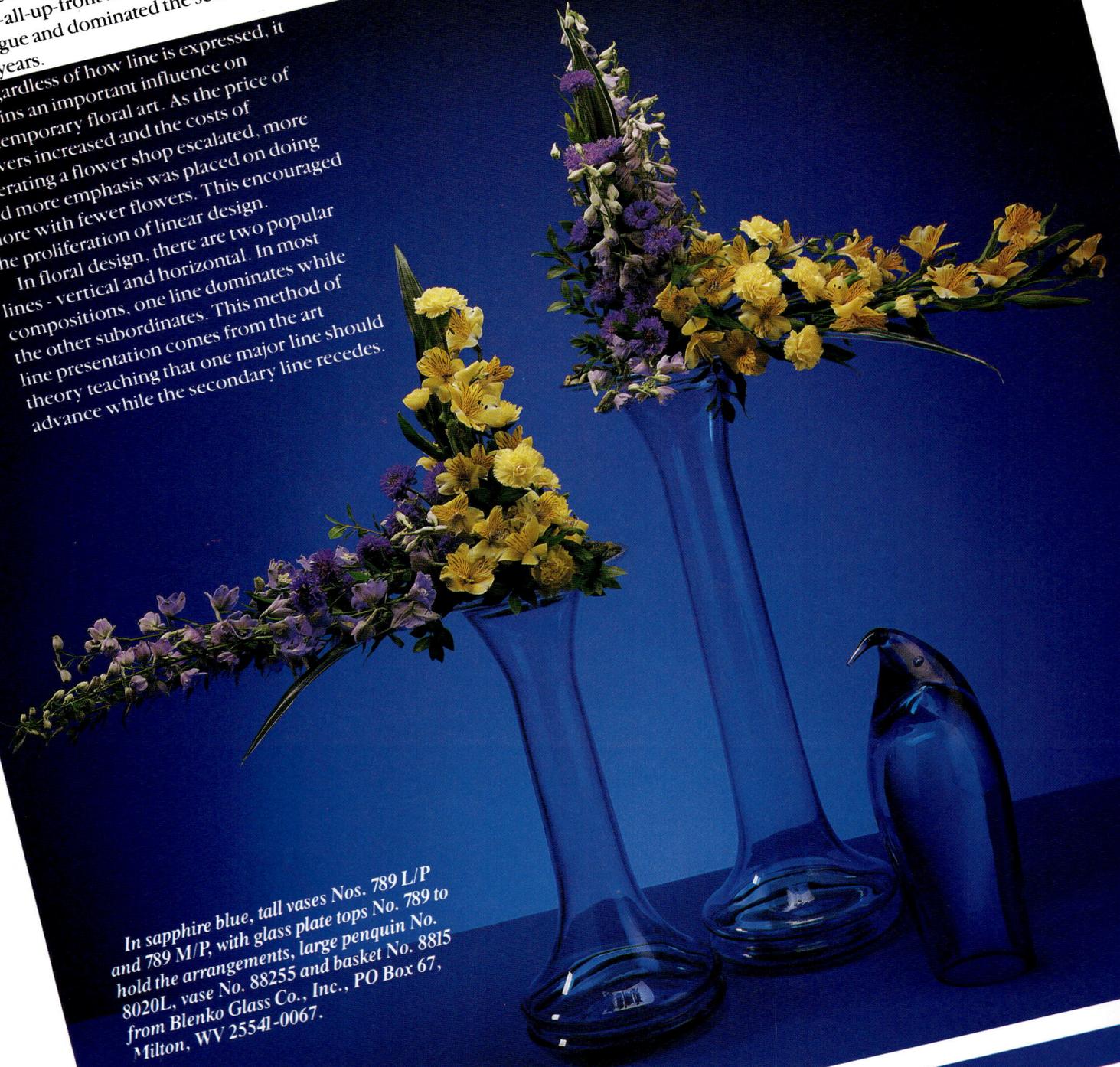

In sapphire blue, tall vases Nos. 789 L/P and 789 M/P, with glass plate tops No. 789 to hold the arrangements, large penquin No. 8020L, vase No. 88255 and basket No. 8815 from Blenko Glass Co., Inc., PO Box 67, Milton, WV 25541-0067.

This composition combines dominant horizontal and dominant vertical lines. As a total composition, the stair-stepped horizontal line dominates.

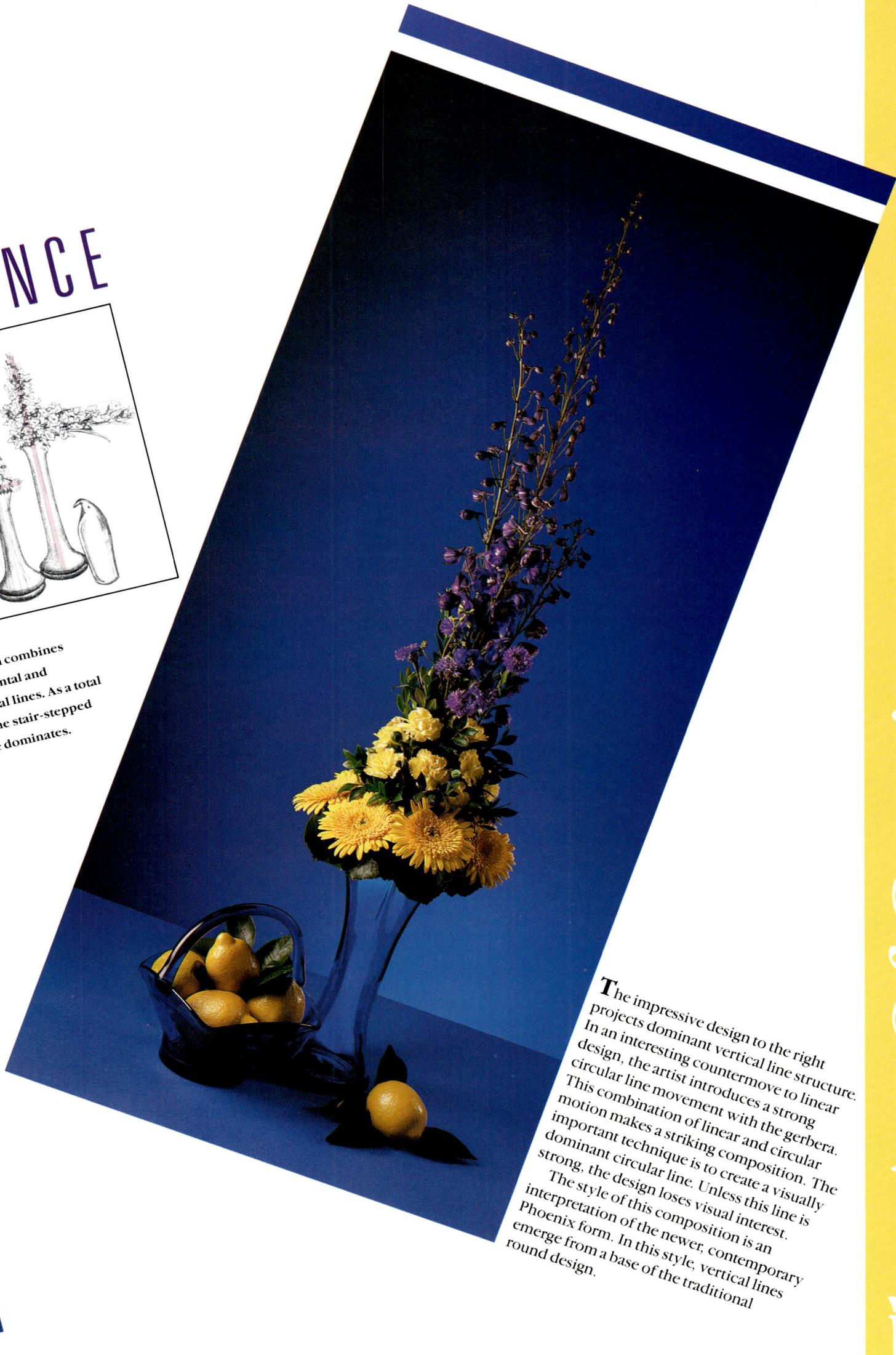

The impressive design to the right projects dominant vertical line structure. In an interesting countermove to linear design, the artist introduces a strong circular line movement with the gerbera. This combination of linear and circular motion makes a striking composition. The important technique is to create a visually dominant circular line. Unless this line is strong, the design loses visual interest. The style of this composition is an interpretation of the newer, contemporary Phoenix form. In this style, vertical lines emerge from a base of the traditional round design.

The Art Of Creating

THE TIMELESS QUALITY OF THE ASYMMETRICAL

- **E**xaggerated height.
- Central line moves from high center to low right.
- Concentration of visual weight on this side.
- Strong front-to-back depth through the central focal area.
- Vertical and horizontal lines join in the focal point with a strong right angle.
- Minimum visual weight on this side.

Stackable containers No. M2 from Midamco, 6630 N. Kostner, Lincolnwood, IL 60646.

The asymmetrical "line" design remains a dominant style for many flower artists. It's especially desirable when materials are limited.

Smartly styled within the guidelines of the established asymmetrical design, the composition pictured illustrates the key asymmetrical construction points. Exaggerate the height. Move the central line from high center to low right. Make sure the height and length lines join at the focal point with a strong right angle. Keep more of the visual weight on the side with the extended horizontal line. Place far less visual weight on the opposite side. Insert all stems to move in and out of a central focal area. Create strong front-to-back depth through this focal area.

Blue and white vase from Three Hands, Inc., 956 Griswald Ave., San Francisco, CA 91340.

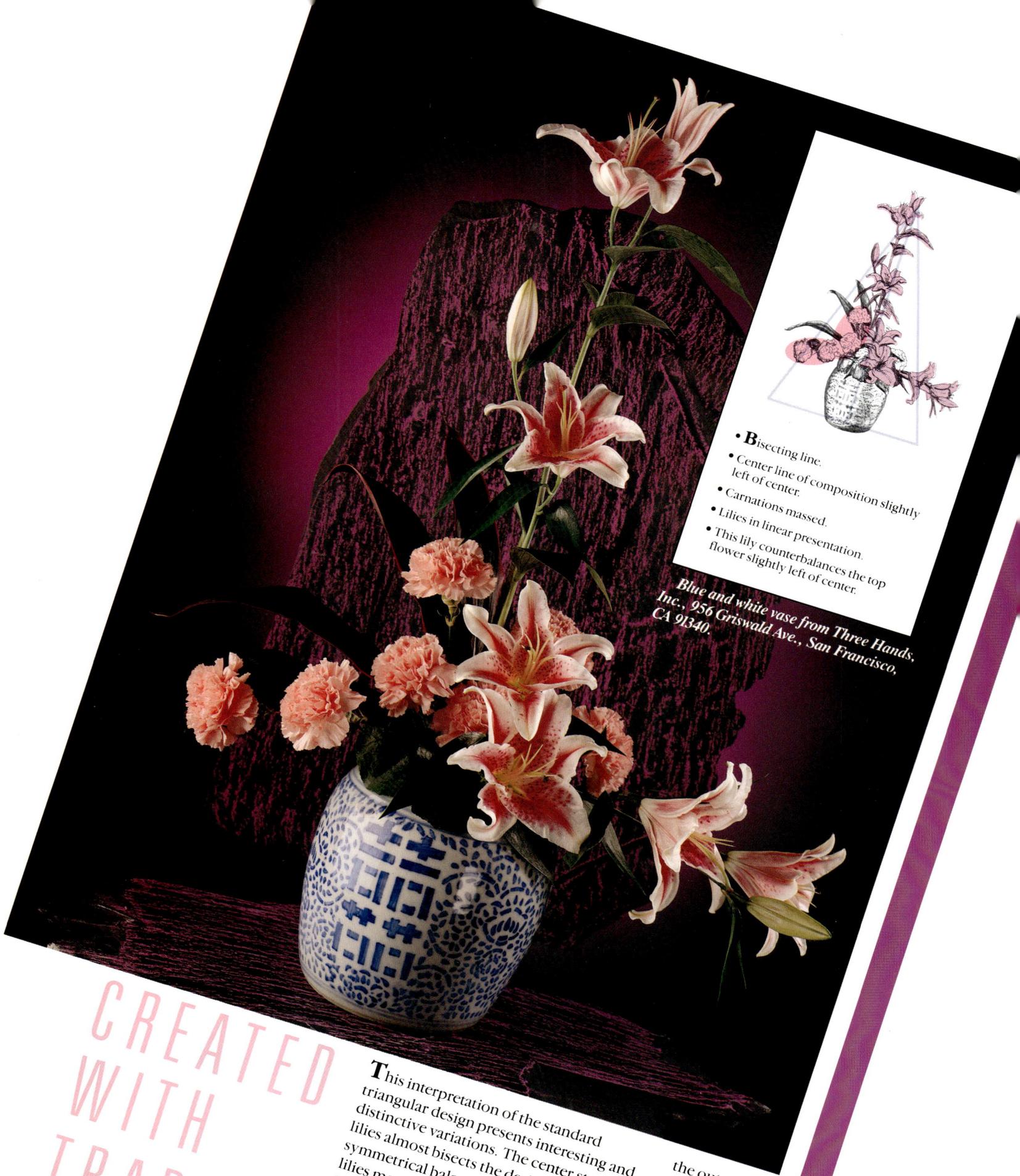

- **B**isecting line.
- Center line of composition slightly left of center.
- Carnations massed.
- Lilies in linear presentation.
- This lily counterbalances the top flower slightly left of center.

CREATED WITH TRADITIONAL STYLE

This interpretation of the standard triangular design presents interesting and distinctive variations. The center stem of lilies almost bisects the design for symmetrical balance. The center line of lilies moves slightly left of center. The lower line of lilies extends slightly beyond the outside perimeter of the triangle to counterbalance the off-center central line. These are the creative nuances that a skilled professional artist can introduce in his designs. Another distinctive technique is the line placement of the lilies contrasted with the massing of the carnations.

MAKE SHAPE THE CUTTING EDGE

Presenting shape with high style and studied sophistication gives your arrangement the cutting edge. It upgrades the look without increasing the price. This cutting edge approach to creative design starts with selecting materials of distinctive shapes. And, fashioning the composition with a flair for arrogant, creative style lifts the design into a new sphere of design excellence.

In this masterminded composition, the artist presents the lilies - the most distinctive flower form - in the dominant visual position. The form of the alstroemeria echoes the form of the lilies. So, the designer presents them in the auxiliary, lower area of the design. The carnations introduce another distinct form and resonate the orange color of the lilies. The artist places them in a strategic visual position for both emphasis and balance. Strands of variegated ivy wander away from the composition, gracefully softening the dominance of the blossoms.

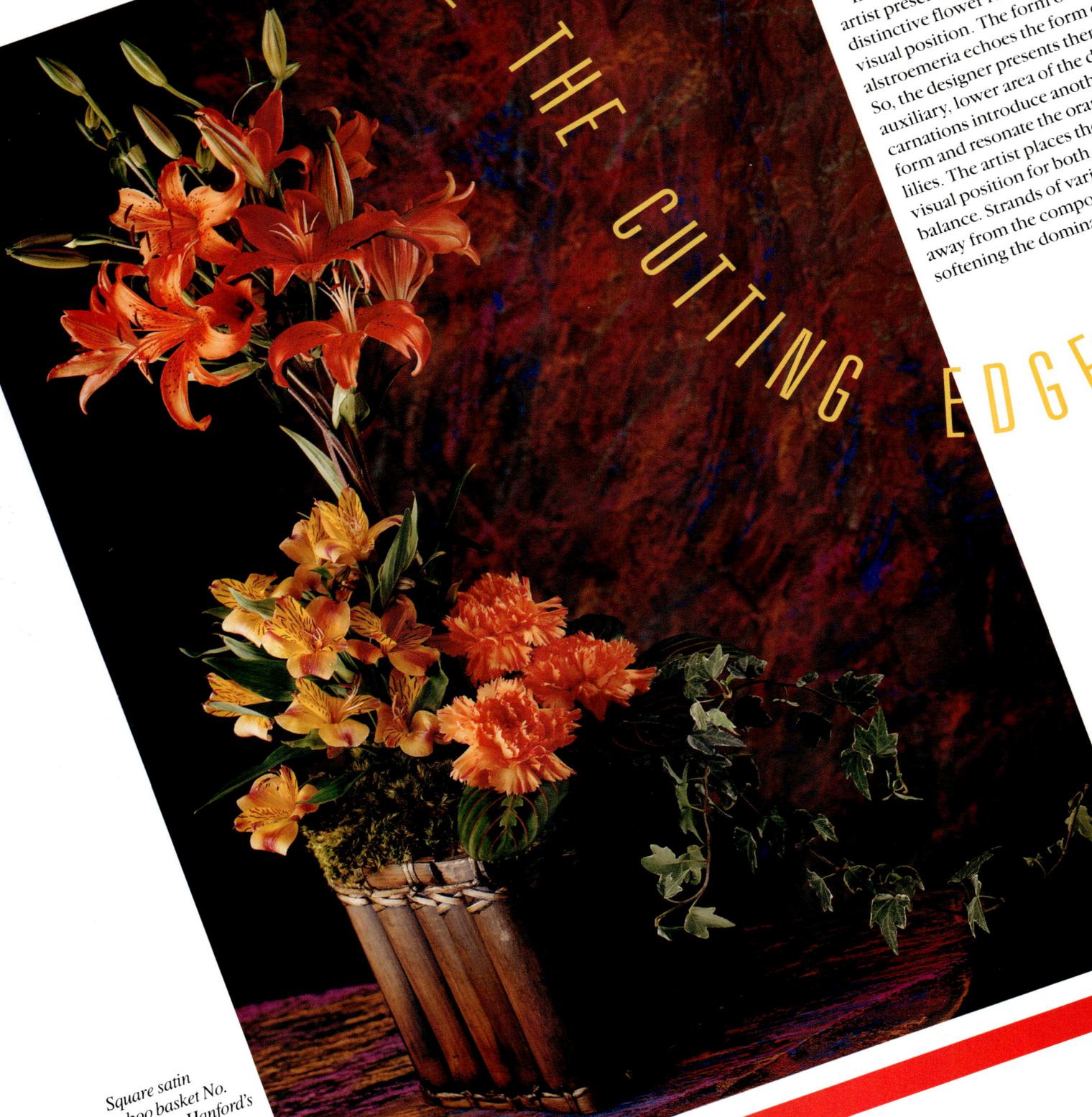

Square satin bamboo basket No. C1203 from Hanford's Floral Masters International, P.O. Box 32666, Charlotte, NC 28205. Knud Nielsen mood moss available from your local wholesaler.

A DELICATE BALANCE OF TEXTURE AND HUE

Bonsai container from a local wholesaler. Similar containers are available from Toyo Trading Co., 13000 S. Spring St., Los Angeles, CA 90061.

Richness of color. Striking contrasts in textures. Studious line movement of materials. Emphasis on tasteful and visionary design. All these characteristics of seasoned creativity make this arrangement stand out with personality and charisma.

The two bright orange strelitzia command the dominant visual position. Very often in creative design, the highest point in the composition is the most visually important. Three richly colored burgundy leucadendron counterbalance the height in a receding horizontal line. Two green ti leaves accent the height; one reinforces the length by forming a complementary color harmony with the leucadendron. The single banksia stands out with shape and texture contrast. This exquisite design is sure to command attention wherever it is sent.

217

Knowledge has little value unless you use it. Once a design concept is internalized intellectually, you must use it to develop your creative skills.

Many people talk about "pavé." Few turn their talk into design. Pavé is a design technique. When presented in a solo role, it moves to center stage and nudges for design style recognition.

Technically, pavé is a jeweler's term explaining a method for setting stones. Stones set closely together without the precious metal base showing between them identify the pavé technique. A cobblestone walk is an interpretation of the pavé technique.

The magnificent floral design pictured is an interpretation of the pavé technique. In creating this interesting composition, the artist combines roses, carnations and Sweet William with galax leaves, equisetum, clump moss, mood moss, deer moss and polished river stones.

This impressive floral monograph offers the impetus for branching into many different applications of the pavé technique. The versatility of the technique allows you to create a pavé design in any size from a small square basket to the greenhouse flat pictured - and even larger when the occasion calls for the unique and visually dramatic. And, pavé is precisely perfect for the home, the hospital, the office or as a decoration for parties and celebrations.

In creating a pavé design, present flowers, foliages and other materials in regimented patterns for an exciting, unusual composition

A FEE

AN OLD CONCEPT- A NEW LOOK

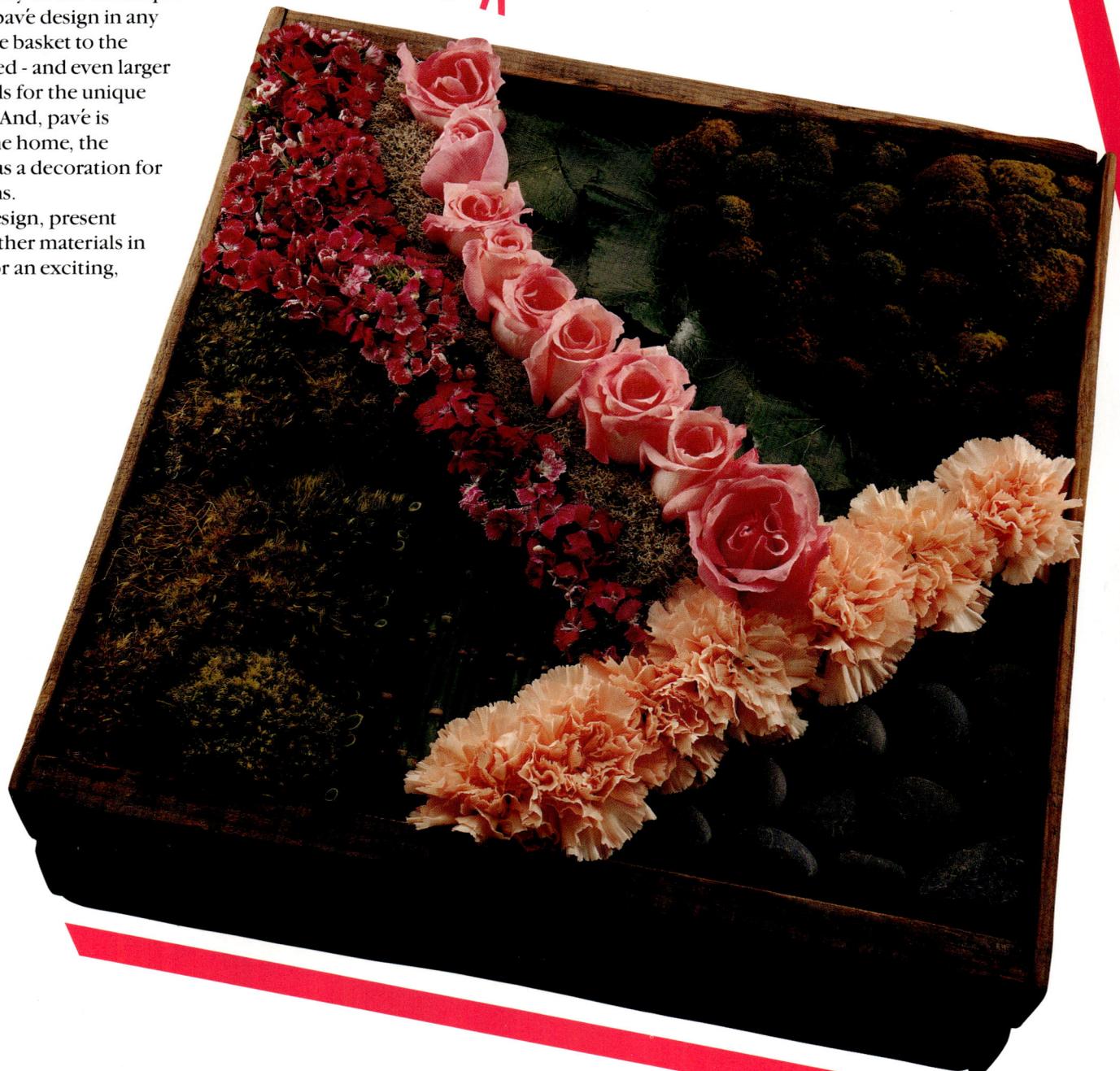

Emerge: To come forth from something • To come out into view • To become manifest

Basing is a system of grouping or clustering. As the name implies, basing is the arrangement of materials at the base of a design from which another design or grouping of materials emerges.

In its purest form, the negative space between the base and the emerging design makes the basing composition stand out with visual independence. In contemporary floral design, artists interpret basing with their own parlance. You see few forms of technically pure basing.

Use flowers, foliages, pods, mosses, stones or any materials for basing. The base must have strong visual interest and "appear to be designed." Sometimes, one group of vertical materials emerges from the base. In other compositions, different groupings of materials come forth from the base design.

The composition pictured is an interpretation of the basing technique. The design of pink carnations, white bouvardia and preserved salal leaves in the central focal area exemplifies basing. The *Dracaena warneckii* emerge from this base as do the oncidium orchids and the miniature heliconia.

Rectangular lily bowl No. L-4 from Coronet Ceramics Corp., 14520 Joanbridge, Baldwin Park, CA 91706. Oasis® floral foam available from your local wholesaler.

Basing is a technique of arranging interesting materials in a visually prominent design at the bottom of a composition. This base serves as the foundation from which other materials emerge.

A
TIMELY
IDEA
AS
OLD AS
THE PYRAMIDS

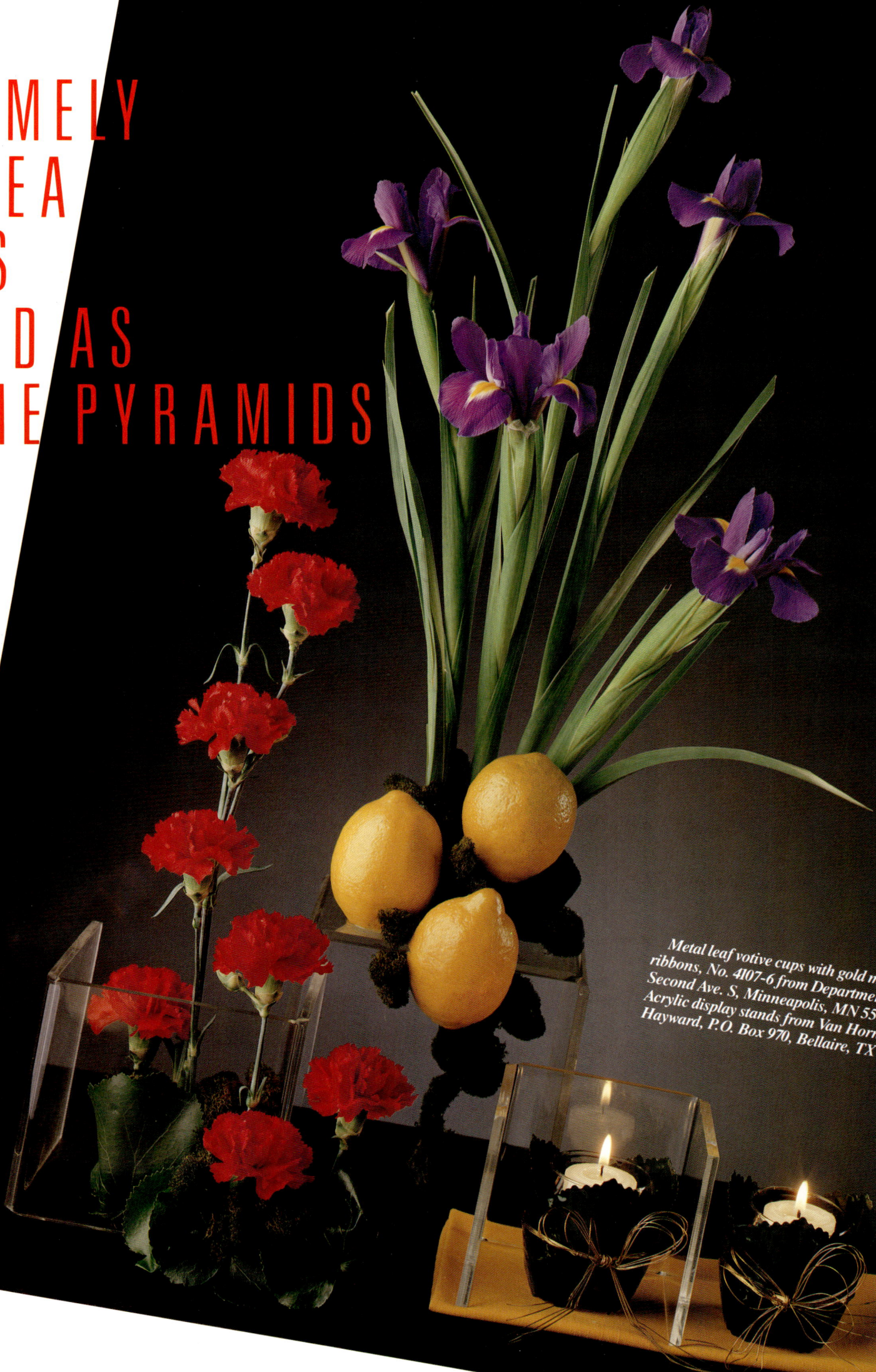

Metal leaf votive cups with gold metallic ribbons, No. 4107-6 from Department 56, 1200 Second Ave. S, Minneapolis, MN 55403. Acrylic display stands from Van Horn-Hayward, P.O. Box 970, Bellaire, TX 77401.

Designing by the numbers has a connotation of an unprofessional hobbyist's approach to floral art. This attitude overlooks the premise that often the inspiration for creative floral design is found in nature.

The Fibonacci Series

In the early 13th century, Leonardo da Pisa (Leonardo Fibonacci), the greatest medieval European mathematician, developed the Fibonacci series. By studying nature, Fibonacci discovered that a progression of numbers revealed the secret to much of nature's structural design, particularly in the field of botany. The seeds of pine cones, pineapples, dandelions, daisies, sunflowers and many other plants appear in an orderly pattern of progressive numbers. Count the leaves on a stem, starting at the bottom. When you reach one that is directly over the one you started with, it will be one of Fibonacci's numbers.

The Fibonacci series is a progression of numbers that runs as follows: 1, 1, 2, 3, 5, 8, 13, 21, 34, 55, 89, 144, and so on, with each number being the sum of the two numbers preceding it.

Follow this explanation and you will understand what Fibonacci is all about. Start with the number 1. 1 + 1 = 2. The last two numbers in this sequence are 1 and 2. Add these two numbers together for the next progression. 1 + 2 = 3. The last two numbers in this sequence are 2 and 3. Add these two together for the next progression. 2 + 3 = 5. Follow this same pattern for as many progressions as you want to develop: 3 + 5 = 8. 5 + 8 = 13. 8 + 13 = 21. Add together the last two numbers in any sequence to arrive at the next number in the progression.

Application To Floral Design

Perhaps you are saying, "I am an artist, not a mathematician. What does the Fibonacci series have to do with professional floral design?"

There is need in all forms of art to bring order to a composition. The Fibonacci series is a method of organization. As a professional floral artist, you must understand two aspects of creative order.

First is the visual, mechanical order. Even though we might fight organization to protect our disorderly working styles, we all feel better when things are in visual order. A designer can stand a messy design bench only so long. Then, he must clean up the mess and get it organized. The designer feels better when he accomplishes this process of bringing things back to order. Supposedly, a disorderly desk is the mark of a creative

individual. Even the most creative person has to bring his desk back to order occasionally. When he completes this ordering, he looks upon his work differently. We all have a need for some order in our lives.

The psychological, subliminal need for order is an important part of perception. Without ever realizing what is going on within us, we seek order and organization. Therefore, when we find things that are organized we feel better. We are more comfortable.

The Fibonacci Design

The Fibonacci series provides an important method of selecting materials for a composition. An artist knowledgeable about the value of the Fibonacci series would select materials for a floral design following the Fibonacci progression. One stem of delphinium, one rose and two carnations. (1 + 1 = 2). Then, he might select one gerbera, two ornithogalum and three tulips. (1 + 2 = 3). The important point is that he selects materials with some sense of progressive order. When the viewer sees the design, even if the similar blossoms are not in distinct groupings, his mind registers order and organization.

Fibonacci Decorations

Another important application of the Fibonacci series is in bringing visual and psychological order to decorations. The table arrangement pictured represents a design created with the Fibonacci progression of numbers. Follow the pattern the artist uses in interpreting the Fibonacci series in this composition.

Across the base of the design you see two single votives and then two red carnations.

Next, one votive, two red carnations and three lemons.

1 + 2 = 3

Then two red carnations, three lemons and five iris.

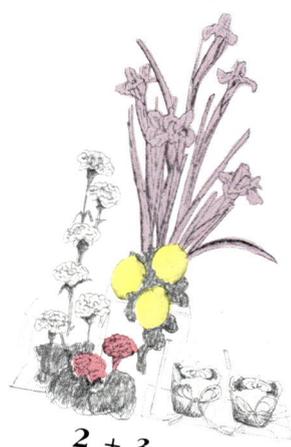

2 + 3 = 5

Finally, three lemons, five iris and eight red carnations.

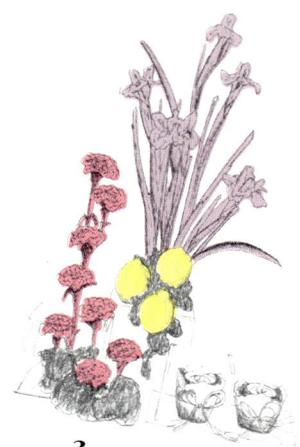

3 + 5 = 8

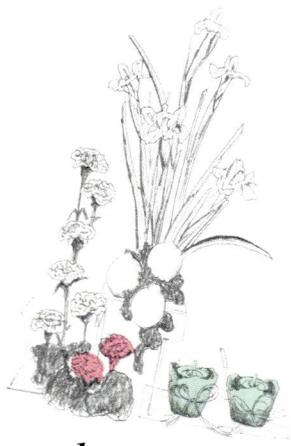

1 + 1 = 2

This composition illustrates a contemporary approach to the Fibonacci series. Don't be mislead thinking that it applies only to contemporary design. Fibonacci number progression is a theory. It applies to any type of design when you want to bring creative order to the presentation.

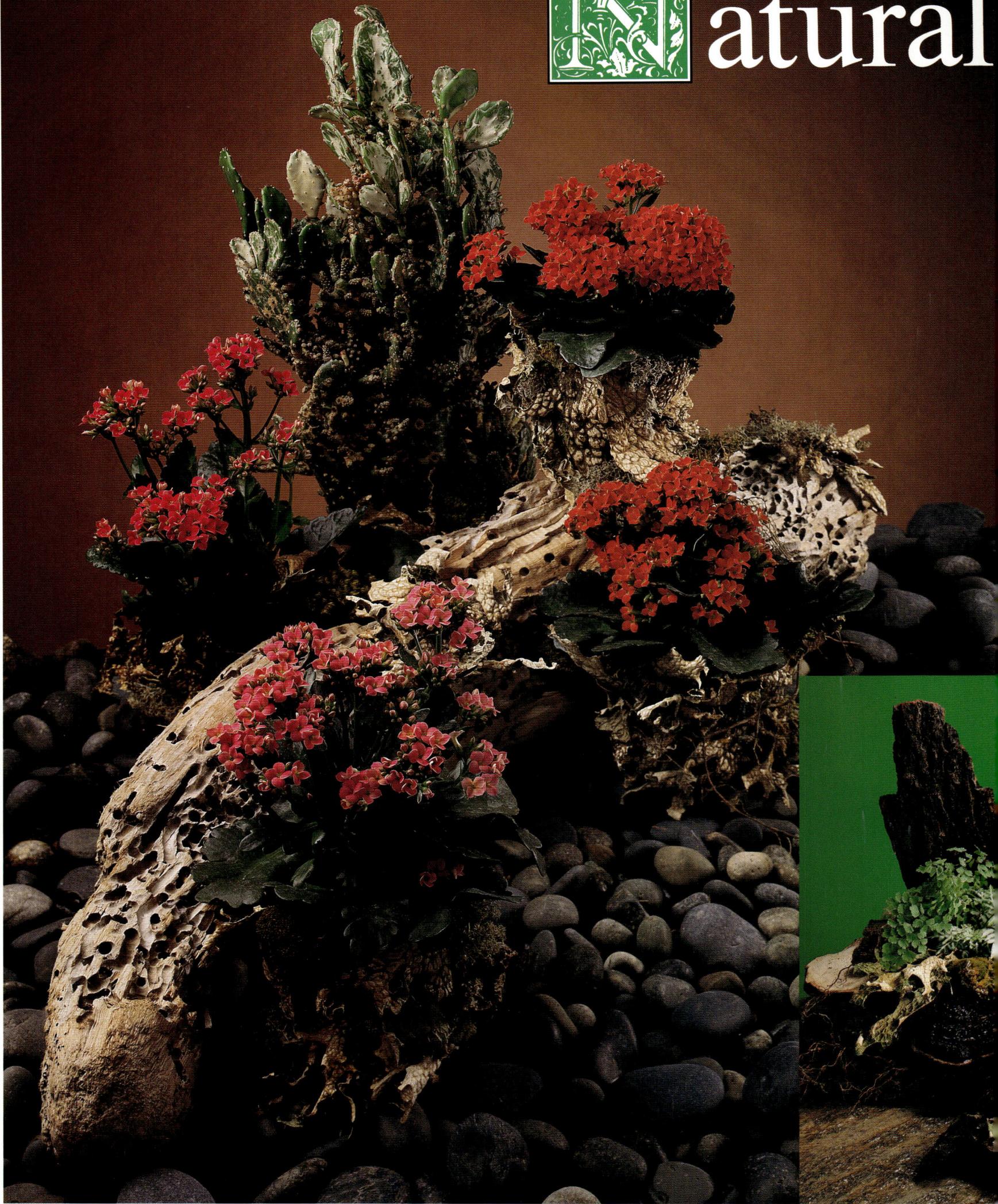

Inspiration

The wonderful beauty of nature is often overlooked in professional floral design.

Sometimes, we get so focused on flowers that we miss all the magnificent creative possibilities that native plant materials provide.

The composition featuring the maidenhair, terrace and rock ferns includes an interesting assortment of tree conks, hemlock bark, roots, old man's beard lichen, chartreuse lichen, grey-black lichen, foliose lichen and clump moss. This impressive design combines wonderful forms and textures.

A natural teredowood chunk provides the setting for the composition featuring the kalanchoe and cactus plants. The artist attached the potted plants to the teredowood chunk with wire and hot glue and then covered them with heavy moss so they could be watered.

The basket for the sarracenia design is Nouvette's No. P599 vine bird's nest hanging basket, available from your local wholesaler. After lining the basket with heavy plastic sheeting, the artist placed a piece of saturated flower foam in the center to hold the sarracenia. Then, he positioned 4-inch fern plants around the foam before arranging the pitcher plant blossoms. Mosses and roots add the finishing touches of nature to the composition.

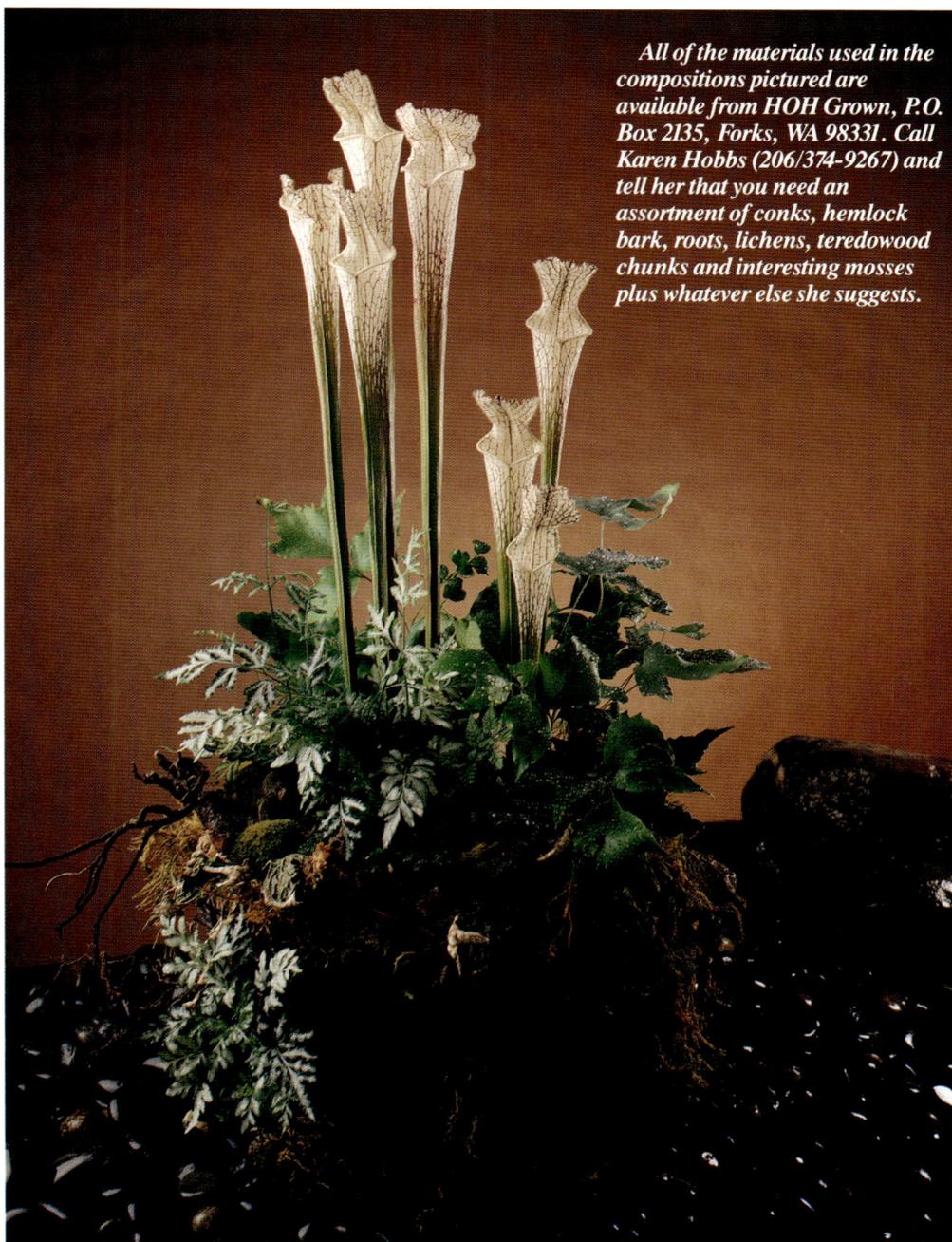

All of the materials used in the compositions pictured are available from HOH Grown, P.O. Box 2135, Forks, WA 98331. Call Karen Hobbs (206/374-9267) and tell her that you need an assortment of conks, hemlock bark, roots, lichens, teredowood chunks and interesting mosses plus whatever else she suggests.

Designing With Nature

Create a DECORATION theme

The practiced eye of a professional floral artist makes all the difference when the charge is to create a sensational silk composition. A silk flower design must either move into an established decoration theme, or set one. Wherever silk flowers decorate, they communicate a personality and suggest a lifestyle.

This presentation demands attention. The unique qualities of the materials hold visual interest. And, the composition exhibits a disciplined approach to contemporary design.

The basket style suggests materials associated with the desert. There's no hesitation about color. The muted lavender, peach and natural tones of the basket are an unexpected diversion for the flame-red silk tree cacti. The scarcity of the desert reverberates in the keen use of materials. The artist avoids declaring a central focal point in the center of the basket. And, the river roots repeat the texture of the basket with a softer, extemporaneous line accent.

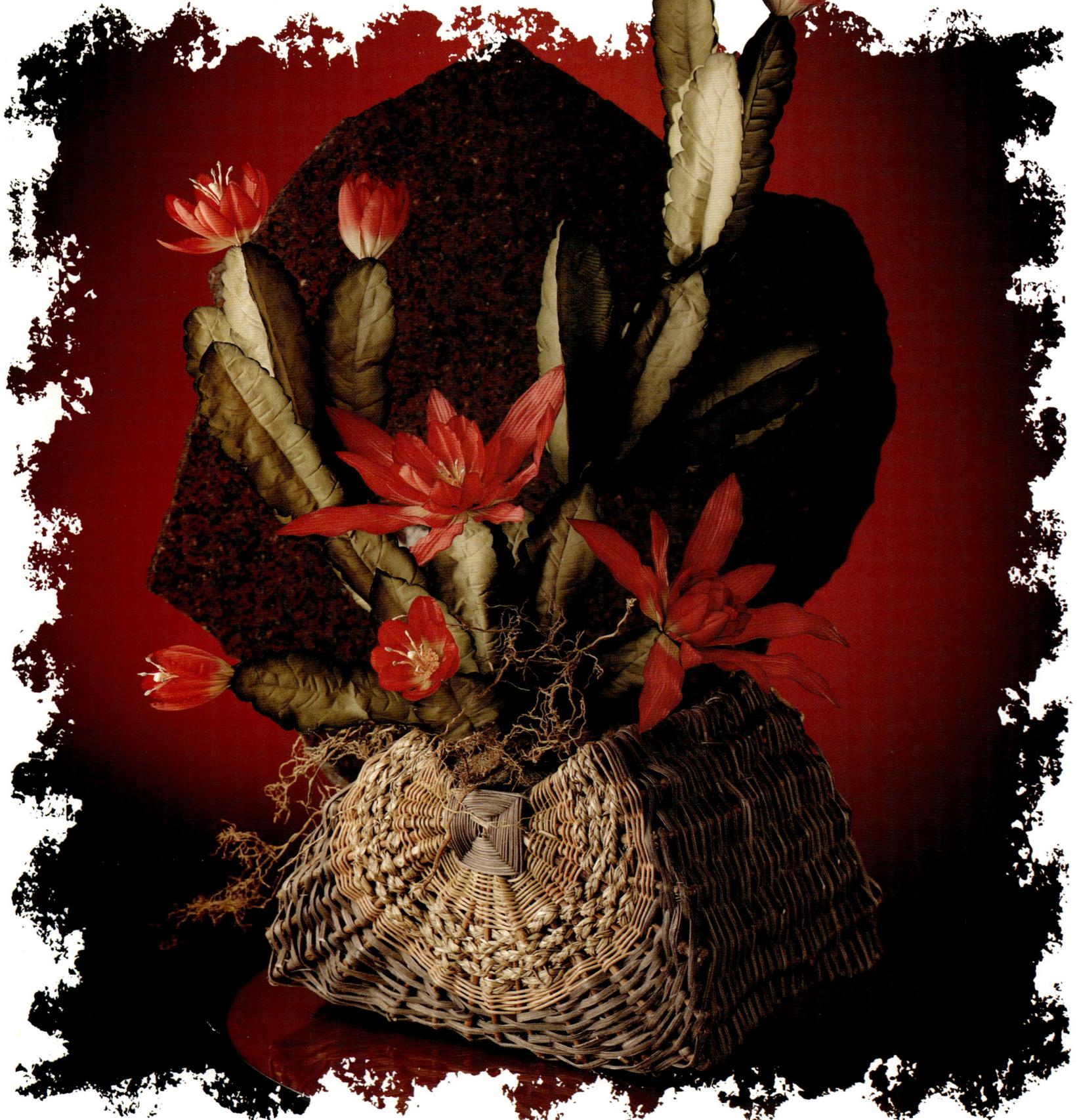

Mediterranean lily No. 935 and crown imperial No. 960 from Dark's Silk Flowers, PO Box 8621, Ft. Worth, TX 76214. Ceramic container from LA Floral Supply, 818 S. Wall St., Los Angeles, CA 90014.

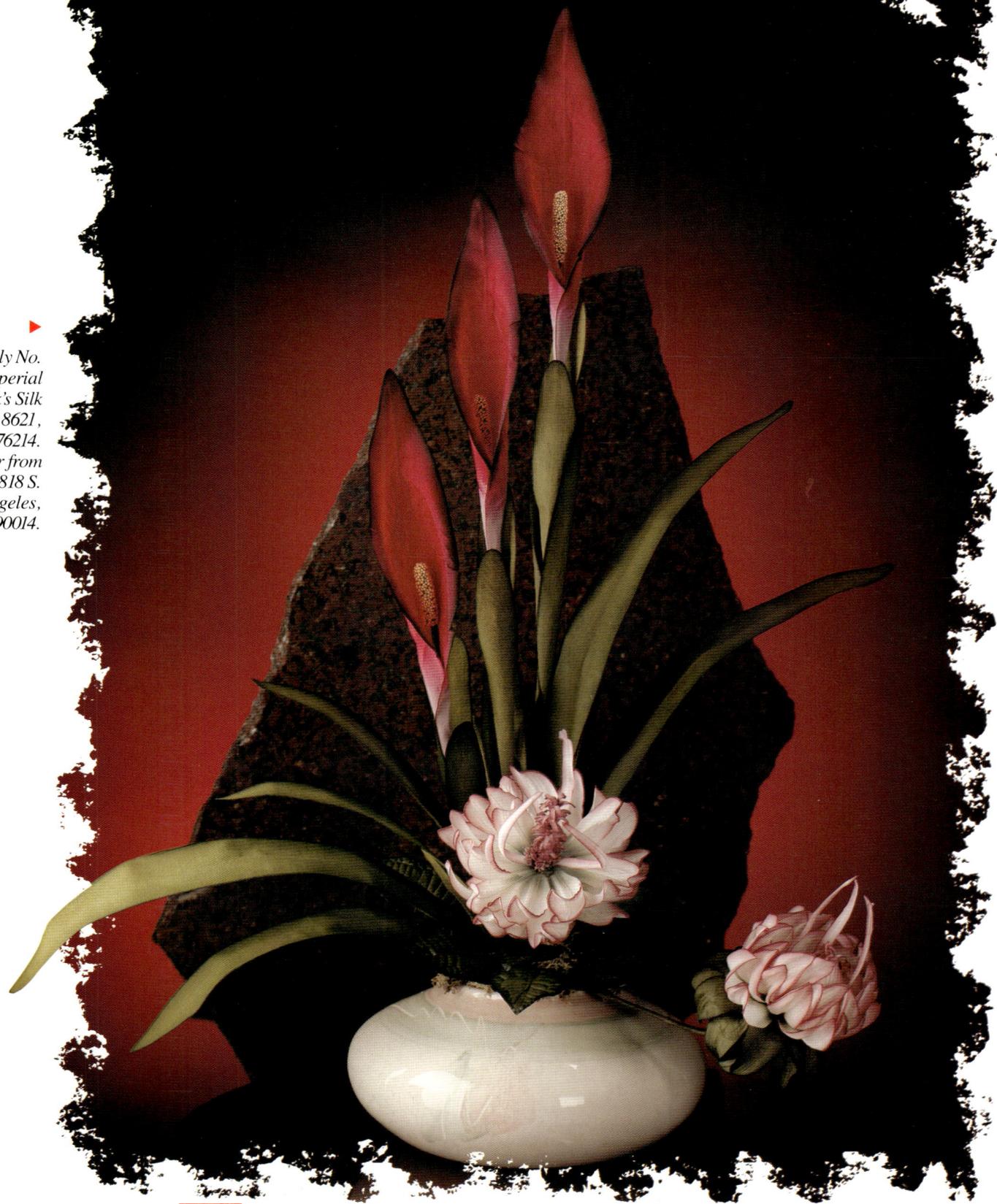

Villa basket, No. V20 from K & D Export Import Co. 225 Fifth Ave., New York, NY 10010. Large tree cactus No. 502 and tree cactus No. 501 from Dark's Silk Flowers, PO Box 8621, Ft. Worth, TX 76124. Root from HOH Grown. Sahara II® dry foam and Knud Nielsen deer moss available from your local wholesaler.

A new season of creativity lives and flourishes with the debut of this special collection of silk flower arrangements. The designs are original and exclusive. And, you can interpret them into your own style and for your own customers. With this exciting selection of silk materials, your imagination can grow stronger and more vigorous.

This spirited composition with Mediterranean lilies and crown imperials conveys a formal yet avant-garde approach to creative expression. Dynamic, youthful design. Spirited, energetic color. Impeccable sensitivity in use of materials.

And, the faultless craftsmanship of an accomplished floral artist.

Follow the artist's perspective for presenting materials. The three Mediterranean lilies move in stately, regimented order. They cautiously radiate towards the central focal area allowing the feeling of distinct parallel lines. One crown imperial declares the focal point without timidity, but does not smother the rim of the container. The placement of the second crown imperial counterbalances the tallest lily. Even the foliages reflect studied precision - two leaves on the right, four on the left.

Silk Flowers

The SEARCH for TIMELESS

Glass vase on stand, No. 37-7026 from Toyo Trading Co., 13000 S. Spring St., Los Angeles, CA 90061. Silk royal princess lily No. R546 and silk wandering Jew No. E765 from Supersilk, 1967 S. Third W., Salt Lake City, UT 84115.

Timeless design reflects a style that transcends all fads and trends. It is comfortable everywhere. It does not bore. Nor does it intrude. Timeless design is a combination of many styles interpreted in different forms.

This delightful composition of silk rubrum lilies, in a well chosen glazed glass vase with a patina-finished metal stand, is an excellent example of timeless design. It has the comfortable contemporary feel of today, yet it reflects traditional refinement.

The design style is uncomplicated. Each material makes a distinctive statement about its color, form and quality. The vertical line softly spirits the composition with impressive line movement. Foliages with exaggerated contrast in size and color flow into and out of the composition with relaxed, suave composure.

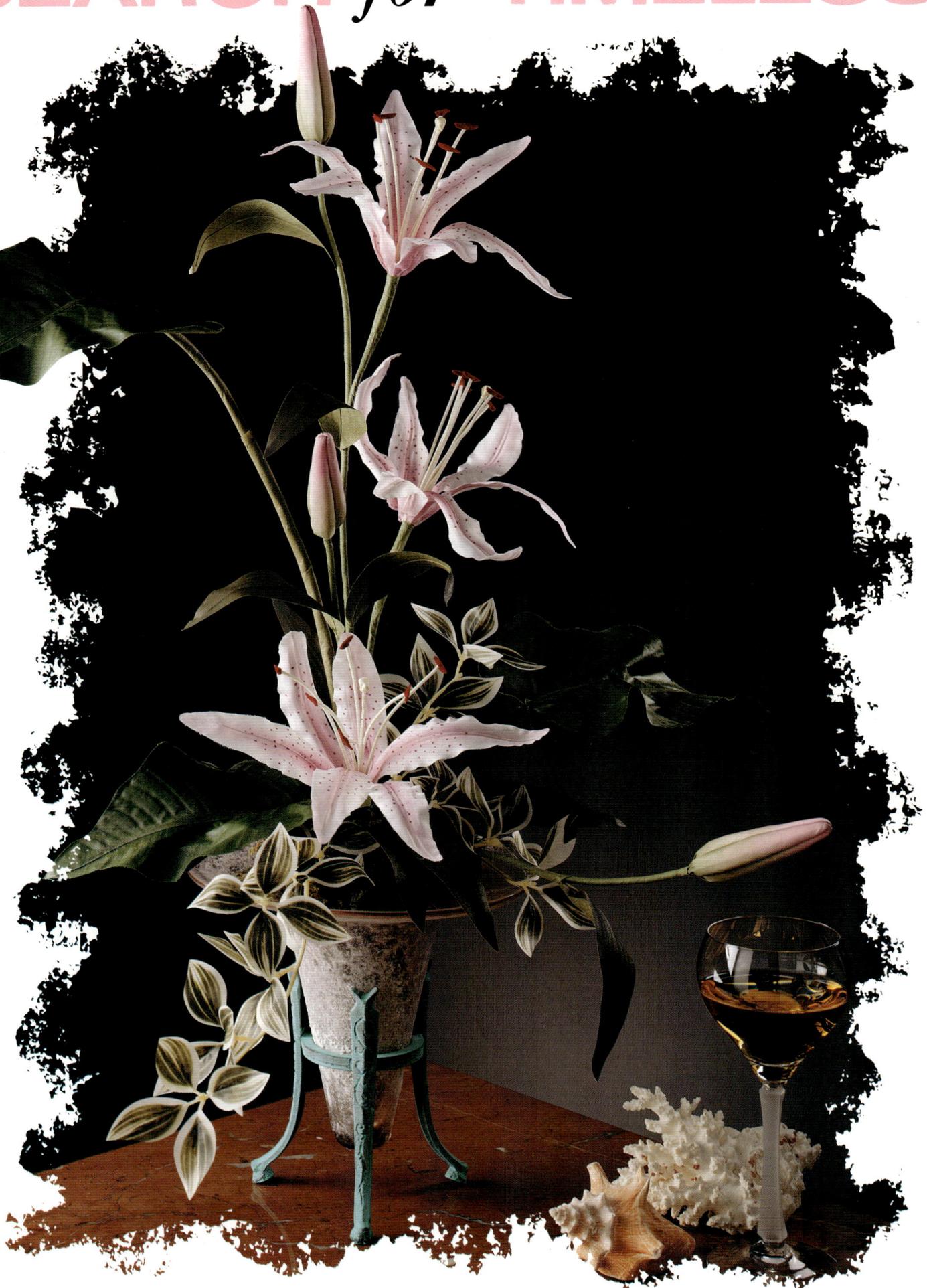

design

Linear movement combined with circular movement gives a design perception of motion. Contrasting line movement creates opposition. In any work of art, opposition produces visual energy.

This eloquent design communicates visual energy. The linear presentation of the leucadendron causes static visual energy. The curving lines of the grape roots activate dynamic energy. In achieving this flow of visual energy, the leucadendron establish the dominant line energy. The grape roots, wild mountain berries and swamp berries introduce the secondary line energy. In all interesting, visually exciting, creative art, there is always an interplay between advancing and receding characteristics.

Extra large lily bowl No. L-6 from Coronet Ceramics, 14520 Joanbridge, Baldwin Park, CA 91706. Silk leucadendron No. R534, wild mountain berry No. P240 and swamp berry No. P241 from Supersilk, 1967 S. Third W., Salt Lake City, UT 84115. Roots from HOH Grown.

Design in MOTION

Imaginative.
Individual.

That's Creati

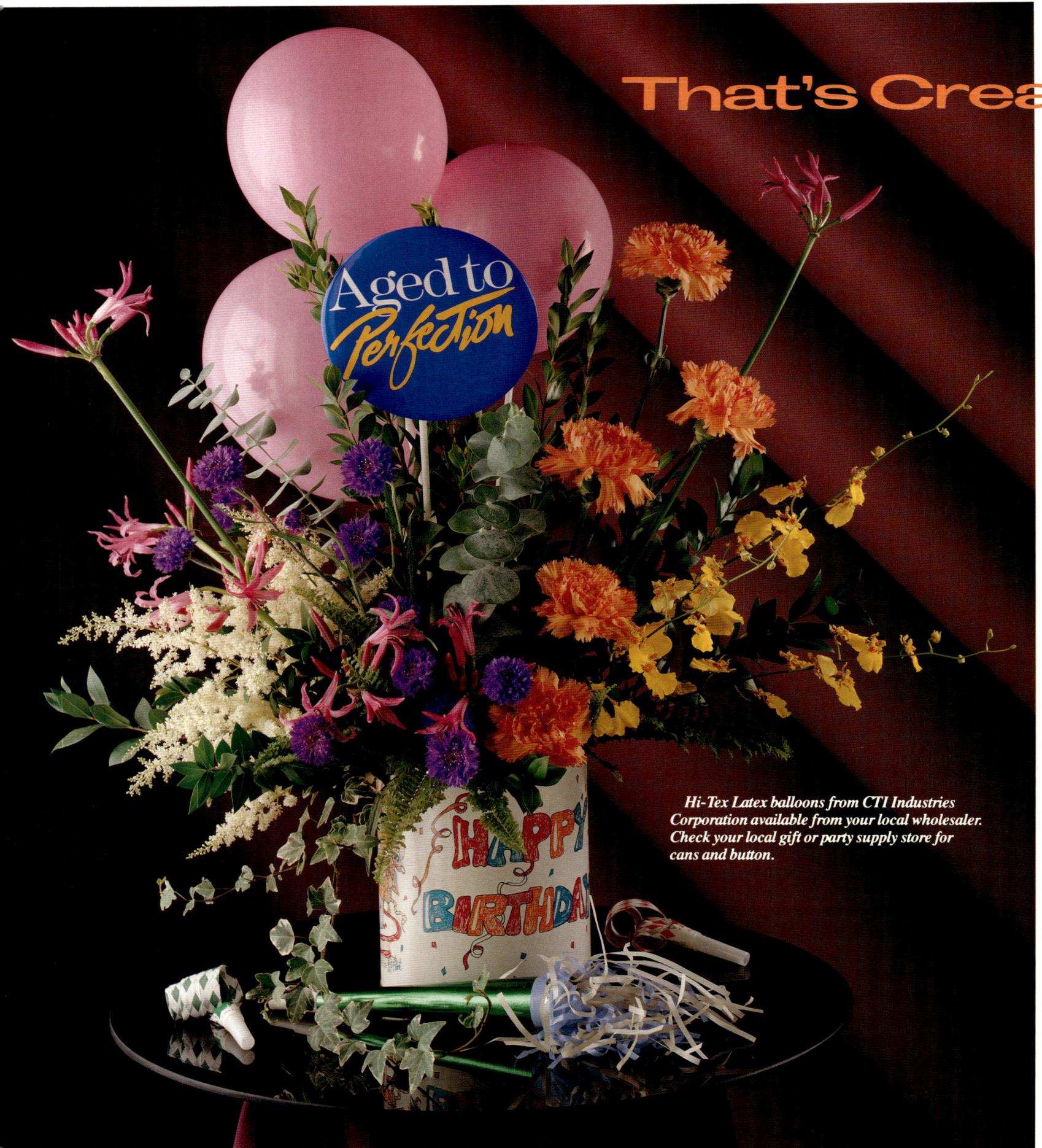

Hi-Tex Latex balloons from CTI Industries Corporation available from your local wholesaler. Check your local gift or party supply store for cans and button.

Creativity is spontaneity.
Letting go.
Celebrating your imagination.

When you have an opportunity to sell flowers for a special birthday, or a birthday for a special person, blast off with all the imaginative, individual creativity you can muster. Creative genius is stretching yourself beyond what is expected.

e Genius.

The container for this celebrating arrangement is a can that gift stores sell to package gifts. The can comes without a label so you have the flexibility of a label for many different occasions. The ''Aged To Perfection'' button is available in many card/gift shops.

Creativity is more than a particular look or style of design. Sometimes it's letting go. Spontaneity. Celebrating your creative talent. The flowers and style of design aren't the point of the design pictured. It's about unleashing a flamboyant approach to design when flamboyance is what the customer needs to send.

Blow Up Your Imagination

Here's a great idea that takes a little bit of hot air and lots of imagination. This entire grape cluster is fashioned with inexpensive latex balloons.

Inflate ten or more Hi-Tex, depending on the size of the grape cluster you want to fabricate. There should be a slight gradation in the size of the balloons. In the grape cluster pictured, the balloons are only slightly inflated to sizes similar to oranges. Anchor the balloons to a kiwi or grapevine in a grape-like cluster. Attach silk grape leaves. Color mist the leaves with Design Master color spray in the appropriate color to complement the color of your grape cluster.

A *great, novel idea.*
Create it in a table-top size or in a gigantic wall decoration.

Accent the grape cluster with fresh flowers. In this composition the freesia are in water tubes.

The ball candles are a new item from Creative Candles.

CTI Hi-Tex latex balloons available from your local wholesaler. Dried kiwi vine from Natural Selections, 1400 McCallie Ave., Chattanooga, TN 37404. Ball candles from Creative Candles, PO Box 19514, Kansas City, MO 64141.

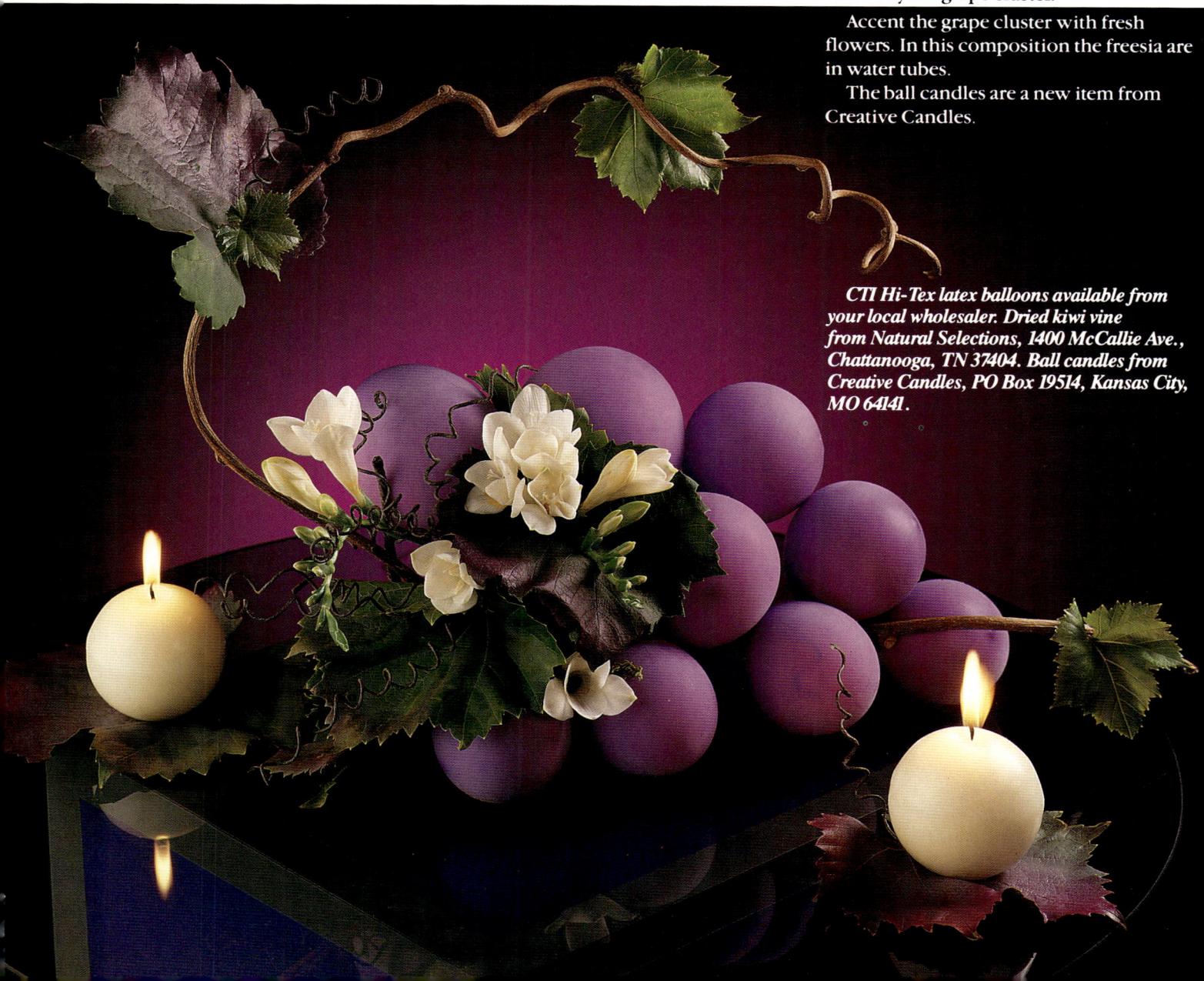

Brilliant Design Ideas

Novelty Design At Its Very Best

Often, quality, creative novelty designs are difficult because the overpowering containers defy creativity. Here's the exception. These unobtrusive novelties are quality, smart and the very best for creative design. They make a statement, but they do not overpower the beauty of the flowers.

The terra cotta duck and dove are two from sets of six each of the birds. Bouvardia and horsetail foliage in the dove figure creates a quality, distinctive novelty look. The duck figure is enhanced with carnations to complete the contour of the body. Note the moss detail and foliage bows around the necks of the figures.

The pottery basket is the perfect decoration for a kitchen shower. And, it's an appropriate gift going to any country-influenced home.

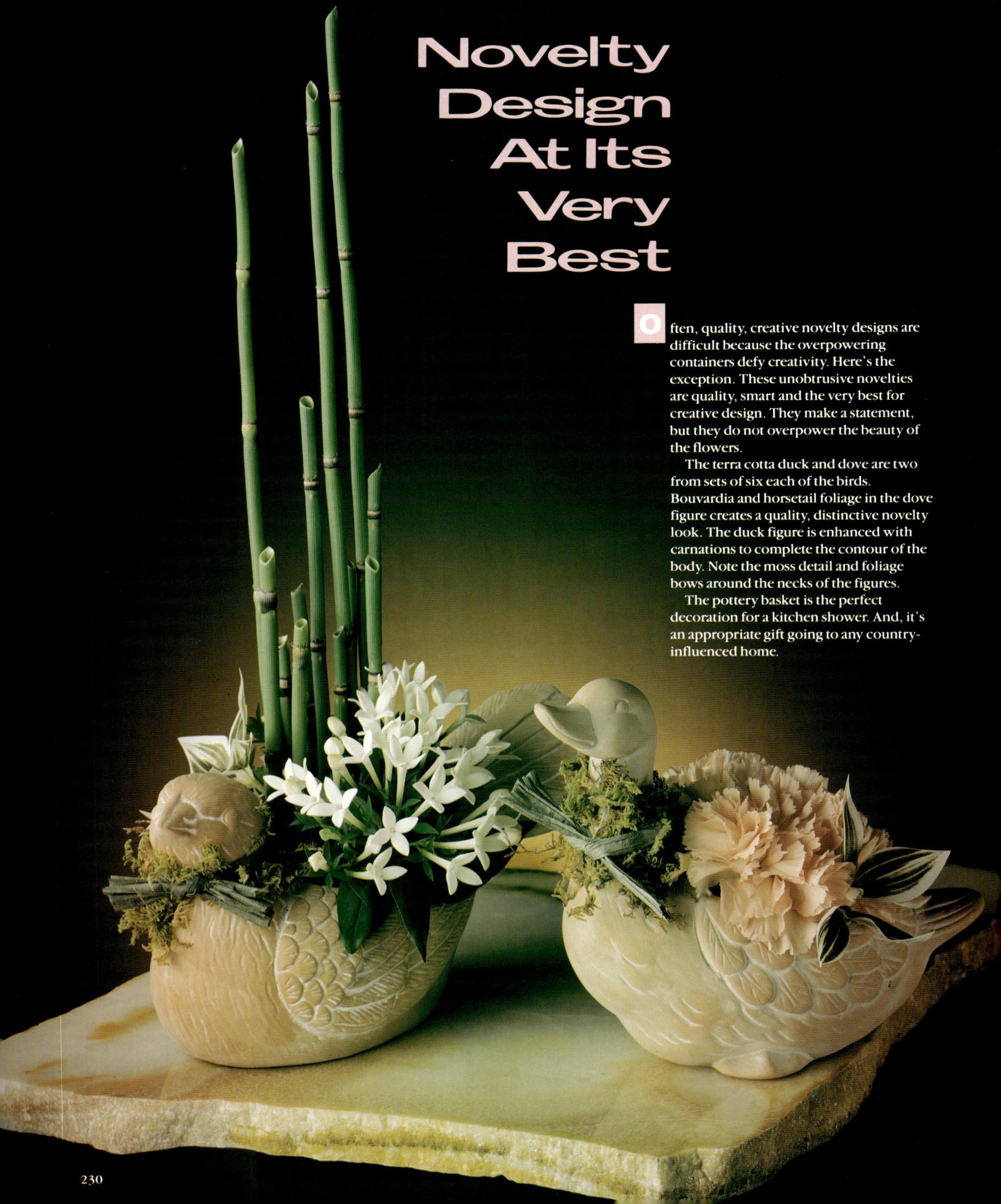

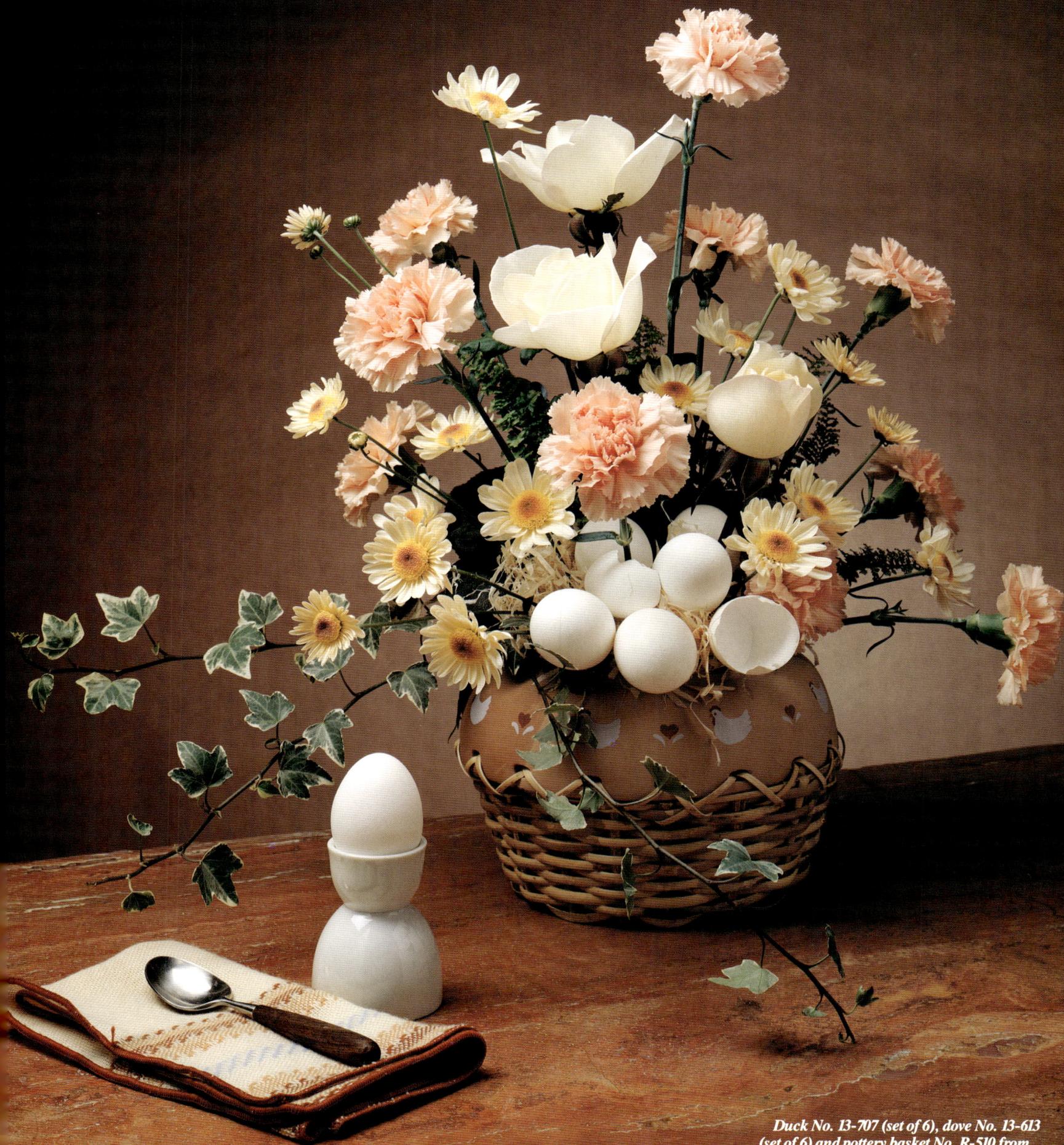

Duck No. 13-707 (set of 6), dove No. 13-613 (set of 6) and pottery basket No. R-510 from Davidson-Uphoff, Inc., PO Box 184, Clarendon Hills, IL 60514.

Dramatize.
Glamorize.
Tantalize.
Merchandise.

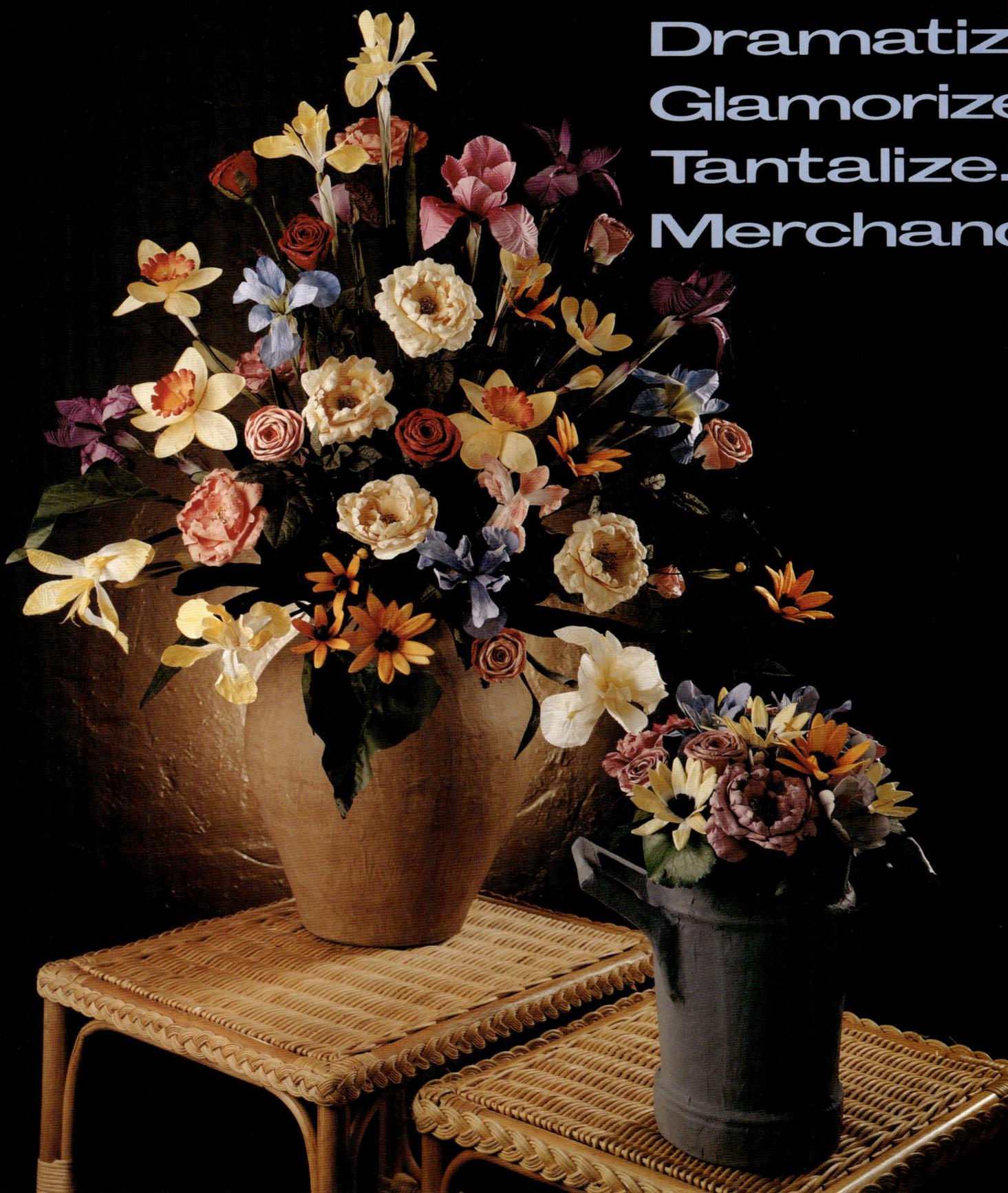

Brown urn No. P1518, flower pail No. P1511, paper flower crocus No. B1276, iris No. B1275, open rose No. B1190, rose No. B1191, black-eyed Susan No. B1270, German iris No. B1196 and daffodils No. B1273 from Hanford's Floral Masters International. Call them at 800-447-4040 and ask for customer service to receive complete information regarding the color selection in paper flowers.

V **isual Presentation** *is the art of making your merchandise so desirable that it creates the appetite to buy.*

The visual presentation of these two new products commands attention, develops interest, and creates a desire to buy.

The paper mache containers are fabulous for paper flowers and dried materials. The urn is excellent for commercial interior work. More appropriate for homes, the handled container is a convenient size for many styles of creative floral designs.

Paper flowers are a popular new look. The muted colors of the paper flowers pictured give an impression of a rich, Old World composition. The flower forms are marvelous and work beautifully in a mass composition or in line design.

Pyramid basket with handle No. P1503 from Hanford's Floral Masters International. Silk brussel sprouts No. K2250 in green, cabbage No. K2239 in peach, celery No. K2235 in green and artichoke No. K2233 in green from K & D Export Import Co., 225 Fifth Ave., New York, NY 10010. Dried kiwi vine from Natural Selections. Nouvette silk needlepoint ivy No. LH1029 and large leaf ivy No. LH208 available from your local wholesaler.

Some designs challenge definition. They refuse to be boxed in and labeled. They are comfortable in any home.

This intriguing basket design with silk vegetables is one of those congenial compositions. The detailing of the design style makes it eclectic.

The strategic placement of the vegetables in this design is the key design style. The peach cabbages create the important front-to-back depth dimension. Celery establishes the vertical height on the left. Brussel sprouts echo this vertical line on the right. The artichokes unify the composition - two clustered to the right, one in the back left receding position, and one glued at the left base of the basket to bring the basket into the complete composition.

Contemporary.
Traditional.
Transitional.

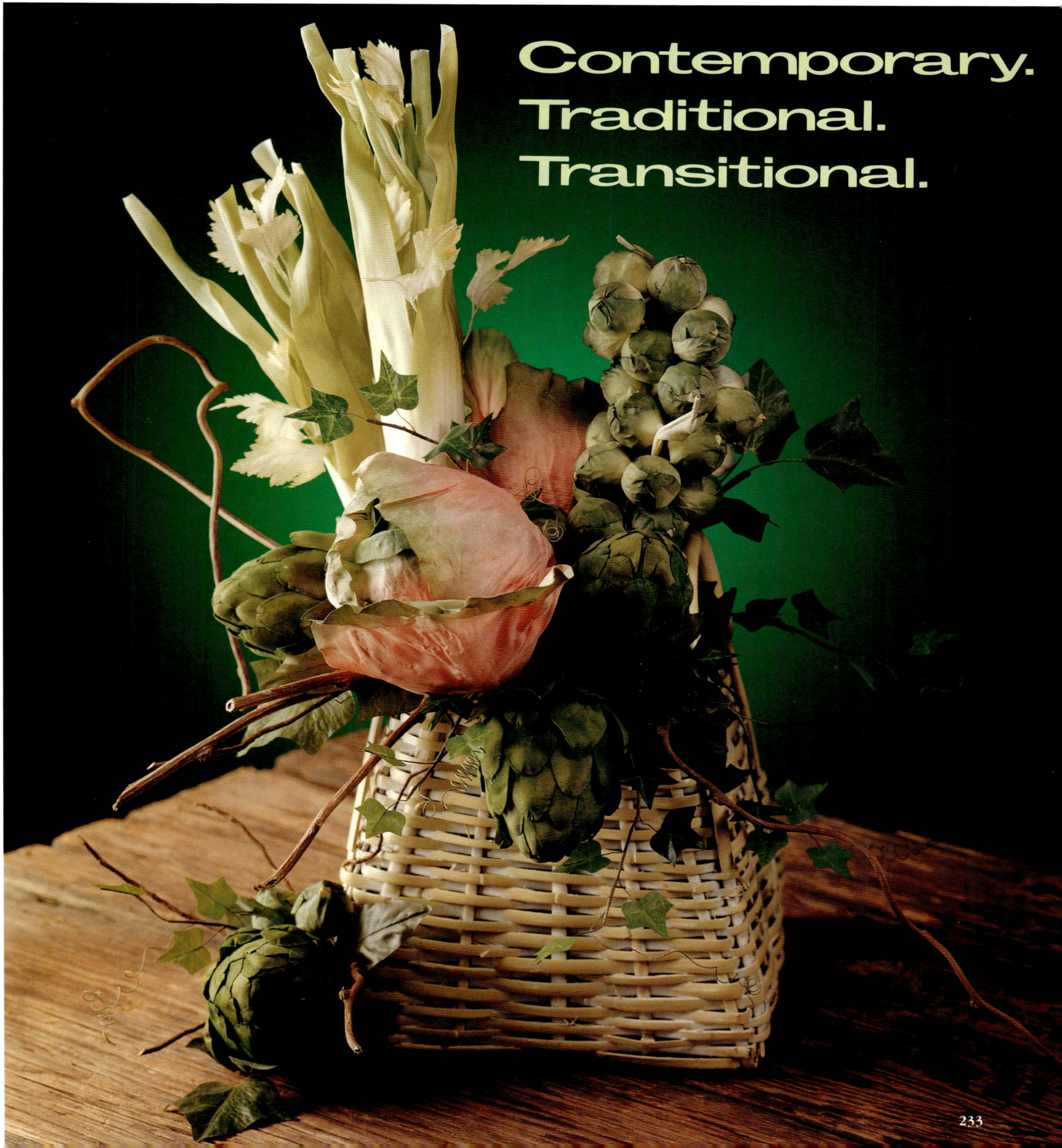

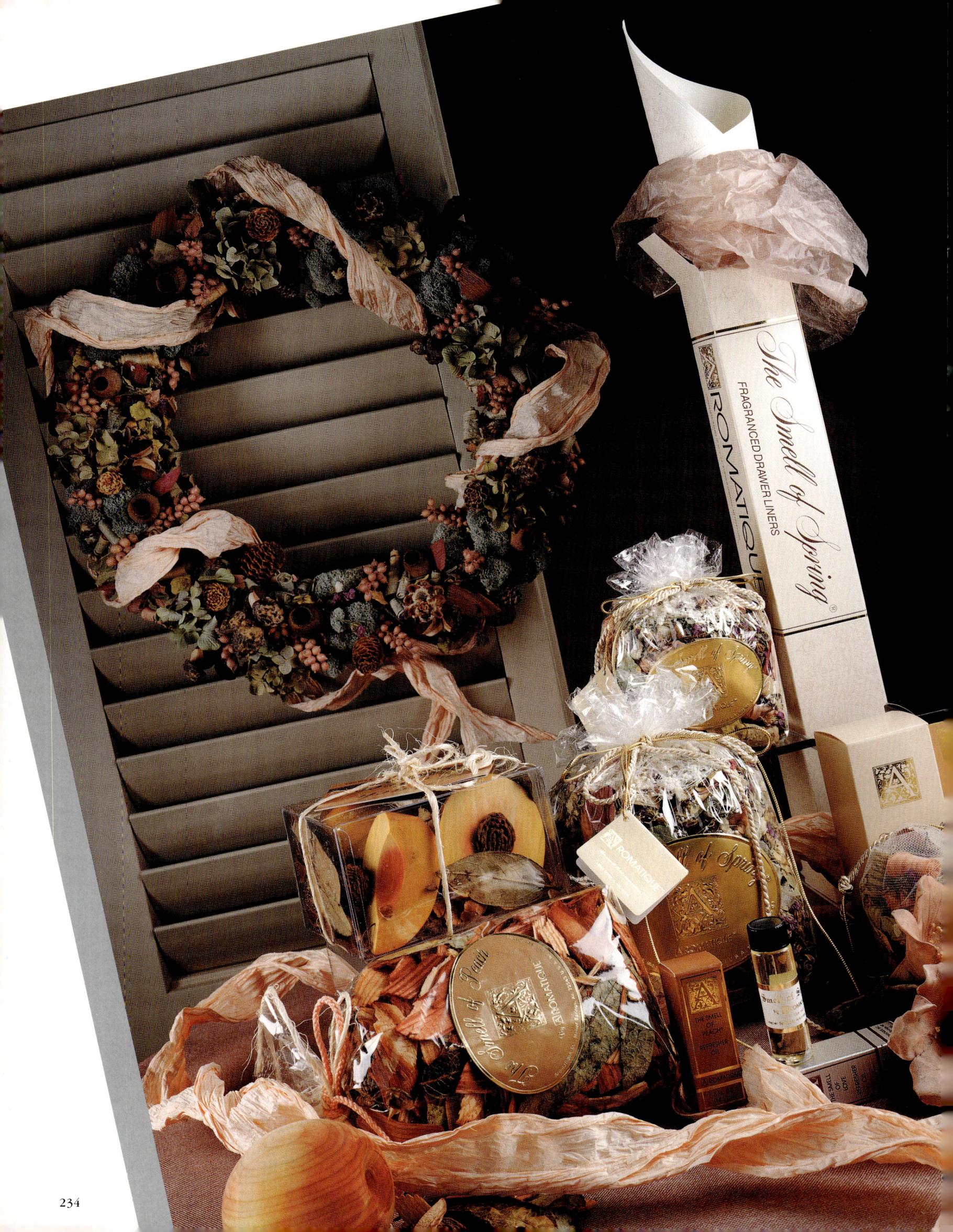

STATEMENT!

Present your merchandise so interest is turned immediately into action...so desire is changed to fulfillment...so the customer decides to buy...so the end result is buying satisfaction.

If you've ever made a presentation to an audience, you know what product presentation is all about. It's about the butterflies in your stomach, the dryness of your mouth, and the tightness in your throat as you nervously wait to speak.

It's about all those people looking at you—staring at you—with their eyes seemingly filled with questions about your ideas as well as your ability.

It's about the audience's probable reaction to your presentation. Will they like you? Accept your ideas? Buy into what you are saying? Talk positively about you when they leave?

Product presentation is commercial communication. There is one important difference. When you give a talk, you might have 30 minutes to convince the listeners. In product presentation, you have 30 seconds. For your product presentation to sell, it must create attention, capture interest, inspire desire and motivate buying action ... and quickly!

The merchandise you want the customer to buy must have basic appeal to the potential buyer. This process of matching up what you are selling to the potential buyer's likes and dislikes has little to do with the persuasive effectiveness of your merchandise presentation. If your customer mentally agrees that your merchandise is desirable, the visual presentation is on the same wave-length with this potential buyer. Then, how you present your merchandise, the interest you create with your visual presentation, does make a tremendous difference in whether the customer buys and how much she buys.

Once your product presentation captures interest, you want it to get that potential buyer engrossed and involved. This is the attention step. Unless the way you present your products captures the customer's attention, she won't seriously consider your merchandise. And, if she doesn't get serious, she won't buy.

Attention, interest and then decision. The decision the customer must make is, "I need it," or "I want it." The customer visualizes the merchandise moving from your store into whatever circumstances she chooses. If the purchase is for self, the customer must anticipate the enjoyment she'll experience from owning it. If the purchase is a gift, then the buyer must visualize the positive response she'll receive from this recipient. All purchases are made to gain and enjoy benefits.

Finally, action. A visual presentation must motivate the customer to act—to buy. This action step might take assistance from a salesperson. Ideally the visual presentation makes the merchandise so enticing, the customer perceives the benefits and makes the buying decision on her own.

The fabulous, engaging presentation of Aromatique potpourri and fragrance products pictured is an excellent example of product presentation. The artist created the wreath on a Knud Nielsen wreath form with potpourri and dried materials. This wreath adds another possible sale to this visual presentation. The Smell of Spring and other decorative fragrance products in the presentation are available from Aromatique, Inc., P.O. Box 309, Heber Springs, AR 72543. Knud Nielsen wreath form and dried flowers available from your local wholesaler.

Presenting Your Products

This feature is about stretching. About reaching out and doing things differently. It's about risking and looking for ways to make your flower shop stand out so people will come to see what is going on.

Are you looking at the merchandise pictured on these pages and saying to yourself, "I could never sell that far out stuff in my store!"?

Some years ago in a seminar on merchandising, Stanley Marcus made this statement. "It is possible to sell both the finest, most expensive merchandise to those who can afford it, and simultaneously sell well-selected, good-quality merchandise at moderate prices to those in other income strata." Don't limit your merchandise possibilities by your restricted world of what you think your customers will buy based on what you have offered in the past.

The most significant concept in merchandising is that the products you offer must bring buyers to your store. This requires innovation and a willingness to go out on the limb and present the distinctive. We're not recommending that you make a big inventory investment. Instead, we are proposing that you add just enough of the unique, so your store lights up with a new look of merchandising brilliance. Remember this key point. Unless your selection of merchandise and your presentation of these products justifies a customer coming to your store, you will never attract buyers.

For the composition of silk liatris, dried flax, strelitzia and canella, the artist placed two small fossilstone display bases on a large one and created the design in the space between.

For the fresh flower and dried materials composition in the Evans Ceramics' bamboo tray, the artist anchored an inexpensive plastic container in the ceramic tray. He hot glued the sea grape leaf and Watercolors™ gyp underneath the ceramic container.

Fossilstone display bases No. 11-3021, -22, -23, -31, -32 and -33 and lamp No. 94-3141 from Toyo Trading Co., 13000 S. Spring St., Los Angeles, CA 90061. Silk liatris No. R545 from Supersilk, 1967 Third, West, Salt Lake City, UT 84115. Knud Nielsen dried materials available from your local wholesaler.

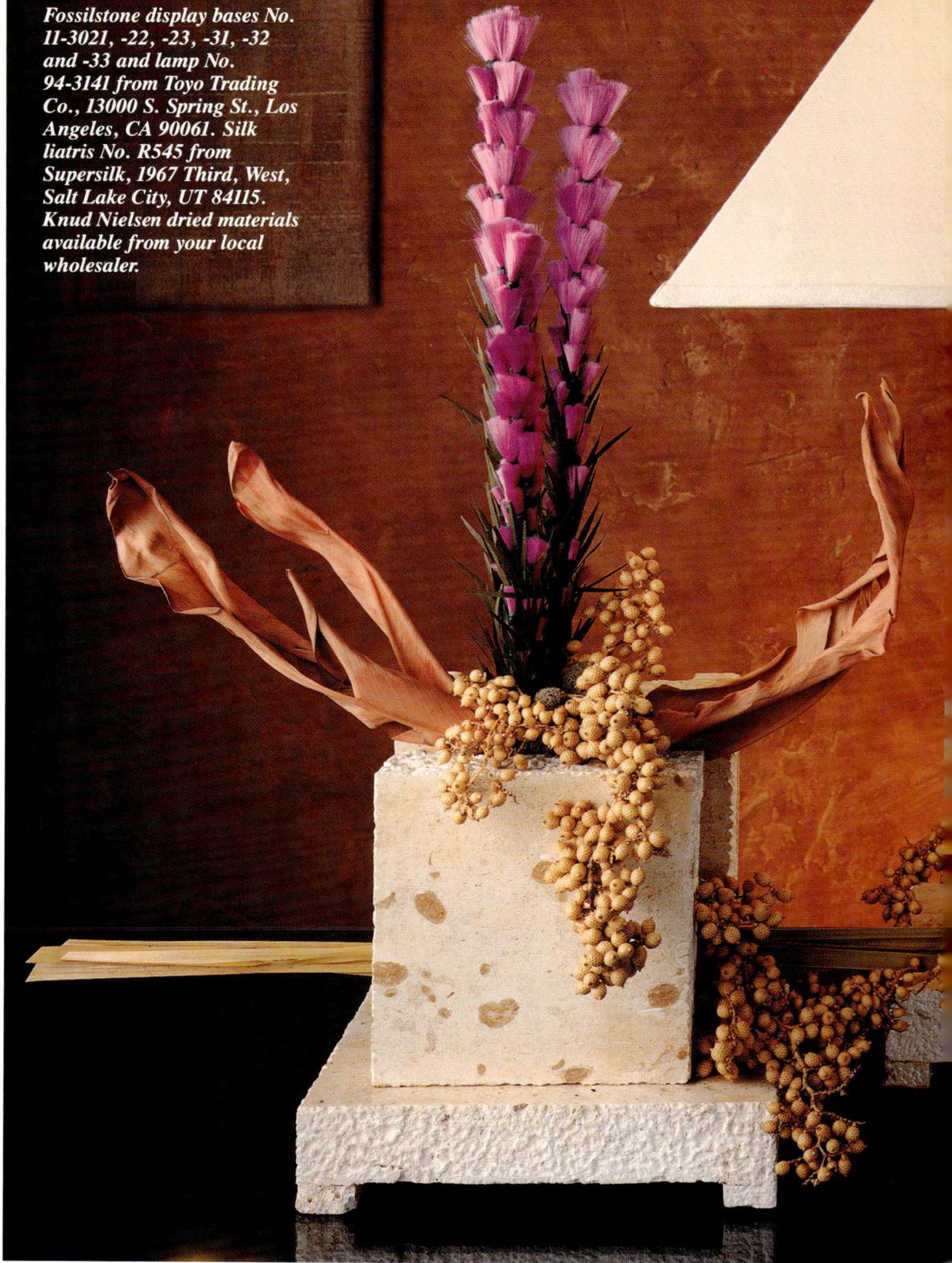

"There is a right customer for every piece of merchandise. Part of a merchant's job is to bring the two together and help the customer make the purchase." **Stanley Marcus**

Bamboo tray No. W40 ATA from Evans Ceramics, Inc., P.O. Box 1212, Healdsburg, CA 95448. Knud Nielsen Watercolors™ sea grape leaves, gyp, canella and blue raffia available from your local wholesaler.

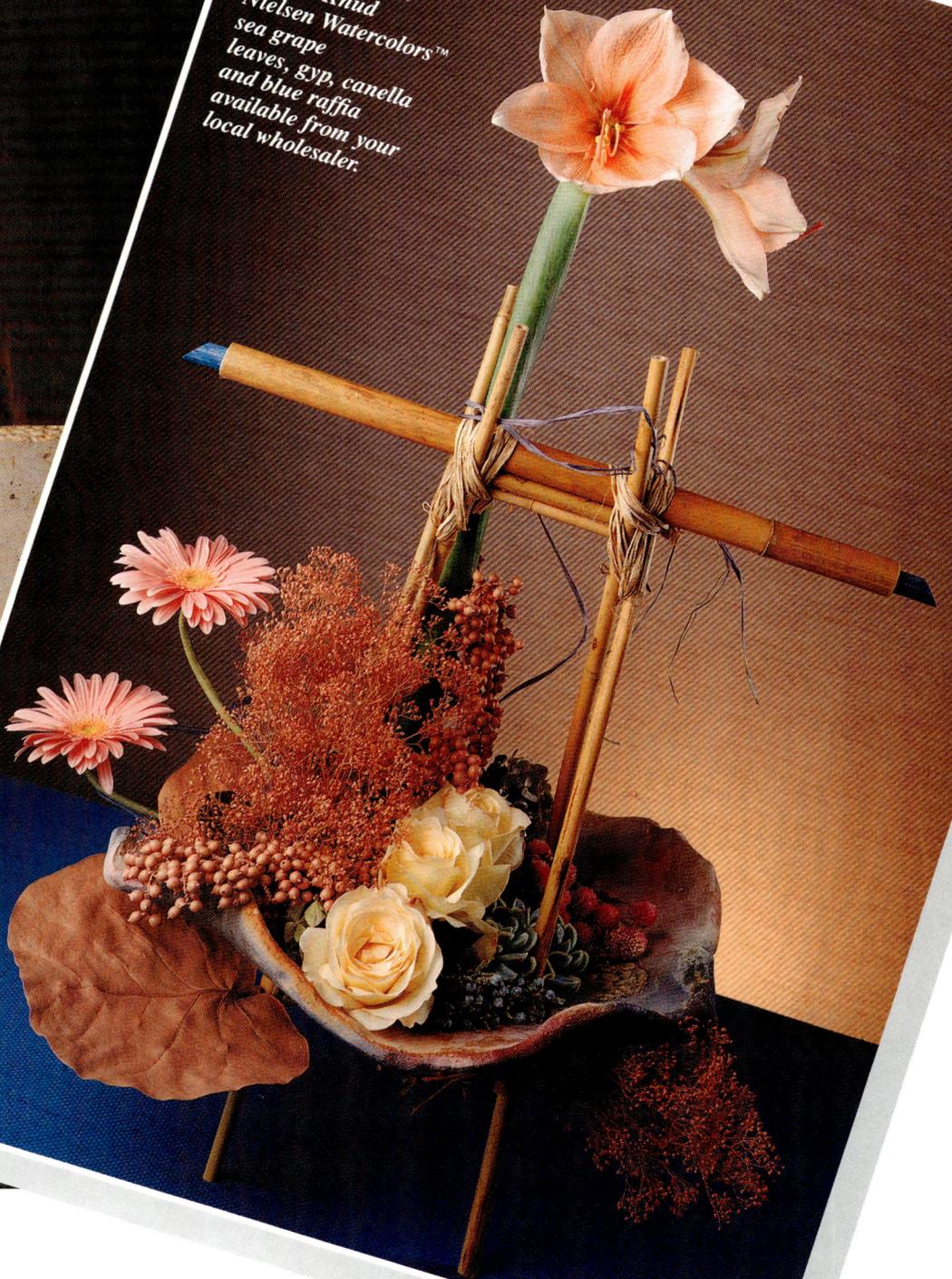

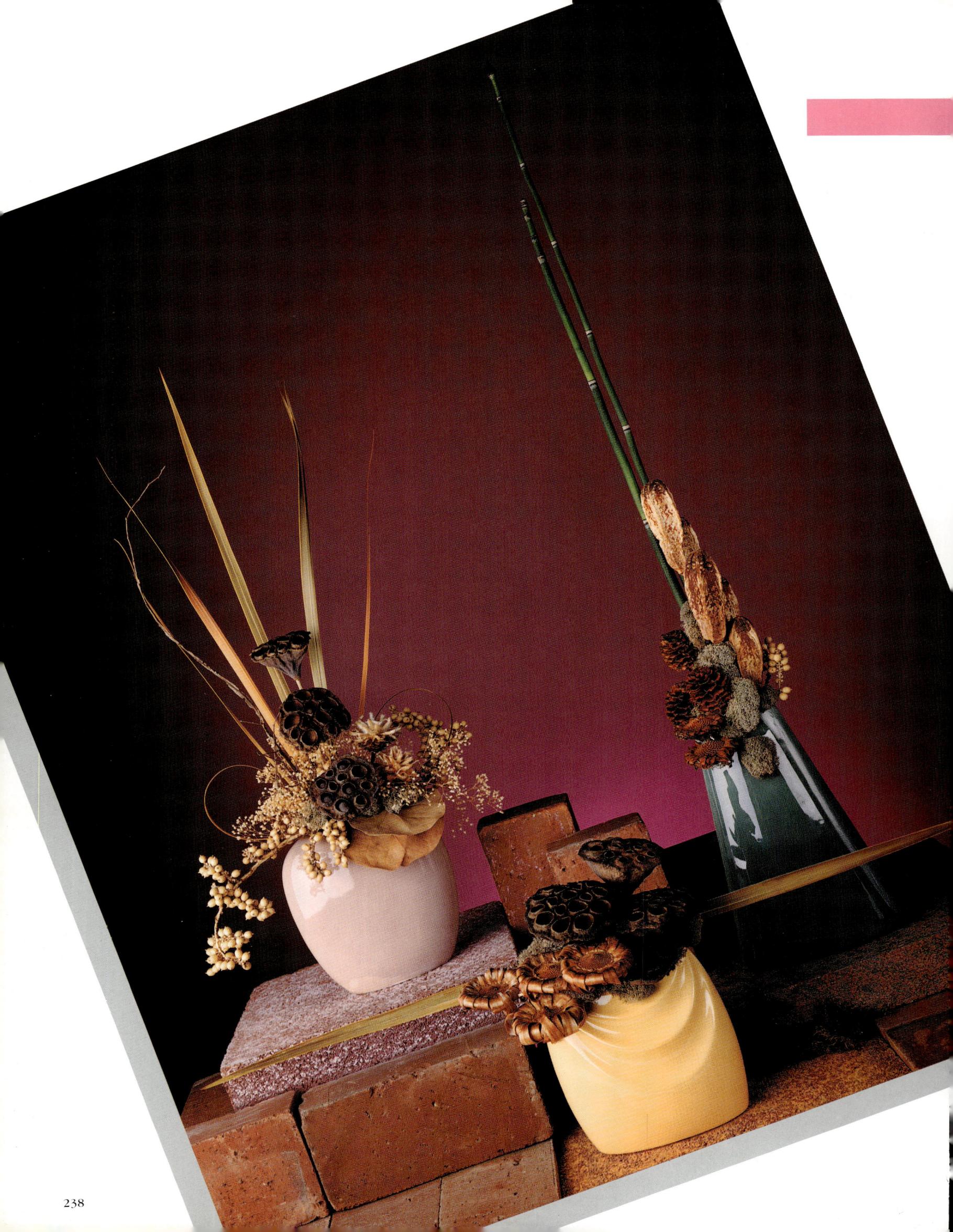

SELLING

Product Design Style

Mauve pillow vase No. 718 from Coronet Ceramics, 14520 Joanbridge, Baldwin Park, CA 91706. Blue-green triangle vase No. 816 from Shorecraft Industries, 2967 N. Goldie Rd., Oak Harbor, WA 98277. Peach container No. H5055 from A. L. Randall, P.O. Box 82, Prairie View, IL 60069. All Knud Nielsen dried materials available from your local wholesaler. Sundae glasses and wire cabinet tray painted yellow available from local houseware stores.

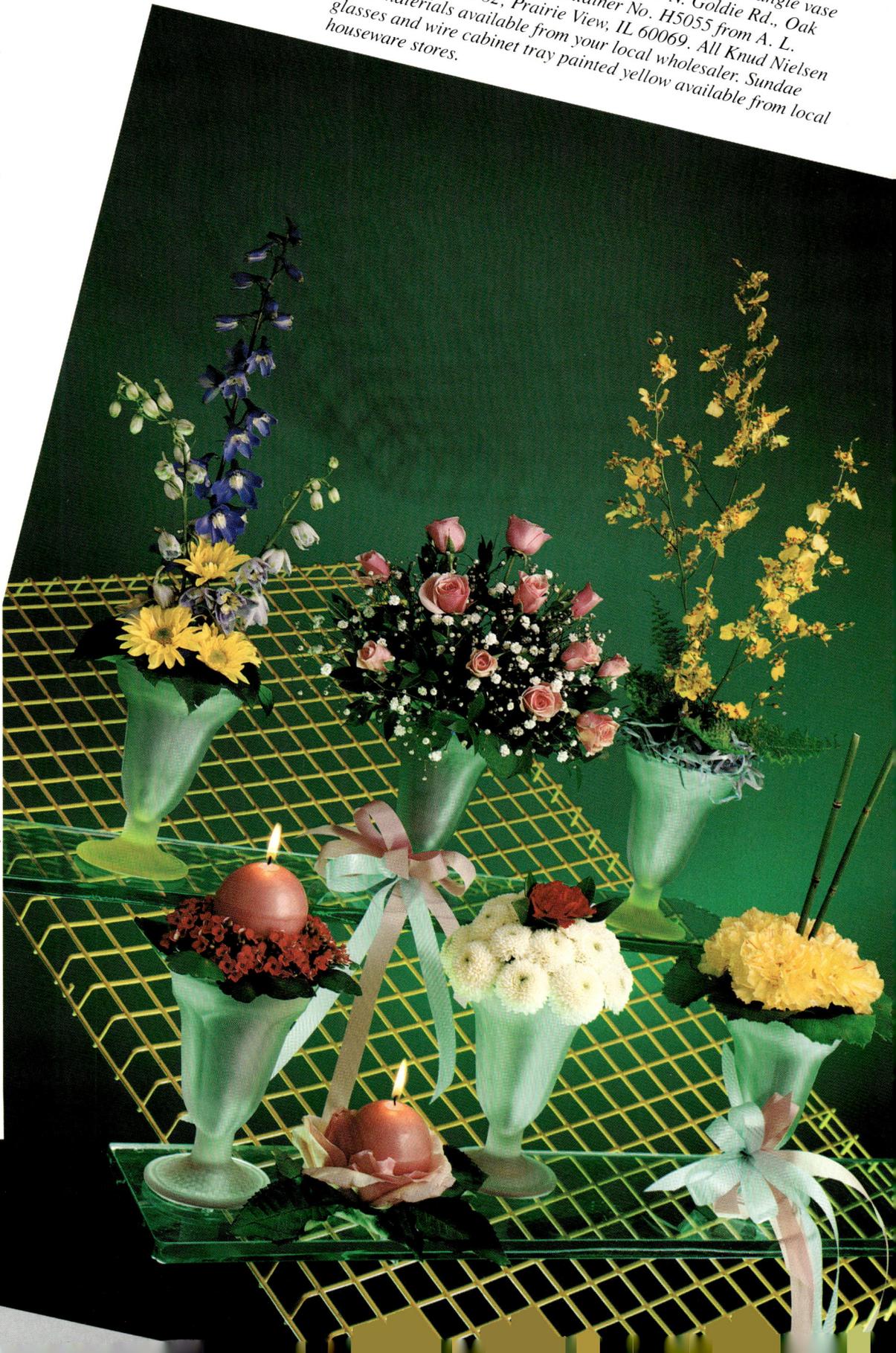

Product presentation and merchandising is an everyday responsibility in a profitable flower shop. The possibilities for merchandising are as expansive as your imagination.

Understanding two terms explains important concepts in product presentation and merchandising: (1) Point Of Purchase and (2) Product Concentration.

Point of Purchase is not a display fixture. Instead, it is the philosophy that the purpose of the product presentation is to sell the exact merchandise displayed. This is a selling concept, not a non-selling approach to parade the shop's creativity.

Product Concentration means total focus on a limited selection of items so the visual impact will be impressive and influential.

Both of the product presentations pictured carry out this Point of Purchase/ Product Concentration concept. The display with three arrangements of dried materials demands that attention is focused on these exact arrangements. Usually, the simple presentation of dried material design is far more impressive and influential to the potential buyer. Overcrowding with a divergent assortment confuses and turns off the customer's buying interest. It would be far better to have three or four displays with three arrangements in each, rather than featuring a huge display with 12 designs. Simplicity sells.

The presentation of sundae glass arrangements is a different merchandising consideration. In this presentation, the objective is to show the variety of possibilities with one idea. When a customer views this display he sees an interesting selection of ideas, flowers and prices. In this case, variety sells.